THE COMPLETE
PRINTMAKER

THE COMPLETE
PRINTMAKER

TECHNIQUES / TRADITIONS / INNOVATIONS

REVISED AND EXPANDED EDITION

JOHN ROSS / CLARE ROMANO / TIM ROSS

EDITED AND PRODUCED BY ROUNDTABLE PRESS, INC.

THE FREE PRESS
A Division of Macmillan, Inc.
NEW YORK

Collier Macmillan Publishers
LONDON

To Sylvan Cole for his long dedication to prints and the artists who create them.

Copyright © 1972, 1990 by The Free Press
A Division of Macmillan, Inc.

The Free Press
A Division of Macmillan, Inc.
866 Third Avenue, New York, N. Y. 10022

Collier Macmillan Canada, Inc.

Printed in the United States of America

Hardbound printing number

1 2 3 4 5 6 7 8 9 10

Paperback printing number

1 2 3 4 5 6 7 8 9 10

Edited and Produced by Roundtable Press, Inc.
Directors: Susan E. Meyer, Marsha Melnick
Project Editor: Sue Heinemann
Text Editor: Virginia Croft
Assistant Editor: Marguerite Ross
Design: Binns & Lubin/Martin Lubin

Library of Congress Cataloging-in-Publication Data

Ross, John
 The complete printmaker : techniques, traditions, innovations /
John Ross, Clare Romano, Tim Ross : edited and produced by
Roundtable Press.—Rev. and expanded ed.
 p. cm.
 ISBN 0-02-927371-4.—ISBN 0-02-927372-2 (pbk.)
 1. Prints—Technique. I. Romano, Clare. II. Ross, Tim.
III. Roundtable Press. IV. Title.
NE850.R59 1990
760'.28—dc20 89-11900
 CIP

Contents

PREFACE vii

ACKNOWLEDGMENTS vii

1 Relief Prints 1

ORIGINS AND DEVELOPMENT OF
RELIEF PRINTING 1

Woodcuts 9

MATERIALS AND TOOLS FOR WOODCUTS 9
PUTTING THE IMAGE ON THE BLOCK 16
CUTTING THE WOODBLOCK 20
PRINTING THE WOODCUT BY HAND 23
PRESS PRINTING 24

Color Woodcuts 28

DEVELOPING THE IMAGE 28
COLOR REGISTER METHODS 30
INKS FOR COLOR PRINTING 33
COLOR PRINTING 35
JAPANESE WOODCUT METHOD 37

Wood Engravings 42

MATERIALS AND TOOLS FOR WOOD
ENGRAVINGS 43
DRAWING ON THE BLOCK 44
CUTTING THE BLOCK 44
PRINTING WOOD ENGRAVINGS 44

Contemporary Relief Methods 46

LINOCUTS 46
RELIEF ETCHINGS 47
HAND-EMBOSSED PRINTS 48
COLLAGE RELIEF PRINTS 49

2 Intaglio Prints 65

ORIGINS AND DEVELOPMENT OF
INTAGLIO PRINTING 65
OVERVIEW OF INTAGLIO TECHNIQUES 75
CONCEPT AND IMAGERY 76
BASIC MATERIALS AND TOOLS 78

Nonacid Techniques 82

DRYPOINT 82
LINE ENGRAVING 84
CRIBLÉ 86
MEZZOTINT 86
CORRECTING ERRORS 87

Acid Techniques 89

MATERIALS FOR ETCHING 89
LINE ETCHING 95
SOFT-GROUND TECHNIQUES 96
AQUATINT 98
LIFT-GROUND TECHNIQUE 103
ADDITIONAL TONAL TECHNIQUES 106
MATERIALS FOR PRINTING 109
PRINTING AN ETCHING 112

Intaglio Color Printing 117

ONE-PLATE METHOD (À LA POUPÉE) 117
SURFACE ROLL 118
CUT-PLATE METHOD 118
LAYERED PLATES 120
STENCILED COLOR 120
CHINE COLLÉ 121
MULTIPLE-PLATE PRINTING 123
TRANSFERS FROM OTHER PLATES 126
VISCOSITY METHOD 127

3 Collagraphs 131

ORIGINS AND DEVELOPMENT OF
COLLAGRAPHS 132
MAKING THE COLLAGRAPH PLATE 133
PRINTING THE COLLAGRAPH 142

4 Screen Prints 143

ORIGINS AND DEVELOPMENT OF
SCREEN PRINTING 143

General Methods and Equipment 147

BASIC EQUIPMENT 147
SCREEN 147
SQUEEGEE 153
REGISTER GUIDES 154
OVERVIEW OF STENCIL TECHNIQUES 156

Water-Based Ink Methods 156

MATERIALS AND TOOLS FOR
WATER-BASED METHODS 157
PAPER STENCIL: POSITIVE METHOD 157
MYLAR AND TAPE STENCILS:
POSITIVE METHOD 158
LACQUER FILM STENCIL 159
WATER-SOLUBLE STENCIL:
NEGATIVE METHOD 160
BLOCK-OUT SOLUTION STENCIL:
NEGATIVE METHOD 162
BLOCK-OUT OR RESIST STENCILS:
POSITIVE METHOD 162
PHOTOGRAPHIC STENCILS 163
WATER-BASED SCREEN INKS 169
PAPER 170
PRINTING WITH WATER-BASED INKS 170

Oil-Based Ink Methods 172

PAPER STENCILS 172
BLOCK-OUT STENCILS 174
RESIST METHODS 176
IMPASTO PRINTING 179
HAND-CUT FILM STENCILS 179
DIRECT PHOTO METHODS 181
DIRECT PHOTO FILM TECHNIQUES 181
OIL-BASED SCREEN INKS 182
PRINTING WITH OIL-BASED INKS 185
SCREEN PRINTING ON OTHER MATERIALS 187
POCHOIR PROCESS 189

5 Lithographs 191

ORIGINS AND DEVELOPMENT OF
LITHOGRAPHY 191

Basic Lithographic Method 199
LITHOGRAPH STONES 199
PREPARING A METAL PLATE 202
PLACING THE IMAGE ON THE STONE 202
USING TRANSFER PAPER 206
ETCHING A STONE 207
ETCHING A PLATE 208
MATERIALS FOR PRINTING 217
PRINTING THE LITHOGRAPH 220
COLOR LITHOGRAPHY 224

**Additional Lithographic
Methods** 227
TONE REVERSALS 227
WHITE LINE ENGRAVINGS 228
WHITE LINES ON A BLACK BACKGROUND 228
WORKING ON HEATED STONES 229
FROTTAGE TRANSFERS 229
PHOTOLITHOGRAPHY ON POSITIVE PLATES 230
PHOTOLITHOGRAPHY WITH DIAZO
SOLUTIONS 231
AMMONIUM BICHROMATE PROCESS 234
GUM BICHROMATE PROCESS 234

6 Dimensional Prints 235

UNINKED EMBOSSINGS 237
CAST-PAPER PRINTS 237
LEAD RELIEFS 240
CONSTRUCTED PRINTS 240
PLASTER CASTS 241
VACUUM FORMING 242
SEWN PRINTS 243

7 Monotypes 245

ORIGINS AND DEVELOPMENT OF
MONOTYPES 246
DEVELOPING MONOTYPE IMAGERY 251
DIFFERENT MONOTYPE TECHNIQUES 252
PAPER SELECTION 257
PRINTING THE MONOTYPE 257
REWORKING THE MONOTYPE 258

8 Photographic Techniques 259

TRANSPARENCIES 259
PHOTOETCHING 262
PHOTOGRAVURE 264
COLLOTYPE 265
HELIO-RELIEF PROCESS 266
COPIER ART 266
DIAZO PRINTERS 268
OTHER IMAGING SYSTEMS 268

9 Computers and the Print 269

BASIC HARDWARE 270
SOFTWARE 272
PRINTING FROM COMPUTERS 276
PHOTOGRAPHING COMPUTER IMAGES 278
NEW ASPECTS OF COMPUTER PRINTING 278

10 Paper for Prints 279

ORIGINS AND DEVELOPMENT OF
PAPERMAKING 279
PRINCIPLES OF PAPERMAKING 281
MAKING A SHEET OF PAPER 284

11 Art of the Book 287

PLANNING A BOOK 289
PRINTING THE BOOK 290
BINDING THE BOOK 295

12 Business of Prints 305

EDITION SIZE 306
EDITION NUMBERING 307
RECORDKEEPING 308
MATTING THE PRINT 308
FRAMING THE PRINT 310
STORING PRINTS 311
SHIPPING PRINTS 312
DISTRIBUTING YOUR PRINTS 312
THE PRINT DEALER'S PERSPECTIVE 314
PRINT-PUBLISHERS AND
COLLABORATIVE PRINTS 316
THE ARTIST AND THE LAW 317

13 Health Hazards 321

EQUIPPING A SAFE SHOP 322
HANDLING HAZARDOUS MATERIALS 324
HAZARDS IN SPECIFIC PRINTMAKING
TECHNIQUES 326

14 School Printmaking 329

MONOTYPES 330
OBJECT PRINTS 331
OFFSET ROLLER PRINTS 331
CARDBOARD AND PAPER PRINTS 332
STENCIL PRINTS 333
STYROFOAM PRINTS 333
COLLAGE PRINTS 333
WOODCUTS AND LINOCUTS 334
3M VINYL AND ACETATE PRINTS 335
GLUE PRINTS 335
STAMPED PRINTS 335
PAPER PLATE LITHOGRAPHY 336
DRYPOINT, EMBOSSING, AND ETCHING 336

15 Sources and Charts 337

SUPPLIERS 337
ETCHING AND LITHOGRAPHIC PRESSES 340
WATER-BASED SCREEN INKS 340
SCREEN-PRINTING INKS 341
PAPERS FOR PRINTMAKING 342

BIBLIOGRAPHY 344

GLOSSARY 346

INDEX 349

Preface

Printmaking today takes place on a number of levels, from the beginner cutting a linoleum block to a sophisticated mixed media extravaganza produced by a professional workshop. The first level— one of searching, learning, and experimenting—usually takes place in a high school or college offering classes in printmaking methods. It is here that many artists first encounter the rigors and rewards of the print, and some may begin to develop a long-term commitment.

The next level of printmaking occurs in or around a university or professional art school campus, or sometimes in a private print workshop. Here one finds an interesting lot of artists, many prominent in their locality rather than nationally. They often work without the support of edition printers and have few assistants, at least on a regular basis. Their prints reflect a diverse and intense vision of contemporary life.

The level of printmaking that receives the most attention involves the major artists who are supported by a complex network of museums, galleries, art critics, and, most important, high-tech artist-printmakers, who produce the prints in conjunction with the artists. No one person has all the skills required for the elaborate works that are possible today. Techniques are mixed with ease, with intaglio, woodcut, screen print, lithography, photocopying, collage, cast paper, and other new methods combined to create works with a profusion of color and texture. New processes, such as helio-relief, have been perfected while old processes, almost forgotten, such as collotype and photogravure, have been resurrected and used again to produce fresh images.

Working with innovative artists, the new breed of print publishers is expanding the vocabulary of the print in exciting ways. Some print workshops are superbly equipped, with presses that can handle prints of a size rivaling large paintings. There are also custom-made paper molds that require three or four people to lift them from the vat of pulp.

While many of the new prints are large, abstract, and colorful, the overwhelming number of participants in contemporary printmaking insures that all directions and viewpoints are represented. There are many ways to make meaningful and wonderful prints. A single artist, working alone, can still produce an image of incredible power and esthetic strength. The technique should be only a means to an end—that of creative expression at the highest level.

Acknowledgments

This revised edition of *The Complete Printmaker* could not exist without the cooperation of a number of artists, galleries, publishers, collectors, and museums. In particular, we wish to thank those artists who helped us with information on their experiments with new printmaking methods, including Myril Adler, Al Blaustein, Gary Edson, Jeremy Gardiner, Issac Victor Kerlow, Margot Lovejoy, Donna Moran, Philip Pearlstein, Miklos Pogany, Thomas Porett, John Risseeuw, Krishna Reddy, Claire Van Vliet, and Mark Wilson.

Lynwood Kreneck, professor at Texas Tech University in Lubbock, Texas, was particularly helpful with his notes on water-based screen printing, as were Lois Johnson, chairperson, and Franz Spohn of the College of Art and Design of the University of the Arts in Philadelphia. Marie Dormuth of Cooper Union School of Art in New York helped us with this technique and enabled us to find student work to reproduce in the screen-print chapter.

Philip Pearlstein lent us color slides of his work at Graphicstudio, University of South Florida, at Tampa, while Donald Saff and Deli Sacilotto were generous and cooperative in providing material and information from this productive workshop. Helen Frederick of Pyramid Atlantic in Washington, D.C., was a source of knowledge about paper, artists, and books, while Ed Colker, provost of the University of the Arts in Philadelphia, shared his interest in the art of the book with us.

We are indebted to Franklin Feldman for his thoughts on the artist and the law and to Sylvan Cole for his notes on the artist-dealer relationship. Ed Colker, Michael Knigin, Monona Rossol, Lois Johnson, and Marie Dormuth read various sections of the manuscript, and we are thankful for their suggestions and criticisms.

Many galleries and print publishers were supportive and encouraging, enabling us to select those artists whose work is in this edition. Ken Tyler, director of Tyler Graphics, an inspiring leader, and his staff, including Kim Tyler and Marabeth Cohen, were extremely helpful in allowing us to research many of their projects. Judith Solodkin of Solo Press granted us repeated access to her fine

workshop, while Peter Kruty and Dan Stack showed us details of their procedures that were invaluable. Maurice Sanchez of Derrière L'Etoile, Bruce Porter of Trestle Editions, Bob Blanton and Bill Wygonik of Brand X, and Adi Rischner, director of Styria Studio, along with his master printer Steve Sangenario were unstinting in their help.

Jody Rhone of Crown Point Press, Diane Iacobucci of Parasol Press, Sid and Ben Schiff of the Limited Editions Club, and Margo Dolan of Dolan/Maxwell were also particularly helpful. Other cooperating galleries include Peter Blum Editions, Brooke Alexander Gallery, Castelli Graphics, the Experimental Workshop, Garner Tullis Workshop, Fawbush Gallery, Petersburg Press, Landfall Press, Pace Gallery, Susan Teller Gallery, Reiss-Cohen, Barney Weinger, and Zabriskie Gallery. Andrew Stasik at John Szoke Graphics was instrumental in obtaining several prints for us, while Reba and Dave Williams shared information and slides of their screen-print collection.

Bill Goldston of Universal Limited Art Editions was cooperative and generous in his help, introducing us to Craig Zammiello, whose expertise in photogravure was impressive. Clinton Clines's notes from an earlier interview on this technique proved essential and we are grateful.

Workshops photographed include Robert Blackburn's Printmaking Workshop in New York, the Manhattan Graphic Center, Rutgers' Mason Gross School of the Arts, directed by Judy Brodsky, and the Pennsylvania Academy printshop with Peter Paone. A number of teachers and public school professionals including Caroline Rister Lee, Natalie Schifano, and Nadine Gordon were especially helpful in obtaining student artwork for the section on school printmaking.

At the Parsons/New School workshop in New York City, William Phipps and Herman Zaage helped in many ways, from compiling lists of suppliers to photographing printmaking procedures. Roberta Waddell, curator of prints at the New York Public Library; Barry Walker, associate curator in the department of prints and drawings at the Brooklyn Museum; and Meg Grasselli at the National Gallery of Art in Washington, D.C., were cooperative and gracious in helping us search for images of prints.

The manuscript was typed by Meg Ross and Diane Rissinger, edited by Virginia Croft and Sue Heinemann, who was the efficient general coordinator of the project. Diane Rissinger compiled the index, and Roundtable Press, with Susan Meyer and Marsha Melnick as the directors, was vital to the completion of this edition of the book.

Many of the photographs are by John Ross and Tim Ross; Ben Ness Photo labs in New York City did most of the processing. The drawings are by John Ross.

Finally, we must thank the president of the Free Press, Erwin Glikes, for his encouragement and the direction so necessary for the completion of this work. Our appreciation also to Roslyn Siegel, project editor at the Free Press, for her patience and enthusiasm.

1 Relief Prints

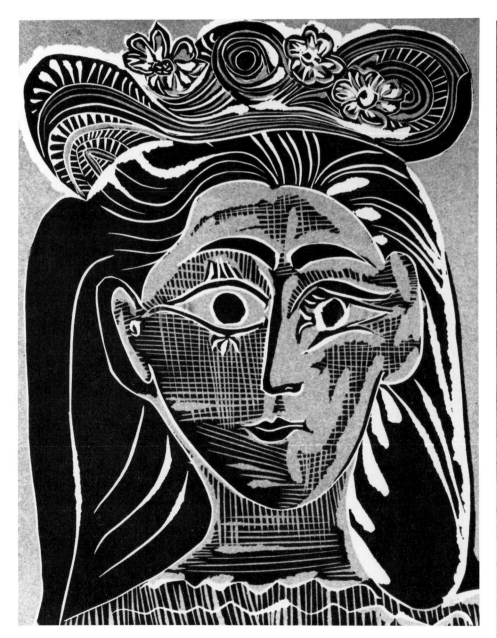

PABLO PICASSO
Woman with a Flowered Hat, 1962
Reduction linocut, 13¾″ × 10¾″
Courtesy Reiss-Cohen, Inc.
Photo by Nathan Rabin

Among the most appealing aspects of relief printmaking are the directness and swiftness of making an image and the simplicity of the materials used in creating it. In a relief print it is the surface of the block that yields the image; the areas that do not print are cut away, as in a woodcut or linocut, or a positive image is created by cutting white lines into the block, as in a wood engraving. In a collage print the relief surface is achieved by adhering materials to a support plate. In all methods ink is rolled on the surface, paper is then placed upon it, and this is either rubbed by hand or run through a press to produce an image.

Of all the forms of expression in printmaking, the relief print is the most ancient. Although it is not possible to relate the rich history of the relief print in a limited space, a few highlights can help illuminate the historical precedence for many technical procedures we use today.

Origins and Development of Relief Printing

The history of the relief print is the history of people's desire to communicate information, first through symbols and later through images and the printed word. The relief print can be traced to prehistoric origins, when early cave dwellers developed a unique iconography in both the Western and Eastern hemispheres. The engraved and scratched lines filled with earth colors that decorated the walls of caves were certainly a precursor to printmaking. Incised, en-

graved, and carved images were an important form of human expression. The earliest evidence of the production of impressions from carved reliefs comes from the Sumerians, who date from 4000 B.C. Among their carved reliefs are stamping devices that they pressed into moist clay. They also carved cylinders of lapis lazuli, alabaster, and other materials, which could be rolled into soft clay to leave the imprint of some authoritative signature. By stretching the imagination a bit, these imprints can be regarded as multiple prints on clay.

The Olmec Indians of Mexico, who date from 1000 to 800 B.C., baked clay tubes with relief designs that were used to print repeat patterns, perhaps on bark or on their own bodies. However, even the Olmecs' use of some form of color to roll out their multiple designs did not lead to printing for communication.

The transition from clay and stone to wood for stamping seems to have occurred in Egypt, where early examples of woodblocks used for printing textiles date to the sixth or seventh centuries A.D. It was also at about this time that examples of printing on textiles and paper appeared in China. The invention of paper in China as early as 107 B.C. had opened up the possibility of multiple printing and the dissemination of images and information.

EARLY WOODCUTS IN THE EAST

The advent of paper answered the popular need to produce rubbings from stone inscriptions of the writings of Buddha. Dampened paper could be pressed into the inscriptions to yield an impression of the forms, or a pad of ink could be rubbed on the surface of the paper so that raised white writing appeared on a blackened ground. We can only guess that the logical next step was to carve the inscriptions into woodblocks, apply a water-based ink to the surface, and pull a hand-rubbed print much as we do today.

The earliest woodblock print bearing an image appears in the 17-foot-long *Diamond Sutra* scroll, printed by Wang Chieh in A.D. 868. This complex figurative image with text was discovered by a

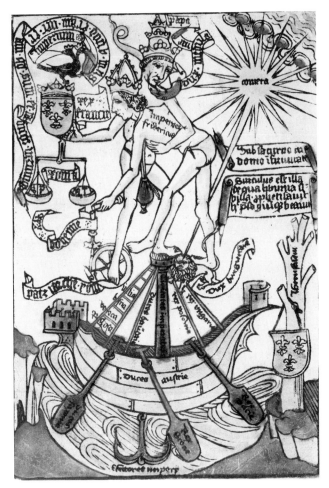

ANONYMOUS
Allegory on the Meeting of Pope Paul II and Emperor Frederick III, 1469–73
Woodcut
National Gallery of Art, Washington, D.C.

Taoist priest when he opened a sealed cave in eastern Turkestan in 1900. Because the text and image were cut from one block, this combination is referred to in the West as a block book. The complex and sophisticated imagery in the *Diamond Sutra* suggests that the Chinese had a much earlier history of printing from woodblocks onto paper and textiles. Color printing from more than one block dates from the same period.

Through succeeding centuries, the Chinese produced thousands of extraordinary block books on medicine, botany, agriculture, poetry, and literature. They printed complex block books with color plates in the seventeenth century, including two "how-to" manuals—the *Ten Bamboo Hall Painting Book*, a collection of exercises in drawing birds, fruits, and flowers, and the *Mustard Seed Garden*—for artists in need of instruction and inspiration. These books were later brought to Japan, where they influenced the development of the Ukiyo-e prints. Although the Chinese developed woodcuts of great skill and beauty, they seem to have lost interest in the medium after a period of years, and there was little further development of color in the Chinese woodcut.

EARLY WOODCUTS IN THE WEST

The woodcut in Western art appears to have evolved in much the same way as it did in the East. It fulfilled a utilitarian need in the printing of textiles and helped to propagate the faith through the printing of images of a devotional nature. In the fourteenth and fifteenth centuries literacy was a rarity enjoyed only by the church hierarchy and the ruling classes. What better method was there to inform the ignorant populace of the late Middle Ages than to produce prints that could narrate the story of Christ, the Virgin Mary, and the lives of the saints?

Paper from the East was known in Spain in the twelfth century, but only when it was produced in large quantities in France, Italy, and Germany in the fourteenth century did the art of the woodcut begin to flourish.

The oldest surviving European woodblock is a fragment of a Crucifixion scene dating from the late fourteenth century. Called the *Bois Protat*, it was

found in a monastery in eastern France in 1899. The block is cut on both sides, but only one side is intact enough to print. Because the complete scene measured a good 2 feet square and paper at the time was never that large, it is thought that it once was printed on cloth for a banner or altarpiece.

In southern Germany, woodcuts began as primitive religious images. Their directness, simplicity of line, and economy of means made them very powerful. They were handbills for veneration, sold for pennies to pilgrims visiting holy places and to the populace on religious feast days. Woodcuts of Christ or the Virgin Mary were often pasted inside traveling chests or onto small altarpieces and frequently sewn into clothing to give protection from evil forces. Many were hand-colored to add reality and make them more appealing.

Although card playing existed in the thirteenth century among the upper classes, it was not until paper came into common use in Europe in the fourteenth century that woodcut playing cards reached the masses. Early images depicted soldiers in Germany and an alphabet series in Italy, and in France cards showed decorative court personages similar to those on today's playing cards.

RELIEF PRINTS IN PRINTED BOOKS

Before printing from movable type took over in the middle fifteenth century, block books similar to those in the Orient appeared in western Europe. Pictures and words were cut on the same block. Outstanding block books were produced in the Netherlands: the *Apocalypse of St. John*, the *Art of Dying*, and the *Pauper's Bible* were copied many times in Germany and the rest of Europe. The block-book Bible provided important models for Master E.S. and Martin Schongauer.

Although movable type had already been invented in Korea and used by the Chinese for many centuries, it was not until the 1450s that Johannes Gutenberg of Mainz, Germany, developed his method of printing from cast-metal type. The block book became obsolete, as did the scribe, and a new era opened in western Europe as printing shops sprang up to fill the demand for books and woodcut illustrations. Although the new press-printed books could not compare with the illuminated manuscripts of the nobility, the middle class at last had access to legible texts.

The second half of the fifteenth century was also the period when dotted metal, or criblé, prints were printed from pewter or copper. Gravers, drills, and punches of narrow sizes and shapes were scooped or hammered into metal to create fine lines that printed white or black when inked and printed as a relief print. This painstaking method was popular in northern Europe but rarely pursued in Italy. The results were decorative but of limited creative influence.

RENAISSANCE MASTERS OF THE WOODCUT

It was at this time that painters began to show an interest in making woodcuts. It is thought that in Ulm, Martin Schongauer's brother Ludwig drew adaptations of Martin's engravings onto wood. In 1486 Erhardt Reuwich of Utrecht, the first artist to be named in print, made a spectacular panoramic woodcut of Venice that was 5 feet long, the first folding plate in any Western book. Later Reuwich's blocks were adapted in the *Nuremberg Chronicle*, a pioneer encyclopedia of world history.

By the late fifteenth century, the great artists of northern Europe—Albrecht Dürer, Hans Holbein the Elder, Hans Baldung Grien, and Lucas Cranach in Germany, and Lucas van Leyden in the

ALBRECHT DÜRER
The Riders on the Four Horses
(From the *Apocalypse*, c. 1496)
Woodcut
Metropolitan Museum of Art, New York
Gift of Junius S. Morgan, 1919

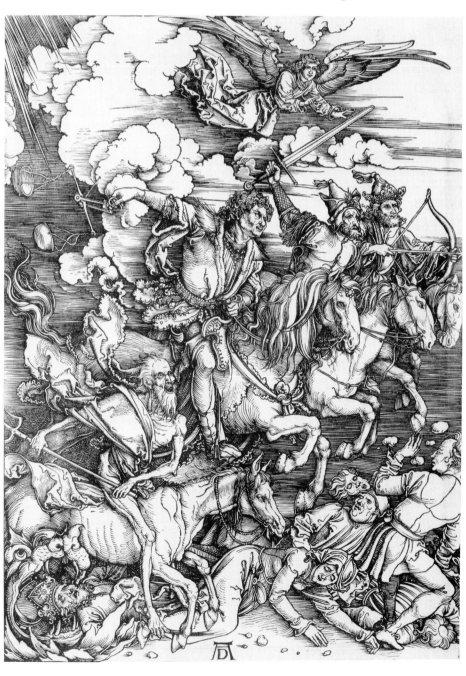

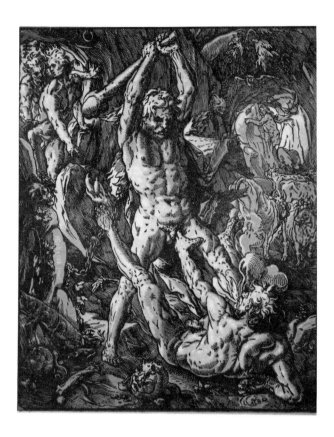

Netherlands—were making woodcuts of great eloquence. Dürer (1471–1528) in particular widely influenced other artists. In addition to numerous single prints, he produced four superb woodcut series: the *Great Passion,* the *Small Passion,* the *Apocalypse,* and the *Life of the Virgin.*

Dürer himself was greatly influenced by Italian Renaissance art, which he had encountered on his travels to Italy when he was in his early twenties. Many of the Italian figurative woodcuts reflected the graceful draftsmanship of Sandro Botticelli, with a thinner, more fluid line than that in northern European woodcuts.

Multiple-block color printing was done as early as 1508 by the German Jost de Negker, with Lucas Cranach and Hans Burgkmair taking up the method soon after. Called chiaroscuro woodcuts, these works resembled tonal drawings in that several values of one color were printed from separate blocks, starting with the lightest tone. The Germans depended on an outline block and added color, while the Italians, notably Ugo da Carpi, minimized the outline and al-

lowed the tones to produce the image in a more painterly manner. Da Carpi copied the work of important masters and emphasized sweeping compositions, which became a popular way of working for centuries.

It is worth noting that Titian (c. 1488–1576) engaged craftsmen to cut his images. His *Pharaoh's Army Submerged in the Red Sea* (1549) is a spectacular work cut by Domenico dalle Greche but probably drawn on the block by Titian. Cut on twelve blocks, it is truly a mural, 4 feet high by 7 feet wide. An interesting inscription on the print reads, "This paper tapestry was drawn by Titian's immortal hand."

THE DEVELOPMENT OF WOOD ENGRAVING

As interest in the intaglio techniques of etching and engraving became more widespread, woodcuts by major artists began to diminish. Because etching and engraving permitted finer detail, they seemed to eclipse the woodcut—at least until 1780, when Thomas Bewick (1750–1828), an Englishman, developed a method of engraving into hard blocks made of boxwood. On this smooth, hard surface, he produced clean, fine white lines with incredible detail that did not break down in printing. When these

boxwood blocks were carefully inked and locked up in a press, thousands of sharp impressions were possible. The method revolutionized the use of illustrations for newspapers, periodicals, books, and advertisements. Soon craftsmen adopted this new method to mass-produce popular paintings, which an eager middle class snapped up, but little imaginative creative work ensued.

UKIYO-E AND ITS INFLUENCE ON WESTERN ART

While Western artists had turned away from the woodcut by the seventeenth century, truly elegant woodcuts called Ukiyo-e, or "pictures of the transient world of everyday life," were created in eighteenth-century Edo, now Tokyo. These prints reflected on the pleasures of life: the world of fashion and beauty, the theater, and erotic, joyous sexual encounters. The origins of Ukiyo-e may have been in the superb little Chinese manuals on how to paint that we mentioned earlier. And according to A. Hyatt Mayor in his *Prints and People,* color printing may have come to the Orient from Europe in 1549, when Saint Francis Xavier arrived in Japan, possibly bringing chiaroscuro woodcuts with him. No matter what the origins, the multicolor prints of eighteenth- and nineteenth-century Japan present us with an eloquent concept of color in the woodcut.

Both chiaroscuro and Ukiyo-e prints used multiple blocks, but the Japanese method differed in using water-based color and dampened rice paper for printing. Such major artists as Utamaro, Sharaku, Harunobu, Hokusai, and Hiroshige made prints of great refinement that also appealed to the poorer classes and the uneducated. Like the medieval woodcuts of northern Europe, Ukiyo-e had little monetary value attached to them. Selling for a few yen, they were bought by travelers as souvenirs and posted in homes.

There are many tales of Ukiyo-e prints first arriving in Paris in the nineteenth century as packing material for art objects. However, as early as 1775 a Swedish naturalist, Carl Peter Thunberg, spent considerable time in Nagasaki as-

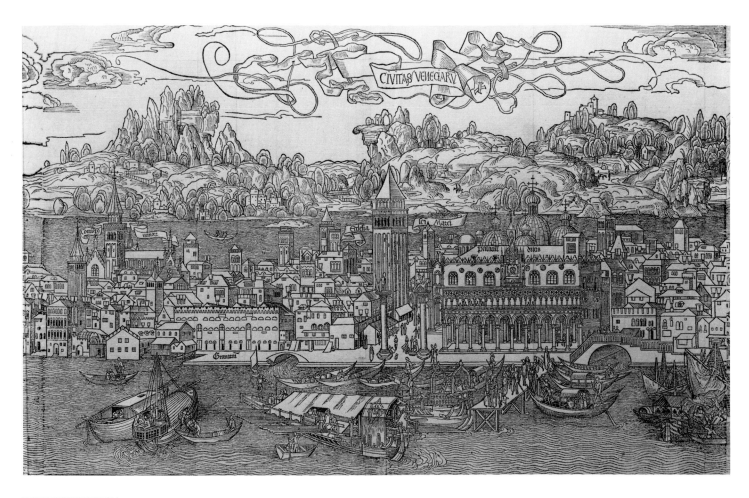

ERHARDT REUWICH
View of Venice, **1486**
(From *Sanctae Peregrinationes*
by Bernhard von Breydenbach)
Metropolitan Museum of Art, New York
Rogers Fund, 1919

Right:
TOYOKAWA YOSHIKUNI
Nakamura Shikan II as Sawai Matagoro, **1829**
Color woodcut, 14¾″ × 9⅞″
Collection of the authors

Below:
THOMAS BEWICK

Wood engraving, 1¾″ × 2⅝″
(shown actual size)
Collection of the authors

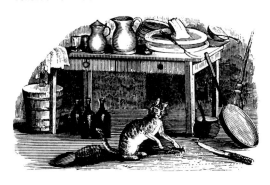

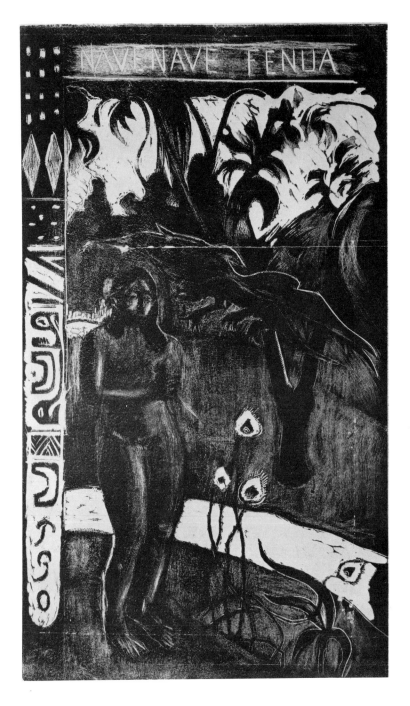

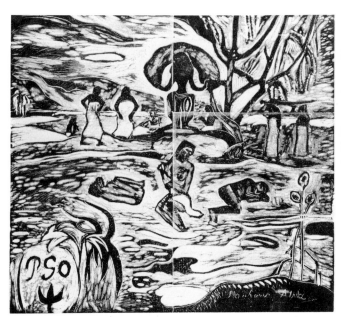

PAUL GAUGUIN
*Mahana Atua (**Feast of the Gods**)*
Woodcut (*top*) and woodcut block (*bottom*)
National Gallery of Art, Washington, D.C.
Rosenwald Collection

PAUL GAUGUIN
*Nave Nave Fenua (**Delightful Land**)*
(From the *Noa Noa Suite*, 1894–95)
Woodcut, 14″ × 8″
National Gallery of Art, Washington, D.C.
Rosenwald Collection

sembling a collection of Ukiyo-e. Dutch sea captains in the early 1800s formed extensive collections that were known in Paris. In 1860 the British magazine *Once a Week* contained articles about traveling in Japan illustrated with some of Hiroshige's landscapes. By 1862 a Japanese curio shop opened in Paris and sold many of the Ukiyo-e prints. When the Paris Exposition Universelle exhibited a large quantity of Ukiyo-e in 1867, the Paris art world became profoundly aware of the art form.

Following this exhibition, many Western artists began to incorporate the concepts of Ukiyo-e into their work. Although the art was declining in intensity and quality in Japan, it had great impact on the avant-garde in Paris. Paul Gauguin, Vincent van Gogh, Mary Cassatt, Henri de Toulouse-Lautrec, James Abbott McNeill Whistler, Edgar Degas, Edouard Manet, and Camille Pissarro were all influenced by the asymmetrical compositions, strong designs, and stylized forms of Ukiyo-e. They admired and frequently emulated the Japanese use of flat color, pattern, and line as intrinsic compositional elements.

The influence of the Japanese print was felt not only in Western painting but also in printmaking. The woodcuts of Paul Gauguin (1848–1903) show a strong Japanese influence. Although the artist conceived his blocks in black and white, he was interested in the use of color. He experimented with printing a block in black, then reinking it in another color, usually brown, and printing it slightly off-register. He added brilliant color to some prints with stenciling or hand col-

oring. Gauguin's innovative approach to the woodcut influenced the woodcuts of the Norwegian artist Edvard Munch (1863–1944), who explored color printing even further and made the actual wood grain an important element in his work. Munch sometimes used separate blocks for each color; other times he used one block cut into separate color areas, inked separately, and reassembled for printing with one rubbing. These are powerful prints, in which color and form are synonymous.

GERMAN EXPRESSIONIST WOODCUTS

In Germany a revival of the woodcut occurred in 1905, when Die Brücke ("The Bridge"), a group of artists in Dresden, turned to the woodcut as an ideal medium for their vigorous expressionism. In their desire to create a new art form and to counteract the romantic classicism of the entrenched academicians, they turned to the simplicity and directness of medieval woodcuts and tribal art for inspiration.

The initial group was led by Erich Heckel and Karl Schmidt-Rottluff and included Ernst Ludwig Kirchner, Emil Nolde, Max Pechstein, and Otto Müller. Käthe Kollwitz and Ernst Barlach, though not part of the group, were influenced by their esthetic direction.

The renewed interest in the woodcut was also a strong part of the Blaue Reiter ("Blue Rider") movement initiated by Wassily Kandinsky and Franz Marc in 1911. Other important artists in the group were Paul Klee, Lyonel Feininger, and Alexei Jawlensky.

MEXICAN POLITICAL AND SOCIAL PRINTS

In the Western hemisphere, José Guadalupe Posada (1852–1913), a self-taught Indian, was a most influential originator of a powerful graphic movement that used the print for political and religious imagery. The Mexican Revolution of 1910–20 and political, social, and religious issues were sources for his lurid humor of throat cutting, firing squads, and All Souls' Day highjinks. His metal cuts and relief etchings were printed for a few pesos, much as medieval woodcuts had been disseminated centuries earlier. Posada's simple, biting images had a significant influence on Diego Rivera, José Clemente Orozco, and David Alfaro Siqueiros.

CONTEMPORARY RELIEF PRINTS

In the United States, the Works Progress Administration in the 1930s helped to revive interest in the print in general, with gifted artists such as Louis Schanker, Stuart Davis, and Milton Avery taking a new interest in its poten-

MAX BECKMANN
Group Portrait at the Eden Bar
Woodcut
National Gallery of Art,
Washington, D.C.
Rosenwald Collection

EMIL NOLDE
Dr. P. (Profile), 1911
Woodcut
Brooklyn Museum
Gift of Mrs. Margarete Schultz

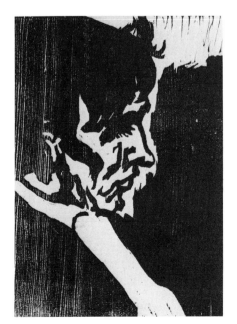

ERNST L. KIRCHNER
Alpine Shepherd, 1917
Woodcut
Brooklyn Museum
Lent by Paul J. Sachs,
Courtesy Fogg Museum

tial. However, it was only after the Second World War that a greater focus on the woodcut could be seen in the work of Leonard Baskin, Antonio Frasconi, and Adja Junkers.

In the late 1940s and 1950s, interest in the use of color in the relief print increased. Carol Summers, Seong Moy, Clare Romano, Edmund Casarella, and John Ross in the United States, and Michael Rothenstein in England, were early experimenters.

In France, Pablo Picasso (1881–1973) was responsible for another major innovation in the 1950s. Using one block for multicolor linocuts, he was probably the first person to devise a reduction method: cutting and printing each color from one block until only the last color portion remains on the block. This eliminated the need for a separate block for each color and ensured more accurate registration (see also the discussion of the reduction method on page 33).

The flexibility of the cardboard relief print, the collage print, and the mixed-media print, along with inventive ways of inking with small rollers, has expanded the use of color. The Op and Pop images of the 1960s and 1970s loosened conceptual ideas about color and helped to break down old taboos about color in the print.

A new wave of interest in the woodcut and the relief print in general has slowly surfaced since the 1970s. This interest is buoyed by the vast multimedia facilities of print publisher workshops. Artists working in these shops have access to power tools, varied materials, and expert advice from first-class assistants and printers; they can combine media and work on an almost unlimited scale. In addition, some Western artists and publishers, such as Crown Point Press, have had Japanese cutters and printers translate drawn or printed images into woodcut prints using traditional Japanese techniques. These Japanese craftsmen can capture with consummate skill highly subtle variations in the sketch or drawing.

Jim Dine, Helen Frankenthaler, Frank Stella, Alex Katz, and Philip Pearlstein have all explored these possibilities in their work. The new focus on expressionism among younger American, German, and Italian artists has also produced some striking relief prints. With its simplicity and directness, the relief print will no doubt continue to be an important medium for the future.

FRANK STELLA
La penna di hu (black and white), 1988
Relief, etching, aquatint, on white TGL handmade paper,
77½″ × 58¾″
Printed and published by Tyler Graphics Ltd.
Copyright © Frank Stella/ Tyler Graphics Ltd. 1988
Photo: Steven Sloman 1988

LEONARD BASKIN
Death of the Laureate, 1959
Wood engraving,
11½″ diameter
Collection of Ben Sackheim

WOODCUTS

The woodcut is one of the most widely known and used forms of relief print. In a woodcut it is the raised surface containing the positive image that is printed. The background area, or negative space, is carved away, creating the white, or nonprinting, areas. As with other relief prints, ink is applied with a roller to the raised surface, paper placed on it, and the image transferred by rubbing the back of the paper or by running the block and paper through a press.

Materials and Tools for Woodcuts

Wood (pine, poplar, birch, pear, cherry)

Woodcut knife

Gouges (small C gouge, raked V gouge)

Roller (4- or 5-inch Hunt Speedball soft rubber)

Glass or Formica slab for rolling ink

Printing ink (letterpress, etching, or litho)

Paper (mulberry, *moriki*, *hosho*, *masa*, and the like)

Sharpening stone (India, Carborundum, or Arkansas)

3-in-1 oil or light machine oil

Plastic Wood for small corrections (tubes are easiest)

Texturing tools (rasps, screws, punches, and the like)

Wooden spoon (Japanese rice spoon or square wooden drawer pull)

Palette knives for mixing ink

Sandpaper (fine, medium, rough)

Brass wire brush (suede brush to bring up wood grain)

General art supplies, including pencils, charcoal, tracing paper, India ink, rags, assorted brushes (from no. 3 pointed sabeline to ¾-inch flat ox hair), black and white poster color, erasers, vinyl work gloves

WOOD

Because many kinds of wood can be used in making woodcuts, you can choose one that best suits the image you are cutting. Even old, worn, discarded boards are usable. Some artists save old boxwood, charred and burned pieces of wood, knotty or rough-sawn logs, and other wood that may yield interesting textures and shapes. With the correct procedure, you can make any piece of wood yield a good print.

Pine The most commonly available wood suitable for the woodcut technique is pine. Soft and easily bruised, it requires very sharp tools to be cut cross grain. Clear pine costs about twice as much as common pine but is free of knots. You can buy pine boards in widths up to 18 inches and occasionally 24 inches, but for larger sizes you must join the boards by gluing the edges, which requires special clamps. Because of pine's softness, lines that are too thin become rounded or bruised during printing; therefore, it is not a suitable wood for fine black line work. To harden the surface and make cutting easier, you can coat the wood with a thin layer of shellac and sand it when dry. Thin the shellac with 50 percent alcohol to help it pene-trate. To prevent warping, you can oil the wood. Linseed oil is acceptable, but it should be applied well in advance of cutting to give the wood time to dry.

Poplar A medium-soft wood that has good cutting characteristics and even grain and is not brittle is sold in many lumberyards as whitewood, or poplar; it is used extensively in inexpensive furniture. Poplar is slightly harder than pine and therefore can hold a little more detail. Not long ago it was possible to buy poplar blocks planed to type-high thickness (0.918 inch) from engraving-block manufacturers. With the decline of letterpress printing, however, these suppliers have almost vanished, and it is rare to find anyone who makes this type of block today.

Cherry and pear woods These hard, dense fruit woods are suitable for very fine lines and long printing. Cherry blocks were, and still are, used by Japanese cutters in the Ukiyo-e tradition because of their resistance to splitting, their

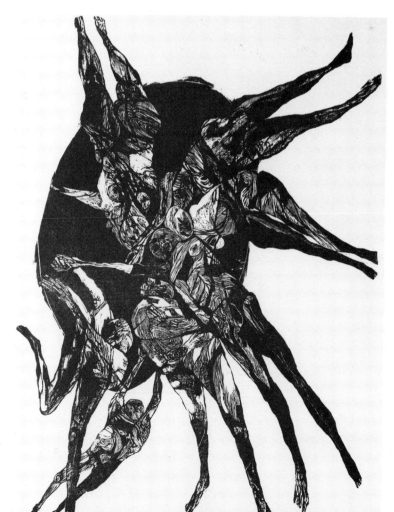

JACOB LANDAU
Funhouse, 1961
Woodcut,
16½″ × 12⅛″
Courtesy of the artist

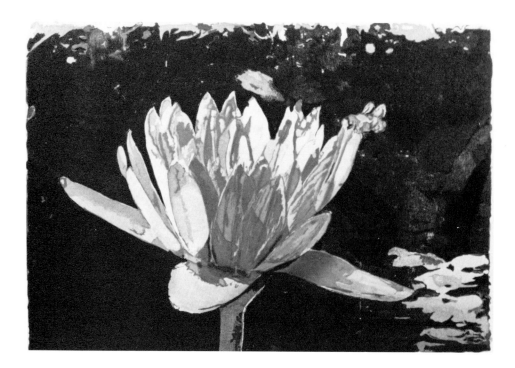

JOSEPH RAFFAEL
Matthew's Lily, 1984
Color woodcut, 32″ × 37½″
Courtesy Pace Gallery, New York

even grain, and their ability to withstand printing pressure and abrasion. Cherry also was used extensively to make backings for photoengraved plates and is still available from the American Printing Equipment Supply Company in Long Island City, New York. Pear wood, which is similar to cherry in its characteristics, is available in Europe but is a specialty wood in the United States.

Birch plywood The even grain of birch makes it an excellent surface for plywood. Available in most lumberyards, birch plywood is more useful than the more common fir plywood because of its even texture and lack of wild grain patterns. It is excellent for large blocks because it can be bought in sheets 4 feet by 8 feet.

Other domestic woods Maple is so hard and dense that it is difficult to cut, but it yields extremely fine detail when properly worked. Walnut also is very hard and dense enough to hold fine, even lines. Oak, although hard, is stubborn and has a characteristic open pore texture that is disturbing. Mahogany is soft, very brittle, and has an open, pecky pore surface that is monotonous. Spruce and hemlock are soft, brittle, and mushy but

can be used for color areas and knotty textures. Cedar is too brittle to cut well, and fir and redwood, also brittle, flake off and chip when cut. In some places it may be possible to obtain pine or gum plywood, which is suitable for large areas. Basswood is soft but usable, particularly as plywood.

Imported woods A variety of woods from Japan are suitable for woodcuts. *Shina* plywood is easy to carve, but unfortunately, large pieces are expensive to ship and so this material is difficult to obtain. A magnolia wood called *ho,* although expensive, is available in small sizes, as is *katsura,* or Judas wood, which is denser and can hold fine detail.

Lauan, a mahogany plywood from the Philippines, is soft and light and has some use as a block for color areas or textures. Swedish plywood in ¼-inch thickness is sometimes available in a wood similar to birch that is finely textured and cuts well.

CUTTING TOOLS AND AIDS

Almost any object that is harder than wood can be used to bruise or indent its surface, and the indentations will print as white marks. A sharp nail or hard pencil will score most woods; paper clips, keys, tin cans, screwdrivers, needles, screws, dental tools, forks, pizza cutters, and plastic swizzle sticks will leave impressions on the receptive surface of wood. You can use any of these imple-

ments to create textures and designs that will print by the relief process, but when you want good control of a shape or an area, you will see why knives and gouges have been used for so many years.

Knives The knife has long been one of the primary tools of the woodcut artist; it can make cuts that no other tool can make and is one of the most useful instruments in the woodcutter's kit. A knife should be made of the best-quality carbon steel, raked back from the point at about a 45-degree angle, and kept very sharp on an Arkansas stone. The edge should be sharpened so that it is straight, not rounded, and the point should be precise and keen if any small cutting is to be accomplished. Handles come in many different sizes and styles, so you should choose one that is comfortable to work with and holds the knife blade very tightly so it does not twist or wobble.

A few simple techniques will help you cut properly with the knife. For broad cutting of large masses and long shapes, hold the knife to cut at an angle of 45 to

Objects that may be hammered or impressed into soft wood: (A) small brads, (B) leather punch with cross design, (C) hexagonal nut, (D) washer, (E) circular chuck, (F) staples.

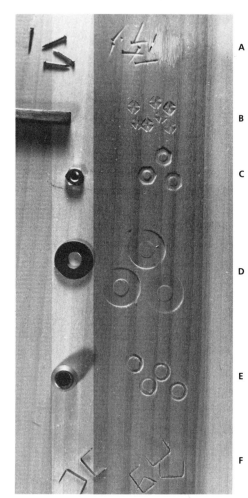

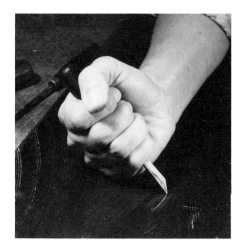

For broad, fast cutting of large forms, hold the knife as shown. Make the first cut at about a 45-degree angle.

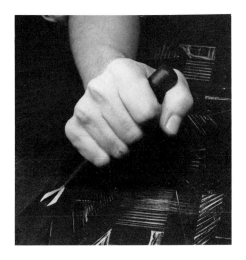

Turn your knife to the opposite side. Make the second cut, again at a 45-degree angle. The sliver of wood should curl up out of the cut.

60 degrees. It takes four cuts with the knife to make one black line; in order to minimize the continuous turning of the block that is necessary if you hold the knife at a constant angle, learn to make the second cut by swinging the knife to the other side, thus releasing the cut splinter. Do not cut too deeply or you will tire quickly and diminish the fluency and responsiveness of your line.

The knife is unsurpassed for the clean cutting of small shapes, where great control and accurate joining of lines are required. The tip of the knife does the most careful work. For this kind of cutting, hold the tool somewhat like a pencil between the thumb and forefinger, and twist and turn it in the direction of the cut. You can use the thumb of your other hand to push the knife into the wood, especially when your hand and arm are not strong enough to maintain the right pressure.

In addition to cutting, the knife can be used to produce linear and textural qualities. It can be used to score the wood with very fine lines, either across the grain or with the grain. It can be used to bring up the grain if you hold the blade perpendicular to the block and scrape against the grain, and it can be used as a chisel to shave away the wood. Its point can be used to develop dot tones. Some very proficient artists use the knife as their only tool for all kinds of cutting, including cleaning out large areas of wood, but other tools such as gouges and chisels are more efficient for this purpose.

Gouges and chisels You should have several kinds of gouges and chisels in your toolbox. The most useful gouge is the raked V gouge; when properly sharpened, it will cut cross grain without tearing and is a joy to use. It is handy to have two or more raked V gouges, the smaller one for detailed lines and the larger one for large areas and coarser textures.

A C gouge, indispensable for general cutting, is available in many sizes and shapes. When the curve of the gouge is very deep, it becomes a U gouge and must be sharpened to a razor edge to cut effectively. We met an artist in Romania who made more than a thousand woodcuts in a thirty-year period using a small C gouge almost exclusively for the entire image on each block. When any tool is used to this degree, the textures can become monotonous and the forms themselves can become constricted by the limits of the tool. Certain shapes and

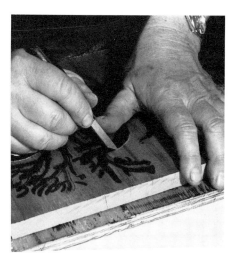

To cut smaller shapes and details, hold the knife somewhat like a pencil. Push it with the thumb of your other hand.

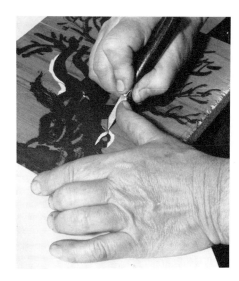

Turn the knife to the opposite angle. When you make the second cut, a small sliver of wood should be loosened. Inside corners are easy to cut with a sharp knife.

The depth of cut does not have to exceed ⅛ inch except in large areas, as in this block cut by Antonio Frasconi.

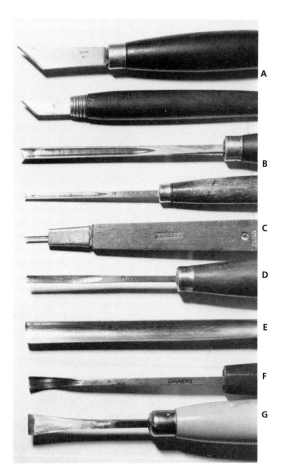

Some of the basic woodcut tools: (A) woodcut knives in two sizes, (B) raked V gouges (large and small), (C) small Japanese C gouge with movable steel gouge, (D) small shallow scoop or gouge, (E) ⅜-inch C gouge, (F) unusual rectangular gouge, (G) fish-tailed straight chisel.

areas demand different tools; for sensitive work it is a good idea to keep at least three or four varieties of gouges at hand.

A small flat chisel is very good for creating soft gray edges when you do not want the typically hard-cut edge that is so characteristic of the woodcut knife or gouge. Antonio Frasconi makes subtle and effective use of the flat chisel, and soft-edged effects are apparent in the prints of Gauguin.

Japanese tools Japanese tools do not differ much from the ones used in the Western method of woodcut, but we do suggest that they be used for the Japanese method (discussed later in this chapter). The Ukiyo-e artisans were ritualistic in their use of tools; certain ones were used only for certain kinds of cutting. The cutters themselves were assigned to very distinct areas of work, depending on their ability. Those who were highly skilled cut the heads and the fine lines of the features and hair. Other cutters worked on the bodies and the pattern of drapery. Less experienced cutters worked on color blocks or unimportant areas.

Their training took as long as ten years, and only a few achieved the skill necessary to work on the delicate faces, hair, and hands.

Japanese tools range from inexpensive student gouges and chisels to very expensive professional tools of the highest quality. Although the cheap tools are soft and will not hold an edge, the small knives are good for detail work and the C gouges cut well for a while. Munakata, a twentieth-century Japanese woodcut artist, would use them until they got dull and then throw them away.

Professional tools are made from two kinds of steel. The shaft is made from low-carbon steel for strength and flexibility; it is laminated to a cutting edge of high-carbon steel for hardness and the ability to retain an edge. When purchasing tools in a store, you can see the difference between professional tools and student tools by inspecting the bevel of the knife edge. The professional tool will have a shiny layer of metal for the cutting edge and a duller layer for the supporting metal.

The best tools are made in Japan and are available from Robert McClain in Eugene, Oregon. *Hangi to* are straight-edged knives, but many other shapes are made, including V gouges, curved scoops, and chisels, and most come in a large range of sizes. You may find the spoon-shaped tools easier to use. The curve in the metal allows you to raise

your hand higher above the block and work with a greater freedom of motion. There is a choice of handles for most of these instruments, including a split, two-part handle that holds the metal securely but permits the shaft to be extended and resharpened if damaged. The split handle is best for the smallest tools. Another choice is the long, straight wooden handle, which can be cut down to custom-fit the hand.

Chisels in small sizes are used for cutting out small areas of wood. Larger broad chisels are used for cleaning out large areas and for making *kento* (register) cuts on the blocks. Sometimes a wooden mallet is used to hit the back of the chisel in order to clear areas in hardwood blocks.

Sharpening It is possible to resharpen your old straight V gouges to the correct angle of rake as shown in the diagram. Grind the tool to the desired angle on a coarse Carborundum stone or on a small grinding wheel. If you use a wheel, do not overheat the tool or you may lose the temper in the steel. Once you obtain the correct angle, sharpen each side of the V gouge as you do a knife, making sure that the two edges meet at exactly the right angle. This point does the cutting, and it must be precise and true for the most delicate work.

Curved gouges are very difficult to

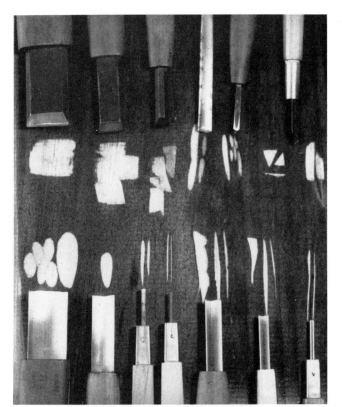

Japanese tools and the cuts they make, including gouges, chisels, and a knife.

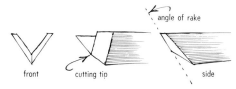

RAKED "V" GOUGE

front cutting tip side angle of rake

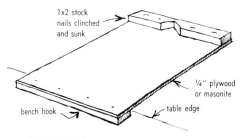

BENCH HOOK

1x2 stock
nails clinched
and sunk

¼" plywood
or masonite

bench hook

table edge

holes
drilled in
table-top

10" 10" 10" 10"

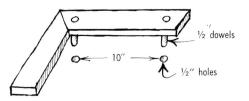

BLOCK SUPPORT FOR TABLE

½ dowels

10"

½" holes

sharpen, and you need a great deal of practice and patience to master the technique. Hold the tool as shown and slowly turn the tool between your thumb and forefinger while keeping the same angle of tool to stone. A number of turns are required to grind the edge evenly. The edge of the gouge should be rotated in small circles on the stone. When the tool is held in front of a light, the edge should not be visible. If it reflects light on any one spot, that area will need more sharpening.

There are a number of stones, both India and Carborundum, that have concave indentations of various curvatures for different-size gouges. These are helpful to the beginner but scorned by old-timers, who insist that the flat stone is sufficient and the human hand is the best instrument for controlling the tool. Lubricate the stone with enough fine oil to float off the tiny particles of steel that eventually would clog the stone. Pike oil, 3-in-1, or any light machine oil will work. Do not use linseed oil.

Bench hooks A bench hook is used to keep the block from moving while a gouge is being forced through the wood. You can make a bench hook using a piece of ¼-inch plywood, Masonite, or composition board as a base. Glue or screw two pieces of 1-inch-thick wood on each end but on opposite sides of the base. Countersink the heads of the screws very deeply in order to prevent

damage to the cutting edge of your gouge. One edge of the bench hook fits on the front of your table and the other side holds the block in position. It is a good idea to have several in various sizes because a small block simply won't work in a large bench hook.

C clamps You can clamp a large block to your table by using a carpenter's C clamp. The pressure of the threaded clamp will indent the block unless several layers of cardboard are added to protect the soft surface of the wood. Clamps are not as convenient as bench hooks because they must be loosened every time you want to move the block.

Gouging jigs Another useful tool is the gouging jig. If you are cutting a number of blocks, you may find it worthwhile to drill a number of ½-inch holes in your table, spaced to receive ½-inch dowels that have been glued to a strip of wood shaped as shown.

The right-angled corner is essential to keep the wood from slipping off the strip. The advantage of this method is that you can drill the holes at the angle you prefer and shift the jig easily to accommodate small as well as large blocks.

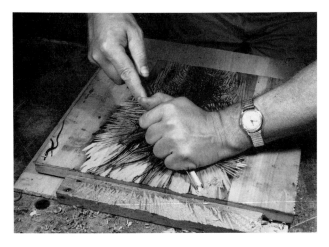

With a bench hook holding the block in position, push the gouge with your strongest hand. Use your other hand as a guide and restraint against the tool, to keep it from slipping out of control.

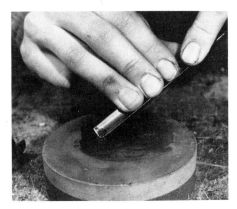

To sharpen a curved gouge, keep the bevel angle steady. Move the gouge in small circles, rotating the shaft of the tool between your fingers.

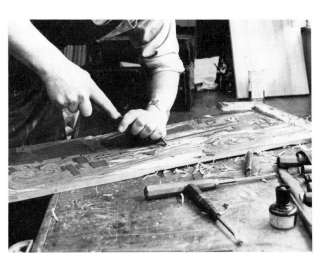

This shows the corner angle in use. It is held in place by the dowels, which fit into holes in the table.

If your worktable is not heavy enough, it will slide across the floor; to prevent this, place it against a wall or another piece of furniture. When a large amount of deep gouging is necessary, you may want to use a small wooden mallet to help drive the gouge or chisel through the wood, particularly if you are working in a hardwood like cherry or pear.

Texturing tools An enormous variety of things, from nails and screws to washers, bottle caps, punches, dog combs, drills, rasps, wire screening, and sandpaper, can be hammered or tapped into the soft surface of wood, and the indentations

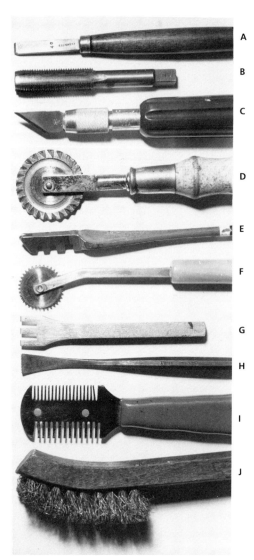

Auxiliary woodcut tools: (A) Multiple scratchboard tools (40 lines to the inch), (B) screw-thread cutting tip (makes multiple grooves), (C) X-Acto knife, (D) pie trimmer (makes a zigzag line), (E) glass cutter, (F) pattern wheel (makes a dotted line), (G) leather punch (for sewing seams), (H) sculptor's rasp (makes multiple grooves) (I) dog comb (useful for coarse multiple strokes), (J) brass brush (accentuates grain or textures wood surface).

will print as white against the black surface of the block. Sculptor's small metal rakes with tiny teeth also produce interesting textures.

Multiple gravers, with a certain number of lines to the inch, ranging from 40 to 120 or more, are made for photoengravers by E. C. Lyons and E. C. Muller in New York City. In the coarser sizes, such as 45-55-65, these tools are useful to the woodcut artist for obtaining closely textured gray tones. They work best with the grain.

Look around you for tools or implements designed for other purposes. A dressmaker's sharp-pointed wheel for marking patterns, a little texture wheel for pastry making, and a sharp-edged pizza-cutting wheel can all be useful tools for the woodcut. Your workshop, basement, attic, kitchen, hardware store, or junk shop may house texture-making tools that you can use to introduce some freshness into your work.

Power tools Several types of power tools are very helpful to the woodcut artist. The most widely available is the electric drill, which can be used with steel drill bits, wire brushes, and other attachments. The block must be securely fastened to the table, or the force of the drill will move it around.

A vibrating tool such as the Vibro-Tool or Vibro-Graver has great potential if handled with skill and care. It can be used with a variety of points, from carbide or diamond tips to files and brushes. This tool is also good for intaglio work on zinc, copper, or Lucite plates. The stroke of the vibrating point is adjustable and can therefore make many types of lines and textures.

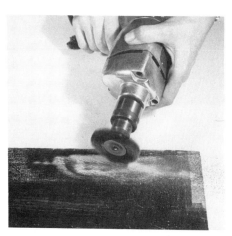

A steel wire brush in an electric drill rapidly gives a coarse texture.

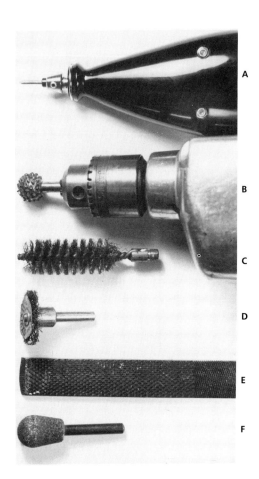

Other tools for texturing wood: (A) motorized Vibro-tool (for metal, wood, or plastic), (B) electric drill with circular bit, (C) brass gun-cleaning brush, (D) wire brush (for electric drill), (E) wood rasp, (F) circular drum of Carborundum.

A flexible shaft hooked up to a small electric motor is a very handy addition to an artist's workshop. There are a number of bits, grinding wheels, rasps, wire brushes, and other points that can be used with it.

All these tools are simply devices for easing the demands on the artist's strength and time. They are as much a part of a printmaker's equipment as the pencil or the knife.

ROLLERS AND BRAYERS

Rollers and brayers are used for inking the surface of the block for printing. They present one of the greatest problems to the artist attempting the relief print. You will soon find that a roller that inks one block properly will not work well on another block. Eventually you will want to have many rollers differing in size and hardness. Rollers are made from a number of materials, ranging from gelatin, soft and hard rubber, plastic, leather, and linoleum, to Lucite

or Plexiglas. It is important to understand the advantages and disadvantages of each type.

Hard-rubber rollers The small hard-rubber rollers with a wooden core that are usually sold for use in printing linoleum cuts are of very little value to the serious printmaker. Rarely even in diameter, they ink an irregular, blotchy pattern at best. The most useful hard-rubber rollers are made of cylinder rubber stock, which is usually available in outside diameters of 1½, 2, and 3 inches, with an inside diameter of ½ inch. Sold in lengths of 24 inches, this material can be cut with a hand hacksaw or on a power saw with a hollow-ground blade (use a slow feed). The inside opening should be fitted with a ½-inch maple dowel cut about ¼ inch longer than the length of the roller. The dowel can then be drilled and mounted in a handle made from flat iron stock about ⅛ inch thick and 1 inch wide. If the iron bar stock is first scored with a hacksaw, it will bend precisely at the proper place to fit the roller.

A hard roller of even diameter will ink the surface of a relief block without inking the shallow gouged or lowered areas. If you want a "clean" print without a lot of gouged texture, then a hard-rubber roller is the proper choice.

Smaller rollers can be fitted with handles of stiff wire, such as the wire from coat hangers, bent into the proper shape with two pairs of pliers. Since the most difficult part of the roller to make is the handle, you should save any suitable handle and simply replace the roller section. You can even buy wallpaper rollers with wooden or plastic rollers, throw away the roller section, and cut a section of cylinder rubber with a dowel insert to fit the handle section. The metal brackets can be bent inward to fit smaller rollers.

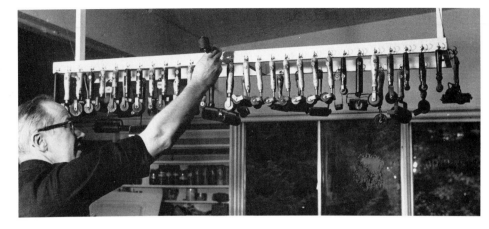

A rack for overhead storage of small brayers, most of them numbered for easy identification.

Soft-rubber rollers Soft-rubber rollers are available from Hunt Manufacturing Company in Philadelphia. Called Hunt Speedball soft-rubber rollers, they come in a variety of lengths from 1½ to 6 inches. The smaller sizes are particularly handy for small color areas. Because the rubber composition is fairly soft, they are useful for collage prints and for inking uneven blocks. They deposit ink on gouged areas very heavily and should be used with discretion. The rollers are too soft for blocks that are not very deeply gouged, unless you want lots of gouging texture to print. They are also too soft for finely cut blocks because thin lines fill in. The small diameter of these rollers is a handicap when you ink a large area.

Gelatin rollers A very sensitive and useful brayer is made from gelatin. It gives a smooth, even distribution of ink. The disadvantages of gelatin, however, are so numerous that it is rapidly being replaced by more durable materials. Gelatin pits very easily, dissolves in contact with water, sags out of shape in very warm weather, indents if left standing on a slab overnight, and is, in general, a delicate and destructible material. It can be very expensive to have your rollers recast every year, as was the custom in commercial printing shops.

Plastic rollers Soft-plastic rollers are now being manufactured that combine the even inking qualities of gelatin with the more durable characteristics of hard rubber. They can be cast in an enormous variety of sizes and are the most useful rollers in the studio. As would be expected, these rollers are also quite expensive. Made of polyurethane or polyvinyl chloride, they will withstand an amazing amount of abuse. We recommend them highly. Large sizes are very expensive but worth it.

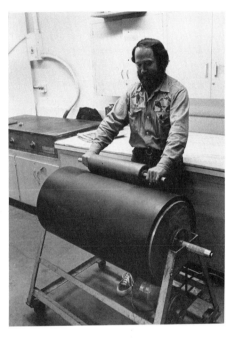

Dick Swift inking a large roller with a smaller one at University of California at Long Beach. A motor turns the roller through a belt drive.

RUBBING TOOLS

The choice of tool for rubbing the back of the print to transfer the ink to the paper can be as personal as the choice of cutting tool. We have known artists who prefer objects that were hardly designed for printing use. These have ranged from an ordinary wooden kitchen spoon to an electric light bulb that a Romanian artist staunchly avowed was the best.

The traditional rubbing tool of the Japanese is the *baren*, a flat, circular disk backing a spiral of cord about 5½ inches in diameter covered with a sheath of bamboo. It is very sensitive for printing water-based inks (see the section on "Jap-

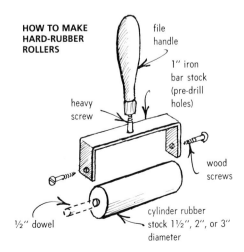

HOW TO MAKE HARD-RUBBER ROLLERS

file handle

1″ iron bar stock (pre-drill holes)

heavy screw

wood screws

½″ dowel

cylinder rubber stock 1½″, 2″, or 3″ diameter

anese Woodcut Method") but usually does not give sufficient pressure for oil-based inks.

We have found a most useful rubbing tool to be two ordinary rectangular wooden drawer pulls glued together. One serves as the handle and the other as the rubbing tool. The handle can be selected to fit the size of your hand. The rubbing portion is usually a 4-inch drawer pull. Because the wood is quite raw, you need to rub a little linseed oil into it in the beginning so that it will glide easily over the back of the print and not tear the paper. After a few printing sessions you will find a lovely patina developing. The flat of the knob is especially easy to use for large areas. The handle is excellent for small areas. Some of our students have fashioned their own tools by using a jig saw and whittling a piece of wood to the desired shape.

Another excellent tool is a Japanese rice spoon made of bamboo, which can be purchased in a Japanese novelty shop. The flat end can be used for larger areas, the handle for smaller ones. Its great advantage is that it fits very comfortably in large and small hands (see the discussion of hand printing on page 23).

INKS AND PAPERS

Inks The oil-based printer's inks normally used for relief and etching prints are available from a large number of manufacturers. They store better in tubes than in cans, making the slightly higher price for the tubes well worth paying. Unfortunately, many colors are not available in tubes. When you must buy cans, make it a practice to replace the circular wax-paper liner carefully, pressing it down and leaving no air bubbles, before sealing the can with the lid. Wipe the rim clean too.

Because oil-based inks are much more flexible, they are generally preferred to water-based inks, which dry very quickly. Water-based inks will be discussed in a later section on the Japanese method (see page 38).

Papers The papers most suitable for printing relief blocks are handmade in Japan from the inner bark of the mulberry tree and other plants and bushes, such as the hibiscus and the

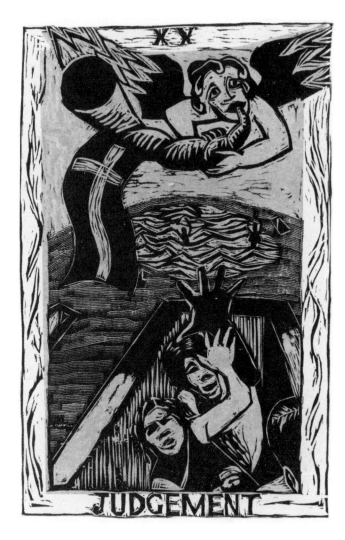

hydrangea. Almost all these papers are used unsized and not dampened.

For very fine lines, as in delicately cut wood engravings and relief etchings, it may be better to use machine-made papers. Handmade papers vary in thickness and have much more surface texture than most machine-made papers of rag content, and fine detail is somewhat harder to print on rough stock. Many domestic papers are suitable, including Mohawk text, Strathmore all-rag book in wove surfaces, and Strathmore bond wove. Some of the European papers are very good for fine detail in press printing. These include Basingwerk light, Arches text wove, Maidstone, Rives light wove, and Opaline, a parchment paper. All of these heavy or textured papers yield more detail if they are dampened slightly. Most of the imported papers can be obtained from large art-supply stores stocking paper or from paper importers and suppliers if you are ordering in quantity.

See the paper chart at the end of the book for further information on the characteristics of the most useful Japanese and domestic papers.

Putting the Image on the Block

Placing an image on a block can be done in a number of ways, using a variety of tools. The method selected will depend on the nature of the image. If you prefer a direct approach, then a brush or felt-tip pen, wide Speedball pen, or black compressed charcoal used freely on a color-tinted block will fulfill your needs. If your image is complex or must be accurate in detail or proportion, it is often better to work out the composition on paper first, then transfer the drawing to the block. The following will give you some approaches we have found to be useful.

PAINTING OR DRAWING ON THE BLOCK

Materials:

India ink

Poster colors (black and white)

Brushes (flat, pointed, and Japanese)

Felt-tip pens in assorted thin and thick sizes

Speedball pen nibs (no. 6 and no. 8)

Black compressed charcoal

General's charcoal pencil (4B or 6B)

Sharpened stick, pen holder, or brush handle for stick drawing

Spray fixative

Two mixing tins

Oil-based inks (red, blue, or gray in tubes or cans)

Rags

Water

Wood (½- or 1-inch clear or common pine or poplar, 15 or 18 inches wide, cut to the desired length, or birch plywood cut to size)

Wood lends itself exceptionally well to mass, both solid and tonal, and to the use of strong line. The density of the wood and the direction of the grain are characteristics that need to be considered in planning the image. By keeping them in mind, you can approach the preparation in a variety of ways, depending on your esthetic direction and your needs as an artist. If you prefer working directly on the block, you should take special care to select wood that has an interesting grain, knot, or rough-sawn texture that can help you evolve the image.

One way to proceed is to paint directly on the wood surface with India ink, working with verve and speed. When the ink drawing is dry, tint over the block with a diluted oil-based ink, in a medium gray or burnt sienna, rubbed in with a rag. The tinting is done so you can see your cut marks. An alternate method is to prepare the block with a thin coat of gray poster color, rubbed on with a rag so that the wood does not become too wet or the pigment too thick. You can carry the block with you as you would a sketch pad or drawing paper and paint directly on it with a Japanese brush, pointed sable, felt-tip marker, pointed stick, wide Speedball pen, or black chalk. Keep some of the background poster color handy for making changes. You may prefer using two brushes, one with black for indicating positive forms and one with gray or sienna for making corrections.

Using compressed charcoal or a 4B or 6B General's charcoal pencil allows a

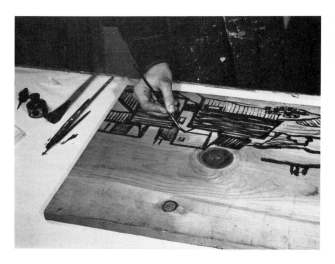

Painting directly on the block with India ink and a brush is a good way to keep the image fresh and strong.

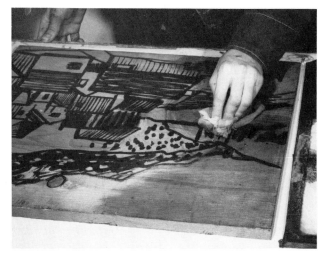

When the ink drawing is dry, tint the entire block with a dilute mixture of printer's ink. Rub red, gray, blue, or some color of intermediate tonal value over the drawing. Pour some solvent on a rag and thin the ink enough to tint the surface.

similar freedom in drawing on the block. The compressed charcoal works especially well because when it is rubbed flat across the wood it shows up the grain in a manner closely related to how the grain looks after printing. Fix the drawing before cutting so that it will not smudge.

We have used this direct method of painting or drawing with our students, who have taken their blocks outdoors to draw the landscape. It can also be used in the studio to work from a model or still life. The results are most often free and spontaneous. Remember that, when printed, your image will be reversed.

CUTTING DIRECTLY INTO THE BLOCK

Materials:

Black printing ink

India ink

Rags

Mixing tin

Water

White chalk

Wood (½- or 1-inch clear or common pine or poplar, 15 or 18 inches wide, cut to desired length, or birch plywood cut to size)

Another method, related to the one just discussed, is cutting directly into the block without a previously prepared sketch. This is most successful when the artist has a clear mental concept of the image. The very act of cutting becomes an important part of the development of the image on the block. The physical motion itself can help achieve a certain freedom in the final work.

The block should be blackened with a rag dampened with India ink that has been diluted with a little water or rubbed with oil-based printing ink thinned with paint thinner. Be sure it is a thin coat, and let it dry thoroughly before cutting. Blackening the block allows your cut marks to be seen.

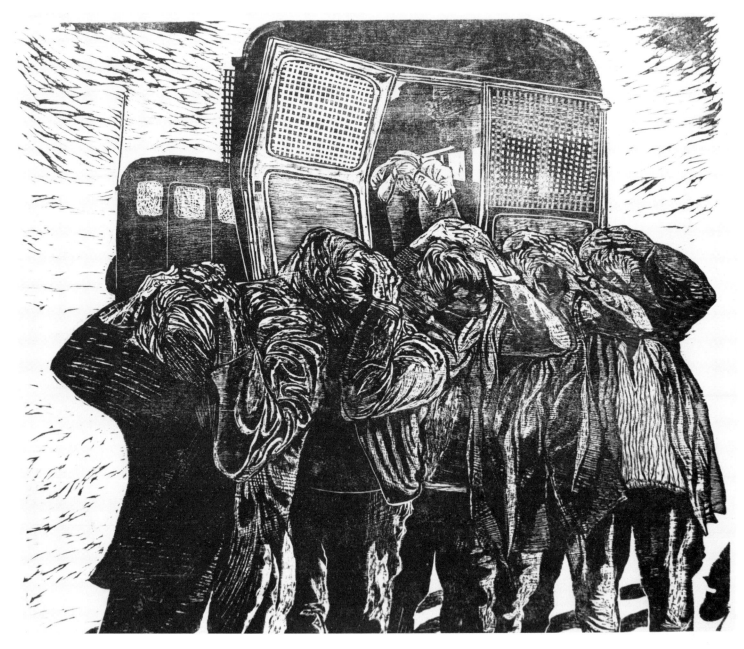

ANTONIO FRASCONI
Los Desaparecidos X, 1988
Woodcut, 29½″ × 41½″
Courtesy Terry Dintenfass Gallery, New York

One of our students produced some impressive prints in this manner by using a discarded birch plywood door. He blackened his block with India ink and, with only a rudimentary positioning of forms with white chalk, proceeded to cut large expressionistic, figurative images with gouges and knives. The beginning woodcut artist, however, must not assume that a large block or gouge and an expressionistic image will necessarily produce a free or spontaneous print.

PHOTOCOPY TRANSFER METHOD

Materials:

Photocopy of drawing to size

Lacquer thinner

Wide, soft brush

Wood (½- or 1-inch clear common pine or poplar, 15 or 18 inches wide, cut to desired length, or birch plywood cut to size)

The fastest and most accurate way to put an image on the surface of a woodblock is to transfer a photocopy of a drawing or photo directly to the block. There are electrostatic photocopying machines that have the capacity to take 42-inch-wide material up to any reasonable length, such as 6 or 8 feet. The transfer agent is lacquer thinner (toluol compound) or lighter fluid, which you apply to the

block with a wide, soft brush such as a Japanese hake brush made of sheep hair. Because the solvent evaporates rapidly, you should place the photocopy face down on the block with no delay. Then rub it with a burnisher on the back to transfer the image to the block. If the drawing is not too large, it can also be transferred through an etching press with considerable pressure. If it is large, it may need fluid application section by section. If a press is used, the wood must be plywood or unwarped plank wood.

It is desirable, when transferring a large photocopy, to tape one side to the block first. Then lift the photocopy and, with a 5-inch-wide hake brush, put the lacquer thinner on stroke by stroke, burnishing after each stroke. This will give a

To make a photocopy transfer, tape the photocopy to the block on one edge only so that it can be lifted out of the way. Apply lacquer thinner with a wide brush to the top edge of the woodblock as shown.

Reposition the photocopy against the block and rub the back with a wooden burnisher, such as a Japanese rice spoon. Do this before the lacquer thinner has a chance to evaporate.

Lift the photocopy and add another brushstroke of lacquer thinner to the block adjacent to the already-transferred image.

Continue stroke by stroke until the entire image is transferred.

clean, precise rendering of the image on the block surface.

You can transfer images to mat board or cardboard plates in the same manner. The quality of the transfer is very high, if done properly. This procedure can save time, particularly if complex images must be transferred.

CHARCOAL OFFSET DRAWING AND TRACING-PAPER TRANSFER METHODS

Materials:

6B compressed-charcoal pencil

Medium H pencil

Thin tracing paper of very transparent quality

Carbon paper

Masking tape

Spray fixative

Japanese rice spoon or wooden drawer knob

Wood (½- or 1-inch clear or common pine or poplar, 15 or 18 inches wide, cut to desired length, or birch plywood cut to size)

Charcoal offset drawing In this method you prepare the drawing on tracing paper with a compressed-charcoal pencil, keeping in mind the need for strong lines and no smudging. After completing the drawing, you place it face down and tape it to the block. The block should be tinted beforehand with burnt sienna or gray poster color or printing ink diluted in paint thinner so that the cut marks can easily be seen. Carefully rub the back of the tracing with a rice spoon or drawer knob, using strong pressure (see page 20). The dense black compressed-charcoal pencil will transfer itself quickly to the block with excellent readability. The same result should occur if you run the block and tracing paper through an etching press with strong pressure. When a press is used, the wood should be plywood or unwarped plank wood. A good spray of fixative will keep the drawing from smudging, and cutting can begin.

Because the drawing is reversed when it is placed on the block, the finished print will look like the original drawing on the tracing paper. There will not be a mirror image such as you get when painting or cutting the drawing directly on the block.

A very quick transferring procedure uses a drawing made with soft pencil or charcoal pencil. Do not fix the drawing. Turn it over, face down, on the block and tape it in position. Rub the back of the tracing with a spoon or a wooden drawer pull.

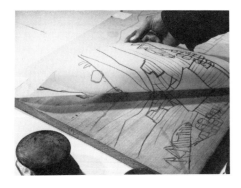

The pencil drawing has now been placed on the block. When the block is cut and printed, everything will be "flopped" back into its original position in the drawing—a great advantage of this method. Lettering is easy to do by this method.

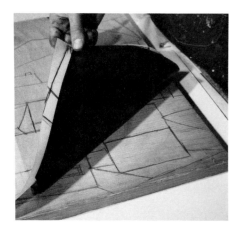

Another way to transfer a drawing is the carbon-paper technique. Tape a tracing of your shapes to the block. Slip carbon paper (typewriter carbon is fine) under the tracing and trace the drawing to transfer it to the block. Use a soft pencil; a pencil that is too hard will indent the wood, and those indentations will print as thin white lines.

Tracing-paper transfer This method can be used if a drawing has already been prepared on paper or illustration board in a manner that relates well to the simplicity of line and mass of the woodcut, with a brush, for instance, or a Speed-ball pen and ink or a felt-tip pen. Make a tracing with a 6B compressed-charcoal pencil, drawing every line and mass with the sharpened charcoal pencil. After completing the drawing, place it face down and tape it to the pretinted block, then rub with a rice spoon, drawer knob, or your fingernail. You can run it through an etching press with considerable pressure if you use plywood or unwarped plank wood.

A variation on this method is the carbon-paper technique. You make a linear tracing of the prepared drawing with a medium-soft pencil, then place the tracing face down on the block with a piece of carbon paper between, as described in the discussion of the offset method of preparing the image. Then you trace the drawing with a medium pencil so that the carbon paper deposits the image with sufficient strength on the block. Be careful not to trace with too much pressure because the wood indents easily. This method is the least satisfactory because an additional step is required to use the carbon paper and because tracing the linear image of a drawing is alien to the concept of the woodcut.

Still another transfer method, used by the Japanese traditionalists, is described in the section on the Japanese method (see page 40).

Cutting the Woodblock

A good way to start to familiarize yourself with cutting tools is to prepare a series of small blocks without planned images. With these blocks you can explore the many cutting and textural possibilities inherent in the tools. By freeing yourself of imagery and finding out what the tools can do in your hand, you can develop a basic cutting vocabulary and also understand the vast potential for tonality through textures. Then you can print these experimental blocks to create a guide for future cutting.

Cutting methods, of course, vary in relation to the development of an idea. With images as varied and personal as they are in contemporary expression, any fixed rules become meaningless. Generally, however, it is a good idea to cut in the direction of the flow of the form, and one sure caution is to avoid overcutting and to undercut wherever possible. It is easy to become carried away with the physical movement of cutting and forget that each cut will appear as a nonprinted area. That is why undercutting and proofing are so important. Developing a block through proofing is as important as cutting the block. If you pull frequent proofs at various stages and work on them with white paint to see how new areas will evolve or use black paint to remove overcut areas or to change imagery, you can develop a freer concept. Do not hesitate to sacrifice the drawn

Steven Sorman using a mallet and chisel on plywood for his screen *From Away* (shown on page 216) at Tyler Graphics, November 1987. Photo: Marabeth Cohen.

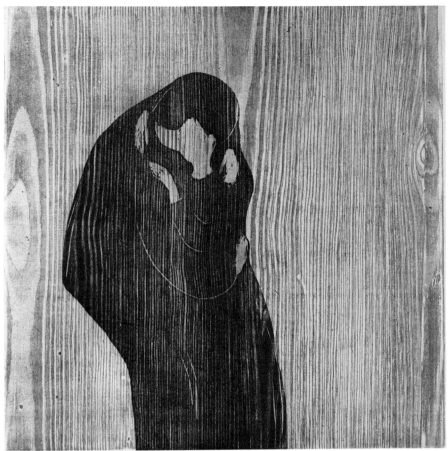

EDVARD MUNCH
The Kiss, 1902
Color woodcut, 18⅜″ × 18 ⁵⁄₁₆″
The Museum of Modern Art, New York
Gift of Mrs. John D. Rockefeller, Jr.

image on the block to constant proofing. The image can easily be reindicated, and it is far more time-consuming to have to correct an overcut block.

Another caution is to try to keep a certain consistency in the scale of cutting. Again, this applies to certain imagery and not to others. In an abstract image, for instance, the scale of cutting does not need to be consistent, but in a landscape or figurative image, the scale, the weight of cutting, and therefore the sizes of the gouges or cuts are very important. Develop spatial relationships by varying the weight of your lines and tonalities.

Areas of tone or grays in a black-and-white print can be achieved in a variety of ways. In his early woodcuts Dürer never relied on texture or wood grain but only on line. He developed form and tonality in his woodcuts just as he did in his pen drawings. Today's expression in the woodcut is comparatively free. Line can, of course, express tone and form, but so can the great variety of textures that are possible with the many cutting and textural tools. Wood grain can play

an extremely important role in the development of an image. Sometimes it has been used as almost the total image, as in Munch's *The Kiss*. Often it is the rich combination of grain, line, black mass, and texture that fulfills the wide potential of the wood.

DEVELOPING THE GRAIN

There are many methods for bringing out the grain of wood. For an image expressed almost totally through the grain, you need careful control. One method is to hold the blade of a woodcut knife perpendicular to the block and lightly scrape the straight edge against the grain. Sometimes thinly scoring with your knife around the area where you want to bring up the grain can help you keep within the form.

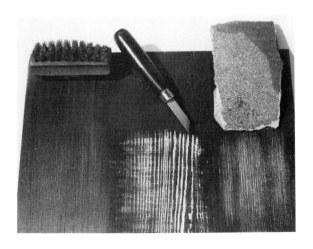

Where less control is necessary, a wire brush like an ordinary suede brush or a copper gun-bore cleaner can be rubbed with the grain. Sandpaper in varying degrees of roughness can also be rubbed with the grain, as can pumice. If you want a rough texture, you can use a power-driven metal brush.

Whatever the method, the scraping, rubbing, or sanding wears away the softer particles of wood between the harder growth layers, forcing the grain to become more prominent.

PROOFING THE WOODCUT

Pulling an impression of the cutting, no matter how rudimentary it may be, is an important aspect in developing the woodcut. You can make proofs without using ink at all. One useful method is to rub the raised cut surface thoroughly with a large stick of graphite. Place a piece of thin proofing paper over the area and rub with a suitable rubbing tool. You should get a clean, sharp, readable impression of the developing block. You can easily make changes right on the proof with white and black poster color if you first spray the graphite impression with some fixative. The graphite method is useful for small areas when the block is in its very early stages. (When cutting is more advanced, ink is recommended.) You can readily remove the graphite from the block by rubbing with a rag sprinkled with a small amount of paint thinner. Another proofing method is to place paper over an uninked block and then rub the back of the paper with a stick of graphite to produce the image (see page 22).

You can also roll the block with a light, even coat of black ink and pull a proof. A useful method is to pull two proofs if you are going to make extensive corrections with black and white poster

Brass brush, flat knife, and sandpaper emphasize granular structure to extent shown.

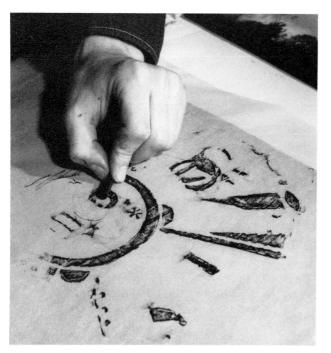

It is possible to take a quick "proof" of a cut block by rubbing a piece of paper positioned on top with lithographic crayon or pastel.

color on the proof. One proof is for making the changes, and the other shows what exists on the block so you can find the areas to be corrected.

Using proofing to develop and change the block greatly reduces the hazard of overcutting and enables the artist to realize the potential of the wood in a clearer, faster way. The greatest surprise for the beginner invariably comes after the block has been lovingly cut, becoming a thing of beauty in itself, a bas relief, where every cut seems to have meaning because of the texture of the wood and the play of light on the relief surface. Then with the first proof comes the unhappy revelation: none of these nuances is evident! There is just a flat relation of white line and mass against black. The whites are usually cut too heavily, too deeply, and too much.

To clean the block without dirtying the recessions on the block, use only a dry rag to clean away the ink. If this is insufficient for proper cleaning, then dampen the rag with just a few drops of paint thinner.

Unfortunately, this kind of preliminary proofing can be done only once or twice because the residue of ink tends to fill in the fine cutting and delicate textures, making it harder but not impossible to see old cut marks. A good cleaning can be accomplished with a sufficient amount of solvent to remove almost all of the ink on the block, so that subsequent proofs and the final prints will retain all the grain and detail that were in the original cutting.

CORRECTING ERRORS IN WOODBLOCKS

It is painstaking, but not impossible, to correct mistakes in wood, and great care should be taken not to overcut your blocks or damage areas that should print. However, certain things can be done to repair small damages and bruises. These methods have distinct practical value and will save many a damaged block.

Plastic Wood, gesso, and modeling paste The easiest and fastest way to repair broken lines, overcut textures, and general overcutting is to fill the damaged area with fresh Plastic Wood, applied in as many layers as necessary to fill the holes. Use tubed Plastic Wood and replace the cap immediately because it dries out quickly. Apply it in small amounts with a little trowel like a painting knife. Do not make any layer more than ⅛ inch thick, and allow each one

Plastic wood can be used to fill cut or gouged areas in a woodcut to correct mistakes. Let it dry thoroughly; then sand it to the level of the block.

to dry. Because a clean base is essential for Plastic Wood to stick properly, it is best to apply it before inking the block. However, most errors or the need to make changes are not discovered until after a proof is pulled. In that case, clean the block well with solvent, especially in the recessions, and dry it thoroughly with a clean rag. It often helps to roughen the surface to be repaired by scraping with a knife. This will help the Plastic Wood bind to the block. The final layer should be slightly higher than the level of the block, but not excessively high or it will be too time-consuming to sand back to level. Sand the high spots with fine sandpaper wrapped around as small a rectangular block as possible. Sand with the grain only, keeping the pressure even and working carefully in order not to damage surrounding areas.

Plastic Wood will not withstand rough treatment and may fall out if the area has been improperly prepared. Press printing also tends to pick out loose areas of Plastic Wood. For extensive areas on long editions it may be better to plug the block or cut a new block. It is relatively easy to use Plastic Wood to fix spots that have not been too thoroughly gouged out. If a section has been completely ruined by excessive cutting and extends over a large area, it may be preferable to try the next method—planing.

Small errors can also be corrected by applying acrylic gesso or modeling paste in much the same way as Plastic Wood. If a small chip is accidentally cut away, you can glue it back immediately with a little carpenter's glue.

Planing When the offending section extends to the edge of the block, it may be

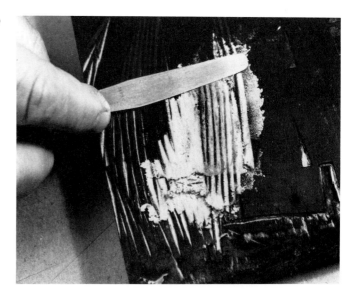

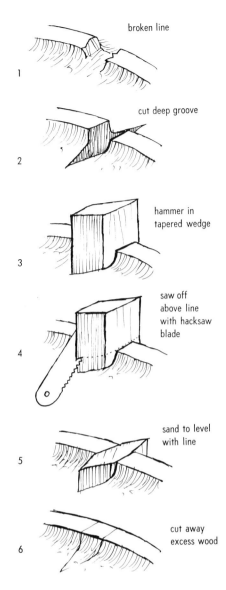

REPAIR OF BROKEN LINES IN WOODCUT

1 — broken line
2 — cut deep groove
3 — hammer in tapered wedge
4 — saw off above line with hacksaw blade
5 — sand to level with line
6 — cut away excess wood

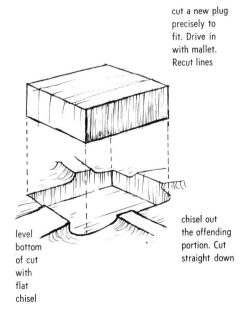

cut a new plug precisely to fit. Drive in with mallet. Recut lines

chisel out the offending portion. Cut straight down

level bottom of cut with flat chisel

PLUGGING A WOODCUT

better to plane the whole section down to fresh wood. This is radical surgery indeed, and will work in only some cases. Plane with the grain and go deep enough to expose enough good wood for proper recutting. When you have finished planing, sand the entire area with fine sandpaper to even out the plane marks. A block treated in this way can be printed only by hand rubbing and will never print properly on a press.

Plugging When a line or two has broken and the block must be printed for a long edition, the best repair method is plugging. Cut a wedge-shaped piece of wood several inches long to use as a plug, then cut a deep, tapered groove in the block through the line that is broken, removing all the wood to be replaced. Hammer the wedge into the tapered cut until it is forced in very tight. Cut off the excess with a hacksaw, sand down to the level of the block, and recut the line. The wedge will fit so tightly that it need not be glued. If you need to repair a larger area than a wedge will cover, you can cut a block shaped to fit a deep incision in your block. The depth of the incision should be more than ¼ inch, and the sides should be cut vertically. The new wood must be glued in position with Elmer's or carpenter's glue, sanded level, and then recut to gain the desired effect. The bottom of the incision should be level enough for the glue to hold the repair block in place.

It is possible to drill circular holes with a bit and then glue in pieces of wooden dowel to fit the drilled holes. This method does not make a good joint and can only be used for small, isolated repairs.

Printing the Woodcut by Hand

The printing of the woodblock is almost as important as the cutting. Without a doubt, sensitive printing through careful inking and rubbing can reveal all the nuances of line and tonality that may be inherent in a block. Heavy inking and heavy rubbing with an improper tool can make a sensitively cut block look crude.

There are a few steps that should be carefully followed to produce good

prints. First, it is important to set up for printing. The cutting table should be thoroughly cleaned with a dust brush to clear away all wood chips. The block should be brushed off with a soft wire brush to remove every tiny chip of wood, which could be picked up by the roller and redeposited onto the block. When little chips become lodged between the paper and the block, they produce tears in the paper during rubbing and ruin the print. All tools used in the cutting process should be put aside. Only the block, a tube of black printing ink, a palette knife, a slab for rolling, a good roller, one or two rubbing tools, and enough precut paper should appear on the worktable.

The choice of roller and ink depends on the intricacy of the cutting. If the block is finely cut with considerable detail and tonality, a hard roller and stiff ink are needed. If the cutting is in loose, large forms, a softer roller and thinner ink can be used.

Squeeze a moderate amount of ink onto the inking slab. Pick up some ink on the roller and roll it out on the slab in horizontal and vertical movements. Be sure the ink is distributed evenly on both the roller and the slab. When there is a thin, even layer on the roller, begin to deposit the ink on the block in a variety of horizontal, vertical, and diagonal movements in order to distribute the ink evenly. This process can be repeated three or four times from slab to block

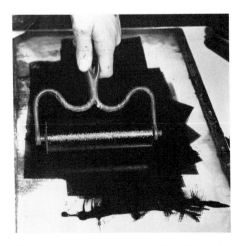

The brayer or roller should spread the ink evenly over the surface. Good ink distribution is vital to a clear impression.

Ink the block thoroughly. Move the roller in many directions, building up the ink gradually. Too much ink will fill the fine textures and delicate cutting.

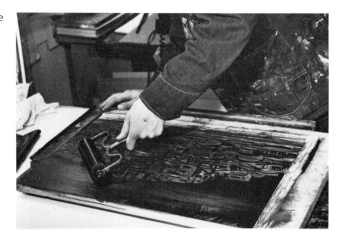

Place the paper in position, using a register frame if you want consistent margins. (The register frame is optional for one-color prints but essential for color registration.)

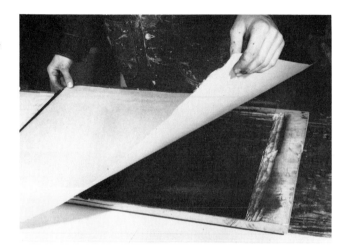

A Japanese rice spoon, made of bamboo, is the rubbing tool. The flat side covers large areas quickly. Use the edge for the greatest pressure and the strongest impression.

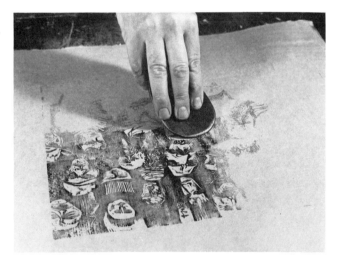

The printing instrument is two wooden drawer pulls glued together. Use good pressure for clean printing.

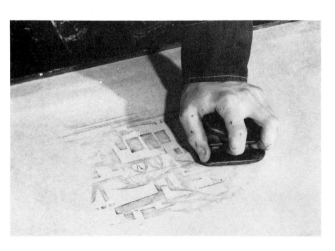

until there is an even, tacky, moderate deposit of ink on the block. Avoid too much ink. Overinking will fill in thin lines and produce a too thick, uneven deposit on the paper.

When the block is properly rolled up, place the paper carefully on it, leaving even margins, and rub lightly with the palm of your hand to smooth out the paper and adhere it to the block. Then rub the paper with your rubbing tool using moderate to heavy pressure. (When rice paper is used, a good precaution against tearing the fragile paper is to place a piece of tracing paper between the rubbing tool and the paper.) Rub in small, even strokes from the center outward, applying consistent pressure, rather than in long, broad strokes that are more difficult to control. Hold the paper down with your free hand. Pick up a corner of the print, being careful not to disturb the register, and check the quality of the printing every now and then. If the paper is medium to thin in weight, some of the image will show through on the back, which will often indicate that there is proper pressure and a proper amount of ink. If the block has been inked too lightly, sometimes it can be carefully reinked if the paper is picked up in small areas at a time, the adhered area held down with the other hand, and the rerolling done without disturbing the register.

A tonal quality can be achieved through printing, and tones can be made to vary in the same print. If one area in a print is planned as a black and another as a gray, rub the black area heavily with the rubbing tool and rub the gray area lightly with just the fingers. Even more controlled grays can be achieved by inking lightly in some areas and more heavily in others and again using a combination of fingers and the rubbing tool for printing.

Press Printing

The sensitive control that you get when you print by hand rubbing the back of the paper is exclusive to this method. However, if you need a large edition or want to print the block together with type, you may want to plan the block for printing in a press. There are several types of presses that you can use.

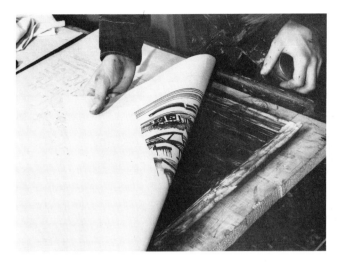

Check the printing by lifting the corners after you have printed the major part of the block. You can replace the paper in position and reprint any light areas. You may need to hold the rest of the sheet with one hand to prevent slipping.

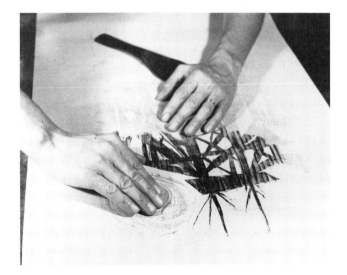

If you want to vary the tonality, use only the pressure of your fingers on certain areas.

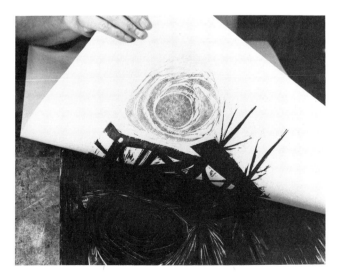

The finger-printed section is much lighter than the spoon-rubbed areas.

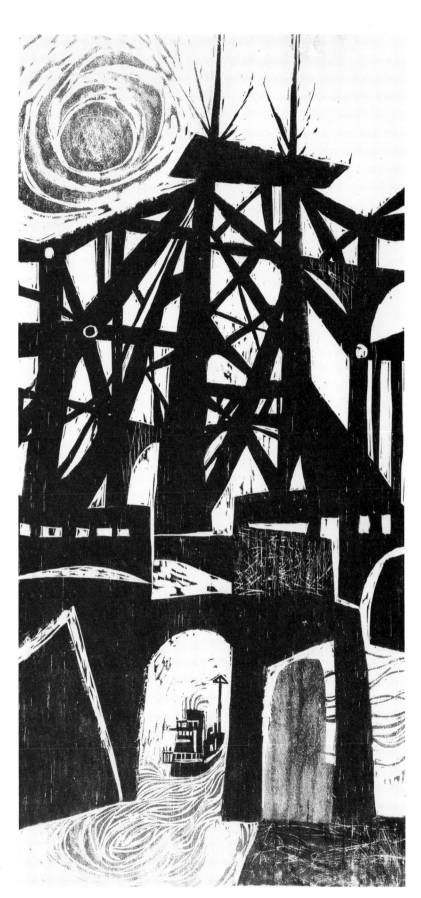

CLARE ROMANO
Bridge in the City, **1955**
Black-and-white woodcut, 22¼″ × 11″
Whitney Museum of American Art

RELIEF PRINTING ON AN ETCHING PRESS

The most commonly available press is the typical etching press, with a bed that passes between two steel rollers. If it has an upper roller that can be adjusted to 1 inch or more above the bed, you can easily print a woodcut on this type of press. The inking is done with hand brayers or rollers. More than one color can be rolled onto the block if the areas to be inked are separated enough to avoid overlapping.

The block need not be perfectly level for printing on an etching press. Slight cupping or curling presents no problem because the contact area between the steel printing roller and the inked block is a thin line about ¼ inch wide. This contact allows the block, even though warped, to print evenly if it is placed on the press so that the grain runs parallel to the length of the press roller. Use newsprint or other absorbent paper, like a blotter, to keep the blanket clean. Normally one blanket is plenty; the pressure may be much lighter than that used for intaglio printing because you are printing from only the surface of the block.

Smoother papers tend to print detail and texture more accurately than rough papers. If you use thin Japanese papers such as mulberry, *sekishu*, or *moriki*, the ink may be forced through them, soiling the blanket. Use additional newsprint to protect it as a precaution. Heavier papers need less packing and are easier to handle.

Avoid handling the inked block while it is in position on the press bed. You can tape paper to the bed and mark the corners where the block fits. It is easy to make little cardboard stops and tape them to the bed to indicate the precise position of the block. The paper can also be controlled this way, making possible an even margin throughout the edition. When you are doing color work, you

HOW TO PRINT A WARPED BLOCK ON AN ETCHING PRESS

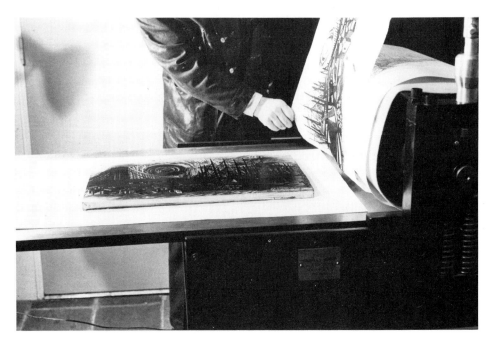

An etching press may be used to print woodcuts if the roller can be raised high enough to accommodate the block. The ink is applied with a brayer. Light packing is used for level blocks, with newsprint and a blotter put under a thin blanket. The pressure is controlled by micrometer gauges.

can use taped cardboard stops as a register system.

Press printing yields longer editions than hand printing because the pressure is distributed evenly over the entire length of the block rather than in small areas, as in hand rubbing.

RELIEF PRINTING ON THE VANDERCOOK PRESS

Editions of several hundred or more in several colors are possible on a Vandercook press. There are many models, differing in size and inking facility. The older models are relatively inexpensive because every commercial printer used to have a press of this kind for proofing typographic matter. Many models have no inking rollers; the inking is done with brayers, and the press simply makes the impression.

Some older Vandercooks have no grippers to hold the paper, making them more difficult to use for large editions than models with grippers. It is possible to do color register work on gripperless presses by linking enough rubber bands to form two strings. Wrap the bands around the cylinder and fasten them with string or paper clips. Slip the paper to be printed under these rubber bands, taking care that the printing surface does

not come in contact with the rubber bands, which can damage it. Mark the packing sheet with pencil as a guide for the paper so you can place successive sheets in a similar position. The register obtained by this method is not as precise as that obtained on more recent presses.

Newer presses have inking rollers attached to the printing cylinder that ink the block in the instant after the printing drum passes over the block. Some presses have motor-driven inking rollers that automatically distribute ink over the surface of the rollers, making them ideal for longer editions.

Lockup The block must be fixed in position on the bed of the press in order to prevent slipping and ensure even margins. The easiest way to fix the block is to use an automatic lockup bar, which is available in different lengths for the varying beds that Vandercook manufactures.

The cheapest lockup is made with pieces of rectangular wood, called furniture, held in place with keys and quoins to lock up the block. Wooden furniture is inexpensive and widely available, even secondhand, since most job printers get rid of their old furniture from time to time. Metal furniture is better than wood, and plastic furniture is even better than metal but is expensive and not commonly available. A great convenience if you do much press printing is to have some magnetic metal furniture handy. You can use this material to lock the block in position temporarily for a few proofs. It is not, however, suitable as a lockup for a large number of impressions.

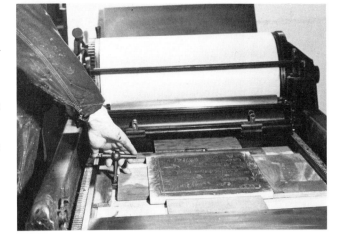

To print an edition on the Vandercook 25 press, the block is locked in position using plywood furniture and conventional quoins. The block must be level.

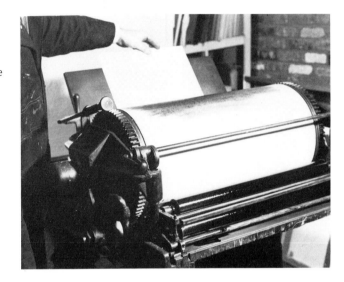

After the block is inked, the cylinder is run to the foot of the press and the paper is placed in position, resting on the slanted paper support. The grippers will pull the paper through the printing cycle.

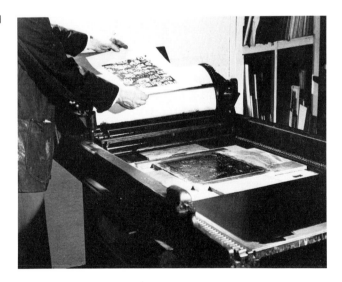

When the cylinder has returned to the head of the press, the grippers release and the printed impression may be checked for flaws.

Wood that is warped or curled may be too difficult to print, since makeready will not suffice to correct this handicap. Therefore, be sure your blocks are level from the start when printing on a proof press, which is fixed in position and cannot adjust to the rollers as an etching press can. The best source of level blocks is from a manufacturer of backing wood for photoengravings. The blocks are usually of cherry or poplar, both very good for woodcuts.

It is possible to print from relief etchings made from zinc or copper plates or from collage plates made from cardboard, paper, cloth, and other materials. If these plates are to be press-printed, care must be taken to get the surface of the plate as level as possible; otherwise, the makeready will be an enormous task. The collage plates should be well sealed and thoroughly glued in order to withstand the suction of the inking rollers and the pressure of the impression cylinder.

Printing It is possible to get an excellent impression on the Vandercook if the preparation of the makeready is done well and the distribution of ink is right. Too much ink will fill in the fine texture of the block and clog the fine lines. It is better to start with a thin film and build it up rather than put too much ink on the rollers and then have to remove it, which also necessitates a washup of the block.

To print a large sheet of paper without slurring or blurring of the edges of the image, you may need to hold the trailing edge of the paper tight against the cylinder as it prints.

Peter Kruty adjusts the tension on a perforated tympan sheet on his Vandercook proofing press at Solo Letterpress workshop in New York.

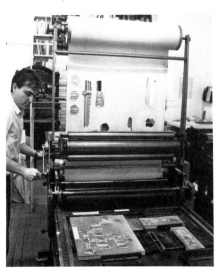

Makeready If you use type-high (0.918 inch) wood that is quite level, you will find good impressions easy to obtain. Slight variations in the printing surface can be remedied by gluing thin pieces of strong tissue paper, called makeready, on the packing sheet over the printing cylinder. Use Sphinx paste, and if the edges of the paper cause a sharp line to print, sand the edges with fine sandpaper to smooth them. Better still, tearing the paper instead of cutting it will usually solve the problem. It may be necessary to glue more than one layer of makeready paper to the packing sheet to bring the printing surface to the proper height. Discard the packing sheet when the edition is finished. Do not attempt to reclaim it for your next print because it will be ruined by the glue.

If you use wood that is less than type-high, slip a few sheets of thin cardboard or oaktag under the block to build up the height of the block. Cut the sheets slightly smaller than the block so they do not stick out and ruin your lockup.

RELIEF PRINTING WITH THE HAND PRESS

The use of the hand press, such as the Columbian or Albion press, has dwindled in fine printmaking. It is suitable for small blocks, however, and some wood engravers still prefer it. The block must be inked with a brayer. Because the edges of the block usually print darker, makeready must be done with care, the packing built up with thin sheets of paper pasted to the packing sheet with Sphinx paste. The makeready paper must be torn or the edges sanded so there is a gradual transition in thickness. The block is placed in the center of the bed of the press, and when the bed is rolled in and out for alternate inking and printing, care must be taken not to cause bumping or jogging, which can loosen the block and cause slurring or blurred prints.

The pressure exerted by one of these old platens is considerable and can easily damage a block if it is excessive. Therefore the pressure should be built up gradually by increasing the number of pieces of paper or cardboard under the block to raise it to proper printing level. Pressure can also be increased by adding to the packing sheets placed under the tympan sheet, which covers the printing cylinder. A tiny speck of lint or sand can cause pitting or denting of the block in any press, including cylinder and platen presses, and great care must be taken to keep the inking slab and roller clean.

A bookbinding press can be used to print small woodcuts if the edition is limited. The pressure is usually good, but the amount of manipulation is quite time-consuming. Hand rubbing is faster.

PRINTING FROM A LOW RELIEF SURFACE

It is possible to print from a surface where the relief is too low to use normal methods, such as an underbitten relief etching. Since inking the plate directly with a roller would almost certainly contact the lower areas, ink a piece of heavy oaktag paper instead. (Or use a piece of heavy acetate or vinyl, which cleans easily and can be reused.) Then place the inked surface on and facing the plate, put a piece of mat board or smooth cardboard on top of that, and run it through the etching press with reduced pressure. Only the raised areas will receive the ink. It is possible to use this process without the press by burnishing or spooning the back of the oaktag carefully and firmly. This will ink the plate, which you can then print onto your paper either by spooning or by using the etching press. William Blake's relief etchings were very shallow and were printed by a similar method.

COLOR WOODCUTS

Color should be used in a relief print to develop a visual idea and express form. It should not be used merely as decoration or as a "tint" on a black-and-white print. The artist who understands and exploits the great potential of color can create a relief print of highly expressive power.

The woodcut block itself has a quality that makes colors take on vibrancy and intensity. It is easy to cut separate blocks for each color and to print them in register to achieve a final impression of many colors in one image. It is also possible to use a single block to print all the colors in a work. This method, known as the reduction or subtractive method, was the one used so eloquently by Picasso in his linoleum color prints.

Developing the Image

The procedures an artist uses in the color relief print are extremely personal, dictated by his or her own esthetic direction. One of the attractions of the color woodcut is its potential for printing transparent colors over each other to create a third color. With this possibility in mind, you can work with a limited palette and still achieve multiple colors and exploit the intrinsic nature of the color woodcut.

KEY BLOCK

Some artists cut a key block containing most or all of the dominant design elements. It is proofed in a single color after being cut, and the proofs used as trials for color relationships. The artist can paint directly on the proofs, using poster color, watercolor, or ink, to develop the image through color and then follow these sketches for cutting the other blocks. The drawback of the key-block method occurs when too much emphasis is placed on the first block and the succeeding colors become only incidental to the design rather than essential to it. The Japanese Ukiyo-e artists used a key block with the major elements in black line and successive color blocks for the areas of mass and pattern.

COLOR ON BLOCK

You can also develop a color sketch directly on a block, painting the image with poster or tempera paint that is thinned to keep the wood grain from filling with color. After completing the design, make a careful tracing of it as a record, then cut the most important color on the block. This first block serves as a master that can be proofed in register onto successive blocks. The tracing you have made will enable you to cut the shapes of the next colors. The drawback of this method is that you destroy your color sketch when you cut the first block.

DAVID SALLE
Portrait with Scissors and Nightclub, 1987
Color woodblock print, 24¾" × 30"
Courtesy Crown Point Press,
New York and San Francisco

yellow, and blue. Because poster colors are opaque, it is a good idea to place the three base colors in small dishes. Then premix as closely as possible the four colors you would achieve by overprinting and place them in small dishes. Yellow and red in overprinting will create orange; yellow and blue will overprint as green; red and blue will overprint as purple; and red, yellow, and blue will yield a brown. Use this palette of seven colors to paint your sketch as freely as you wish, and you can achieve a good approximation of what you will realize in the finished print. If the white of the paper is considered as a color in the sketch, eight colors could result in the final print. The sequence of printing and whether you print wet over wet or wet over dry, as discussed later in the chapter, will determine the intensities and dominance of the colors.

Pastels can be used in a similar fashion, as can colored pencils. Both are excellent for small-scale work if used on tracing paper or transparent vellum. Colors can be applied over one another in a single drawing to approximate the quality of overprinted inks. Felt pens using dyes are excellent, although they tend to fade after a few months. You can even use colored paper to make a collage sketch as a guide for a color relief print, again by selecting and extending the number of colors with overprinting in mind.

Whichever medium you choose, you will have to make a tracing of the first key color. The completed sketch can serve as the master guide for all the blocks to be cut. The results from this method are not likely to be as fresh and spontaneous as from other, more direct approaches. However, the increase in control of color relationships has certain advantages for those artists who desire complex color statements. The choice of method is really determined by each artist's personal direction.

RICHARD BOSMAN
The Wave, 1987
10-color woodcut (cut by the artist), 30" × 38"
Courtesy Experimental Workshop, San Francisco

However, it eliminates one transfer and keeps the first block vigorous and fresh, which is a very positive factor.

SEPARATE COLOR SKETCH

The most complete control is obtained when a carefully worked-out color drawing is completed on a separate sheet. This is an excellent means for those who must have a completely realized solution before they start. The sketch should be made in a medium that can reflect the transparencies possible in color overprinting. Watercolor is good, colored inks are better, and poster color or tempera is suitable if used properly.

If you use poster colors for your sketch, it is a good idea to visualize the additional colors that will be created as colors print over one another. You can do this by premixing the colors for the sketch. As an example, you may decide to make a three-color woodcut in red,

Color Register Methods

There are many ways to achieve accurate registration of colors. The choice will depend on your imagery and the kind of control you wish to exercise. If your approach is loose, a freer system such as the reduction method might be best. If your concept depends on great accuracy, the multiple block system may be best. Study each procedure in relation to your needs or your sketch.

MULTIPLE BLOCKS AND REGISTER FRAME

After completing your color sketch, select the first block to be cut. It may not be the color you will print first, but it should be the color that displays the largest percentage of image so that subsequent color blocks can be registered and cut in relation to it. After it is cut, you will need to place this first image on each successive block in proper register, or juxtaposition, so that each color area will print in the correct relation to it.

A register frame is easy to construct. On a base of ¼-inch plywood, Presd-wood, or composition board, nail or glue two pieces of 1-by-2-inch wood as shown. These pieces are at right angles to each other and hold the block in place. If you use cardboard, linoleum, or other thin blocks, you can construct the frame from thin stripping, making sure it approximates the thickness of the block you are printing. Along the edges of the frame, nail or glue two strips of thin ⅛-by-1-inch wood stripping to serve as a paper guide. Take care to leave an open corner when you fasten the stripping so that your thumb can comfortably adjust the paper. Wooden 12-inch rulers make excellent paper guides.

Ink the first block fairly heavily and place it in the frame. Slide the block against the long edge of the frame until it touches the other, perpendicular edge. Make sure that the long side of the block is firmly fitted in the frame. This position must be duplicated every time the block is printed. If the block is square, both sides will fit securely, but it is more likely that the block will be slightly out of square, with one side fitting solidly and the other side touching at one point only. When the block is in position, tape a piece of tracing paper to the edge of the frame.

OFFSETTING ONTO SUCCESSIVE BLOCKS

Tracing paper is preferred for offsetting the cut image onto uncut blocks because it is not absorbent and will hold a great deal of ink on its surface. Let the tracing paper drop down over the well-inked first block. Rub your hand over the back of the paper to hold it firmly. Then rub the back of the tracing paper with a rubbing tool to obtain a heavy deposit of ink on the paper. It is essential to have an amply inked image because it must suffice for offsetting onto additional uncut blocks.

Lift up the tracing paper with the imprint of the block on it, being careful not to remove the paper from the frame. Slip out the block that has just been printed. Turn the block over to its uncut side and slip it back into the register frame carefully in the same position. (Both sides of the block can be used.)

Drop the tracing paper onto the block. Rub it with your hand to adhere it and then use a rubbing tool to achieve a

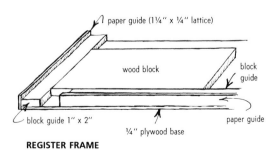

paper guide (1¼" × ¼" lattice)

wood block

block guide

block guide 1" × 2"

¼" plywood base

paper guide

REGISTER FRAME

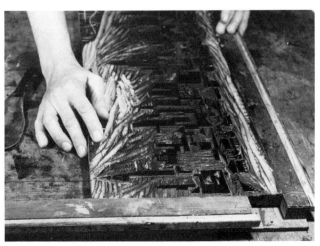

When printing color blocks, always place the block, using the block guides, into the register frame in the same way for each printing to achieve a consistent register.

strong image on the uncut block. Lift up the tracing paper again, remove the block, and slip in the next uncut block. Repeat the process until the first cut image has been successfully transferred, in position, onto each uncut block.

Let the offset images dry on the uncut color blocks. Wash off the ink from the first cut block with odorless paint thinner so that the pores of the wood do not become clogged. After the offset images are dry, you can indicate the second color in chalk or trace it on the block from a drawing. Care must be taken to make the image of the second color slightly larger so that the colors will overlap and no gaps of white paper will appear between forms. This technique, called trapping, requires an overlap of ¹⁄₁₆ inch or so.

After cutting the second color block, you repeat the offset transfer, placing the image on tracing paper and then on the third and succeeding blocks that are to be cut. This time, instead of using a dark ink, use a light red or green ink so that the image from the second block can be seen clearly in relation to the first one.

The key to using this method effectively is to avoid cutting any of the blocks completely. The composition can then develop organically, and changes can easily be made after first proofing. When printing an edition from the register frame, trim the paper in advance to have two straight sides at right angles to each other. These sides fit into the paper guides on the frame and must always be placed in the same manner, from block to block, in order to maintain color registration. The best way to hold the paper is by diagonally opposite corners, which gives you the most control. Slide the paper along the long edge of the paper guide until it hits the short side. Then lower the paper onto the inked block and print it by rubbing. Once the ink has adhered the paper to the block, the block can be moved out of the guides for the printing process. Inking should also be done with the block away from the frame edges in order to keep the frame clean and to help keep paper margins clean. If the registration is a tight one, you may want to tape the paper in position on the register frame and move only the blocks in and out of the frame.

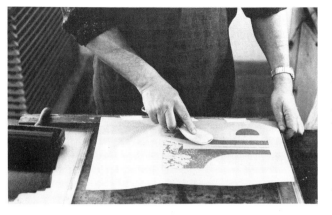

To transfer a design cut into a block to another block in order to achieve color register, ink the block, then place it in the register frame. Put a piece of nonabsorbent paper (tracing or bond paper) in position with masking tape. Rub the paper with the spoon to print the inked design.

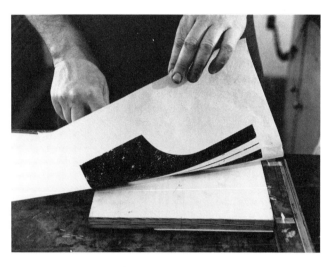

Now turn the block over or place a new, uncut block in the register frame, leaving the taped tracing paper in position.

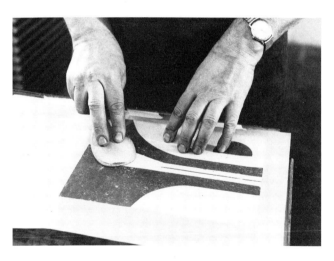

Transfer the wet ink from the tracing paper to the uncut block by rubbing with the spoon. The tape will keep the paper in the correct position.

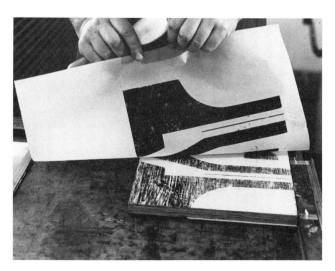

The design has been transferred, in register, to the new block. This will enable you to see exactly where the first block will fall in relation to the new block.

JAPANESE REGISTER METHOD

The Japanese register method requires blocks somewhat larger than the printed area because the register guides are cut into each block. The white margin around the print is established by the register guides. Small right-angled key stops are cut into one corner and one side of the block. They do not have to be cut very deeply, as they must hold only the edge of the paper; about three times the thickness of the paper is enough (see drawing for details). The paper is fitted into the stops each time an impression is to be pulled. The stops are cut into each block in succession, as the blocks are cut. The previously cut block is transferred to the uncut blocks either by the Japanese method of gluing the key proof to each block (see page 40) or by the Western method of offsetting a proof inked on tracing paper onto the next blocks. Because the Japanese register method restricts the size of the margins, most Western printmakers do not use it.

PIN REGISTER

An adequate method for registering small prints employs two long needles. Common pins are usually too short for any but tiny prints. After cutting the first block, take a heavily inked proof on strong, tough paper. While the paper is still on the block, punch two needles through the paper into the block. The holes must be close to the outer edge of the paper and far enough apart to ensure adequate control. Remove the needles, then the inked proof, and place the proof, image down, on the next block. Transfer the image by rubbing the back, and punch holes into the new block through the same holes in the paper. Now cut the second block, and continue this process until all the blocks are cut.

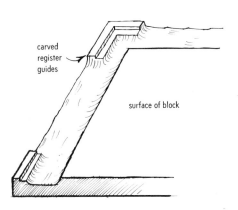

JAPANESE REGISTER METHOD

carved register guides

surface of block

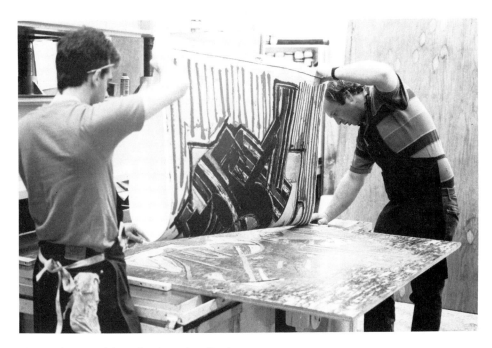

John Hutcheson and Jim Lefkowitz register Frank Stella's *La penna di hu* by center marks on each side of the sheet at Tyler Graphics. Photo: Marabeth Cohen.

The pinholes in the paper are usually easy to burnish closed when the print is dry.

The needle method has great disadvantages: only small editions can be printed before the process becomes too tedious, and large prints are too difficult to handle. Also, during printing you may need help to keep the paper taut and away from the inked surface until the needles find the holes in the wood.

SMALL BLOCKS OR PIECES

You may need to register a small block or found object in a certain position on a color print. If the block is of thin material, such as cardboard, engraving metal, cloth, or the like, it can simply be glued to a base block of plywood, Masonite, or chipboard. If the block is of thicker material, such as 7⁄8-inch wood or 3⁄4-inch plywood, or cannot easily be glued in place, you can make a base board out of heavy paper or cardboard. Cut this material to the size of the key block or the size of the print. Mark the position of the small block on the base board so that you can return the block to the correct position each time it is inked.

When you are printing from very thick material such as rough-sawn planks or log sections, machine parts, and the like, you have to make a special jig or frame to hold these pieces in place.

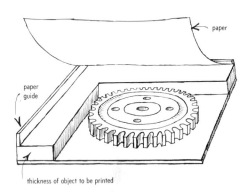

paper

paper guide

thickness of object to be printed

REGISTER FOR THICK RELIEF-PRINT OBJECTS

JIGSAW METHOD

An interesting method of making a color print from one block should be mentioned because it eliminates register problems yet enables the artist to use multiple colors. This approach was used by Edvard Munch, the gifted Norwegian Expressionist painter and printmaker, whose bold and symbolic use of color in prints was unique for his time. Although he would employ four or five colors in one print, he often printed them from one block that was sawed into separate pieces, very much like a jigsaw puzzle. After separately inking each piece, he would fit the elements together again and print the complete image quite easily with one rubbing.

Two Beings was printed from one block carefully sawn into two separate pieces. The two simple elements, the

Antonio Frasconi places small blocks on a marked cardboard sheet in order to control their register for a color print. It is not necessary to cut the same size blocks for each color.

PETER PAONE
The Garden, 1989
Reduction linocut, 20″ × 26″
Courtesy of the artist

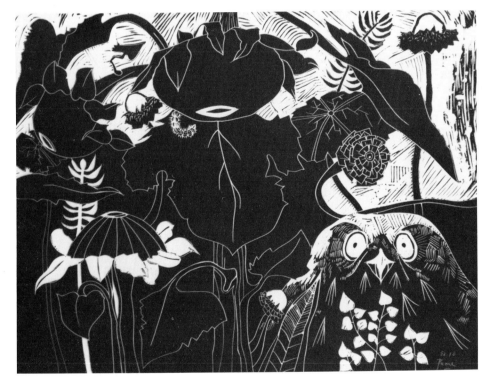

couple and ground and the sky, were cut along the edges of their forms. A thin dividing line appears in the print where a slight space occurs between the forms. This line becomes an integral part of the design and seems to preview the white separating lines that appear so frequently in contemporary intaglio plates that are cut into separate pieces, inked, and reassembled in printing. Mat board or cardboard can also produce this effect if it is cut into segments, inked separately, then reassembled into correct position for printing. Of course, the surface of the mat board should be sealed with lacquer, shellac, or polymer gesso before inking.

REDUCTION METHOD

The reduction method is best described by its name. One block is reduced in stages to a multicolored print. It is an interesting and creative procedure for the experienced artist, but the uninitiated should prepare a careful sketch to help clarify the sequential cutting of areas.

The first color is sometimes printed from the whole block. Sometimes a minimal amount of the block is removed to designate the first color. The number of the edition must be determined before printing the first color, as there is no possibility of reprinting. After printing the first color, remove all the ink from the block, indicate the second color on the block, and cut away all the unwanted wood. Ink the block with the second color and print it over the first color. Repeat the cutting and inking until a satisfactory image develops. With this method the area of the block is reduced with each cutting, and therefore the larger areas of color must be cut first. The final block, of necessity, contains only a small percentage of the area of the original block. It may be necessary to allow the first color to half dry or dry completely before the second color is printed. This will depend on the colors chosen and how much the second color is absorbed into the first color.

Picasso completed a fine series of vibrant color linocuts between 1958 and 1963 that are reduction prints. They are interesting to study in preparation for using this method.

Inks for Color Printing

The chemistry involved in the production of today's printing ink is so complex that a new profession has evolved, that of ink chemist or engineer. Some manufacturers go to great lengths to keep their formulas secret, but the technology has become so sophisticated that the artist and printmaker can purchase fine-quality inks. It is suggested that you buy ink from a well-established commercial firm and conduct a few simple tests of the permanence of some key colors. You will probably find that the great majority of colors are relatively permanent and a small number fade quite rapidly and are unsuitable for use.

In general, the earth colors—the ochres, umbers, and siennas—are usually permanent. The cadmiums—yellow, orange, and red—are also permanent in most cases. The addition of black, white, transparent extender, and the phthalo blues and greens makes a fairly complete palette.

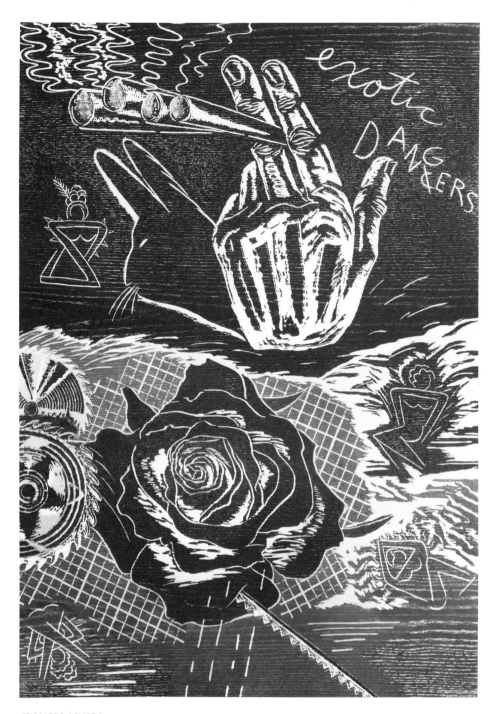

FRANCES MYERS
Exotic Dangers, 1987
Color woodcut, 44″ × 32″
Courtesy of the artist

The colors that tend to fade are the reds, magentas, purples, and certain blues. The pigments used in the manufacture of the inks are responsible for the fading in almost every instance. Usually, manufacturers do not specify which pigment has been used in the composition of an ink, making it difficult to predict which color is not permanent. When in doubt, roll a thin film of ink onto a few white mat cards. Place one in

the sun, one in a shady spot, and file another away inside a book or cabinet. After a month or two you will see the amount of fading in each case. Very few colors will pass the sun test without some fading, but all should pass the shade test. Use the best pigments you can get. We have used good-quality etching ink that is adaptable for relief prints, etching, and collagraphs.

Because printmakers have a prime interest in the permanence of their colors, they must take proper care to guarantee that all their inks are stable. Many artists mix their own colors by adding a good-quality oil paint (one without excessive filler, binder, or extender) to a transparent white ink extender in order to get

the proper viscosity. Oil paint directly from the tube, although made of high-quality ground pigments, rarely has enough stickiness to roll out properly for inking a relief print. The amount of transparent extender (basically a varnish) will vary according to the viscosity required. In any case, add only the minimum extender needed to achieve good rolling quality. A small amount of dry magnesium can be added to the color to make it stiffer.

It is more useful to purchase opaque than transparent inks and mix them with transparent white, which is not a white pigment but a transparent varnish of tannish color that does not alter the intensity of other colors. Mixing allows you to control the amount of transparency and to add transparency to any color you choose. The primary colors, called process colors by ink manufacturers, can produce a wide range of hues and, used with black and white, can extend your palette to a very wide spectrum. However, such colors as emerald green and intense magenta or purple may have to be purchased specially in order to get the maximum brilliance and intensity.

Unless you use up ink rapidly, you should buy it in tube form. Many makers provide a good range of colors in large tubes (about 1 inch in diameter and 7 inches long). Although tube ink is slightly more expensive per pound than ink in cans, it is much more convenient to use. We have some tubes of ink that are twenty years old and still in good condition. Replace the caps carefully after cleaning them with a rag or palette knife.

If you do use canned ink, wipe the rims and lids and replace the circular wax paper by smoothing it over the surface of the ink, eliminating any air bubbles. When ink skins over, the top must be scraped off and discarded. Even a small piece of dried ink skin can be an annoyance when printing. To retard drying out, you can cut a circle of heavy vinyl by tracing the bottom of the can for size and tap it firmly on the ink surface. There are also spray cans of sealers for cans of ink, which are available from ink manufacturers and are useful in preventing drying out. A thin film is sprayed over the ink surface.

Color Printing

Sensitive printing is a vital step in the completion of the colored image. A thorough knowledge of overprinting and color sequencing enables the printmaker to exploit color with variation and inventiveness.

Transparencies can be used in overprinting to achieve a wide color range with just a few colors. Adding transparent white does not appreciably alter the color quality of the inks; up to 80 percent can be added to an ink to achieve the desired transparency. The transparent white should be added on the mixing slab and mixed well with a palette knife. The amount of transparency is determined by the color. A lemon yellow or bright orange needs little or no transparency because of the natural transparency of the color itself.

You will find that it is much easier to roll up a block with color inks because they have a softer consistency. Less ink is required on the block and less rubbing in printing. If delicate cutting is to be printed, you may find it desirable to add some powdered magnesium to the ink in order to stiffen it. Experiment with different inks to find which are best suited for your work.

Generally speaking, dark colors are printed first and light ones last in order to achieve the most effect from overprinting with transparent inks. However, there are times when a dark or black block is a key block and it is necessary for the image to print it last.

The quality of a color print can be greatly changed if the sequence in printing is reversed. Experiment to find the various possibilities that exist through sequential printing. You can also use colored papers for a wide range of effects. Japanese *moriki* paper comes in a fine range of colors. Light colors can be printed over black and off-black papers. High-key colored papers and subtle colors can all be used with very surprising results.

WET AND DRY PRINTING

Different qualities in the print can be achieved by printing wet on wet or wet on dry. Usually when transparency is used, the colors are printed wet over dry or semidry inks. Sometimes when two colors are close in value, even with some transparency added to the second color, they must be printed wet on wet for the best transparency results. It is difficult to make firm suggestions because so much depends on color values. Experimentation with the blocks is of prime importance; the best results come after a few possibilities are tried.

ACHIEVING TEXTURE

One of the important reasons for selecting the woodcut as a means for color printing is that it is possible to achieve textural variations and surfaces that are unattainable in other print media. Interesting color variations can be produced by overprinting a combination of a smooth block and a textured block or two textured blocks. Flecks of pure color will appear in whatever pattern the textures make, sometimes creating illusions of the formation of a third color much the way colors are formed in pointillist or optical painting.

PRINTING TWO COLORS ON A BLOCK

There are other possibilities in the printing and the planning of color blocks. Two or three colors can easily be printed on one block if the colors are in isolated areas. Small rollers can be used very successfully to ink these areas. There are some small Hunt rollers that come in sizes from 1 ½ to 6 inches. There are also smaller rollers 1 inch in length and ½ inch in diameter. All these rollers are quite soft and very good for nondetailed work. If a harder roller is desired, it is best to make your own. Check for sources and methods in the section on rollers (page 14).

RAINBOW ROLL

Colors may be merged or blended on a roller and the blend transferred to the block to print as graded tones. Place the colors on the inking slab, one after the other, with a palette knife. Take a roller large enough to encompass all the colors and work it back and forth over the slab with a minimum of side movement. The colors will merge together and blend as the side-to-side motion is increased.

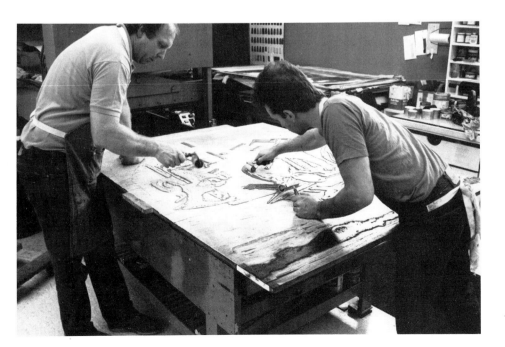

John Hutcheson and Jim Lefkowitz use small brayers with different colors to ink *La penna di hu* by Frank Stella at Tyler Graphics.

CAROL SUMMERS
Rainbow Glacier, 1970
Color woodcut,
36½" × 37"
Courtesy Associated
American Artists Gallery

Once the roller is properly and evenly charged with the blended colors, the block can be inked.

When this procedure is done on a motorized press, the blending continues until eventually the colors are so thoroughly merged that they become a single tone.

SOLVENT TECHNIQUE

The artist Carol Summers has developed a unique method of color printing from separate blocks that is worth mentioning. Summers works with large, simple, stylized or abstracted forms, very often of landscape or architecture. He cuts his blocks fairly deeply, usually of ¼-inch plywood. After cutting the blocks, he places an uninked block in a register frame, lays a piece of woodcut paper down on it, and rolls a thin film of oil-based ink right on the back of the paper with small rollers. He inks separate blocks in registration in this manner, essentially inking and printing in one operation. When all the blocks are printed and the ink is still wet, Summers sprays the whole print with a thin film of odorless paint thinner, using a garden mister or a Pre-val spray bottle. The colors run together slightly, giving a watercolor effect to the printed image. This spraying method can be used only with adequate exhaust ventilation or outdoors.

Sometimes Summers combines the traditional method of rolling ink on the block with rolling ink on the paper. At times he prints on the back of the print so that the image is diffused. The results are very handsome and quite similar to rubbings.

For a graded or rainbow roll, the colored ink is placed on the inking slab with a palette knife. Then a roller large enough to cover the entire surface of the block is rolled over the patches of ink.

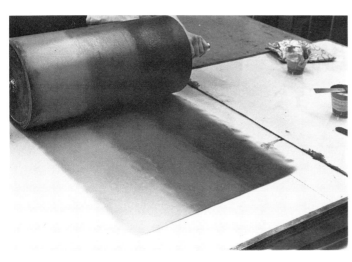

Continuous rolling in one direction will level out the ink film on the slab and on the roller. Some blending may be accomplished by a slight sideways shifting of the roller on the slab to merge adjoining colors.

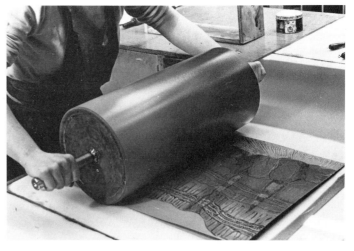

When the film of ink is even and blended, the roller is passed over the block. The rainbow of colors has now been transferred to the raised surfaces.

Japanese Woodcut Method

Given the rich history of Ukiyo-e, it is important to describe some of the basic methods the Japanese used so eloquently in their prints. The Japanese approach to printing the color woodcut is vastly different from our contemporary approach, which uses the wood grain as an important element and relates the printing to overprinting colors. In Ukiyo-e the use of water-based inks and the application and blending of watercolor washes directly on the blocks resulted in amazing watercolor qualities and impressions that seem to us more like monotypes. However, the application was so skilled that the printers were actually able to repeat the complicated wash effects and make consistent multiple editions.

The traditional approach of Japanese artists to the use of their materials is quite ritualistic. Although mastering the manual skill demanded of Ukiyo-e artisans is an impossibility in our culture, adapting some of the methods is very possible for the contemporary artist. With this in mind, we will give some rudimentary information on materials and procedure.

MATERIALS AND TOOLS

Basic woodcut tools (page 9)

Wood (cherry, poplar)

Cutting knife

V gouge

C gouges (2 sizes)

Small chisels

Large chisels

Whetstones for sharpening tools

Baren for rubbing

Animal glue in stick form

Alum (3 to 4 ounces)

Library paste or rice paste

Pigment

Brushes (large and small horsehair) for applying color

Brush for sizing (called a *dosabake*)

Sumi ink

General equipment for stacking

Paper, boards for cutting, bowls

Wood Cherry or *yamazakura* wood (a species of wild cherry) was almost the only kind of wood used by the traditional Ukiyo-e artists. A very hard wood, cherry is difficult to cut but was necessary for the fine lines and great detail so prevalent in Ukiyo-e prints, as well as for the large editions that were common.

Traditional Ukiyo-e blocks were always cut with the grain, and a regular grain was preferred. Selecting the wood was a very important aspect of preparing the block. The wood was most often cut from the central portion of a tree, between the heart and the bark. The blocks were allowed to season for a few years to make them quite dry, an important quality because the blocks needed to absorb some of the water-based pigments during printing.

Contemporary Japanese artists are very likely to use any wood that relates to what they wish to say. Bass plywood, one of the woods most commonly used, is inexpensive and easy to cut and comes in large sizes. Its unobtrusive grain also makes it desirable. American plywoods such as birch and fir are available and can be successfully used. Birch plywood in ¼-inch and ½-inch thicknesses, imported from Finland by Stewart Industries, is ideally suited for the woodcut in general and for the Japanese method in particular and is quite inexpensive. In addition to plywood, boards of pine, poplar, or fir can be used.

Whetstones Tools are sharpened on whetstones, called *toishi*, which are made of sedimentary natural stone or a ceramic material. The ones of natural stone have a tendency to form uneven ruts from the sharpening process, although ruts can be prevented by moving the tool around the stone. Ceramic whetstones are available in a molded shape that aids in the sharpening of curves and angles, and small slipstones are made especially to remove burrs from the inside of V gouges or curved scoops. Whetstones are available in three surfaces: fine (*shiageto*), medium (*chudo*), and coarse (*arato*). The fine stone will keep edges sharp during normal cutting if used regularly. The coarse stone will remove nicks or bruises from the knife and is reserved for drastic changes in the angle or deep sharpening.

You should soak a whetstone in water, not oil, for a few minutes before using it. When you start to sharpen, a creamy paste will form that helps the cutting action. Keep the angle of the knife constant or you will round the cutting edge. Remove the burr from the tip by lightly grinding the top side of the knife with a few strokes. You can protect the cutting edges of your tools by keeping them in a canvas roll or carrier (*to ire bukuro*) or in a storage box.

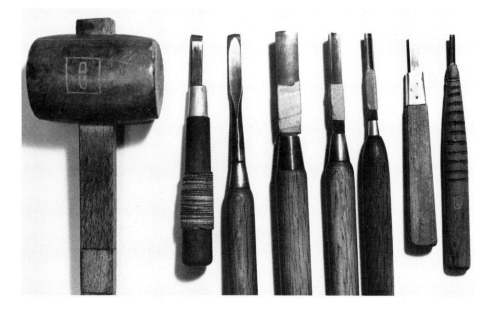

Mallet, chisels, and gouges used by Ansei Uchima in cutting his blocks (frequently made of birch plywood).

Baren The *baren* is the pressing and rubbing tool used for printing. An ingenious, simple tool, it is beautifully designed for use on porous Japanese paper. It consists of flat, coiled strands of cord, strips of bamboo sheath, and a backing disk. The backing disk holds the coil of cord. About 5 ½ inches in diameter, it is made of many layers of Japanese paper that are molded on a form, covered with silk tissue, and lacquered. The bamboo sheath is used as a covering and as a rubbing surface on one side and is twisted into a secure handle on the other side.

The *baren* comes in different weights depending on the thickness of the cord. The thicker the cord, the stronger the pressure it can exert in printing. Only a few traditional printer-artisans can make a proper *baren*, but all Japanese artists cover their own. The inside of the *baren* lasts for years and can be recoiled. The bamboo sheath covering must be replaced often because of the constant rubbing. For the Western artist who is not ready to cover or make a *baren*, adequate ones are available in some art-supply stores, such as Robert McClain in Eugene, Oregon. A professional *baren* can cost hundreds of dollars, but several inexpensive grades are available. You can also buy the parts of a *baren* and put it together yourself, following the directions that come with it.

Pigments At the core, the difference between the Japanese method and the Western method of printmaking is the use of water-based pigments by the Japanese and oil-based inks by Western artists. Water-based pigments are usually mixed with rice paste, which acts as a binder. It can be purchased in tubes or it can be prepared from rice flour and water.

You should experiment with a variety of water-soluble paints before deciding which will best express your image. You can purchase powdered paint from sev-

eral suppliers and mix it with water to make a paste. By experimenting on paper, you will find, for example, quite a difference in printing quality between *sumi* black, watercolor black, gouache black, and poster black. *Sumi* ink is more of a dye and really penetrates the paper. Watercolor is a bit more uneven but penetrates the paper too. Gouache penetrates less but prints strongly, and its colors are of excellent quality and not fugitive. Poster color can print unevenly, with some of the color penetrating and some lying on the surface. Library paste can be added as a binder to all these pigments.

Any good quality brand of tempera or watercolor, such as Winsor & Newton or Grumbacher, will work well.

Brushes In Japanese printmaking, brushes instead of rollers are used for applying pigment to the block, as well as for blending and grading color. Two sizes are used, one for applying pigment over large areas and one for small areas. The brushes are made of horsehair and wood or bamboo. Most Japanese artists soften the hairs of their brushes by rubbing them against a piece of sharkskin with a little water for a half hour or longer to soften the ends and split the hair tips.

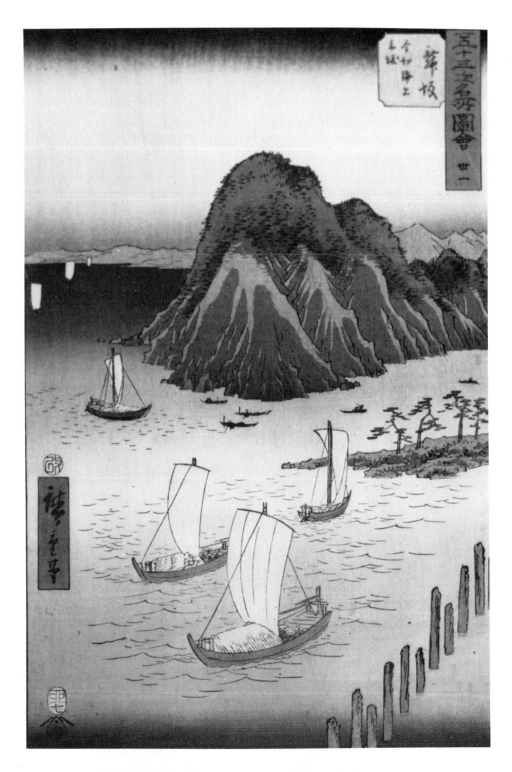

ANDO HIROSHIGE
Maisaka on the Tokaido Road
Color woodcut, 13½″ × 8¾″
Collection of the authors

These large watercolor brushes (called *enogu-bake*) are used by Ansei Uchima for putting the color on the block.

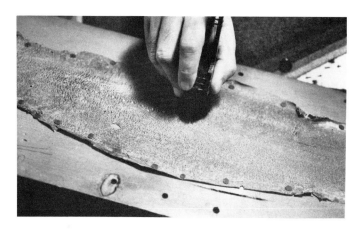

The ends of the hairs on the brushes are split and softened by rubbing them against a piece of sharkskin nailed to a board.

Two *barens*, the one on the right with a split in its bamboo sheath cover, which will be replaced.

Here the *baren* is taken apart. On the left is the cover that is to be replaced, at the top center the coil bamboo card, and at the bottom center the backing paper that gives the *baren* its circular shape. The piece of bamboo sheath on the right will be shaped and trimmed to form a new cover for the *baren*.

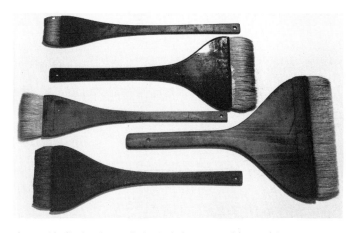

These wide flat brushes, called *mizubake*, are used for applying water or sizing to the sheets of paper.

Paper The choice of paper is in many ways more important in the Japanese method than in the Western method. The degree of absorbency is important to the kind of effect desired in the image. Absorbency is affected by the strength of the sizing used on the paper. *Hosho, torinoko,* and *masa* papers are all readily available in this country and produce good results. They are absorbent, yet strong, and allow the printer to rub extensively without tearing. Because they are so tough, they also seem immune to shrinkage and expansion, a very useful characteristic in the Japanese method.

Presized paper is available with one or both sides sized from Nelson Whitehead, Aiko, or direct from Japan. *Kizuki-bosho,* the paper used by Ansei Uchima, is sized on both sides and is made by a Tokyo manufacturer whose family has been making paper for seven generations.

SIZING PAPER

The artist who wishes to exploit the sensitivity of pigments to different kinds of sizing should have some knowledge of sizing techniques. Sizing, or *dosa*, is prepared by boiling dry animal glue in water and adding alum after the glue has dissolved. The relative amounts should be:

1 gallon water

8 ounces glue (animal glue in stick form)

3 to 4 ounces alum

Preparation To prepare the mixture:

1 Place the water in a pan or double boiler large enough to accommodate the dipping of the 10-inch long brush that is used for applying the sizing.

2 Break the stick glue into pieces and place them in the water.

3 When the glue has softened a bit, place the pan over medium heat and stir constantly with a wooden stick or spoon. Heat slowly until the glue has melted.

4 Add the alum and mix very well.

5 Strain the sizing through a double thickness of cheesecloth to filter out extraneous particles.

Application Using a broad, flat brush called a *dosabake*, apply the sizing while it is hot.

1 Lay the paper flat on a large drawing board or wooden tabletop.

2 Dip the brush in the sizing and drag it across the paper one stroke at a time. Start at one end and work quite vigorously, then slow the movement toward the edge to allow uniform coverage.

3 Hang the paper with clips on a line to dry.

4 After one side is dry or semidry, repeat the process on the other side.

WORK SETUP

The Japanese artist's work setup is organized in a highly traditional manner. It is a logical arrangement and works very well. We recommend that artists who are seriously interested in this method use it entirely or adapt some aspects of it.

There are four major pieces of equipment: a small chest of drawers to hold pigment and brushes, a printing bench to hold blocks, a box with a shelf to hold dampened paper, and a flat board to hold paper after printing (it should be twice the size of the paper). Additional equipment includes brushes for applying pigment, a bowl for water, a paste container, and a container for camellia oil or

baby oil, which is applied to the *baren* to help it move freely. Most of this equipment has been tested for centuries and is very useful.

The Japanese artist sits cross-legged on the floor in front of the setup. If this is uncomfortable for the Western artist who has different sitting habits, the equipment can be arranged on a table for greater comfort.

PREPARING THE DRAWING

Ukiyo-e artists did not cut their own blocks. Therefore their drawings for the cutter had to be very accurate and finished pieces of work. The artist would make a line drawing of the key block with *sumi* ink on thin paper. For today's artist, a good paper to use for this method is *minogami*. The paper should be sized with *dosa* and rubbed with a *baren* to flatten it and to keep it from wrinkling when it is pasted on the block. *Sumi* is still the best ink to use and can be applied with pen or brush; ordinary ink is unsatisfactory because it blurs when the paper is pasted on the block.

PASTING THE DRAWING ON THE BLOCK

Pasting the drawing on the block (*hanshita*) takes great skill. The paper is thin and soft, and after absorbing the paste, it is quite difficult to manipulate. Try to work according to the following steps:

1 Apply rice or library paste evenly to the block with the palm of the hand. Roughen the surface a little to produce a slight texture that will make it easier to position the paper on the block.

2 Let the paper fall lightly on the block, drawing side down, and quickly maneu-

ver it into proper position before it sticks. Because the drawing is face down on the block, it will print as it was drawn and there will be no reversal of image.

3 Rub the middle section lightly to fix the position. Hold the left edge with the left hand and rub the paper up and down with the right hand from the right edge to the left edge.

4 Continue rubbing the paper until it sticks firmly.

5 When the paper is half dry, rub it with your fingertips until little rolls of paper wear away and the drawing becomes clearly visible. The paper will be rubbed down to a thin layer, and the drawing will appear to have been made on the block.

6 The block is ready for cutting after it is dry.

CUTTING THE BLOCKS

The key block is cut first from the artist's original drawing, which has been pasted to the block. The knife, or *to*, is used to cut all the important or delicate lines in the composition. The lines are cut so that they are thicker at the base than at the printing surface. They should look something like a pyramid in cross section, which requires that the knife be held at an angle of 60 to 75 degrees during cutting. Normally the knife is held with the thumb on top of the handle and the other four fingers wrapped around it. The cuts are made by drawing the knife toward the body and turning the block as necessary. The other hand may be used to guide the blade in delicate or difficult areas.

After the fine lines are cut in a small area, gouges (*aisuki*) are used to clear out

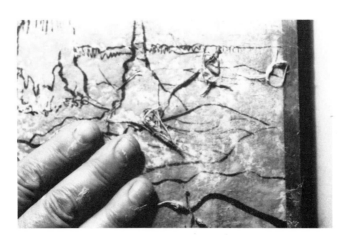

The keyline drawing (*hanshita*) is put face down on the cherry block with rice or wheat paste. While slightly damp, the back of the paper is rubbed with the fingertips to remove some fibers and make the drawing clearly visible.

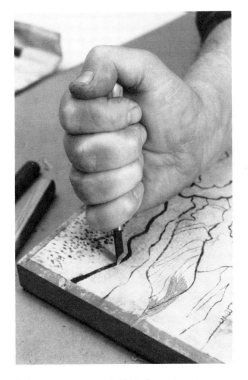

A Japanese woodcut knife (*to*) cuts into the cherry block at a 60- to 70-degree angle.

the open spaces between them. Then large gouges (*marunomi*) are used to clear larger furrows, until finally a chisel (*soainomi*) is needed for really large open areas. A mallet is usually employed with the large tools because so much wood is removed with each stroke.

Register guides Each block has register guides, or *kento*, cut into it. These two projections (see drawing on page 32) are first cut into the key block and then transferred by printing onto each successive block, where they are cut in exact juxtaposition to the key block. The print from the key block is called *kyogo*. The register guides also control the margin of the print. Each color requires either a separate block or enough clearance around it so that it can be inked without contaminating other parts of the design. This distance is normally about 2 inches but can vary according to the size of the brushes used in inking.

Slight corrections in the register of the blocks can be made either by cutting into the *kento* guides or by adding to them with thin slivers of wood to change the placement of the paper on the blocks. If the color areas do not fit the key block, they can be corrected only if they are larger than they need to be and thus allow some trimming. If the areas are too small to fit the key, nothing can be done to save them and the block must be recut.

PREPARING THE PAPER FOR PRINTING

The paper should be moistened an hour or two before printing so it can absorb the water uniformly. Using a long flat brush called a *mizubake* or a spray gun, apply water to every other sheet. Pile the sheets neatly and place a board with a weight on top to keep them flat.

After about two hours, you can arrange the sheets on a board designed for this purpose. Lay the first sheet at the left edge of the board and place each successive sheet so that its left edge lies about an inch to the right of the left edge of the preceding sheet. When you reach the right edge of the board, begin again at the left edge and repeat the procedure until all the paper is arranged. Lay a thick sheet of paper across the top of the pile. You can apply additional water to the top piece of paper with the *mizubake* brush. Cover the stack with a piece of wet cotton fabric and leave overnight.

You will learn how to judge the proper

amount of moisture in the paper after a little experience. Dry weather and humid weather affect the paper and must be taken into consideration. If necessary, either add more water or place newsprint between every two sheets. If margins become too dry during printing, they must be moistened. If printing must be suspended for any reason, care must be taken to cover the paper with thick wet paper and wet cotton fabric.

APPLYING THE PIGMENT TO THE BLOCK

Pigment is placed on the block with a small bamboo-sheath brush called a *tokibo*. Then a small quantity of paste is placed on the block, and pigment and paste are mixed and spread over the block with the horsehair applicator brush, with a few drops of water added if necessary. Mix only pigment and paste on the block. Allow the brush to become saturated with pigment and move it in every direction on the block, first using a

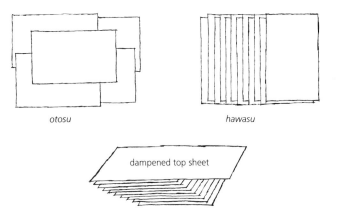

otosu hawasu

dampened top sheet

METHODS OF STACKING DAMPENED JAPANESE PAPER

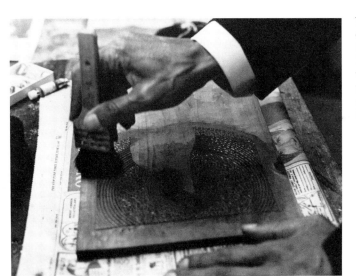

Toshi Yoshida, in a demonstration in Provincetown, Massachusetts, applies watercolor to a cherry woodblock with an *enogu-bake*, or color brush.

circular motion to ensure mixing with the paste. Next, use a straight motion across the grain to make the application uniform.

To create gradations, rub the block with a wet rag in the area where you want less color. Dip only one side of the brush in the pigment and rub the brush back and forth over the block a few times to produce a graded tone from the wetness of the block and the pigment.

PRINTING WITH THE BAREN

Use four fingers to grip the handle of the *baren*, placing the thumb over the handle. Pressure on the *baren* should be exerted from the palm of the hand so that the force of the rubbing is not just from the wrist but from the whole arm. Stroke the back of the sheet lightly with the *baren*, moving in a circular motion to secure the paper on the block. Next dip a cotton-tipped stick into the camel-

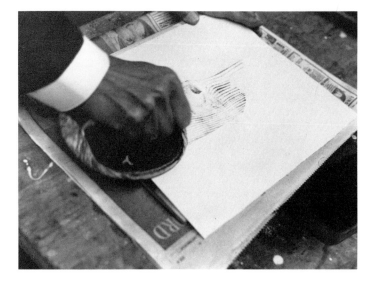

The paper is placed on the freshly inked block and then rubbed with the *baren* by Yoshida to make the impression.

lia oil and dab it over the rubbing surface of the *baren*. Before each printing, rub the *baren* on a cotton cloth to remove any excess oil.

Try to use the weight of the whole body when rubbing. Start at the right-hand corner nearest yourself and continue moving forward in a zigzag motion. When you reach the top of the sheet, start at the bottom again, until the whole sheet is rubbed. Use the *baren* in short strokes. Proper printing quality is

achieved when the pigment penetrates about one-half the thickness of the paper. Before removing the paper, rub the edges well and across the grain to make sure the image is uniform.

With your left hand, carefully remove the print from the right corner. Place it carefully on the paper board and examine it for printing quality as well as color relationships.

WOOD ENGRAVINGS

Until the eighteenth century, woodcut images were always cut into wooden boards whose vertical length was cut from a variety of medium-soft to hard-grain trees. Thomas Bewick, the eighteenth-century English engraver, is often given credit for first using the end grain of the wood. He cut his images directly into the wood with gravers instead of knives and gouges and printed from the relief surface of the block. Unlike the woodcut, the image was developed as an intricate pattern of white lines. There is no doubt that other artist craftsmen experimented with wood engraving before Bewick gained fame for his outstanding book illustrations. However, he used the method so extensively and developed it with such skill and sensitivity that there are no contenders for his position as innovator.

The possibilities for detail and tonality in wood engraving soon made it the most popular and practical method for reproducing illustrations in books, maga-

zines, and newspapers. The durability of a wood engraving, due to the closeness of the end grain of such hardwoods as boxwood and maple, allowed enormous numbers of impressions from one block. A copperplate engraving of the day would begin to break down after fewer prints. One of Bewick's blocks, an illustration for a Newcastle newspaper, produced an edition of 900,000 prints without wearing down. Another great advantage of the wood engraving was the ease of locking it up with type and printing in one operation.

The adoption of wood engraving by a growing printing industry hungry for illustrations soon proved destructive to original creative expression. Numerous craftsmen of unbelievable skill worked to reproduce drawings and to interpret paintings for mass consumption through wood engravings. Scores of classics illustrated with Gustave Doré's wood engravings and cut by highly skilled craftsmen had a ready market among the rising middle class. Wood engraving flourished as a purely reproductive process until the

late nineteenth century, when photoengraving began to replace it.

Inevitably, the photoengraved linecut and halftone supplanted the wood engraving in the printing industry, and today there are virtually no skilled wood engravers working in that trade. Creative wood engraving, however, was revived in the twentieth century by imaginative book illustrators in England, Germany, and the United States, with notable contributions by Fritz Eichenberg and Lynd Ward in the United States. Then, in the late 1940s and early 1950s, truly innovative concepts began to be explored. American artists like Misch Kohn, Leonard Baskin, Fritz Eichenberg, and Arthur Deshaies tried such things as using large-scale blocks and a freer handling of tools, helping to reinstate wood engraving as a medium that complemented contemporary images.

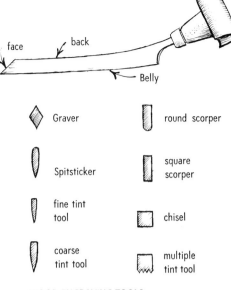

WOOD ENGRAVING TOOLS

FRITZ EICHENBERG
The Follies of Old Age, **1972**
Wood engraving, 18″ × 12″
From *In Praise of Folly* by Erasmus

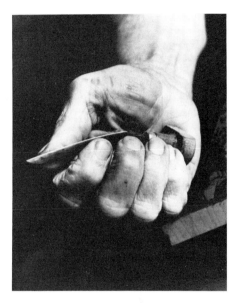

The engraving tool is held like this, with the thumb along the shaft of the tool.

Materials and Tools for Wood Engravings

Gravers (various sizes)
Wood (end grain maple or boxwood)
Scorpers
Spit stickers

WOOD

Turkish boxwood, the most desirable of all woods, is now very hard to get and therefore quite expensive. It is available only as a veneer. The next most sought-after wood is West Indian boxwood, which is about half the price of the Turkish variety. Even cheaper is domestic maple, which is half the price of West Indian boxwood.

Engraving blocks must be made by specialists who use precise planing and finishing machinery. Because many small pieces go into a larger block, gluing and fitting are critical. One of the few manufacturers that still produces blocks of good quality is American Printing Equipment Supply Company.

ENGRAVING TOOLS

The tools used for engraving lines are called gravers or spit stickers, and the tools used when tones are built up are called tint tools. Spit stickers are normally used for curved lines, but gravers can also be used to cut curves. Scorpers or chisels are used to clear out large areas of white in the same way gouges are used for woodcuts.

The diagram above shows an engraving tool and its parts. The curved belly serves the purpose of keeping the tool

away from the block while the line is being cut. If the tool were straight, the belly of the tool would dent the wood at the beginning of the stroke.

To hold a wood-engraving tool, pick it up from the table as shown in the photo. The thumb guides the tool as it is being pushed by the palm of the hand. When curves are being cut, the wood is turned, not the tool. To facilitate the turning of the block, a leather sandbag has traditionally been used as a base for the block, although many substitutes can be devised. The sandbag is the most efficient support for smooth turning when precise curves are being cut, and anyone who wants to do much engraving will find it a worthwhile acquisition.

PAPERS

Rough handmade papers are rarely suited for wood engravings, and then only when the blocks are press-printed. The best prints are taken on smooth, thin paper. Japanese papers such as *kitikata, gampi, torinoko,* and Japanese vellum (quite costly) work well. Machine-made papers that are smooth and soft yield better results than heavy, hard papers. It may be necessary to dampen some papers, but they should be damp only, not soaked, as some papers disintegrate when too wet. If you print on a damp sheet by hand burnishing, use a thin, dry piece of paper such as tracing paper between the burnisher and the damp sheet as a buffer.

Drawing on the Block

All the detail and texture you want in your final image must be cut in the block. Wood engraving is done on the end grain of the wood, which offers none of the wood grain, saw marks, or knotholes commonly found in woodcut blocks. There is no variation in resistance to the tools the artist uses.

In general, it is easier to cut white lines into a black background than to cut

The design is painted directly by Lynd Ward on an end-grain block with India ink in preparation for a wood engraving.

The tool is pushed through the wood, while the block is turned into the cut. The block has been tinted red with oil color to make the cuts more visible.

around a black shape on a white background. This simple fact, as true for a woodcut as for a wood engraving, should be remembered as you prepare your design. The variety of stipples, tones, tints, and textures depends upon the ingenuity of the engraver, but tones based on white lines or dots are easier to cut than those based on black lines or dots. If you want crosshatching, for example, you will find that white-line crosshatching is simple but black-line crosshatching requires cutting out tiny white squares, a tedious procedure at best.

You can draw directly on the block with pencil or ink to establish the basic areas of your design. You can also transfer the drawing by using carbon paper. If you use pencil, make sure it is not so hard that it indents the blocks. Indentations will print as white lines and can ruin a block. Fix the pencil drawing with any good charcoal or pastel fixative so that it doesn't rub off as you work. If you use ink or a felt-tip pen, fixative will not be necessary.

You can blacken your block with India ink before you begin and use light-colored pencils or white charcoal to transfer your design onto the block. This method allows you to visualize your final result much better than when you work on the natural color of the wood. Too much fixative swallows up the tracing, however; a good compromise is to tint the block with a gray or charcoal-colored ink, then use black pencil or charcoal to outline the design. When this is fixed, it will remain visible.

Do not work out your preliminary sketch so completely that cutting becomes a mere tracing of your design. Instead, make the sketch an indication of what you want and put your effort into the cutting itself, so that it will be fresh and spontaneous. It is important to keep your enthusiasm strong; repeated tracings and redrawings of a design are boring and tiring. Besides, the textures and tonalities of wood engraving are difficult to approximate in a sketch, and it is pointless to spend hours indicating something that you can do better by cutting into the wood.

Cutting the Block

When cutting white areas with the scorpers or gouges, be careful to remove the shoulder of wood that is left after the outline has been cut. This edge doesn't show until the block is being printed and, if printed, must be cleared away afterward. Use a thin card to protect the edges when you are gouging out white areas. If you do dent the edges of a black area with the belly of the tool, sprinkle a few drops of water on the dented spot. Light a match and hold the block over the flame so that the water steams and the wood expands back to its original shape. Minor dents can be removed in this way; deep bruises require plugging.

Printing Wood Engravings

Printing a wood engraving is similar to printing a woodcut, except the ink used must be very stiff and the paper smooth and fine. Thin, runny ink will clog or fill the fine textures and tiny stipple openings in the block. You need to distribute the ink in thin, even film on a gelatin or plastic roller. When printing with a burnisher, rub carefully over the entire surface of the paper, using even, steady pressure to eliminate streaks and light spots. There must be enough black area for the ink to act as an adhesive and grip the paper, keeping it from slipping. If your block has only a small percentage of black, it may be necessary to print the block in a press.

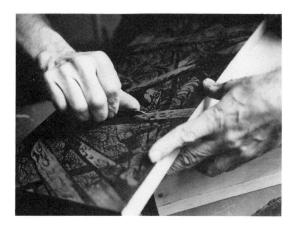

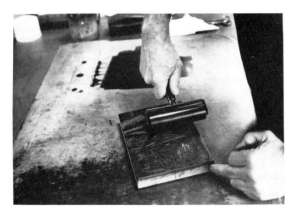

The lever exerts a downward pressure on the form. Because the entire surface is printed at once, great pressure is needed.

A thin film of stiff ink is rolled over the block with a good roller. An even coat of ink is essential for a fine proof.

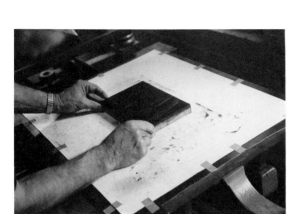

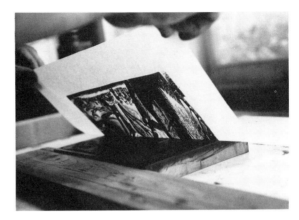

The proof is pulled from the block. The piece of wood in front of the block serves as a guide for the paper, keeping the margins consistent.

The inked block is centered on the bed of the press by Lynd Ward.

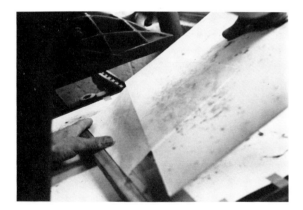

The paper is eased onto the block with a piece of cardboard. The thin paper tends to sag, and the cardboard prevents premature contact with the inked surface.

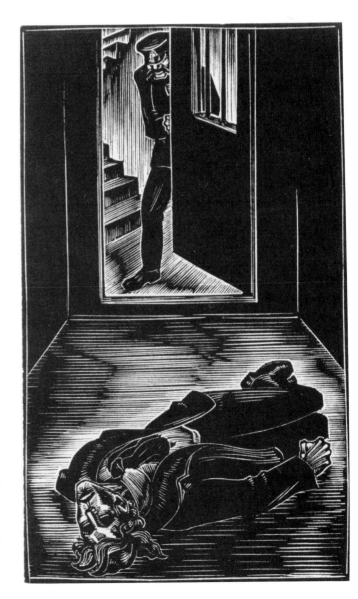

LYND WARD
From *God's Man*, 1929
Wood engraving, 5" × 3"
Published by Jonathan Cape
and Harrison Smith, 1930

CONTEMPORARY RELIEF METHODS

The search for new materials has been a natural outgrowth of the changing character of the print in the last ten to fifteen years. Artists have become aware of the exciting potential of materials that have been developed primarily for industry but can be used for creative purposes. Support boards such as Novaply, Presdwood, Homasote, and Formica are the result of combining natural fibers with new plastic compounds. New adhesives and binders are available, such as acrylic polymer latex, jade glue, methyl cellulose, and epoxy. Inks have been manufactured to meet a staggering variety of uses on all sorts of materials, such as plastics, rubber, fabrics, glass, wood, and paper, and can be made to dry hard, soft, flexible, stretchable, electrostatic, or even heat sensitive.

Linocuts

Linoleum's use as a craft material and as a means of introducing young children to printmaking has caused many serious artists to avoid it. This is unfortunate. Because a material is simple, easy to obtain, and easy to cut does not mean that it does not offer some rather good features. Excellent work has been done with linoleum by major artists like Matisse and Picasso. Matisse was able to produce a sensitive bold line with great fluidity in his *Seated Nude*. Picasso used linoleum for his important series of color reduction prints.

This method was very common some years ago, but linoleum is being replaced by vinyl compositions, which are usable when not heavily textured. It is still possible to find sheet linoleum, which is usually sold by the yard in floor-covering stores. Avoid patterned or textured varieties and search for solid white, light gray, or tan colors, which will make your preparatory drawings easily visible. Prepared blocks can still be purchased in

art-supply stores, but they are usually small and expensive. They are mounted on plywood to make them suitable for letterpress printing. It is relatively easy to mount larger sheet linoleum on plywood yourself using rubber cement, Elmer's, Sobo, or acrylic gesso as the adhesive. However, if a linoleum plate is to be printed on an etching press, it should be left unmounted. (Detailed discussion of these possibilities is included in the intaglio chapter.)

The cutting tools used for linoleum can be the same ones used for the woodcut. Although linoleum is fairly soft and offers little resistance to cutting, there is an abrasive material in it that destroys the cutting edge of tools. Therefore you must sharpen your tools frequently. If you heat or leave linoleum in the sun before cutting, you will be able to carve it with greater ease.

One of the advantages of linoleum is that it can be cut in any direction without resistance and is sensitive to punctures and scratches, which allows textural surfaces to be imposed into it. One way to create interesting textures is to arrange textured objects that are not too high, such as sand, wire, metal washers, or watch parts, on linoleum; place a piece of smooth cardboard on top; and run it through an etching press. The

objects will leave sharp and clear impressions on the linoleum.

A linoleum cut is easy to repair. Simply cut the incorrect area out and reglue another piece of linoleum on the backing board.

Although linoleum contributes little of itself as a material, it serves as an easy vehicle for color. The slightly pebbly quality of its surface can lend a very subtle texture.

PRINTING LINOCUTS

The linoleum block is printed in exactly the same way as the woodcut. Rolling the ink and rubbing by hand are done no differently. However, there is an advantage to press printing the linoleum relief that the woodcut does not have. Because unmounted linoleum is thin and flat, it can be printed with medium pressure on any etching press. Its relief surfaces can be rolled with ink, the paper placed in position, and a light blanket placed over it.

ETCHING LINOLEUM

Linoleum can be etched with caustic soda (sodium hydroxide) and printed as either a relief print or an intaglio print. Various resists, such as etching ground,

RICHARD BASIL MOCK
Insight Whisper II, 1985
Linocut with hand coloring, 26″ × 30″
Publisher/printer Solo Press, New York

PHILIP PEARLSTEIN
Jerusalem, Kidron Valley, 1988
Color woodcut and heliorelief process,
36″ × 94″
Copyright © Philip Pearlstein and Graphicstudio
University of South Florida, Tampa, 1988

Philip Pearlstein works on Mylar separations (see photographic techniques) for *Jerusalem, Kidron Valley*, at Graphicstudio, University of South Florida at Tampa.

asphaltum, heated paraffin wax, or varnish, can be painted on the block and later scratched into or incised. The caustic soda, which should be used in a saturated solution, is very dangerous and must be handled with care. It is brushed or swabbed onto the linoleum and replenished as it loses its strength. Deep biting takes hours, unfortunately, and this disadvantage is a serious handicap.

Relief Etchings

You can draw or paint with etching ground on the surface of a zinc etching plate, then deep-etch the plate in nitric acid. The areas that are not protected with the ground will be eaten away, as much as halfway through the zinc. Remove the ground with mineral spirits, ink the surface of the plate with a roller, print the plate onto paper in an etching press with less pressure than used in intaglio printing, and you will have a proof of a relief etching. The surface prints while the etched lines do not, exactly the opposite of an intaglio print or etching. There are many variations of this proce-

Detail of Philip Pearlstein's *Jerusalem*.

dure, but the principle is that of a linecut in photoengraving, which is printed by the letterpress process, with only the plate surface inked. Relief etchings can be printed on a Vandercook or other proof press when the plate is blocked with plywood or a similar material to bring the printing surface to type height (0.918 inch).

ETCHING THE PLATE

The zinc can be covered with an even coat of etching ground (see the intaglio chapter), which, when dry, acts as a resist to nitric acid. When you draw through this ground with a needle or a sharpened stick, you expose the zinc un-

JOSÉ GUADALUPE POSADA
Calavera Huertista
Relief etching on zinc alloy

derneath. Put the plate in a nitric acid solution (4 parts water to 1 part acid is a strong bath; 8 parts water to 1 part acid is a weaker solution). The lines will be etched into the plate and, when the plate is inked, will print as white lines on a black background. The amount of time required in the acid will vary according to the depth of line desired. To bite an open area requires an hour or more to lower the zinc enough to allow the roller to pass over it without touching it with ink. The danger in a long bite in the acid is that the zinc may overheat. This causes the acid to etch faster and the process to speed up and become uncontrollable. The plate must be removed from the acid, cooled in water, and the acid allowed to cool before continuing to etch. Weak acid and slow biting are preferable for deep biting a plate.

The Mexican artist José Guadalupe Posada, who completed an estimated 20,000 prints, developed a system for deep etching zinc plates for relief printing. He would complete an initial drawing with greasy ink on the zinc. Then he would sprinkle powdered rosin on top of the ink, turn the plate over, and tap it on a table so that the rosin would remain only where it stuck to the greasy ink. The plate was etched in a bucket of diluted nitric acid at 3° Baumé (12 parts water to 1 part acid) for 15 minutes. It was removed from the acid, rinsed in water, dried, and then placed on a hot-plate to cause the rosin and ink combination to melt somewhat and run down over the edges of the etched image. This prevented undercutting of the edges, which is a problem in all deep biting. When cooked, the plate was re-inked with a hard roller, more rosin dusted on, and the entire process repeated: etching, rinsing, drying, heating, cooling, inking, and rosin dusting. This was repeated four or five times, with the

acid increasing in strength each time in order to bite deep enough. As the plate was etched, the sides of the bite were protected in successive melts of the rosin-ink topping.

Delicate white lines need much less etching than deep, open areas. The fine lines should be protected from overbiting by covering them with ground, asphaltum, or other acid-resistant compounds after they have been etched to their proper depth.

REPAIRING A RELIEF ETCHING

When a zinc plate is etched, it may be necessary to change poorly drawn or incorrect passages. Repairing a relief etching is a rather tricky process. First, scrape the entire area evenly to eliminate all ridges and bumps. With the face of the relief etching protected by news-

paper, turn the plate down on a polished metal plate, such as a surface of ¼-inch steel. Then hammer the back of the plate over the offending area until the zinc is forced to the proper level again. (Use wooden calipers to locate the proper spot to hammer on the back of the plate.) You must hammer fairly vigorously, using a rounded hammer. With careful work, you can force up a considerable amount of zinc and make repairs by re-etching the scraped-out areas. This process is called repoussage.

Hand-Embossed Prints

Although the inkless embossed print and the color or black-and-white print with raised, or embossed, areas may seem like contemporary innovations, embossing was done by the Japanese as early as the eighteenth century. It is said that Masanobu was the first of the Ukiyo-e artists to use embossing. Sometimes artists used it to define pattern in garments, and sometimes they embossed an object such as a scroll or a headdress. Utamaro used embossing in some of the women's faces of his prints, and Harunobu, Buncho, and Shunsho also employed it effectively in their prints. Crude embossing was done in England in the early eighteenth century by J. B. Jackson, and French artists in the late nineteenth century experimented with inkless embossings much like cast-paper prints.

Hand embossing a relief print is done by forcing dampened, thick Japanese rice paper into the recessions or cut-away areas in a woodcut, linoleum cut, or any relief block. The areas that are embossed are the negative white areas. The print can be designed for embossing alone or can combine embossing with the use of color. When color is used, the embossing should be the last operation. The paper is so sensitive to the depressions in the wood that even delicate woodcut strokes, holes, and textures appear strongly embossed.

Heavy Japanese paper takes embossing best because the fibers are pliable and less likely to tear. *Torinoko*, *kochi*, and *masa* papers give excellent results. Dampen the paper slightly by dipping it in water and removing it immediately.

Blot it well between blotters until the paper is almost dry. (You can emboss without dampening the paper, but there is greater chance of tearing.) Place the paper on the block, using the register frame if other colors have been printed first. Press firmly into the recessions with the curved chrome burnisher used in etching. The burnisher works very well because it can be forced into small places and has smooth sides that do not mar the paper. If the point on the burnisher is ground down and dulled, there is less danger of tearing. The Japanese sometimes use the elbow for pressing the paper into the recessions on the block, a method that works suprisingly well.

Collage Relief Prints

The relief print is open to endless possibilities, including found objects like charred wood, driftwood, intricate printed circuits, crushed tin cans, and container lids. You can ink and print anything from a manhole cover to the weathered door of a barn. During some of our experimentation with unorthodox materials, one student inked his own face with a soft roller and printed himself with quite interesting results. However, if you go to such lengths, be sure to use nontoxic, water-based inks.

The wisest procedure is to gather objects and store them for future use. Seeing objects together can often give you ideas for images. Systematizing your collection can also be useful. Organic materials like wood and plant forms can be collected, inked, and proofed to see what possibilities they have. Manufactured objects can be intriguing when gathered together: gaskets, gears, parts of clocks, screening, plastics, machinery, tin, aluminum, or copper that can be cut with a pair of shears. Soft materials like cloth, dust, sand, tubed solder, metal particles, lace, string, oilcloth, or embroidery produce completely different images. Sometimes an object must be transformed—by hammering, for example—in order to print it more easily. Soft materials and organic matter can be soaked in acrylic liquids and hardened, then printed as single units, or they can be glued down on a block with Elmer's glue or gesso.

You can develop rich source material by printing a whole group of objects that

Relief-rolled traffic sign, printed on translucent paper on an etching press and viewed from the back of the sheet.

Paper laid on top of an embossed metal traffic sign and then inked on top of the paper with a hand brayer.

Above:
Relief-rolled sequins, paper tissues, paper towels, and sand in wet gesso on mat board, printed on an etching press at Manhattanville College by Kathleen Dixon.

Left:
Broken glass, inked and printed by rubbing.

Right:
Relief-rolled found objects: toothpicks, paper clip, electronic copper disk, clock part, razor blade, flat machine part, washer, luggage key, electronic disk, and clock gear. All printed on an etching press.

Metal gasket printed in different ways: (A) dilute ink applied with a rag with gasket used as a protective stencil; (B) ink rolled directly onto paper with gasket used as a protective stencil; (C) relief-rolled and printed on an etching press.

techniques that became popular in the sixties and seventies.

Basically cellocut is the utilization of a liquid plastic material consisting of sheet celluloid dissolved in acetone. Solutions of varying consistencies are used to coat any smooth surface such as Masonite, Presdwood, copper, brass, aluminum, or zinc plates. A thicker solution is applied to form a heavier raised surface. After the liquid has set, it can be worked with etching or woodcut tools. The plates can be printed in relief or intaglio, by hand or on an etching press.

CARDBOARD RELIEF PRINTS

The flexibility of cardboard, its ease of cutting, and its availability make it an ideal material for the relief print. In fact, two- or three-ply chipboard can be handled very much like wood. Fome-Cor board and corrugated cardboard, however, are unreliable surfaces because they compress unevenly under pressure. Sharp tools are needed for cutting cardboard; industrial single-edge razor blades are ideal because they can be discarded when they become dull. An art knife with blades that can be resharpened is suitable for fine detail cutting, although cardboard is not particularly suited for very fine work.

Cardboard can be cut into and peeled away very much as wood can. Sometimes the lower surface can be inked and printed if that enhances the composition. It is best to cut areas with some angulation away from the edge of the form, just as wood is handled, so that the form does not break away during printing. Textures can be hammered or scratched into the cardboard with a variety of instruments, from a dressmaker's wheel to punches and rasps.

It is best to use rag mat board, or museum board, because it is an archival product that will not disintegrate with age. It will last longer than ordinary pulp mat board, which becomes brittle, turns brown, and eventually self-destructs from age. The better-quality board is more than double in price, but it is still cheap compared to other plate materials. We are still printing plates made from pulp boards twenty years ago, although they must be handled with care.

vary greatly in texture and form, then cutting out the printed images and manipulating them into compositions. It is easier to explore the possibilities of printed images than those of objects. After determining the relationships of the objects, you can trace their silhouettes on cardboard or Masonite in order to position them, or you can glue them to a board for more permanence during the printing of the edition. Experimentation and inventiveness are key.

PRINTING THE COLLAGE RELIEF

Printing a collage relief print is not much different from printing a woodcut, except the collage print, because of its porous and varied surfaces, requires

more inking and softer rollers. For very rough surfaces, a soft ink and a soft roller will help to achieve the nuances of surface textures. A fairly absorbent, sensitive paper gives the best results. If the paper is thin, a second sheet may be inserted between it and the burnisher to prevent tearing. Often rubbing with the hand and fingers is sufficient to print rough surfaces, and the burnisher can be used for smooth areas. If the paper is quite thick, dampening it lightly and blotting it well may make it more supple and malleable around uneven surfaces. In all instances care must be taken to keep the paper from tearing.

CELLOCUTS

The cellocut process was developed by Boris Margo, a painter, printmaker, and sculptor. Margo's work, which started in the 1930s, was a forerunner of the assemblage, collage, and acrylic adhesive

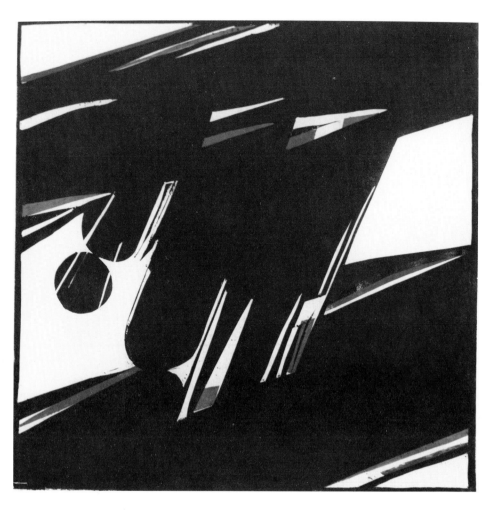

EDMOND CASARELLA
Connection, 1988
Relief papercut, 20⅛″ × 20⅝″
Courtesy of the artist

A freer method of cardboard relief is achieved by cutting out all the forms completely, arranging them on a piece of three-ply cardboard or ⅛-inch Masonite until the relationships are satisfactory, and then gluing them down with Elmer's glue or gesso or lacquer and coating them to seal the surfaces. Papers of various thickness, in addition to cardboards of different thickness, from three-ply chipboard to mat board to shirt cardboard, can be used. Masking tape also makes a quick, easy material for building up linear structures.

Both the cardboard and the collage relief must be sealed with clear plastic spray, diluted Elmer's glue, gesso, or lacquer. If this is not carefully done, the whole composition will break down during inking and cleaning with solvents after printing. Sometimes the sealing of the surface can become structural if undiluted gesso is used. The brushstrokes become integral parts of the form. Cutting cardboard away for some forms and painting the image with gesso to utilize other forms can become a very free way to work. The gesso should be fairly thick if it is to print as a structural image.

Cardboard collage and other collage relief plates are easy to repair—indeed, this quality largely accounts for their wide acceptance and popularity. You can glue new pieces in position very quickly with any one of a number of good adhesives, such as polymer gesso, Elmer's glue, thickened lacquer, model cement, and the like.

Printing the cardboard relief Printing the cardboard relief is not too different from printing the woodcut. Although the surface of the cardboard must be well sealed, it is still more absorbent than wood and will take a little more ink. The soft rollers suggested for printing the collage are very good. Sometimes just hand rubbing without a burnisher is all that is necessary because of the looser consistency of the inks and the softer surface of the cardboard relief.

Using cardboard with the woodcut
Cardboard as a relief material can have a dual purpose. It can be used as a means of expression on its own, and it can also be used in combination with the woodcut to make color plates or to make corrections. There are times when a key block of some complexity is cut out of wood, but the additional colors have simpler forms and can be cut out of cardboard. In such instances, using cardboard for the color plates is logical and easy. A woodcut can also be repaired by shaving down the wood and inserting cardboard, either two- or three-ply mat board or chipboard. It is important to glue the areas down securely with Elmer's or gesso and seal the surface with plastic spray or diluted Elmer's glue or gesso.

WOOD VENEER AND BALSA WOOD COLLAGE PRINTS

Wood veneers in a variety of grains can be used successfully in developing a collage relief that can be inked and printed like an ordinary woodcut. The veneers can be glued to any rigid surface, such as ¼-inch Masonite or ¼-inch plywood. We have had students glue the veneers with gesso or animal glue to ¼-inch plywood, then develop both the veneer and the plywood upon which it was glued with interesting effects.

Balsa, the wood used in model building, is particularly well suited for geometric concepts. It comes in a wide range of strip sizes and thicknesses and is readily available in art-supply stores, especially those that serve architecture students. The balsa, though very soft, can

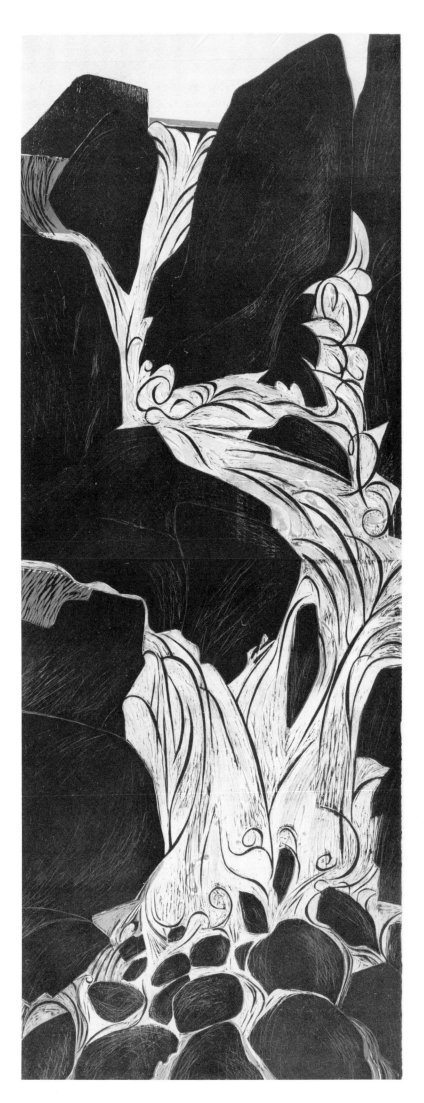

CLARE ROMANO
Big Falls, 1986
Woodcut and collagraph (8 colors), 60″ × 22″

be cut and gouged after gluing. It is suitable only for very small editions, however, and wears rapidly with hand rubbing and printing.

HARDBOARD PANELS

Made from compressed wood particles bonded with urea resins, hardboard is sold under different brand names, such as Masonite or Presdwood. It can be used with some success as a block for cutting relief images and textures. Hardboard that is tempered (treated with penetrating oils) works best. The untempered material does not cut well, although it is suitable for large, shaped areas of flat color or tone. Tools must be very sharp for cutting or gouging tempered hardboard. One side is quite smooth and can be used for some detail work. The other side has a rough texture that resembles a fabric weave. It can quickly become monotonous and should be used sparingly. The linear and textural range of hardboard is certainly less than that of wood blocks.

Power tools can be handled with success to enrich the surface and impose textural qualities on either side. They can also be used on the smooth side to develop linear and structural imagery. Masonite also has considerable potential as an intaglio plate.

ADHESIVES

Certain adhesives that dry to a hard consistency can be used to create textures or linear images. These include Plastic Wood, Miracle Adhesive, Liquid Steel, Liquid Aluminum, Duco Cement, wood putty, polymer acrylic gesso, jade glue, PVC adhesive, modeling paste, and many other products. Some of the glues can be reinforced texturally with sand or Carborundum, which is sprinkled into the wet images and left to harden. The material can be painted, scraped, or otherwise applied to a hardboard, matboard, or plywood base plate. The plates may be suitable for inking and printing either in the relief technique or by intaglio methods.

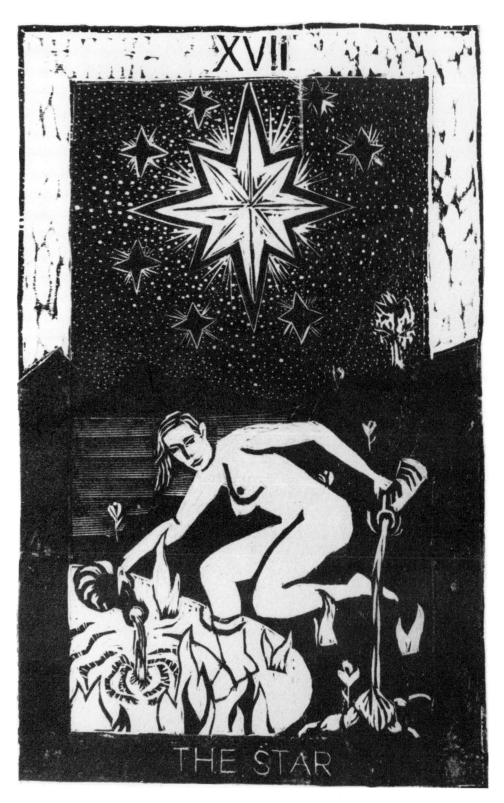

TIM ROSS
The Star, 1985
Woodcut and *chine collé*, 8¾″ × 5⅝″

STAMPING

Many surfaces may be inked and printed. Bottle caps, wine corks, jar bottoms, machine parts, wooden numbers, sign-makers' letters, and other found objects can be printed but are too bulky or awkward to be glued in position on a base board. Make a cardboard or oaktag position sheet, cut holes in it where you want to print a particular shape, and use this position sheet as a guide for printing, directly on the finished print, whatever shape you choose. Simply stamp the shape onto the paper, using adequate pressure and cushioning the paper with a few blotters or newsprint sheets under it. Repeat patterns can be attained quickly and with little trouble by using stamped shapes.

You can cut simple forms into soft erasers and even Art Gum erasers. These are wonderful little stamps and make repeats easy. You can quickly create a forest by cutting two or three trees from erasers or small wood or cardboard. You can ink the stamps with rollers, with conventional stamp pads, or by rolling out color onto a slab, pressing the shape into the color, and then stamping it onto your print.

GESSO OR PLASTER BLOCKS

A very fast way of making a relief print is by using plaster as the basic material for the block. When the plaster is semidry, it is quite workable with a variety of tools, and images and textures can be developed with remarkable ease. The technique is fairly simple and requires no special skill or equipment.

Place a piece of Plexiglas, Lucite, ¼-inch plate glass, Formica, or any smooth-surfaced, flat material on a table. Make a frame of 1-by-2 or 1-by-3 lumber and lay it flat on the Plexiglas, arranged to fit the size of block that you want to make. You can use masking tape to hold the frame in position.

In a large mixing bowl or pail, mix enough plaster to cover your plate to a depth of ¾-inch. Add the plaster to the water in a pail large enough to permit stirring. Use ordinary builder's plaster and mix well with a stick. It should be thin enough to pour.

Pour one-half of your mixture onto the Plexiglas. The smooth surface will make the printing surface of your dried plaster block. When half the mixture has

To make a plaster block a form is constructed of 1-by-2-inch wooden strips taped in position on a sheet of smooth plastic. The wet plaster is poured into the form, then a piece of screening or wire mesh is fitted into the plaster to give it strength. Before the plaster has completely hardened, it is turned over; the smooth surface may then be painted with India ink and is easily incised or scratched.

A three-dimensional assemblage of cast-plaster impressions made form Antonio Frasconi's inked woodcuts.

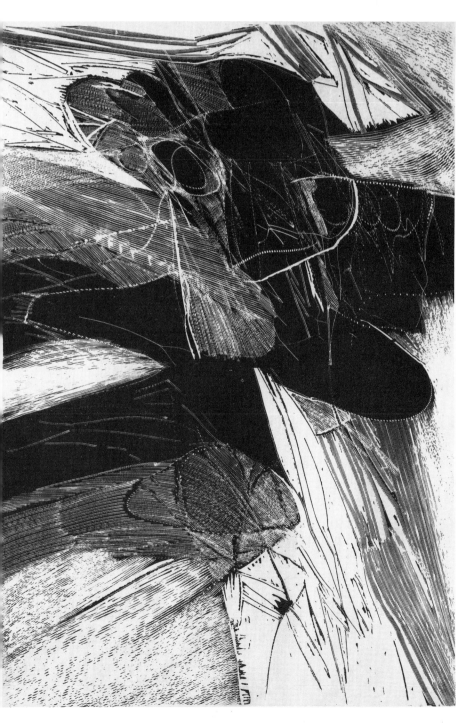

ARTHUR DESHAIES
Cycle of a Large Sea: Unbeing Myself, **1961**
Plaster relief engraving, 54" × 36¾"
Brooklyn Museum

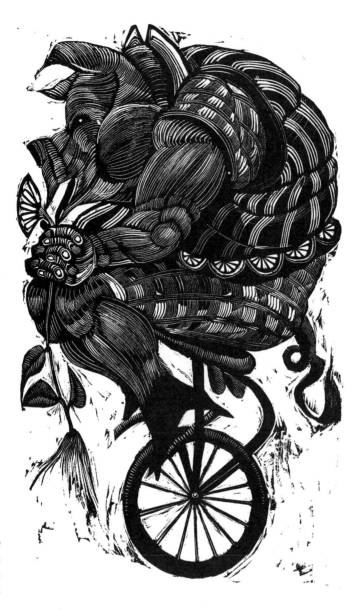

JAMES GRASHOW
Pig Parade, 1962
Wood engraving
Courtesy of the artist

If you brush the smooth surface of the plaster with a coat of India ink, each mark will be clearly visible as you scrape or scratch the surface. Because plaster dries rather slowly, the time that you have to work on the damp block will vary with the temperature and humidity. You can work with great speed while the block is damp. When the plaster dries, it becomes very hard and will yield fine detail and thin lines. If you want to soften the block after it is dry, soak it in water for 5 or 10 minutes to restore some of the qualities of easily cut new plaster. If you have overcut an area or want to fill some lines, add new plaster with a palette knife, let it harden, and sand it smooth with fine sandpaper.

Before printing the plaster block, seal the surface by spraying it with a few coats of clear lacquer. This seal will make the block easier to clean and will toughen the surface for the brayer and the inking. Printing should be by hand rubbing only. Press printing is likely to split the brittle plaster and crack it beyond repair.

In addition to traditional relief methods, we have noted a few of the innovative materials that may suggest images or a direction for your ideas. If you allow yourself to be receptive to the new possibilities of relief imagery, you will soon discover your own areas to explore and new procedures to invent.

been poured into the frame, put the pail aside and place a piece of aluminum or copper window screening, previously cut to fit your block, on the wet plaster. It should be slightly smaller than the finished block. The mesh will act as a stiffener and internal brace for the plaster and will give it strength and resistance to breaking. When your screening is in place, pour the remaining plaster into the frame. The screening will be sandwiched between the layers of wet plaster. After 20 minutes or so, the plaster will feel hot. It can be removed from the frame at this time.

While the plaster is soft, scratch into it or work in whatever manner you choose with nails, needles, screws, and the like.

FRANK STELLA
Pergusa Three **(from the** *Circuits Series***), 1983**

Relief, woodcut, on white TGL handmade,
hand-colored paper, 66" × 52"
Printed and published by Tyler Graphics Ltd.
© copyright Frank Stella/Tyler Graphics Ltd. 1983
Photo: Steven Sloman

57

FRANCESCO CLEMENTE
Untitled, 1984
Color woodblock, 16¾″ × 23″
Crown Point Press,
San Francisco and New York

JUERGEN STRUNCK
NC-12, 1985
Relief print (4 parts), 49½″ × 49½″
Courtesy of the artist

Opposite page:
WAYNE THIEBAUD
Hill Street, 1987
Color woodblock, 37″ × 24½″
Crown Point Press,
San Francisco and New York
Photo: Colin McRae

59

Plate 1: First color

Plate 2: Second color

Progressive I: First and second colors

Plate 3: Third color

Progressive II: First, second, third colors

Plate 4: Fourth color

Progressive III: First, second, third, fourth colors

Plate 5: Fifth color

JOHN ROSS
Brokedown Palace, **1971**
Cardboard reduction print, 14⅛″ × 20⁵⁄₁₆″

YVONNE JACQUETTE
Times Square (Overview), **1987**
Woodcut, 22¾″ × 28″
Experimental Workshop, San Francisco

WARRINGTON COLESCOTT
The Last Judgement: Judgement, **1987–88**
Color etching (multiple plates, *à la poupée*),
27½″ × 22″
Courtesy of the artist

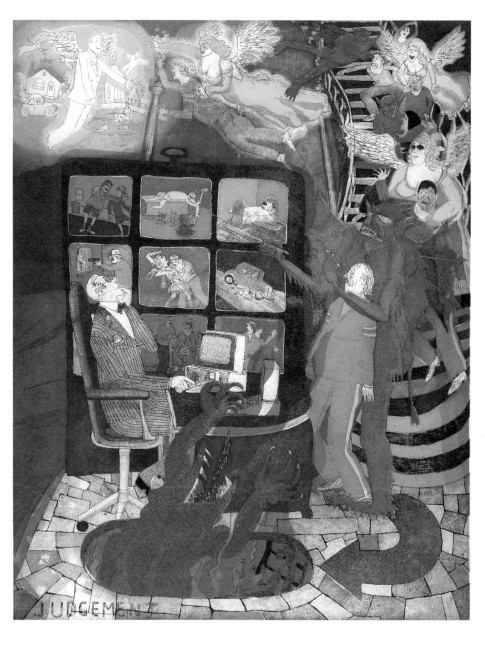

KATJA OXMAN
In the Dimness, **1983**
Color etching and aquatint
(multiple plates), 24″ × 36″
Courtesy of the artist

FRANK STELLA
La penna di hu, **1988**

Relief, etching, woodcut, screen print, stencil,
hand-colored, on white TGL handmade paper
55½" × 66"
Printed and published by Tyler Graphics Ltd.
© copyright Frank Stella/Tyler Graphics Ltd. 1988
Photo: Steven Sloman

ROLF NESCH
Toy, **1965**

Metal collage print, 22⁹⁄₁₆" × 16½"
Collection Walter Bareiss

RICHARD DIEBENKORN
Green, 1986
Color etching, 53½″ × 41¼″
Crown Point Press,
San Francisco and New York

CLARE ROMANO
Red Canyon, 1982
Color collagraph (cut plate),
22″ × 30″
(intaglio-wiped and relief-rolled;
inked separately, assembled
on the press)

2 Intaglio Prints

Under the umbrella of intaglio we find the largest number of printmaking techniques. Engraving, etching, drypoint, mezzotint, aquatint, soft ground, and collagraph all fall into the intaglio category because the image is produced from below the surface. A print is made by inking the incised lines and recessed textures of a plate, wiping the surface, placing damp paper over the plate, and running it through an etching press. In a relief print only the surface of the plate is inked and printed.

Origins and Development of Intaglio Printing

The earliest intaglio prints can be traced to the work of fifteenth-century European metal craftsmen. Goldsmiths and armorers were engraving on metal long before the first engravings were printed on paper. Goldsmiths were highly respected, and most of the early engravers who experimented with printing on paper had been apprenticed in goldsmiths' workshops. In fact, printed engravings may very well have evolved out of a need to record a design engraved on a piece of armor or a decorative gold object.

The goldsmith's art of engraving with a sharp tool into precious metal was highly refined, compared to the art of the woodcutter, or *formenschneider*. The latter was ranked with woodcarvers and joiners, whereas the goldsmith had substantial artistic training. The basic value of engraving on metal, as well as its greater flexibility, attracted painters to the art.

MASTER LCz (LORENZ KATZHEIMER)
The Temptation of Christ, c. 1492
Engraving, 8¹⁵⁄₁₆″ × 6½″
National Gallery of Art, Washington, D.C.
Rosenwald Collection

MASTER PW
Playing Card: The Knave of Parrots, c. 1500
Engraving
National Gallery of Art, Washington, D.C.
Rosenwald Collection

The first engraver on metal known by name was Martin Schongauer (1440–1494), a gifted fifteenth-century German painter. His work was characterized by expressive line and delicate shading using a network of crosshatching done in the Broad Manner, a style developed in Germany. His art represents a transition from the stiffer northern Gothic style to the freer, more opulent style of the southern Renaissance. Schongauer's work was a great influence on the young Albrecht Dürer.

Another important artist in Germany toward the end of the fifteenth century was the Master of the Housebook (so named for his drawings of medieval household gear and other subjects in a manuscript known as the *Housebook*). He used a freer, more painterly approach to produce the first drypoints, which were probably scratched with a needle on pewter and yielded few impressions. The Housebook Master inspired Dürer to make three drypoints, which are among his rarest prints. However, because so few prints could be pulled from a drypoint, artists interested in marketing their work to a larger audience preferred engraving. It was not until more than one hundred years later that the creative genius of Rembrandt revived the drypoint and used it extensively to achieve rich tonalities without waiting for acid biting.

ITALIAN RENAISSANCE ENGRAVING

In Italy, the art of engraving developed more directly out of the classical ideals of the Renaissance. One of the earliest Italian engravers was a goldsmith named Maso Finiguerra, who worked in silver and gold in a process called niello. In niello work, the metal was engraved in lines, and the lines were filled with a black substance, nigellum, formed by a fusion of copper, silver, lead, and sulfur; this gave the metal a strong light-and-dark quality. The gold or silver surface was burnished, and the recessed, engraved design appeared black in the bright ground. Hind discounts the possibility that the very first prints on paper were made from niello designs, as scarcely any niello prints go back as far as 1450, even though a type of niello was practiced by the Romans. He feels it is more likely that the niellists began taking impressions of their work on paper after observing the practice among engravers.

EARLY GERMAN INTAGLIO PRINTS

According to Arthur M. Hind in *A History of Engraving and Etching,* the earliest dated intaglio print is the 1446 *Flagellation* from a series on *The Passion of Christ* by an anonymous German engraver known as the Master of the Year 1446. Two other important unknown artists of this period who showed exceptional expressiveness and control of the medium were Master E.S. and the Master of the Playing Cards. The latter worked parallel lines in a vertical direction, seldom crosshatching, which Hind suggests is the mark of a painter rather than a goldsmith. The playing cards, depicting religious subjects or royalty, were sold at religious festivals and country fairs and were an active source of income for artists and engravers, as well as woodcutters.

MARTIN SCHONGAUER
The Passion: Christ before Pilate, late 15th century

Engraving, 6⁷⁄₁₆″ × 4⁹⁄₁₆″
National Gallery of Art,
Washington, D.C.

DOMENICO DE BARBIERE
(after Il Russo)
Two Flayed Men with Their Skeletons

Etching, 9½″ × 13⅛″
Metropolitan Museum of
Art, New York
Elisha Whittelsey Collection
Elisha Whittelsey Fund,
1949

Other artists began to engrave in metal specifically for printing. Two methods of working evolved in Florence: the Fine Manner, developed by Maso Finiguerra, and the Broad Manner, based on the German style. As the terms suggest, the Fine Manner was characterized by fine lines laid closely together and cross-hatching that emulated the tone of a wash drawing. In contrast, the Broad Manner used broader lines and emulated a pen drawing. Both techniques appear in the powerful engraving *The Battle of the Naked Men* by Antonio Pollaiuolo (1432–1498), one of the great prints of the late fifteenth century. This work shows not only a high level of skill but also a remarkable knowledge of the human body in a variety of gestures.

Andrea Mantegna (1431–1506) was another important Renaissance artist who produced freer, more open imagery in the style of pen drawings. He seems to have been an early developer of the atelier system of working, with craftsmen doing most of the engraving. Of more than twenty-five plates attributed to him, it is doubtful whether Mantegna himself engraved more than seven or eight. Of

ALBRECHT DÜRER
The Dream of the Doctor
(Temptation of the Idler), c. 1498–99
Engraving
National Gallery of Art, Washington, D.C.
Rosenwald Collection

Dürer produced an incredible body of work in both woodcut and engraving and was the first important artist to experiment with etching. He etched only six plates; because he used iron, the acid bit in a ragged fashion and the line lacked the clarity and precision of line engraving. However, a spontaneity and a freer linear quality prevail in the etchings. There are indications that, prior to Dürer's experiments, some engravers used etching to start their plates and then further developed the lines with the engraver's burin.

Dürer's search for classical beauty and perfection served as a bridge between the northern Gothic and the Renaissance movements. His travels in Italy and exposure to great Renaissance masters like Andrea Mantegna and Giovanni Bellini made a lasting impact on him. He copied elements from Mantegna and Antonio Pollaiuolo in an allegory called *Hercules.* Later his own work was unmercifully copied, down to the famous monogram, by Marcantonio Raimondi in Venice.

SEVENTEENTH-CENTURY ETCHING

Although etching began tentatively and modestly in the sixteenth century, it was only in the seventeenth century, with improvements in its chemistry and the introduction of copper plates, that it really flourished. Jacques Callot (1592–1635), a highly accomplished French etcher who studied and lived in Italy, made great contributions to the development of the medium. He produced more than a thousand, mostly small etchings that were gems of caricature and the grotesque. Especially important were the military subjects in his biting series *The Miseries of War.* He made remarkable technical innovations, such as developing a tough, hard ground that accepted delicate detail and allowed months of work on a plate that would bite cleanly, without foul biting or chipping.

Another of his innovations was the echoppe, a steel cylinder slanted at one end. By twisting this slanted etching tool

those by his hand, *The Battle of the Sea Gods* is masterfully composed; it was copied by Dürer.

ALBRECHT DÜRER

Of all the painter-printmakers working in the late fifteenth and early sixteenth centuries, Albrecht Dürer (1471–1528) was perhaps the most illustrious. A master of woodcut, engraving, etching, and drypoint, the German artist invented modern watercolor, painted in oil, and drew in every known medium except red chalk. Dürer generally worked his plates himself, as did another important artist of this period: Lucas van Leyden in Antwerp. In allowing his enormous versatility and creativity a free rein in his prints, Dürer helped to free printmaking from its craft origins. Printmakers after him were trained as artists rather than as craftsmen in wood or metal.

on a copper plate, Callot could draw a thin line that swelled heavier, much as an engraved line swells. After biting, he would further strengthen the line with an engraving tool. He also evolved the practice of repeated biting and different biting times for thinner and heavier lines. In essence, he developed a method of etching to simulate engraving. Though this would seem to be a misuse of the etching process, his work did open the medium to more inventive uses by his contemporary Hercules Seghers and by Rembrandt, truly the giant of etching.

Hercules Seghers (1590–1645) was a singularly original printer-etcher who came to etching as an iconoclast, experimented with biting methods, and was no doubt the first artist to explore color in etching, using pigments instead of inks. He appears to have used color, often varied in tone, for his line work and added other tones by hand, either before or after printing. In addition to paper, he often used canvas or linen for printing. He also devised some methods that appear similar to our contemporary lift-ground technique. In *Prints and People*, A. Hyatt Mayor describes how Seghers used a water-soluble syrup to draw on a bare copper plate. After the lines were dry, he coated the plate with a ground, and when it was dry, he soaked the plate

MARCANTONIO RAIMONDI
The Carcass, 1518

Engraving
National Gallery of Art, Washington, D.C.
Rosenwald Collection

JACQUES CALLOT
The Temptation of St. Anthony, 1634
Engraving, 14¹⁄₁₆″ × 18⅛″
National Gallery of Art, Washington, D.C.

in water, dissolving the lines and biting them in acid. Where the lines were too wide, he pitted them with some granular material, producing an aquatint effect. It is not surprising to learn that Rembrandt was his friend and no doubt developed some of his innovative approaches by observing Seghers's methods of producing moody, mysterious landscapes. Rembrandt actually owned one of Seghers's plates and reworked it.

REMBRANDT VAN RIJN

Rembrandt van Rijn (1606–1669) was certainly the most gifted painter-etcher of his century, if not of all time. No doubt influenced by Caravaggio and his followers, he was a brilliant master of

chiaroscuro, presenting the drama of light and dark not only in his paintings but also in his prints. He brought a painter's restless probing and experimenting with subject matter to a new graphic medium. A real understanding of his genius can best be obtained by examining impressions taken at various stages in the evolution of one of his prints. At the Metropolitan Museum of Art's print study room, for example, it is possible to compare side by side the various states of *Christ Crucified Between Two Thieves*,

REMBRANDT VAN RIJN
*Christ Crucified Between the Two Thieves (**The Three Crosses**)*, **States I, 1653** (*top*)
and IV, c. 1660 (*bottom*)
Drypoint and engraving, 15¼″ × 17¹³⁄₁₆″
Top: The Pierpont Morgan Library, New York
Bottom: National Gallery of Art, Washington, D.C.
Ressing J. Rosenwald Collection

which underwent enormous changes in concept and execution in its evolution. In the last state, shown here, new figures have completely replaced scraped out ones on the left side. The plate has been darkened by powerful vertical and diagonal drypoint strokes, which create the drama of light in an abstract and turbulent manner. The figure of Christ, however, remains the point of focus, as in the earlier state.

An estimated three hundred plates came from Rembrandt's hand, varying richly in subject matter, from landscapes to portraits to biblical compositions of great strength. They show technical and esthetic innovations previously unseen in etching. Rembrandt used drypoint in combination with etching to produce rich blacks and enhance the drama of chiaroscuro. He experimented with different inks and papers, with variations in biting times, and with successive biting to create spatial and tonal qualities that were unique.

THE DEVELOPMENT OF MEZZOTINT

Few truly creative etchings were produced in the century following Rembrandt, but his experiments with tone and chiaroscuro may have had some bearing on the development of a tonal process in engraving called mezzotint. Ludwig von Siegen (c. 1609–1680), an amateur Amsterdam artist of German and Spanish origin and a former soldier, is credited with the invention of the mezzotint in 1646. He used a roulette, a kind of spiked wheel, to produce pits of various shapes and sizes. (This strange tool, in its broader barrel form, was amusingly called the "engine," perhaps because of its mechanistic use.) The resulting dot patterns worked the plate from light to dark, rather than dark to light, as the mezzotint is done today. Prince Rupert of the Palatinate, who worked in Germany and England, refined the method still further and produced some handsome prints.

The mezzotint rocker as we know it was developed by Abraham Blooteling around 1671, the year he did two small portraits of Erasmus and Frobenius after Holbein. This curved tool has a serrated end that, when rocked crisscross many times over a plate, produces a rough surface, which yields a rich, velvety black. A scraper is subsequently employed to shave down the raised areas to

a variety of heights that, when inked and wiped, produce a multitoned effect. The technical skill and dexterity of the early mezzotint artists were impressive but, unfortunately, were used mainly to reproduce paintings. The mezzotint became particularly popular in England, where the "dark manner" seemed well adapted to simulating the effects in British painting.

EIGHTEENTH-CENTURY ETCHINGS

The eighteenth century produced some interesting etchers, primarily in England and in Italy. In England, the social satirists William Hogarth (1697–1764) and Thomas Rowlandson (1756–1827) were immensely popular. In Italy, Giovanni Battista Tiepolo (1696–1770), the last of the great Venetian painters, created delicate, airy etchings. He tried to duplicate the openness and lightness of his paintings by using lightly bitten lines laid with little or no crosshatching. Another Venetian, Antonio Canale (1697–1768), known as Canaletto, etched numerous images that glorified the beauty and charm of his city. These prints helped to intensify a lingering interest in architecture among Italian printmakers, which peaked with Giovanni Battista Piranesi (1720–1778). His most important work, the fanciful *Invenzione Capricciosa di Carceri*, known as the prison series, was nurtured by his experience as a set painter for Venetian opera houses and his passion for archaeology and engineering. His love for Rome inspired him to create more than 130 *vedute*, or views, that were eagerly collected as mementos of that great city.

FRANCISCO GOYA

The most important painter-etcher of the late eighteenth and early nineteenth centuries was without doubt Francisco Goya (1746–1828). His visionary work, done with incredible skill in the newly developed aquatint method, is important not only for its unique compositional simplicity but for its political and social statement.

Los Desastres de le Guerra, Goya's biting images of the French occupation of Spain, is one of the great commentaries of all time on the horrors of war and man's inhumanity to man. His *Caprichos* were fanciful, courageous satires of court life in which he attacked the corrupt

JOHN MARTIN
The Destruction of Sodom and Gomorrah,
1831
Mezzotint with etching, 7½" × 11⁷⁄₁₆"
Courtesy Fitch-Febvrel Gallery, New York

GIOVANNI BATTISTA PIRANESI
The Smoking Fire (Plate VI, Second Edition),
1749–60
Etching, engraving, and sulfur tint or open bite
with burnishing, 21⁵⁄₈" × 15⁷⁄₈"
Collection of the New York Public Library

FRANCISCO GOYA
Se Repulen (*They Spruce Themselves Up*), **1799**
From *Los Caprichos*
Etching, burnished aquatint, and burin, 8⅞″ × 5¹⁵⁄₁₆″
National Gallery of Art, Washington, D.C.
Rosenwald Collection

court of Charles IV and the Inquisition.

Goya's combination of line etching with tonality reveals his inspiring technical facility and remarkably creative use of aquatint. Although aquatint had been introduced by Jean Baptiste Le Prince (1734–1781) in France only a few years before Goya began etching, it was Goya who used the technique with such artistry. Le Prince obtained his tones very much the way we do today, with a dust box and bellows. Besides being used for black-and-white tonalities, aquatint proved to be a popular method for early experiments with color printing in the late nineteenth century.

EARLY PRACTITIONERS OF COLOR ETCHING

Although Seghers had experimented with color in the early seventeenth century, overprinting separate plates in register did not take place until the early eighteenth century. In the 1720s Jacob Christoph Le Blon (1667–1741), a German artist who settled in Amsterdam, used a three-color process based on Isaac Newton's theory that tonal values are

composed of three cardinal colors: blue, yellow, and red. On the basis of this color theory, Le Blon superimposed his plates to produce tonal variations, often using a fourth plate for his blacks. His idea was good but his means imperfect, and the prints were marred by garish streaks because the colors failed to combine.

In England in the late eighteenth century, color methods called the "pastel manner" and the "crayon manner," which look like contemporary soft-ground techniques, were used. Simulations of the soft line of pastel or crayon were painstakingly drawn by perforating the etching ground with various needles and roulettes. In the pastel manner, a succession of plates were used to print a variety of colors imitating pastel.

By the end of the eighteenth and in the early nineteenth centuries, color prints from English mezzotints were being turned out in multiple colors from a single plate using the *à la poupée*, or doll's, method. This involved wiping various colors onto selected areas of a plate using rag stumps that, tied at one end with a string, resembled little dolls.

An unorthodox approach to color was taken by William Blake (1757–1827), a contemporary of Goya. Blake was a

unique and strange combination of religious mystic, writer, and engraver. He developed a highly personal imagery and experimented with engraving, relief etching, and color techniques. His illustrated books of poems, called "illuminated printing," combined figures and words that swirled and flowed in a style that seems a very early precursor of Art Nouveau. These books were usually printed in one color and frequently tinted with watercolor. In some instances he used a transfer method for additional color by painting a card with his design in tempera and offsetting the color to the print by rubbing.

Despite all these early experiments, relatively few color etchings were produced until the late nineteenth and early twentieth centuries. Then artists such as Camille Pissarro and Mary Cassatt, inspired by the influx of Japanese color woodcuts, revived the color processes, in particular the *à la poupée* and multiple-plate methods (see pages 117, 123).

TWENTIETH-CENTURY REVIVAL OF ETCHING

After Goya, the remainder of the nineteenth century brought only a steady decline in etching as a creative medium. Great technical proficiency and the popular demand for reproductions of paintings produced little interesting etching, except by Charles Meryon (1821–1868) in France and James Abbott McNeill Whistler (1834–1903), the American artist who settled in England.

The revival of etching in a truly explorative and creative manner came with the advent of Expressionism and Modernism in Europe. Lovis Corinth (1858–1925), a German Expressionist, produced strong drypoints that reflected the social discontent of the period. The Belgian James Ensor (1860–1949), in his strange, provocative etchings, showed an interest in both experimentation and personal symbolism. Käthe Kollwitz (1867–1945), another German Expressionist, portrayed moving episodes in the lives of the socially and politically downtrodden through her powerful etchings. Other artists as varied as Georges Rouault, Jacques Villon, and Joan Miró produced significant etchings.

The etching genius of this century, superseding all others in audacious experimentation and creative resource, was certainly Pablo Picasso (1881–1975), who

WILLIAM BLAKE
A Prophecy, 1793
Fragment of canceled relief-etched copper plate
National Gallery of Art, Washington, D.C.
Rosenwald Collection

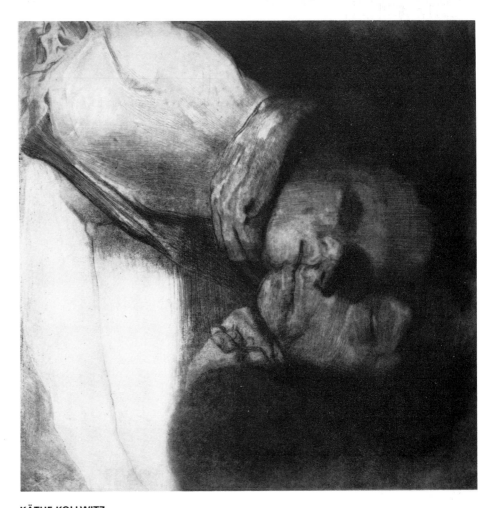

PABLO PICASSO
Blind Minotaur Led Through the Night by Girl with Fluttering Dove, c. 1935
Etching, burnished aquatint, and drypoint, 9¾″ × 13¹¹⁄₁₆″
National Gallery of Art, Washington, D.C.
Rosenwald Collection

KÄTHE KOLLWITZ
Death, Woman and Child, 1910
Softground and etching (evolved through 10 proof states to final eleventh state)
Collection of the authors

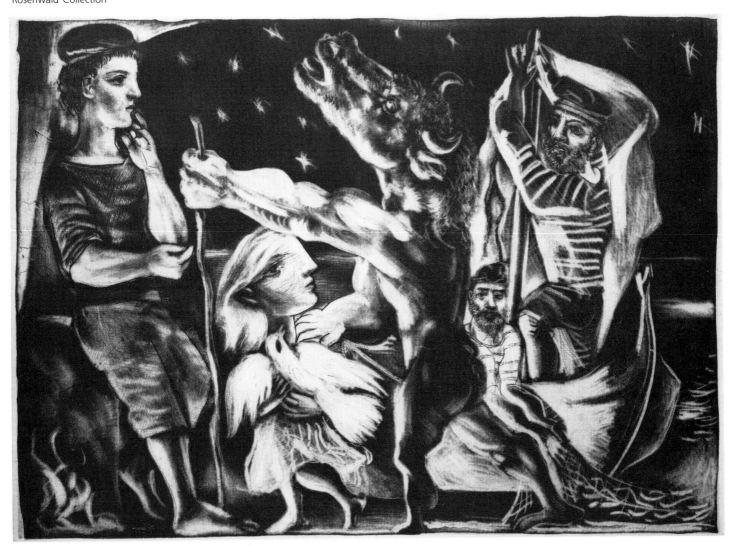

was born in Spain but worked most of his life in France. The range of his creativity in print media and especially etching is staggering. From the romantic realist etching *The Frugal Repast* of 1902, through his Cubist etchings around 1911, to the Goyaesque *Satyr Unveiling Sleeping Woman* and the Vollard Suite, both of 1936, Picasso created inspiring works of great personal vision.

ETCHING IN THE UNITED STATES

Some interesting etchings were produced on the American scene during the first part of the twentieth century by Edward Hopper, John Marin, and John Sloan. Then in the 1930s there was a modest revival, thanks to the support of the Works Progress Administration (WPA).

However, it was at the beginning of World War II, when many European artists relocated to the United States, particularly New York City, that innovative concepts in printmaking began to take hold in our country. The seminal figure implementing this change was Stanley William Hayter (1906–1988), a British painter-printmaker whose early training was as a research chemist. Hayter had established a unique workshop in Paris in 1927, called Atelier 17, where he taught classes in engraving and etching to artists interested in the print. He also provided facilities for established artists such as Pablo Picasso, Max Ernst, Alexander Calder, Marc Chagall, Jacques Lipschitz, and Alberto Giacometti, who were experienced in the print and interested in the methods Hayter encouraged.

Hayter shared the Surrealist belief in the liberating power of impulse and the unconscious. His primary interest was in engraving and in the flow and release of the engraved line, to which he brought a new freedom and inventiveness. He experimented with materials, expanding the range of tonality, and worked with a method developed by Krishna Reddy and Kaiko Moti that exploited the different viscosities of printing inks.

In 1940 World War II forced him to move the workshop to the New School for Social Research in New York City, where it remained until 1950. In this new location it became a place where refugee artists like André Masson and Chagall could work and meet American artists. During those years Jackson

JOHN SLOAN
Sixth Avenue—Greenwich Village, 1923
Etching, 5″ × 7″
Courtesy Susan Teller Gallery, New York

STANLEY WILLIAM HAYTER
Death by Water, 1948
Etching and engraving, 13¾″ × 23½″
Courtesy Sylvan Cole Gallery, New York

Pollock, the Abstract Expressionist artist, worked there and was influenced by the principle of automatism that Hayter espoused.

Artists like Gabor Peterdi and Mauricio Lasansky were nourished by these new approaches and in turn nurtured their students at the Brooklyn Museum School and Iowa State University. Print workshops such as the Pratt Graphic Center and Robert Blackburn's Creative Print Workshop also served a growing need for locations where artists could make prints and exchange ideas.

In 1957 Tatyana and Maurice Grosman courageously started a modest enterprise called Universal Limited Art Editions in West Islip, Long Island, an hour's drive from New York City. Larry Rivers, in collaboration with the poet Frank O'Hara, created a book project by drawing images of his wife, Clarissa, in compositions with birds and lines of poetry written in O'Hara's hand. This col-

laboration helped to launch the present marriage of painter and sculptor to the publishers of fine prints, an accomplishment with a long history in Europe.

Tatyana Grosman's workshop, June Wayne's Tamarind Workshop, Ken Tyler's Gemini Editions, and Crown Point Press are just a few of the fine-art edition print shops that provided the impetus for new images in prints. Major artists like Frank Stella, Jasper Johns, James Rosenquist, Louise Nevelson, Jim Dine, and Chuck Close were attracted to creating prints because they could work with skilled technicians and use sophisticated equipment to produce imaginative works in new and mixed media. Some of these artists had never made prints before. Others like Nevelson had the opportunity to use techniques and work on a scale not possible in the 1930s and 1940s when she had first made prints. A new era in the intaglio print had begun.

Overview of Intaglio Techniques

The term *intaglio* (from the Italian *intagliare*, meaning "to carve or cut into") covers a multitude of processes using metal plates for traditional techniques, such as engraving, etching, drypoint, aquatint, soft ground, lift ground, and mezzotint; more contemporary methods such as the collagraph (discussed in a separate chapter); and many other additive techniques, among them Carborundum and epoxy prints. The latter usually use unconventional materials for their plates, such as cardboard, Masonite, or Plexiglas, and are printed as intaglios. Drypoints can also be done on Plexiglas, but because the material is less durable than zinc or copper, it does not retain the image for many prints.

There are three basic steps in printing an intaglio plate: (1) a soft but not runny ink is pushed into the lines or depressions in an etched or collaged plate, and the surface of the plate is then wiped clean, leaving ink in only the recessed areas; (2) the plate is placed on the bed of an etching press, and etching paper, dampened with water to soften its fibers,

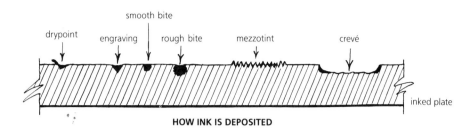

HOW INK IS DEPOSITED

is placed on the inked plate; (3) the plate and paper are rolled through the press with substantial pressure, so that the dampened etching paper is forced into all the lines and recessions of the plate to produce a richly inked impression.

There are two broad categories of intaglio processes: those that do and those that do not use acid to create an image on the plate. In place of acid, sharp tools can be used to engrave, scratch, or pit the plate, as in line engraving and stipple engraving, or criblé. Scratching and scoring can be done with a needle or a mezzotint rocker, again without acid, as in drypoint and mezzotint. And power tools can also be employed to produce images without acid.

The processes that use acid to bite lines or depressions into metal plates are etching, aquatint, soft ground, lift ground, and ancillary surface-texturing techniques using experimental stop-out methods.

Basic engraving techniques since Dürer and etching techniques since Seghers and Rembrandt have changed little in succeeding years. In etching, the main difference seems to be the more abundant supply of solvents today. Although there are variations in hard- and soft-ground recipes and procedures, early formulas for the grounds that protect the plate from the acid often use some of the same ingredients used today. Aquatints and soft and lift grounds, which were developed later, as well as recent photo processes and the use of power tools, are the exceptions.

Nonacid Techniques	Acid Techniques
Drypoint	Etching
Engraving	Soft ground
Criblé	Aquatint
Mezzotint	Lift ground
Collagraph	Embossing and
Other additive methods	open biting

NONACID TECHNIQUES

Drypoint This process involves scratching into the plate with a sharp needle. The scratching raises a metal burr that catches and holds the ink when the plate is wiped, yielding a rich, rough line with soft edges, unlike the crisp line of engraving or the sharply defined line of etching.

Engraving In this linear process, sharp, crisp lines are made by pushing a hard steel engraving tool called a burin into a copper or brass plate. Different-size burins create lines of varying widths. Pushing the burin deeper into the metal also yields a thicker line. Tonal areas are developed by engraving parallel and crosshatched lines. Stippling, producing fine dotted areas with an engraving tool, also creates tones. The printed engraving is an image of great clarity and precision.

Criblé These prints are made by hammering indentations in a plate with a variety of different-size punches or pointed tools. In the fifteenth century the plate was rolled on the surface. Today criblé is rarely used to complete a print but may be employed in combination with other methods and printed intaglio.

Mezzotint Often called *manière noire*, or the black method, mezzotint derives from repeatedly pressing a curved, serrated mezzotint rocker over the surface of a copper plate until it makes thousands of tiny little indentations. After the entire surface has been roughened, producing a rich black, scrapers and burnishers are used to develop soft tones from dark grays to middle grays to whites.

EVAN SUMMER
Landscape XV, 1985
Etching, engraving, and drypoint, 23″ × 29″
Courtesy of the artist
Photo: Don Weigel Studio

Collagraph As the name suggests, a collagraph is made from a collage plate, created by gluing materials onto a base plate, which is usually cardboard, hardboard, aluminum, or another similar material. Acrylic gesso or polymer medium are excellent gluing agents because they dry hard, yet are flexible; they can also be used in a painterly manner for image making. The collage plate is inked by the intaglio method, allowing the added materials to produce sensitive textured, tonal, and linear imagery. Any other adherents that dry hard, such as liquid solder, epoxy, lacquer, and varnish, can be used.

ACID TECHNIQUES

Etching In etching, a metal plate of copper, zinc, or brass is covered with an acid-proof hard ground made of asphaltum, beeswax, rosin, and solvent. Wherever the artist scratches lines or textures in the ground, the acid will bite with clear definition. The longer the plate is left in the acid, the deeper the open lines will become, making them print heavier and increasing the strength or darkness of the print.

Soft ground This kind of etching is done on a plate covered with a thinly applied hard ground to which petroleum jelly or tallow has been added. Since this ground never really hardens, a line or texture can be impressed into it. A line similar to a pencil stroke can be achieved by drawing on top of a textured or granular tracing paper placed over the soft ground. The texture of the paper will be picked up and the resultant line can be etched with acid. Fabric, cloth, and other materials can be pressed into the ground, and when etched and printed, their textures are faithfully replicated. Prepared commercial soft ground can be purchased in either liquid or paste form.

Aquatint This technique is used to achieve tonal areas in an intaglio plate. The term stems from the Latin *aquafortis*, meaning "strong water" (in this case, nitric acid), and the Italian *tinto*, meaning "tone." Tones are bitten into the plate after the surface has been partially covered with many tiny particles of rosin (adhered to the plate by heating) or given a 50 percent coverage of enamel spray paint from a pressurized can. The acid bites the open areas around these particles, creating uniform pitting in the plate. The longer the bite, the deeper the pits and the darker the printed tone. Aquatint is most often combined with line etching and other methods. When rosin is used to achieve a tone, fine to coarse rosin powder can be used to produce textural qualities.

Lift ground This method offers a free, painterly way of producing an intaglio image. A brush, pen, stick, or rag is used with a water-soluble material to paint, draw, or daub directly onto a clean plate. When the drawing is dry, a thin coat of liquid hard ground is applied over the entire surface of the plate. When the ground is thoroughly dry, the plate is placed in a tepid water bath and the drawn areas lift off, exposing only those areas on the plate and leaving the negative areas protected by the ground. The open lines or areas can then be bitten in acid, or the plate can be aquatinted and bitten.

Embossing Printing deeply bitten areas of a plate without ink creates an embossed print. These deep bites, which occur after the plate is left for long periods in the acid, can be created by the lift-ground technique or by traditional line etching. After the uninked plate is run through the press, the recessed areas form raised areas in the print.

Concept and Imagery

Intaglio is attractive to many artists because of the great versatility and tactile potential of the plate, which can yield

ELAINE DE KOONING
Torchlight Cave Drawing #1, 1985
Aquatint, 20″ × 26¼″
Courtesy Crown Point Press,
New York and San Francisco

varied and complex imagery. Linear structures can be delicate or bold, resembling soft pencil work or lively crayon marks. The incised line of the etching plate yields a raised line of ink in the impression that has a crisp, intense, and forceful character. The great pressure of the etching press achieves a closer conjunction between the paper and the plate than that of any other graphic process. Tones can be velvety, subtle, or dark; textures can be deeply penetrating, sharp-edged, or embossed, and are par-

ticularly suited to contemporary visions.

The medium is also quite flexible. Because changes can be made with relatively minor effort by scraping out lines that need revision, the artist can repeatedly rework difficult passages without discarding the rest of the image.

Familiarity with a variety of methods is helpful in finding the ones best suited to your own vision. The richness of a print depends on the technique used, and many techniques can be combined in one plate. Knowing that working a plate can involve line, textures, tonal masses, deep biting in open areas, and embossing can help you explore the me-

dium for its intrinsic qualities and develop your own individual imagery.

If an artist wishes to work directly from a subject, he or she can work right on a naked plate with a drypoint needle or a brush with lift ground or use a needle to draw on a grounded plate. The result can be fresh and spontaneous.

Neither painting nor drawing allows the artist to try a number of different solutions at the same time without destroying the original. In contrast, with the print, different versions can be tried out on proofs before one is selected and the plate is reworked. A preparatory drawing can be made on tracing paper, placed face down on the plate with carbon paper underneath, and traced through. After biting and proofing the plate, the artist can develop the image by working out ideas directly on the proofs with pencil, pen, or brush. Making additions or deletions can be an important part of the evolution of the print.

Color in the intaglio print has many possibilities, particularly when both intaglio and surface rolling are exploited. It is possible to ink a single etching plate in

JASPER JOHNS
The Seasons, 1989
Intaglio from 4 copper plates, 26¾″ × 54¼″
Printed by John Lund, Craig Zammiello, and Hitoshi Kido
Photo: courtesy Universal Limited Art Editions

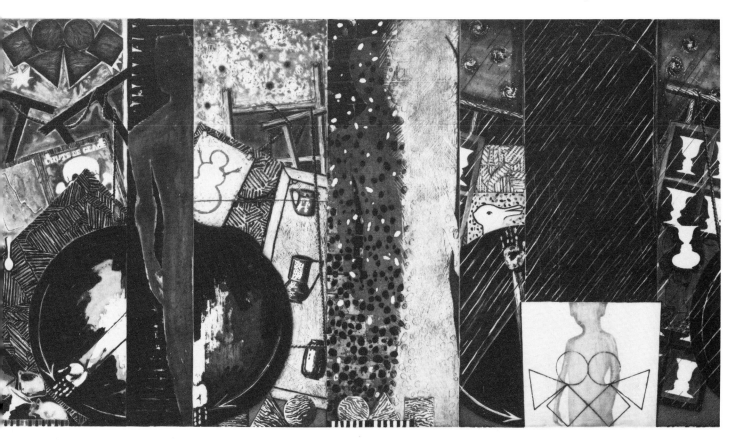

By using a white carbon paper, you can transfer a drawing on tracing paper to a hard-ground plate. Flop the tracing-paper drawing and slip a light-colored carbon or pastel-prepared tracing paper beneath it to transfer the drawing to the plate. Flopping the drawing will make the image in the print the same as in the original drawing.

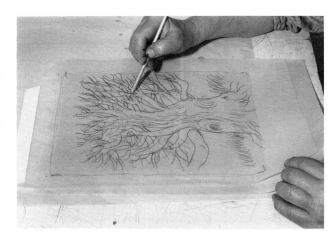

When you trace through the carbon, the image will be transferred to the plate. Now you can use a needle to scratch the ground, exposing the metal for the etch.

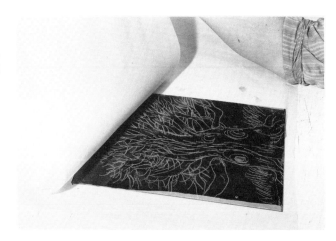

many colors to create a color print. It is also possible to print several plates, each inked in a different color, one after the other on the same impression. There are a number of other ways to create color prints with the intaglio method, such as cutting plates apart, inking them separately and assembling them on the press, and printing multiple colors in one roll through the press. Intaglio color can also be combined with other printing processes, such as woodcut, silkscreen, or lithography. In most cases the intaglio plates should be printed last to retain the raised lines.

The intaglio process is a print medium with a unique, individual voice, with a great potential to yield prints that expand an artist's intention and invention. However, producing an etching that is a work of art is very subjective and depends on the esthetic values of the individual.

Basic Materials and Tools

The tools and equipment needed for intaglio printmaking depend somewhat on the personal requirements of each artist. The following list includes the tools that are generally used for most processes and are essential in furnishing your work area. Additional tools related to specific techniques will be listed where those processes are discussed.

Etching plates (zinc, copper, brass)

Draw tool (for cutting plates)

Scraper

Burnisher (curved)

Sharpening stones (India, Arkansas, Carborundum)

Light machine oil (for sharpening)

Acid trays (plastic or stainless steel)

Acids (types discussed in section on acids)

Glass measuring cup (1-quart size)

Hard ground

Soft ground

Crocus cloth

Emery paper (320, 400, 600)

Fine steel wool

Metal cleaner (such as Noxon)

Engraver's charcoal

Tarlatan (crinoline)

Gum arabic

Rags

Asphaltum

English chalk (whiting)

Alcohol

Paint thinner

Fishing tackle box or art bin (to organize small tools)

Soft wool felts (1 medium weight, 1 heavy)

Rollers (4- or 5-inch solid-core Hunt Speedball)

Brushes (2-inch flat for grounds, no. 3 or 4 pointed for stopping out)

Watch or clock with second hand for timing

Black poster color

Pencils, litho crayons (soft)

Tracing paper

Carbon paper

Metal files (coarse and fine such as mill bastard)

Hotplate

Rosin (powdered or lump)

SELECTING A METAL PLATE

Copper Because of its even texture, uniform ductility, and excellent printing qualities, copper is the preferred metal for etching, drypoint, aquatint, engraving, and mezzotint. It wipes to give a brilliant proof and does not alter colors when used for color prints, except for a chemical reaction with vermilion. It resists corrosion and may be steel-faced, an electrolytic process that deposits a thin layer of iron on the copper surface. Steel facing gives support to fine details and burrs and permits hundreds of prints to be pulled without diminishing the image. Copper can be purchased with an acid-proof backing prepared for photoengravers; it is usually 16 or 18 gauge. Uncoated copper of similar gauge and thin roofing copper are also available from metal suppliers, who sell it for building flashing. Dutch mordant, ferric

chloride, or nitric acid will bite copper. Dutch mordant is preferred because it bites slowly and evenly. With ferric chloride, the copper plate must be turned upside down so that particles do not form in the bitten areas, or it must be removed from the acid at 5-minute intervals and rinsed off before being returned to the acid. Nitric acid bites fast and unevenly. (Additional information on acids is included in the section on acids.)

Zinc The fact that it is usually less expensive than copper makes zinc a very desirable metal for beginning print-makers and students. You can purchase 16 or 18 gauge, the standard size, fairly easily. Micro metal seems to be the most available. Zinc does not bite as cleanly as copper, and its molecular structure makes a brilliant wiping more difficult to achieve than on copper. Yet, since it bites so much faster, it is an interesting metal to use for quick, experimental effects. In color printing, the chemistry of zinc alters some colors, turning yellows green, whites and pinks grayish. Zinc cannot be steel-faced easily, and because it is a softer metal, it does not hold up for drypoints and aquatints as long as copper does. Nitric acid in a variety of strengths for different types of biting is used for zinc.

Brass In many ways similar to copper, brass is actually an alloy of copper and zinc. It wipes clean, bites very slowly, and is about the same price as copper but does not come with a backing. There are some artists who prefer it to all other metals. Dutch mordant, ferric chloride, and nitric acid can be used for biting.

Steel Used for engravings for centuries, steel is still used today in the Bureau of Printing and Engraving in Washington, D.C., to make engravings for postage stamps. It is excellent for engraving but is harder than all other metals, requiring much pressure to be applied to the burin. Drypoint, although possible, is difficult. Because steel is so hard, aquatints and lines will not wear down. However, it must be given a high polish or it will print with a tone. Scratches and changes are difficult to remove, and a backing must also be applied. Polished,

commercial-gauge, cold-rolled mild steel, .062 to 16 gauge, is best for intaglio. Plates left in storage may rust from dampness in the atmosphere, so they should be protected with a coat of wax ground or asphaltum when not in use. Nitric acid is the acid to use for biting.

Aluminum and magnesium These are soft metals and thus generally uncertain choices for etching, drypoint, or engraving, to be used only when nothing else is available. Although aluminum can be etched in stannous chloride or ferric chloride, it does not etch well. Nor does magnesium hold up, although it can be etched. Both are more widely used in lithography, and we have used them as base plates or cut plates for collage platemaking. There are also some artists who have found magnesium plates useful for their special needs. Fred Becker, an American artist, likes to use them for engraving because when he pushes his burin into the metal no burr forms and the metal removed just crumbles away. He also finds it quite easy to use oversize burins with the metal. For etching, he uses a solution of 20 parts water to 1 part nitric acid, or a vinegar and salt solution with enough salt added to produce a saturated solution.

CUTTING A PLATE

Metal plates are most economically purchased in large sheet sizes. A standard size for zinc and copper is 24 by 36 inches, but 18 by 24 inches and smaller sheets are available. Large sheets, of course, require hand cutting or cutting in a professional workshop. In a small home workshop, a draw tool or a sharp scraper can be used for the job.

Using a draw tool To cut a plate with a draw tool, first measure the plate and mark it with a soft pencil where you wish to cut. Avoid making fingerprints on the metal because the acid content of your hand will eventually mark the plate. To prevent scratching, place a clean sheet of paper on the metal's surface, right to the cut mark. Use a steel ruler or T-square as your guide for the draw tool; place masking tape on its underside to keep it from slipping. On a large plate, it may be helpful to use C clamps to secure the ruler or the plate. Pull the draw tool along the ruler's edge, scoring the metal.

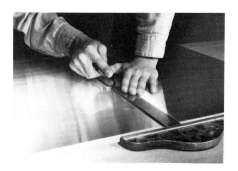

Cutting a zinc plate with a draw tool requires repeated cuts in the same groove. A steel straightedge is useful; it can be clamped in position, if necessary.

When the groove is deep enough, the plate should break cleanly along the scored line if it is turned over the edge of a table and bent down and up several times. Do not scratch the surface of the zinc.

Repeat this three or four times, or until a groove has been dug about two-thirds through. Then move the plate to the table edge and break it through. If the groove is deep enough, the plate will break easily. If not, score it further until it breaks. Some artists use the tip of a steel scraper instead of a draw tool. Whichever feels comfortable, and works, is the right tool.

Using a plate chopper The easiest way to cut a metal plate is with a commercial chopper, if you have access to a print workshop or school department that has one. Operated either by a hand lever or a foot treadle, a chopper is accurate and sturdy. Its function is similar to that of a paper cutter, and it resembles a miniature guillotine, with a blade secured on both ends. Plate cutters can still be purchased fairly easily from used printing

equipment dealers in large cities. They are easy to come by because photo offset dominates the printing industry and photoengraving shops have rapidly dwindled, lessening the need for such equipment.

Using power tools Metal plates can be cut with a carbide-tipped circular saw, but unless you are very familiar with power tools, this option is dangerous. It is very important to take the obvious precautions in handling power tools and to avoid loose clothing that can get caught in the machinery. Goggles to protect your eyes from metal particles are also a prerequisite.

CUTTING IRREGULAR-SHAPED PLATES

Freeing oneself from a rectangular format can be important creatively. Moreover, it is quite easy to obtain an odd-shaped plate by using acid or power tools. The following acid method is simple.

Acid method

1 Brush a heavy coat of asphaltum or liquid ground over the entire plate.

2 Draw or scratch the shape you want with a thick, blunted needle through the ground.

3 Etch the plate in a strong acid solution long enough to bite through the plate. Zinc will be bitten through in about 2 hours in a 3-to-1 or 4-to-1 solution (3 parts water to 1 part nitric acid).

4 Check the plate frequently for signs of overheating. If a smoky vapor rises from the plate, it is overheating. Such smoking produces excessive acid fumes. If this occurs, remove the plate from the acid and cool it in water before proceeding.

5 When the plate has cut through, wash off the ground with paint thinner and bevel all the edges with a file or scraper.

Saw and torch cutting Plates can also be cut into unusual shapes with a jigsaw or a coping saw. Zinc is soft and cuts easily, while copper needs more time and effort to shape. An acetylene torch cuts through a metal plate in seconds, leaving an irregular molten edge that has a rich textural quality. The propane and butane gas torches used for soldering do not cut fast enough for general use, but they may be helpful when you do not need sharp cutting. Again, exercise great caution in using open-flame and gas-fired tools. They should be used only by experienced artists and in supervised classes.

Cardboard plates Another way to obtain irregular shapes for intaglio plates is to cut the shapes from cardboard or heavy paper. (For a description of this technique, see the collagraph chapter.)

BEVELING THE PLATE

All metal plates must have their sharp edges beveled before printing to prevent them from cutting the paper or felt blankets. It is wise to do preliminary beveling before working on a plate to avoid cutting yourself on the sharp edges. When etching, it is important to do the final beveling after the acid biting is complete, since the acid often roughens up the plate edges, and clean edges in a final print are considered desirable.

This plate chopper is used to cut zinc and copper etching plates at Indiana University. If the chopper has a gripper bar, place cardboard between the gripper and the plate so that it doesn't scratch the plate.

Here a Dremel power saw is used to cut jigsaw shapes in a zinc plate.

This zinc plate is being cut with a Cuts-All power saw, which is more powerful than a Dremel. The plate is cut from behind to prevent scratches from the machine.

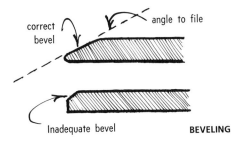

BEVELING

A coarse and a fine file are used for beveling. Hold the file at an angle to the metal and push it away from you so that it shears the metal. A sharp scraper also produces a fine bevel if it is held at an angle along the plate and vigorously pulled toward you. If the scraper makes little ridges or corrugations in the edge, change the angle of cut slightly to reduce them. Sandpaper, emery paper, and a burnisher, as well as engraver's charcoal, can be used to smooth and polish the bevel to a high, mirrorlike finish.

The corners of the plate should be rounded to eliminate sharp points that could catch the tarlatan wiping cloth or cut your hand if you hand-wipe the plate. All the edges of the plate, including the bottom edges, should be rounded.

Thin plates need no beveling, as the edges are not high enough to cut the paper. Thick cardboard, Masonite, and linoleum plates should be beveled to ease the press rollers over the thick material and prevent the plate from slipping as it is printed. Make sure that the press rollers are adjusted for these extra-thick plates.

A routing machine creates a 45-degree bevel, which can then be refined with a scraper and filed to a gentler bevel that will work better when the plate is being printed.

An electric belt sander can also be used to bevel the plate, but it requires caution as the belt cuts very rapidly. Safety goggles should be worn. Some shops use an electric grinding wheel to bevel plates, but this is even trickier than the belt sander. Particles of metal are thrown all over the area, again mandating the use of safety goggles.

DEGREASING THE PLATE

An etching plate must be cleaned of any surface grease or oil before a ground, an aquatint, or a lift ground is applied. Even new plates are usually protected by a thin film of oil to counteract oxidation.

If the plate is not thoroughly cleaned, the ground may break down during biting. If a plate is not degreased, a rosin or spray-paint aquatint may print unevenly.

Clear kitchen ammonia (not the cloudy kind), alcohol, or vinegar can be mixed with whiting (calcium carbonate) to make an excellent cleaning solution. Place about a teaspoon of whiting on the plate and add just enough ammonia, alcohol, or vinegar to make a thin paste. Rub the paste thoroughly over the whole plate using clean fingers, a hand in clean surgical gloves, or an immaculately clean cloth. Then carefully rinse the plate of all the cleaning material. When the water runs off the surface in a thin, unbroken film, the plate is free of any greasy substance. If this does not occur and uneven globules of water appear, the plate is not grease-free and the process must be repeated. Be sure to remove any residue of whiting, which can cause streaking and unevenness when the plate is aquatinted.

Dry the plate by fanning it or heating it on a hotplate; be sure to allow the plate to cool before applying aquatint or ground. Do not try to blot it dry with paper or cloth because such materials may deposit lint. Handle the plate by its edges to prevent fingerprints.

POLISHING THE PLATE

At one time or another it may be necessary to polish your plate, even though most new plates come with a high polish. Polishing ensures clean wiping and can restore surfaces after scraping or burnishing. Note that a drypoint plate must be polished *before* it is worked on to avoid damaging the burr. With engraving, polishing has an added benefit: making it easier to see fine work. With aquatints, however, aquatinted areas must not be polished unless drastic lightening of a tone is desired.

A new plate can be polished with engraver's charcoal and water. Sprinkle water on the surface and rub the edge of the charcoal back and forth with even strokes. Jeweler's rouge and a soft cloth (crocus cloth) or fine emery paper (no. 400 or finer) also produce a fine polish. An electric drill fitted with a cotton buffing wheel works rapidly but must be handled carefully to avoid overworking.

If tarnish appears to mar a surface, rub plate polish or magnesium carbonate into the area with soft leather to restore the surface.

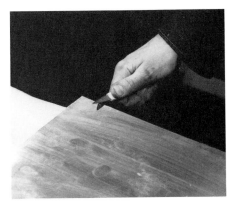

The plate should be beveled. One method is to use the scraper to remove the metal. Wrap tape around the lower part of the scraper to protect your thumb.

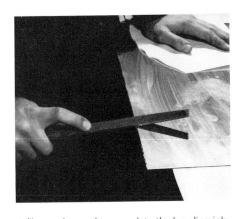

A file may be used to complete the beveling job. In this case a mill bastard is used to finish the edge. For rougher work a coarse file is helpful. To use the file efficiently, hold it as shown and pull it to a corner without up-and-down motion.

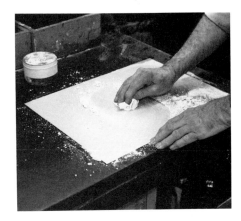

Whiting and alcohol are used here to degrease a plate. These agents will be washed off with water. Another method of degreasing is to dip the zinc plate in 8-to-1 nitric acid for a few seconds. Handle the plate with care since oil from fingerprints can damage a ground.

NONACID TECHNIQUES

Although the acid-bitten plate offers the most long-lasting and efficient matrix for an edition of prints, some of the most dramatic, velvety blacks in all of printmaking are achieved through the drypoint and mezzotint methods.

Drypoint

Drypoint is the most direct of all intaglio techniques. A sharp drypoint needle and a metal plate, preferably copper, are all the materials required. Acid and ground are not used. The image is produced by scratching the metal surface with a sharp needle and raising a burr. The burr holds the printing ink and prints with more effect than the incised line itself, which is usually quite shallow and holds little ink. When the burr is new, the print has rich, dark blacks, but when the burr starts to break off and wear down, the blacks get weaker and grayer until the plate has lost much of its character and vigor. The actual thickness and tonality of the line are determined more by the angle of the needle and less by the pressure exerted as the burr is raised.

Although the process may be simple in theory, free of the complex procedures of etching and the demanding skills of engraving, it is quite difficult to control when delicate drawing and tonalities are required. It is true that tonal areas can be reworked if they are too light, or scraped or burnished down if they are too dark, but the reworking of a single line can destroy its freshness. A drypoint on zinc will yield only 25 or 30 impressions. Copper will furnish about double that number and, when steel-faced, may yield from 100 to 200 decent impressions.

Dürer made a few drypoints, but it was Rembrandt who used the technique with extraordinary mastery and freedom. His need for expressiveness and spontaneity seems to have been met by his imposition of strong, rich drypoint lines on previously etched images, as in *Three Crosses* (page 70).

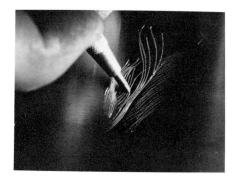

The drypoint needle scratches the plate, throwing up burr on one or both sides of the line, depending on the angle of cut. The angle shown produces a double burr.

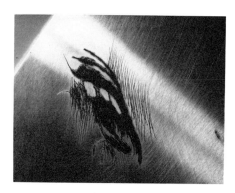

When inked, the drypoint burr traps and holds a large amount of ink, printing the velvety black line so prized by drypoint connoisseurs.

MATERIALS AND TOOLS

The main materials and tools for drypoint are as follows:

Copper plate (use zinc only for experiments)

Diamond- or sapphire-point needle or carbide-tipped steel needle

Black etching ink (Le Franc is especially good; Graphic Chemical acceptable if some oil is added)

Plate oil

2-inch cardboard squares

Etching paper (German Etching, Arches)

Plate Copper is the most logical metal to use for drypoint because a burr raised in copper holds up in printing far longer than a burr raised in zinc. A drypoint in copper can also be steel-faced to harden

the burr. This is an electrolytic process that enables the artist to print quite large editions without wearing down the burr. The same procedure in zinc is not practical because the zinc would have to be copper-faced in order to receive the steel.

Bevel the edges before you start scratching into the plate so that you do not cut yourself on the sharp edges. When your drypoint is drawn, you will be ready to print.

Needle An industrial diamond needle is number one and a sapphire needle number two in desirability. (When purchasing either of these tools, be sure the stone extends out of the setting enough to allow cutting at an acute angle.) Both of these tools are quite expensive but well worth the investment if you do a great many drypoints. They handle quite easily, do not need sharpening, and produce excellent results.

A carbide-tipped steel needle also produces good drypoints and is enough for a beginner to start with. Some artists have used a variety of unconventional tools such as awls, steel scribes, or sharpened

Dan Stack at Solo Press in New York is about to immerse a copper plate in the electrolyte solution in a plastic vat in order to steel-face the plate, hardening the surface for longer wear in printing.

dentist's tools with good results, depending on the line desired.

A good needle should be ground without flat sides or facets. If the sides are flat, the needle may remove metal rather than create a burr. The point should be round in cross section and tapered to a point that is fine but substantial enough not to break under pressure.

Diamond and sapphire points do not need sharpening. However, a carbide steel point requires periodic sharpening to be capable of raising a proper burr. Use an oil stone, about 3½ inches in diameter, rough on one side and smooth on the other. The rough side should be used only when drastic sharpening is required. The smooth side is adequate for keeping a tool in shape. Use a light machine oil such as 3-in-1 oil.

Electric engraving tools Although called electric *engraving* tools, these are in essence drypoint tools. As the needle works across the plate, a burr is raised, and it is this burr that holds the ink. There are a number of good models on the market, and they are available in most well-equipped hardware stores. Dremel and Vibrograver are very satisfactory brands and usually have a sharp point of carbide steel, although some models come with a diamond point. One Vibrograver model has its motor in the handle and is comfortable to use. Some models have a speed control so that the quality of the line will reflect the motor speed and your movement over the plate.

To sharpen an etching needle, rotate it in your hand while the point contacts the oil-coated stone. To draw on a grounded plate, the needle only has to break the ground. For drypoint, however, the needle must be sharper to cut into the ungrounded plate.

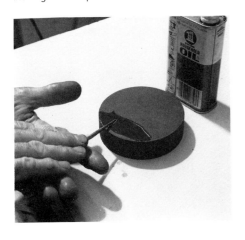

AUGUST RODIN
Victor Hugo

Drypoint
National Gallery of Art, Washington, D.C.
Rosenwald Collection

DRAWING ON THE PLATE OR TRANSFERRING A SKETCH

How an artist develops an image on a plate is very personal. Some artists are spontaneous and can work directly on the plate. Mary Cassatt considered drypoint a great challenge to her draftsmanship and would draw with her drypoint needle directly from the model onto her plate. Other artists are more comfortable sketching with a litho pencil or crayon on the plate and using those lines as a guide for the needle. With both these methods, the image is reversed when printed. To avoid the reversal, a soft pencil drawing can be made on tracing paper, placed face down on the plate, and run through the press. This not only produces a print without reversal, but also avoids the need to trace the image using carbon paper.

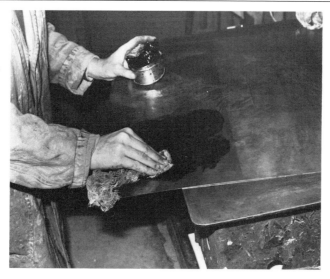

Here the etched plate is inked with a crinoline pad at Atelier Desjobert, Paris. Inking can also be done with a brayer.

MAKING A DRYPOINT

Hold your needle in a manner that feels comfortable. If you vary the angle, you will produce different burrs and get lines that vary in intensity and color. If you hold the needle almost vertically, you will create a burr on both sides and get a line with a dark center and soft edges. When you angle the needle, the burr rises on the opposite side and will print softly on the burr side. As the angle increases, the burr increases and the line thickens. Too great an angle, however, produces a weak burr that will not withstand many printings.

Become familiar with what the needle can do. On a test plate, try out a variety of lines and curves. The more pressure you put on the needle, the stronger the line will be.

To check your progress, rub some soft black ink onto your plate and wipe it gently with a soft tarlatan and your hand. It is better not to proof a drypoint as you go along because the burr could wear down. If you need to make corrections, you can do this easily with a scraper and a burnisher because the burr does not protrude enough to be resistant.

INKING THE DRYPOINT

Since the preparation for inking a drypoint is the same as for an etching, you should refer to the discussion of inking an etching plate on page 113 for general procedures. The following procedures are specific to drypoint.

Select a medium-soft ink such as Le Franc black etching ink. If the ink is too stiff, add a little plate oil and mix well.

Spread the ink gently with a 2-inch cardboard square. Do not scrub because the burr is somewhat fragile and too much pressure can damage it. Spread the ink over the entire plate surface, removing the excess but allowing an ample amount to cling to the image.

Wiping with a tarlatan comes next. Use a piece about a yard square that has been rinsed in water to remove the starch, then dried. Soft tarlatan is used for drypoint wiping in order to retain the soft-edged line. Crumple the tarlatan into a flat-bottomed ball and wipe the plate in small circular motions to remove heavy deposits of ink. Turn the tarlatan several times so that you keep working with a clean side. Use gentle motions.

Finally, wipe the plate with the edge of your palm in a gentle stroking motion to get an even plate tone and clarity. Be sure to wipe your own hand off periodically to keep it clean. Do not overwipe the plate because a light, even tone is desirable for drypoint.

PRINTING THE DRYPOINT

To learn about the use of the press and printing, see the discussion of printing an etching on page 115. The important difference between printing an etching and printing a drypoint is that less pressure is used on a drypoint plate than on an etching or an engraving plate. The ink on a drypoint plate is primarily attached to the raised burr, while an etching or an engraving has many recessed lines and pitted or textured areas that require more pressure to print well. The felts for a drypoint should be soft and fluffy to give a good impression. German Etching and Arches paper are recommended for drypoint.

Line Engraving

Although it seems quite simple, requiring only a sharp burin and a metal plate to produce a line, engraving demands great control. As the burin is pushed into the plate, it removes the metal and creates a swelling, tapering, recessed line. The engraved line is unique, with a crisp, precise character and clean edges.

MATERIALS AND TOOLS

The main materials and tools for engraving are as follows:

Copper plate

Dutch mordant for biting

Burins of varying thickness (square- and diamond-shaped)

Multiple-tint tools

Wax crayon (black)

Sharpening jig for burins

Burin The basic engraving tool is the burin, a shaft of very hard steel, bent at the handle at about a 30-degree angle, which allows the pushing handle to clear the plate as the tool is pushed. In cross section the burin is square- or diamond-shaped and is sharpened at an angle of

The burin forces up a metal sliver or burr. The incised groove is sharp and clean and prints well in long editions.

about 40 degrees. The square shape is preferred for curved and swirling lines and the diamond shape for finer and deeper lines.

The burin should be kept very sharp. Polish its underside on a fine India or hard Arkansas stone, then sharpen its face in a jig made especially for this purpose. Use light oil, such as Pike oil, 3-in-1, or light machine oil, as a lubricant. Linseed oil is not suitable for sharpening tools as it will clog the pores of the stone.

Flat gravers and gouges Mainly used in wood engraving, gravers and gouges have limited use in copper or zinc. However, a creative person can experiment with them and produce interesting wavy or choppy lines and textures. Remember to remove any burr thrown up by these tools or the raised burr will catch and hold ink like a drypoint line.

Multiple-tint tools These tools can be used to create tones and textures. They should be sharpened to a keen edge for metal engraving. The very fine multiples (65 lines or more to the inch) will produce soft grays and blacks.

DRAWING ON THE PLATE

The freedom of drawing directly on the plate can be very appealing. The image will be reversed in printing, however, and may show some distortion. When drawing directly, you can use a wax crayon, a lithographic crayon, or a grease pencil. After completing the drawing, dip the copper plate in Dutch mordant for a few seconds. The surface of the plate will discolor slightly. Remove the plate from the acid and rinse it with cold water. The greasy lithographic or wax crayon will act as a resist and the acid will not affect the drawn areas. Remove the crayon with paint thinner, and the drawn lines will appear as shiny surfaces and act as a guide for the burin.

If you wish to avoid the reversal caused by direct drawing, make a drawing on tracing paper, flop it over on the plate, place typewriter carbon paper or white waxed carbon under it, and trace over the drawing. The carbon or wax deposit will act as a resist when you immerse the plate in acid, as described above.

The burr is very sharp and will cut your hand if not removed. Remove it as you engrave each line or group of lines. Use a very sharp scraper; a dull scraper will scratch the plate.

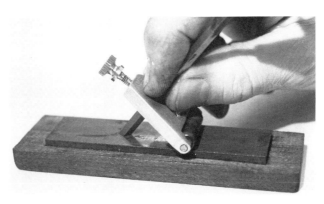

A sharpening jig is used to hold the burin at a constant angle.

Here a multiple-tint tool scratches a series of lines into a plate.

ENGRAVING THE LINE

The burin is held as shown in the photo. The thumb and the forefinger guide the tool, while the palm of the hand gives the basic forward thrust. It is important to remember that the plate is pushed into the tool as much as the tool is pushed into the plate. This technique reduces the possibility of slips and allows greater control of the line being engraved. When cutting long, sweeping curves, the hand that holds the tool actually moves very little; instead, the other hand pushes the plate into the tool.

You can turn the plate more easily when making curved or swirling lines if you put a few pieces of cardboard, taped together, under it. They should be smaller than the plate itself and serve as a pivot or swivel for turning the plate into the burin.

Start the line by raising the handle of the burin slightly until the point is driven into the metal. Then lower the handle until it is almost touching the plate. When you push the plate into the burin, a long sliver of metal will be forced out by the point of the tool. Be

SCRAPER

masking tape

careful to remove all burrs and raised points of metal with a very sharp scraper. They are hazardous because of their sharpness and, if not removed, will present a problem when you ink and wipe the plate. They are particularly sharp when the burin is taken out of the line suddenly. Make sure the scraper has a very keen edge, or it will scratch the plate and cause unpleasant gray streaks where you have used it. You must then remove these streaks with engraver's charcoal or a burnisher, which proves that dull tools will always cause trouble. Remember to use the scraper all over the plate. Check the plate thoroughly before printing to avoid cutting yourself.

Remember that you need many lines placed close together to form a dark tone. The engraved line is so precise and clean that it takes more lines than you can imagine to produce a gray value over any considerable area.

The characteristic swelled line of the engraving, which is thin at the beginning of the stroke and then swells to full strength as the tool bites more deeply, was highly regarded by artists of earlier years for several reasons. It is capable of yielding a wide variety of effects ranging from delicate to powerful. As a matter of fact, when etching started to supplant engraving, early etchers like Callot used a special tool called an echoppe to simulate the engraved line. By rotating this tool in their fingers, artists could start with a thin line and then increase the thickness as the line was drawn.

ECHOPPE

PRINTING THE ENGRAVING

Engraved plates are capable of producing large editions. Refer to the section on printing an etching on page 112 for general setup and procedures. The only difference to note in printing an engraving is that a stiffer ink is needed for an engraving because the crisp engraved line will not hold an oily ink so well. A smooth etching paper such as Rives BFK produces good printing results.

Criblé

A criblé print is made by hammering a variety of different-size punches into a metal plate to create dotted areas and patterns. Light-toned areas are produced by massing indentations together, and darker areas by sparse groupings.

Today it is quite rare to see a print that is made totally in the criblé method. Early criblé plates were relief-rolled and no doubt printed on a press. In contemporary work the punching and dotting can be combined with etching and engraving and printed in relief or intaglio.

If you want to experiment with criblé, use a practice plate first to try out a variety of different-size punches and see

MARIO AVATI
Night and Day, 1984
Color mezzotint, 14″ × 17″
Courtesy Newmark Gallery, New York

what kind of dotting you can effect. Keep the punches sharp and use a hammer to tap them into the plate. Print a few trial proofs in both the intaglio and relief methods to see which you prefer.

Mezzotint

Mezzotint is actually a drypoint method. As the mezzotint rocker digs into the surface of a plate, the sharp points of its serrated edge raise tiny burrs next to the pits they are making. Few contemporary artists, however, have the time to rock a plate long enough to produce the velvety black impression so characteristic of the best work. Rocking a plate can take hours because it must be rocked completely in one direction, then at right angles to the first direction, then in the diagonal directions, and finally in the directions between the diagonals (see the diagram of rocking angles). At least eight rockings are necessary over the complete surface of the plate. Needless to say, the plate should be copper, because zinc yields so many fewer impressions; after all the work of rocking, you will want an adequate edition.

When the plate is rocked to completion, it will print as a solid black. The image is then created by scraping and burnishing on the rough surface of the mezzotint. Special knife scrapers and

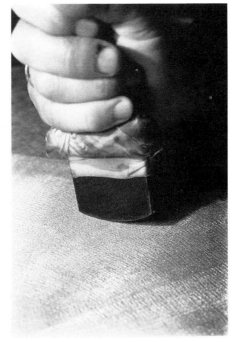

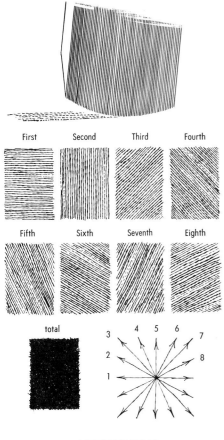

First Second Third Fourth

Fifth Sixth Seventh Eighth

total

MEZZOTINT CHART

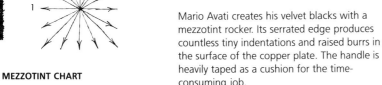

Mario Avati creates his velvet blacks with a mezzotint rocker. Its serrated edge produces countless tiny indentations and raised burrs in the surface of the copper plate. The handle is heavily taped as a cushion for the time-consuming job.

Herman Zaage burnishes whites and tones on the rocked mezzotint plate.

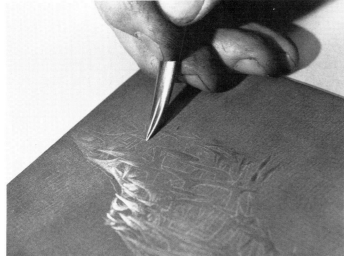

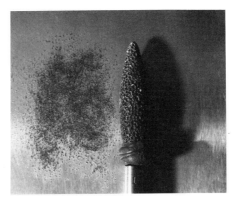

A regular roulette produces a more mechanical tone than an irregular tip. A number of patterns and sizes are available.

An irregular roulette with a carbide tip will roughen the plate surface into a deep black, if desired. The tone produced is close to a mezzotint black in effect.

fine burnishers are available that make very delicate work possible. The rich quality of the blacks should be exploited, though; it would be silly to scrape large areas of a mezzotint.

For particularly small details, it is necessary to work in dark lines and tones with the point of a needle or a roulette wheel. Very small rockers made for detail work are helpful in reworking areas that have been overscraped. Roulettes are made in various sizes and in a number of patterns and textures. The irregular roulette is good for matching the texture of the rocked plate. In England a rocking apparatus is used to guide the rocker as it moves across the plate, making the lines parallel and easy to control.

MOCK MEZZOTINT

A deeply bitten aquatint will approximate but not equal the dense, rich black of a mezzotint. By lightening areas with a burnisher and steel wool, you can approximate the effect of a mezzotint. Several artists have exploited this shortcut to good effect. When printing an aquatint worked in this manner, the ink should be oilier than usual, and the plate hand-wiped. Do not paper-wipe except for the highlights. Take as few proofs as possible during the working of the image. For a large edition, the copper plate can be steel-faced.

Correcting Errors

In nonacid techniques, changes in the image can be made by adding, removing, or otherwise altering parts of the design. It is rare that an artist will complete a plate without wishing that certain areas could be redone. A number of corrective measures are available to improve the drawing, strengthen the composition, or enrich the textures of the image.

SCRAPING, BURNISHING, AND POLISHING

It is almost inevitable that some lines or tones will need to be eliminated or reduced in value. The scraper, a three-sided wedge of hardened steel, is the tool

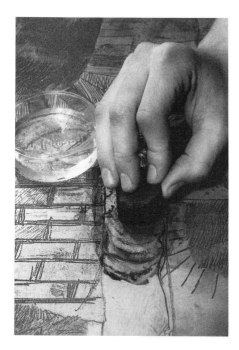

Minor scratches may be removed by polishing the plate with engraver's charcoal and water.

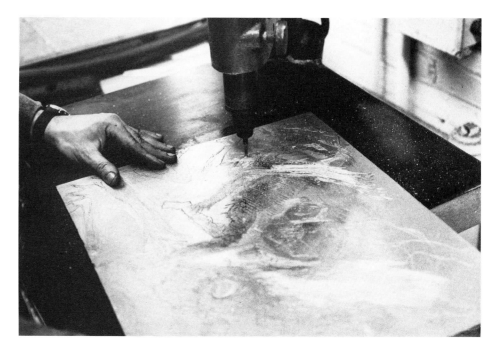

Al Blaustein uses a photoengraver's router to remove unwanted lines from a zinc plate at Pratt Institute in Brooklyn. The router is locked into position and the plate is tilted slightly to control the depth of cut.

usually chosen for this job. Scrapers come in many sizes and shapes and are virtually indispensable to the etcher. Some methods, such as the mezzotint, rely exclusively on the scraper for the development of the image, while almost all techniques have some need for this useful tool, which acts like an eraser.

When working over a large area, use enough pressure and keep changing the angle of cut so that you do not build up ridges or "drifts"—minute corrugations in the surface of the plate. A dull tool will add scratches instead of removing them, so keep the scraper sharp on a fine India or hard Arkansas stone. You can wrap the steel shaft with masking tape to protect your fingers. The edges do the cutting, and there are usually three edges to each tool, allowing you to remove a lot of metal in a short time. You must scrape over an area and not just along a thin line, or the scraped indentation will print as a gray smudge.

After you finish scraping, you have to smooth the surface of the plate further using sandpaper, 400 grit or finer. This surface will also print as a smoky gray tone and must be burnished and charcoaled to a smooth polish. You may find

it necessary to use jeweler's rouge for the final polishing if you want a brilliant white. Engraver's charcoal, made from hard maple, is usually used with water to increase its efficiency. A few drops sprinkled on the area to be polished will be sufficient. Without water, charcoal does not cut so well.

REPOUSSAGE

If the plate has been scraped to such an extent that the surface is simply too low to print properly, it may be necessary to force the metal back to the original level from the back of the plate. This raising, called repoussage, can be done in several ways.

On the back of the plate, outline in crayon or chalk the area to be raised, using two pieces of wood fastened together as a caliper. Place the plate, face down, on a smooth metal sheet. With a ball-peen hammer, tap the back of the plate, with either the rounded or the flat part of the hammer, gently at first, to force the metal up to the level of the printing surface. Then sand and polish the surface until it is smooth and even.

As an alternative to repoussage, you can glue paper shims on the back of the plate, in position, under the scraped area. Run the plate and shims through the etching press several times, using enough pressure to force the metal up to the required level. In fact, regardless of the method you use to raise the metal, it is a good idea to glue paper shims on the back of the plate to prevent the scraped area from being pushed down again by repeated printings under strong pressure.

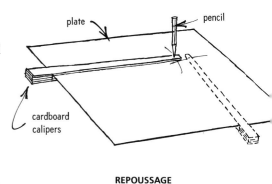

REPOUSSAGE

ACID TECHNIQUES

The process of putting an acid-resistant material smoothly over a metal plate is called grounding a plate. When the ground is dry, it can be scratched or drawn into with needles and other tools to expose the metal. Placing the worked plate into an acid bath then etches or bites these lines into the plate. The ground is removed, and the plate is then inked, wiped, and printed on an etching press to complete the making of an etching, a technique that has intrigued and challenged artists for more than four hundred years.

It is possible to complete a plate using one etching technique only, such as line etching, soft ground, or aquatint, but it is fairly common to mix methods and techniques on the same plate. Each technique has its own characteristics, and these strengths can be exploited to contribute to the image's success.

Materials for Etching

Although certain methods of intaglio platemaking do not require acid (such as drypoint, engraving, and mezzotint), there are many others that do require a mordant etch in order to put the image on the plate. The copper, zinc, and other metal plates are similar in both acid and nonacid techniques.

ETCHING GROUNDS

The acid-resistant covering that protects the plate is called the ground. There are many formulas for making grounds, but only those that use chemicals available today will be discussed. Some exotic chemicals of past ages are difficult to obtain; there is little advantage in knowing a formula that specifies the use of "rosin of Tyre" if you can't find it.

Liquid hard ground The most commonly used ground is a liquid ground, which is painted on the plate with a wide, flat, soft brush. Although several companies manufacture liquid ground (both Graphic Chemical and LeFranc are acceptable choices), it is easy to make a large batch yourself and then bottle it for future use. The ingredients, which are easy to obtain, are mixed in the following proportions.

2 parts asphaltum
2 parts beeswax
1 part rosin (powdered)

These ingredients are dissolved in paint thinner or benzine of low volatility. Although heating hastens the process, it creates a penetrating odor that requires excellent ventilation; moreover, the hot ground is quite flammable, making it prudent to use the slower but safer method, without heat.

Because rosin is the hardest ingredient and the slowest to dissolve, it is placed in the benzine or paint thinner first and allowed to dissolve, with occasional stirring. The beeswax is added next, along with more paint thinner. Asphaltum most often comes in a liquid state and is therefore added last to the mixture of rosin and wax. The usual procedure is to make the ground somewhat thicker than required and then to add solvent to each batch as you use it. Good ground will take an amazing amount of solvent without becoming too thin.

Apply the ground with a flat, soft, wide brush. Camel hair and squirrel hair are good. A Japanese hake brush made of sheep's wool will work, but the hairs frequently come out and must be removed from the ground. Push the tip of the brush into the hair to pick it up, then wipe the hair off on a scrap of paper. If there are still a few minor brushmarks in the ground, put it on a warm hotplate for several seconds while it is still wet to distribute the ground and speed the drying process.

Several commercial grounds are made with ether or chloroform as a solvent. They dry very quickly and are not brushed on but poured over the tilted plate. The plate is then twirled or spun in order to spread the ground rapidly over the entire surface. It takes only a few seconds to cover the plate. When these grounds are dry, they are very slick and hard and can be handled quite a bit without being damaged. Such a ground can be used as a stop-out varnish, covering areas you don't want to bite, because it dries so quickly. It tends to feather or bleed, however, and must be handled carefully. Moreover, the cost of commercial ground is very high, and most artists find that making their own ground is much cheaper.

Asphaltum thinned with paint thinner or mineral spirits can be used as the ground if the work to be done doesn't have fine lines. It will flake off if it is too thin and is no substitute for a good liquid ground. However, mixed with gum turpentine, asphaltum makes a workable ground and is excellent for very long, deep biting and for covering areas when cutting through a plate.

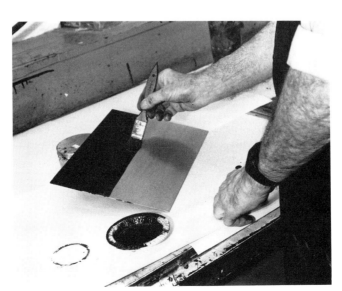

Liquid ground should be flowed onto the plate with a wide soft brush. At Universal Limited Art Editions Craig Zammiello has achieved excellent results with Senefelder's asphaltum thinned with gum turpentine.

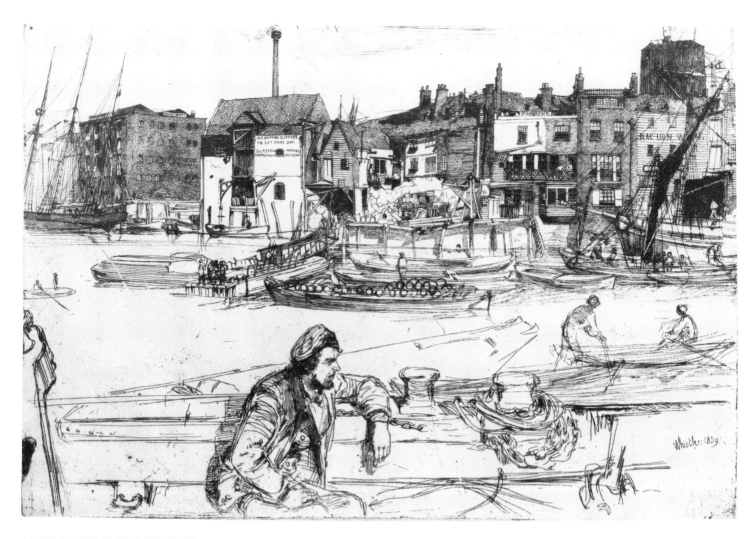

JAMES ABBOTT McNEILL WHISTLER
Black Lion Wharf, **1859**
Etching, 6″ × 8⅞″
National Gallery of Art, Washington, D.C.
Rosenwald Collection

Hard ball ground This is more difficult to make than liquid hard ground because it must be heated to melt the ingredients together. The ingredients are the same as for liquid hard ground, but no solvent is used. Several companies sell good hard ground (called ball ground because it looks like a dark ball about the size of a golf ball), so you can buy it quite easily. Weber, Cronite, and Graphic Chemical all offer hard ground at reasonable prices. LeFranc is a bit more expensive but is very good.

The etching plate must be heated on an electric or gas hotplate so that the ground melts enough to spread easily. Do not overheat it or the wax will bubble, smoke, and burn. After melting the ground, you can then roll it over the warm plate into a smooth, even, trans-parent coat. The roller can be of hard rubber if the plate is not allowed to become too hot. A linoleum roller is especially handy but hard to find. Leather rollers are still available from Rembrandt Graphic Arts but are expensive. Soft-rubber or gelatin rollers should not be used to spread hard grounds because they will melt or be deformed by the heat.

We have seen dabbers used so skillfully to apply a ball ground that the wax appeared to be absolutely even over the entire plate. The plate should be warmed just enough to melt the ground, then rapidly worked over with short, dabbing strokes. A dabber can easily be made from a piece of umbrella cloth or fine silk, some cotton, and a 3-inch disk cut from two or three pieces of cardboard. Soft glove leather or chamois makes an excellent cover for a dabber. Keep different dabbers for hard and soft grounds. Soft ground will contaminate the dabber with petroleum jelly or tallow and leave soft spots in the next hard ground you use it on.

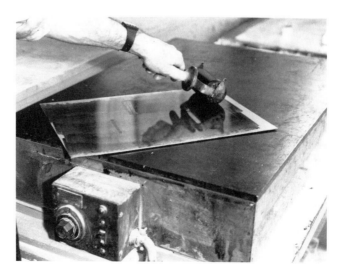

To apply a hard ball ground, the plate should be heated on a hotplate until the ground melts and can be spread evenly with a hard roller. The roller here is made of hard linoleum. Hard rubber may be used if the plate is not too hot. Soft rubber and gelatin are not suitable for this work.

Janes ground A very hard, thin, durable liquid ground called Janes ground is made by the Cronite Company in New Jersey. While the plate is held nearly vertical, the ground is poured on and allowed to flow over the plate until it leaves an even coat. This should be done in a stainless steel or shallow glass pan so that the run-off ground can be poured back into the can. Do not use a plastic tray because the ground will dissolve it. Janes ground is well worth its high cost because, when dry, it will withstand considerable rough use. It is particularly receptive to the transfer of a pencil or charcoal drawing. Simply place the drawing face down on the grounded plate and run it through an etching press with somewhat less pressure than for normal printing.

Staging-ink ground A good, hard, tough ground called staging ink, a commercially prepared compound sold by photo-engraver's supply houses like Harold Pitman, is useful for long bites. It is brushed evenly over the plate, then heated to about 250° or 350°F over an electric hotplate. It can be removed with mineral spirits.

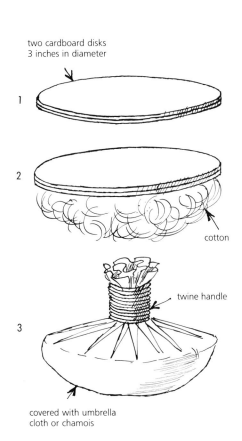

two cardboard disks
3 inches in diameter

1

2

cotton

twine handle

3

covered with umbrella
cloth or chamois

MAKING A DABBER

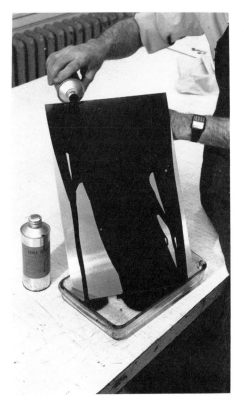

Hard grounds such as Janes ground can be poured. Here a tray catches excess ground, which will be returned to the can.

Smoking a hard ground Since the color of most grounds is close to that of copper, it is not easy to see what you have drawn. When using a hard ground, occasionally it is helpful to smoke the plate and transfer your drawing onto the blackened plate so that you can see the drawing better and see the lines as you open them with the needle.

The traditional method of blackening a plate is to smoke it with the carbon deposit from a candle or taper. The plate must be warmed to soften the ground so that the carbon will color it completely and not simply remain on the surface. Use a small hand vise to grip the edge of the plate, cushioning the jaws of the vise with a few pieces of cardboard to prevent scratching. Warm the plate over a hotplate or a gas burner, but don't let the ground bubble or smoke. Light a taper or candle that will smoke and pass the candle under the plate, grounded side to the flame. You may use a wick and a glass jar containing kerosene, grease, or petroleum jelly. Move the flame constantly, and don't touch the ground with the wick. The carbon deposited on the ground should fuse with it and form a solid black coat that will not rub off. Your needle will now make lines that are plainly visible.

Here an overhead rack made from wire coat hangers supports the plate while it is smoked. The rack is hung from the ceiling on wires.

Liquid soft ground A soft ground, even when dry, remains soft and sensitive to pressure. Different textures can be impressed into it, and these textures are then bitten by the acid into the plate. You make soft ground by adding petroleum jelly to liquid hard ground and mixing it thoroughly in the following proportions:

1 part petroleum jelly
3 parts hard ground by volume (depending on the softness desired)

Other materials, such as tallow or lard, can be mixed with hard ground. In such recipes you should add more of the soft

A card is used to draw into a soft ground. Where the edge touches the plate, it picks off the ground, and these lines may be bitten in the acid.

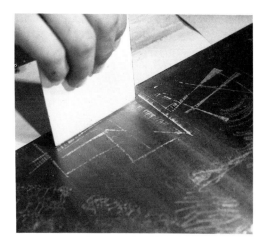

Dissolve the rosin in the alcohol and add dye for the desired color.

When it is necessary to bite the plate very deeply, you can protect unbitten areas of the plate by covering them with Contact paper, which is actually made of plastic, not paper, and has an adhesive backing. The plastic resists the acid. Adhere it firmly to the plate by burnishing the edges or running the Contact-covered plate through the press.

ACIDS

The acid biting the metal plate creates the image. Familiarity with how the acids work and which are best to use for specific metals is essential to making etchings.

When diluting acids, always put the water into the container first, then add the acid. Use a glass measuring cup and work slowly and carefully. Never leave an acid where it can accidentally be knocked over. Put it away in a locked cabinet when you are not using it.

It is advisable to keep a solution of ammonia and water handy, in case acid is splashed on clothing, to neutralize the action of the acid with the base. Because a drop of acid will eat a hole in clothing very rapidly, work aprons or old clothes are essential in the shop.

material to the liquid ground, up to equal volumes of each. Petroleum jelly, however, is easier to obtain, and its composition is more dependable than either tallow or lard.

Soft ground should be applied with a wide, smooth brush in a very thin, even film. The sensitivity of the ground changes as it thickens, and an irregular ground will give uncertain textures.

Paste soft ground The paste soft ground made by LeFranc is excellent, and the one by Weber is quite good; both are very easy to apply. Heat the plate moderately, dab a few spots of paste onto the plate, and roll it out to a thin, even film with a moderately soft roller. Do not use a plastic or gelatin roller on the warm plate, because the heat will damage the roller.

Stop-out varnish Any acid-resistant compound that dries quickly can be used as a coating on areas where you don't want biting to occur in the acid solution. Quick-drying ether- or chloroform-based grounds can be used. Hard ground is always handy and, when the length of drying time is not an important factor, makes a suitable stop-out, except it tends to feather at the edge. Asphaltum is frequently used, since it is kept in every etcher's shop. Commercial stop-out varnish is usually alcohol-based, with rosin and coloring dissolved in it. You can make your own stop-out with this recipe:

1 part powdered rosin

3 parts alcohol

Small quantity of alcohol-based dye for color such as Dr. Martin's

Nitric acid One of the most useful acids is nitric, which will etch either zinc or copper. When purchased in a technical grade, it is very strong and quite dangerous and should be handled with care (see the health hazards chapter), but it is not necessary to buy chemically pure nitric acid for etching. The acid is mixed with water to various dilutions. The stronger solutions, such as 4 parts water to 1 part nitric, are usually used for deep biting or strong line work; the weak solutions, such as 8 or 12 parts water to 1 part nitric, are usually used for aquatints and fine lines.

Zinc plates release white bubbles of hydrogen gas in nitric acid, indicating the strength of the acid. Intense bubbling shows a fresh, strong acid, and faint bub-

bling results from weak or exhausted acid. When deep biting a plate in strong acid, check it periodically for excessive bubbling, because the action may heat the acid and plate. Heat causes the acid to bite faster and, if untended, may release nitrogen dioxide into the air. The gas may be orange or colorless, and a heavy exposure can cause pulmonary edema.

Because of the heat generated as the acid removes large quantities of metal, it is wise to place a tray of cold water alongside the acid tray. When the plate becomes too warm, slide it into the water for a minute or two to cool it. If the plate gets too warm, the ground will become soft, and as the biting increases in vigor with the heat, the whole process may escalate out of control, ruining the plate by false biting and unwanted corrosion. If the acid heats too much, add sodium bicarbonate to neutralize the reaction, then quickly remove the plate.

Nitric acid quickly loses its strength during deep biting of large areas, and the solution must be replenished frequently. Provide plenty of ventilation for this procedure because the fumes are noxious. Ideally the area should have local exhaust ventilation with an outside vent. The fumes are also corrosive and will cause most metal nearby to rust unless lacquered or otherwise protected.

Plates from photoengraver's supply houses are usually back-coated to protect

WILLIAM BAILEY
Untitled, **1987**
Etching and aquatint, 11″ × 14″
Courtesy Parasol Press, New York

GABOR PETERDI
Wetland in the Forest, **1984**
Intaglio with drypoint, 29″ × 39½″
Courtesy Jane Haslem Gallery, Washington, D.C.

the reverse side. Scratches and nicks are common, however, and if not protected will soon become very deep and, in rare cases, bite through the plate. Check the backs of plates being bitten deeply, and retouch scratches with asphaltum or stop-out varnish.

Nitric acid biting into zinc produces a ragged, irregular line if the plate is left too long in the acid. Nitric acid that has been used to etch copper will turn greenish. This mixture should not be used with zinc because it will cause false biting in the etching ground or lift the ground off the plate.

Dutch mordant This acid, used for copper plates, is favored by artists who want even, close tones and no accidental effects or textures. It bites slowly and is wonderful for fine lines and aquatints since the depth of the bite is easy to control. Because no bubbles are produced, careful observation of the solution's action is necessary. To see the biting, you can add a small amount of nitric acid to the mordant; bubbles will form, allowing you to check the progress of the etch.

To make your own Dutch mordant, use the following standard formula:

10 percent hydrochloric acid
2 percent potassium chlorate
88 percent water

A slotted piece of wood is used to hold a copper plate upside down in ferric chloride in order to allow the sediment to fall in the acid bath.

A Baumé hydrometer is about to be placed in a ferric chloride solution to be tested. The hydrometer works simply: it floats in the solution and the top of the liquid marks a number on the gauge, indicating the specific gravity of the solution and thus its density.

Dissolve the potassium chlorate in warm water first, then add the hydrochloric acid. A stronger formula can be made by doubling the hydrochloric acid and potassium chlorate.

Precautions, such as mixing under an exhaust fan, must be taken when combining the acid with potassium chlorate. Chlorine gas is created when the solutions first mix and must be vented for about 10 minutes.

Be sure to label all your acid solutions clearly. The mordant turns greenish-blue after its first use and is easy to identify, but it should be labeled as a matter of policy and good housekeeping.

Ferric chloride Long used by commercial photoengravers, ferric chloride (iron perchloride) is able to bite copper plates with precision and is useful for fine work and aquatints. This acid, which bites very slowly, produces only small amounts of gas when it etches and is not very harmful to the skin.

Plates should be turned face down in ferric chloride solution to allow precipitate to fall out of the lines, where it would eventually clog if left to accumulate. The plates should be shimmed up on wax balls or wooden legs to allow the acid to circulate. This method prevents visual observation while the plate is biting and mandates an accurate timing procedure, which some artists dislike.

The plate can be etched face up if 10 percent hydrochloric acid is mixed with the ferric chloride. Some sediment may still form, so check the plate as it is bitten. A timing chart should be made that lists the number of minutes that it takes to etch lines and tones of different desired depths.

Ferric chloride is normally sold as a saturated solution with a Baumé of 45°. The Baumé, or specific gravity, can be measured with a Baumé hydrometer. Ferric chloride as an undiluted liquid is a viscous solution that will etch slowly. The strongest solution possible, about 35° Baumé, is made by adding an equal part of water to the acid. This mixture is stronger because the water frees the acid so it can react faster, but further dilution weakens the acid.

Aluminum etch While aluminum is too soft for general work, it is cheaper than zinc or copper, and some beginning stu-

dents may find it useful for experimenting with elementary techniques. An acid to etch aluminum can be made by mixing the following chemicals into 10 parts warm water: 1 part potassium dichlorate, 1 part sulfuric acid, and 1½ parts hydrochloric acid. All these chemicals are mixed by weight, not volume.

Acid trays For plates up to 30 by 24 inches, it is possible to buy white plastic photo trays such as Cescolite or Jax trays that successfully resist acids. These trays are readily available and are not expensive. Black rubber photo trays can also be used, but they disintegrate in time and are not as durable as the white plastic. Stainless steel trays are best of all because they are strong and unbreakable, but they are also quite expensive. Moreover, hydrochloric acid, Dutch mordant, and ferric chloride will eventually corrode stainless steel. For larger plates you may have to order custom-made plastic trays from a photo-supply house. Note that lacquer thinner dissolves some photo trays, so be sure to test the tray first in order to avoid softening the surface when you use this solvent.

It is easy to make trays from pieces of 1-by-4-inch pine, with a bottom of ¼-inch plywood or hardboard. Although you can waterproof this type of tray with tapes and varnishes, the easiest way to make it usable is to line the inside of the tray with vinyl or plastic sheeting, fold it over the sides, and staple it to the outside of the frame. This lining makes the tray suitable for water and all acids, and you can construct any size you want quickly and cheaply. The plastic sheeting must be replaced frequently, as it tends to de-

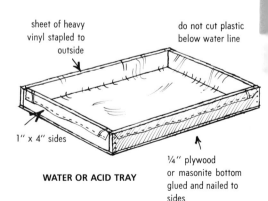

sheet of heavy vinyl stapled to outside

do not cut plastic below water line

1″ x 4″ sides

WATER OR ACID TRAY

¼″ plywood or masonite bottom glued and nailed to sides

By squeezing the bulb, you can induce fluids to flow from the large storage container to the smaller can. This type of siphon is useful for draining acid trays and transferring liquids without spillage.

velop pinholes and tears, particularly if the plates have sharp edges, but you will find this type of tray easy to maintain and inexpensive.

Emptying acid trays The most convenient way to drain acid from a tray is from a spigot built into the bottom. This type of tray is very expensive, however, and not all artists can afford it. A useful substitute is a hand-pumped siphon that operates on gravity once the siphoning process is started. There are siphons available from automobile-accessory stores that are designed to siphon gasoline and similar fluids. They are made from a white plastic that is acid-proof and have plastic hoses ¼ inch in diameter. They will drain a gallon of liquid in about 3 minutes, which is the major disadvantage of the method. The time may seem excessively long when you are cleaning up the workshop, but because there is no danger of spilling the acid, the wait is worthwhile. The siphon can also be used to transfer paint thinner, lacquer thinner, and other fluids from one container to another.

Small quantities of acid can be poured into a funnel set in the mouth of a container. Plastic containers are useful

but occasionally develop leaks; glass bottles are breakable but never leak. Acid bottles should have plastic caps or ground-glass stoppers. Metal caps soon corrode from the fumes in the bottle.

Biting the plate Plates should be eased into the acid bath to prevent splashing or spilling the solution. A hooked dental tool makes a convenient implement for holding the plate as it is immersed in the acid—ask your dentist for old tools. Be careful not to scratch the ground. Examine the plate after a few minutes to see if the lines are all biting correctly. A false bite may occur in a section of plate where the ground has been bruised or damaged. Remove the plate promptly and cover the offending areas with a commercial stop-out varnish, rosin dissolved in alcohol, shellac, or even liquid hard ground.

If the acid is nitric, gas bubbles will form in the lines. They can be removed by lifting one edge of the plate out of the acid with a hook and letting all the acid drain off the surface. Then replace the plate in the solution. Bubbles should be removed regularly to prevent an irregular, ragged line, unless this effect is desired. The traditional turkey feather is still used to remove bubbles, and as long as it does not scratch the ground, it is a helpful tool, though somewhat inefficient. With soft grounds, it is not possible to brush the plate with anything because of the danger of scratching. These plates must be lifted and drained.

Drawing on the immersed plate If certain lines are not biting properly, it is possible to work on the plate while it is still in the acid bath. Francis Seymour

Haden (1818–1910), a nineteenth-century English etcher, frequently worked on his plates while they were still in the acid. Good needles will corrode rapidly, but resharpened dental tools work admirably for this process because they are stainless steel. Remember, however, that the longer the lines bite, the deeper and darker they get. This means that all delicate work should be done last and heavier lines should be needled in as soon as possible.

Line Etching

The artist who relies on fluent drawing to realize his or her images will find that the etched line offers tremendous advantages over a line drawn with pen and ink. While a pen may occasionally run dry, the etching needle needs no ink to complete its stroke. The needle will not sputter or drip if it is twisted or if its direction is changed suddenly.

An etched line can vary from the faintest scratch to a deep black stroke ⅛ inch wide. The thickness of a line can be increased while you are drawing by using a needle with a wider point or by leaving the plate in the acid for a longer period of time. Even wider lines can be obtained by using multiple strokes or by the lift-ground process.

It is easy to draw through a wax ground with a needle—so easy, in fact, that this process is normally the first one learned when an artist studies the intaglio technique. It is more difficult to control a drypoint line and far more difficult

The plate should be eased into the acid tray and then lifted on end every minute or so in order to remove gas bubbles. Do not brush a soft ground to remove bubbles.

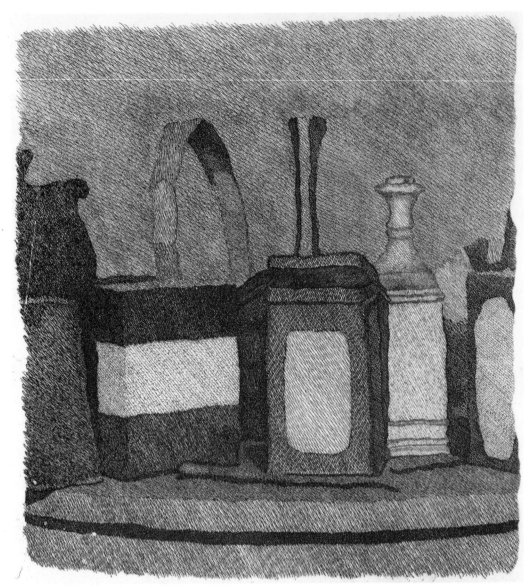

Soft-Ground Techniques

The traditional use of soft ground is to replicate the quality of a soft pencil line. This is done by drawing through a thin sheet of tracing paper, such as a thin pastel or watercolor paper, onto a plate that has been covered with soft ground. Because the ground remains sensitive to the touch even after it is dry, the plate must be handled with care. Even a fingerprint will be bitten, and other slight scratches and bruises will show. Make a bridge from a piece of thin plywood, as shown, to keep your hand away from the surface as you draw.

If you use a hard pencil or ballpoint pen, the line will be relatively thin, but if you use a blunt stick or the curved end of a burnisher, the line will be fairly wide. As you draw, the textured surface of the paper will pick up the soft ground from the plate. The line will have the characteristic pebbly texture of the paper after the plate has been bitten in the acid. You can tape your sketch, drawn on thin tracing paper, to the table in position over the grounded plate, and slip various papers in different textures between the sketch and the plate to get a variety of textures in the line.

After completing the drawing, lift the plate carefully and place it in the acid. Keep other plates free of the soft-ground plate to avoid marks. Allow the plate to remain a little longer than a hard-ground plate, since some residue of soft ground

to achieve success with line engraving. A variety of tools can be used to draw through the ground. Almost anything that can scratch through the ground will suffice as an etching needle.

Creating a dark area with lines only requires that many lines be placed close together, usually crosshatched and often bitten in the acid in several applications of crosshatching. (Rembrandt used this process with power and sensitivity to obtain his rich darks and tonal effects.) If lines that are closely spaced are left too long in the acid, they fuse together and eventually lose their individual character. Dense blacks are achieved only through the multiple biting of many crosshatchings, with each series of lines bitten properly.

To make a line etching:

1 Prepare the zinc or copper plate by cleaning it thoroughly to remove grease and other dirt (see the discussion of degreasing the plate on page 81).

2 Place the ground over the surface of the plate by brushing on a liquid ground or rolling a ball ground over the warmed plate to get an even film. Let it dry.

3 If you choose to use a prepared drawing, transfer it onto the plate using carbon paper or chalk.

4 Draw through the ground using a needle or another sharp point.

5 Etch the plate in acid (nitric acid for zinc; ferric chloride, nitric acid, or Dutch mordant for copper). Time your line from just a few minutes for a fine line to 15 or 20 minutes for a heavier line when biting zinc. Copper bites more slowly and will require a longer biting time.

6 Remove the ground with a solvent. The plate is now ready for inking, wiping, and printing.

Frequently an etching will need certain lines strengthened and intensified. Instead of regrounding and rebiting the plate to correct a few lines, you can use a burin to engrave the lines a little deeper. Remember, however, that an engraved line will print as a very sharp black and may stand out from its etched neighbors with noticeable strength. Be discreet in your use of this technique.

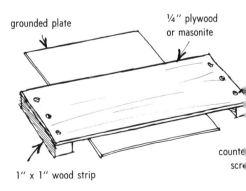

grounded plate

¼" plywood or masonite

1" x 1" wood strip

counte
scr

BRIDGE FOR SOFT GROUND

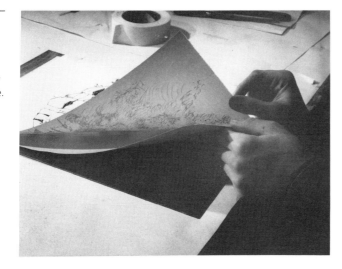

The line quality of a soft ground can be controlled by placing a textural paper under your drawing next to the plate.

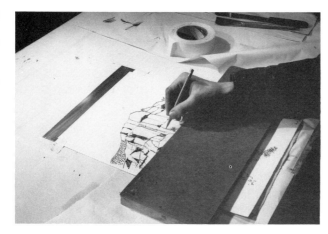

When using a soft ground, it is wise to employ a "bridge" to raise your hand away from the sensitive surface. Draw with heavy pressure to make sure that the paper presses into the ground, then remove the paper.

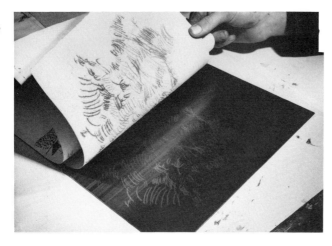

Check that the textured paper has been forced through to the soft ground, exposing the metal. Varying the pressure gives different weights to the lines. Increasing the length of the bite in the acid also darkens the lines.

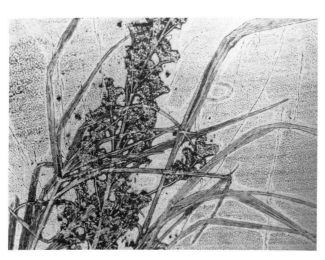

Grasses and plants can be impressed into a soft-ground plate. The impression of vegetation here was run through an etching press with less pressure than required to print an etching. The texture and creases in the background are from the wax paper used to protect the blankets from the ground. (Wax paper is used because it is not very absorbent.) A soft-ground plate should be bitten soon after the ground is applied because it can be easily damaged.

often acts as a resist even where the line has been drawn.

For a free, more contemporary use of soft grounds, you can place fabrics, crushed tin foil, or similar materials on the plate in the desired position on the soft ground. Place a piece of very smooth, nonabsorbent tracing paper or wax paper on top of the material with a sheet of newspaper over all this to protect your blankets from the soft ground, which may be forced through the porous fabric. Run the plate through the press with somewhat less pressure than that used for printing. You can use corduroy, burlap, denim, lace, linen, and other fabrics, as well as paper, cardboard, gasket material, cork, string, and other found items as long as they are not too thick and can be safely run through the press. You can also press any object into the ground to make an impression without running it through the press. If you don't want certain areas to bite, stop them out with ground or asphaltum before you immerse the plate in the acid.

It is possible to use the point of a needle in the same way as on a hard ground. The line will be sharp and clean after biting. In fact, soft ground is very useful when you are reworking a plate that has already been bitten. It clings to the irregularities of the etched plate better than the normal hard ground and prevents foul biting around the edges of deeply bitten lines.

The longer you let a soft ground sit after you have applied it, the less sensitive it becomes. If you want maximum receptivity to textures, you should use the ground immediately after it has dried, but allow some time for it to set (depending on the heat or humidity of the workshop) before placing the plate in the acid.

Textured fabric may be pressed into a soft-ground plate with a hard-rubber roller.

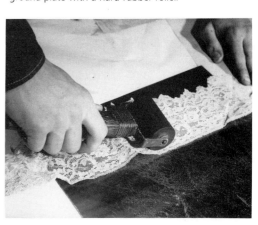

Aquatint

The process of aquatint should be mastered by every printmaker who intends to do serious work in etching. The wide variety of grays, ranging from delicate, light washes to rich, deep blacks are indispensable to the artist who wants tonality in his or her work.

The principle of aquatint is simple. Tiny droplets or particles of acid-resistant material are dusted or sprayed over a degreased zinc or copper plate. The material should cover about 50 percent of the surface, and if it is rosin, the plate must be heated to bind the rosin to the plate. The plate is placed in a weak solution of nitric acid, the usual proportions ranging from 1 part nitric acid in 8 parts water to 1 part acid in 12 parts water. The design is put on the plate by masking those parts that are to appear white with an acid-resistant ground or stop-out. The acid attacks the unprotected portions of the plate, creating little pits, but not the tiny spots that are covered by the droplets. The darkness of the

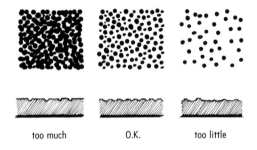

too much O.K. too little

AQUATINT COVERAGE

tone is increased by leaving the plate in the acid solution for longer periods, deepening the pits, which can then hold more ink and create darker tones when printed.

MATERIALS

The special materials needed for aquatint include:

Rosin (lump or powdered)

Dust box

Dust bags (made from nylon stockings or other fine mesh)

Hotplate

Liquid detergent

Corn syrup

Sugar or honey

Spray enamel paint

India ink

Gum arabic (liquid)

Gamboge (a yellow watercolor)

ROSIN DUST-BAG METHOD

Finely ground rosin can be dusted over the plate from a small cloth bag that is shaken or tapped from a short distance above the plate. You should do this in a draft-free place and practice until you can apply a fairly even dusting of rosin to the plate. The bags can be made from several layers of fine nylon stockings or fine broadcloth. The fineness of the cloth and the number of layers determine the size of the rosin particles that slip through. You should be able to control the quantities of rosin powder by flicking the bag with your fingers.

The fineness of the powder will affect

the texture of the aquatint tone. If the powder is coarse, the larger particles of rosin will cause larger white dots to appear in the finished print. If you want a coarse tone, you may have to crush lump rosin with mortar and pestle to the right consistency, because prepared powdered rosin is always ground to a very fine powder. For a wide latitude of textures in the tones, it is helpful to have several bags of rosin of varying degrees of coarseness at hand.

Rosin dust is an allergen and can induce an allergic reaction in those people who are sensitive to it. A dust mask that is rated for toxic particles is highly recommended.

ROSIN DUST-BOX METHOD

The best control over an aquatint tone is obtained with a dust box, in which a cloud of rosin dust settles evenly over the plate. The box can be constructed in several ways but has a ledge or open shelf near the bottom upon which to place the plate. The cloud of rosin is raised with a hand bellows or a motor-driven fan. The plate is not placed on the shelf immediately, but only after the heavier particles of rosin have settled. The finer particles float longer and drop more slowly to the bottom of the box. This process allows great control over the evenness of the tone. (A piece of cardboard or stiff paper several inches larger than your plate can be placed under it on the shelf to eliminate airstream tones that occur if the plate is placed directly on the shelf rods.)

ERIC FISCHL
Year of the Drowned Dog, **1983**
Six color etchings, soft-ground, aquatint, drypoint, and scraping, 23″ × 70¾″
Courtesy Peter Blum Editions, New York

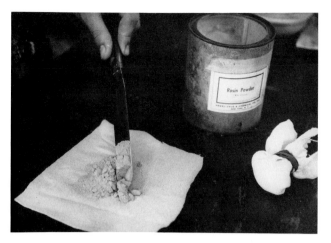

To make an aquatint bag, place a few spoonfuls of rosin powder on a square of porous cloth. Fold up the corners of the cloth square and tie it with string or a rubber band. Different degrees of coarseness can be kept in separate bags. A coarser grind requires a coarser mesh fabric.

This homemade aquatint box is made out of a corrugated carton. Harold Altman is holding the rubber bulb used to agitate the rosin.

Flick the aquatint bag with your finger to force the powder through the mesh of the cloth. Experiment in a place free of drafts or sudden breezes. An even misting of rosin powder is essential.

This rosin box at the San Francisco Art Institute is agitated by pivoting it on an axis.

The easiest way to blow the rosin dust into the chamber is to use a vacuum cleaner set in reverse in order to blow the air out. Set the nozzle into a hole in the bottom of the aquatint box for the best results.

Another method for agitating the rosin powder is to revolve the entire box on a pivot, placing the plate on its shelf when the larger pieces of rosin have settled. The disadvantage of this method is that the large plates in use today make the revolving box a very cumbersome affair. A simpler solution would seem to be the bellows or motor-operated box.

Remember that rosin dust can be explosive. Eliminate any possibility of sparks in the construction of your dust box. If you have a revolving brush as the means of creating the dust cloud inside the box use brass or bronze bushings, which will not cause sparks.

All rosin-dust aquatints must be adhered to the plate by heating. A hotplate that can reach a temperature hot enough to melt rosin (300° to 350°F) must be used. Electric heat is safer than a gas flame, but either type will work.

Place the rosin-dusted plate carefully on the hotplate. The fine particles are very sensitive to air currents. Be sure your fingertips do not touch the particles. Constantly turn the plate while it is on the hotplate to allow the rosin to adhere evenly and to prevent hot spots where the rosin may liquefy into a solid layer. Turning the plate during heating is easier if you fold 3-by-5-inch index cards in half and use them as handles. Another way is to place a large sheet of newspaper between the hotplate and the plate and move the plate by manipulating the newspaper. Heat-proof gloves and index cards are best for large plates.

By viewing the plate from the edge, you can see the rosin turn from a light yellowish white powder to a transparent color when it is hot enough to adhere. If the rosin powder does not adhere firmly to the plate, it will float off when placed in the acid and the tone will be spoiled.

Hotplate In general, ink at room temperature, if wiped when fresh and not left to dry out, will yield good prints, particularly from plates that are normally bitten and not worn. However, plates that need very rich and full printing can

Here Herman Zaage at the New School in New York City is placing a plate on cardboard inside an aquatint box after the rosin has been agitated. The cardboard will prevent a slight shift in air pressure from the plate, which would make the edges accept less rosin.

Custom-made hotplate built on level with tabletop at Indiana University.

The rosin particles darken to an amber color when they are hot enough to fuse the plate. Heat the plate just enough to cause the rosin to adhere to it. With too much heat the rosin melts into an impervious coat that the acid cannot penetrate evenly.

be warmed to bring out their best characteristics, making the hotplate essential in the etcher's studio, not just for fusing rosin aquatints.

The following problems may arise from use of the hotplate:

1 If the plate is overheated, it may bake the ink into the finer lines, causing them to print faintly.

2 Large plates sometimes buckle when heated. To prevent this, place the plate on the heating surface while both are

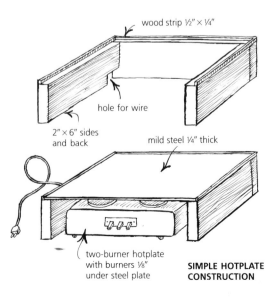

wood strip ½" × ¼"

hole for wire

2" × 6" sides and back

mild steel ¼" thick

two-burner hotplate with burners ⅛" under steel plate

SIMPLE HOTPLATE CONSTRUCTION

still cool and bring the heat up so that both warm up together.

3 If the plate is printed when it is too hot, it may dry the paper somewhat and create spotty effects. The heat dries the paper quickly, in any case, so that it is difficult to register the second plates in multiple-plate color printing.

Nevertheless, slight warming does enrich a weak plate and enhance tonality. Learn to be judicious in your use of the hotplate. It certainly is necessary in a cold workshop.

The best hotplates are made commercially, usually for restaurant kitchens where quantity frying is done, but they are very expensive unless purchased from a dealer in used kitchen equipment. A good hotplate can be made from a two-burner electric heater of excellent quality. Arrange a piece of ¼-inch steel plate on a frame of wood or angle iron so that the electric heater can slide underneath and almost touch the underside of the steel plate. You can shim up the heater with a fire-resistant material. The area of the steel plate should be large enough to accommodate your larger plates and should have a flush top surface with no screws or nails sticking up to damage your plates.

Some etchers still insist that open-flame heaters are better for melting rosin on aquatints than electric heaters. Exercise extreme caution with them to minimize the risk of fire in the print shop, which is crammed with highly flammable materials.

SPRAY-PAINT METHOD

A very rapid way to create an aquatint is by spraying the plate with a fine mist of enamel paint from a pressurized paint can. With a little practice, you can make this procedure practically foolproof. It is particularly useful when you want light and middle-value gray tones or gradated tones. Start spraying off to the side of the plate to be sure the spray is working well, then spray the plate and stop spraying only after the spray is off the plate. Work back and forth in a regular pattern, holding the can about 12 to 14 inches away from the plate surface. Experiment with various brands of paint until you find one that sprays a mist fine enough to suit you. Some brands spray little drops, which will cause coarse white speckles in your printed tone. Do not use spray cans when they are nearly empty, as they tend to sputter and spatter irregular drops.

The advantages of spray paint are that it dries almost instantly, it does not have to be heated, and it makes graded tones easy to create. The disadvantages are obvious: the spray tends to be extremely toxic and should be used with an efficient venting system or sprayed outdoors. The work area must be cleared of anything that could be contaminated by the spreading mist of paint. In addition, it may be necessary to respray the plate after it has been bitten in the acid for 3 or 4 minutes. Rinse with water and dry the plate before respraying. A very long bite in the acid can wash off the particles of paint, and therefore deeper black tones may require a heated rosin aquatint. Only by experimenting can you determine the method that best suits your requirements.

CREATING THE IMAGE

The choice of image and approach to using tone in aquatints is purely individual. An artist can begin by using tone only or a combination of tone and line. A tonal sketch in charcoal or soft pencil can help you fully visualize the possibilities of aquatint.

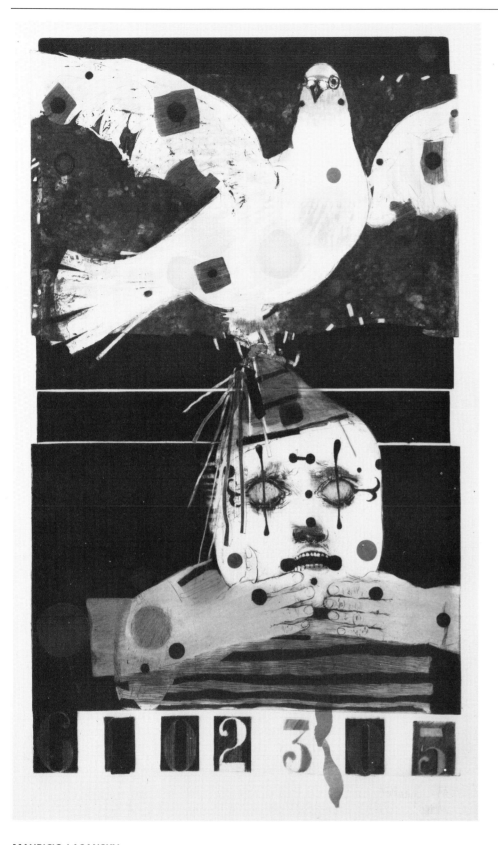

MAURICIO LASANSKY
Kaddish #5, 1978–80
Color intaglio (etching, engraving, soft-ground,
aquatint, electric stippler, scraping, and
burnishing from 19 plates), 41⅝″ × 23⅜″
Courtesy of the artist

If you are adding tones to a line etching, you can indicate them on a first proof to help guide you. Keep the range simple. Two or three tones to begin with will give you ample range and allow you to understand the process. Many of Goya's powerful aquatints were made with only two or three tones added to a line etching.

You should also keep in mind that making an intaglio print is a fluid, creative endeavor, allowing you to work back and forth. Processes can be done in any order deemed necessary to produce an exciting image. Some basic procedures will be helpful for your first efforts, but remember that rules are best kept loosely. When you have determined what tones to use, proceed as follows:

1 Put the rosin powder on the plate and fuse it with heat. Let it cool.

2 Cover any white areas with stop-out varnish and allow it to dry. Check the aquatint chart on page 102 for biting time.

3 Place the plate in an 8-to-1 or 12-to-1 acid solution and time your bite.

4 Remove the plate from the acid, rinse it off, and carefully blot it dry. Then cover the first tonal area you have just bitten with stop-out varnish, exposing only the areas of the next darker tones.

5 Bite the second tone, but remember to add the biting time from the first already bitten tone. If the first tone needs 10 seconds and the second tone requires 30 seconds, the timing for the second bite will be only 20 additional seconds since the tone was exposed during the first bite. Bite all additional tones in a similar way.

6 After the biting is completed, wash the rosin off with denatured alcohol and proof the plate. If you used ground as a stop-out, remove it with paint thinner.

REAQUATINTING TO DARKEN TONES

For a rich black, more than one coat of rosin is desirable. Vary the size of the rosin particles by using a medium and then a fine grade of rosin. The different-size particles will ensure better coverage. If a fine coating of rosin is used for a dark area requiring a long bite, the acid may bite around the particles, leaving an open-bitten gray area.

If an aquatinted tone is not dark enough, follow the same procedures to

	10 SEC
	20 SEC
	30 SEC
	45 SEC
	1 MIN
	2 MIN
	3 MIN
	5 MIN

A zinc plate, bitten in fresh 8-to-1 nitric acid, yields tones as shown in this test proof. Paint spray was used for the aquatint.

plied to the aquatint plate. Any acid-resistant varnish will work if you understand how to use it. In general, weak acids and slow biting are better because they allow for careful control, but you may want to use strong acid for a rough effect and then develop the image further from there.

An aquatint on copper can be bitten in Dutch mordant or ferric chloride, but the time needed to achieve the darker tones is much longer than with zinc; it may be 30 minutes or more. You can bite copper aquatints in nitric acid with a strong solution (3 parts nitric to 5 parts water) in much less time but not with as much control.

In general, zinc plates are so much softer than copper that they yield far fewer prints, particularly in the case of aquatints. You will find that zinc aquatints will start to weaken and the prints become lighter and lighter after only twenty to fifty impressions. If you need large editions, use copper plates, bitten in ferric chloride or Dutch mordant, and steel-face them. You can renew the steel facing several times to prolong the life of valuable plates.

SANDPAPER AQUATINTS

You can obtain a gray tone by using sandpaper instead of rosin or paint, although the quality of the tone may not be as fine or even. The procedure is simple. Place a thin coat of hard ground over a plate and let it dry. Put the plate face up on the bed of your etching press, cover the plate with a piece of medium sandpaper, and run it through the press with the pressure reduced. It may be necessary to run the plate and sandpaper through several times in different positions to assure an even tone. The particles of sand puncture the ground, leaving pits where the acid can bite the plate. Technically, the effect is the reverse of the rosin aquatint, but the tones look similar to the eye. Stopping-out procedures are the same as before. A drypoint quality can be achieved by placing the sandpaper over a clean plate without ground and running it through the press with heavy pressure.

EDGAR DEGAS
Head and Shoulders of a Woman
Etching, 4½" × 4⅞"
Metropolitan Museum of Art, New York
Bequest of Mrs. H. O. Havemeyer, 1929
The H. O. Havemeyer Collection

darken it. A light gray tone can be bitten into a zinc plate in 10 seconds if it is placed in an 8-to-1 nitric acid solution. The longer you leave the plate in the acid, the darker the tone gets. After 3 minutes in the acid, the tone is quite dark (about 85 percent of black), and it gets darker very slowly, taking 8 or more minutes to develop into a rich, dark value. If you have covered too much of the plate with particles of rosin or paint, you may never get a really deep tone.

In fact, for a really deep tone, it may be necessary to bite an aquatint two or three times. This is true for the rosin aquatint as well as the spray-paint type. You should examine the rosin dusting or the paint spray between the bites to make sure that enough texture remains to keep the tones strong.

Quick-drying grounds, such as ether- or alcohol-based grounds, are not suitable for delicate linear stop-outs because they tend to feather or spread when ap-

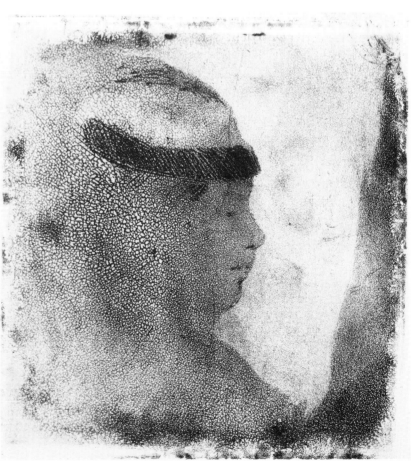

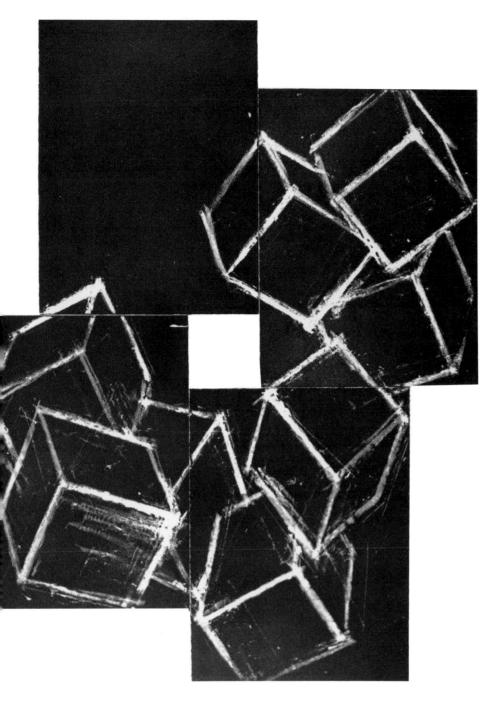

MEL BOCHNER
Second Prelude, 1988
Aquatint, 35⅞″ × 27⅝″
Courtesy Parasol Press, New York

Lift-Ground Technique

This process enables you to use the intaglio plate for the liveliest, most autographic brushed line or mass that you can produce. It is a direct process; if you paint a black line on the plate, you get a black line on the print. The image is brushed on with a water-soluble paint solution. There are several formulas that work well. Picasso used a solution of sugar melted in boiling water, colored it with black gouache or watercolor, and finally added gamboge, a yellow watercolor paint. One usable formula for lift ground is:

1 part poster color
1 part liquid gum arabic
Squirt of liquid detergent

Another is:

5 ounces corn syrup
4 ounces black India ink
3 ounces powdered syrup
¼ ounce liquid gum arabic

You may prefer yet another formula:

10 parts simple syrup (1 part sugar to 5 parts water, boiled to a syrup)
3 parts black poster color
2 parts liquid detergent
(Gum arabic is optional)

The use of poster paint alone is inadvisable because the binders in the paint do not dissolve completely. It must be mixed with gamboge, soap, or gum arabic to help it dissolve. Do not attempt to use the paint too thinly or for wash effects. It should be quite thick as it flows from your brush. You can also use a pen or dip fabric or other textured material into the solution and then place it on your plate.

WHITE EFFECTS AND SOFT EDGES

To get a soft white line, you can use a grease or wax crayon to draw directly on the aquatinted plate before it is bitten. Press hard enough to deposit the wax or grease on the plate, where it will act as a resist to the acid. The harder you press on the crayon, the more wax you can deposit on the plate and the less the acid can bite through. Light tones need more crayon, dark tones need less. (See also the discussion of creeping bite on page 108.)

It is easier to draw on melted rosin, which is quite hard and durable, than on spray paint, which is delicate and easily damaged. The best crayons are soft litho crayons, children's wax crayons, Craypas, or even wax candles. You can soften hard edges with crayon too. If you want the aquatint to fade gradually into a white background, use fine sandpaper to soften the edge, after it has been etched.

FLOUR-OF-SULFUR METHOD

For delicate wash effects, the flour-of-sulfur method is very easy and produces soft, pale tones. You need only olive oil and precipitated sulfur powder, called flour of sulfur, which you can keep in an old saltshaker. Use the olive oil as a paint, brushing it directly on the surface of the plate where you want the tone. Shake the sulfur powder onto the oil, blow the powder off undesired places it has fallen on, and let the plate sit for a few hours. The sulfur will bite into the plate, but to a very shallow depth, which may wear rapidly but produces delicate, soft tones of gray.

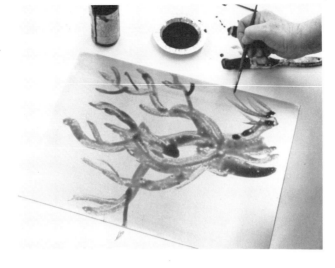

Lift-ground is painted on the degreased plate.

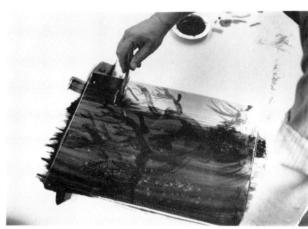

After the lift ground is dry, a slightly thinner than normal hard ground is applied with a wide brush to ensure that the paint solution under it will lift.

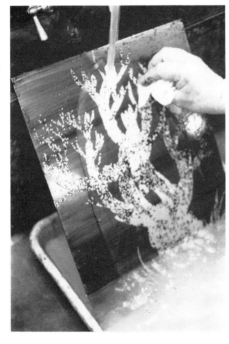

After immersing the dried hard-ground plate in warm water, it may be necessary to coax some areas with cool running water and a soft cloth.

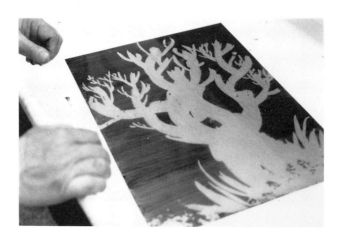

After all the lift ground is removed, the zinc plate is placed in an 8-to-1 nitric bath for 2 to 3 minutes so that when an aquatint is applied it will be below the level of unbitten areas. This prevents smudging the aquatint ink across the open areas during wiping.

It is imperative that the plate be absolutely free of grease, or the paint will not stick (see the section on degreasing the plate on page 81).

Follow this procedure for lift grounds:

1 Clean the plate thoroughly with whiting and ammonia or use a commercial metal cleaner such as Brasso or Noxon and rinse well.

2 Immerse the plate completely in a dilute solution (8 to 1 or weaker) of nitric acid for a couple of seconds, then wash it and wipe dry. The surface may be mottled but it will be grease-free.

3 Apply your design by painting the positive areas and lines with a lift-ground solution.

4 When your drawing is dry, apply a thin coat of liquid hard ground evenly over the entire plate and let it dry thoroughly.

5 Put the plate into a tray of warm water and let it soak. The lift-ground solution will dissolve slowly, leaving the plate exposed where you have painted.

6 Gently brush or rub the surface to hasten the process. Do not be in a hurry; it is better to let it soak than to rush and scratch the ground. The entire drawing should be exposed.

7 Bite the plate for a minute or two in 8-to-1 nitric acid to make wiping the plate easier during printing. This will lower the surface level that will carry the tone.

8 Spray the plate with a fine mist of paint spray, or dust an even coat of rosin powder over the plate and fuse it with just enough heat to melt the rosin.

9 Bite the plate again in 8-to-1 nitric acid for the time needed to develop the dark that you need (see page 102).

10 Wash off the rosin with alcohol and the ground with mineral spirits. The plate is now ready for proofing.

If the lines of a lift ground are not too wide, they will hold the ink without aquatinting. In freely bitten plates, large areas that have long bites in the acid may be tonally interesting without aquatint because the acid action can produce areas of character.

The spray-paint aquatint technique is recommended over the heated-rosin aquatint method. It is easier to apply

spray paint than to heat rosin dust and possibly damage the ground. Make sure that the spray can is adequately filled and that the nozzle is not clogged. Test it on the back of the plate before spraying the grounded surface. This is no time to overspray, flooding the drawing with paint and ruining it. The spray should be evenly applied, with about 40 percent coverage of the surface. Check it under an engraver's glass for proper coverage. Bite the plate as for a normal aquatint. You can vary the darkness of the grays by stopping out and biting for various lengths of time.

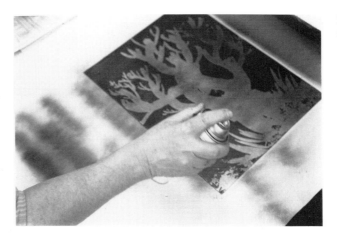

Spray paint is applied for the aquatint tones.

PETER MILTON'S PROCEDURE

Peter Milton, an artist who has completed many complex and detailed prints charged with fascinating imagery, has used the lift-ground method with extraordinary skill and patience. He has described his procedure so thoroughly that we are presenting this letter he wrote describing his work on *October Piece* (shown on page 106).

"I draw the image directly on an ungrounded, scrupulously clean copper plate (zinc can be used) with pen and sugar ink. Some of the more textural areas I put on with tissue paper and then refine extensively. In *October Piece* the grass areas were started with a paint roller and sugar ink. One of the greatest advantages of sugar ink is that it can be easily removed during the shaping of the images and the modifications of texture. It can be either flaked off or removed with a damp tissue. But all traces of sugar must be removed in the latter case or the whole area will later lift.

"I make the sugar ink by dissolving enough sugar in heated India ink to make a heavyish syrup when it cools, and then I dilute it to workable consistency by adding more ink. In low-humidity conditions a few drops of glycol antifreeze retards drying and improves the handling of the ink. I use a Hunt no. 107 hawk quill and no. 104 mapping points, with the point often touched up and refined with polishing paper as a sharpener. The point must be cleaned often to keep the ink flowing freely.

"When the drawing is finished, the plate is covered with an extremely dilute (benzine) hard ground using this formula: 2 parts asphaltum, 2 parts beeswax, and 1 part rosin. The ground

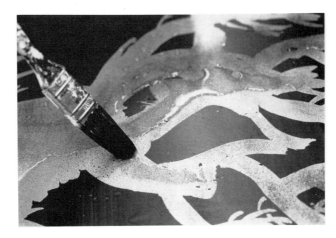

A 1-to-4 solution of nitric acid is brushed onto the plate to etch the spit bite.

must be even, and I have found a bubble level useful in leveling the plate to even the settling of the liquid. I use a 2-inch white bristle brush. If there is any streaking of the liquid, it will be due to the ground's not being dilute enough. It is very gratifying to know that one has many chances to get the ground perfect. If, after drying, the ground seems too thick (will not lift well), too thin (will false-bite), too uneven, or too rough with impurities, the plate can be flooded with benzine and cleaned with a very soft absorbent material without injuring the drawing. I usually try five to eight times before I am satisfied.

"The plate is then placed in a tray of hot water, just hot enough to be uncomfortable to the hand, and left until the water has cooled to room temperature. The sugar in the ink reacts with the

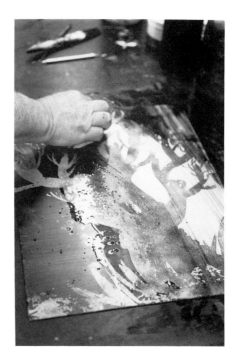

The hard ground and spray paint are washed off with paint thinner.

PETER MILTON
October Piece, **1969**
Lift-ground etching, 17¾" × 23⅞"
Courtesy of the artist
Photo: Eric Pollitzer

water and swells, making the ink soften; the ground over it loosens and can be rubbed away by hand. The plate is methodically and vigorously rubbed until the metal is exposed at every point that there was a sugar-ink mark. There is no mark so delicate that it shouldn't lift if everything has gone right.

"I etch the plate in the manner normal for copper, with Dutch mordant and many stopping-out steps, using rosin/alcohol/methyl violet dye as the stop-out varnish. Any mark or shape too broad to

hold ink well during the printing can be strengthened. Since a heated aquatint is likely to foul the ground, I either spray on a rosin/alcohol solution through an atomizer or use a commercial paint spray, such as Krylon flat black enamel.

"Later I add much straight engraving with the burin to refine the image, and it is at this stage that the figures take on their rather photographic quality. I do not use photoengraving aids, and while this is impractical, it is curiously satisfying. I do use photographs extensively, but only to draw from. In *October Piece*, I spent around three to four months on the preacid drawing stage and two to three months on the postacid engraving.

"It must be said that the approach I am using is probably as antithetical as can be conceived to the more-or-less

contemporary printmaking concepts, which emphasize openness to materials and to the medium itself. As much as anyone, I would hate to see such procedures as I have just outlined lead us back to the kind of frozen tedium that afflicted printmaking for so many years before its present health."

Additional Tonal Techniques

There are a number of other ways to achieve tonality that deviate from the standard procedures for aquatint, including spit bite, creeping bite, and the foam-rubber method.

SPIT BITE

The hard edge of an aquatint can be varied in a number of ways. You can achieve a drybrush effect with a brush that is partially charged with ground. It creates a grainy texture that softens the stroke of the brush. Another way to obtain variations in the tone is to use a procedure commonly called spit bite. Delicate wash effects with soft, graded edges are possible with this method. The process does not require a lift-ground procedure, although the best control over the drawing is obtained that way.

The following materials are needed especially for spit bite:

Nitric acid

Dr. Martin's Non-Crawl

Ethylene glycol

Soap (liquid or solid)

Gum arabic

There are several ways of working with spit bite. The strongest effects require that the plate be given an even tone of aquatint spray or powdered rosin, fused well to the surface. It is possible to work directly on this surface by painting it with water to which a little Dr. Martin's Non-Crawl or ethylene glycol or even a little soap has been added. You can tint the water with dye or watercolor to make it easy to see. After you have painted a small area with water, drop some pure nitric acid into the water deposited by your brushstrokes. Be careful not to let large drops give your line a spotty character. It is possible to flow the acid on smoothly with a small eye-dropper, an old brush, or even cotton swabs. The acid will bite quickly, and in a minute or less it will have bitten strokes into the plate.

Another method requires 1 part nitric acid mixed with 12 parts gum arabic (the same strength as that used in lithography). Paint with this mixture, using a soft brush, and leave it on the aquatinted plate for approximately 30 minutes. Do not allow the solution to dry on the plate but keep replenishing it.

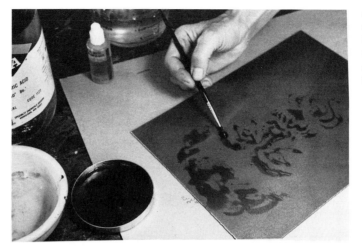

A solution of water and gum arabic or noncrawl is painted onto a zinc plate that has an aquatint ground on its surface.

Here nitric acid is dropped or brushed into the water painting. In varying solutions it may be brushed directly on the plate. The drops should be dispersed instantly, however, or they will bite in a spotty manner.

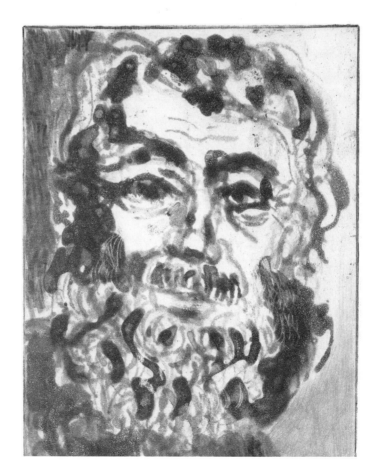

This plate was bitten with spit bite only. Five separate sprays of aquatint were used.

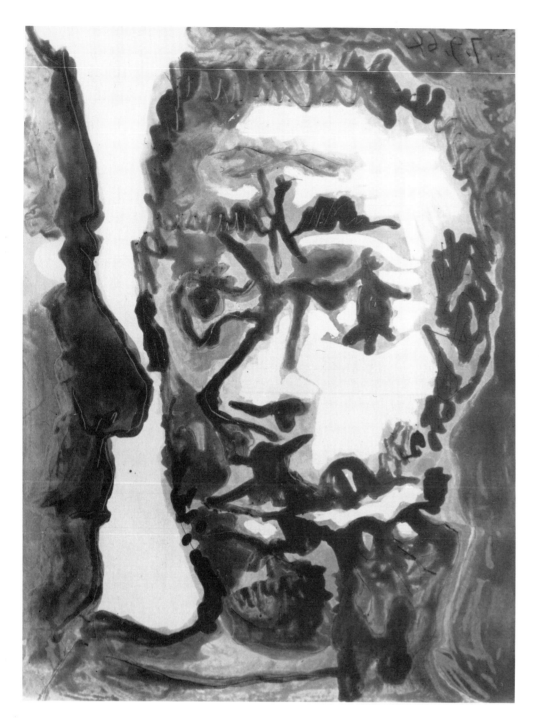

PABLO PICASSO
Head and Profile (Tête et Profil), 1964
Spit-bite aquatint, 16½″ × 12⅝″
Courtesy John Szoke Graphics, New York

CREEPING BITE

Another method of obtaining a gradated aquatint tone is to place two triangular wedges of wood (painted with several coats of asphaltum) in the acid tray and slowly move the plate deeper into the acid to obtain a varied tone (see the illustration).

FOAM-RUBBER METHOD

There is an alternative method that has been used currently with success by George Nama in his classes at the National Academy of Design in New York City. It is a soft-ground process that takes the place of an aquatint. Using ¼-inch foam-rubber sheeting as the texturing agent, follow these steps:

1 Cut the foam-rubber sheet slightly larger than your plate.

2 Brush a soft ground evenly over the plate and let it dry.

3 Place the plate on the bed of the etching press with the foam rubber on top, in contact with the soft ground. Put a piece of barrier paper, such as wax paper or newsprint, between the foam rubber and two blankets to protect the blankets.

4 Run once through the press with less pressure than that used in printing.

5 Remove the foam-rubber sheet and stop out the areas that are not to etch.

6 Bite the plate in acid for enough time to attain the desired tone. You can get darker tones by stopping out and re-etching the plate.

7 Wash off the soft ground with paint thinner. The plate is ready for a proof.

It is possible to paint directly onto the plate with pure acid, but the action of the mordant is so strong that it can undercut the rosin or paint drops. This deep groove will cause the area to bite as a crevé (without texture), and it will therefore not print as dark. It seems strange that dilute acid will bite a darker gray than pure acid, but that is the case. It is difficult to control tonalities with this process, however, and several bitings may be necessary.

The best control with the spit-bite technique is obtained when you put the drawing on the plate with a lift-ground procedure, then either spray-paint or fuse rosin particles onto the plate, and brush with water on the exposed areas. Paint the pure acid into the water with a brush. Your tones will resemble a wash drawing and have irregular textures and tonalities. You can burnish to lighten certain strokes effectively because the aquatint is not deeply bitten and responds quickly to the burnisher. For wash effects and soft edges, sand with fine sandpaper and then work with the burnisher to lighten the tone of the lift-ground aquatint. This procedure, used in conjunction with the spit bite, can produce delicate wash tints.

CREEPING BITE

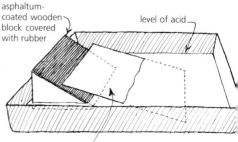

asphaltum-coated wooden block covered with rubber

level of acid

aquatinted plate, moved deeper into acid for darker tones

Materials for Printing

The wide variety of materials available to printmakers can be confusing to the beginner. It is economical to use high-quality papers, inks, and other materials. If you pull a proof on cheap newsprint and it turns out well, there is no way you can prolong the life of the acidic paper and the proof will eventually self-destruct. Good housekeeping procedures will help make printing a creative time instead of a messy chore.

PAPER FOR ETCHING

Etchings are printed on damp paper because the fibers must be soft and pliant in order to be pressed into the incised lines and indentations of the metal plate. The ability of the paper to withstand the abuse of printing, dampening, pressure, and stretching without tearing or discoloring is of primary importance. The most highly prized papers are made of all cotton, with little sizing, long fibers, and no chemical residue. Good papers come from Europe and Japan, with France, Italy, and Germany still the primary producers of rag papers suitable for intaglio printing.

Proof papers Good proof impressions can be taken on index paper, cover stock, Basingwerk, or other papers that do not disintegrate when they are dampened. It is possible to use newsprint for a rough proof, but it is so soft that it tears easily and, of course, it is extremely perishable. For a finished proof, it is wise to use the paper on which you will print the entire edition so you can judge the tonal values exactly as they will appear in a final print. Proof papers need not be 100 percent rag because you are not concerned with the permanency of the proof.

Index paper suitable for proofs is made by a number of mills. Cover-stock possibilities for proofing include Mohawk Cover, Pericles Cover, Weyerhauser Starwhite Cover, Tuscan Cover, and Carrara Cover. Other useful papers are Pastelle, Tweedweave, Alexandra, and Beckett Cover, as well as papers that may be available locally.

Edition papers Papers suitable for editions of intaglio prints include American Etching, A/P Etching in rolls, Arches Aquarelle, Arches Cover, Arches En-Tout-Cas in rolls, Arches Text, Basingwerk (for proofing and editions), Copperplate, Copperplate Deluxe, Coventry Rag Heavyweight, Crestwood Black, Domestic Etching, Fabriano Classico, German Etching, Indian Handmade, Italia, J. Barcham Green Watercolor Paper, Lenox 25, Lenox 100, Millbourn, Murillo, Rives BFK, Rives Heavy and Light, Roma (Fabriano), Rosaspina (Fabriano), Somerset, Stonehenge, Strathmore Artists Paper, Umbria, Utrecht, and Whatman Handmade. Other papers can be used if tested

and handled properly. Certain specialty papers with unusual colors or textures can be used if the image needs it.

Water trays For small sheets of paper, standard-size photo trays made of white plastic are suitable. Larger sheets may need a tray made to fit. To construct one, follow the directions for making an acid tray, using 1-by-4-inch sides and a plywood or Presdwood bottom, and lining it with a sheet of heavy vinyl. The most convenient tray has a spigot built in

EDWARD HENDERSON
Untitled, **1988**
Etching, aquatint, and spit bite, 31″ × 23¼″
Courtesy Castelli Graphics
© Walker Art Center, 1988
Photo: Jim Strong

DAVID BECKER
Crosspaths, 1984
Etching, 13″ × 19″
Courtesy of the artist

to allow easy drainage. Paper left in a tray will form slime and mildew after a few days. The odor generated from this mess can be highly unpleasant, so keep your water trays clean by regular rinsing. Add a few drops of household bleach to the water to keep mold to a minimum.

In classroom situations, where a number of printmakers are working at the same time, the student's initials may be penciled on a corner of each sheet of paper to reduce the confusion that comes when many similar papers are being soaked at once.

ETCHING INK

The chemical components of etching ink are very simple: plate oil (a thickened linseed oil) and powdered pigment. Although it is relatively easy to make your own ink, some commercial brands are very inexpensive and of good quality. Be sure to buy your ink from a reputable manufacturer. It is usually sold in 1-pound cans.

When using ink from a can, you must take care to keep it fresh. Always replace the wax-paper liner and scrape the ink from the top of the can; this will ensure a good seal when the lid is replaced. It is more important to put the paper disk on the ink, with no air bubbles underneath, than to put the metal lid on the can. If the ink hardens over, you must skim off the top to reach the fresh ink underneath. If you make your own ink, store it in cans or jars with a similar paper disk as a seal against air. An excellent remedy for the ink can is used at the Columbia University print shop. In this shop, ink is bought from Graphic Chemical in card-board tubes that are then used in caulking guns.

There are several black pigments that will make good ink, such as bone black, Frankfort black, vine black, lampblack, ivory black, and drop black. Mars black is generally not suitable for etching ink. Vine black is denser than bone black, so it will print more of the subtlety in the line. Bone black is lighter and absorbs oil. Frankfort black has little body to it and is warm-toned, while lampblack is very blue.

These blacks can be mixed together to exploit the best characteristics of each. One pigment does not have all the qualities essential to good ink, such as intensity and strength of color, even texture, and easy wiping. The addition of umber or ochre or blue will make the ink take on warm or cool tones as it is wiped. Mix the dry powdered pigments first with a palette knife, then add a small quantity of plate oil. Use a grinding muller for small quantities of ink,

and an old litho stone or a glass or marble slab as a grinding surface.

Rudy Pozzatti, of Indiana University, suggests the following ink formulas:

For general printing:
3 parts vine black
1 part bone black

For drypoints:
4 to 6 parts vine black
1 part bone black

For engravings:
2 parts vine black
1 part bone black

When very large quantities of ink are needed, some schools use power mixers to combine the pigment and oil. Power mixers, however, are economically feasible only when hundreds of pounds of ink are needed, to offset the initial cost of the equipment.

The thickened linseed oil that must be used in making ink can be purchased as plate oil. If the oil is not thickened, the ink made from it is difficult to wipe and prints weakly. Plate oil has different viscosities. No. 00 plate oil is thin and light; it is often used to loosen an ink. Raw linseed oil can also be used to thin an ink. No. 3 plate oil is thick; it is good for grinding the ink. Sometimes No. 3 plate oil, because it is so dense, has some drier in it.

Eugenol (a substitute for oil of cloves) or olive oil can be used to retard the drying of ink. Only a few drops are needed. The addition of Easy-Wipe compound to the ink will lessen the stiffness and make the ink more manageable when it is wiped.

Gloves When you are inking large plates or printing a big edition, you'll find it helpful to wear work gloves. The problem of inky hands is ever present in the workshop, and gloves keep at least part of the ink off. Hardware stores sell cotton work gloves with knit cuffs, which are useful. Rubber or vinyl gloves work best if you sprinkle some talc inside so that your hands won't perspire. Surgical gloves work well if you powder them

BILL JENSEN
Etching for Denial, 1986–88
Etching, 24¼″ × 19½″
Courtesy Universal Limited Arts Editions, Inc.

inside. The gauntlet type of glove is too awkward. Leather gloves are good if you have an old pair that you don't mind soiling. Remember that gloves must be removed for hand wiping and for handling the paper.

ETCHING BLANKETS

The printing blankets normally used in the etching press are made of woven wool felt. They are available in several thicknesses, from around ⅟₁₆ to ³⁄₁₆ inch. They are usually sold by weight and are quite expensive. They can be washed in Woolite or a mild detergent every time they become dirty or stiff from the accumulation of dried sizing from continuous printing. To dry woolen blankets, block them to the correct size to prevent shrinkage and pin or nail them to a wall, a table, or a piece of plywood. Since steel nails will rust, you should use thin aluminum ones.

Although woven felt is best in the long run because of its fine, even texture and its ability to withstand hard wear, pressed felt blankets cost less than half as much. Pressed felt is available in white and gray and in many thicknesses. Coarser in texture, it is not always desirable for fine, even aquatints or large areas of even tone, which may be given a mottled or blotchy look. Pressed felt is good for roughly bitten plates or collagraphs. A piece of 1-inch-thick foam rubber can also be used as a blanket for collagraphs or in conjunction with a blanket. The foam rubber breaks up quickly and, unless it is handled carefully, has a very short life. In an emergency, ordinary colored felt can be used, as can three or four new blotters, which will print etchings that are not too deeply bitten.

Blankets should be cut to the width of the roller and somewhat shorter than the length of the bed. They should be aligned carefully to square with the bed. Crooked blankets can get caught in the press and the corners become cut or

The blanket of this press at Centro Internazionale della Grafica di Venezia, is on a continuous loop. The need to handle the blanket is minimal. You must avoid the seam of the blanket, however, or it will mark the print.

torn, a common sight in print workshops where many beginning printmakers are working. Do not leave blankets in the press overnight. They get damp from contact with printing papers and can rust the rollers and the bed through continued contact. Hang the blankets over a wooden bar or roll them up and put them away.

The number of blankets used in actual printing depends on the depth of the inked lines in the plate. If the grooves are very deep, three or four blankets are needed to squeeze the paper down into the lines to pick out all the ink. If the lines are shallow, two blankets should be enough. A thin, woven felt in good condition should be placed next to the dampened printing paper. The second blanket should be thicker and might even be a pressed felt instead of a woven felt. We have used blankets in any number of combinations, and whatever works well is the right method.

THE ETCHING PRESS

So many presses are being made at this time that we have prepared a chart showing the manufacturer's name and address, the type of press the firm makes, and other information that seems appropriate (see chapter 15). Used presses are scarce, although more should be coming on the market as the total number of presses increases. Old, ungeared presses turn up now and then, but they should be checked for worn bearings or bushings. Beds tend to warp, too, and should be checked with a straightedge. Warps of more than $\frac{1}{16}$ inch in the center can cause trouble.

The basic etching press is a steel or Benelux bed that passes between two steel rollers. There are usually guides to keep the bed from moving out of position or from falling off the end of the press. Small presses may be ungeared, but presses with beds wider than 18 inches should be geared. It is a difficult job to print large plates by hand unless the gearing system is very efficient.

Chain-driven presses are very common because they can have high gear ratios, making it easy to print deeply bitten plates, which need great pressure. Some of the better presses are made by Charles Brand, Graphic Chemical, Rembrandt Graphic Arts, Meeker-McFee, American-French Tool Company, and Wilfred Kimber. Check with the manufacturer for the latest prices; they have been going up constantly.

Motorized presses are made by many companies because of the demand for large presses. A "dead-man" switch is advisable on a motorized press. The switch will stay on only as long as the printer is holding it. Our own press is a 30-by-50-inch motorized Charles Brand, which has worked well for years.

Micrometer gauges are a big help when plates of different thicknesses are to be printed or when blankets are frequently changed. They are essential in a school or workshop with many students. Without micrometers, the adjusting screws have to be changed by trial and error, which results in a ruined print now and then. Pressure can also be adjusted by adding or removing blankets. To establish pressure, run an uninked plate and paper through the press. Then see if the impression from the lines and beveled edge is clear. A slight increase in pressure can be obtained by adding a blotter or two on top of the blankets before running the press.

Printing an Etching

Printing the etching plate can either enhance or diminish the quality of the image. Proper procedures are essentially simple and require only a little practice to achieve rich, sparkling impressions. No matter how beautifully your plate has been designed and etched, it must be printed with care to achieve its full strength.

DAMPENING THE PAPER

Many papers can be soaked directly in a tray of water and placed between clean blotters, which are then rolled with a wooden rolling pin or hard-rubber or plastic roller to absorb the excess moisture from the sheet. There should be no visible surface moisture on the paper, as this could interfere with the proper reception of the ink during printing.

To check press pressure, an uninked plate and dampened paper were run through the press. The embossment reveals the amount of pressure produced.

Most papers need only a few minutes in the water bath to be ready to use. For proofing plates and for printing small editions, this method is satisfactory, but because rolling the paper between blotters is time-consuming, it is faster to prepare paper in advance when larger editions are wanted.

The day before you print, you can prepare a stack of paper, twenty or more sheets, by dampening every other sheet with a moist sponge. Stack the sheets together and wrap them tightly in vinyl or oilcloth, and the moisture will be distributed evenly throughout the stack in 24 hours. Make sure the sides are covered or the edges will dry out. The amount of water needed depends on the absorbency of the paper, which can be determined only by experience.

Waterleaf papers (with no sizing), such as German Etching, Arches Cover Black, and Copperplate & Crisbrook, must not be immersed in water trays or soaked with a sponge because they tend to tear or disintegrate when wet. They should be sprayed with an atomizer. Every other sheet should be moistened; then they can be placed in a stack and wrapped with plastic. Experiment to see how much each sheet should be sprayed.

INKING THE PLATE

The ink must be forced into the etched or engraved lines, the surface wiped clean, and the plate printed onto dampened paper through the etching press. There are several methods of applying the ink.

Inking with cards A very quick and easy way to ink a plate—and accomplish a good part of the wiping—is to use matboard or cardboard rectangles, about 3 by 4 inches, as small squeegees to push the ink over the surface of the plate and into the lines. You will save a great amount of tarlatan or crinoline by using the cards because most of the excess ink will be removed before you start rag wiping. Cut scrap pieces of mat board into long strips 3 or 4 inches wide, then cut one or two strips at a time into the rectangles that you need. Because the edges of the cards must be straight and smooth, a good paper cutter is the best

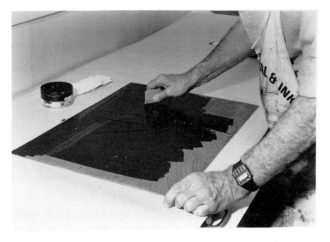

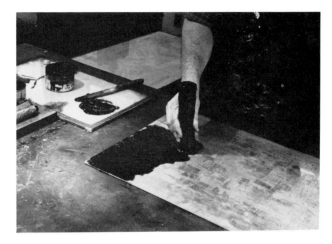

Inking an etched plate with a cardboard squeegee is a fast, efficient method for normally bitten plates. In all inking methods, dirt is a constant hazard. Grit can scratch an aquatint while you are wiping the plate.

An etched plate is inked with a dabber made of old etching felts. This procedure is useful for very deeply bitten plates.

tool for the job. Instead of cards, you can use plastic squeegees or, for large plates, a rubber window-cleaning squeegee.

Inking with a roller Small paint rollers, 3 to 6 inches in length, are good for distributing ink over the plate and getting it into the lines. Mohair and short-nap rollers are easiest to clean and are preferred, but almost any nap will do. The problem comes when you have to clean the roller after you have used it. If it isn't cleaned, it soon hardens into a rocklike cylinder and is more trouble to clean than it's worth.

Inking with a dabber Rolled scraps of blanket felt make good dabbers, useful for pushing ink into the incised lines of an etching plate. The felt strip should be 5 to 8 inches in width and 20 inches or more in length. Roll it tightly and use string, masking tape, or rubber bands to hold it in place. Cut the ends even with a hacksaw or sharp knife, and keep cutting new felt as the ends harden. Dried ink is a distinct drawback to the dabber, which is useful mainly for small plates or for spots that have been missed with the card or roller.

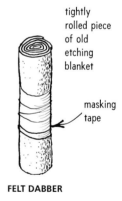

tightly rolled piece of old etching blanket

masking tape

FELT DABBER

wrapped with twine

stuffed with cotton or cloth

LEATHER DABBER

After wiping with cards, take a crinoline or tarlatan rag and wipe in a circular motion with little pressure. When the image is fairly clear, but still a little hazy, stop wiping with the rag. Too much rag wiping weakens the lines.

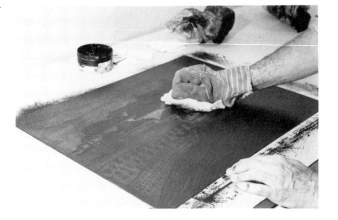

A hand wipe is accomplished with a light, fast stroke, using the side of the palm. A few strokes should brighten the area and wipe the surface clean.

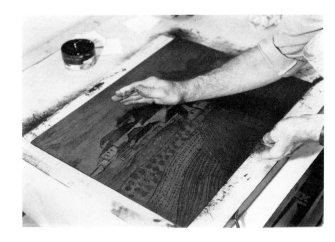

A paper wipe polishes the surface even more than the hand and gives a more brilliant plate tone. Some plates need paper wiping more than others. To keep rich aquatint tones, use a minimum of paper wiping.

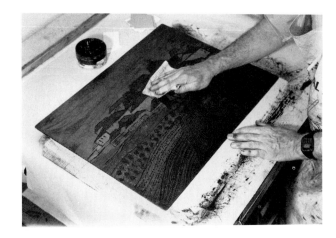

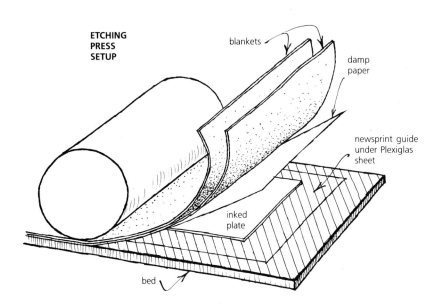

ETCHING PRESS SETUP

blankets

damp paper

newsprint guide under Plexiglas sheet

inked plate

bed

Dabbers can also be made of leather, which is easier to clean and to keep soft and supple. The leather is wrapped around cotton waste or an old soft rag and then tied with string into a shape that makes a good handle. To scrub ink into very deep lines, you can use small bristle brushes, such as a fingernail brush or toothbrush.

WIPING THE PLATE

The initial wiping of the inked plate should be done with tarlatan or crinoline, which is somewhat like starched cheesecloth. It should be balled into a mass that fits the hand comfortably. You can wipe, using light pressure, in a circular motion or in one direction after another. The purpose of wiping is to remove most of the ink from the surface of the plate while still leaving it in the etched lines. At a certain point, when the design is visible but somewhat hazy or smoky, the rag wiping should be stopped. If the plate is overwiped, the lines will be weak or broken and tonal values will be dry or light. A little oil of cloves added to the ink beforehand will prevent quick drying and lengthen the time you can spend on the wiping.

If the tarlatan is too stiff to wipe well, you can do one of the following to soften the material:

1 Wash the amount you need in water to remove the excess starch. Allow it to dry overnight before using.

2 If you are in a hurry, wash the tarlatan in alcohol, which dries rapidly.

3 Rub a length of tarlatan against a press leg to dislodge excess starch.

Hand wiping At the point when the etching design is still slightly blurred, you should start the hand wiping. If too much ink still remains on the plate, it will not wipe clean, as it should after a few strokes with the edge of the palm. Copper wipes faster than zinc. Plates with large areas of white are more difficult to wipe than darker, more tonal plates, because more ink must be removed from the surface. Some printers use a hotplate to soften the ink and make wiping easier.

Use the side of your palm and wipe quickly, with very light pressure, over the surface of the plate. Wipe thoroughly, removing all the smears and surface

blurs. Wipe your hand frequently on a cloth or some newspaper kept close by. You cannot wipe a plate clean with dirty hands. Work quickly and efficiently, and don't forget to wipe the edges of the plate too. The plate must now be printed promptly. If you wait too long, the ink will start to dry and the print will be weak and pale.

Paper wiping On some plates you can use newsprint or pages from an old telephone book instead of your hand to wipe the ink from the surface. The paper polishes the metal and makes for a brilliant print with whiter whites than your hand can produce. Too much paper wiping, however, may overwipe the plate. In general, aquatint tones will be richer if hand-wiped only. Those areas of the plate that are white or very light can be lightly paper-wiped just before printing. Do not use paper towels or tissues to wipe because they are too absorbent and pull too much ink from the etched lines.

Wiping plates is somewhat tricky and requires a little practice to achieve good results, but no magic touch is necessary. Students can learn to ink, wipe, and print plates in a professional manner in a very short time. Roughly bitten plates, collagraphs, and materials other than copper or zinc are more difficult to print, however, and some experience is desirable to get the best results from printing these kinds of plates.

PREPARING THE PRESS

The bed of the press should be run out to one side of the press. Put clean newsprint on the bed to keep the impression paper clean. A print can be ruined by smudges of ink in the image or in the margins. Some printers tape a sheet of heavy acetate over the newsprint and wipe this surface clean with rags or paper towels.

Many print shops cover the press beds with a sheet of ⅛-inch clear plastic (such as Lucite or Plexiglas) taped flush to the edge. This can be cleaned easily after each printing. Sheets of paper with register guides can be slipped under the plastic and used to keep margins similar when an edition is printed. A grid can be ruled on a sheet of index paper or made from graph paper taped together, placed under the plastic sheet, and used as a

guide for placing the plate and the paper correctly. In any case, the bed of the press should be clean and free of dirt, dust, or particles of any kind.

Place the freshly inked and wiped plate on the clean bed, inked side up. Put it down without sliding or moving after it touches the bed. Some printers wipe the back of the plate because ink always appears there. If you move the plate, you may create smudges on the clean bed, and they could print.

POSITIONING THE PAPER

Hold the dampened paper with paper picks on diagonally opposite corners for the most control in handling the sheet. Place the paper on top of the plate, cen-

tering it to obtain even margins. If you want consistent margins in edition printing, you should mark the newsprint paper to note the positions of one side and one corner. Mark it before printing. Smooth the blankets over the paper. In classroom situations it is best to place a clean piece of newsprint between the back of the dampened paper and the blankets, to absorb sizing from the paper or if your blankets are dirty or your paper is so thin that there is danger of the ink coming through to stain the blankets.

PRINTING THE PLATE

The best prints are pulled from a freshly inked and wiped plate. Ink starts to dry in 15 or 20 minutes, so nothing should be allowed to interfere with the printing

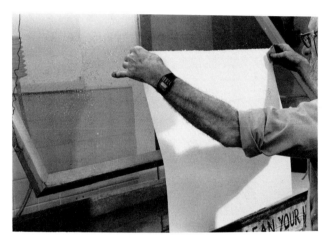

For printing, the paper must be soaked in water to soften the fibers. Many papers can be completely immersed and left to soak. This should be done before you start the inking and wiping process. Pick up the dampened paper with "picks" made of folded paper; then drain the sheet on a screen over a water tray.

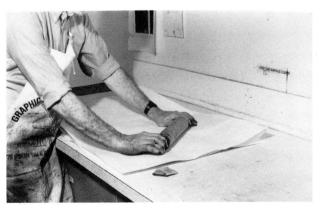

Excess moisture can be removed with blotters and a rolling pin.

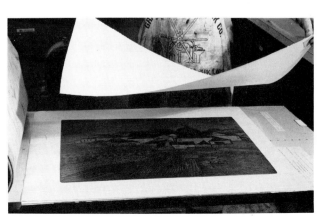

The paper is handled from two opposite corners and placed over the plate.

Run the plate, paper, and blankets through the press once. The pressure should be enough to force the paper into all the etched lines, pulling the ink out of them.

cycle once it has been started. Run the plate through the press once. If the pressure has been properly set, one printing should be enough. Every time you double-print a plate, passing it through the press twice, you run the risk of a double image or a blurred print because of slight shifting of the paper. It will shift if the lines are not deeply bitten or if the paper dries and shrinks a little from contact with a warm plate. If you must adjust the pressure, do it quickly so that the paper does not dry in the blankets. Loss of humidity causes the paper to shrink.

Remove the proof by lifting the edge with paper picks. Pull the proof slowly enough to prevent tearing of the soft paper. Too much pressure will cause the print to be mashed into the plate, sometimes so tightly that it is impossible to save the print. If the plate curls, the pressure is too great. Run it through the press face down to straighten it out.

When a small plate is run through a press, runners or strips of metal the same thickness as the plate should be positioned near the edges of the press bed. This will prevent the press bed from warping under the repeated uneven pressure of one small plate.

A print can sometimes have the correct pressure, but during editioning prints skip or slur along an edge parallel to the roller. Check to see if there is an inadequate bevel on the plate. If the plate still skips, try turning the plate to meet the roller at a 45-degree angle.

DRYING THE PRINT

A buckled or curled print will never fit properly into a mat or frame. If you want to save the deckle edge or keep the sheet intact, you will have to dry your prints between blotters. Place the print on a blotter, put a sheet of clean newsprint over the freshly printed ink, then another blotter. Make a stack of six to eight such prints, then weight the pile with ½-inch Novaply underlayment board or plywood. (The boards should have been previously coated with two coats of exterior paint to prevent them from absorbing too much water and eventually curling or twisting.) Use boards that are larger than the prints so there is even pressure over the drying prints. Change the blotters 30 minutes after a wet print is placed between them. Most of the dampness will be removed by frequent changes early in the drying process, and the time needed under the blotters will

be greatly shortened. One or two days with frequent changes should be sufficient for most papers.

If it is important to keep the crisp character of the raised ink of the printed etching line, then the prints should dry in the open, possibly in a silkscreen drying rack, for at least several days or until the ink has hardened. The prints should then be resoaked in water and stacked in blotters and weights in order to flatten the paper.

Embossed prints need special treatment in order not to flatten the embossment. These prints can be placed under a couple of blotters with no other weight on top. Change the blotters early and frequently and after the paper is almost dry; then add some weight to the top of the stack when the sheets have hardened enough to retain their shape.

If you are in a hurry for a dry proof, without embossing, you can staple the wet proof to a wall or board (made of Homasote or plywood). Place the staples ¼ inch from the edge of the paper, no more than 2 or 3 inches apart. Of course, the paper must be trimmed after it is dry, which usually takes only a few hours. The paper will dry before the ink hardens, so the fresh print should be covered with a slip sheet of newsprint if it is to be carried. The shrinkage of the paper flattens a good deal of the embossment of the plate.

CLEANING AND STORING THE PLATE

Clean the plate with mineral spirits, paint thinner, or, if it is very dirty, lacquer thinner. Coat the plate with asphaltum, heavy grease such as petroleum jelly, or hard ground to keep it from rusting. If you are going to store the plate for a long time, after applying a ground, wrap it in wax paper, then in newspaper or brown wrapping paper. Do not leave newsprint in prolonged contact with the plate, as the acid inherent in the paper will corrode the plate.

When printing small plates (as shown by the dotted lines), runners the same thickness as the plate should be placed on the edge of the press bed under the blankets. This keeps the bed from warping.

INTAGLIO COLOR PRINTING

Good-quality etching inks are made in the United States and Europe by a number of manufacturers. Because color can be applied to plates by relief as well as intaglio methods, a great variety of inks are useful to the printmaker: litho, letterpress, and intaglio inks, as well as oil paints. If you want to simplify your ink purchases, start with etching inks only. These can be both rolled and wiped.

Keep your ink cans clean and the edges wiped, so that the lids can be removed easily next time you want the color. Replace the paper or plastic disk and press out the air bubbles whenever you store the ink, even overnight. If you have mixed a special batch of color for an edition, keep it in empty ink cans or in tubes bought for this purpose. We have kept ink for years in this manner. It is good economy to buy ink in quantity. It never seems to decrease in price and with proper storage will remain usable for many years.

In theory, only the most brilliant primary colors are essential, so that, together with black and opaque white, all other colors are possible. In practice, however, it is essential to add brilliant emerald green and an intense purple in order to extend your palette to these hard-to-match colors. We find that a warm black and several deep earth tones are so convenient that they are prac- tically indispensable. Actually, we have on hand more than seventy different colors in sizes ranging from small tubes to 5-pound cans because we were fortunate to buy some ink from a fine-art printer who closed his shop.

One-Plate Method (à la poupée)

A method long popular with French printers is to ink a single plate with many colors—*à la poupée* (*poupée* is the French word for "doll"). The name de-

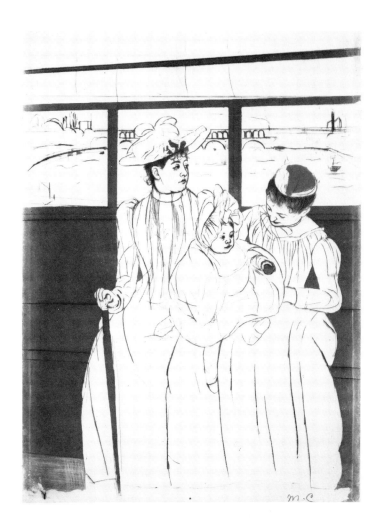

MARY CASSATT
In the Omnibus, c. **1891**
Soft-ground etching, drypoint, and aquatint printed in black, 14⅜″ × 10⅜″
National Gallery of Art, Washington, D.C.
Rosenwald Collection

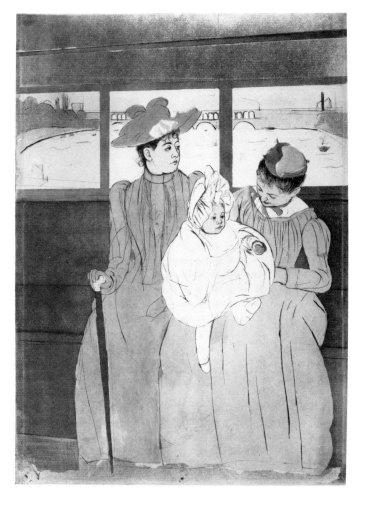

MARY CASSATT
In the Omnibus, c. **1891**
Soft-ground etching, drypoint, and aquatint printed in blue, brown, tan, light orange, green, yellow-green, red, and black, 14⅜″ × 10⅜″
National Gallery of Art, Washington, D.C.
Rosenwald Collection

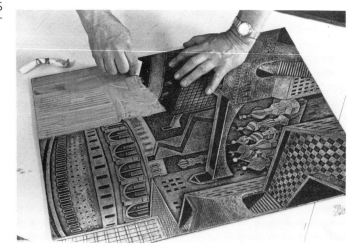

The *à la poupée* method uses several colors on one plate. The first color is spread in a selected area with a small cardboard card. Each area to be inked is defined by forms you choose within the plate.

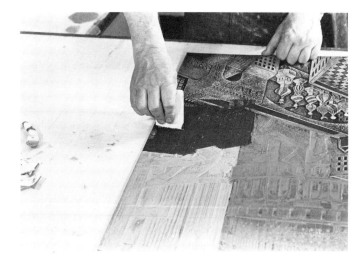

The second and third colors are forced into the grooves and recessions of the plate with clean cards.

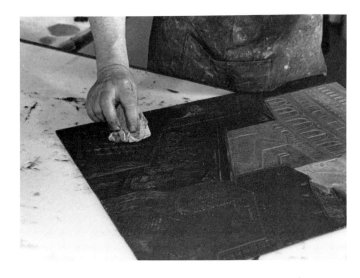

Clean pieces of tarlatan or crinoline are used to wipe each separate color area of the plate. Avoid too much merging or blending of color.

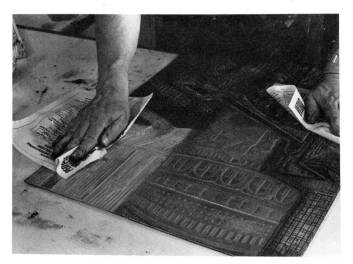

The final wipe can be done with a hand or newsprint.

rives from the use of small, cloth dabbers tied at one end (and thus resembling doll's heads) to blend many colors on a single plate. It is best if the color areas are delineated somewhat from each other, especially as, during the final wiping, a certain amount of blending and mixing of colors is inevitable. Wipe the lighter colors first and use a separate piece of tarlatan or "doll" for each color. When you come to the final wiping, use clean pieces of newsprint or, if you are wiping with your hand, be careful to keep the darker colors from contaminating the lighter colors. It is possible to print somewhat consistent editions, although precisely similar impressions are virtually impossible with this method.

On a zinc plate, cadmium yellow will turn into a dirty green and white ink will print as a gray. A color called diarylide yellow is somewhat less reactive with the metal. Copper affects light colors, too, but much less than zinc.

Surface Roll

You can roll a surface color of letterpress ink over an intaglio plate immediately prior to printing. The intaglio lines will stand out on top of the background color with clarity. The background film of ink must be thin and even, and a large roller, in perfect condition, achieves this best. Try to place the color on the plate with the least number of rolls to avoid pulling too much ink from the intaglio lines, weakening them and contaminating the color.

Cut-Plate Method

If you cut a zinc, copper, or collage plate with a jig saw into sections, somewhat like a puzzle, each section can be inked and wiped with a different color etching ink, the parts put back together, and the reassembled plate printed. Printing a uniform edition is much more likely with this method because the colors have much less chance of making contact with each other. Frequently, however, there is a white line around many of the forms because the cut removes metal and these cuts cannot hold ink; they therefore print with a white "river" or "thread." If this white line is utilized as part of the image, it can enhance the print.

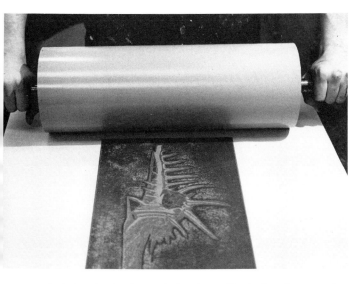

An etched plate that has been inked and wiped by the intaglio process is about to have its surface covered with a thin film of relief ink from a large composition roller. This roller should be large enough to cover the entire plate in one roll.

Frank Stella paints with stop-out varnish on etched magnesium plates for *Giufà e la berretta rossa* with Ken Tyler at Tyler Graphics, June 1988. Photo: Marabeth Cohen.

Etched magnesium plate for Frank Stella's *Giufà e la berretta rossa* at Tyler Graphics (see page 297).

A segmented plate is laid out on the inking table and intaglio ink is spread with a cardboard square into each segment. In this case there are five separate shapes, which will receive five separate colors. The sections are wiped with tarlatan and newsprint.

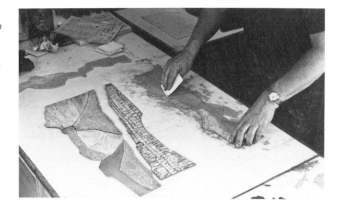

The last section also receives a relief roll of another color with a soft-rubber brayer.

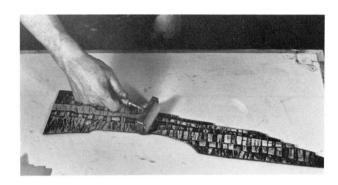

Because the brayer is small and picks up intaglio ink with each pass, it must be cleaned of excess ink by rolling it over clean newsprint. You may have to repeat this three or four times for a segment like the one here.

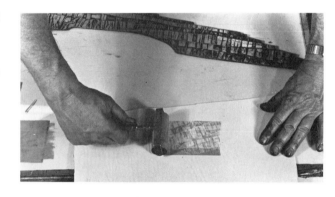

When all the segments are inked, they are assembled on the bed of the etching press and printed in the normal manner.

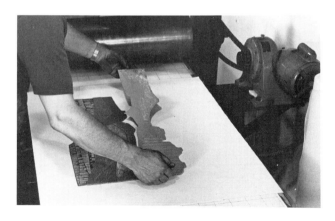

Plates can be cut into pieces with a high-temperature cutting torch or a saw or by deep biting in an acid bath; thinner plates can be cut with tin snips or scissors. On cardboard or Masonite plates, you can use knives, razor blades, jeweler's saws, or jig saws. A plate cut into four sections will yield eight colors in an easily controlled process. Some eugenol or oil of cloves might be added to the ink if the process takes more than an hour or so. This retards the drying of the earlier inked sections and gives you more time to work. Of course, you can ink these plates by the relief process as well, using rollers or brayers and letterpress ink.

Layered Plates

Layers of thin copper or lithographic zinc plates, each one etched through with different images and inked in separate colors, can be placed one over the other and printed in the etching press. The lowest plate in the group, or the base plate, should have the largest surface area. Each succeeding plate should be smaller than the previous one.

Stenciled Color

Color can be placed on an etching plate prior to printing by the stencil process, using cut paper or sheet metal as the stencil. In this process the color shapes must be planned in advance and cut from acetate or an ink-resistant paper, such as oaktag or an oiled heavy bond paper. The shapes should be somewhat larger than actually wanted because the thickness of the paper hinders the roller from contact with the plate along the edge of the shape. A soft-rubber or plastic roller can be used to roll the color on the plate. The procedure works best when executed in the following manner.

Cut the openings in the stencil, using a razor blade or sharp knife. If you need overlapping colors, you must have separate stencils for each color. This practice is somewhat dangerous because the first color stenciled on the plate may be disturbed by the next stencil. Do not attempt too complicated a scheme for overlapping colors. When your stencils are cut, mix the stencil color, using letterpress ink or etching color made less

viscous than normal by the addition of linseed oil. The viscosity of the stenciled color must be less than that of the ink used for the intaglio lines in the plate.

Now ink and wipe the plate with the basic etching ink, of normal or thick viscosity. Place the plate, face up, on a sheet of newsprint (acetate or glass is suitable) and position your first stencil over your inked etching plate. If you are printing an edition, you can tape the stencils in position and mark the position of the plate. First roll out your color on a separate inking slab, using a soft-rubber or plastic roller. Then apply a thin, even film of the color into the area to be stenciled on the plate. The roller should be large enough to cover the entire shape at one pass to avoid streaks. Be careful not to pull up the stencil, as it will tend to adhere to the ink on the roller. The ink deposit should be as perfect as possible to avoid having to go back and roll again. The first roll usually pulls up some intaglio color, which is transferred to the roller, where it can contaminate the stencil color or be deposited back on the etching plate in the next pass of the roller. The plate may now be printed, in the usual manner, in the etching press. Because of the time involved in the inking process, it is helpful to add oil of cloves to the etching ink to retard drying.

It is possible to add color to an etching impression that has dried. The stencil method may be used, but because the color will lie on top of the intaglio ink, it should be a thin, transparent film unless it is to remain as a surface color, sitting on top of the intaglio impression. The stencil is placed directly on top of the paper and the color rolled on with soft-rubber or plastic rollers. You can use water-based color for this technique; because it sinks down into the paper and is naturally transparent, it often works quite well. If too much color is deposited on the print, blot it off with clean newsprint.

Chine Collé

In this method you place thin pieces of colored paper, cut or torn to a desired shape, into position on your plate. You then glue the paper and print the image

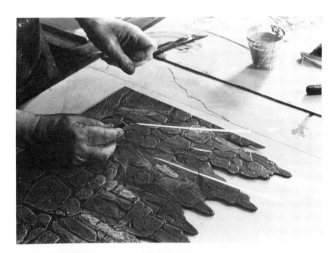

Transparent vinyl stencils are being prepared for this intaglio plate. Only certain areas are to be inked, so the stencil will protect those areas that must not receive ink from the roller. The shapes to be cut are marked on the vinyl with a grease pencil or litho crayon.

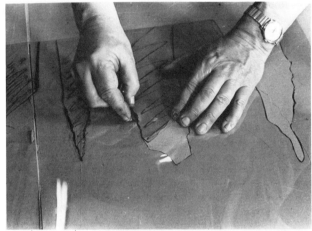

The vinyl is placed on a clean sheet of chipboard, which serves as a cutting board. A razor blade or X-Acto knife is used to cut upon areas in the vinyl.

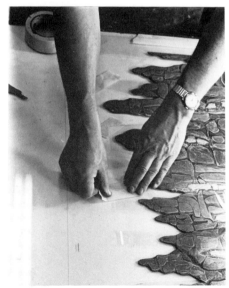

The intaglio plate is inked and wiped in the normal manner and placed on the inkling slab; the stencil is taped into position with masking tape.

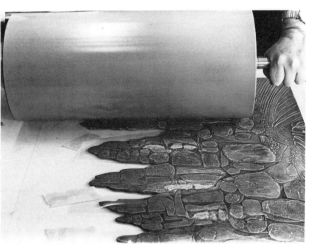

As the large, soft roller is passed over the plate, the stencil protects those areas not meant to receive color. If, however, the stencil is not taped to the slab, it will adhere to the sticky ink and be picked up by the roller with each pass.

with one roll through the press. The intaglio plate will impress its textures and forms into the colored paper.

The procedure for *chine collé* is simple, but it must be done without wasting time at the critical point of gluing. First cut or tear the colored paper into the form you want. If it needs to be dampened, put it in the water to soak along with the heavier printing paper that will carry the entire image. This could be Arches Cover, Stonehenge, Rives BFK, Lenox 100, or the like. Now ink and wipe the plate and place it on the bed of the etching press. Blot all the paper to be used and keep it near the press on a convenient table. Brush the prepared adhesive evenly over the back of each piece. Place these pieces glue side up, in position on top of your inked plate. Quickly place your full sheet of heavier paper over all this. Run it through the press with normal pressure. The small pieces will adhere to the larger sheet, with the inked image on top. Dry under blotters in the usual manner. If you wait too long to print a plate, the glued pieces may dry out. Practice a few times to check the paste solution in an actual printing situation. No glue should ooze out around the edges, and all the surfaces should adhere well.

You can use a number of colored papers. Choose ones that are very thin (such as rice papers), have relative permanence, and do not run or bleed in water. (If you cannot find the color you desire, apply a thin coat of acrylic paint to Japanese rice paper or thin drawing paper.) Some papers must be presoaked in water to soften the fibers, particularly Strathmore charcoal paper (100 percent cotton), Canson Mi Teintes, Fabriano Roma, and Ingres. These should be softened in water and blotted very thoroughly until they are only damp. If the paper is too wet, it will dilute the glue used to paste it down and weaken the bond. On the other hand, some Japanese papers, such as *moriki*, *mingei*, and *tosa*, do not need dampening because they are so porous that they do not curl when the paste is applied. Because they are thin, they adhere beautifully. Many new handmade 100 percent rag papers are available from New York Central Art Supply, Crestwood Paper, Andrews Nelson Whitehead, and Aiko.

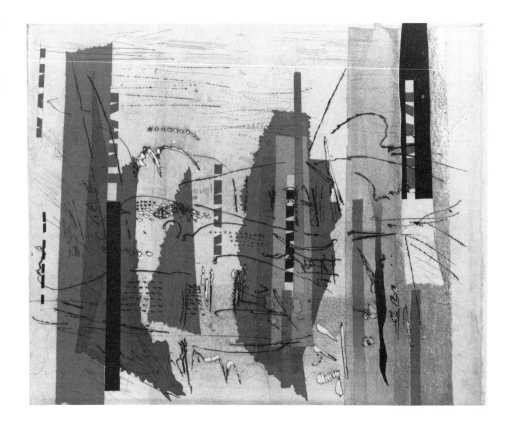

MISCH KOHN
Gertrude's City
Engraving and *chine collé*, 12¼" × 14⅞"
Courtesy of the artist

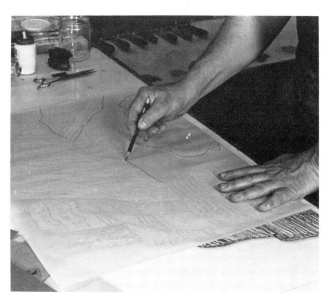

The *chine collé* process uses pieces of thin colored paper, which are glued to the support paper, under the printed image. First decide which shapes in your print should receive the colored paper and draw them on tracing paper. Cut them out with a scissors or razor blade.

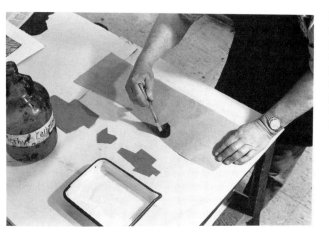

Ink and wipe the intaglio plate and place it on the bed of the press ready for printing. Coat the back of the cut colored-paper shapes with a glue solution—methyl-cellulose glue, library paste, potato starch, arrowroot paste, wheat paste, or the like. Work quickly.

The adhesives used for *chine collé* vary from the traditional—library paste, potato starch, arrowroot paste, and wheat paste—to the most recent, methyl cellulose and jade glue. Methyl cellulose has a very low acid content and can be removed with water. Jade glue, a polyvinyl acetate adhesive with a neutral pH, is more permanent and can be removed only with ethyl alcohol or acetone. Both of these products and most of the pastes listed can be obtained from Talas in New York City, as well as a few well-stocked art-supply stores. All can be thinned with water to an easily brushable mixture and applied with a wide, soft brush such as a camel's hair or Japanese hake brush.

Multiple-Plate Printing

With multiple-plate printing you can produce richly colored imagery quite different from other color-print methods. This process exploits the nuances of overprinting color by using a separate plate for each color. For example, if you start with the primaries, yellow, blue, and red, you can achieve green, purple, orange, and brown tones through the mixtures created as colors print over each other. If you leave areas of the paper bare, the white or color of the paper can be perceived as an eighth color. In addition, if each plate contains a variety of techniques such as line etching, aquatinting, deep biting, and soft ground, lush color qualities will enhance the overprinting.

PREPARING THE PLATE

To visualize some of the enormous possibilities inherent in this method, it is helpful for beginners to prepare a color sketch with colored pencils, watercolors, or pastels—materials that can simulate the quality of overprinting. At first limit your palette to three colors you wish to use. Although the primaries give the most obvious results, many other combinations can also produce interesting effects. After the drawing is complete, select the color that has the most information on it to serve as your key plate.

Place the pieces of colored paper on top of the inked intaglio plate, glue side up.

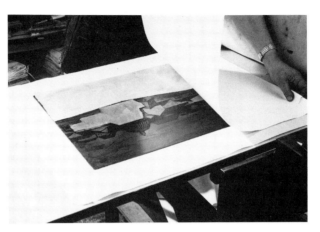

Place heavier support paper, which will carry the entire image, on top of the plate and the glue-coated pieces of colored paper.

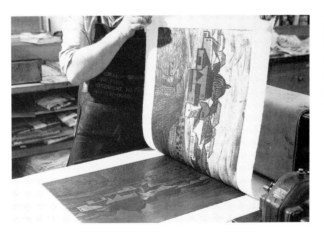

After it is run through the etching press, the inked image is impressed into both the colored papers and the support sheet to which they have been glued.

Masking or strapping tape

register tab

REGISTER TABS

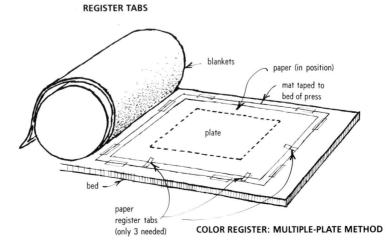

blankets

paper (in position)

mat taped to bed of press

plate

bed

paper register tabs (only 3 needed)

COLOR REGISTER: MULTIPLE-PLATE METHOD

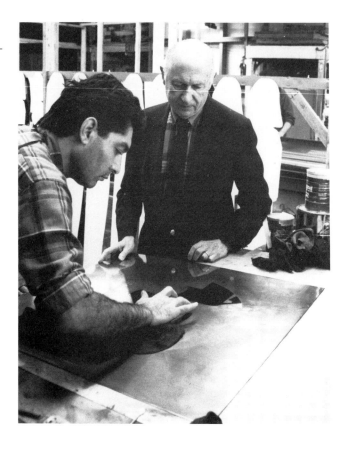

Will Barnet observes Shamsi Khuda, master printer, hand-wipe an aquatint plate from Barnet's eleven-color intaglio print *Twilight* at Styria Studio, New York.

Trace the imagery of that color onto a piece of tracing paper and transfer it to your first plate using carbon paper. Reverse the tracing so that the plate will print the way your drawing was planned. This will serve as your key plate and as a guide for registering the colors of subsequent plates. Etch the key plate in whatever method you choose and use an appropriate registration system for transferring the image. The mat registration method is a simple one to use (its description follows).

Multiple plates can also be prepared without a preliminary sketch. If you prefer to work spontaneously, develop your image directly on the first plate. Use a proof of the plate to indicate further color development with watercolor or colored pencil and proceed to offset the first plate's image onto the remaining plates as described in the following paragraphs. This can be an interesting way to work because it is difficult to anticipate exactly how colors will overprint.

MAT REGISTRATION

The mat method is an easy system to use for both transferring the image from the key plate to subsequent plates and for printing the edition. It requires a sheet of mat board with an opening cut into it of the same size as the plates to be printed. The board should be thinner than the plate or it will emboss into the print.

The mat should be given several coats of clear acrylic spray to minimize absorption of water and to facilitate the removal of ink smudges and the like. If it is not sealed with acrylic spray, printing a large edition will cause the mat to warp or buckle.

Of course, all the plates need to be trimmed to the same size so that each will fit precisely into the opening of the mat. Any shifting of the plates results in just that much variance in the precision of the register. The mat should be taped to the bed of the press and should be large enough to accommodate the paper that is to be printed, with room for the margins.

The printing paper can then be taped on one end to the top of the mat, or it can be secured under the roller and not moved during printing. The plates can all be inked at one time and inserted one after another in the mat aperture and printed.

TRANSFERRING THE KEY-PLATE IMAGE

After the plate is etched, inked, and wiped, it can be placed in the aperture of the registration mat and printed onto a sheet of dampened smooth paper. When pulling the proof, keep one end of the sheet trapped under the roller of the press or taped to the mat. This will prevent the paper from moving. Remove the first plate and replace it with a clean, unworked plate. Lower the printed im-

pression of the first plate on top of the second plate, and run it through the press to transfer the image. Remove the plate, and if there is a third plate planned, repeat the procedure.

Next, with a light drypoint line, trace the major shapes or forms of the images so that they can serve as a guide for additional colors. Now the second plate can be developed with whatever technique you want. If a ground is applied, be sure it is thin so that the drypoint image is visible. After the second plate is etched, its image can be transferred to the third plate using the same procedure.

PRINTING THE PLATES

After all the plates have been completed, the proofing of plates and printing of the edition are essentially the same as the method for transferring the key-plate image to the other plates. Mat registration or one of the alternative methods described below can be used for final printing.

Although the key plate was used to transfer the image onto additional plates, it is not necessarily the plate you print first for the final edition. The sequence of colors can also vary. Either light colors or dark colors can be printed first, depending on the effects you want. If you use intaglio wiping with relief rolling, you can enhance color possibilities still further. You can also combine other methods such as stenciling, *chine collé*, and *à la poupée* to expand color possibilities still further.

Printing multiple plates in register is complicated by the fact that the dampened paper stretches as moisture is added. When printing two or more plates, the shrinkage that occurs as the paper dries out causes problems in registering subsequent plates. Do not plan a register that will require precision that cannot be easily obtained by whatever method you employ. In general, color registry in intaglio processes is not so accurate as that obtained in other procedures, such as silkscreen, woodcut, and lithography. For this reason, many artists create mixed-media prints, making use of the advantages of several processes in their images.

Ink both the plates at the same time, then place the first plate in the mat opening and place the paper on top,

taped to the mat or lined up with its edge. If you don't use tape, print the first plate but stop the roller while it is still on top of the end of the paper. This will keep the paper from shifting while you remove the first plate and replace it with the second plate, previously inked. When you print the second plate, it should be in correct register. Since the color from the first plate will still be wet, it will merge with the color from the second plate, giving good secondary hues from the overprinting.

ALTERNATIVE REGISTRATION METHODS

Although mat registration is easiest, there are several other possible registration methods.

Trapped-paper registration The trapped-paper method is accomplished by keeping the paper caught under the blankets and using metal weights for registration. These weights can be heavy metal with at least one straight side. Some shops use the metal furniture from old typesetting systems, which were originally used as spacing material in letterpress lockups. When the first plate is printed, the press roller passes over the plate, with the end of the paper left trapped under the

blankets. Before the plate is moved its place is marked by butting two weights next to two plate edges. The next plate will then fit exactly into the place when the first plate is removed. When the weights are taken up and the trapped paper lowered, registration is achieved.

Template registration A device now in use for registering color etchings consists of two pieces of metal or cardboard with L-shaped corner projections on each. The outer piece is fixed to the bed of the press either with tape, glue, or screws. The other part is fitted into the notch of the first piece. This serves as the element that actually places the inked plate in

WILL BARNET
Twilight, 1988
Eleven-color aquatint, 19¾" diameter
Courtesy Styria Studio, New York

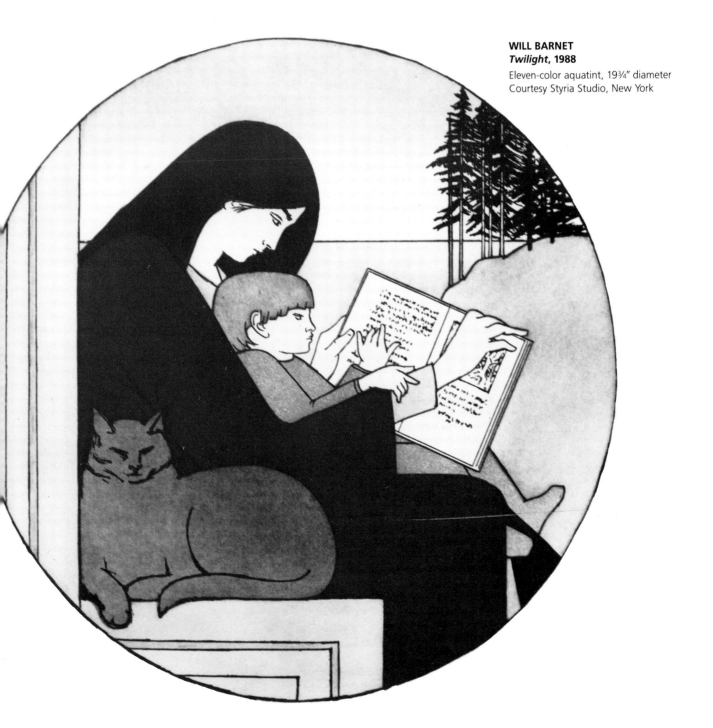

Another method for registering multiple plates requires two pieces of cardboard or metal with corner protrusions extending about ½ inch on each piece. Tape the first piece to the bed of the press with duct or masking tape. Place the first plate in position on the bed of the press. This plate is segmented, so you must be careful to prevent smudging of ink around the edges of the press bed.

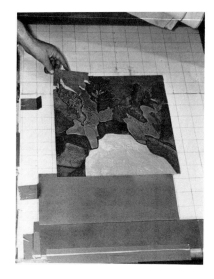

Remove the second notched register piece from the press bed. The plate must not be moved during the process.

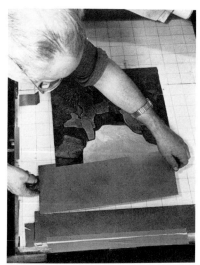

Now position the dampened printing paper by placing it in the tape-register guides. The first register piece is still taped to the bed, and this acts as a stop for the paper. Print the first plate and put it between dampened sheets of newsprint to keep it moist while you ink and wipe the second plate.

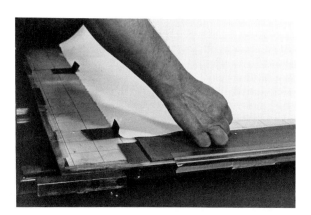

Put the cardboard register piece back in position on the bed. Also put the second plate, inked and wiped, in its place on the bed of the press. Remove the movable register guide from its place, again making sure that you do not disturb the plate. Print the impression from the first plate, putting it back into the register tapes as before. The two impressions should be properly registered.

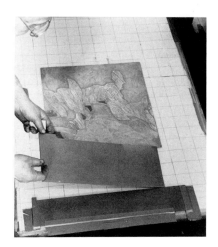

position. When all the parts have been snugly fitted, the second piece is removed. The plate is then ready for printing. The length and width of the movable section are determined by the size of the plate and the margins desired. Registration tabs of tape can hold the paper in position or, if you allow enough margin, the end of the paper can be left under the roller of the press. It can then be flipped back over the roller while the plates are changed. When it is replaced in position, it should still be in correct register. If the paper isn't long enough to be trapped under the roller, you may use heavy weights to hold one end of the paper in place when changing plates. Of course, the weights must be removed before printing.

Hand-flipping registration A rather primitive method of registering two plates consists of pulling a proof of the first plate, leaving the paper face up on a table, then placing the second plate, face down, directly over the impression of the first plate. The only difficulty with this method comes when you attempt to turn the plate and paper over in order to print it on the etching press. It takes good pressure with your hands to keep the paper from shifting as it is flipped over in contact with the plate. The process is useful for proofs and trying out various color combinations. Edition printing requires fixing the position of the plates with the mat method previously described.

Transfers from Other Plates

Images from other plates can be transferred to your intaglio plate. Any relief plate, such as a photoengraving, woodcut, or linoleum cut, or a textured element such as fabric, a found object, or the like can be inked with a surface rolling of medium-viscosity ink. This can be transferred to a large, clean roller of sufficient size to take the entire image in one roll. From the roller it can be transferred again to the surface of your base intaglio plate. Guide strips of 1-by-2-inch wood can be used to keep the roller under control as you transfer the ink from the initial plate to the roller,

then onto the base plate. Of course, the first deposit of ink should be fairly heavy in order to withstand the three transfers involved in the process.

Viscosity Method

This is a unique method of multicolor printing using one plate. The process, developed by Krishna Reddy at Stanley William Hayter's Atelier 17 in Paris, relies on three important attributes: the development of a plate with multiple levels, the use of inks of different viscosities (stiff and oily), and rollers of varied durometers (soft and hard).

In addition to the previously listed materials for the intaglio method, you will need:

Multilevel metal or collagraph plate

Light plate oil or linseed oil

Powdered magnesia

Hard roller (approximately 60 durometer)

Soft roller (approximately 20 durometer)

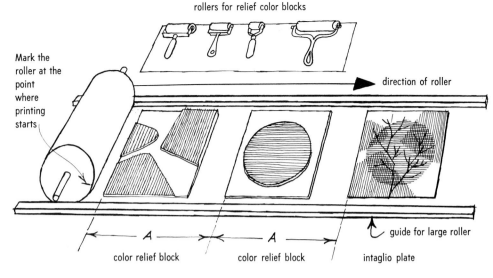

COLOR REGISTER SYSTEM

To create multicolor prints from a combination of relief blocks and an intaglio plate, the intaglio plate should be inked and wiped first. Use oil of cloves in the ink to retard the drying time. Next ink the surface of the relief blocks with small brayers, using letterpress ink with less viscosity than the intaglio ink. Place the blocks and plate in the sequence shown, making sure that the circumference of the large roller is adequate to carry the complete image. Mark the edge of the large roller at the point where the blocks start to print. At each complete turn of the roller, the point where the next block should be placed will be clearly evident. Mark this point on your table so that the blocks align properly in each printing cycle. As you roll the roller over each block, the color will be picked up on the roller and transferred to the intaglio plate at the end of the cycle. This plate should be printed promptly in the etching press, using dampened paper.

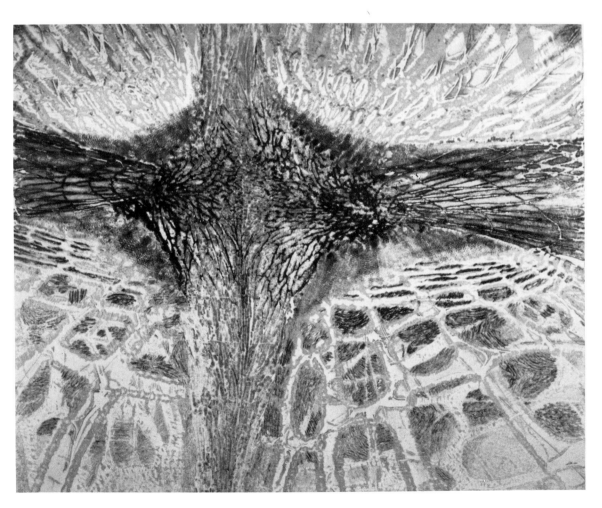

KRISHNA REDDY
Flower Formation
Color engraving,
etching, 16″ × 18″
Courtesy of the artist

REJECTIVE VISCOSITY METHOD

FIRST ROLLER
(can be rolled more than once)

SECOND ROLLER
(one pass only)

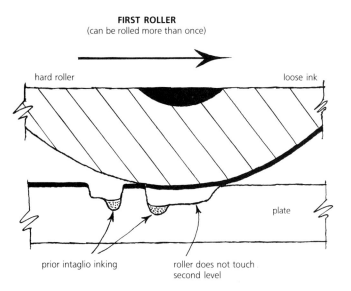

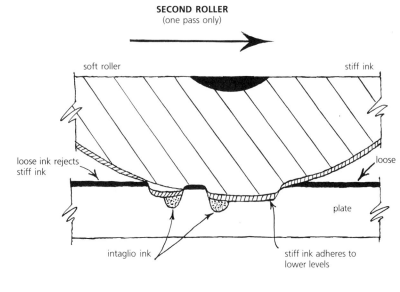

These drawings show the basic sequence of the rejective viscosity method. After the deeply etched intaglio lines have been inked and wiped, the first roller of 60 durometer (hard) is covered with loose, runny ink and passed over the plate. The second roller of 20 durometer (soft) is covered with stiff ink and passed over the plate with heavy pressure. The loose ink rejects the stiff ink on the surface, but the soft roller pushes the stiff ink onto the lower levels of the plate.

ADDITIVE VISCOSITY METHOD

FIRST ROLLER
(one pass only if intaglio ink picks up)

SECOND ROLLER

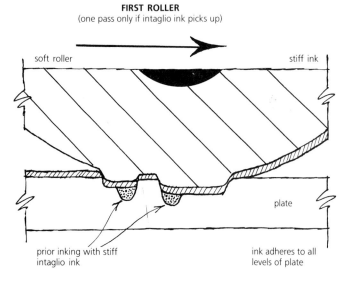

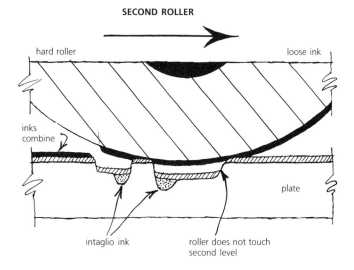

These drawings show the additive viscosity method of inking the plate, after normal intaglio inking and wiping. The soft roller, covered with stiff ink, presses into the deep recesses as well as the surface of the plate. On the next pass of the hard roller, which is covered with loose ink, the inks mix where the roller contacts the upper surfaces of the plate.

In the viscosity process at least three different colored inks are used. The first ink can be right from the can or adjusted to ensure a normal intaglio wiping. The second ink should be as shown, very soupy or loose, so that it runs from the palette knife. Thin the ink with raw linseed oil or thin plate oil.

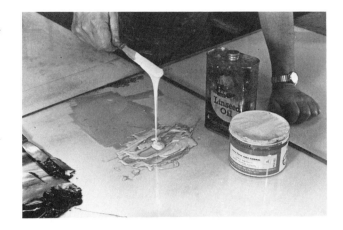

The third color should be much more viscous or stiff and should cling to the palette knife as shown. Use little or no oil in this step. In fact, you may have to add magnesium carbonate (dry magnesia) as a stiffener.

Test your viscosities by rolling out a strip of the soupy ink with a small brayer on a glass slab. Use yellow or another bright, light color.

With a second brayer inked with the more viscous color, roll a strip of color directly over the first ink. The first color should almost completely reject the second color. If it does, you are ready to try your plate.

Start your plate by creating at least three different levels. The lowered levels can be achieved by open-biting areas with acid to reveal various strata of the metal. You can then work into these levels with line etching, soft ground, engraving, and other techniques to develop additional depths that will hold the color in various intensities. This process can lead to surprisingly rich, luminous, multicolored imagery.

The collagraph also offers a simple way to make these levels, without extensive biting in acid, and it is therefore an ideal technique for this inking procedure. Again, try to incorporate textures and linear cutting at the various levels so that a greater color range can be achieved. Very exciting color effects are possible.

You must have at least two rollers large enough to ink your plate in one pass, one of a hard durometer of 60, the other of a soft durometer of 20. You must also alter the viscosity of your ink, either with light plate oil or linseed oil to soften it or with dry magnesia (magnesium carbonate) to stiffen it. You will also need a sufficient slab area and tables to roll out an even film of ink with both rollers.

Normally the inks should be of complementary hues, almost primaries in their intensity, in order to achieve the most brilliant mixed colors. However, interesting, less obvious results can be achieved with more subtle colors.

First ink and wipe the plate with etching ink of medium viscosity, fairly stiff and not loose or runny. Most commercial etching inks, such as Graphic Chemical, are of medium viscosity and can be used right out of the can for intaglio color. Make your next color of low viscosity, very soupy or thin. Roll out a thin, even film of this ink with the hard roller. Pass it over the plate once with light pressure. It will ink only the highest, most raised surfaces. Next roll out a stiff ink altered with dry magnesia with your soft roller. Pass this over the plate with heavy pressure. A strange effect will be observed. The surface with the thin, soft ink will reject the stiffer ink almost completely. The lower levels of the plate will take the stiff ink because

there is no loose ink film on those surfaces.

Each roller that you use should be large enough to cover the entire plate area in one pass. Smaller rollers require several passes over the plate and pick up ink on the first pass, then transfer this ink back to the plate on the second pass, thereby contaminating the image with "ghosts" or "echoes" from the roller. The larger rollers should also be cleaned after each print is inked.

It is difficult to print an entire edition consistently because of the many possibilities for variation with the viscosity method. The stickiness of the ink varies with the temperature and also changes as the day goes by. It tends to dry out on the slab. The pressure of the roller is hard to control by hand, and the amount of ink film on the roller is crucial to the amount deposited on the plate. You must have a very organized setup to produce a consistent edition.

If you learn to control two rollers and three batches of ink, you may want to try a fourth color with another roller of intermediate durometer to ink only the middle levels of the plate. Both Hayter and Reddy have developed this technique to a high degree of control and

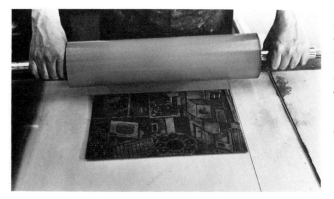

Ink and wipe the plate with the first color of normal intaglio viscosity. Place it on the inking slab. Roll over the plate with a hard roller (60 durometer), with the less viscous ink softened with linseed oil, pressing evenly but not heavily. Only the top relief surfaces should take the ink.

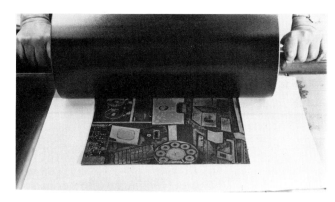

The next roller should be soft (20 durometer or less). Press down on the roller to force it into the lower levels of the plate. Only plates with several levels will print well with the process. The soft, less viscous relief ink should reject the stiffer ink and retain its color, while the stiffer ink stays in the deeper levels of the plate. Roll only once with this soft roller. Print the plate in the normal manner on the etching press.

have produced intriguing work with viscosity printing.

In many cases a plate can yield very interesting color qualities by altering the viscosity of inks without your resorting to the complications of the total viscosity method. You can use relief-rolling techniques with both large and small rollers and relief ink of less viscosity than intag-

lio ink. This process allows for more control of the inking film, and it is easier to print editions.

The almost endless range of techniques and combinations of techniques contributes to the richness of the intaglio process. In addition, the potential for color is so varied that the esthetic possibilities are enormous. New ways of expression are always present in this medium, allowing for continued innovation and invention.

3 Collagraphs

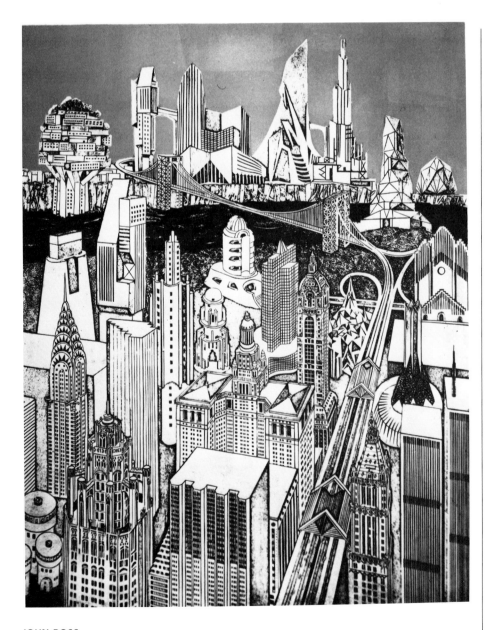

JOHN ROSS
City of Dreams, 1985
Collagraph, 36″ × 28″

A collagraph is a print made from a collage of various materials glued together on a cardboard, metal, or hardboard plate. Plastic, such as Lucite or Plexiglas, can also be used as a support for the glued materials. The word *collagraph* should not be confused with the term *collotype,* which is a mechanical printing process developed in the nineteenth century that uses a photogelatin process to achieve varied tonalities. Other names have been given to the method, such as collage intaglio, collage print, or collograph, spelled with a second *o.* The term *collagraph* seems to describe the technique best.

A collagraph plate can be printed as an intaglio plate, with the ink in the recessions, or as a relief plate, or as a combination of intaglio and relief, usually on an etching press. The plate can be inked by both intaglio and relief methods, with rollers used for inking the raised surfaces and conventional intaglio processes used for inking and wiping the recessed lines and areas. An inkless impression of the plate can be pulled for embossed effects.

Collagraphs can be combined with other methods, such as etching or photo-etching, with the etched plate printed separately or adhered to the collagraph plate. Collagraphs can also be combined with totally different media, such as lithography or screen printing, to produce mixed media prints. The possibilities for texture, embossing, and color overprinting are numerous.

Origins and Development of Collagraphs

It is difficult to pinpoint the origins of the collagraph method because several artists were working simultaneously with similar ideas and materials. There are prints from the nineteenth century that indicate the addition of adhesives to copper or zinc plates, such as Pierre Roche's two-color gypsograph published in 1893 in the magazine *L'Estampe Originale*. Using gypsum, he built up the surface of the composition and probably printed his work without a press.

The collage and assemblage experiments of Pablo Picasso, Georges Braque, Juan Gris, and Kurt Schwitters in the early years of the twentieth century led to later innovations in printmaking that placed real objects on the plates, including newspaper clippings, bits of cloth, pieces of tin, silk, burlap, and sand. Rolf Nesch, a Norwegian artist, apparently was the first to use this concept in his printmaking efforts. He developed what he called a metal print in 1932. He would solder pieces of metal to his plates, drill holes, and sew elements together with metal wire. Despite his inventiveness, Nesch was little known in the United States until twenty or thirty years later.

Boris Margo, working in the 1930s in New York, was probably one of the earliest American artists to experiment with adherents on plates. He would dissolve celluloid in acetone to build up areas of varying thickness. He often impressed textures or imbedded materials into the liquefied areas of the plate, which he then printed by relief or intaglio or embossed in the paper.

Edmond Casarella, another American artist, experimented with cardboard collage prints in 1947 and 1948. He glued layers of cardboard and paper together with rubber cement, an impermanent but handy adhesive. These "paper cuts,"

KURT SCHWITTERS
V-2, 1928
Collage of colored and printed papers with pen and ink and crayon, 5⅛" × 3½"
Sidney and Harriet Janis Collection,
gift to the Museum of Modern Art, New York

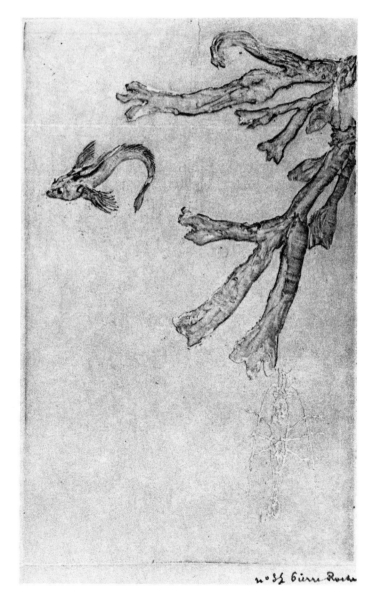

PIERRE ROCHE
Algues Marines, 1893
Color gypsograph on paper, 6¾" × 4¼"
University of Georgia Museum of Art, Athens, Georgia
Gift of the University of Georgia Foundation, 1972

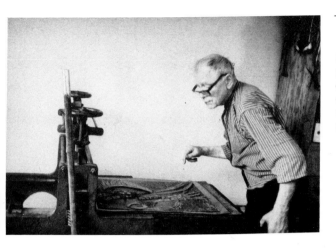

Rolf Nesch places an inked plate on the press. Six to eight blankets will be used to capture the deep emboss-ment of the heavily textured plate.

Pieces of metal are soldered to a base plate to form the image of two birds. Nesch's materials include copper and brass sheets cut with tin snips and hammered and punched to produce rich surfaces.

as Casarella called them, were mainly relief-rolled and then hand-printed. Roland Ginzel, also American, started to use cardboard plates after a fire in his studio destroyed most of his zinc plates. In 1955 he cut into the cardboard, creating multiple levels, and applied lacquer to create different surfaces, adding a scratched graffito effect to the lacquer before it dried. Ginzel also sprinkled Carborundum into the wet lacquer, which, when dried and printed, produced tonal effects similar to aquatint.

Another early practitioner was Glen Alps at the University of Washington, who actually coined the term *collagraph*. From 1956 to the late 1980s, Alps worked steadily in the medium, as an artist and a dedicated teacher. Dean Meeker at the University of Wisconsin, James Steg at Tulane, and Edward Stasack at the University of Hawaii are all early users of the collagraph as an expressive means of printmaking.

In the 1950s Clare Romano and John Ross, two of the authors of this book, began to cut out cardboard shapes, glue them to a backing sheet, and print them for the most part as relief prints. In the early 1960s they began to use acrylic gesso as the adhesive and textural agent, adding sand and fabric to enrich the tonal range. They printed these plates in an etching press, by the intaglio method, and often cut them apart to alter the rectangular format and exploit the addition of color to the image.

Making the Collagraph Plate

The collagraph plate is so easy to make that this medium is suitable for artists of various skill levels. Children can safely construct a collagraph matrix and then

ink and print it with a good chance of success. Yet the most sophisticated and knowledgeable artist can find this an expressive technique for developing complex tonal and textural images. It needs little equipment, and platemaking can be done on a table in the kitchen as well as in a well-equipped print studio.

PREPARATORY DRAWING

You can work out your idea in small compositional drawings on tracing paper, indicating the material to be used on the plate. Also indicate mass and line and define the shapes or forms. From the original sketches you can develop a more complete, full-scale drawing. The finished drawing should be drawn heavily with a soft 6B pencil or a charcoal pencil on tracing paper so that it can be transferred directly onto the base plate. Do not fix the drawing, as this will prevent it from being transferred.

Place the drawing face down and tape it to the base plate (when it is printed, the image will again be in its original orientation). Put the plate and the taped unfixed drawing on an etching press and run them through the press with one etching blanket. If the pressure is correct, the drawing will be transferred to the base plate. You can accomplish the transfer by hand rubbing or burnishing, but it is quicker to use the press. Now fix the drawing onto the plate with fixative so that it will not smudge.

MATERIALS AND TOOLS

This listing includes a wide variety of materials for many different approaches and methods. Use those items that suit your techniques.

Razor blades (single-edge industrial)

Razor blade holder (available in hardware stores)

Mat knife or X-Acto knife with interchangeable small blades

Tin snips, large and small paper scissors

Scoring tools (nail punches, rasps, dental tools, etc.)

Dremel electric jig saw (for cutting cardboard, thin metal, Masonite, or hardboard)

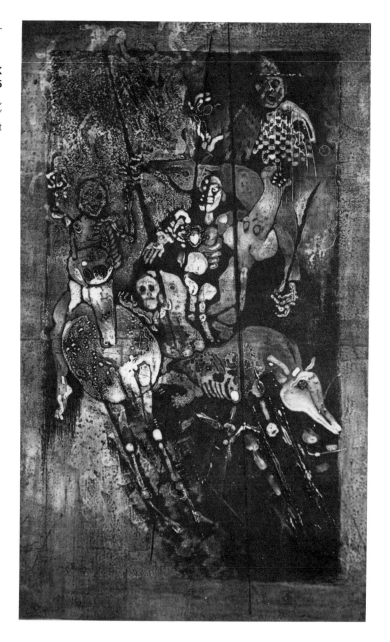

EDWARD STASACK
Four Riders, 1966
Collagraph,
29½″ × 17¾″
Courtesy of the artist

Saber saw (for cutting wood and heavier hardboard)

Jeweler's saw (for delicate small work)

Sandpaper (fine, medium, and rough)

Palette and mixing knives

Small cans and jars (for mixing gesso and glue)

Jars (for water)

Rags or paper towels (for cleaning up)

Weights (bricks, vinyl-wrapped books, and the like)

Carborundum in different grades, fine sand, crushed walnut shells, or coffee grounds

Sticks (pointed or blunt, for drawing and scoring in wet gesso)

Acrylic polymer gesso

Acrylic polymer emulsion (matte or gloss medium)

Modeling paste

White glue (Elmer's glue, Sobo, Weld-wood)

PLATE CONSTRUCTION

The base for a collagraph plate must be compatible with the glue or adhesives used on it. The edges of cut forms should be beveled before being glued to the base plate to prevent white, un-printed threads around the forms. Also make sure the base plate is not so thick that it will present problems in printing as it goes under the roller of the etching press. Thick plates are very difficult to print, particularly if the glued material is built up to more than ⅛ inch thick. Actually, not much textural depth is nec-essary because the slightest variation in level will print clearly. This sensitivity to very delicate differences in surface quality is one of the great pleasures of the collagraph technique.

The advantages and disadvantages of various base materials are listed here.

Mat or mounting board Common mat board is made from groundwood pulp filler, surfaced on each side with sheets of paper glued to the core. This material will eventually dry out and rot from the acid inherent in the pulp. It takes some years for this to happen, however, so if you pull all your proofs and editions in a

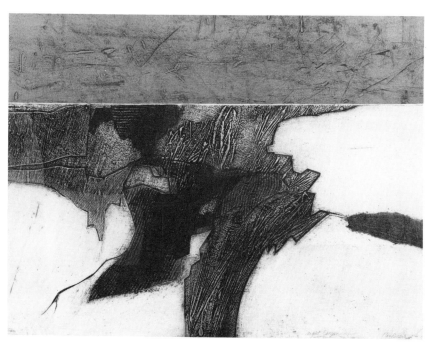

CLARE ROMANO
Night Canyon, 1976
Collagraph (four colors), 22″ × 30″
Photo: D. James Dee

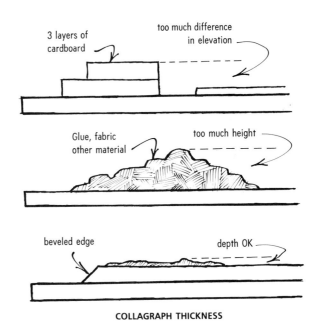

Cut the edges at a bevel to facilitate printing. Here polymer acrylic gesso is used as the glue and the sealant.

COLLAGRAPH THICKNESS

short time, you can utilize cheap mat board. If you want your plates to have a longer life, you should consider buying rag mat board (museum board), which has a neutral pH and is somewhat harder and tougher than pulp board. It is more expensive but, compared to zinc or copper plates, is quite reasonable in cost. Both types of mat board are available in ¹⁄₁₆-inch thickness, with museum board made in two ply or four ply (¹⁄₃₂ and ¹⁄₁₆ inch thick).

Mat board is relatively soft (the corners are easily damaged), making it very simple to cut with a razor blade, jig saw, or sharp knife, so you can easily segment a plate into pieces for color printing. Because both gesso and polymer mediums adhere well to mat board, it is well suited for collagraph plates. When a water-based adhesive is used, such as gesso, polymer medium, or white glue, the mat board tends to buckle or warp, especially if large pieces are glued on it. This can be minimized by gluing a separate piece of paper to the back of the warped plate; the two opposite surfaces counteract each other. Be sure to smooth out all the air bubbles and lumps when you apply this backing paper to the plate. Spraying the board with acrylic lacquer before gluing will help seal the surface and prevent it from absorbing too much water from the glue.

Chipboard, gray board, or news board This uncoated gray cardboard is supplied in a number of weights. The single thickness is too thin for plates, but the heavier weights are usable if you do not object to the acid content of the wood pulp from which the board is made. Cardboard will turn brittle and eventually disintegrate after a number of years. It is suitable for work by students and by artists whose edition printing is completed promptly. It should be treated carefully during printing and handling, as the corners are vulnerable.

Illustration or Bristol board Most illustration board is made from rag-content paper glued to a good-quality pulp core and makes a good base plate for collagraphs. The quality of the core varies widely. If high-quality, the board is relatively permanent; if not, it has the same disadvantages as mat board. Four- or five-ply Bristol board is suitable as a support for collagraphs as long as the plies do not separate.

Poster board, box board, or thin cardboard These boards are almost always made of wood pulp, sometimes surfaced with paper on one or both sides. They are not suitable for collagraph plates because of their lack of rigidity and the poor quality of the paper. Colored poster boards tend to bleed or run when a water-based glue is applied. Surface paper often separates from the core board.

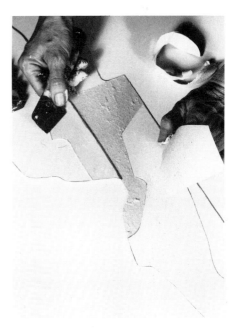

Removing the surface layer of mat board exposes the pulp underneath, creating a rougher texture that will print as a gray tone.

JOHN ROSS
Homage to the City, **1984**
Collagraph, 30″ × 66″

Hardboard panels Wood chips glued together with a waterproof adhesive form the composition of Presdwood, Masonite, and other hardboard panels. One side is usually smooth and the other rough. It does not warp as easily as paper boards, but it will buckle or warp when water-based adhesives are used on it. Two thicknesses, ⅛ and ¼ inch, are standard. The thinner panel, which comes in 4-by-8-foot sheets, is more useful because the ¼-inch panel can present difficulties in printing. The edges of both thicknesses should be beveled to help in printing.

Upson board This wood pulp product, about ¼ inch thick, should be shimmed with strips of cardboard at both ends of the plate where it enters and leaves the roller of the etching press. It takes glue well but has a mechanical, pebbly texture that can be monotonous.

Plywood panels Choose plywood that is thin and tough enough to withstand the rigors of printing and cleaning. Because of its softness, it can be crushed or dented in the etching press. You can treat it with linseed oil or coat it with polymer to seal the surface. Most adhesives work well on wood, so that all sorts of materials can be glued to its surface. You can sand the surface or scour it with a steel brush to emphasize the grain and cut it with mat knives, gouges, and saws.

Zinc, copper, and aluminum Metal plates are durable but expensive. Because they are not absorbent, many adhesives will not stick to them unless the surface has been abraded. You can use coarse sandpaper, Carborundum, or a steel wire brush to roughen it enough for glue to bond. You can also aquatint the surface of the plate enough to hold an adhesive. Epoxy cement, Miracle Adhesive, Liquid Aluminum, and Liquid Steel will adhere to metal with good results. In addition to gluing on materials, you can use drypoint to incise images on a metal plate.

Plastic sheets Plastics such as Plexiglas, Lucite, and Formica wipe very clean in printing, although eventually they get scratched. Because they are tough and durable, drypoint lines can also be scratched into their surfaces. Not all adhesives work well on plastics, however, because of their nonabsorbent quality. PVC adhesive, epoxy, polymer medium, and lacquer will bind if the plates are clean and grease-free. They can be cleaned with paint thinner, but lacquer thinner and acetone will dissolve most panels. The laminated plastic sheets frequently used for countertops are difficult to work, brittle, and obstinate to cut, and generally are useful only as a last resort.

Linoleum, rubber, or vinyl tiles Sheet linoleum is still being produced but is getting hard to find these days. It is easy to cut, cleans well, and takes many adhesives. Although it must be beveled well to go through the press smoothly, it is an excellent material for relief prints and can be used in conjunction with other plates for color overprinting. its disadvantages are that it is brittle, breaks easily, and scratches more easily than most of the materials listed here.

Rubber and vinyl tiles have interesting textures that can be quite useful. Some of these simulate stone, brick, and abstract patterns. Be sure to test the materials you are using because certain tiles will dissolve in some of the solvents used in cleaning and gluing.

ADHESIVES

A number of glues can be used to adhere collagraph materials to a base plate. The bond should be permanent, flexible, impervious to the solvents used in cleaning, and waterproof enough to resist the dampness of the printing paper.

Acrylic polymer emulsion Sometimes sold as matte or gloss medium, this compound is used for mixing and glazing acrylic pigments in painting. An excellent adhesive, it will bind cardboard, cloth, sand, and many other materials together and dries colorless and transparent. The gloss emulsion wipes clean when printed in the intaglio technique, whereas the matte medium retains a slightly gray tone.

Gesso (acrylic polymer latex) This is a base of acrylic polymer emulsion to which a pigment (such as titanium oxide) and calcium, magnesium, and aluminum carbonates and silicates are added. If a finely ground pumice is added to give the coating tooth, the dried gesso will print with a gray tone when it is inked and wiped as an intaglio print. Gesso is an excellent adhesive and retains its flexibility when dry. It will adhere mat board, chipboard, paper, fabrics, sand, Masonite (hardboard), and some metals to a backing board. Most of the solvents used to clean ink from printing plates, such as mineral spirits, paint thinner, turpentine, kerosene, subturps, and the like, have no effect on gesso after it has dried. However, it can be dissolved with lacquer thinner, toluene, acetone, or benzine, all of which are dangerously toxic chemicals. Avoid these solvents in your workshop (see the chapter on health hazards).

Modeling paste When gesso is thickened with ground marble powder, it becomes modeling paste, which has the consistency of wet plaster and is easily worked into strong textures. It can be used with gel medium to increase its flexibility.

White glues Elmer's glue, Sobo, and Weldwood glues are emulsions of polyvinyl acetate resin in water. They are white in the container but dry clear and hard. Essentially, they are light-duty adhesives and are good for paper, cardboard, porous fabrics, and sand. They are not suitable for plastics, metal, rubber, or leather. When you use a white glue as an adhesive, be sure to seal the surface with a coating of shellac, acrylic lacquer, or varnish. If you leave it unsealed, the dampness of the printing paper may cause the plate to stick.

GLEN ALPS
Space Tensions, **1956**
Collagraph (black and white), 22″ × 28″
Courtesy of the artist
Cut paper and cardboard were glued to a base of ¼-inch Upson board with beveled edges. Clear lacquer and ground walnut shells were used for gray and black tones. The plate was intaglio-inked, wiped with a cotton cloth, and printed on an etching press.

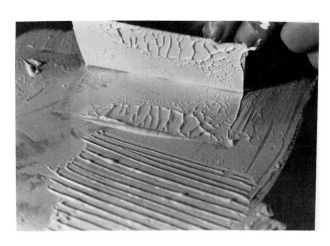

When the gesso has reached the right tackiness, it yields this type of texture if you press a piece of board into it and then lift the board while still wet.

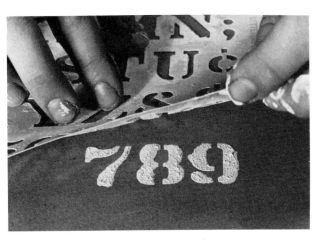

You can use stencils for letters and numbers if you stipple thickened gesso through the apertures onto the baseboard. The heavy texture of the gesso will harden and hold ink when dry. In this case the numbers will print reversed because they are correct on the plate.

Epoxy Metal and plastic can be glued to base plates with epoxy resins, which are two-stage adhesives that are mixed just before use. A resin is mixed with an equal amount of amine hardener, then applied to both surfaces, which are pressed together and allowed to dry completely, for several hours or perhaps overnight. Both epoxy resins and amine hardeners, which are mixed together to form the bonding agent, are irritants and toxic, even in small quantities.

Shellac This can be used as an adhesive as well as a sealant. It should be fairly thick when used as a glue. A 5-pound mixture is thick enough, but suppliers are stocking 3- and 4-pound cuts as an economy measure. Shellac dries hard and sometimes becomes brittle if it is too thick when applied. It is dissolved in alcohol and therefore dries quickly. The shelf life is short, however, so do not use old shellac, as it will never dry properly.

Other commercial adhesives There are many brands of adhesive available in hardware stores, such as Duco Cement, Miracle Adhesive, Liquid Steel, Liquid Aluminum, and Ambroid. Many of them are useful to the artist for texturing possibilities and for gluing metal to metal (such as Liquid Steel and Liquid Aluminum). Most are expensive. Follow the directions on the label.

Soldering and brazing Some artists find that metal-to-metal adhesion is best done with heat by soldering or brazing. Tin or lead solders melt at 700°F or lower. Brazing techniques use silver solder at higher temperatures. Brass, copper, zinc, tin, and various alloys can be permanently joined by either method. Copper and brass are easy to join, but zinc melts at a very low temperature and should be handled with care.

You will need a soldering iron, a roll of acid-core solder, a fine file, and a suitable place to work. (Clear the workspace of flammable materials.) You must coat the area where the metals are to be joined with flux before applying the solder, unless you are using a rosin-core solder. You can join flat pieces of metal by applying a thin layer of solder to the edges and pressing a hot soldering iron firmly on top of the joint. Feed in a little extra solder from the side and press the pieces together with a stick or a screwdriver. This will sweat them together, and the solder will be sucked into the joint. Keep the pressure on until the joint has cooled because metal expands when heated and the pieces tend to separate. The solder can be filed after it has cooled, but work carefully because soldered joints can break under stress.

Lacquer This material can be brushed or sprayed on, either as a sealant or as an adhesive if thick enough. There are many formulations for lacquer, most of which are used as furniture finish or wood sealer. Lacquer is useful as a final coat on a collagraph to seal rough papers and fabrics from the penetrations of printing ink and solvents. However, lacquer is toxic, as is lacquer thinner, which usually contains toluene, xylene, benzolene, and the like—all dangerous to use. For these reasons we prefer polyurethane or acrylic polymer medium.

Spray adhesives Although manufacturers claim that the adhesives sold in pressurized cans are permanent, we have yet to find a spray that is both permanent and not loosened or dissolved by the solvents used to clean the collagraph plate after printing. In other words, if you find a spray adhesive that works for you, you are on your own. There are none that we can recommend. The fumes from many of them are particularly toxic, and they should be used with caution and only with excellent ventilation.

Rubber cement or wax These materials are widely used in graphic design studios for preparing camera-ready mechanicals. They do not make a strong, permanent bond, and the usual cleaning solvents dissolve both. In an emergency, they can be used, but the plates will yield only a small number of proofs. When there are so many excellent adhesives on the market, there is no point in using unsuitable materials.

Rivets or clips We include riveting and clipping, although no adhesive is involved, because they do attach pieces of material to each other. If rivets or grommets are too thick, they can ruin paper, blankets, or press rollers, so flatten them with a hammer before printing. Metal plates can be sewn with copper wire,

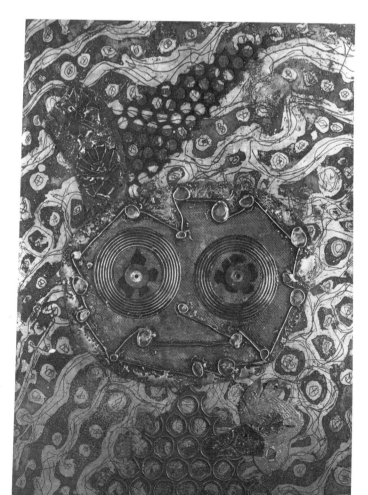

ROLF NESCH
Toy (plate), 1965
Metal collage plate,
22⁹/₁₆″ × 16½″
Collection of
Walter Bareiss

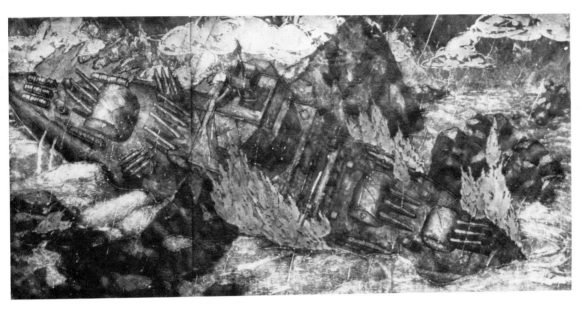

then inked and printed on the etching press. Metal clips can also be used, but they should be hammered flat before inking and printing begin.

MATERIALS FOR CREATING TEXTURES

To get a full-value dark from a collagraph plate, you must apply an evenly textured surface to the plate, somewhat like an aquatint, that will hold enough ink to print well. Many fabrics and other materials that are tonal by nature will yield a large variety of grays. The most practical solutions are described here.

Sand, Carborundum, or crushed walnut shells
The richest black in the collagraph technique is achieved with sand. Pour dry sand onto a wet coating of gesso or polymer medium, and the sand will stick to the glued area. When it is dry, turn the plate on its side and tap it to make the excess sand fall off. You can save the excess for future use. For a sand container, use an ordinary household jar with a metal lid; punch a dozen holes in the top and use it like a salt shaker to sprinkle the sand.

Carborundum, or silicon carbide, makes a finer texture than sand. You can also use ground walnut shells, which are available in some paint-supply stores as a texturing agent in house paint. Coffee grounds have been used, but must be well glued to the board.

After the gesso has dried and the excess sand is removed, the plate should be sealed with a couple of coats of polymer gloss medium (thinned 50-50 with water) to hold the grains of sand in place. You can control the tonality by adding more coats of polymer medium or lacquer spray to lighten the tone.

You can also paint freely with gesso or polymer medium on a base plate of mat board and establish tones where you want them by sprinkling sand into your wet painting. A linear painting or one with strong divisions of shape or form works best.

Sandpaper You can adhere sheets of medium sandpaper to the base plate to cover large areas quickly. Coat the back of the sandpaper and the face of the plate with gesso or polymer medium, press them together, and weight while drying. Then seal the surface with lacquer spray. Fine sandpaper loses its texture too quickly, while the rougher grades tear the wiping tarlatan and cleaning rags to shreds.

Cardboard Many shapes, forms, and textures can be made by cutting or tearing cardboard and gluing the pieces to a base plate. Cardboard is cheap and easy to handle, cuts and tears with simple tools, and adheres well to most plates. It can be incised with razor blades or an X-Acto knife to make lines that will print somewhat like an etched line in a metal plate. Thicker pieces of board should be beveled before they are glued to the base plate to make printing easier and elimi-

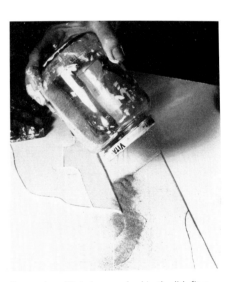

From a jar with holes punched in the lid, fine sand is sprinkled into wet gesso. It will harden into a rough surface and print as a dark value. Tap off the excess sand. Carborundum, which is less abrasive, can be used instead of sand.

By tearing rag mat board with your fingers, you can create soft-edged shapes for pasting on a collagraph plate.

nate white or unprinted edges around the shapes. Thinner boards, such as box board or one-ply cardboard, do not need to be beveled.

Paper Thin papers can be crumpled or folded if they are glued on both sides. There should be no air pockets under the paper; if there are, you can slit or puncture the sheet to allow the air to escape and then press the surfaces together again to ensure adhesion. Bond paper and good-quality stock will wrinkle without falling apart, but newsprint or pulp paper are so weak that they disintegrate when wet.

Adhesive tapes All sorts of adhesive tapes can be used in making a collagraph plate. Gummed paper tape comes in many widths and should be thoroughly sealed with polymer medium or lacquer spray after it is glued. The same should be done with computer tapes after they are adhered to the plate with glue. Masking tape, cellophane tape, and transparent mending tape can also be used. Because their adhesives may be dissolved by the solvents used in cleaning the ink from the plate, all of them must be sealed with polymer medium or lacquer spray.

Organza A wide range of tonality can be achieved by gluing silk organza or nylon organdy to the surface of a plate with a 50-50 mixture of polymer gloss medium and water. Use a wide, soft brush when applying the adhesive. When the fabric has dried, it will yield a dark tone, similar to aquatint. To obtain lighter grays, add more coats of polymer medium or even thicker gesso. The more coats of glue you add, the lighter the tone will print. You can paint directly as you would onto canvas and achieve painterly effects with a brush, sponge, or squeegee, or you can glue other materials into the organza for collage-like results. The plates, when printed, resemble aquatints or mezzotints.

Other fabrics Many other fabrics are suitable for inclusion on collagraph plates. Finer materials like broadcloth, rayon or silk organza, and linen should be glued to the plate with as few coats of polymer medium or gesso as possible so as not to clog the fine mesh of the fabric. The more glue used, the more the texture is reduced.

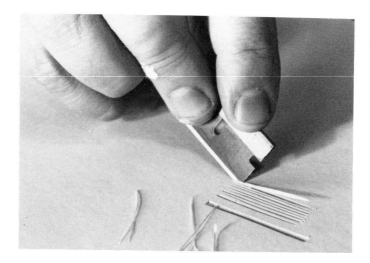

Fine lines can be cut into smooth mat board with a sharp razor blade or X-Acto knife.

Torn mat board is glued to the baseboard and excess gesso is removed with fingers.

Here, thin bond paper is coated on both sides with acrylic polymer gesso. The paper is wrinkled while it is still wet with gesso. It must be pressed down thoroughly with your fingers.

Burlap, corduroy, bouclé, knits, and other decorative weaves are suitable for collagraph plates and will give you a wide range of textural possibilities. These coarsely woven materials must be saturated or soaked with polymer medium or gesso in order to seal them from the inks and solvents used in printing. Loose threads should be securely glued down. Material that is especially thick, such as carpet, is unsuitable because it is difficult to print in an etching press.

Make sure that everything is dry before printing. If you print a plate that is still wet, the glue will squish out and spread all over the plate, probably gluing the paper to the plate. You can use low heat to help dry heavy, thick fabrics.

Plant material Leaves from trees and bushes can be adhered to a base plate. Use fresh material when possible; old, dried plants are too brittle and fragile to withstand the wear that gluing and printing demand. Thick, soft plants that hold

moisture in their stems are not suitable, however, because they will be crushed in the etching press and ooze over the plate. Heavy plant stems or woody twigs are too difficult to adhere to the plate or too thick to print in the press. Rice grains and wood chips are hard to handle. Use your common sense when you want to try a new material.

Plastic and metal foil These materials are impervious to most adhesives and present special problems. Roughening the surface with sandpaper will give the glue more of a chance to grip. Thin foil, however, is particularly difficult to glue because it is hard to sand and keeps lifting off the plate.

Sheet acetate and heavy vinyl can be adhered to a plate with polymer medium. Metal foil and plastic sheeting come with contact cement on one side, but their edges should be sealed with polymer emulsion so that plate-cleaning solvents will not get under them. All the smooth plastics and foil will wipe clean and print white.

Found objects The collagraph method is particularly appropriate for exploiting unusual objects. If you cannot print directly from the object, you may be able to take an impression from it in gesso, polymer medium, or cardboard and print from that impression. Other items such as coins, washers, gaskets, small gears, and the like can readily be glued to a collagraph base plate. Be careful not to use material that is so thick that it will ruin your blankets or, in extreme cases, dent the rollers or bed of your press.

Embossed greeting cards can be used as plates for printing. Tin cans and metal containers that have embossed designs and letters are also suitable. It is a good idea to fill the back of the embossed card with a coat or two of gesso or even Plastic Wood so that the pressure of printing will not flatten the embossing. Scrape with a card or putty knife to leave the filler only in the hollow of the embossing. After this hardens, glue the card in place on your plate.

Perforated metal or plastic grids and strainers have been used successfully for printing. Screening made of copper, aluminum, or plastic can be secured to a base plate or printed separately if the piece is large enough. Other found objects can add new designs and textures, presenting new challenges to the artist.

These plates show various textural possibilities:
(A) Different forms of adhesive tape are used, from masking tape to black cellulose tape. Repeated printing tends to loosen certain tapes, because the usual solvents dissolve their adhesives.
(B) This is part of a tulip-tree leaf, showing the stem and veins branching out.
(C) This metal-covered gasket must be inset into a cardboard plate or its excessive thickness will make it difficult to print.
(D) Fine lines like these may be cut into smooth mat board with a sharp razor blade. Use spray lacquer to seal the cut edges; gesso is too thick and will fill the finest lines.

The printed results:
(A) The smooth photo tapes wipe clean and therefore print a very light value.
(B) The tulip-tree leaf prints its characteristic shape and forms.
(C) The metal gasket prints beautifully because it wipes so clean and gives such good detail.
(D) The razor-blade cuts have a sharply linear effect.

Gesso is forced out of a syringe to create dimensional figures on a cardboard ground. A detail of the printed result is shown on the right.

Syringe designs If you can obtain a plastic medical syringe, you can use it to make linear designs on your collagraph plates. Fill it with thickened gesso, allowing no air to be trapped inside. The rubber gasket on the plunger will force the gesso out in a controllable stream. If the gesso has enough body, it will hold its shape until dry, when the design can be printed in the usual manner.

A coin may be embossed into mat or illustration board by running it through the etching press. Put another board on top to protect blankets.

Printing the Collagraph

Although the basic printing process is the same for etching (see page 112), it is more difficult to print a collagraph plate than an etching made on a zinc or copper plate. Keep in mind, if you desire color, that the highest level of the plate will be the easiest to ink with relief rollers. Also be aware that the collagraph holds more ink than an etching in its textures, making the wiping more difficult and time-consuming. The tonality of the impression can vary greatly, and the amount of ink left on the surface of the plate is critical. Only by taking a proof can you tell just what the print will look like.

The surface of the collagraph plate is being lowered so that a metal gasket about 1/16 inch thick can be glued in position. The outline of the shape has been marked and a sharp razor blade used to cut halfway through the cardboard. Now several layers of cardboard are being peeled off.

A note of caution: If a long, straight line is incised in the plate and then positioned so that it is perpendicular to the printing roller on the press, the ink may be forced out at the end of the line, resulting in an ink blob. To correct this, fill the line somewhat with gesso, or turn the plate so the line is parallel to the press roller.

A small bristle brush like a fingernail brush can help to force ink into the crevices and depths of a plate. Clean it in paint thinner after each printing session or the ink will harden. Also, be sure to use a strong, heavyweight paper, such as Murillo, Arches Cover, or Somerset, to withstand the stress of the heavily textured collagraph plate.

After gesso is applied to the lowered plate area and the back of the gasket, the gasket is fitted into the recessed area of the plate. It is pressed firmly or weights are placed on it until it is set.

4 Screen Prints

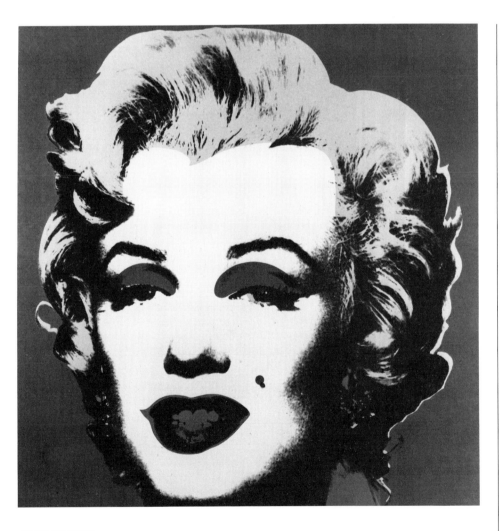

ANDY WARHOL
Marilyn, **1967**
Screen print (oil-based ink), 36" × 36"
Collection of Reba and Dave Williams
© Copyright 1989 The Estate and Foundation of Andy Warhol/ARS N.Y.

Of all the print methods in use today, screen printing is no doubt one of the newest, yet it has ancient origins. It is also one of the simplest, most direct procedures for obtaining multicolor images. The screen print is produced on a rectangular frame over which fine fabric—silk, polyester, nylon, Dacron, or organdy—is stretched. The fabric is "blocked out" wherever unprinted areas are to appear, and water- or oil-based color is squeegeed or brushed through the open mesh of the fabric, producing an image on the surface below. The instrument most often used to push the color through is actually called a squeegee. It consists of a wooden or metal casing that holds a plastic or rubber blade that guides the color.

Origins and Development of Screen Printing

The antecedent of screen printing is stenciling, which was used to make symbols and decoration in prehistoric times. Evidence of early humans' clever application of a most familiar and accessible stencil, their own hands, appears on the walls of two caves, Gargas and Tibiran, in the French Pyrenees and in Maltravieso in the Spanish province of Estremadura. On these walls are more than two hundred prints of hands, curiously deformed by disease or accident, but placed with a decorative sense of pattern and rhythm. They are the earliest examples of spray painting and stencil

143

printing. Black obtained from carbon or manganese deposits, red from iron oxides, and ochre from the earth were perhaps sprayed from a reed tube, blown from the mouth, or daubed around the hands to create negative prints on colored grounds. In other instances, the hands were pressed into color and printed on the walls as positive imagery.

In the Fiji Islands of the South Pacific, indications have been found of early stencils made of natural materials such as leaves, which were printed with vegetable dyes onto garments and bark. However, because of the fragility of the materials, little has survived.

STENCILING IN CHINA AND JAPAN

A sophisticated use of the stencil process evolved as early as A.D. 500 in Japan and A.D. 1000 in China. Stenciled duplicate images of Buddha have been found in the Caves of the Thousand Buddhas in western China. Later the Chinese used stenciling on precious silks, a sought-after commodity that was probably introduced to the West by Marco Polo in the late thirteenth and early fourteenth centuries.

The Japanese, in their search for greater detail and precision, created several innovations. They cut intricate images of great delicacy and complexity from double sheets of thin, waterproof papers. Between the double sheets they glued fine threads of silk or human hair to hold free-standing stencil forms and thin linear areas together. Sometimes the silk threads or hairs were attached to the stencils in a regular grid so fine that, when the stencil was printed on silk with delicate water-based colors or dyes, the lines of the grid were not visible. Some sources think that this meshlike weave may have suggested the use of silk fabric as a printing vehicle. In addition to stenciling robes and decorations, Chinese and Japanese artists and artisans also made stencil pictures and screens.

STENCILING IN EUROPE

In Europe the stencil process grew more slowly and more primitively. During the Crusades red crosses were sometimes stenciled onto robes by a crude method of printing through fine cloth stretched over iron hoops. Pitch or tar may have been used as a resist for the design. Free-floating shapes, however, were difficult to incorporate in these early designs.

European craftsmen developed the more utilitarian aspects of stenciling. In northern Europe stencils were used to color playing cards and religious pictures printed from woodblocks. Gradually, the craft began to be used to enhance furniture, fabrics, and wallpaper. In seventeenth-century England stencils were used to apply flocking to wallpaper. In France stenciled wallpaper enjoyed great popularity under the inventive influence of Jean Papillon. Oiled-paper stencils and thin metal stencils were often used to produce intricate designs. Homes in New England in the late eighteenth and early nineteenth centuries were filled with stenciled papers, walls, floors, textiles, and furnishings.

It was not, however, until Commodore Matthew C. Perry's journeys to Japan in the mid-nineteenth century and the opening up of Japanese trade that Western craftsmen began to incorporate the more sophisticated Japanese stencil methods.

TEXTILE PRINTING

In the West it is difficult to pinpoint the transition from the open stencil process to the use of silk to hold more intricate stencil patterns. It seems likely that experimentation was going on in Germany and in the Lyons district of France as early as 1870, although before World War I cardboard and zinc stencils were still used in the textile industry, with color applied with stiff brushes. The earliest recorded patent for a silkscreen process was awarded to Samuel Simon of Manchester, England, in 1907. Simon's patent was for a screen; he did not use a squeegee to distribute the color but instead employed a bristle brush similar to that used in stenciling. Improvements and developments took hold fairly rapidly, although there was early secretiveness about the new process.

Before the development of screen printing, most fabric was printed using engraved rollers or hand blocks. This process was expensive and limiting, whereas the new screen process was economical and allowed textile manufacturers to use freer designs and brighter colors, which penetrated more deeply into the fabric. These features acted as incentives, leading to great technical ad-

vances and the use of massive automated machines. Photographic processes made the reproduction of intricate designs possible. Other developments increased productivity. In 1964, for example, a new rotary screen printer was invented in the Netherlands, in which a constantly rotating cylindrical screen prints the color, making it possible to print 2,400 yards in one hour.

OTHER COMMERCIAL DEVELOPMENTS

In the United States the screen print developed almost exclusively within the commercial printing industry. In 1914 in San Francisco, a commercial artist named John Pilsworth perfected and patented a multicolor screen process, called the Selectasine method, which led to wide use of the screen print in the growing advertising industry. It was a reduction method similar to one used for some relief printing. Only one screen was used and the largest color area printed first; then part of the design was blocked out with glue and a second color printed; and so on until the print was finished. Other companies devised similar processes, and stiff competition ensued, with each firm guarding its methods. Posters, displays, signs, and billboards were produced in great quantity. Soon other commercial applications appeared, and the industry expanded rapidly. The potential for printing on diverse kinds of materials and surfaces—furniture, lampshades, rugs, glassware, plastic, leather, toys, and textiles—was almost endless. Glass and plastic cylinders, tin cans, and a multitude of unusual shapes could easily be printed.

By 1925 automated screen-printing machines had been developed. And in 1929 an Ohio screen printer named Louis D'Autremont developed a knife-cut stencil film, patented under the name Pro-Film, that gave sharp, clean edges to forms. Nu-Film, a later, improved product developed by Joseph Ulano, was simpler to cut and adhered more easily to the screen. To complement the greater precision in the craft, paint manufacturers developed faster-drying inks for the automated printing machines, which could produce 2,000 to 3,000 impressions an hour.

Although photographic processes were used for textiles and wallpaper in England in the late nineteenth century, they

ANTHONY VELONIS
Washington Square, 1939
Screen print (oil-based ink), 6¼″ × 8⅝″
Courtesy of the artist

were generally slow to develop. Eventually, however, photographic processes became the most important of all processes in commercial screen printing. They have been applied not only to visual material and packaging but even to printed circuitry for the electronics industry.

RISE OF THE SERIGRAPH

Although commercial screen printing underwent a period of frenetic development in the 1920s, it was not until the 1930s that a few artists and printmakers began to see its potential for personal expression. During the Depression, a number of artists interested in the esthetic possibilities of the medium formed a group under the leadership of Anthony Velonis in New York City and received permission from the Works Progress Administration to establish a unit in screen printing. The WPA was a unique agency established by President Franklin D. Roosevelt to alleviate the widespread unemployment created by the Great Depression. Artists were given weekly stipends to create posters, prints, paintings,

murals, and other artworks. It was the first time in American history that artists received federal subsidies so that they could continue to make art.

This group of artists expanded the creative aspects of the screen print through their experiments with stencils, tusche, textural possibilities, and color overprinting (which was unknown to commercial printers). By the end of the 1930s many artists began to try their hand with the new medium. However, because exhibition opportunities were limited, due to the screen print's earlier commercial association, it was felt that a new name for the prints might link it to the fine arts and lead to greater success. According to Velonis, his research led to the coining of a new word, *serigraph*, from the Latin word *seri* (meaning "silk") and the Greek word *graphos* (meaning "to draw or write"). This new term was also favored by Carl Zigrosser, a New York gallery director and later curator of prints and drawings at the Philadelphia Museum of Fine Arts, who organized the first all-serigraph exhibit in April 1940.

Soon galleries began to show some of the new screen prints. More and more artists, including Guy Maccoy, Robert Gwathmey, Harry Sternberg, Harry Gotlieb, and Elizabeth Olds, found the process creatively challenging. Museum curators and critics began to express an interest in the new medium.

By 1940 the National Serigraph Society was founded. Its active program of

traveling exhibits, lectures, and portfolios of prints helped to sustain and broaden interest in the serigraph. Artists such as Ben Shahn, Mervin Jules, Ruth Gikow, Edward Landon, and Hyman Worsager were intrigued by the medium.

With the rise of Abstract Expressionism in the 1950s, there seemed to be a diminished interest in the serigraph among serious artists. The artists using the medium appeared to focus on technical mastery rather than content, and their images were more or less confined to a regional realism—except for Jackson Pollock and Hans Hofmann, who did a few screen prints. The general decline in interest appears to have permeated even those early enthusiasts from the WPA days, because by 1962 the National Serigraph Society ceased to exist.

INFLUENCE OF POP AND OP ART

With the advent of Pop Art, however, the screen print was revived and given new energy with visual imagery that literally replicated popular commercialism. No longer was the fancy word *serigraph* useful or needed. Artists were producing *screen prints*, and they were bold, huge, and multicolored. These prints flaunted photo processes, and they were truly American in content and in process. Andy Warhol's Campbell's soup can images of 1962 probably did more to revitalize the medium than any other artwork since the screen prints of Velonis and his group in the 1930s.

Warhol, with his early career as an advertising illustrator; James Rosenquist, with his experience as a billboard artist; and Roy Lichtenstein, with his knowledge of commercial printing processes—all brought huckster conceptualization into "high-art" statements. Their new imagery used the medium so inventively, without restrictions, that the screen print again became a vehicle for serious, sustaining art.

Paralleling the Pop Art of the 1960s was Op Art, a new abstract art that concerned itself with illusion, perception, and the physical and psychological impact of color. Sometimes only black and white were used, but usually hard-edged juxtapositions of saturated, often complementary colors were made to create a

strong three-dimensional illusion of color, form, space, and movement on the two-dimensional surface. This work had its roots in the visual experiments of Josef Albers and Victor Vasarely. When Vasarely in Europe began to create screen-printed images, Op artists in the United States soon translated their images into the medium as well.

In addition to the Op artists, Minimalists like Ellsworth Kelly and Brice Marden have found the accuracy and simplicity of the medium highly adaptable for their work. Other artists, such as Lucas Samaras, Claes Oldenburg, and Robert Rauschenberg, have been intrigued by the innovative printing possibilities of the medium. Working both two- and three-dimensionally, they have experimented with mixed media and kinetic ideas, incorporating photo processes quite frequently into their work. And there are also figurative artists such as Alex Katz, Will Barnet, and Ernest Trova, who have exploited screen printing because it is relatively easy to use numerous colors and to achieve the transparencies and nuances of flesh tones.

The process has come a long way from the tentative serigraphs of the early 1930s. The esthetic concerns are continuing to expand, suggesting that the screen print will remain an important means of expression for the last decade of the twentieth century and the ensuing decades of the twenty-first century.

Above:
HARRY STERNBERG
Riveter, **1935**

Screen print (oil-based ink), 11 1/16″ × 11 1/4″
Collection of Reba and Dave Williams

Left:
JACKSON POLLOCK
Number 19, **1951 (printed 1964)**

Screen print (oil-based ink), black and white,
19″ × 16″
Collection of Barney Weinger
One of six screen prints, first printed in 1951 by Jackson Pollock and Sanford McCoy in an edition of twenty-five. A second printing of fifty was completed in 1964. The screens were made by the photographic method, which was unusual for fine-art prints at that time.

GENERAL METHODS AND EQUIPMENT

The screen print is one of the most painterly of the print media. The possibilities of using many colors, of exploiting line and mass in a very free manner, of handling the printing ink in thin glazes or thick impasto, suggest a great kinship with painting. Moreover, the screen print serves as an easy bridge to printmaking for many artists because the tools are familiar ones. A brush or pen filled with tusche (a black, inklike liquid), a lithographic or wax crayon, or stick tusche can be used directly on a screen with delicacy or boldness, depending on the artist's approach.

The possibilities of the screen print are so varied and its history so short that its potential has hardly been tapped. Multiple colors can be employed with the ease of changing a screen, and the subsequent printing is a relatively rapid process. The simplicity of the method, however, can result in its misuse to simulate paintings rather than to make a unique statement through its own intrinsic qualities.

Because photo processes are so available, it is wise to keep in mind that the artist can be seduced by them. In the hands of an unimaginative artist, these techniques can result in a print that lacks forcefulness and a sense of transformation. But if photo processes are used as simply another creative tool, interesting results can occur.

Working methods with the screen print vary. Some artists prefer to make a carefully worked-out sketch; others feel more comfortable letting the work evolve out of the process itself, with each screen leading to the next. Each method has merit. With a fully developed color sketch, little is left to innovation, but the study also enables the artist to control form and color easily, especially in the early stages of learning what the medium can do. Combining both approaches, you can start with a thumbnail color sketch for the first color screen, print it, and then work out subsequent colors by painting directly on the first proofs.

Basic Equipment

One of the great attractions of screen printing is that a press is not necessary and the equipment can easily be constructed by anyone having a rudimentary knowledge of carpentry. Another attraction is that large prints in multiple colors can be made more easily than with any other medium. In addition, the workspace does not need to be an elaborate studio with mechanical equipment. A sturdy table and a place to dry prints are the basic needs.

Screen printing can be done with either water- or oil-based inks. Commercial fine-art printers by and large continue to use oil-based inks and processes. Many individual artists, professional schools, and college art departments, however, are switching to water-based methods because they are less toxic. With the new formulations of these inks, it is possible to obtain a consistent professional quality in editioning. The specific materials used for these two different methods will be discussed later in this chapter. The basic printing equipment, however, is the same for both processes, including a screen, a squeegee, and a drying device or rack.

The screen consists of a rectangular wood frame (aluminum is sometimes used) over which silk, nylon, Dacron, or polyester is stretched and stapled; it is hinged at one end to a flat baseboard. The squeegee is the tool that pulls the ink across the screen, pushing it into the surface below, and the drying device or rack allows for clean drying and efficient production. All three can be built by hand or purchased ready-made.

Screen

The screen has three major components: the frame that holds the fabric, the fabric, and the baseboard.

Basic materials for construction:

2-by-2-inch or 2-by-3-inch frame strips (kiln-dried, clear pine or comparable softwood; redwood for large screens)

1¼-inch to 1½-inch flat-head screws

Angle irons or screen-door braces and screws or corrugated fasteners (to reinforce corners)

Staple gun (heavy-duty) and ¼-inch staples

Self-adhering tape, solvent-resistant tape, or gummed paper tape, 2 to 3 inches wide, with strong glue coating

Clear shellac or lacquer (to coat paper tape)

Stretching pliers

Screen fabric (silk, nylon, Dacron, or polyester)

Powdered cleanser or no. 400 Carborundum

2 adjustable clamps and hinge combination with wing nuts or 2 removable 3-inch pin hinges and screws

2-by-2-inch wood strip hinge bar (if pin hinges are used)

¼-by-1-by-6-inch wood drop stick or hinged double-leg screen prop

Baseboard of plywood, Novaply, Formica, or chipboard

Clear shellac or polyurethane varnish (to seal baseboard)

2 hooks and eyes (to secure base for transporting)

Metal handle (for easy carrying)

General tools:

Hammer

Screwdriver

Drill and bits (countersink bit useful)

Saw

Square

Carpenter's rule

Sandpaper (medium and fine)

Soft marking pencil

FRAME CONSTRUCTION

The wood for the frame should be kiln-dried (so it will not warp) and clear (no knots). It can be pine, redwood, spruce, or poplar. (Aluminum frames are available commercially but are more expensive. They have an advantage in commercial production, where screens may be immersed in a cleaning tank not suitable for wooden frames, and are generally sturdier.)

JEAN-MICHAEL BASQUIAT
Back of the Neck, 1983
Screen print with hand painting, 50½″ × 102″
Brooklyn Museum, Brooklyn, New York
Charles S. Smith Memorial Fund

Decide on the size frame you need by determining your image size and the most common paper size on which you will print. Oversized prints are difficult for the beginner to control, but too small a screen can be constricting. A small image can be masked onto a large screen, but a small screen limits the size of the print too drastically. A good starting frame might be one that can accommodate a 22-by-30-inch sheet of printing paper, a fairly standard size. The printing frame must be at least 3 inches larger on all sides to allow you to squeegee from top to bottom or side to side. You will have room for an ample reservoir of ink and be able to pull the squeegee either toward you or away from you.

Small frames can be made of 2-by-2-inch wood; larger frames need 2-by-3-inch for greater strength.

Joining The choice of construction depends on the artist's skill at simple carpentry. The corner joints should be lap construction. An easy lap joint can be constructed using 1-by-2-inch strips pre-cut to the same length and staggered to form laps. Or you can make a very quick, inexpensive, and fairly temporary screen of double-weight canvas stretchers glued and screwed together.

It is important to check your corner angles with a carpenter's square to be certain they are true. Angle irons, screen-door braces, or corrugated reinforcing fasteners can be added for strength, with screw sizes chosen in relation to wood thickness. If angle irons are used to reinforce the underside of the joints, they can also keep the screen slightly elevated from the paper for "off-contact printing" (page 171).

Take the time to construct your frame well and see that, whatever method of joining you select, the corners are square and tight, with no gaps and uneven surfaces. The frame should lie flat, with no twisting. Sand it well, especially where the fabric is to be stretched, so that no tears will occur. The frame must be rigid enough to withstand the tension of

Shiplap
from 2x2 stock

Shiplap
from 1x2 stock

SCREEN-PRINT FRAME JOINTS

tightly pulled fabric without bending or warping.

The surface must be flat and smooth; an uneven, rough surface will make printing uneven. It is wise to sand the wood and give it a coat of clear shellac or polyurethane varnish, front and back, to prevent warping and to ease cleanup. To give a smooth surface to the base, cut a sheet of cardboard or ⅛-inch tempered Masonite to the size of the frame and nail it to the base.

Remember that your screen is your only printing "machine." If you use care in building it, it will outlast you.

Precut and ready-made frames Artists living in or near large cities should investigate purchasing the necessary equipment from commercial sources (see the list of suppliers at the end of this book). Precut, premitered, pregrooved, kiln-dried pine frame materials are available at reasonable costs. Assembling such frames is very easy and fairly inexpensive. The pregrooved system for attaching the fabric allows you to change it quickly, without the need for careful stretching and stapling. Most suppliers will make wood or aluminum screens with fabric stretched to order.

SCREEN MATERIALS

In the recent past, many new synthetic fabrics have become available. These materials have intrinsic qualities that, in specific usage, allow greater fidelity of image and accuracy of register. For this reason, the use of the term *silkscreen* to describe the medium is an anachronism; *screen print* is a more accurate term.

For some drawing techniques, such as direct tusche or litho crayon, silk is best. For photo processes with direct emulsions, nylon and polyester fabrics produce excellent results. The materials range from Swiss silk, American silk, Japanese silk, Dacron, monofilament nylon, cotton, or silk organdy to wire cloth made of phosphor bronze, copper, brass, or stainless steel—all monofilament materials. Stainless steel and phosphor bronze metal screens are used mostly by commercial screen printers for long runs. Their rust-resistant quality gives them the added advantage of accepting any type of ink for printing and any solvent for cleanup. Irregularly shaped frames and very small or very large frames will hold up through many, many printings. But one must be careful not to dent or puncture these frames during adhering, printing, or cleaning because any damage will destroy the screen.

Screen fabrics are sold by the yard in widths from 40 inches to more than 6 feet. They come in a variety of weaves, strengths, and meshes. Understanding some of these classifications will help you to select the proper fabric for your method. The two main types of weave used in industry today are the plain, or taffeta, weave and the gauze weave. Twill weave is used for metal mesh fabrics. The plain or taffeta weave is a general-purpose weave. It is strong and yields sharp detail. Silk, polyester, and nylon, all plain-woven, are the most frequently used fabrics.

Strength refers to the woof and warp (horizontal and vertical) threads of the fabric. Stronger fabrics are constructed with better fibers and will not stretch easily, so they can be used and reused for long runs. The strength of silk, Dacron, polyester, and organdy is denoted with Xs. A single X is the weakest and XXX is the strongest. The weight most used for oil-based ink screen printing is XX, or double weight. Mesh sizes range from 6XX to 25XX. The higher the number, the finer the mesh. The average mesh size for most work is 12XX to 14XX. Textile printing requires fabric with a greater percentage of open area and usually uses a mesh of 8XX or 10XX. The greater the open area, the greater the ink flow, and the less detail. Halftone printing requires a very fine mesh.

Silk The silk used for screen printing is imported Swiss silk of the finest grade. Very good American and Japanese silk also work well. Although many synthetic fabrics are suitable for special purposes, silk, though expensive, is still best for general use. It is extremely tough and can be used and reused many times. Silk is a multifilament fabric, with each strand composed of innumerable finer strands, allowing paper stencils to adhere well and tusche and crayon drawing to produce sensitive results. Most solvents, such as mineral spirits, turpentine, alcohol, and lacquer thinner, can be used without harming the silk—but be sure that you have good ventilation and use protective gloves. Indirect emulsions such as Ulano Hi-Fi Green or Blue adhere very well and can be removed easily with a hot-water spray or an enzyme cleaner. Silk, however, is not well suited for direct photo emulsions because it is an organic material and strong acids and alkalis can destroy it.

Dacron This synthetic has many properties similar to silk but is less expensive and is therefore often used as a substitute for Swiss silk where economy is a concern. It is a multifilament fabric with finer uniformity and more durability than silk and allows ink to pass through easily with very fine printing results. The solvents used on silk can also be used on Dacron without problems.

Nylon Although nylon is very much like silk in its "feel," it has a tendency to stretch during long runs or when water-based materials such as glue and tusche are applied. It is best to stretch nylon when it is wet to ensure that it dries very taut and will hold up better in preparing images and in printing. Nylon, a monofilament fabric, is available in large widths. It will not absorb the ink and yields uniform printing and very good registration. It is best used for long runs

with direct photographic film. Again, most solvents used for silk work on nylon.

Polyester The new polyester fabrics are replacing nylon, Dacron, and Vinyon because of their versatility, stability, and strength. Registration with polyester fabric is excellent because it retains its tautness when stretched over large expanses under all conditions. The multifilament varieties have some of the qualities of silk, taking crayon and tusche drawing very well and giving excellent detail. Polyester is also available as monofilament; the 240-260 mesh monofilament being the material best suited for water-based inks. Again, the solvents listed for silk work well on polyester; moreover, polyester is not harmed by strong acids or alkalis.

Organdy Although less expensive than silk, organdy is really too coarse for fine work. It is also less durable and adapts poorly to water-based materials because water slackens the material. Nevertheless, it is appropriate for junior and senior high school students because of its reasonable price.

STRETCHING THE FABRIC

It is important to stretch your fabric tight on the frame. If it is not tight, has slack and sags, images will blur and close registration will be difficult. If you have stretched canvases for painting, you will find this procedure very similar. On large screens it is especially important to stretch the fabric tight because any looseness will be exaggerated as the squeegee is pulled across a wide expanse. In this case you will find that a pair of pull pliers, like those used for stretching canvas, will help you grip and pull the fabric over the wide expanse. If you are preparing several screens for multicolor printing, be sure you stretch all of them with the same degree of tension to ensure accurate register.

Humid days and dry days can affect screen tension. Wet the fabric before stretching to allow for these changes. Stretch nylon fabric in stages and wet with water to keep it taut. Silk should be wet down with detergent and rinsed well to remove sizing and to allow for a tighter stretch.

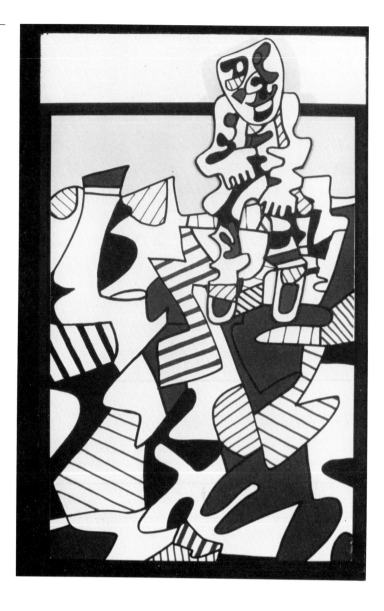

Staple-gun method Use a heavy-duty
staple gun with ¼-inch staples.

1 Cut the fabric a few inches larger than
the outside dimensions of the frame.

2 Wet the fabric to ensure a tight stretch
and lay the fabric over the frame, taking
care to lay it with the threads running
parallel to the frame.

3 Staple several staples in the center of
the frame of the longest side. Space the
staples about ½ inch apart and angle
them to prevent tears.

4 Pull the fabric tight on the opposite
side and again staple several staples from
the center out.

5 Repeat the procedure from the center
of each short side until all sides are com-
pleted.

6 Hammer the staples into the frame so
they are flush with the surface.

7 Trim away any excess fabric that over-
hangs the frame edge.

Groove and cord method For small
frames the groove and cord method is
one of the easiest. Frames can be pur-
chased with a precut groove, or you can
cut a groove in the frame lengths before
assembling a frame. The groove, which
goes down the middle of each length,
must be cut slightly smaller than the
diameter of the cord or rope to be used.
Be sure it is sanded smooth so that the
fabric will not tear. The cord should be
very sturdy and about one-third larger
than the groove. Power tools are neces-
sary for this procedure, but stretching is
rapid and fabric removal easy.

1 Cut the fabric a few inches larger than
the outside dimensions of the frame.

2 Wet the fabric in warm water to re-
move the sizing and place the fabric over
the frame with the weave running paral-
lel to the frame.

3 Cut a length of cord long enough to
run along the four sides.

To stretch the fabric, cut it a
few inches larger than the
outside dimensions of the
frame. Wet it, then lay it over
the frame, with the threads
running parallel to the frame.
Staple several staples in the
longest side, working from the
center out. Space the staples
about ½ inch apart and angle
them to prevent tears.

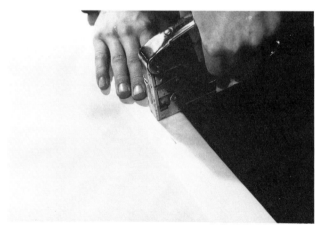

Pull the fabric tight on the
opposite side and again staple
from the center out. Repeat
this for the short sides.
Hammer the staples into the
frame so they are flush with
the surface. Trim any excess
fabric that overhangs the
frame edge.

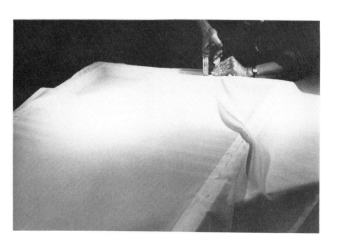

4 Begin in a corner and press the cord and fabric into the groove with your fingers. Keep the fabric pulled tight until you reach the first corner.

5 Continue around the corner pressing the cord into the groove and stretching the fabric, until you complete all four sides.

6 Check for wrinkles. Reset if necessary. Tap the cord with a mallet.

7 Use a thin piece of wood or a Tite-Stretch tool to drive the cord into the groove to achieve a very tight stretch.

8 Trim off the excess fabric.

Commercial stretching devices Commercial printers use a variety of devices to ensure tight stretching, especially on large screens. The Aluma-frame is similar to the Tite-Stretch method but uses an aluminum frame; it is ideal for silk, synthetics, or metal mesh fabrics.

The Cam-Lok method uses an aluminum frame for mounting the fabric and aluminum bars that snap into place over the "frame." Bolts along the edge of the frame are used with the bars to tighten the fabric and hold the unit in place. It is a fast, easy method, and the unit is sold by commercial silk screen-print suppliers.

Finally, there is the Newman Roller Frame, which employs a racket action to adjust the tension of the mesh, allowing adjustments without restretching.

WASHING THE STRETCHED FABRIC

After the fabric is stretched, it should be thoroughly washed to tighten it further and to remove sizing so that all materials and stencils will adhere easily. Mild soap, detergent, powdered cleanser, and powdered pumice can be used with water and a nylon brush for cleaning polyester and nylon fabrics. There are also special commercially manufactured preparations for cleaning nylon, such as Screen Prep and Mesh Prep, which are scrubbed on with water. Silk requires only a mild soap or detergent.

Be sure to rinse any fabric well to remove all residue of the cleaning agents. Then allow the screen to dry by placing it fabric side up.

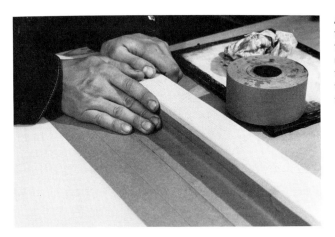

Apply gummed paper tape to the inside of the screen. Fold the tape in half lengthwise, moisten it, and adhere it so that half lies on the fabric and the other half fits tight against the inside frame.

Reinforce all corners with small strips of tape folded in an L-shape to fit tight.

TAPING THE SCREEN

In order to isolate the image from the edge of the frame and to create a well to hold the printing ink, it is necessary to apply tape to the stretched fabric and over the frame front and back. This also prevents ink from seeping under the frame and allows for easier cleaning. Ordinary 3-inch brown paper tape of very good quality with a backing of heavy water-soluble glue is easy to use and holds up quite well after many printings.

To tape the screen:

1 Cut four strips of tape equal in length to the four sides of the frame.

2 Moisten the tape with water and apply it to the underside of the screen. It should establish the inside border and overlap the wood, just covering the staples but not reaching the frame edge. It should extend ¾ inch or so onto the screen. Glue down all four strips and rub them firmly so that they adhere well.

3 Cut four more strips as before and fold them in half lengthwise. Turn the frame over, fabric side down. Moisten the tape and adhere it so that one half lies on the fabric and the other half fits tight against the inside of the frame. There should be a margin of at least 1½ inches of tape on the sides of the screen and at least 3 inches on each end to serve as a well for the ink and a place for the squeegee to start and stop. If printing is to be done from side to side, allow for wells on each side. Make certain that the tape on the inside of the screen extends ¼ to ½ inch beyond the tape on the underside to create a smooth edge for the margin. If the tapes terminate in the same place, there will be a buildup at the edge that will hinder smooth printing as the squeegee is pulled over it.

4 Cut additional strips to fill out any gaps, and reinforce all corners with small strips of tape folded in an L shape to fit tight.

APPLICATION OF SHELLAC OR POLYURETHANE VARNISH

After the tape is dry, apply thin coats of clear shellac or polyurethane varnish. If thinning the shellac is necessary, remember to thin it with alcohol in a well-ventilated area. The coating can be ex-

tended ½ inch onto the fabric on the inside and outside of the screen to seal the tape edges. Use a small flat brush about ½ to 2 inches wide and a straight-edge to guide the brush (be careful not to splatter onto the image area). Do not despair if an even edge is difficult to obtain even with a guide. The edge of the image can be masked with thin visualizing paper at printing time.

If you print with water-based inks, you can use a solvent-resistant tape that does not require a sealant. However, it is thicker than gummed tape and, for smooth printing, must be kept a significant distance from the image area.

ATTACHING THE BASEBOARD

Once the screen is ready for printing, it must be attached to a base to create a printing unit. The baseboard can be constructed of ½-inch fir plywood and ⅛-inch tempered Masonite. Both should be cut about 2 inches larger than the frame on all sides and the Masonite nailed to the plywood to give it a smooth surface. Plywood, even after sanding, often has a strong grain that can create uneven printing. Masonite, even in ¼-inch thickness, can warp. Together, however, they make an ideal baseboard. A good baseboard can also be made of ½- or ¾-inch Novaply, which is smooth and thus does not require a Masonite top.

After the base is assembled, a thin, carefully applied coat or two of shellac or polyurethane varnish will seal the surface on both sides. It is a good idea to sand between coats.

Clamp hinges The best way to attach the screen to the baseboard is with adjustable clamp-type hinges, which are inexpensive and easy to attach. They allow the screen to be engaged or disengaged by simply turning a wing nut. The hinge is screwed to the base and the frame is secured by the clamp, making the screen easy to remove for image making or cleaning. It is necessary, however, to use a double piece of chipboard on the base to compensate for the clamp hinge's ¼-inch bottom piece, which raises the whole screen up from the base. When thick stock is used, the chipboard can be removed.

Hinge bar Another versatile method for attaching the frame to the base is to use

a hinge bar the same height as the frame. The bar is attached to the base with bolts and wing nuts. The nuts and bolts allow the bar to be raised and lowered as stock of different thickness requires. The frame is attached to the bar with pin hinges.

Pin hinges Still another easy method is to attach the frame directly with removable pin hinges. Begin by positioning the frame on the base so that an even amount of base protrudes around the frame. Mark the position of the frame and hinges with a soft pencil. Attach the hinges to the base with a piece of cardboard between the hinge and the base to allow for easy removal of the pins. This can be attached by drilling the hole in the leg prop larger than the screw used to attach the leg to the frame. The leg should also have an application of shellac or polyurethane varnish.

Place the screen frame securely against the hinges. Position the hinges at right angles and mark their locations. Screw the hinges carefully into the screen frame.

ALIGNMENT BLOCKS

A simple method for locking the frame into position is to use wooden alignment blocks. Cut two small ½-inch-thick

Seal the paper tape with shellac, thinned with alcohol to brushing consistency. Two coats are better than one. The screen is ready for printing when dry.

Clamp hinges in operation. Several types are on the market. Most will take frames up to 2 inches in thickness.

blocks measuring 1 by 2 inches. Place the frame in the down position on the baseboard. Butt the blocks against the frame and outline the position of the blocks on the baseboard. Remove the blocks and raise the screen. Drill holes in the baseboard where the blocks can be screwed into position. Make a slot in the block the width of the screw and about ½ inch long. Butt the blocks against the frame while the frame is in the down position and screw them into the base. To realign the blocks, unscrew them, adjust their position, and reattach. Small angle irons can be used instead of wooden blocks.

ANGLE IRONS FOR ALIGNMENT

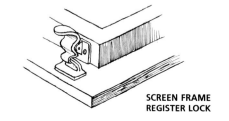

SCREEN FRAME REGISTER LOCK

SCREEN-RAISING DEVICES

During printing, it is important to be able to raise the screen after each stroke of the squeegee so that the printed sheet of paper can be removed and a new sheet placed underneath. Feeding paper and registering it under the frame require two free hands.

Leg prop One of the simplest devices is a ½-inch-thick strip of wood about 1 by 8 inches. This can be screwed to the side of the frame. Allow the hole in the prop to be larger than the screw's diameter so that the prop will dangle free when the screen is lifted to an approximately 45-degree angle, leaving you free to print with two hands. When printing with water-based inks, it is wise to have two leg props, one on each side. Even better, construct a double-legged screen prop hinged to the front of the screen (see drawing). This provides excellent stability.

Spring lift Another simple device consists of a vertical support near the back of the frame with a screen-door spring attached to both the support and the frame by a wire. Small cup hooks on each end facilitate adjustment.

Spring-loaded side kick There are many types of commercial side-kick arms for screen frames. They work on a tension-spring principle and are very useful if extra money is available for such equipment. They vary in price and can be purchased from any well-stocked commercial supplier.

The side kick can be clamped or screwed to the side of the screen frame. When the screen is flat in the printing position, the spring stretches out flat, and when the screen is raised, the spring contracts, allowing the screen to assume two positions. A small wheel at the end of the device facilitates smooth movement.

Counterbalance lift The counterbalance lift is a simple apparatus that works well for long runs. A wooden strip is attached to the frame beyond the edge of the

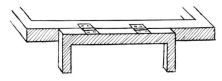

FRONT VIEW OF DOUBLE-LEGGED SCREEN PROP

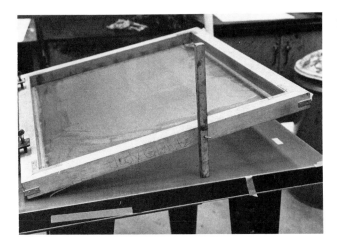

A simple ½-inch-thick strip of wood about 1-by-8 inches attached to the side of the frame serves as a leg prop that raises the screen and allows both hands to be used to place the printing paper.

printing table. An adjustable weight can then be attached at varying distances from the screen to determine its lifting capacity.

Pulley lift A pulley lift is a great help for large screens and long runs. A counterbalance lift raises the screen and holds it in position at just the right angle for feeding paper on the baseboard.

Frame bolt An ordinary sliding bolt is a handy device for raising the screen an inch or so. It does not replace the prop arm, which is necessary during printing. The bolt is very useful when drawing with tusche, glue, Maskoid, and the like because it allows the screen to be raised enough to clear the base yet remain horizontal enough so that liquid drawing materials do not run.

Handle and latch A handle and latch to hold the screen to the base are useful if the screen is to be transported even short distances. The handle can help keep the hands clean during printing and allows easier raising and lowering of the screen.

Squeegee

The squeegee is the tool that does the printing, distributing the ink over the screen surface and forcing it through the fabric mesh onto the paper. It consists of a plastic or rubber blade about ½ inch thick inserted into a handle, usually made of wood. The squeegee should be at least ½ to 1 inch larger than the image on both sides to ensure full coverage, and 1 to 2 inches smaller than the inside dimensions of the frame so that it will pull freely.

The selection of a blade should be determined by its use. Different blade shapes and materials are used for different kinds of screen printing. The square-edged blade is used for general printing. (See diagram for other types.) The ends, however, should be rounded to avoid digging into the stencil or fabric.

The flexibility of the squeegee blade is measured in durometers, indicating softness or hardness. Measures range from about 40 durometers for a soft grade to 70 durometers for a very hard grade. The durometer range for general use is 50 to 60. Soft squeegees apply a thicker layer of ink, which may be desired for flat colors. Sharp, hard squeegees are good for halftones.

The composition of the squeegee blade is important. Three of the most frequently used materials are rubber, polyurethane, and neoprene. The rubber widely used for squeegees is actually a synthetic rubber, tannish in color, called *buna*. It is very versatile, outlasts most other blades, does not need frequent

PROFILE OF SQUEEGEE BLADES

For general printing with thin even deposits

For printing on uneven surfaces and very delicate textile work

For heavy deposit of ink such as light color over dark and fluorescent inks

For textile printing with heavy deposit

For printing on glass

For ceramics

sharpening, does not streak, and can be used with oil- or water-based colors. It is also compatible with all solvents, including lacquer thinner and alcohol.

Polyurethane plastic is usually an amber color and transparent. It is very durable, rarely needs sharpening, and is compatible with all printing inks and solvents. Its only drawback is that it is more expensive than the rubber blade.

Neoprene is a black material that is adaptable for use with oil-based inks. The disadvantages are that its edge dulls more quickly than other blades, requiring frequent sharpening, and as the rubber wears, it has a tendency to deposit fine particles during printing.

The handle of the squeegee should fit the hand securely. The feel of the squeegee and the fit of the handle are very important for even printing. The most commonly used handle is for two hands. A one-hand squeegee is pushed across the screen with one hand gripping a vertical handle fastened to the center of the casing. Many artists find edition printing easier with a one-hand squeegee pulled side to side instead of toward you. This gives even pressure, is easier on your back, and keeps your hands clean.

Printing with a two-hand squeegee can be made easier if dowels or rods are inserted on both ends of the handle so that they protrude over the frame to prevent the squeegee from falling into the ink reserve. A cross stick attached to the top of a one-hand squeegee will accomplish the same objective.

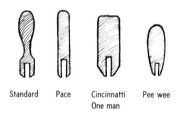

Standard Pace Cincinnatti Pee wee
 One man

SQUEEGEE HANDLE SECTIONS

prop to keep handle
out of ink supply

ONE-HAND SQUEEGEE

 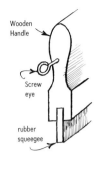

Wooden
Handle

Screw
eye

rubber
squeegee

Garnet paper glued
to board

HANGING SQUEEGEE

SQUEEGEE SHARPENER

SHARPENING THE SQUEEGEE

After long use most squeegee blades will develop rounded edges. For sharp printing, square edges are necessary. A sharp blade also deposits a thinner film of ink.

A squeegee sharpener can be purchased from large commercial screen-print suppliers. It consists of a piece of garnet cloth attached to a base with a wood upright to guide the blade. The device should be as long as the longest squeegee in your shop. The blade is passed back and forth over the cloth in an upright position, like a carpenter's plane, and the abrasive action of the garnet cloth restores the blade to a sharp, square angle. Fine sandpaper can be used instead of the garnet cloth.

If a squeegee becomes nicked or cut, you can sand off small nicks. A deep cut, however, requires cutting away a slice of the blade. Remove the blade from the holder and use a metal straightedge to guide a sharp mat knife or razor blade in cutting the squeegee blade. Replace the blade in the holder and sand it carefully on the garnet cloth or fine sandpaper.

A wise precaution against squeegee damage is to attach a screw eye to the handle and hang it up.

Register Guides

The function of register guides is to fix the position of the printing paper so the image prints in the same place each time. Securing accurate register guides to the baseboard of your screen is thus an important part of the general preparation for printing. These are a number of different register systems, from very simple tabs to an involved Mylar-flap method that can be helpful to reestablish a registry system if it has gone awry or if

deckled paper is being printed to the edge. The registration system you select will depend on the intricacy of the image and the thickness of the printing paper, board, plastic, or fabric on which it is printed.

Three register guides are needed: one on the side (the left side if you are right-handed, the right side if you are left-handed), about in the middle of the baseboard, and two on the bottom corner. The paper must be cut with squared corners or registration will fail. The guides, which need not be more than ¾ by 1½ inches, must be secured firmly to the baseboard or cardboard, or to a vacuum table (see diagram), if one is used. (Essentially, a vacuum table is a tabletop drilled with hundreds of small holes. A motor beneath it draws air through the holes, creating suction, and holds the paper firmly against the surface during printing, allowing for great accuracy in printing.) The guides can be fastened to the baseboard with glue (use a nonpermanent type for easy removal) or taped, stapled, or tacked down depending on the type used.

Register strips Cardboard, plastic, acetate, and thin metal are very good for general use. In all cases, the material must be slightly thicker than the printing paper so that the guides will serve as stops. Fasten the strips in position with nonpermanent glue, tape tacks, or staples, depending on the material.

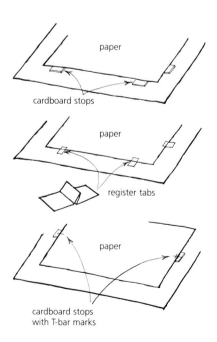

paper

cardboard stops

paper

register tabs

paper

cardboard stops
with T-bar marks

REGISTER SYSTEMS FOR SCREEN PRINTS

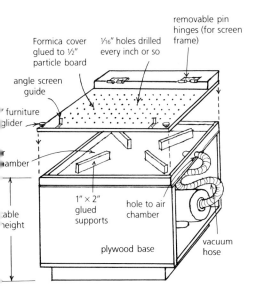

VACUUM SCREEN TABLE
(from Lynwood Kreneck's studio)

Metal button tabs are used for accurate registration. Punched-out holes in the printing paper hook onto the tabs and secure the paper.

Metal button register This system hooks punched holes onto little metal button devices to register large prints. Two tabs of film or thin cardboard with a hole punched in each are taped to the back of the printing paper, extending beyond its edge. Two metal buttons attached to a thin metal base (available from commercial screen-printing suppliers) are taped to the printing table beyond the screen frame area and in alignment with the buttons. The paper is registered by fitting the holes onto the metal tabs, which hold the paper securely. Because a wide paper margin is necessary to accommodate the tabs, the paper must be trimmed after printing. An alternative method is to punch the printing paper itself in the margin and then trim it after printing.

Hooking the paper on the tabs may be too time consuming for printing with water-based ink. Using register strips may be easier.

Mylar guide for screen registration
When you are printing a color print from separate screens, it is necessary to register each screen before printing. In this method sheets of Mylar are used to position each screen in register with the previously printed color. Cut a sheet of Mylar a little larger all around than the printing paper. When the position for the first color is proofed on printing paper, place the Mylar in position over the image area and the register tabs, taping it to prevent shifting. Now print the first

color onto the Mylar sheet and mark the position of the registration marks accurately with tape on the Mylar. Remove the Mylar sheet and edition the first color.

When the second color screen is ready for printing, tape a piece of paper to the baseboard and proof the second color. Now position the Mylar with the first color and registration marks accurately over it. New register marks for the second color's position, seen through the Mylar, should be attached to the baseboard. Remove the Mylar and edition the second color. The screens for all subsequent colors are registered in this manner.

Mylar-flap register for deckled paper
Cardboard or tape stops for registration can be used only when your printing paper has straight edges. When deckled-edge paper or irregular sheets are used for printing, the Mylar-flap system may be more accurate. Each color is printed accurately on one sheet of Mylar and allowed to dry. The Mylar then serves as a register system for printing.

Cut a sheet of Mylar a little larger all around than the printing paper. Tape the front or side end of the Mylar to the baseboard or the printing table so that it lifts easily off the base and hangs loose when not in use.

Edition your first color on your printing paper and allow the ink to dry. Print the second color on the Mylar. Position your print with the first color under the Mylar. Lift the Mylar and print the second color. The Mylar remains in its hinged position and is used to position the second color for each print. All subsequent colors can be registered this way.

This is a tedious method, but it is very good for tight registration and when paper with a deckle is used. It may be a little too slow for printing with some water-based inks, which tend to dry too quickly. It does, however, work well with oil-based inks when speed is not paramount.

Crossmark register A system that is especially helpful in setting up registration is to use crossmarks on all your screens and setup or proof sheets. The easiest method is probably to cut the crossmarks out of film stencil and adhere them to the screen well outside the top, bottom, and sides of the image. Print the crossmarks on your setup sheet and when the register is perfect, place register strips or tabs on the baseboard for paper placement. Position the second screen over the first print and add the crossmarks to the second screen to coincide exactly with the marks on the first. Once register is established, block out the crossmarks so they do not print. Continue each color in this manner. Commercial color printing utilizes this crossmark system with great accuracy.

MYLAR-FLAP REGISTER

Register for heavy stock When very heavy stock, cardboard in particular, is being printed, a heavier register guide is needed. A screen with an adjustable hinge bar to allow for the thickness is also necessary for accurate printing.

A simple register device can be obtained by buying the small 1-by-2-inch metal strips sold in hardware stores and gluing or screwing them to the baseboard in proper position for register. The strips are manufactured with holes, making screwing easy. Similar metal guides are sold by commercial suppliers for the printing trade. They are cadmium-plated, ½ by ¾ inch long, and cost very little for a set of three.

Another device for cardboard registration is one that has a lip to hold the board. We suggest you make this guide only if a simple metal cleat does not do the job. Cut a cardboard strip about 1½ by 2 inches. Cut a piece of thin plastic or thin metal just slightly larger, so that the plastic or metal overlaps the cardboard, and round the corners. Fit the two pieces together in position and nail them right to the baseboard in proper placement to take the cardboard.

Double-thick masking tape built up to the appropriate height is also useful for thicker boards.

PLACEMENT OF SKETCH IN REGISTER GUIDES

After selecting the register system you will use, it is important to position your image with as much care and accuracy as possible. The system is only as accurate as the person using it. If you have made a sketch, cut it to the size of your printing paper and register it in the guides. Tape it down and prepare your screen with the stencil method desired, using the sketch as a guide for cutting or painting directly on the screen.

After finishing your work on the screen, remove the sketch and proof your color on some newsprint or similar stock to see that it is what you want. Insert your precut printing paper in the register marks and proceed to print.

The second screen is best prepared from the first color printing using the same procedure for accurate registration.

Overview of Stencil Techniques

Screen printing is essentially a stencil method for producing images. Various stencil techniques are used to block out areas of the screen: the areas left open will print.

Blocking out can be achieved with a variety of materials, including paper, glue, shellac, commercial block-out, film stencils, and photographic processes. Combining glue with a resist material such as tusche, wax crayon, or Maskoid can produce interesting results. Other methods have been developed by individual artists for their personal use. It is impossible to cover each one. In discussing water-based and oil-based processes, we will list the methods most commonly used by artists. Experiment with different stencil methods to find the one that best suits your imagery. Combinations of methods can, of course, be used.

MATERIALS AND TOOLS FOR WATER- AND OIL-BASED METHODS

As noted, the specific techniques are described separately under the sections on water-based and oil-based inks because the solvents and other materials must be compatible with the choice of ink. Nevertheless, there are certain materials and tools common to both processes. The following list contains recommended materials, but is not exhaustive. Experiment with other materials and compare notes with fellow artists.

X-Acto knife and assorted blades
Stencil knife (available from screen-printing suppliers)
Single-edge razor blades
Masking and Scotch Magic tape (¾ or 1 inch)
Black china marker
Korn's liquid and stick tusche for screen printing
Wax crayons
Rubber cement
Maskoid or E-Z liquid frisket
Lacquer film stencil
Denatured or anhydrous alcohol
Paint thinner or mineral spirits (used minimally with water-based methods)
Lacquer thinner
Tracing or bond paper
Sponges
Fingernail brush (to clean screen)
Paper towels, newspapers, and rags
Rubber gloves

WATER-BASED INK METHODS

Historically, artists and industrial printers used oil-based inks almost exclusively because of their permanence and durability. These inks were used to print on paper, plastic, glass, and other surfaces. Although water-based inks for textiles have been on the market for many years, these inks, which are manufactured to be absorbed into more porous fabrics, are often too thin for printing on paper. Suppliers for artists and schools have, however, at last developed very fine water-based inks that yield excellent results on paper.

A major advantage of water-based inks is that they are less toxic than oil-based inks and water can be used for cleanup. However, not all water-based inks, emulsions, block-outs, and cleanup materials are completely nonhazardous. It is important to know the properties and chemistry of the products you are using, to read labels, and to follow safety precautions.

Fortunately—thanks to experiments in school workshops, by individual artists, and by a few master printers—today there seems to be little or no difference in appearance between water-based and oil-based inks printed on the same stock. In other words, there are no esthetic disadvantages. And water-based inks dry faster, allowing for rapid pulling of proofs. Another plus is that cleanup is more efficient.

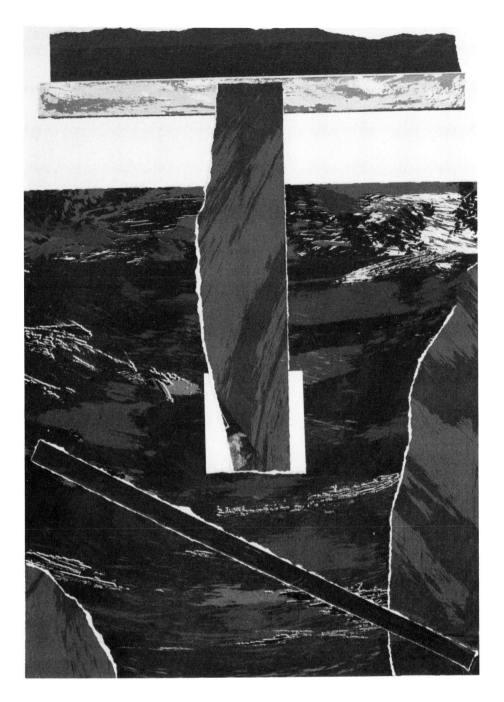

DONNA MORAN
Image 69, 1988
Screen print (water-based ink), 30″ × 22″
Courtesy of the artist
This image was produced by the reduction
method. The negative areas were blocked out
for the printing of the first color. Then the ink
was washed out of the screen and new areas
were blocked out for the second color. This
method was repeated until the desired image
was achieved. (See page 33 for a discussion of
the reduction method with relief prints.)

water-based ink, the following tips are
also helpful:

1 To ensure tautness, soak the polyester
in water before stretching. Do not crease
the fabric.

2 If the fabric is to be stapled to the
frame, place cotton cloth tape between
the staples and fabric to prevent rust.

TAPING

After the screen is stretched and thor-
oughly dry, apply a good-quality white or
silver duct tape. (Paper tape and shellac
will not hold up for many water clean-
ups.) Extend the tape into the printing
area and over the frame to protect the
staples as described earlier.

SQUEEGEE

Coat wooden squeegee handles with
polyurethane varnish or paint to protect
them from water-based inks and water. A
metal handle is desirable. Blades of gray
rubber or translucent polyurethane of
medium durometer work best. Advance
No. 60 Durometer Everlast Squeegee is
good. The blade must be kept sharp.

PRINTING SURFACE

A surface of white Formica laminated to
a plywood base gives even printing.

Materials and Tools for Water-Based Methods

For water-based inks, it is best to use Pe
Cap or Monotex monofilament poly-
ester, with a 240–260 mesh for general
printing and a 260–300 mesh for finer
detail and halftones. Generally it is
easier to print open flat areas with a
lower number or coarser weave. A still
lower mesh count of 190–210 may be
used for simple student work. A yellow
mesh is preferable to white when photo
stencils are used because it is nonreflec-
tive and absorbs light during exposure.

In addition to the stencil materials
listed on page 156, the following may be
used with water-based inks:

Photo mount paper

Freezer wrap

Clear Contact paper

Mylar or Denril

Hunt Speedball screen filler

Shellac (orange or white)

Oil pastels

Soft lithographic crayons no. 10–1

Caran d'Ache watercolor crayons

10-15 cardboard 4-inch square squeegees
(to distribute screen block-out solution)

Scoop coater (to spread block-out across
screen)

STRETCHING THE FABRIC

Follow the procedures outlined earlier
for preparing the frame. However, with

Paper Stencil: Positive Method

There are two types of stencils: positive
and negative. With a positive stencil, the
block-out material fills in the back-
ground and the actual image is printed.

With a negative stencil, the image is blocked out and the background is printed.

An easy stencil method uses paper to block out areas that do not print. However, depending on the stencil paper used, it may not withstand extended printing or produce accurate registration.

Intricate stencil forms can be cut with an X-Acto knife or a special stencil-cutting knife. The stencil paper can also be torn to achieve a rough edge. All forms must be adhered to the screen with ink deposited in the first pull of the squeegee. Therefore it is wise to use simplicity in designing the first stencils.

It is important that stencil paper for water-based inks not absorb water, disintegrate, or wrinkle. Try a few tests with different papers to find the one that suits your needs best.

PHOTO MOUNT PAPER

The accomplished screen-print artist Lynwood Kreneck has found that photo mount paper, which is available in thin, flat sheets, works well because it is water-resistant. Another advantage is that it is translucent, which allows a drawing to be placed underneath to guide your cutting. The screen and stencil can be reused after cleanup, which is very easy.

1 Cut the piece of photo mount larger than your screen opening so that ink does not seep through beyond the image area.

2 After securing register tabs to your baseboard, place a sheet of proof paper in position. Position and tape a sketch, if you choose to use one, on top of your proof paper to use as a quick guide for cutting. Raise or remove your screen so it won't be in your way.

3 Now place your photo mount paper over the sketch and in the register marks. Tape the photo mount down temporarily so it will not slip.

4 Cut out the areas that are to print and remove them.

5 This step is optional. Kreneck suggests lowering the screen and applying a barely warm iron (at the lowest setting) to the screen so that the photo mount adheres. Although the photo mount will adhere without heat, the advantage of ironing is that the stencil will remain on

the screen after cleaning and is good for long runs.

6 Remove the temporary tape and you are ready to print. Place a generous quantity of ink at the top end of your screen and, holding your squeegee securely, pull the ink across in one firm stroke, adhering the stencil to the screen. The stickiness of the ink attaches the paper stencil to the screen (see page 170 for more details on printing procedures).

FREEZER WRAP

A very accessible and inexpensive stencil material is the translucent plastic-coated paper used for wrapping and freezing food, available in supermarkets. The plastic coating makes it waterproof and thus desirable for use with water-based inks. It is also easy to cut.

1 If a sketch is used as a guide, place it in position in the register guides under your screen. Raise or remove the screen temporarily so that it won't be in your way. If the image is intricate, you may want to use a light box to see it more clearly.

2 Cut the piece of freezer wrap a few inches larger than the screen opening. Tape it temporarily over your drawing with the shiny side up and proceed to cut or tear out the parts that will be the printed image. Use a sharp X-Acto knife or a new single-edge razor blade. Do not overcut corners. If you cut beyond them, ink may leak out during printing.

3 Position your cut stencil under the screen and tape it with good-quality masking tape under or to the side of the screen frame, not to the mesh. Place a piece of proof paper in the register marks, and you are ready to print. Follow the instructions for printing the photo mount stencil.

After the printing is completed, the stencil is usually discarded. However, with care, it can be cleaned and reused.

CLEAR CONTACT PAPER

Because of the adhesive backing, it is possible to cut intricate stencil images from clear Contact paper, available in hardware stores.

1 Cut a sheet of clear Contact paper larger than the screen opening.

2 If a sketch is used, work over a light box so that the image can be seen. Otherwise transfer it with carbon paper under the sketch. Remember that because the adhesive is on the underside of the Contact paper, the image will be reversed when you attach the stencil to the screen and print it. You can eliminate the reversal by cutting on the backing side, but be sure you cut through both the backing and the Contact paper. Or you can simply reverse your drawing and cut on the top surface of the Contact paper. Do not overcut the corners.

3 Very carefully peel the backing away from the stencil. Turn the screen so that the underside is up and carefully position the stencil with the adhesive against the screen. Gently rub the stencil, pressing out any wrinkles or air bubbles. Turn the screen to its printing position, place a piece of tracing paper over the fabric, and burnish the whole stencil area with your thumbnail to ensure adhesion.

4 After printing, peel away the stencil and discard it. Using gloves, clean any residue of the adhesive from the screen with paint thinner or acetone.

Mylar and Tape Stencils: Positive Method

There are several other materials you can experiment with in making stencils, including Mylar, Denril, and tape.

MYLAR OR DENRIL

Frosted or clear Mylar or Denril (.005 mil plastic sheeting) can be used effectively for stencils. These stencils are not affected by the humidity of the inks, do not stretch, and can be washed off and reused after printing. Do not, however, use acetate for stencils because it will stretch during printing.

1 Cut the material at least 1 to 2 inches larger than the screen opening. Because the material is so transparent, it is easy to use a sketch as a guide. Do not overcut the corners.

2 Position and tape the stencil to the underside of the screen.

3 Follow the printing instructions for photo mount paper.

TAPE

Various kinds of tapes can be experimented with for stencil making. Tape is very easy to attach but is limited to linear or geometric imagery. It is easy to remove and easy to clean up.

1 Cut the tape to the desired lengths before attaching it to the underside of the screen. Burnish it firmly with your thumbnail from the top of the screen. Place tracing paper between your thumbnail and the fabric to act as a buffer.

2 Firm squeegeeing is necessary because the thickness of the tape may give some resistance. Pull the tape off when finished. Wearing gloves, clean off any remaining adhesive with paint thinner or acetone.

Lacquer Film Stencil

Although we have tried to confine our methods with water-based inks to the ones using the least toxic solvents, we reluctantly include the lacquer film stencil because it is the only method, other than photo processes, that allows the artist to produce large editions with accurate registration. Use it only if it is not possible to use photo emulsions.

Lacquer film stencil consists of a colored lacquer film laminated to a paper or plastic backing. The areas to be printed are carefully cut with a sharp knife and stripped away from the backing. The film is then adhered to the underside of the screen with adhering fluid and the backing is peeled away.

1 Position your sketch in the register tabs on the baseboard, and tape it down.

2 Cut a piece of film larger than the area to be cut and tape the film, lacquer side up, to the sketch.

3 Disengage the screen from the baseboard to make it easy to manipulate during the cutting. Using the stencil knife, cut out the areas to be printed. Make sure cuts, but do not cut through the plastic or paper backing. Overcut the corners of the shapes slightly to ensure that the corners will be clean when the film is removed.

4 Remove the film carefully from all the areas to be printed, leaving the backing intact. Make some cuts in the backing to allow air to escape during the adhering of the film to the screen.

5 Be sure the screen is thoroughly clean to ensure successful adhering. If a greasy cleaning agent like mineral spirits has recently been used, clean the screen with lacquer thinner, acetone, or a commercial screen cleaner. If the screen is new and may contain some sizing, wash it with a dilute detergent, rinse it well, and allow it to dry.

6 Adhere a piece of 3-inch masking tape, sticky side up, to the backs of the four corners of the film, leaving 2 inches free. Carefully remove the tape holding the film to the master sketch and lower the screen. Adhere the tape on the film corners to the screen, being careful to keep the film in position.

7 Remove the sketch from the baseboard and place a number of newspaper sheets as padding between the baseboard and screen. Lower the clean screen over the newspaper padding.

8 During the adhering process keep the cap on the can of adherent when not using it so as not to inhale the fumes unnecessarily. It may be helpful to wear thin plastic gloves when applying the fluid, and it is essential to use it under an exhaust fan or with other good ventilation.

9 Do not rush to adhere the film to the screen. Make pads from two clean cotton rags. Keep one dry and one wet with adhering fluid but not dripping. Dampen a small area on the top of the screen with the wet rag. Quickly apply the dry rag to the spot and rub it. This drying action helps to adhere the film. As the film begins to adhere it will appear darker. Press hard when rubbing. It is very important not to saturate the area with adhering fluid because too much fluid will dissolve the film or cause blurred edges.

10 A good place to start the adhering process is in the center of the image, working out to the edges on all sides simultaneously, to prevent wrinkling. Work small areas at a time for the best control.

11 When the entire film has been adhered, allow the screen to dry for some minutes to be sure none of the areas are still moist. Then lift the screen into an upright position, remove the masking tape that held the film to the screen, and begin to remove the backing.

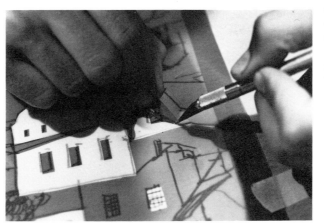

To cut a lacquer stencil, place the stencil on your drawing with the emulsion side up. Using a small frisket knife or sharp X-Acto knife cut through the emulsion but not the backing paper. Peel away the lacquer film. Save the scraps in a jar.

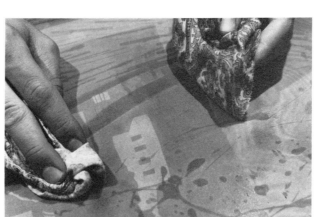

When the stencil is cut, put it in position under your screen. Take two rags, one in each hand, one soaked in adhering fluid and one dry. Rub the area over the stencil with the adhering-fluid rag, using heavy pressure. Quickly switch hands and, again using strong pressure, rub the area with the dry rag.

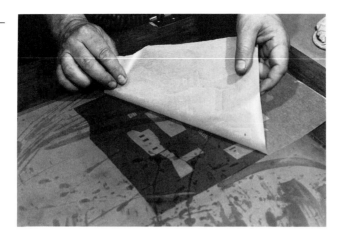

When the lacquer stencil has been adhered (by literally melting it into the fabric), turn the screen over and peel off the backing paper from the stencil. Check carefully; if any edges are not adhered, repeat the process in these areas. Be careful, as too much adhering fluid will dissolve the stencil.

12 Starting at the corners, peel the backing away from the screen very slowly. If the film has been properly applied it should come off easily. If any film areas are not completely adhered and begin to come off with the backing, return the screen to the adhering position and repeat the adhering process.

13 After the film is thoroughly adhered and ready for printing, clean the underside of the screen with a cloth dampened with mineral spirits to be sure the screen is clear of adhesives used in manufacturing film. To remove the film from the screen after printing, pour a generous amount of film solvent (for removing film) over the whole film area, allow it to sit for 4 or 5 minutes, and then rub the whole area with a large clean cloth. Again, do this under an exhaust fan or with good ventilation, and wear gloves.

Water-Soluble Stencil: Negative Method

This method combines a Ulano Amba water-soluble stencil (cut from water-soluble film attached to a plastic backing) and Hunt Speedball screen filler. The image can be more intricate than one cut from freezer wrap and is not destroyed when the ink is washed out at cleanup time. However, the cutout area must be planned as the blocked-out or negative area because it is the background that prints.

This is a good method to use for detailed work if a photo process is not available. But it is a bit complicated.

1 Tape your sketch to a piece of white mat board and tape the water-soluble stencil, cut larger than the drawing, over it.

2 Cut and peel away the areas of the stencil image.

3 Prepare your screen with a border defined by a paper stencil or screen filler. The screen fabric should be 240–260 mesh monofilament polyester.

4 Place your screen in clamps or hinges and put the finished hand-cut stencil on a buildup of paper in position underneath the screen. Lift the screen and moisten it well with water.

5 Lower the wet screen over the stencil and blot the excess moisture with newsprint. Press down firmly with your hands.

6 When the stencil is adhered and dry, remove the screen from its hinges or clamps and turn it over. Carefully remove the plastic backing from the dry hand-cut stencil.

7 Working only on the underside of the screen, to which the stencil is attached, squeegee two thin coats of Hunt Speedball screen filler over the water-soluble stencil. Use a different direction for each coat and allow the first coat to dry before applying the second. Clean all the excess screen filler from the margins with a damp sponge.

8 Heat the screen filler with a hair dryer to bake it on and make it more water-resistant.

LYNWOOD KRENECK
Rich Kitchen–Poor Kitchen,
© **1987**
15-color screen print with 6 airbrushed pochoir (stencil) colors (water-based ink),
6″ × 8¾″
Courtesy of the artist

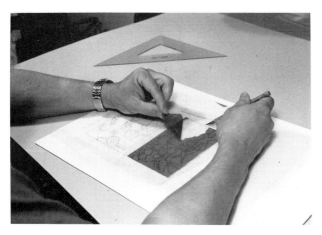

Lynwood Kreneck uses a negative method for blocking out areas. He hand-cuts a water-soluble stencil to define his intricate imagery. (Photo © Lynwood Kreneck)

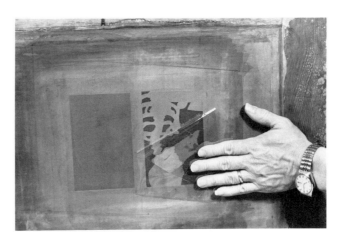

When the stencil is dry, the screen is turned bottom side up and the backing is removed from the hand-cut stencil. (Photo © Lynwood Kreneck)

The finished hand-cut stencil (Ulano Amba Water-Soluble Indirect Film Stencil) is placed on backing material to ensure close contact with a water-dampened, 240 monofilament polyester screen when it is lowered onto the stencil. The previously applied Ulano TZ Diazo direct photo emulsion creates a permanent border for subsequent printings. (Photo © Lynwood Kreneck)

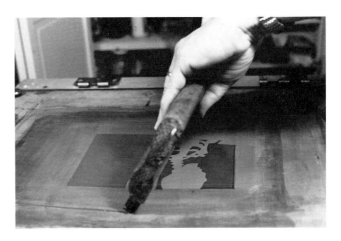

With the bottom side of the screen up, two thin coats of Hunt Speedball Water-Soluble Screen Filler No. 4570 are squeegeed across the stencil, in a different direction for each coat, and allowed to dry between applications. All excess filler is cleaned from the margins with a damp sponge and a hair dryer is used to further bake the filler and make it impervious to water. (Photo © Lynwood Kreneck)

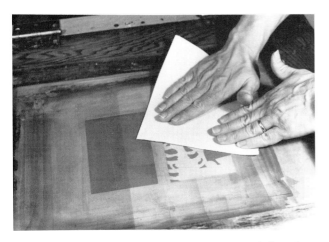

The lowered screen is blotted with newsprint paper and allowed to dry. (Photo © Lynwood Kreneck)

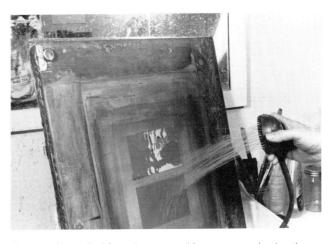

The stencil is washed from the screen with warm water, leaving the mesh open where the film was adhered. This procedure creates a block-out stencil that is the exact reverse of the original hand-cut image. (Photo © Lynwood Kreneck)

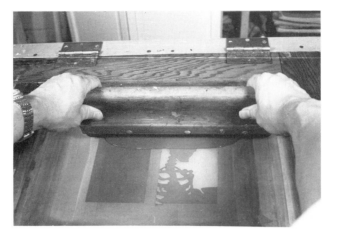

The first color is made of 12 drops of Createx Pure Pigment, mixed with 2 parts Createx Gouache Base and 1 part Createx Lyntex Base. It is printed in a flood stroke, using a sharp, medium-durometer squeegee and a vacuum table to hold the paper taut. Each succeeding stencil is made in the same manner. (Photo © Lynwood Kreneck)

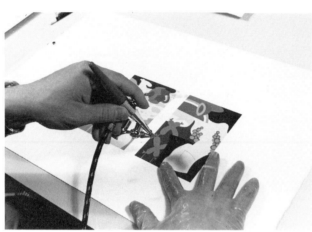

After all the screen colors have been printed and the edition completed, Kreneck cuts stencil areas from a finished proof to ensure exact registry. Some Createx pigment and a very small amount of rubbing alcohol or water are combined to achieve a proper flow for six additional colors that are airbrushed through the stencil onto the finished prints. (Photo © Lynwood Kreneck)

9 When the drying process is complete, place the screen in a sink and wash out the water-soluble stencil with a warm water spray. As the stencil dissolves, it carries away the screen filler covering its surface, leaving the mesh open where the stencil was adhered.

10 This procedure creates a block-out stencil of screen filler that is the exact reverse of the original stencil. The image is now ready to print. Use a flood stroke (see page 171) and a sharp, medium-durometer squeegee.

Block-out Solution Stencil: Negative Method

Painterly, free qualities can be obtained by painting directly on the screen with a non-water-soluble liquid. Hunt Speedball screen filler is a block-out developed for this purpose. Areas where it is painted will appear white after printing, and the unpainted areas will print.

1 Elevate your screen a few inches so that the filler can be applied without seeping through. Try a variety of tools

and materials, both conventional and unconventional, for painting. Use brushes, a Japanese bamboo pen, an atomizer for spraying, sponges, and rags. Also transfer textures onto the screen with materials that have been brushed or rolled with the filler.

2 Apply the filler thinly and let it dry. If the solution thickens, thin it with water and keep the cap on to prevent evaporation. Fan it dry.

3 When the filler is thoroughly dry, the screen can be printed.

4 When the printing is finished, wash out the ink with water and the screen filler with hot water and a cleanser such as Wisk.

Block-out or Resist Stencils: Positive Method

A variety of resists can be used to create positive stencils.

CRAYON BLOCK-OUT STENCILS

Drawing directly on a screen with wax crayons or oil pastels, or painting with masking fluids such as Maskoid or E-Z liquid frisket; will create textured areas.

Because wax crayons, oil pastels, and masking fluids are not soluble in water, their marks will protect the screen area where they are drawn and will print as open areas when water-based ink is squeegeed across the screen. Wax crayons are made by various manufacturers, with Crayola probably the best-known brand. Oil pastels also come in a a variety of brands, including the familiar brand Cray-Pas.

1 With the screen resting firmly on a flat surface, draw freely or with a sketch under your screen. Apply the wax crayon or oil pastel heavily so that the marks will not rub off when the squeegee is pulled vigorously across in printing. Textured material such as rough paper, cloth, leaves, or wood grain may be placed under the screen and the wax crayon or oil pastel rubbed on the fabric to reproduce the form or texture.

2 Define your margins with a paper stencil, block-out, or photo emulsion. Place your printing paper in position and squeegee the ink across.

3 When the printing is complete, wash the ink from the screen with cool water. The crayon marks will not wash out with water and can be left on the screen if a second printing is desired. To remove the wax crayon or oil pastel, use paint thinner or acetone and a soft rag. Be sure to wear gloves and work in good ventilation.

DRAWING FLUID RESIST

This procedure is comparable to the tusche and glue process used with oil-based inks. In this water-based ink technique, Hunt Speedball drawing fluid is used in conjunction with Hunt Speedball screen filler to create a positive image on the screen. The drawing fluid is a blue solution easily seen on the screen, and it can be applied with any material or tool that can produce marks on the screen without damaging it. Use a bamboo pen, brush, roller, cardboard applicator, sponge, spray, and the like. If the fluid needs thinning for use with a bamboo pen or brush, it can be diluted by up to 50 percent with water.

1 Prop the screen up about 2 inches in a horizontal position. Apply the drawing fluid in the manner you've selected.

After the drawing has set, raise the screen to a vertical position and fan dry or use a hair dryer.

2 When thoroughly dry, return the screen to the propped-up horizontal position. With a stiff cardboard squeegee or a scoop coater about 4 inches square, apply the screen filler to only the top side of the screen. The screen underside is left uncoated in order to facilitate the washing out of the positive areas. Start at the top of the screen, depositing even, sure strokes in one coat. Do not go back over an area.

3 When the screen filler is thoroughly dry, gently wash the drawing fluid from the screen with a cold water spray. This will open up only the drawn, positive areas and leave the block-out filler to protect the negative areas. If any areas are difficult to remove, gently scrub them with a nylon brush. Hold the screen up to the light; if any pinholes are apparent in the background filler area, stop them out with a brush and some block-out filler.

4 When the screen is thoroughly dry, it is ready for printing. Follow the procedures for printing on page 170.

LITHOGRAPHIC AND CARAN D'ACHE CRAYON RESIST

This process is similar to the one just described. Instead of drawing fluid, soft lithographic and Caran d'Ache crayons can be used to draw positive, textural images on the screen while Hunt Speedball screen filler is used as the negative block-out.

1 Draw directly on the screen or, if textured areas are desired, place a textured object (such as a coin, rough paper, leaves, or fabric) under the screen and rub the crayon on the surface.

2 Raise the screen and, using a scoop coater filled with Hunt Speedball screen filler, coat the entire printing side of the screen in one pass. A cardboard squeegee cut larger than the image may be used.

3 When the filler is thoroughly dry, wash out the crayon image with cold water. The filler will remain in the negative background areas and the crayon marks will be open and ready to print.

Burlap is placed under the screen and the screen surface rubbed with a soft lithographic crayon, revealing the texture of the burlap.

CARAN D'ACHE WATERCOLOR CRAYON MONOPRINT

This method produces a kind of replicated monoprint good for about four or five prints. The image is drawn directly on the screen, and transparent base (a tint of color can be added) is squeegeed onto the screen. The transparent base acts as solvent, releasing the pigment onto the printing paper.

1 Place the screen in position for printing. Use a paper stencil or other material to define your printing area.

2 Draw with two or three different Caran d'Ache watercolor crayons directly onto a clean screen. Be sure to deposit an ample amount of pigment.

3 Place your printing paper in register and, using a flood stroke (see page 171), squeegee transparent base, along with a color tint if desired, across the screen and over the crayon drawing. Let it set for about 30 seconds, print, and repeat the flood stroke. The crayon will print for four or five impressions and can be reapplied as the image fades.

4 After printing, a hot-water spray will remove any remaining crayon marks and the ink. Sponges and bar soap help.

Photographic Stencils

The use of photography for the preparation of screen printing has greatly enhanced the creative potential and scope of the medium. Fine detail, sensitive tonality, and close color registration are easy to achieve with the photo process. There is also an enormous range of materials that can be used to create imagery,

from hand-drawn positive transparencies and photographic positive or negative transparencies to photograms and collage. Photo stencils are also extremely durable and hold up well after hundreds of printings.

PREPARING TRANSPARENCIES

There are instances when drawing a transparency may result in greater spontaneity than using a photographic transparency, and combining them may also produce interesting qualities. At any rate, to fully understand the potential of photo imagery, it is helpful to know the range of methods for producing a transparency.

Hand-drawn positives A positive opaque image on a transparent surface is an essential element in a photo stencil. It may be painted, drawn, or applied with an opaquing medium onto matte or frosted Mylar or another transparent material.

You can draw with a china marker on Mylar or textured vinyl sheets. Rub the marker over a rough surface to achieve a textured effect. Apply opaque liquids with a paintbrush or an airbrush. Try pen, Stabilo pencil, tape, Benday dots (large enough not to fall through the mesh), letters, patterns, and other effects on your sheet. A collage effect can be developed by combining photographic positives or negatives with drawn and painted ones. The photographic elements should be adhered with transparent tape onto the Mylar or similar sheet.

The opaque areas will block out light and allow the photo emulsion to harden

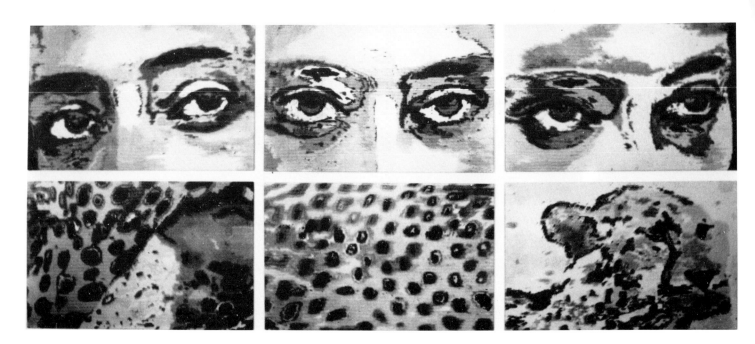

SIMONE BERGER
Untitled, 1988

Screen print (8 colors screen-printed on 6 fabric panels with water-based textile colors), 4′ × 8′
Courtesy Cooper Union School of Art, New York
Video images of the cheetah and eyes were put into a computer and manipulated for the selection of color combinations. Kodaliths were made from printouts of the eight colors, exposed onto an emulsion-prepared screen, and printed.

in the open negative areas during exposure to light. The drawn areas are not affected by the emulsion because the light cannot pass through. After light exposure, the photo emulsion will wash off with warm water, leaving the open areas for printing.

Photograms In addition to painting, drawing, and collaging images on a transparent sheet, you can create interesting images by making photograms directly on an emulsion-prepared screen. In a darkroom, using a safelight, place solid objects that will not allow light to pass through, such as scissors, combs, coins, hairpins, eyeglass frames, leaves, or cut paper on a screen prepared with photo emulsion. Expose the objects and the screen to a photoflood. A vacuum exposure table cannot be used because the three-dimensional objects would defeat the vacuum process. If you have made some photograms in a photo enlarger and know basic darkroom techniques, this method may appeal to you. You will need to experiment to determine the exposure time.

Photocopy transfer Excellent photo positives can be produced by transferring a photocopied image onto translucent vellum. A black-and-white image photocopied on Nekoosa paper works best.

1 Place the image face down on a piece of vellum. Rub the back with a cotton ball dampened with acetone.

2 After dampening the back of the image evenly, firmly pull a wooden or metal ruler across the back to offset the loosened photocopied image onto the vellum. Do this only once, because the acetone-dampened paper stretches during the procedure and could produce a double image if rubbed twice.

Magazine or newspaper transfers A method similar to the procedure above can be used to produce positive transparencies from black-and-white magazine or newspaper reproductions. Place the image face down on the adhesive side of a piece of Contact paper. Rub it well with a burnisher so that it lies flat, with no air bubbles. Place the Contact paper with the image adhered to it in a tray of lukewarm water so that the paper the reproduction is printed on will soften and can be gently rubbed off, leaving the image on the Contact paper. This should produce a positive photo image.

Photographic positives or negatives See the chapter on photographic techniques for information on preparing Kodalith or a similar brand film positive or negative.

TYPES OF PHOTO SCREEN-PRINTING TECHNIQUES

There are many methods currently in use that produce fine-quality photo images for screen printing. The major manufacturers of photo emulsions and photo

systems market a variety of products with directions and fact sheets to accompany them. We will describe a few of them currently in use or new and promising. However, since products and systems are periodically updated, it would be wise to request literature and information for both water-based and oil-based photo processes from the major companies, including Ulano Corporation, Majestech Corporation, Naz-Dar Company, the Advance Group, and Colonial Printing Ink Corporation.

DIRECT PHOTO EMULSIONS

To prepare a screen for a direct photo process, a sensitized emulsion is coated directly on a screen fabric. After the emulsion is dry, the screen is exposed with a no. 2 photoflood bulb or in an exposure unit in contact with the positive. A fan is needed to cool the photofloods during exposure because they generate considerable heat. After exposure, the screen is washed out with warm to hot water.

Wherever there is drawn or photographic imagery on the screen, the exposure light will not penetrate the emulsion. Wherever areas have no image, the light will penetrate and harden the emulsion. During the wash-out process the unpenetrated emulsion in the image areas will wash out, leaving them open and ready for printing, while the hardened emulsion in nonimage areas will serve as a block-out.

A direct screen emulsion is often the choice for artists working with water-based inks. There are two types of direct

screen emulsions, one sensitized with diazo salt and the other with ammonium bichromate. They are easy to apply and remove from the screen, relatively inexpensive, and produce good results. Of the two, the diazo compound seems to be more popular because the images are a bit sharper and have less of the light bounce, or halo, that sometimes appears when bichromate emulsions are used. Diazo-treated screens can also be stored longer—from 3 to 12 months under darkroom conditions—before exposure. This is an asset in a large shop because coated screens can be prepared ahead of time and are ready for exposure when needed.

The chemicals in both types of emulsion require cautious handling and careful following of directions. It is very important to wear gloves and a dust mask when measuring and mixing the solution, and to wear gloves and use adequate ventilation when applying the emulsion in a darkroom. Of the two emulsions, the diazo compound is less hazardous to handle and produces such fine results that we have included only the diazo method here.

The major suppliers manufacture diazo-sensitized photo emulsions under a variety of names. Some are presensitized emulsions; others are sold with a diazo sensitizer in powder or syrup form that is oxidized with emulsion to sensitize it. A dye is often added so that the emulsion is more visible on the screen. Many of the emulsions can be used for both water- and oil-based inks. Check the specifications to determine how to use them.

Majicol T White photo emulsion, produced by Majestech, gives very good results with water-based inks. It contains the premixed diazo sensitizer, enabling you to use it directly from the container. Ulano makes two products, 800 PER and IX-99, which are presensitized and do not require the addition of a diazo-sensitizing powder or syrup to the emulsion. The Ulano 900 series is not premixed and requires the mixing of a diazo powder or syrup with the emulsion to sensitize it. Advance makes Raysol Universal DM-567 Zero Plus, which is waterproof, solvent-resistant, and reclaimable. It can be used with all screen-printing inks, both water- and oil-based.

Preparing the screen The preferred fabric for direct photo emulsion work is a monofilament polyester or nylon in a mesh of 240–300, depending on the fineness of the detail. It has a high percentage of open area, allowing ink to flow freely through the strands, and is easy to clean. "Anti-halo" fabric dyed yellow or orange will prevent light from passing through the fabric at the image edge and ensure clean edges.

It is very important to have a degreased, clean screen as a first step toward producing a sharp photo image. Many types of problem-causing contaminants are not visible to the naked eye: petroleum residues from inks or wash-up solvents, fabric-weaving oils in new fabric, perspiration or oils from the skin, airborne dirt, dust, engine-exhaust hydrocarbons, and the like. Degreasing greatly reduces the risk of stencil-making failure, extends the printing life of the stencil, and helps to alleviate pinholes.

Mechanical roughening, or abrading, is highly recommended for nylon or polyester and should precede degreasing. Most of the major screen-printing suppliers manufacture suitable products. Although the following two-procedure method uses Ulano products, other brands such as Magi-Prep, manufactured by Majestech, are also effective.

1 Dampen the fabric. Sprinkle Ulano No. 2 Microgrit, or silicone carbide 500 grit, on the printing side. Rub the microgrit back and forth across the mesh with a damp, natural fiber rag until the rag begins to fray. Rinse the mesh with water.

2 Apply Ulano No. 3 Screen Degreaser, which is specially formulated to remove a variety of contaminants, to a wet screen with a wet medium-stiff brush until a light foam develops. After the foam subsides, rinse the screen thoroughly from both sides, including the frame and frame corners, with hot or cold water. Do not use household scouring powders, solvents, dishwashing liquids, or liquid household cleansers.

Applying the emulsion Since photo emulsions are light-sensitive, they should be applied in a darkroom illuminated with a yellow or red safelight. Before applying the photo emulsion, mask the printing area with solvent-free tape. The following procedure uses Majicol T White photo emulsion. (If another emulsion is used, be sure to follow the directions on its label.) A separate dye is available to add to the Majicol emulsion to make it more visible. When not in use, this emulsion requires refrigeration.

1 Wearing gloves because the emulsion is somewhat toxic, stir the emulsion with a plastic stirrer and fill an anodized aluminum or stainless steel scoop coater. Select a scoop coater just narrower than

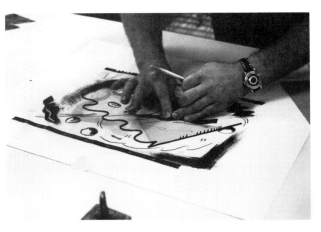

A transparent Mylar positive is created with soft lithographic crayon, black acrylic paint, opaque tape, and similar materials in preparation for a photo screen print.

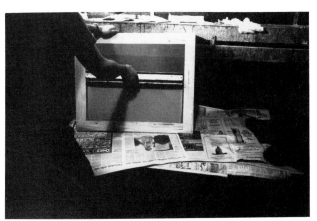

Magicol T White Photo Emulsion is applied in a scoop coater.

the taped screen area so that a thin, even coat can be applied. If the scoop coater rides over the tape, it may deposit too little in the central area, resulting in uneven coverage.

2 Place the clean, dry screen in a tilted position, underside toward you, and pull the scoop coater from the bottom up. Tilt the coating edge toward the fabric as you pull up so that the emulsion pours onto the fabric. When you reach the top tape, tilt the coater down a bit to catch any drips. Apply only one coat.

3 Fill out the sides between the scoop coater and the tape with one stroke of a cardboard or photographic squeegee for each side. Scrape off any excess from the frame. If there are thick spots, the emulsion will take longer to dry.

4 Pour the excess emulsion back into its container and refrigerate. Clean the scoop coater immediately with a sponge and warm water. If dry particles remain, they will cause trouble when you next use the coater. Use gloves for all cleanup and quickly wash off any emulsion that splashes onto your skin.

5 Dry the emulsion-coated screen in a tilted upright position in complete darkness or with a yellow or red safelight. Wait until it is perfectly dry to the touch.

Exposing the screen After the emulsion-coated screen is dry, expose the screen with the positive or negative transparency on an exposure table. (See the chapter on photographic techniques for additional information.)

1 As shown in the photo above, place the Mylar positive, with the drawn side up, on the vacuum table in a darkroom with a yellow or red safelight as the only illumination. Place the emulsion-covered underside of the screen over the Mylar. (If you use a photo transparency, place it with the emulsion side up. A good rule to remember is always to have the emulsion sides in contact.)

2 Position a cord from inside the screen near the image and wrap it around the frame. Drop the black rubber cover of the exposure table over the screen. The cord allows the air to have a channel for escape when the vacuum is activated. If

The emulsion-covered underside of the screen is positioned over the Mylar positive on a vacuum exposure table. A black rubber cover will be dropped over the screen before the vacuum switch is turned on.

the frame is warped, take care that the cord does not get under the frame. An unwarped wood or aluminum frame is best for photographic exposure.

3 Turn on the vacuum switch so that all the air is pulled out from under the rubber cover, permitting a very snug contact between the transparency and the emulsion-coated screen. (In the example, 26 pounds of pressure were used.)

4 Expose the screen for the correct time. Here the screen is exposed for 2 minutes, the correct exposure for the Majicol T White photo emulsion and this exposure unit. Other products and images may require a different exposure time. If the exposure is too short, the emulsion will wash out too easily or incompletely. If the exposure is too long, detail may be lost and it may be difficult to wash the emulsion out. Check the manufacturer's fact sheet for the suggested exposure time. The most accurate method is to try different time exposures on a test screen. Be sure to duplicate all the conditions of the test.

Washing out the emulsion

1 After the screen has been exposed, hose it with a medium-fine spray of tepid water. Wet the back but spray only from the front to soften the emulsion. The image will begin to wash out, and when completed the clear screen in the image areas will be evident. Gently and carefully blot the screen with newspaper to eliminate the risk of water marks or chemical glazing in the image area. Fan dry. In any case, follow the directions on your emulsion container as procedures may vary with different formulations.

2 If the image does not wash out completely, carefully spray with a 50 percent solution of haze remover or reclaimer and water to help clear it. Use this solution with caution or it may dissolve all the emulsion. The wash-out operation removes the unhardened emulsion from under the drawn or photo areas, leaving them open so that during the printing process ink will pass through the fabric to produce the image. Where there is no imagery in the transparency, the ex-

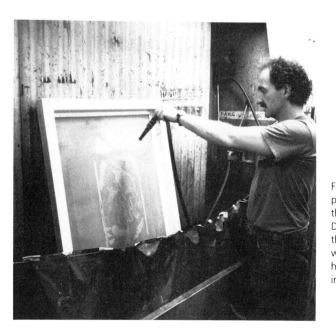

Franz Spohn, lecturer in printmaking at the University of the Arts, College of Art and Design, in Philadelphia, washes the entire screen with warm water to remove the unhardened emulsion from the image areas.

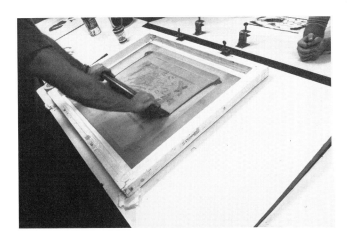
A first color is printed with a flood stroke.

posure light will have hardened the emulsion, which will serve as a block-out during printing.

3 Hold the screen up against a light to check that all the image area is visible as clear, open mesh. Give another cool wash over both sides of the screen and immediately fan dry. The screen is now ready for printing with water-based inks.

If the emulsion washes out too quickly, destroying the image, the following may apply:

1 Emulsion applied too heavily.
2 Exposure time too short.
3 Screen not thoroughly dry.
4 Water spray is too hot or too forceful.

If the image doesn't wash out after 5 minutes, the following may apply:

1 Emulsion-prepared screen subjected to light prior to exposure.
2 Exposure time too long.
3 Water spray too cool.
4 Water spray not forceful enough.
5 Screen stored too long before shooting.

These are some of the possible pitfalls. Experience is, of course, the best teacher—and keeping a notebook of exposure times and data on each print. If all fails, reclaim the screen, dry and recoat with emulsion, and reexpose it.

Reclaiming the screen Reclaiming a screen after using a photo emulsion, whether for water- or oil-based inks, is

accomplished through a chemical reaction. The appropriate chemical for the fabric and stencil is applied to the hardened stencil, causing it to soften, break down, and wash away, so that the screen can be used again. Follow the material data sheets for each product carefully and wear rubber gloves. If spraying a solution is necessary, wear a mask to prevent inhaling.

Reclaiming a screen after use of an emulsion produces the best results if done as soon as possible after printing and if done with a motorized pressure hose. If only a garden-type nozzle is available, cleaning the screen can take up to 15 or 20 minutes, as opposed to 2 minutes for a motorized pressure hose.

DIRECT PHOTO FILM

Another direct photo method uses a pre-sensitized photo film attached to a plastic backing sheet, which can be adhered to the screen with water, yet is compatible with water-based inks. After it is attached to the screen it is exposed through a positive transparency with ultraviolet light.

An example is the Ulano CDF/TZ water-resistant film system, which adheres with water, without the need for

chemical or screen emulsions. It is ideal for small or large stencils on all types of fabric except natural silk. An excellent fact sheet is available from the manufacturer and should be carefully followed.

Adhering the film Because the Ulano CDF/TZ film has a relatively high sensitivity, all procedures should be done in a darkroom with a yellow safelight.

1 Carefully degrease the screen in the method suggested for the direct method.
2 Cut a piece of film an inch or two larger than your image (return unused film to the package and seal).
3 Place the film emulsion side up on a padded baseboard. (The emulsion side is the one that feels tacky when touched with a moist finger.)
4 Moisten the screen well with water and lay it on top of the film.
5 Apply a firm squeegee stroke and blot off the excess water at the base of the screen with a paper towel. This simple stroke adheres the film to the screen.
6 When the screen is completely dry, the polyester backing will peel off easily. An electric hair dryer blowing air at 100°F can speed the process, or a circulating fan can help.

Exposing the film Place the photographic or hand-drawn positive transparency emulsion side up in contact with the presensitized film on the bottom of the screen. Use a vacuum frame with a flexible rubber blanket.

Check the product fact sheet for the recommended light source and exposure time. Because the film thickness is constant and not influenced by a screen emulsion, the exposure time remains the same. The light has to travel the full film thickness to harden the stencil. The better the light quality and the higher the light intensity, the better the resistance

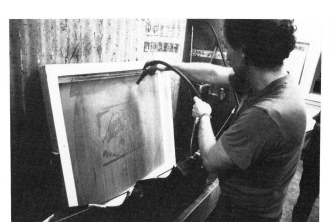

Hose the water-based ink from the screen with warm water as soon after printing as possible.

and the resolution of the stencil. Try to keep the film-to-lamp distance as short as possible. A longer exposure makes a harder film; resolution is improved by shorter exposure.

A wise procedure is to take the time to test appropriate exposure times for various light sources and presensitized photo films since individual light sources vary greatly in the amount of light they put out. Ulano supplies a detailed chart called a Step Wedge Test, which will help you to test exposures and determine time with controlled accuracy.

Wash-out Cold or warm tap water may be used. Warmer water speeds up wash-out slightly. Fine details need high water pressure to open up, and therefore a high-pressure spray is suggested.

1 Wet the underside first, then wash out from the printing side until the image is open. Finish off from the printing side. The washed-out stencil is extremely hard.

2 Blot both sides with clean newsprint.

3 Dry, touch up, and fill in any un-covered surrounding area or pinholes with screen filler. The screen is now ready for printing with most water-based inks.

Removing the stencil

1 Remove ink from the screen with water before it dries.

2 Apply stencil remover (Ulano No. 4 liquid or No. 5 paste) and let stand for 5 minutes.

3 Spray out with a high-pressure spray.

4 Remove any ink or film haze residue with Ulano Haze Remover No. 78.

EXPOSING FROM PROJECTION

When the production of a positive trans-parency is difficult because a large size is desired or because of a lack of photo-graphic equipment, it is possible to use a very sensitive screen emulsion and project your image directly on the screen. In this process a screen is coated with a special emulsion (from the Rockland Colloid Corporation) under a red, am-ber, or yellow-green safelight. As this emulsion is a solid below 100°F, the bot-tle containing it must be immersed in hot water until enough becomes liquid to coat the screen. The temperature in the scoop coater should be about 90°–95°F.

One coat is usually enough (use a scoop coater), and the screen is dried in a dry, dark area. The emulsion is so sensitive that it can be exposed directly from a color slide (choose a high-con-trast image) in an enlarger, from an opaque projector, or from a slide projec-tor, thereby eliminating the need for a full-sized positive transparency.

Exposing the screen It is possible to use small (35mm) negatives as the image source by contact printing the negative onto a film such as Kodalith Type 3 using Kodalith developer. The small positive can now be used in the enlarger or projector and projected onto the sen-sitized screen. If you use a color slide as the image source, choose one that has blue tones rather than red or yellow hues, as the latter take an extremely long time to expose. Normal exposure for a medium-sized screen under an enlarger will be about 1 minute at full aperture. If you have access to a graphic-arts pro-cess camera, you can place the sensitized screen in the film holder part of the camera and photograph the artwork di-rectly onto the screen.

Developing the screen The developer is supplied with the emulsion and comes in the form of pellets that are added to cool water. It contains caustic soda, a dan-gerous chemical that generates heat, and therefore care must be taken to keep the concentrate from contacting the skin. Be sure to use gloves. When the developer has cooled to 65°–68°F, place the screen in a tray and brush the developer liber-ally on both sides of the screen, allowing it to run into the tray. Develop for 2 to 3 minutes, but do not overdevelop or the screen may not wash out. Screens can also be soaked by immersion in a tray, or the developer can be sprayed on. Discard the developer after each use.

Wash-out Next the screen must be washed with warm water (110°–120°F) until the unexposed areas dissolve and wash out. The light will have hardened the exposed parts. Wash-out should take place in a few seconds. Then the lights can be turned on and cold water run over the screen for a minute or two to set the emulsion. Blot the screen with paper towels or clean newsprint to remove ex-cess water. Remove the blotters imme-

diately and discard. Block out the portions of the screen that are not to print. The screen can be used with either water- or oil-based inks.

Reclaiming the screen Dissolve the hardened emulsion from synthetic or metal screens with full-strength household bleach. Wash thoroughly with hot water and dry. If oil-based inks are used, screens must be degreased with hot alkali before reuse.

Screens made of natural materials (silk or cotton) will dissolve in bleach, and so an enzyme-type emulsion remover must be used. This can be obtained from screen-printing suppliers or from Rockland Colloid Corporation.

Water-Based Screen Inks

As more and more artists and schools have adopted water-based screen-printing methods, manufacturers of screen-printing inks have responded by producing high-quality water-based inks along with retarders, extenders, and transparent bases. However, the properties of each brand vary, and it is wise to try out a few in order to discover which are best suited to your imagery.

The most frequently used water-based inks are Createx pure pigment, Hunt Speedball permanent acrylic ink, Hunt Speedball water-soluble ink, and TW Graphics WB 1000 water-based ink. Their properties are described in the chart at the end of the book. Because individual needs often determine which ink produces the best results, we are not endorsing any particular product. Some artists have even used Golden or Liquitex acrylic paints mixed with transparent base and a few drops of glycerin with good results. But these colors are far more costly than screen-printing inks.

CHOICE OF INK COLORS

The color names of screen-printing inks do not always coincide with those of oil paints or watercolors. Ink manufacturers sometimes give fanciful names to their colors, making selection difficult. It is best to request color charts before ordering inks. Purchase small test amounts from a number of manufacturers and do some test runs to see which ones work best for you. Some typical warm and cool colors are:

Red: warm (scarlet, cadmium, fire); cool (magenta, alizarin, cerise)

Yellow: warm (medium yellow); cool (lemon yellow)

Blue: warm (ultramarine); cool (phthalo blue, peacock, process blue [cyan])

If you are printing color with photo halftone screens or tonal washes, it is a good idea to try the process colors used by commercial printers to achieve the widest color range. The process color inks are cyan (blue), magenta (red), yellow, and black. By overlaying these colors, you can produce virtually any color you want (aside from those that require special inks, such as gold and silver).

TRANSPARENT BASE

Transparent base is important to the preparation of ink for printing. Its function is to make the ink more transparent, to extend the ink, and to aid in printing fine details, especially halftones and lines. Generally, the transparent base manufactured for most water-based inks is excellent. It mixes easily and is buttery in consistency.

The base must be mixed in well with a large mixing knife aided by cardboard squares. If not properly mixed, the ink will print with streaks. The amount added depends on the desired transparency: 10 to 60 percent is acceptable. Some colors such as yellow and orange are more transparent and require less transparent base.

The screen print is such an excellent medium for overprinting transparent colors that experimentation is certainly worthwhile. Printing one transparent color over another, of course, gives a third color, but the sequence in printing them produces different color effects. The subtlety possible through overprinting is remarkable. Printing a transparent red over a yellow will give a different orange than printing the red first and the yellow over it. A general rule is to print light colors over more intense ones for greater transparency and color change.

RETARDERS AND EXTENDERS

Each manufacturer produces a retarder that helps prevent the ink from drying.

Check the fact sheet on the product for usage.

There is also a nontransparent extender base that bulks up the color, extending it without making it transparent.

INK MIXING

Mix very small test amounts at first to find the percentage of each color required to produce the color you want. After mixing, tap out a very small amount with your finger onto a sample of the paper you will use for printing to check the color. Add a small percentage of transparent base to the color to see how much transparency you want. You can add between 10 and 50 percent (or more if necessary). Mix the ink and the transparent base thoroughly and check its transparency by tapping it out again on a swatch of your printing paper. Remember that transparent colors such as yellow and orange will require less transparent base than blues and reds.

When mixing two or more colors, start with the lighter color and add the darker color slowly to test the amount needed to achieve the color and value you want. For example, when mixing a green, start with yellow and slowly add blue until the desired hue is achieved.

Test a small sample by squeegeeing some of the mixture through a test screen. Check the color after it has dried. The colors often appear darker on the palette than after they are printed. Make notes regarding the percentage of each color needed to mix the hue and value desired. Use measuring spoons and cups to accurately gauge percentages.

ADDITIVES

The ink should be smooth and buttery for good printing quality. Different brands of ink vary in their viscosity and some do not require additives. However, there are occasions when a drop or two of glycerin, a small amount of water, or retarder needs to be added to the ink to improve its printing quality.

ESTIMATING INK QUANTITY FOR PRINTING

It is very important to mix enough ink to finish a complete run. Stopping printing to remix a color necessitates washing out a screen to prevent drying and runs the risk of color changes in the edition.

Estimating the amount of color needed for edition printing is tricky, and even with mathematical projections, experience is the best instructor. Many factors must be considered:

1 A large edition, of course, requires more ink, as does a large image area.

2 The printing surface affects the amount of absorbency, and thus the consumption of ink. Paper, cardboard, and fabric absorb more ink than plastic or glass.

3 A coarse screen mesh consumes more ink than a finer mesh. An 8XX or 10XX mesh allows more ink to be deposited because the openings are larger than in 12XX or finer.

4 The stencil thickness also determines the amount of ink deposited. A paper or nonphotographic film stencil allows more ink to be deposited than a thin photo stencil.

5 A sharp-edged squeegee used with firm pressure during printing deposits less ink than a dull, soft squeegee used with less pressure.

One gallon of ink is estimated to cover 1,000 square feet of surface. One quart will cover 250 square feet. If your print is 2 feet by 3 feet, or 6 square feet, an edition of fifty will cover 300 square feet.

You need a little more than 1 quart of ink to print that edition, so estimate 1½ quarts, allowing for waste and cleanup. It is far better to mix too much ink and have color left than to mix too little and run out during printing.

Purchase your colors with this in mind. To start with, a quart of each basic color should be sufficient, along with a gallon of transparent base of the same brand as the color. You will soon know which colors you use most frequently.

Keep ink mixing and paper in separate locations so that the areas of work and storage are kept clean. Mixing quantities of ink can be done in plastic mixing bowls or containers that have lids and can also be used for storage. It is helpful to store inks labeled with a swatch of the color taped to the container.

Paper

The papers used for water- and oil-based screen printing are similar. Thin papers are not desirable because they can warp or buckle during printing. Heavily textured paper can cause uneven ink coverage. Sized papers produce good results

because the ink is not absorbed into the paper and sits on the surface. When there is considerable ink coverage for multiple color printing, the weight of the ink becomes a factor and a heavy paper holds the surface weight best.

A few recommended papers for screen printing are Arches Cover, Arches 88 Silk Screen, Rives BFK, and Stonehenge. Refer to the paper chart in Chapter 15 for more details. Generally, any heavy, acid-free paper works well, but you will find some work better for certain ink brands. When you test color samples, test different papers too.

Cut and stack all your edition paper beforehand in a clean place near your printing frame. Allow at least 10 to 15 percent additional sheets for spoilage. Have five to ten sheets of inexpensive proof paper close by along with a quantity of newsprint for trial prints.

Printing with Water-Based Inks

Before you start to print, it is very important to create a setup that will allow you to work efficiently. The complete quantity of ink required should be mixed and stand ready in a container. Cardboard squares for distributing ink and paper for

Metal clips strung on a taut wire serve as an inexpensive drying rack at the University of Wisconsin.

printing should be stacked ready for use. A drying device or rack should be nearby. Register guides should be in position and ready to receive paper, and the screen should be attached to the base and ready to go. A few sheets of newsprint should be placed on the baseboard as a cushion to allow good screen contact with the paper. A sheet of proof paper should be placed in the register guides and a squeegee with a central handle—facilitating a firm grip and firm pressure—should be placed in an accessible spot near the screen. (Two-hand squeegees are acceptable if this feels comfortable.)

When printing with water-based ink it is very desirable to have a partner to help: one person to print and one to feed the paper. It is essential not to hesitate or to delay as ink can dry in the screen.

Lower the screen and pour a moderate amount of ink in the taped area at the side of the screen, taking care to spread it evenly across the whole width. Stand in front of the table, place the squeegee in the ink, hold it at a 45-degree angle with a firm grip, and pull it across the screen.

It is extremely important to have a sharp squeegee and hold it at the proper angle with medium pressure. Contacting the screen at a 45-degree angle is important. If ink builds up under the squeegee, causing it to lose its sharpness, wipe the buildup away with a soft, clean cloth. Avoid using a tool that might nick or scrape the blade.

After completing the first printing, place the squeegee on a nearby palette. Lift the screen and prop it on its leg. Remove the proof. If the impression is good, start to print the edition.

If you are squeegeeing side to side you will simply reverse your pull after the first printing. If you are printing top to

This commercial, spring-controlled, metal drying rack at Cooper Union School of Art in New York is very efficient, storing many more prints than other kinds of racks.

bottom it is helpful to have a free-standing table. You can simply walk to the other side and pull the squeegee toward you after a new piece of paper is in position. Without such a table you just push up with the squeegee. Add more ink as necessary.

As the finished prints come off the screen, place them carefully in a drying rack. If a rack is not available, string a wire out like a clothesline and use metal clips or clip clothespins to hold the prints for air drying. A third person to place prints in the rack or hang them during a long run is a great help. After a few printings, you will establish a rhythm, and should be able to complete the edition easily.

FLOOD STROKE

Printing with a flood stroke is a very useful method because it keeps the screen mesh moist while a new sheet of paper is being inserted in the register guides.

1 Immediately before each printing stroke, lift the screen about 2 inches on the printer's end. The screen leg or a wedge may be used.

2 With the screen in this semi-raised position, push the squeegee in the opposite direction from the printing stroke, giving the whole screen a clean coat of ink in one pass. Use less pressure, but keep the squeegee at about a 60-degree angle. Many screen printers prefer side-to-side printing with a one-handle squeegee. If you print from left to right, the flood stroke should be right to left. Keeping this rhythm of opposite strokes is important for even inking and accurate registration. (Pulling the squeegee frontally can also produce good results. Select the method that is comfortable for you.) Medium, even pressure is important for good distribution of ink.

OFF-CONTACT PRINTING

If the screen does not pull away from the print easily, it may "kiss" the print, leaving a halo. To avoid this, try printing

FLOOD STROKE

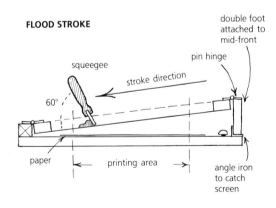

OFF-CONTACT PRINTING

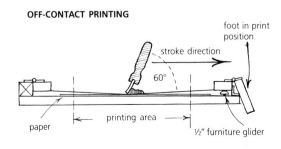

with the screen elevated about ½ inch above the printing paper. This can be accomplished by nailing a ½-inch furniture glider to the baseboard to keep the frame elevated under the frame corners. Squeegeeing the ink across the printing frame at about a 60-degree angle with a medium- to hard-durometer squeegee creates the necessary pressure to accomplish contact for printing. And when the stroke is completed, the screen fabric springs back up, immediately after touching the printing paper—leaving a clean, clear image.

WASHING OUT INK

It is very important to clean the ink out of the screen as soon as possible after printing. Do not allow it to dry or cleaning will be more difficult. Hosing with warm water and soft scrubbing with a sponge are generally sufficient.

If the stencil is not going to be used again, clean it out immediately after printing. It is very important to follow the manufacturer's instructions and to use gloves and an apron. If a power hose is used, wear a mask to protect yourself from misting or vapors from screen cleaners, which often contain chemicals and caustic substances.

STORAGE OF INKS

Excess ink can be scraped and squeegeed from the screen and stored in plastic containers with lids. Some oil-based inks may dissolve plastic or vinyl containers. When using those inks, it is best to use tin cans and cut a piece of heavy vinyl to

the size of the opening and lay it flat on the ink surface with no air bubbles.

Some water-based inks develop mold during hot weather or in warm storage areas. Just scrape off the mold and use the rest of the ink.

SURFACE SCALING

It is possible to seal a water-soluble printed surface by squeegeeing a clear coat of either Liquitex acrylic gloss or matte medium through the screen. Because these materials are insoluble in water when dry, be sure to clean the screen immediately with liquid detergent and a hot-water spray when the coating is finished.

HAZE REMOVERS

When a screen has been used for many, many printings and a variety of colors, the screen fabric will develop ghost images from previous printings that do not wash out. Darker colors will stain more than lighter ones. These stains can be disturbing when you prepare subsequent images and can hinder accurate resolution of photo transparencies.

Special products called haze removers are manufactured for the express purpose of removing ghost images. However, they contain caustic chemicals and must be handled with extreme caution. Consult the manufacturer's instructions and data sheets and use only in a well-ventilated area with a strong exhaust fan. Wear gloves and a mask that will protect you from vapor inhalation. Haze removers are not recommended for open studio or school use. A safe alternative, of course, is to stretch new fabric if ghosts make new images hard to see or if photo work is to be done.

PRINTING PROBLEMS

A variety of conditions can arise in printing that may need correcting. The following are some common problems:

1 *Ink dries in screen*: Mist the screen and print repeatedly onto smooth newsprint until the image clears of dried ink. Use flood strokes. If ink dries in the fabric, use the household cleanser Fantastik or a pressure spray, or both.

2 *Ink too thick, detail lost and areas don't print*: If the ink feels too thick, try adding one or two or all of the following very judiciously: a drop or two of glycerin, a small amount of water, or a small amount of transparent base. Mix very well. Do not, however, add water to the TW Graphics ink; instead, use butyl carbitol as a thinner or retarder.

3 *Image prints too light or uneven*: Bear down on the squeegee with more pressure.

4 *Heavy buildup of ink around printed edges*: Add opaque color to your ink since the ink may contain too much water.

5 *Streaking*: Be sure the ink has been well mixed. Use a firm, even pressure on your squeegee.

6 *Halos or "kissing"*: When the print sticks to screen, try off-contact printing. The ink may be too dry. Thin it as described under 2 above. The fabric may be stretched too loosely. Tighten or restretch. Try a swifter stroke with your squeegee. If you are dealing with a large open area or photo image and have this problem, use a vacuum table.

OIL-BASED INK METHODS

In general the equipment for oil- and water-based techniques is the same, as are the register systems. The difference is that the inks require different solvents, block-outs, screen fillers, stencil systems, photo emulsions, and so on. In addition to the basic equipment suggested on page 156, you will need the following materials for printing with oil-based inks:

Silk (12XX to 14XX mesh), polyester, or nylon

LePage's glue

Water-soluble block-out

Lacquer block-out

Glycerin

Acetic acid (vinegar)

Visualizing paper (19 × 24 inches)

Acetone

Oil-based inks

Paper Stencils

This stencil process is the same as for water-based inks except that visualizing paper is most commonly used for the

stencil, along with oil-based inks for printing and mineral spirits for cleanup.

TYPES OF STENCIL

Visualizing paper This thin, translucent, white paper manufactured for commercial artists' layouts is one of the best papers to use. It is semitransparent, semi-absorbent, and flexible, and should not be confused with tracing paper. Tracing paper is too brittle even in the thin variety, although it does sometimes adhere well enough.

Other papers For certain mottled effects a very absorbent paper such as newsprint, rice paper, or tissue can be tried. It gives a soft printing quality that may be desirable but is useful only for a very short run because it disintegrates. Some of our students have used wrapping tissue and bathroom tissue, which produce interesting textures that hold up for a nominal printing.

RICHARD ESTES
Times Square, 1981
Screen print (approximately 100 colors, oil-based ink), 18″ × 24″
Courtesy Parasol Press, Ltd.

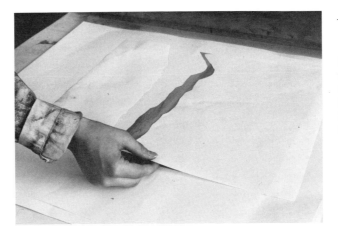

Lift the screen. Place paper shapes on the board under the screen to create the stencil and prevent the oil-based ink from passing through the screen when you start to print.

CUTTING THE STENCIL

A paper stencil can be made in numerous creative ways. Tearing will produce soft edges; a wood-burning tool can make holes or feathery edges. The surface can be sanded to allow ink to penetrate in some areas. A paper punch or rotary-cutting and dot-making device can open up patterns and lines.

If a sketch of the work to be cut is made, register it in the register guides and tape it to the baseboard. If no sketch is used, simply cut or tear the forms to be used.

Place the visualizing paper or other suitable paper over the drawing but not under the register tabs. Be sure the stencil paper covers the printing paper. Tape it to the baseboard.

If the drawing is easily seen through the visualizing paper, you may proceed to cut out the areas to be printed. Remember that the areas you remove will be the areas that are printed. If the drawing is intricate or hard to see, you may want to trace it first, then cut it.

If there are floating parts in your stencil, it is best not to remove the cut-out sections until the stencil has been adhered to the screen; then pick out the unwanted sections with a tweezer. This eliminates the possibility of the loose parts moving out of position. A floating area can also be fixed to the screen with a dab of LePage's glue or by cutting a small hole in the shape and placing

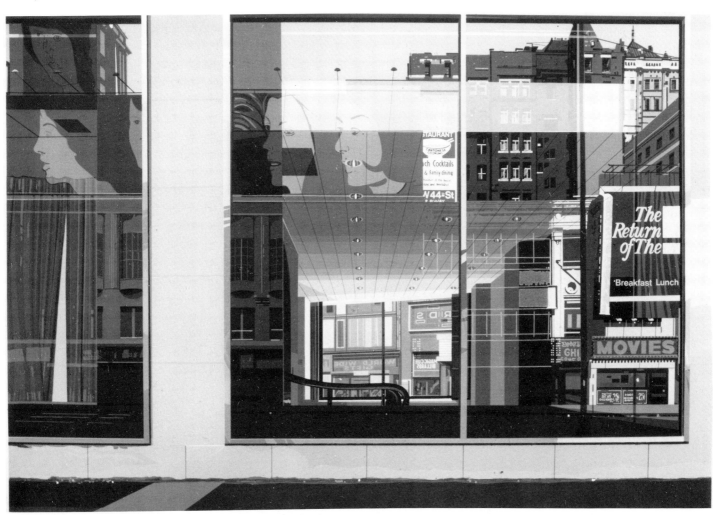

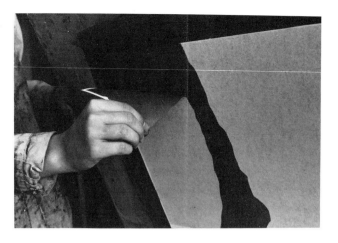

When you have printed enough impressions, peel the paper from the bottom side of the screen and clean it with screen wash or paint thinner. The paper stencil method is good for a small number of prints, as the screen may not be cleaned without ruining the image.

Magic tape behind it, with the gummed side face up; the tape will stick to the screen when finger pressure is applied just before printing. Or place a small drop of water-soluble glue on the top side of the screen with a cotton swab until it adheres to the loose piece of stencil underneath; allow the glue to dry.

For the actual placement and adhering of the paper stencil to the screen, use the steps described for water-based inks on page 158. Substitute visualizing paper for the photo mount paper or freezer wrap.

PRINTING THE STENCIL

1 Mix the ink to be used with roughly 50 percent transparent base to make printing smoother. If the ink is too transparent, add more color; if it is not transparent enough, add more transparency. The amount of transparency depends on the degree of transparency in the color being used. Mix enough ink to allow printing without interruption.

2 Place an ample amount of ink across the top of the screen.

3 Squeegee the ink firmly across the screen. The stencil should adhere easily with the first printing. Continue printing the edition. Do not let the screen dry out.

4 Refer to the section on water-based printing techniques for a discussion of flood-stroke and off-contact printing. Both processes can also be used with oil-based inks.

CLEANUP

First place a thick bed of newspapers between the screen and the baseboard. Remove all the excess ink from the screen and the squeegee with cardboard squares and save it if it is reusable. The

more excess ink you remove, the easier the screen will be to clean.

Carefully remove the stencil and place it on clean newspapers. If the stencil is very simple, it can sometimes be cleaned with a small rag if great care is taken. However, the stencil is usually not reusable, and so it is wise to print the whole edition at one time. The stencil cannot be left on the screen because the ink would dry and clog the screen.

Proceed to clean the screen and squeegee with clean rags, screen wash, xylol, or mineral spirits wearing solvent-resistant gloves. Remove the newspapers as they soil, always working with clean newspapers and rags until the screen is thoroughly clean. A good test is to run a white rag over the screen; it is clean when color can no longer be seen on the rag. This cleaning method can be used with all oil-based screen printing.

Block-out Stencils

Any procedure for screen printing that uses a stencil technique—whether the stencil is made of paper, lacquer film, photo emulsion, or glue—is essentially a block-out method. However, in the lexicon of screen-printing techniques, the term *block-out* is generally used to refer to the application of such hard-drying liquids as glue, lacquer, shellac, or commercially prepared block-out. Today hand-cut film stencils and photographic methods are commonly used by fine-art and commercial printing establishments, but individual artists interested in the spontaneity of brushstroke, splatter, stipple, and drybrush techniques will continue to prefer liquid block-out media. The quality of the soft edge produced by the block-out medium on the fabric of the screen still holds the interest of many artists.

The block-out method is an easy, fast, and economical way to produce an image. In addition to the paper stencil, it is a fine method for an artist's first attempts at screen printing and can be used for both negative and positive imagery.

MATERIALS

In addition to the materials already mentioned, you will need:

Shellac

Anhydrous alcohol

Poster colors

4 × 6-inch pieces of cardboard (for squeegeeing glue)

Brushes, sticks, pens, and the like (for applying glue)

Texture materials

Medium-soft roller

Brushes of different types, from stiff-bristled to sable, will give varied effects to the glue application, contributing to inventive use of line and mass. Speedball pen nibs that are not sharp will give a good line, while sticks that are not sharp will produce a different drawn quality. Glue can also be dripped onto the screen with sticks. Any tool, as long as it is not sharp and will not puncture or tear the screen, is usable.

DIRECT GLUE STENCIL: NEGATIVE METHOD

An easy way to create a brushed-on stencil is the direct glue method, which is a negative method. The glue mixture can be applied to the screen in a variety of ways to produce free, painterly, textured effects; hard-edged forms; or line images. Nothing has to be washed out. When the glue is dry, the stencil is complete and ready for printing. The ink will print in the areas where glue has not been applied.

Glue should not be applied to the screen directly from the can because it is too thick and will tend to chip and flake when dry. The best results are obtained by mixing the glue with water and a water-based coloring agent such as poster color to tint the glue and make it visible during application. A mixture of 2 parts

This experimental proof was done with a direct glue block-out method, so the negative spaces print. Glue was painted and dripped onto the screen; it was also rolled on the bottom of a tin can and rough textured wood, and then offset onto the screen. In addition, glue was applied to water-dampened areas on the screen to achieve soft edges. Blotting with paper towels achieved even more texture. (Courtesy Pratt Institute.)

LePage's glue to 1 part water and 1 part coloring agent is very satisfactory. Add a few drops or more of glycerin to make the glue more flexible.

Different effects may require thickening or thinning the mixture by adding more glue or more water. Individual creative needs will determine the necessary changes.

If you prop the screen up with two small squares of two-ply cardboard in each corner when applying the glue to the top of the screen, it will not come in contact with the sketch. Remember that you need to apply glue to all the negative areas, those areas that will not print and will appear as whites in the finished print. If you use this method with subsequent screens and additional colors, interesting images can result.

Experiment with different tools for applying the glue. Aside from brushes, pens, and the like, try applying textures with a sponge, a crumpled cloth, or crumpled paper. Brush on glue in an area, then blot it with wax paper or absorbent paper. Or leave the wax paper on until the glue partially dries and then pull it off for another interesting texture.

Experiment with the transfer method. Apply glue to a textured surface with a medium-soft roller. Place a piece of non-absorbent paper, such as tracing paper, on the glue-covered textured surface and offset the textured glue onto the paper. Immediately lay the tracing paper face down on the screen and offset the glue by rubbing the back of the tracing paper with your fingers.

The choice of textured surface is very wide. If a surface can be rolled with glue and an offset made, it will successfully transfer. Raised letters on plastic, metal, or wooden containers offset well. Other textured materials are interesting to work with. A sponge, a rag, or crumpled paper, wet with glue can also be used along with the rolled objects.

Another way to produce variations is to apply the glue to a dampened screen. Soft edges will occur where the glue and dampened screen blend.

A glue stencil can yield somewhere between 150 and 200 good impressions before pinholes begin to appear in blocked-out areas. For longer runs, shellac, lacquer, and film stencils are recommended. However, shellac and lacquer require the use of more toxic solvents for reclaiming and are harder to wash out unless the screen is coated with a glue sizing first.

WATER-SOLUBLE BLOCK-OUTS: NEGATIVE AND POSITIVE

Most of the water-soluble block-out materials available from commercial screen-printing supply houses are excellent. Although they are more expensive than LePage's glue, they dry faster than the glue and produce a strong, flexible film for many impressions. Because the fluid is tinted, it can be seen clearly. Two of the best-known brands are Water-Sol and Blox. They can be substituted for any of the glue procedures and are very durable and flexible and can produce long runs. Reclaiming the screen is easy since the block-outs can be washed out with warm or cold water. The block-outs are compatible with all oil-based inks.

SHELLAC BLOCK-OUT: NEGATIVE AND POSITIVE

Shellac is used only infrequently as a block-out agent. Its advantages are that it is very durable, it can withstand thousands of printings, and its orange color

makes it very visible when painted on the screen. Five-pound cut shellac is the most useful kind because it has a thick consistency that can be thinned with denatured or anhydrous alcohol, making it quite economical. It can be used with all oil-based inks.

There are, however, major disadvantages, including the unpredictable drying time of shellac and the difficulty in cleaning it from an unsized screen.

Sizing the screen There are two advantages to sizing your screen with a glue mixture before using shellac as a block-out. The first is the ease of painting the image and the second is the ease of cleanup. The sizing mixture consists of 1 part LePage's glue to 3 parts water, which is thinner than the mixture used for glue block-out. With the consistency of light cream, it flows on freely and fills the fabric mesh. To apply it:

1 Prop up the screen at least 1 inch with newspapers underneath to catch the excess glue.

2 Use a 4-inch cardboard square to distribute the glue mixture thinly and evenly over only the top side (squeegee side) of the screen surface. Allow the sizing to dry.

3 If a sketch is used as a guide, slip it beneath the screen. Lower the screen and rest it flat on the sketch. Apply the shellac or any other water-resistant block-out to the areas that are not to print.

4 Remove the sketch and allow the shellac to dry.

5 Wash the glue sizing from the printing areas of the stencil. Rub the top surface of the screen with a water-saturated sponge to dissolve the glue sizing and allow those areas to be printed. Do not allow water to seep to the underside beneath the block-out areas. Use a dry, absorbent cotton rag to remove any remaining water or glue. Hold the screen up to the light to see that image areas are clear of glue. The screen is now ready to print.

Cleanup With a glue-sized screen, only water is needed, making cleanup much easier and less toxic. First rinse the bottom of the screen with a sponge filled with cold water. Repeat on the top side.

As the thin glue sizing under the screen dissolves, the block-out will peel off. This occurs because the block-out no longer has a base to cling to, leaving the screen clear again.

It is more difficult to reclaim shellac from an unsized screen. Both sides of the screen should be rubbed with denatured or anhydrous alcohol, saturated clean rags, and bristle brushes.

LACQUER BLOCK-OUT: NEGATIVE AND POSITIVE

Although lacquer has been used as a block-out in the past, we do not recommend it because of its toxicity and the need to clean the screen afterward with lacquer thinner, which is highly toxic.

Resist Methods

The great advantage of resist methods is the comparative ease of drawing and painting in line and mass and texture. The freedom of expression and direct positive image are often an attraction to painters who have never made prints.

The resist method is based on the principle that a waxy or greasy substance resists water. Greasy substances such as liquid or stick tusche, liquid wax or wax crayon, rubber cement, Maskoid, or even asphaltum varnish are used alone or in combination to design a positive image on the screen. A great variety of tools can be used: brushes, pens, sticks, rags, sponges, and the like. When the image is thoroughly dry, a thin coat of a special glue mixture is applied to the entire open screen area to act as a blocking agent. When the glue is dry, the wax or tusche is washed out with mineral spirits, turpentine, or paint thinner, leaving a free, positive image for printing.

MATERIALS

In addition to general screen-printing materials, you will need:

LePage's glue

Glycerin

Vinegar

Water-soluble block-out (a substitute for glue mixture)

Tusche (liquid and stick)

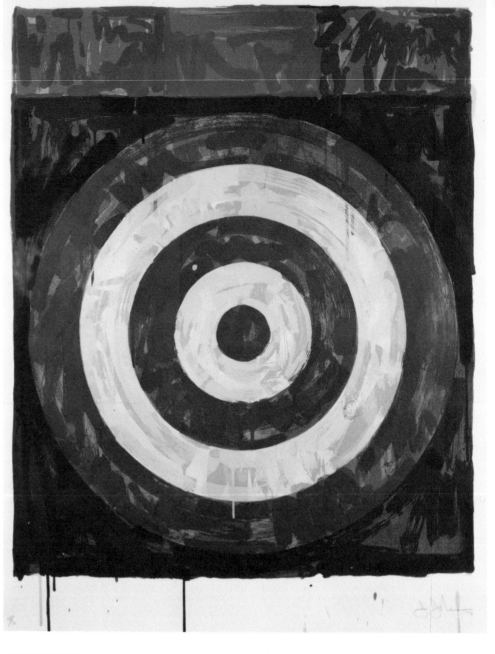

JASPER JOHNS
Target, 1974
Screen print (oil-based ink) by Simca Print Artists
34⅞″ × 27⅜″
Collection of Reba and Dave Williams

Cornstarch (for sizing)

Wax or lithographic crayons (soft)

Liquid wax (sold as resist for ceramics)

Rubber cement

Maskoid or E-Z liquid frisket

Brushes

Speedball pens

Textured materials (such as corrugated board, wire screening, wood)

The glue mixture used for the following resist methods should be a little thinner than the glue mixture used for direct negative application, so that it is easier to wash out the tusche or wax. The formula we have found very satisfactory is:

50 percent LePage's glue

40 percent water

8 percent vinegar (to help harden the tusche)

2 percent glycerin (for more resilience)

LIQUID AND STICK TUSCHE

Many kinds of liquid tusche are marketed under a variety of names. In fact, most large suppliers list their own tusche products in their catalogs. There is liquid tusche manufactured especially for screen printing, but Korn's lithographic tusche is also good for screen printing.

Some tusche can be thinned with water; other kinds use mineral spirits. All can be washed out when dry, with kerosene, mineral spirits, paint thinner, or the like. In all cases the tusche should be a thickish liquid; if applied too thinly, it will be hard to wash out. If it is too thin,

pour a little onto a blotter or absorbent paper towel to let the liquid evaporate. (Read the directions on the label.)

Tusche also comes in a stick form that produces a crayon-like drawn mark on the screen. Lithographic crayons can be used for the same purpose. A heavy deposit must be applied to the screen in all cases.

Cornstarch sizing Sizing the screen with a cornstarch solution before applying the tusche helps to close the mesh and creates a smoother work surface, minimizing the seepage of tusche through the fabric.

1 If a drawing is used, trace it onto the fabric with a pencil.

2 Using a sponge, coat the screen with the cornstarch solution (1 heaping tablespoon of cornstarch dissolved in a glass of lukewarm water). If the underside is coated instead of the top, the drawing will remain intact.

3 When the sizing is dry, the surface is ready to be drawn on or painted with tusche. The sizing gives the fabric a chalklike surface that will wash out when the tusche is removed.

Applying liquid tusche For liquid tusche, follow these steps:

1 Be sure the screen is clean of grease and soap residue. Rinse well.

2 If a sketch is to be used, slip it under the screen in the register guides. Raise the screen slightly off the sketch by slipping some cardboard squares under each corner.

3 Stir or shake the tusche very well because thick particles often settle to the bottom. If the tusche is too thin, allow some liquid to evaporate overnight. If it is too thick, thin it with water or turpentine, depending on the type. It is very important that the tusche be about the consistency of heavy cream to achieve the best results.

4 Apply the tusche as heavily as possible to the top surface (the squeegee side) with brush, pen, or other instrument. All the positive forms are created with the tusche.

5 Do not try to create tonal effects with tusche. Tonal qualities can be developed through textures or with stick tusche or litho crayon.

6 Apply the tusche so that it has a solid black quality and fills all the screen mesh. To achieve this you must work with a clean screen. Check the screen by holding it up to the light. Some areas may need a second application.

Applying stick tusche, litho crayon, or wax crayon Stick tusche, litho crayon, or wax crayon can be applied in areas where texture or variety of line is desirable. Use the softest grades of litho crayons (nos. 00, 1, 2, and 3), and make the drawing heavier than you want the finished print to be, to allow for a slight loss of image in the process. In order to put down a heavy deposit of crayon on the screen, it may be helpful to place cardboard under the area being coated to keep the fabric from being strained.

Texture rubbing Textures can be rubbed right through the screen. Place an object or pattern with a rough surface under the screen and rub the stick tusche or litho or wax crayon over it. Be careful not to use any sharp objects that could damage the screen. Apply the stick tusche or crayon liberally.

Applying glue Glue should be applied only after the tusche is thoroughly dry.

Korn's lithographic tusche is heavily applied to a slightly raised screen so that the pores of the fabric are filled.

By placing a leaf under the screen fabric and rubbing the veined surface with a heavy deposit of soft lithographic crayon, the shape and textures of the leaf will be clearly visible.

Writing with wax crayon and painting with tusche are done directly on the screen, along with rubbings of stick tusche and litho crayon from corrugated board and rough-textured wood. (Courtesy Pratt Institute.)

After the tusche and lithographic crayon images have been completed, the solution of LePage's glue, water, glycerin and vinegar is poured onto the well of the screen.

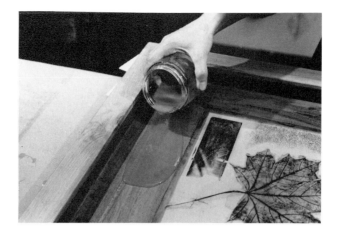

A cardboard squeegee is used to deposit a thin coat of the glue over the entire surface of the fabric.

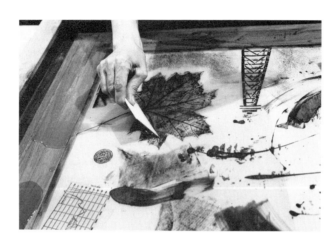

When the glue has dried, wash out the tusche and litho crayon with rags soaked with odorless paint thinner. If the tusche and litho crayon have been amply applied and the glue used thinly, the image areas should wash out, leaving the glue as block-out.

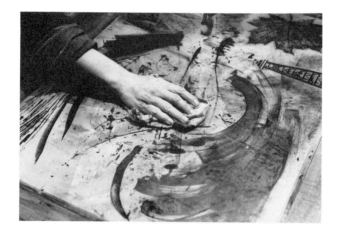

1 Pour a moderate amount of glue mixture on the screen margin on the top surface (the squeegee side), not on the image area. Be sure the screen is removed or raised at least ½ inch from the base on all sides to keep the glue from seeping onto the base.

2 With a sharp-edged cardboard square, squeegee the glue over the tusche area and over the whole screen in thin, even, overlapping strokes, but do not let the glue seep through the screen. If the cardboard is large enough, one stroke is desirable. Allow the glue to dry thoroughly.

Some artists prefer adding a second coat of glue after the first has dried, but two coats are rarely needed if the glue is applied well. With one coat, little pinholes sometimes appear in the first two or three proofs, then disappear with printing.

Washing out the tusche

1 After the glue is thoroughly dry, re-attach the screen to the baseboard and place a padding of newspapers between the baseboard and the screen.

2 Place the screen in the down position and liberally pour kerosene or mineral spirits over the whole image. Kerosene works best and remains wet the longest. Allow it to sit for 20 or 30 minutes for easier wash-out.

3 Rub the tusche with a clean rag, remove the newspapers, and repeat the process.

4 Raise the screen and rub both sides of it simultaneously with solvent-soaked rags or two cellulose sponges to clean it well. The tusche should wash out easily if it was applied thickly enough to the screen and a thin coat of glue was laid over it. If troublesome areas remain, use a soft nailbrush or two old toothbrushes face to face on each side of the screen to clean the difficult spots.

Reclaiming the screen After the edition is printed and the screen thoroughly cleaned of ink, wash the glue from the screen with warm water and clean rags.

LIQUID WAX

The liquid wax sold as a resist for ceramics is a good material for designing a positive image. It is soluble in water in its liquid state and can be washed out with mineral spirits when dry. It can be colored with poster color for easier viewing.

After the wax is applied and allowed to dry, the screen is coated with glue block-out, as in the tusche and glue method.

MASKOID STENCIL

This stencil is made with a liquid synthetic latex called Maskoid or E-Z liquid frisket. It is similar to the tusche and glue method but in many ways easier to use because it can be removed easily and does not stain the screen.

When dry, Maskoid is insoluble in water and alcohol but can easily be removed from the screen by rubbing with a piece of natural rubber or a rubber-cement pickup (dry rubber cement rolled into a ball and used as an eraser).

1 Apply the Maskoid with a brush to the positive areas that will print. Free, fluid lines and masses are easy to define.

2 When the Maskoid is dry, use a cardboard square to apply the glue mixture

given on page 176 or any other water-soluble block-out over the entire screen. Spread the glue in a thin, even coat, as described for the tusche and glue method.

3 When the glue is dry, remove the screen and place it on a clean, flat surface of cardboard or paper.

4 Remove the Maskoid with a piece of natural rubber. Rub the dry Maskoid at a sharp angle. If the glue coat is thin, the Maskoid should come off easily, and the screen can be printed.

Impasto Printing

The screen print produces an essentially flat surface, except when enamels are used, and therefore some artists may find it interesting to explore the use of impasto printing. Because the method involves paper and mat-board stencils and a heavy deposit of thickened ink, it is necessary to use a coarser fabric in order to print more ink.

Because of their thickness, enamel inks can be overprinted several times with ordinary stencil devices to achieve a thick deposit of ink. However, enamels take longer than poster inks to dry, making the method laborious.

Norio Azuma, a New York City artist, utilizes a very effective method to achieve a thick, granulated deposit of ink. He turns the screen over so that the underside is up and brushes water over the entire area or just on an edge of a form. He then sprinkles some granules of sugar on the dampened area, allows the sugar to settle in for about 5 minutes, and taps the screen underneath the area to shake off loose sugar particles. After placing the screen in printing position, Azuma squeegees color through two to four times, in different directions, sometimes lifting the screen to check the deposit of ink and squeegeeing again until he has the desired thickness. The granules of sugar adhere well to the screen and allow a thick deposit of ink in their area. Fifty to seventy-five prints can be printed with one sugar preparation.

A simpler system utilizes heavy paper or cardboard for the ordinarily thin stencil. You can thicken poster ink with cornstarch until it is the thickness of sour cream. Slowly and evenly squeegee the ink across the screen. The amount of pressure on the squeegee will determine the amount of ink deposited. Less pressure, more ink; more pressure, less ink. The thick stencil will allow a thick, textured deposit of ink to print on the paper. If the cornstarch begins to clog the screen, clean the screen carefully and resume printing.

TEXTURED OBJECTS

Another method involves gluing down textured objects such as burlap, rope, canvas, or cardboard to the baseboard, with rubber cement or any other temporary glue. You place a thin printing paper, registered in position, over the glued objects; then, using transparent inks, proceed to print. A heavier deposit of ink will occur in the recessions than in the raised areas, giving an interesting effect. The uneven bed can cause register problems, so proceed carefully.

Hand-Cut Film Stencils

The hand-cut film stencil is similar to the paper stencil but allows far more detail, sharp imagery, and great durability. The areas to be printed are carefully cut from the film with a sharp knife and stripped away from the backing. The film is then adhered to the underside of the screen and the backing peeled away, leaving a perfect stencil. It can be used for thousands of printings and is very dependable for precise registration.

There are two types of film stencils. The first consists of a water-soluble emulsion attached to a polyester base and requires only water to adhere it to the screen. The second consists of a thin sheet of lacquer attached to a plastic backing and requires a lacquer thinner-based fluid to adhere it to the screen. Because of the toxicity of this adhering fluid, the water-soluble film stencil is preferable. Water-soluble film can be used with all oil, lacquer, and vinyl-based inks, but never with water-based inks. Lacquer film can be used with all inks except those with a lacquer or vinyl base.

WATER-SOLUBLE HAND-CUT FILM STENCIL

For the water-soluble film stencil, we have listed products manufactured by Ulano Corporation. Other companies manufacture similar products.

Ulanocut green or amber film stencil (green is better for fine detail; amber peels more easily)

Stencil or X-Acto knife (Ulano stripping knife model PL is excellent)

Clean rags

Cellulose sponges

Ulano screen degreaser (Ulano Chemical Line No. 3)

Medium-stiff brush

Ulano microgrit (Ulano Chemical Line No. 2)

Ulano No. 60 Screen Filler or No. 10 Extra Heavy Blockout

Cutting the stencil

1 Prepare a sketch, position it in the register guides on the baseboard, and tape it down.

2 Cut a piece of film larger than the stencil being cut, then center and tape it, emulsion side up, over the sketch.

3 Holding the stencil knife vertically, use the tip to cut out the areas to be printed. Make sure cuts, but do not cut through the plastic or paper backing. Overcut the corners of shapes slightly to ensure that they will be clean when the film is removed. The corners will close up when the stencil is adhered.

4 Carefully remove the film from all the areas to be printed; a pair of tweezers is helpful. Leave the backing intact. Make some cuts in the backing to allow air to escape when the film is adhered to the screen. Remember that the cut-out areas will be the printed areas.

5 Pick up any loose bits of film to keep them from adhering to the screen.

Transferring the film to the screen
The screen, whether new or used, should be well stretched and thoroughly cleaned. (See the section on cleaning and degreasing at the beginning of this chapter.) Ulano screen degreaser is recommended for easy adhesion. Allow it to dry thoroughly before adhering.

1 If the film has been cut in position on the baseboard, it is in the correct position for printing. Put the screen frame back in its hinges.

2 Place a few tabs of masking tape, sticky side up, temporarily on each corner so that when the screen is lowered, the film will not shift.

3 Carefully remove the tape holding the film in the master sketch and lower the screen. Adhere the tape on the film corners to the screen, being careful to keep the film in position.

4 Remove the sketch from the baseboard and place a padding of newspaper sheets between the baseboard and the screen. Lower the clean screen over the newspaper padding.

5 Sponge both sides of the screen with a sponge thoroughly wet with cool water.

Using a clean sponge, thoroughly wet both sides of a well-stretched screen with water.

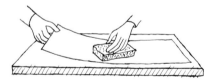

Turn the screen over and place the film side of a cut stencil against the bottom of the screen. With light pressure, move the wet sponge over the entire plastic backing to adhere the film to the screen fabric.

With the frame flat, blot the film from the squeegee side with newsprint. Peel off the plastic backing sheet when dry. A cold-air fan may help speed drying.

ADHERING WATER-SOLUBLE HAND-CUT ULANO GREEN FILM

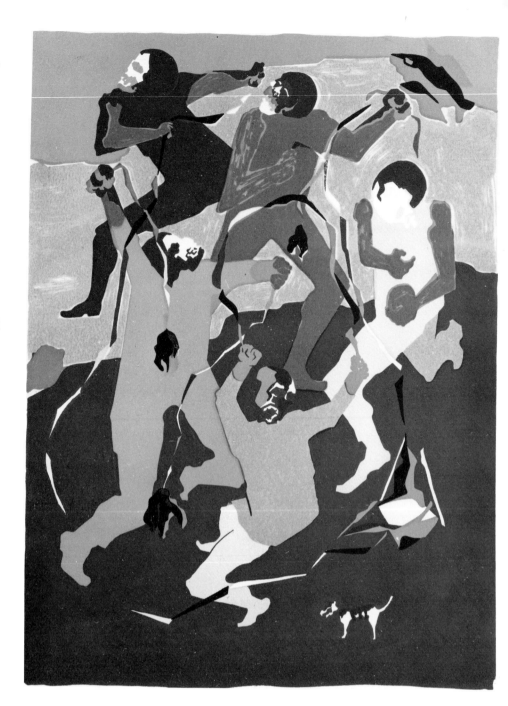

JACOB LAWRENCE
Untitled, 1983
Screen print (oil-based ink), 12½″ × 9¼″
From *Portfolio of Hiroshima* by John Hersey with a new poem by Robert Penn Warren, published by the Limited Editions Club, New York

6 Turn the screen with the bottom up and place the film side of the cut stencil against the bottom of the wet screen. Using light pressure, move the wet sponge over the entire surface of the plastic backing to adhere the film to the fabric.

7 Blot up the excess water. Then, 2 to 3 minutes after blotting, lift the frame for drying. A cool-air fan will facilitate drying. Do not dry your stencil in or near heat.

8 When the fabric is dry but before the stencil is completely dry, fill any open areas between the stencil and the frame with Ulano No. 60 Screen Filler or No. 10 Blockout. Apply it to the underside of the screen and over the polyester support.

9 When the screen filler and the stencil are completely dry, the backing sheet can be peeled off. Start at a corner and slowly peel the polyester back at a 180-degree angle, parallel to the fabric. If there is any resistance in peeling, stop and fan-dry the screen longer. The stencil is now ready for printing.

Cleaning the screen Remove the ink with the proper solvent as soon after printing as possible. Ulanocut green film stencil and the screen filler or block-out can be removed with hot or cold water.

LACQUER FILM STENCIL

Because the use of lacquer film stencil requires rather toxic solvents to adhere and remove it, we recommend its use only when there is no other alternative. It is described in the section on water-based inks (page 159).

Direct Photo Methods

The basic difference between the photo methods for water- and oil-based inks is that the emulsions coated on the screen for water-based inks are *not* water-soluble when hardened and require chemical screen reclaimers or household bleach for cleaning the screen, whereas emulsions used for oil-based inks require only water for screen reclaiming. This may appear to be a contradiction, since the use of water-based inks is associated with less toxicity. However, oil-based inks also require extensive use of petroleum distillate–based solvents for cleanup.

BICHROMATE-SENSITIZED EMULSION

Although the bichromate emulsion has been in use for a longer time than the diazo emulsion, the diazo is much preferred because it is easier to use and produces sharper, clearer images, which are not as affected by the halo or light bounce that the bichromate method produces. Diazo-treated screens can also be stored for a few months before exposure without the emulsion hardening and becoming difficult to remove. Therefore, although the bichromate system is still available, we will discuss only the diazo system.

DIAZO-SENSITIZED EMULSION

There are a number of diazo-sensitized photo emulsions manufactured by leading suppliers under a variety of trade names. All have basic similarities: they consist of a base emulsion, a diazo sensitizer, and a dye concentrate to make it more visible. Each manufacturer sells its own block-outs, screen degreasers, and related products. We suggest that you request product catalogs and data sheets for detailed, current information.

Preparing the screen Use a monofilament polyester or nylon with a 175–285 mesh, and degrease it thoroughly, following the method suggested on page 165 or using a product compatible with the emulsion you select.

Preparing the diazo emulsion Although Naz-Dar, Ulano, and Colonial all make good products, our example uses a mixture of 20 grams of Advance Raysol (dye 488xx) diazo photo-screen sensitizer powder with 1 gallon of DM 747 series photo emulsion. This excellent, easy-to-use emulsion is combined with a dye in the factory so that only the sensitizer needs to be added. It also comes in smaller ratios, 5 grams to 1 quart. It can be used with all oil-based, lacquer, vinyl, and acrylic inks.

1 Since all photo emulsions are sensitive to light, they should be prepared with a safelight.

2 One thin even coat should be applied to the underside of the screen with a scoop coater and allowed to dry for 15 or 20 minutes. We have had very good results with one coat. If a second coat is applied, be sure it is thin and applied to the inside of the screen. For further directions, see the instructions for coating the screen with emulsion in the section on water-based inks (page 165).

3 Expose approximately 1½ to 2 minutes for a 65 halftone screen. (Check the manufacturer's suggestions or step exposure for other halftone screens.)

After the edition is printed, wash the ink out of the screen promptly with mineral sprits. Wash out the emulsion with cold water and a pressure hose.

Direct Photo Film Techniques

There are indirect and direct photo film techniques. In the *indirect* method, a presensitized film attached to a clear plastic backing, such as Ulano Hi-Fi Green, Hi-Fi Blue, or Colonial Five Star, is first exposed, developed, and washed out in the darkroom, and then adhered to the screen. These are good all-purpose films. Some require the extra step of developing with A and B powders, which should be mixed according to instructions.

In contrast, in the *direct* method a presensitized emulsion-coated film attached to a transparent backing is adhered to the screen *before* exposure to ultraviolet light. Although all the major companies have similar products, the "no developer" type of film is preferred. Ulano has one of the most appealing products, called Ulano CDF 3, which does not require developing or hardening.

PREPARING THE SCREEN

The following method uses a multifilament polyester or nylon screen. It is imperative that the screen fabric be clean.

1 Dampen the fabric with water. Sprinkle Ulano Microgrit No. 2 or 500-grit silicon carbide liberally on the printing side of the screen.

2 Scour the fabric with a wet natural-fiber rag from the printing side until the rag begins to fray. Rinse with cold water.

3 Follow by degreasing with Ulano Screen Degreaser No. 3 (roughening and degreasing can be combined in one operation using Ulano Gel 23). Because the cleaning and degreasing are so important for good resolution, it is wise to use the manufacturer's product recommendations. If the Ulano product is not available, satisfactory degreasing can be achieved with one of the automatic dishwasher powders. However, use them with caution because they can clog the screen. Do not use household scouring powders.

ADHERING THE FILM

All handling of presensitized film should be done in a darkroom with a yellow safelight.

1 Cut a piece of film an inch or two larger than your image and return the remaining film to its container.

2 Position the film emulsion side up on a table.

3 Lower a wet screen onto the film. Touch up any dry areas with a wet sponge.

4 Immediately pull a clean, dry squeegee across the fabric, adhering the film tightly to the fabric. The capillary action of the film will adhere to the screen.

5 Remove the excess water and allow the screen to dry. Use a cool-air fan to speed drying time.

6 When the emulsion is thoroughly dry, the polyester support can easily be peeled off. If it does not peel off easily, the film is not dry.

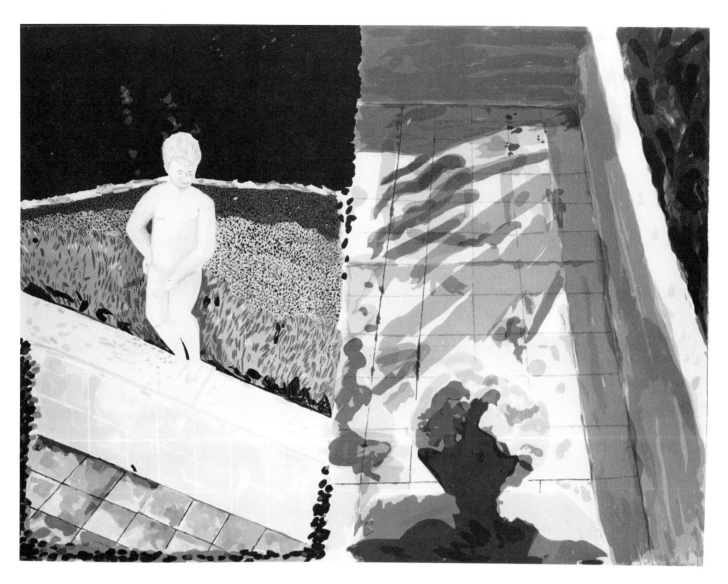

JENNIFER BARTLETT
In the Garden #116, 1982–83
Screen print (115 colors, oil-based ink)
29¼" × 38¼"
Courtesy Paula Cooper Gallery, New York
Photo: eeva-inkeri

EXPOSING THE FILM

1 Place the film positive emulsion side up on a vacuum table.

2 Use a step wedge exposure chart to determine the best exposure. Longer exposures yield harder stencils.

WASH-OUT

1 A hard spray of cold or warm water is helpful. Wet the printing side first, then wash out from the squeegee side. Finish spraying from the printing side.

2 Blot both sides with newsprint.

3 When dry, touch up any surrounding open fabric areas with block-out. The stencil is ready to print with most solvent-based inks.

REMOVING THE STENCIL

1 After printing, immediately remove the ink from the screen with solvent.

2 Brush on Ulano No. 4 liquid or No. 5 paste or an equivalent brand and let it stand for 5 minutes, no longer.

3 Rinse with a hard, intense water spray (a commercial power spray is best).

4 If any ink or film residue resists cleanup, use Ulano No. 78 Haze Remover paste.

Oil-Based Screen Inks

There is an enormously varied selection of oil-based inks for screen printing available. Experimentation with new inks, colors, and methods has kept pace with the tremendous demand for high-quality commercial screen printing on a wide range of materials, including paper, plastics, cloth, glass, and metal. Inks have been perfected that have special properties related to each printing surface. These advances are of great importance to the creative artist working with the screen print as an expressive medium.

INK CLASSIFICATION

There are two major classifications of the inks used in screen printing by artists. These classifications relate to how they dry—by evaporation or by oxidation. Two other types, little used by artists, dry by polymerization and by penetration.

Drying by evaporation The inks that dry by evaporation include ethyl cellulose inks, vinyl inks, lacquers, and a wide number of quick-drying poster inks and water-based inks. All these inks dry by the evaporation of the solvents that carry the pigment. After printing, the solvents dry, leaving a film of pigment on the surface. Some inks dry more rapidly because they contain faster-drying solvents. However, the drying time cannot be too rapid or the inks would dry in the screen.

Drying by oxidation The inks that dry by oxidation dry more slowly. First their solvents dry by evaporation and then the chemical in the pigment dries by oxidation. Each ink dries in a manner that depends on its chemical makeup.

Many oil-based inks dry by oxidation. Enamel inks for printing on porous surfaces such as cardboard or wood and on glossy surfaces such as glass and Masonite belong to this category. The drying time for enamels can vary from 6 to 12 hours.

Drying by polymerization The inks that dry by polymerization belong to a small group generally used in commercial printing and little used by artists. Most are formulated from a blend of epoxy resins, and some require a catalyst to be mixed with the ink as the manufacturer directs. Some will dry in air, but heat drying is recommended to achieve maximum adhesion.

These inks are excellent for application to glass, tile, metals, rigid plastics, and printed circuit-board markings. All screen fabrics may be used.

Drying by penetration Inks that dry by penetration are prepared for rapid absorption by the printing material and are very fast drying. The more absorbent the stock, the quicker the drying. The application of these inks is most common in the commercial printing of signs, wallpaper, and the like and in textile printing, where the penetration of color to the underside of the fabric is so important.

POSTER INKS

Poster inks are used most frequently by creative artists who make screen prints. They are so much in demand because they work very well on paper and cardboard, the supporting materials most frequently used for artist's prints.

We have found a great variety of poster inks to be excellent. They are formulated in a broad range of finishes from matte to high gloss and are easy to use.

ENAMELS

Enamels are more difficult to use because they dry by oxidation and thus require a lengthier drying time than poster inks. New formulations have shortened the drying time to as little as 1 hour for a faster-drying type.

VINYL INKS

The vinyl inks are specially formulated for printing on soft or rigid vinyl surfaces, and improved manufacture allows them to dry much faster. They are extremely durable and adhere exceptionally well, which makes them widely used for commercial purposes. However, Pop artists created provocative screen-print images on soft vinyl, both dimensional and flat, and their example has led other artists to try vinyl inks.

LACQUER INKS

Industrial lacquers and decal lacquers are the two main types of lacquer inks. These inks have wide industrial application, but the artist may be interested in them because they print well on paper and cardboard, and a special lacquer ink has been developed for metal foil.

Use lacquer inks and the manufacturer's recommended solvents with caution, as they are highly toxic and flammable. They require excellent ventilation and fire prevention.

ACRYLIC INKS

Acrylic inks are excellent for printing on rigid acetate, polystyrene, Plexiglas, Lucite, and similar plastics. Their adhesiveness and durability are very good, enabling them to be used very successfully for the vacuum-forming process.

ARTISTS' OIL COLORS

Artists' oil colors dry by oxidation. They can be substituted for screen-printing inks when certain colors are desired. However, the high cost of good-quality artists' oils prohibits extensive use because so much ink is needed in screen printing. Inexpensive oil colors are not more economical because they contain little pigment and much oil.

The great advantage of artists' oil colors is that they are permanent. Because the pigment is of high quality, they can be used as tinting agents. They can be mixed with small or large quantities of transparent base to achieve a semitransparent or transparent quality. The color and the transparent base must be mixed carefully and thoroughly. Add transparent base gradually to the oil color and mix it evenly with a large mixing spatula. The amount varies according to the intensity of the color. Norio Azuma uses only good-quality artists' oil color thinned with a little turpentine and with a little transparent base added.

It must be pointed out that the color can take a day to dry, thereby delaying the printing process considerably.

FLUORESCENT INKS

New color possibilities can be found in daylight fluorescent inks. Images by Pop and Op artists opened up the possibilities for printing with fluorescent inks, which once were used only on posters and billboards.

TONERS

Toners are extremely well-pigmented and finely milled inks that make excellent transparent colors when mixed with transparent base. They are not formulated to be used alone. Their highly concentrated state requires test printing through the screen to be sure of color quality. They may also be added to standard white inks to produce a wide variety of shades. Because of their concentration, add only very small amounts of toner to the white until the proper shade is reached. Then add transparent base in the necessary amount. Be sure to mix the toner and base well. Poor mixing will cause streaking in printing.

METALLIC POWDERS AND INKS

Metallic inks are available ready-mixed and can be used straight from the can. They are very easy to use and produce excellent printing results.

A wide range of gold, silver, and copper powders are also available from most large manufacturers of screen-printing inks. When mixed with the proper vehicle and thinner, the powders give perfect adhesion and brilliance. Clear vinyl acetate and butyrate lacquers are recommended by most manufacturers for mixing. You wet the powder with the recommended thinner until a heavy paste is obtained, add clear base, and mix well. Follow the manufacturer's instructions in all cases.

Although mixing the powders is a little more tedious than opening the premixed inks, the powders do have certain advantages. Metallic powders are brighter than ready-mixed metallic inks and seem to retain their metallic quality longer after printing. An added advantage is that you can combine powders of different tonalities to make new mixtures.

Experimentation with both premixed inks and powders is suggested for those artists who wish to use metallic inks extensively. Metallic powders require monofilament fabric; check the manufacturer's recommendations.

RICHARD CHIRIANI
Untitled, **1982**
Screen print (poster colors), 24½″ × 34″
Courtesy Brand X Editions, New York
Drawn on Mylar and photographically exposed onto a presensitized screen. Printed in transparent poster color blacks.

VARNISHES AND ADDITIVES

The additives and varnishes for oil-based inks listed below are not so different in function from those for water-based inks. The solvents, of course, must be compatible with the inks.

Be sure to tell your supplier the kind of ink you are using when purchasing additives. Transparent base and solvent are the two most necessary items; the others can be purchased as the need arises.

Transparent base As noted earlier, transparent base can make the ink more transparent, extend it, add body, and aid in the printing of fine details, especially halftones and lines. In general, the transparent base manufactured for most poster inks is excellent. It is produced in matte and glossy finishes, mixes easily, and is buttery in consistency.

Extender base Used primarily as a low-cost extender of ink, extender base can also improve printing quality by giving body to the ink. If 1 part base is mixed with 2 parts ink, it does not alter the color quality. For long runs it is very useful in keeping ink costs down. Do not confuse extender base with transparent base, which is used primarily to achieve transparency, although it does also extend the ink.

Cornstarch An expedient, easily available material, cornstarch can be used to thicken an ink when transparent base or extender is not on hand. Add it very minimally as it can clog the screen.

Retarders and reducers Some of these additives act as thinners to allow the ink to flow more easily. Others slow the drying process and prevent clogging. It is important to use the type specified for the ink you are using because the chemical components are different. Since most manufacturers use number or letter designations for their products, it is important to check their data sheets.

Binding varnishes Specific varnishes are recommended by their manufacturers for certain inks to prevent screen clogging when printing on absorbent surfaces. It is important to check all specifications for inks. Some binding varnishes increase the flexibility of the ink, an important factor if the print is to be folded. If transparent base or extender base makes up approximately 50 percent of an ink, 5 or 10 percent of binding varnish should be included in the additive to improve the ink's adhesion.

Varnishes for overprinting Overprinting varnishes are used as a clear gloss coating over the printed image to add a shine or to protect or to do both. Many different kinds are manufactured, and selection often depends on the ink used. The varnish intensifies the colors in a manner difficult to duplicate with inks, even when glossy ones are used. Varnishes are colorless and will not alter the hue of the printed inks. They can be printed successfully with 12XX multifilament fabric. Be sure the print is thoroughly dry before overprinting varnish. It will usually air-dry in 2 to 3 hours.

Solvents The solvent we like best for general cleaning in all media is odorless paint thinner. It is less greasy and less toxic than turpentine. If odorless paint thinner is not available, ordinary paint thinners such as Varsol, Varnolene, and mineral spirits are widely available. If used with care, they can also act as thinning agents for some screen-printing inks. Other solvents such as turpentine, benzine, kerosene, and naphtha can upset the chemical balance in some inks, actually causing them to dry in the screen or dry too slowly. (See the solvent chart in the chapter on health hazards for more information.)

INK MIXING

Poster inks are recommended for beginning screen printing. Experiment with other inks as you gain experience. Begin with a range of colors from warm to cool, and purchase inks in the smallest size available, usually a pint.

The general procedures for mixing oil-based inks are not very different from water-based inks. The solvents, additives, types of stencils, and cleanup methods are where the basic differences lie. With that in mind, refer to the paragraphs on ink mixing in the section on water-based inks for instructions.

STORING INKS

For storing oil-based inks, metal cans may be more desirable than plastic because some of the solvents in oil-based inks can disintegrate plastic containers. All excess ink can be scraped from the screen and squeegee and stored in a tin can covered with wax paper or aluminum foil secured with a rubber band. Screw-top jars are generally not too desirable because if ink hardens between cap and jar it is almost impossible to open the jar without breaking it.

The inks can usually be kept from six to eight months. A scum will develop, but after you peel it off and mix the ink well, the ink is normally quite usable.

Printing with Oil-Based Inks

Refer to the section on water-based inks for general registration and printing procedures, which are much the same for oil-based inks. The following comments apply to both methods:

1 When printing multiple colors it is ideal to work with a separate screen for each color, with each screen carefully registered. More than one screen is quite an investment for a beginner, but as you become seriously involved you will find separate screens a more efficient way to work. For example, you can proof colors at will, as long as you do not use paper stencils, which are difficult to retain after cleanup.

2 If transparent colors are used, print the darkest colors first and the lightest last in order to ensure good transparency.

3 If opaque colors are used, it is usually a good idea to print the light colors first. If that is not possible, print the largest color areas first.

4 When colors butt against each other in an image, allow a hairline overlap to prevent the appearance of unwanted white rivers between colors. The enlarging of the image to allow for overlap is called trapping in commercial printing.

REDUCTION PRINTING USING ONE SCREEN

It is possible to print many colors using one screen in a method similar to the one Picasso used in his linoleum reduction prints (see page 33). In this procedure an accurate keyline drawing in India ink is made on the screen. When dry, the India ink cannot be washed out with mineral spirits, benzine, or similar solvents. Each outline should conform to a different color area, with a key given for each color. If a white area is desired, it should be blocked out before printing. After the first color is printed, the area it occupies on the screen is blocked out and the inking of the second color proceeds. This blocking out of each previous color image continues until the last color is printed. Opaque ink should be used because of the repeated overprinting, which produces an interesting impasto effect in the finished print.

SPLIT FONT OR RAINBOW INKING

The term *split font* derives from a process in commercial printing where more than one color is added to the fountain, or printing source, and blended during printing. In other words, with this method it is possible to achieve tonal effects with two or three colors on one screen. Defined areas can be taped or blocked out on the screen and inks of different colors placed above the two areas and squeegeed across. Another, freer method is to place two or three different colors of ink across the top of the screen and to squeegee them across the screen. The printing itself will create a gradual blending of colors. After ten or twelve prints the blending will diminish and more ink will have to be added.

FLOCKING

The technique of flocking is being explored by many innovative screen-print artists. It is a method of applying fibers of wool, nylon, or viscose material to a screened adhesive. The flock has a velvety appearance when printed. For scores of years flocking has been used commercially—in the wallpaper industry, advertising, and toy manufacturing.

A variety of adhesives are manufactured commercially for all surfaces. Most can be used with all types of 6XX to 8XX

A Fil Bar automatic screen printer from Graphic Equipment, Boston, being operated at Brand X Editions, New York.

multifilament or 85- to 110-mesh mono-filament screens. Flocking, however, must be done immediately after the application of the adhesive. Overnight drying is also necessary.

The adhesive is applied through any stencil form onto the surface to be printed. Be sure you buy an adhesive that works with your particular surface. Adhesives are made for printing on wood, paper, cloth, glass, and other surfaces. For mixing, mineral spirits and ordinary screen thinner work well, but check the specifications of your adhesive.

After the adhesive is printed, the flocking material can be applied with a sieve or flocking gun. The least expensive and simplest device is an ordinary flour sieve, or you can construct a sieve from a frame and wire screening.

Flocking guns vary in cost from moderately priced ones for use with a vacuum cleaner hose to more expensive units available from well-stocked screen-printing suppliers. Elaborate electrostatic flocking units have been developed for commercial use, but they run into hundreds of dollars, making them impractical for the artist.

Allow the prints to dry overnight and take care that nothing disturbs the surface. After the adhesive is thoroughly dry, gently shake off any excess flocking.

A wide range of reflective materials such as glass beads, tinsel, spangles, mother-of-pearl flakes, and diamond dust can be applied to prints in a similar manner.

CLEANING THE SCREEN

How the screen is cleaned after using oil-based inks depends on the ink used. Lacquer and vinyl inks, for example, require their own solvents. Most printing, however, is done with poster color, whose solvent is paint thinner.

After printing is finished, it is imperative to clean the screen immediately or the remaining ink will dry and make cleaning very difficult. The screen can be removed from its hinges or left in position. Place several layers of newspaper under the screen. Remove all remaining ink from the screen using the sharp edges of cardboard squares and return the ink to its container. Wearing solvent-resistant gloves, sprinkle the screen with paint thinner if poster colors are used and use rags or cellulose sponges to mop up. Replace the layers of

After the printing session is over, clean the screen with the appropriate solvent. For oil-based inks, use screen wash or paint thinner. Place newspapers under the screen to absorb the solvent.

newspaper under the screen frequently and change rags and sponges often until all the ink is removed from the frame and the taped areas of the screen. Hold the screen at an angle or upright and scrub the back and front simultaneously.

When clean white rags no longer show signs of color, the screen is clean. Hold the screen up to the light to check for difficult-to-remove ink. Clean the squeegee and your mixing slab well. Take care how you store rags soaked in solvents, as they are a fire hazard. A metal can with a lid especially made for holding discarded paint rags is a good safety measure.

The screen is either put away until the next printing or prepared for the second color; if several screens are being used, the screen for the second color is set on the pin hinges, the register guides checked, and the next printing started. Because poster colors dry quickly, the first printing will be dry and the print ready to receive the second color.

COMMON PRINTING PROBLEMS

The printing problems associated with water-based and oil-based inks are often similar but again differ because of the solvents and additives used. Some of the following problems repeat those discussed in the water-based section but involve the use of solvents.

Uneven printing Uneven printing may be caused by uneven pressure or a need to build up the printing bed with a moderate thickness of newsprint or newspaper. It may also be caused by poor mixing of the ink with the base—be sure to mix ink thoroughly. Or the ink mixture may be too thick and therefore not spread consistently; if this is the case, add transparent base or thin it with a very small amount of mineral spirits. Check to see that the squeegee is smooth and sharp. Keep the quantity of ink consistent while printing. Replenish the ink as necessary for even distribution.

It is helpful to use two rags for stubborn areas. A small bristle brush can also speed up the process. Take care, however, not to damage the glue area with the brush.

Screen clogging If the screen clogs during printing, build up a bed of newspaper under it to improve contact. Try increasing the pressure on the squeegee, scrubbing it back and forth to force ink through the screen and possibly loosen the clogged ink. If this does not work, clean the screen lightly with solvent. If ordinary solvent is not strong enough, use acetone or lacquer thinner. Commercially prepared screen-declogging sprays are also available. If a paper stencil is being used, carefully remove the stencil, clean the screen, and reuse the stencil if possible.

Clogging may also be caused if turpentine or benzine have been used to thin the ink because these solvents evaporate rapidly, contributing to the premature drying of inks. A small quantity of drying retardant, glycerin, or oil of cloves can be added to the ink to slow the drying process. Try to avoid printing in a hot room or where air currents may dry the screen.

Printing beyond stencil If printing occurs beyond the edge of a paper stencil, offsetting ink beyond the edge of the print, wipe off the excess ink from under the screen. Decrease squeegee pressure and avoid rippling the stencil because ink can get trapped in the ripples. If the stencil is stretched, slit it and tape it in the troublesome area to flatten it out. The ink mixture may also be too thin. Add transparent base and pigment to thicken it. Pad the bed with newspaper to allow for better contact.

Uneven edges If edges are uneven, the tape may be improperly applied and be lifting up. Retape the problem areas. The base bed may need padding with newspaper to ensure better contact. The squeegee blade may be dull; sharpen if necessary. Use strips of visualizing paper to give a clean, sharp edge instead of relying on tape to determine the image edge.

Registration problems If registration is improper, check the stencil to be sure it was cut accurately to match your sketch or previous printing. Check to see that the registration guides are secure and receiving the paper properly. Be sure the screen fabric is taut; loose fabric will cause rippling during printing and throw registration off. Check for play in the screen hinges. If the screen wobbles, use alignment blocks to ensure good register.

Screen Printing on Other Materials

Because screen printing is so versatile, it is used quite extensively by industry for decorating products made of glass, plastic, metal, ceramic, fabric, wood, and other materials. It is even used in the electronics industry for printed circuits. As a result, new inks have been formulated and simpler methods developed for printing on these varied surfaces.

The fine artist interested in experimenting with such surfaces has a great opportunity to explore ideas that would not have been possible a few years ago. The manufacturers of screen inks publish detailed data on the kinds of inks and processes necessary to obtain good results. Check those sources periodically for new information.

FABRIC

Screen printing on fabric can be divided into two broad categories. One involves the creative printmaker who is interested in the use of fabric as a material to receive imagery because of its unique properties. The other originates in the textile industry and attracts the creative artist who wishes to screen-print original designs on fabric.

Screen-printed fabrics became widely used in the 1930s, at about the same

MARIAN SIMS
Mona Lisa, 1976
Screen-printed silk quilt (approximately 60 colors, oil-based ink), 72″ × 64″
Collection of Patricia Bramsen
Photo-screen-printed images of the *Mona Lisa* and hand-cut stencils of geometric forms were printed with Nazdar oil-based textile colors on squares of silk 1 foot by 14 inches. Each square was heat-set with a warm iron so the printed fabric could be laundered. The pieces were sewn together as a quilt and filled with synthetic batting.

time that fine-art screen prints became popular. Textile manufacturers began to use the process for their more artistic patterns and to commission well-known designers to create them. Semiautomatic screen-printing machines were developed that were capable of printing large quantities of fabric. The use of screen-printing processes allowed more penetration of color into the fabric fibers, producing a brilliance and variety in textiles that were soon sought after by the fashion industry.

Simultaneously, smaller artist-run screen-printing studios developed, acquiring an important place in the industry because they could produce one-of-a-kind and shorter runs of distinctive designs for specialty markets. Since the equipment and materials required for screen printing on fabrics are generally not too costly, and new formulations of inks and dyes and processes have made it simpler to achieve outstanding results, experimental approaches and designs are relatively easy to accomplish without great cost.

The recent interest in fabric printing developed out of the Pop esthetic of the sixties, when a more open, experimental attitude toward materials and ideas was introduced. Screen-printed fabric prints sometimes incorporate trapunto (a quilted design in high relief; the image is outlined in a running stitch that is worked through at least two layers of cloth padded with layers of cotton batting). Dimensional fabric prints may be layered, loose-hanging, or combined with other materials such as plastic, wood, glass, mirrors, beads, flocking, or glitter (see the chapter on dimensional prints).

Our interest in fabric printing is related to its application as a fine-art print medium rather than its more utilitarian aspects. In general, the hand and photo stencil processes already described for screen printing can be applied to printing on fabric as long as the stencil material is compatible with the ink and solvent. Some differences occur in the printing setup. When small pieces of fabric are printed, they are handled much the way paper is. The screen is hinged to a backboard with allowance made for some built-up padding of felt or similar material to ensure close contact and penetration of the ink during printing. The fabric is placed under the screen, taped or pinned to the backboard, then printed and removed.

It is wise to experiment with a variety of fabrics. Thin nylon or cotton netting, such as that used in bridal veils, produces interesting transparencies when layered. Heavier canvas, cotton, silk, and satin are other possible choices. Selecting the right fabric depends on the concept of the piece. With some thought and planning, you will be able to produce imagery that opens a whole new approach to screen printing.

WOOD

For screen printing, ½-inch or ¾-inch clear shelving pine or poplar, without knots, in lengths up to 8 feet and widths up to 18 inches, makes a satisfactory wood surface. Hardwood varieties of ¼-inch plywood, 4 by 8 feet, in maple, lauan, and mahogany are also usable. The surface should be as smooth as possible. Any depressions or imperfections can be corrected with wood filler, Plastic Wood, or wood putty. It should be carefully applied according to directions, allowed to dry overnight, and sanded smooth.

A sealer is also helpful to close wood pores so that ink will not soak into the wood. A mixture of 1 part clear shellac to 2 parts alcohol can be thinly applied with a soft brush and allowed to dry for 24 hours.

MATERIALS OF VARYING THICKNESS

When printing on materials that have different thicknesses, such as wood, glass, or styrene, it is necessary to improvise a setup to raise the screen to the thickness of the material being printed. This is easily accomplished by adding four pieces of wood, cut to establish the correct height, one under the hinge bar and the other three under the other sides of the screen.

An all-purpose ink suitable for wood, styrene, acetate, vinyl sheet, and coated metal is Naz-Dar 9700, which comes in thirty or more colors and toners, has good adhesion, and dries in normal room temperatures. It can be printed with photographic or hand-cut film stencils and requires 200-mesh monofilament polyester or nylon screen. For washing up, use Naz-Dar SW 37 screen wash or lacquer solvent.

ALEX KATZ
Ada, 1988
Screen print (enamel ink), 65″ × 10⅛″ × 3/16″ on a 10″ × 10″ aluminum base
Courtesy Styria Studio, Inc., New York
Sixty-nine enamel colors were screen-printed from 15 hand-drawn screens on a hand-cut aluminum silhouette. Before the colors were printed, a white enamel ink, manufactured for outdoor exposure, was screened on the surface of the aluminum cutout. During printing, velvet fabric was stretched over the printing table to prevent the cut-out figure from slipping.

which is applied with a brush or roller to a print underneath. The stencil is usually made of bond paper, thin copper or brass, or an oiled paper such as tag, tympan paper, or press packing paper.

After each color is printed on Katz's silhouettes, they are stacked for drying at Styria Studio.

Steve Sangenario, master printer, at Styria Studio in New York, assisted by Napo Escobar, adjusts the shims to build up the areas around Alex Katz's *Ada*, a free-standing screen print, with the 3/16-inch-thick cut-out aluminum.

GLASS AND CERAMIC

Printing on glass or ceramic requires an epoxy resin ink, which is complicated to use because a catalyst to improve adhesion must be added. This is a more toxic material and should be used carefully according to the manufacturer's instructions. Its positive feature is that it air-dries in 2 to 3 hours, or 7 to 10 days for maximum adhesion.

Pochoir Process

The stencil process (called *pochoir* in France) is a simple way to add color areas or shapes to a print or even produce a whole print. Very little equipment and space are required. Apertures in a stencil serve as a guide for the color,

MATERIALS

The special materials needed for oil-based and water-based colors are:

Pen with India ink, or Rapidograph

Thin bond paper (for oil-based colors)

Thin copper or tympan paper (for water-based colors)

Stabilo pencils (for marking copper)

Scotch Magic Tape No. 811

Oil-based screen-printing inks or oil paint in tubes

Transparent base

Poster or watercolor pigment

Large, round white-bristle stencil brushes

Mat board or illustration board

SINGLE STENCIL

In this method a single piece of bond paper acts as the stencil for as many as twenty or thirty colors. As each aperture is cut into the stencil paper, the piece that is removed is saved and replaced when the printing of that shape is finished. The piece is held in position with Scotch Magic Tape No. 811, which is removable. As the printing proceeds, eventually the stencil is held together solely by the tape.

This method does not work with water-based inks because they wrinkle and buckle the paper stencil. Use oil-based screen-printing inks, mixed with transparent base, or oil paint in tubes. Apply the ink with a fairly large, round white-bristle stencil brush. The brush should be lightly charged with ink and the ink put down with a circular motion. The thinner the stencil paper, the sharper and cleaner the edge of the paint film will be. It is wise to have a precise master drawing in reserve, in case it is necessary to replace a stencil that has worn out or is too badly torn to function.

Accurate registration is vital with this process. The stencil itself can be taped to a piece of mat or illustration board so

This pochoir stencil by Jerome Rettich is made of bond paper. Each aperture is cut out as needed, and after the color is applied, the paper shape is replaced and held in position with tape.

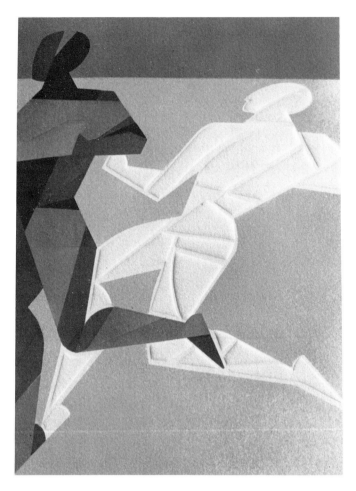

JEROME RETTICH
White Shadow, 1978–79
Pochoir screen print (oil-based ink), 9⅛″ × 6¾″
Courtesy of the artist

Bruno Jacomet, guest artist at the University for the Arts, College of Art and Design, in Philadelphia, demonstrates the pochoir technique using thin metal stencils, a soft brush, and water-based paint.

that it cannot shift. Each piece of paper that is to receive the image should be cut with a true right angle and this corner should be fitted into a register tab of heavy paper or thin mat board that acts as a guide for the printing of the entire edition.

MULTIPLE STENCILS

In order to speed the edition of a large, complicated stencil print, it is desirable to use many stencils, perhaps one for each color. This procedure enables several printers to work on the image at the same time, passing the partially printed paper from one person to the other. It can be done with either oil- or water-based inks, depending on the type of stencil used.

Each stencil should be cut with precision in order to achieve proper registration. One way to ensure this is to make a key plate and, using lithography or screen printing, print an outline of the image on all the stencil sheets before

cutting. Each stencil sheet will then have exactly the same key image as all the others.

It is a good idea to print a few extra stencil sheets in case some wear out during the printing of the edition. Stencils that are to be used with water-based pigments must be made of thin copper or brass sheets or of oil-permeated stock called tag or tympan paper. The stencils should be cleaned and dried after each printing session.

As one of the newer printmaking processes, and one so extensively associated with commercial printing, screen printing will no doubt develop new usages and materials for fine-art printing. Changing directions of fine artists will also open areas for exploration. It will be interesting to note these developments, and, better still, to be involved in initiating them.

5 Lithographs

FEDERICO CASTELLON
The Traveller, 1963
Lithograph, 21⅜″ × 16⅞″
Courtesy Hilda Castellon

Lithography differs from the other graphic processes in that it depends on a chemical reaction instead of the physical separation of the inked and uninked areas. It is the antipathy of grease to water and water to grease that is the basis of lithography.

Artists are attracted to lithography because of its ability to capture the freshly drawn stroke of a pencil or brush with its characteristic qualities intact. Modeling, tonality, and the immediacy of the artist's hand are all preserved throughout the process. It is the most autographic of all the print techniques.

Origins and Development of Lithography

When Alois Senefelder (1771–1834) first developed his new printing process, he called it "chemical" printing; it was also known as *steindruckerei* (stone printing) and polyautography. A method of etching on stone had been tried by Simon Schmid in Germany in 1787 with some success, but it was Senefelder, in 1798–1799, who developed the process we know as lithography.

The commonly accepted story, now considered apocryphal, is that Senefelder's mother asked him to write down a list of laundry. Having no paper handy, he wrote this list on a clean piece of limestone with some homemade ink. Later he decided to etch the stone to see if he could ink and print it. After some minutes of etching, he tried to ink the

stone and print it, but without much success. When he tried to wash the stone with soap and water, however, he found the key to the new process. The parts of the stone that had no writing remained damp and clear when inked again because of the antipathy of water to the greasy ink on the roller. The writing was still greasy and the ink was attracted to it. Lithography was born.

Senefelder was not an artist but an aspiring playwright. The son of an actor, he was naturally interested in the theater and was trying to perfect a printing method for cheaply reproducing his own plays. He succeeded in printing some musical compositions by Franz Gleissner, a court musician, who paid for the copies and supported Senefelder in further refining the lithographic process. Senefelder designed a press capable of printing the inked stones and eventually received a royal franchise from the Bavarian king that legally protected his work, at least in his own country.

Although Senefelder never received enormous financial reward for his invention, he earned enough to set up a print shop in Offenbach and to train craftsmen in the method. He perfected transfer printing from paper drawings and lettering. He also experimented with color printing, refined ink formulas, tried aquatint processes, and worked on printing textiles from cylindrical plates. His book *A Complete Course of Lithography*, published in 1819, is still a source of information concerning the process, although it came ten years after another German, Gottlob Heinrich von Rapp, wrote *The Secret of Lithography*, which revealed the details of the method to anyone interested enough to purchase a copy.

SPREAD OF LITHOGRAPHY

The new technique quickly spread throughout Germany, to France, England, Holland, Spain, the United States, and many other countries, without benefit to Senefelder. Artists soon realized that with the new "lithography" they could draw directly on paper or stone and the print would reproduce with amazing fidelity all the tonal gradations and many nuances of the original drawing. Many artists tried the process with excellent results. In 1801, for exam-

EUGÈNE DELACROIX
La Soeur de Duguesclin, 1829
Lithograph, 9²⁹⁄₃₂″ × 7¹⁵⁄₁₆″
Metropolitan Museum of Art, New York
Harris Brisbane Dick Fund, 1923

ple, the artist Wilhelm Reuter completed some prints in the Offenbach workshop of Johann André. He went on to make about 150 lithographs. Other early lithographs were produced by such diverse artists as the American Benjamin West and the Swiss Henry Fuseli (Heinrich Füssli), as well as Thomas Banker, John Varley, James Stothard, Robert Hills, H. B. Chalon, and others. In 1806 William Blake made a linear drawing in the method, although he later returned to his more familiar engraving technique. In France lithography met with enthusiastic approval from such leading artists as Eugène Delacroix, Théodore Géricault, Eugène Isabey, and Paul Gavarni. But it was Francisco de Goya (1746–1828) and Honoré Daumier (1808–1879) who were the true giants of the medium, turning the technique into fine art.

Goya worked his first lithographs in Madrid by drawing on paper and transferring the drawing to the litho stone, but with only limited success. It was not until he went into exile in Bordeaux, that he mastered the technique that was to suit him so well. He worked directly on the stone, propped vertically on an

easel, with crayons, brushes, and scrapers. In 1825 he produced the four lithographs in the *Bullfight* series, powerful and dramatic studies that show how well the new method could reflect the visions of a master. The painter Cyprien-Charles-Marie-Nicolas Gaulon pulled an edition of one hundred impressions from each stone and was, incidentally, immortalized by Goya in a lithographic portrait produced in the same year.

Honoré Daumier, whose drawings for the publications *La Caricature* and *Le Charivari* remain a model for political cartoonists to this day, was one of the most productive and influential of all artists to use the lithographic process. His output of more than 4,000 lithographs represents forty years of creative and indignant comments on French society, made in collaboration with the editor Charles Philipon.

FRENCH LITHOGRAPHY AFTER DAUMIER

In France lithography was accepted as a graphic medium with great potential. Artists loved the direct process, which unlike the woodcut or etching, reproduces the initial stroke or brush line with the utmost fidelity. Lithographic workshops proliferated, and by 1838

FRANCISCO DE GOYA
Bullfight in a Divided Ring (from "Bulls of Bordeaux"), 1825
Lithograph, 12½" × 16¼"
National Gallery of Art, Washington, D.C.
Gift of W. G. Russell Allen

HONORÉ DAUMIER
King Louis-Philippe Contemplating the Past, Present, and Future (from *Le Caricature* no. 166), 1834
Lithograph, Collection of the New York Public Library

there were 280 in Paris alone. One of the artists to take up this medium was Edouard Manet (1832–1883), whose fresh drawing and simplified forms appealed to a public now accustomed to the medium. Henri Fantin-Latour, Camille Pissarro, Edgar Degas, and Paul Cézanne also made lithographs of great distinction. Many of these artists made prints that replicated ideas expressed in their paintings, although both Degas and Pissarro also produced inventive prints that were distinct from their paintings.

RODOLPHE BRESDIN
The Good Samaritan, **1861**
Lithograph, 23½″ × 17½″
Collection of the authors

Detail of Bresdin's *The Good Samaritan*.

1 8 THS 2

DEVELOPMENTS IN COLOR LITHOGRAPHY

Color lithography developed almost as soon as the method itself was perfected. Senefelder experimented with color printing, mainly to master calico printing, and produced some color prints in 1809. Other early color lithographs were produced by Josef Lanzedelly with Peter Fendi in Vienna, around 1819–1823, and by Franz Weishaupt in Munich, in 1825. It was Godefroy Engelmann, however, who in 1837 detailed the method of chromolithography in a portfolio by R. Jean, B. L. Huber, Villeneuve, Viennot, and others. He was awarded a gold medal from the Société Industrielle of Mulhouse in 1838. Unfortunately, he died only ten months later at the age of fifty-one.

Color lithography was welcomed everywhere. It made inexpensive color prints available to a larger public than was possible with color engravings and etchings. A natural outlet for the bright colors possible with color lithography was the production of posters, magazines, and other advertising matter. Unfortunately the technique soon degenerated into the reproduction of vulgar, sentimentalized, commercial kitsch.

In London, the center of an industrial expansion in the mid-nineteenth century, the demand for brightly colored advertising caused a rapid development of poster printing. It was there that a French artist named Jules Chéret (1836–1932) became familiar with the technique of making large multicolored sheets. He brought this knowledge back to Paris in 1866 and produced many large posters, which were seen by Henri de Toulouse-Lautrec (1864–1901), a genius who did much to further the tradition established by Chéret. Lautrec became passionately involved with lithography and produced almost four hundred images in his short life. Two other important artists who explored the possibilities of color lithography at this time were Edouard Vuillard (1868–1940) and Pierre Bonnard (1867–1947).

The tradition of artists working in the lithographic medium was so strong in France that almost every major painter (with the notable exception of Claude Monet) tried the technique at one time or another. Paul Gauguin, Vincent van Gogh, and Auguste Renoir made a few lithographs each, although their major production was in painting.

Odilon Redon (1840–1916) was entranced by the lithograph and produced almost two hundred images between 1878 and 1908, mostly concerned with the world of fantasy and imagination. He was keenly aware of the Symbolist poets and their explorations of the mysterious, obscure, and ambiguous; at the same time his work anticipated the Surrealists of the twentieth century. Redon was a talented violinist who took particular delight in Debussy, Berlioz, and Beethoven. His black-and-white lithograph *L'Art Celeste* (1894) reflects this fascination.

ODILON REDON
L'Art Celeste, **1894**
Lithograph,
12⅜" × 10⅛"
Metropolitan Museum
of Art, New York
Gift of A. W. Bahr, 1958

NINETEENTH-CENTURY ENGLISH AND AMERICAN LITHOGRAPHS

As early as 1803 Philipp André, director of the lithographic workshop in London under Senefelder's permission, published a portfolio of artists' lithographs called *Specimens of Polyautography*, which included works by Konrad Gessner, Thomas Stothard, Richard Cooper, and Henry Fuseli. The lithographic tradition in England was further expanded by Charles Hullmandel (1789–1850). In 1818 he published a portfolio of *Views of Italy*, in 1824 a book entitled *The Art of Drawing on Stone*, and in 1835 color lithographs of facsimiles of Egyptian tomb paintings.

Thomas Shotter Boys (1803–1874) produced beautifully organized architectural views. Some of these were colored by hand but others were completed in color on the press. Another English-born artist, Richard Parkes Bonington (1802–1828), who spent much of his short life in France, created seventy lithographs, mostly of detailed architectural images similar in spirit to those of Boys. Some of these were printed in England by Hullmandel. The Swiss painter Henry Fuseli lived in London and produced some interesting early prints.

One of the first artists to use the new technique of lithography in the United States was Bass Otis (1784–1861). He produced a number of prints dating from 1818 in the *Analectic Magazine*, published in Philadelphia. In New York the first lithographic print shop was started by Barnet & Doolittle in 1822. Rembrandt Peale, Thomas Cole, Thomas Doughty, and Thomas Moran also made prints in the early days of American lithography. An enormous popular success was achieved by the firm of Currier & Ives, founded in 1834 by Nathaniel Currier in Boston but then moved to New York. More than 7,000 lithographs, most colored by hand by a team of women artists, were issued by this firm. They appealed to the popular taste, with subjects of every description—shipwrecks, fires, animals, folk tales, city views, portraits, and anything else that the public might buy. Several of the many artists who worked on these images were capable and creative people who were directed by the pressures of the marketplace into sentimental and commercialized pictures. Louis Maurer and Fanny Palmer, for example, worked on hundreds of images for Currier & Ives, collaborating on certain scenes with other staff artists. Their work was often banal but sometimes strong and effective.

GERMAN AND NORTHERN EUROPEAN LITHOGRAPHS

Because of Senefelder's early visit to London and later move to Vienna, the technical development of the lithograph was left in some confusion in Germany, and for the most part crayon drawing was the method used. Many reproductive drawings of paintings were completed, and workshops grew in size and number as the efficiency of lithography became more and more appreciated.

Toward the end of the nineteenth century, Edvard Munch (1863–1944) created some of his most famous images in lithography, including *The Scream* (1895) and *Madonna* (1902) in which his intense, personal expressionism is dominant. About this time Max Liebermann, Lovis Corinth, Käthe Kollwitz, and Max Slevogt, who produced more than 2,000 lithographs, were setting the foundations for the Expressionist movement. This flowered with the work of a group called *Die Brücke* ("The Bridge"), which included Ernst Ludwig Kirchner, Erich Heckel, Emil Nolde (for one year only), Karl Schmidt-Rottluff, and Max Pechstein. They deliberately made lithographs with the most primitive means, in calculated disregard of conventional techniques: using very few stones, erasing images after a few proofs, adding color sometimes by painting on the stone as if for a monoprint. Their goal was a fresh, direct image with little or no precedent as inspiration.

The Expressionist vocabulary was continued in the lithographs of Paul Klee (1879–1940), Alfred Kubin (1877–1959), and Wassily Kandinsky (1866–1944), who were part of the *Blaue Reiter* ("Blue Rider") group in Munich. Klee's idiosyncratic images were based on personal symbols and internal reflections.

PICASSO, MATISSE, AND MIRÓ

In twentieth-century France lithography was pursued by Pablo Picasso (1881–1973) in his quest for new images and new forms. He mastered most of the

PABLO PICASSO
The Bull, 1945–46
Lithograph (*top to bottom:* second, eighth, and ninth states), 11½″ × 16½″
National Gallery of Art, Washington, D.C.
Ailsa Mellon Bruce Fund

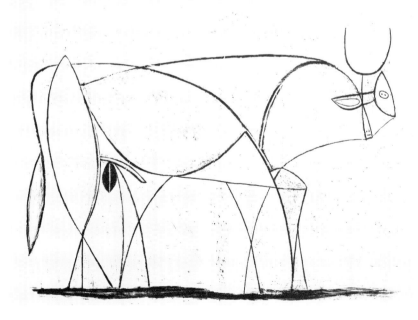

graphic techniques, and lithography was no exception. In Mourlot's workshop in Paris, Picasso completed his eleven states of the artistic development of a bull from realistic form to abstract minimalism. In addition, he worked in many other print workshops, where he experimented and explored methods and techniques with a flood of innovative ideas.

Henri Matisse (1869–1954) worked intermittently on prints. His lithographs were in the main black and white, both in line and in more modeled, tonal expressions. The heavily modeled images were usually drawn directly on the stone, while the linear impressions were done on transfer paper. Although Matisse made more etchings than lithographs, the latter are more reflective of the ideas in his concurrent paintings.

Joan Miró (1893–1983) lavished his later efforts on color in his print work, both in lithography and in intaglio. He illustrated a number of books and produced portfolios and individual images that demonstrate his mastery of both print techniques.

TWENTIETH-CENTURY AMERICAN LITHOGRAPHS

Early in the twentieth century, lithographs of note were produced in the United States by George Bellows (1882–1925), who studied with the influential teacher Robert Henri, and by James Abbott McNeill Whistler (1834–1903). Joseph Pennell (1857–1926) worked with both etching and lithography; Arthur B. Davies (1862–1928) was also proficient in several printmaking techniques, working with Bolton Brown, a foremost lithographic painter. Charles

Sheeler (1883–1965), Grant Wood (1892–1942), and Stow Wengenroth (1906–1978) all worked extensively in the medium, sometimes using the New York printer George C. Miller, a dependable craftsman who pulled many thousands of prints for American artists.

Louis Lozowick (1892–1973) created a series of city images of outstanding quality, well designed and strongly mod-eled. Stuart Davis (1894–1964), an early enthusiast of abstract art, started his first lithograph in Paris. Rockwell Kent (1882–1971), the illustrator, author, and adventurer, worked with lithographs as well as wood engravings.

The painter and muralist Rico Lebrun (1900–1964) was an exceptional drafts-man whose figurative work is solidly stated. Federico Castellon (1914–1971), essentially a self-taught artist, had a re-markable early career in printmaking, in both lithography and etching. His im-ages are haunting in their dreamlike, surreal character. To get the best quality, his stones were frequently printed in Paris at Desjobert's workshop.

The dearth of lithographic workshops in the United States prompted June Wayne to create the Tamarind Lithog-raphy Workshop with the support of the Ford Foundation. It opened in Los An-geles in 1960 and eventually moved to the University of New Mexico at Albu-querque after succeeding admirably in its

stated mission of "stimulating and preserving the art of lithography" in the United States. Garo Antreasian, one of the technical directors of Tamarind, also created his own prints there. Indeed, a large group of American artists, including Richard Diebenkorn, Sam Francis, Louise Nevelson, Nathan Oliveira, Leon Golub, and James McGarrell, made lithographs at Tamarind. However, Tamarind's prime function was to train printers in litho techniques, and this they did with impressive results. Among the craftsmen/artists trained at the workshop are Ken Tyler, Joe Funk, Joe Zirke, Michael Knigin, and Irwin Hollander. All of them have opened their own workshops and are, in turn, training other young people as lithographic printers and publishers.

Tatyana Grosman, of West Islip, Long Island—who started with not much more than enthusiasm, a used litho press in her living room, and several litho stones found in her garden—has encouraged many of America's foremost artists to make lithographs for her. Larry Rivers was the first artist to collaborate with Grosman in the fledgling Universal Limited Art Editions, or ULAE. As it grew in space, equipment, and staff, ULAE attracted other artists, including Jasper Johns, Robert Motherwell, Robert Rauschenberg, Jim Dine, and James Rosenquist. Printmaking workshops have proliferated throughout the country. Prints are getting larger, mixed techniques are common, and multicolored prints are easy. Roy Lichtenstein, Romare Beardon, and Arakawa have used multiple techniques in creating their images. Joe Tilson has used screen printing and collage, and Jennifer Bartlett combined screen printing, lithography, etching, drypoint, and woodcut in the large, multiple-sheet print *Graceland Mansions* in 1979.

There is another printmaking environment, the college and university workshop, in which creative faculty members have been making fine lithographs for years. William Walmsley of Florida State University has worked on his *Ding, Dong Daddy* series for more than twenty years. Robert Nelson has worked at several colleges with his inventive, fluid, and beautifully drawn fantasies. Charles Massey of Ohio State, Rudy Pozzatti of Indiana University, and Jack Damer at the University of Wisconsin are others who have been producing creative work and teaching at the same time.

BASIC LITHOGRAPHIC METHOD

As noted earlier, lithography depends on a chemical reaction. In this method the image is drawn on a piece of Bavarian limestone or fine-grained metal. The image is then "etched" before printing with a mixture of dilute nitric acid and gum arabic, although the etching serves mainly to fix the greasy drawing to the stone and to desensitize the undrawn areas from receiving the ink. The acid is so dilute that it does not eat away the stone, as the word *etch* implies. The inking is done only after a thin film of water has been sponged over the printing surface. The water prevents the greasy ink from adhering to the undrawn surface while it is attracted to the equally greasy image or texture.

The surface of a litho stone or plate feels smooth to the touch, unlike the rougher surface of an etching plate or the even deeper variations of a relief block such as a woodcut or linoleum cut. A print is made when a sheet of paper is placed on top of the inked stone and pressed against it.

Lithograph Stones

The traditional material on which a lithograph is made is limestone from Solnhofen and Kelheim in the Franconia district, north of Munich. The quarries are still active, although production is limited to the demand from fine artists, universities, and art schools. Marble has been used occasionally, though not very successfully, with stones quarried in England, France, and the United States, but the stones from Bavaria are the most widely used. They are 94 to 98 percent calcium carbonate, with slight amounts of silica and other minerals present.

The stones vary greatly in hardness, color, and imperfections but have one thing in common: they are heavy. Their great weight makes them difficult to ship and dangerous to handle. Large stones are usually moved on wheeled carts or tables or small forklifts, and a large multicolored lithograph on stone requires lots of manpower to complete.

Yellow or whitish stones are soft and usually do not take a fine grain as well as gray or blue-gray stones, which normally are harder. In general, the middle range of gray to yellow-tan stone is the best for hand lithography. White or soft yellow stones are too uneven for delicate crayon work but may be suitable for simple areas of tone.

Some stones are mottled or contain variations in color. Veining or spotting is quite common and does not necessarily impair the usefulness of the stone. The defects that can cause problems are parti-cles of extraneous material, which can flake off, leaving tiny pits or spots. Actual cracks in the stone do occur, and the heavy pressure used in printing may split a stone. Stones should be thick enough to resist cracking; at least 2 inches for small stones and 3 to 4 inches thick for larger stones.

PREPARING THE STONE

New stones must first be leveled to ensure accurate printing. Test the stone with a straightedge and a few pieces of thin paper; tracing paper or newsprint will do. Cut four or five pieces about 1 by 3 inches and place them spaced evenly under the edge of the straightedge. If you can easily pull out any piece of paper, the stone is low at that spot.

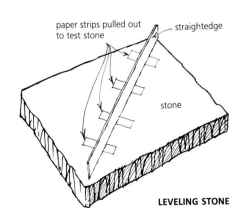

paper strips pulled out to test stone · straightedge

stone

LEVELING STONE

DAN WELDON
Canyon XII, **1988**
Lithograph, 10″ × 8″
Courtesy of the artist

A light-duty lift at Indiana University can handle stones weighing several hundred pounds.

The grain of the stone is clearly evident in this enlargement of a lithograph by Daumier.

Repeat this test at a number of places on the stone to check its entire surface. Check the thickness of the stone all around its edges with a pair of calipers to make sure it is even. Slight irregularities can be corrected by grinding, which is done with another stone or with a levigator, a cast-iron or metal disk attached to a handle.

The surface of the stone must be smooth and flat to serve as the base of the drawing that will be inked and printed. Old stones that have been printed previously need less leveling, but they have been known to lose their even surface because of improper grinding and therefore should also be checked.

GRINDING THE STONE

The materials you will need are:

Lithograph stone (or 2 if stones are ground together)
Straightedge
Carborundum (grits 80, 100, 150, 220)

Levigator
Flat file and Carborundum block

A strong table or sink is necessary if many stones are to be ground. A good, serviceable graining table can be made easily and inexpensively by a carpenter or handyman. You can also turn an existing sink into a grinding sink if it is large enough, by inserting a wooden rack inside the walls of the sink.

If you build a sink, make it strong and solid because the stones are heavy and the grinding action will eventually loosen a weak construction job. The legs can be made of 4-by-4-inch stock, the sides of 2-by-10-inch material, and the bottom of ¾-inch plywood, exterior grade. Bolt the legs to the basin for permanence. The basin can be painted and the joints lined with cloth tape and re-painted, or it can be lined with heavy vinyl, folded from a large sheet and stapled above the water line. For a first-rate job, line the sink with zinc, aluminum, fiberglass, or stainless steel.

The drain should be constructed so that the heavy sludge that inevitably accumulates will not be washed into the plumbing. The sediment will eventually clog the trap. In many graining tables a short piece of pipe protrudes an inch or so above the bottom of the ink, permitting the sludge to collect in the bottom, where it can be shoveled out at intervals. The drainpipe can be connected by a rubber hose to a pail or to the plumbing drainpipe.

Grinding a large stone is made easier by the levigator. The first grinding is made with coarse Carborundum (80 to 100 grit) and water until the sludge on the surface becomes light gray, dry, and sticky. The stone and levigator are then washed thoroughly, new Carborundum added, and the stone ground again. If the stone has been used before, the image should be removed with the coarse Carborundum, which may require five or six grindings. Wash the stone again and grind again with 150 or 180 grit followed by two or three final grindings of 220 to achieve a moderately fine-grained stone. A smooth finish is suitable for fine-line pen or brushwork, while a rougher finish is good for crayon or larger brushstrokes. Transfers of photo material, type, lettering, or similar imagery should be made on fine-grained stones.

The graining table in the Paris workshop of Edmund and Jacques Desjobert. The water and sludge drain out through a hole in the bottom into a pail, which is emptied every day or two. Elaborate equipment is not necessary for beautiful work.

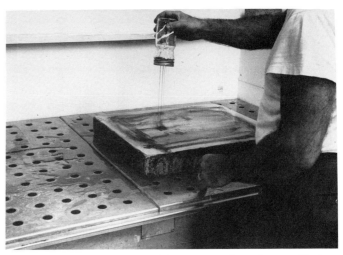

Carborundum is sprinkled thoroughly over a stone by Rudy Pozzatti in the University of Indiana workshop.

The levigator is used for rough grinding because it spins rapidly on an off-center handle.

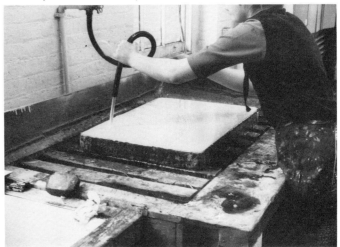

The stone is rinsed with water to remove all particles of stone and Carborundum. It is then left to dry before being drawn on.

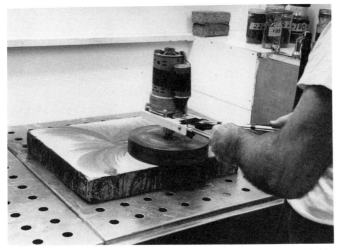

A power-driven levigator at a University of Indiana workshop is guided by Rudy Pozzatti.

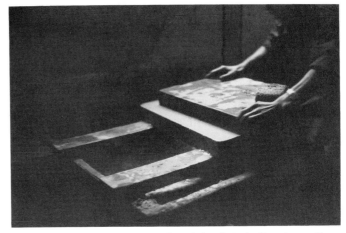

Two stones are ground in Desjobert's workshop in Paris. Note the position of the hands.

Use a pattern of graining that will evenly distribute the abrasion over the surface. If you use another stone as the grinding agent, you will have "killed two birds with one stone," and both will be resurfaced. Stones should be ground with a figure 8 rotating motion in the pattern shown (see illustration).

Be sure to level the outer edges of the stone, as the center tends to get more abrasion. Clean the stone thoroughly when the graining is complete so that all the tiny particles of stone and grit are washed away. If they are allowed to dry on the stone, they may lift off later, during printing, and leave white spots in the image.

pattern for graining large stone with another stone

GRAINING A LITHO STONE

The edges of the stone should be rounded or beveled with a flat file and then polished with a coarse Carborundum block, pumice stone, or Schumacher brick. If this is not done, the sharp edges tend to catch ink and print when you are pulling the edition; they also chip during handling.

After the stone is washed and dried, it is sensitive to both grease and water. If it is not to be used at once, it should be wrapped in clean, nonoily paper (not newspaper or printed matter) and stored.

Preparing a Metal Plate

The expense and trouble of working on heavy limestone blocks have caused many artists to shift to metal plates. They are light, inexpensive, and can be stored in a fraction of the space required by stones. Aluminum, zinc, and magnesium are popular, and even paper plates are workable. When stones are scarce and multicolor work is planned, the key image may be placed on the stone and succeeding colors on metal plates.

Aluminum plates are commonly available, whereas zinc ones are less so because the major consumer, the commercial offset-lithography print shop, prefers the cheaper, disposable aluminum plate. Aluminum is less sensitive to grease than zinc and conversely is more sensitive to water. Therefore the nonprinting or white areas on aluminum tend not to scum or fill during printing. Zinc is sensitive to grease, but the nonprinting areas are hard to keep clean and free of scumming and smudges. Because metal plates are nonabsorbent, especially compared with limestone, the images have an inse-

cure hold on the metal and must be properly etched, gummed, or inked.

Zinc plates can be regrained after use by a plate-graining machine, which uses steel marbles and an abrasive, usually aluminum oxide powder. The machine oscillates the marbles over the plate, and the abrasive, mixed with water, puts a tooth or texture on its surface. This is usually done by a commercial firm specializing in this work. Plates to be regrained should be thick enough to withstand the procedure, a minimum of .010 inch in thickness.

To make sure a metal plate is receptive to grease in crayon or tusche, it is often necessary to counteretch the plate with a solution that is flowed over the plate, usually in a tray. Only a few minutes are enough to remove any surface oxides that may inhibit the adhering of the grease to the plate. The plate is then rinsed with water and dried with hot air, a fan, or by blotting with clean newsprint. It is now ready for the image.

Placing the Image on the Stone

The traditional drawing media for stone are greasy crayons and lithographic tusche. These materials are still widely used, but many other media have been developed in recent years. Photographic techniques, transfers, rubbings, and a number of unorthodox solvents and substances have expanded the possibilities of lithography enormously.

The only essential characteristic of a drawing medium is greasiness. In addition to prepared litho crayons or tusche, such items as animal fat, petroleum jelly,

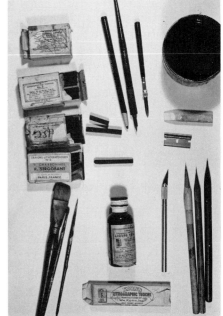

Starting at the top, clockwise, are some of the items used in placing the image on the litho stone: litho pencil, straight pen, ruling pen, can of oil-based liquid ink, snake-slip stone, razor blade, some needles, pointed X-Acto knife for scraping, jar of liquid tusche, block of solid tusche, some brushes, and selection of litho crayons of varying hardness.

soap, tallow, oil, or sweat can be used to produce textures and shapes on a stone or plate. Solvents such as gasoline, turpentine, alcohol, mineral spirits, and countless other chemicals have been employed to dilute, dissolve, or emulsify the grease to form unusual shapes, patterns, or textures.

You may sketch your drawing on the stone with a nongreasy sanguine Conté crayon. Its red color will remain distinct when the actual image is completed in black. Do not, however, draw too heavily with Conté crayon; it has a tendency to reject grease drawn over it. Also be cautious about using graphite pencils for preliminary sketches because there may be some grease in the graphite that could print when the image is etched, inked, and printed. You can make a greaseless transfer paper of Conté crayon rubbed evenly over a sheet of tracing paper and smoothed out with a stump, cotton, or chamois. This, placed face down on the stone, will enable you to trace drawings and shapes from another sheet onto the stone.

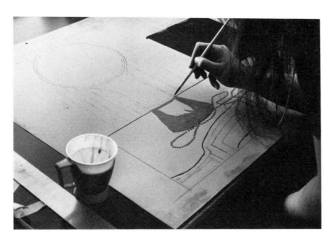

Gum arabic solution is painted on a zinc plate. When the entire area is covered with black tusche, the gum prevents the tusche from adhering—so wherever the gum was painted prints white.

CONVENTIONAL DRAWING MEDIA

Lithographic crayon This crayon is a mixture of a greasy material like soap with wax, shellac, and a coloring agent like lampblack. It is precisely formulated and numbered according to hardness, ranging in the United States from 00, which is very soft, to 5, which is the hardest. (Unfortunately, European crayons use an opposite numbering system, with no. 5 being the softest.) The crayons are sold in stick and pencil forms, and both work equally well on metal plates and on stone. They can be rubbed with the finger or with a cloth or stump to achieve gray tints or to intensify black areas.

Most artists find it desirable to have several grades of crayon on hand in the studio. The harder grade, sharpened to a point, can reach deep into the grain of the stone to give an accurate reflection of the value that will finally print. The artist's needs will determine how tools are handled, but a study of work produced in the past reveals a wide range of tonalities, textures, and techniques. Lithography is a very responsive medium for artists to whom the drawing touch on the stone is important.

Lithographic tusche For wash effects, the most commonly used material is tusche, which is a greasy substance that comes in liquid form or in solid sticks. It is dissolved in either water or solvents such as alcohol, lithotine, turpentine, or lacquer thinner. The tusche can be applied with brushes or with pens, including ruling pens; in fact, some of the earliest lithographs were done with a pen. It can also be sprayed or stippled.

The effectiveness of tusche depends on its grease or fat content, and therefore its black pigment, which is added merely to make the solution visible, does not reflect the true value of the applied tusche. It takes some experimentation to determine how a tusche wash will print. In general, tusche dissolved in solvents penetrates the stone better than tusche dissolved in water and therefore will print a little darker. Liquid tusche should

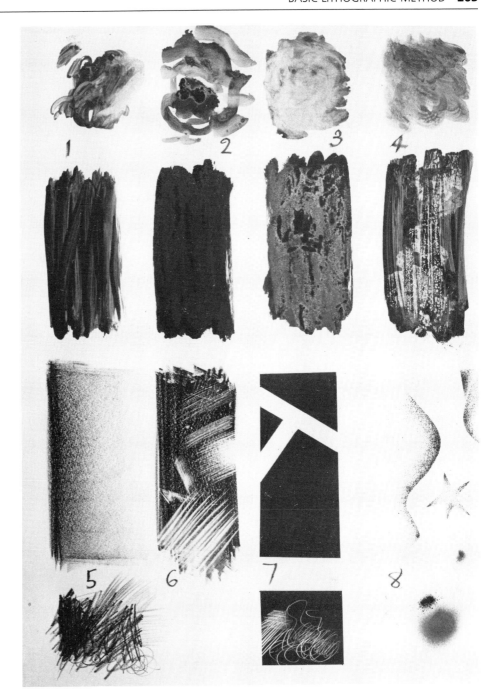

These textures and tones can be obtained from the use of tusche and crayon. Numbers 1–4 are brushed areas of tusche, used as washes on top and solids on bottom. In areas 3 and 4 the tusche was blotted with a paper towel while still wet. Areas 5 and 6 were made with a stick of litho crayon, with some scraping by a needle and a razor blade. Area 7 was masked off with masking tape on the edges as well as on the inside area. The bottom section was scraped with a razor. Area 8 was sprayed with tusche through an airbrush using paper stencils to control the shapes.

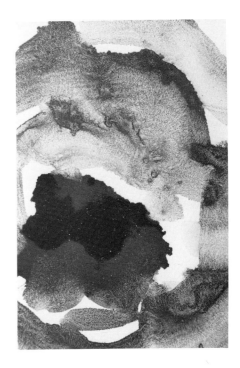

An enlarged section from area 2 above, showing wash effects possible with liquid tusche.

be shaken before use and should be fresh, not old or partially dried out, for better control of graded washes.

Autographic and rubbing inks These inks, like tusche, are a suspension of greasy or fatty particles in a pigmented base, usually of lampblack. Autographic ink makes a strong black solid when used full strength. It can be diluted to flow in a ruling pen, lettering pen, or straight nib for drawing. Rubbing ink, in solid form, can be rubbed with a piece of cloth wrapped around your finger to transfer gray tones to the stone or plate.

USING TEXTURES

The conventional crayon and tusche lithograph has not proved versatile enough for many present-day artists, who demand much more flexible methods. The textures of various papers and fabrics (corduroy, lace, bouclé, denim, and tweeds are good choices) can be transferred to the stone with little trouble. Soak the fabric in any greasy solution, such as litho ink dissolved in turpentine or soap solution colored with tempera. Other possibilities are machine oil, animal fat, or axle grease, colored with litho ink or even letterpress or etching ink so that you can see what is happening on the stone. (The cost of tusche militates against its use as a soaking agent because so much would be needed.) Blot off the excess solution between newspapers before placing the ink-impregnated fabric on the stone. Use wax paper as a frisket to define shapes and areas. Put another piece of wax paper on top of the fabric to protect the rolling pin or hard-rubber brayer you use to press the fabric into contact with the stone. You can also run it through the press to transfer the image. Turn up a corner of the wax paper and the fabric to check the transfer of the texture.

You can also cut shapes from cardboard, corrugated board, charcoal paper, or cheesecloth and dip them into a greasy solution, remove the excess grease on newspaper, and place them on the stone in the desired position. Thin pieces of greasy paper can be run through the litho press if they are covered with wax

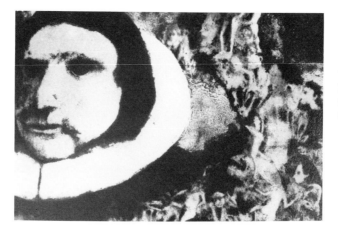

The wash textures in this color litho by Frederico Castellon are defined by delicate crayon work.

In this enlarged detail, liquid tusche has been blotted with paper towels while still wet.

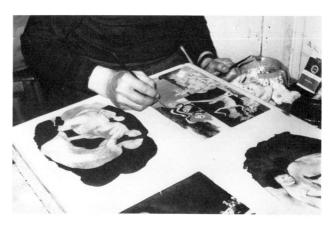

In the Desjobert Atelier in Paris, Castellon works on a color stone for his "Mask of the Red Death" series. Later he uses a hot-air hair dryer to speed the drying of liquid tusche.

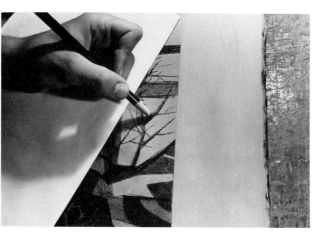

Using a litho crayon directly on the stone produces a grainy stroke. Protect the stone from the grease on your hand with a piece of stiff paper.

Corduroy dipped in liquid tusche or greasy ink may be used as a texturing agent.

A leaf may be inked with liquid tusche and placed on a clean piece of board or paper. A clean large roller can then receive the ink from the leaf.

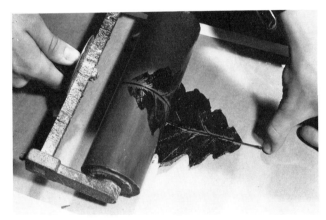

An area of tone has been deposited by a no. 2 litho crayon and then scraped with a needle and a razor blade to get white lines on a dark background.

The impression from the roller is transferred to the sensitive stone. This roller is plastic, with a 2½-inch diameter and an 8-inch circumference.

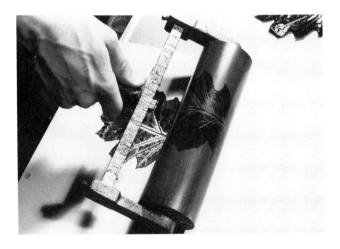

paper and blotters. Use just enough pressure to capture the texture on the stone. Dip string, thread, and ribbons in the greasy solution and use the same methods to transfer them to the sensitized stone.

To print wood grain, wire mesh, coins, sand, leaves, ferns, or other textures that are not easily dipped into a grease solution, it may be simpler to use a rubbing technique. Take a piece of thin bond or any other good-quality, thin, nongreasy paper, place it on top of the piece of wood or other textured surface that you want, and make a rubbing of the area with litho crayon. Use the side of the crayon and apply good pressure. When you have the proper amount of texture on the paper, place it between sheets of newsprint and put everything between damp blotters, to make your textured image lie flat without wrinkling when you run it through the press against the stone. Five minutes or so will soften the fibers of the paper enough to make it limp. If it gets too wet, the crayon textures may dissolve, so be careful. When the paper is pliable enough,

put it in position on the stone, which will be more receptive to the crayon if it is warmed in advance. Put several damp blotters or paper on top, put the tympan over all, and run it through the press once with strong pressure.

You can use an airbrush or spatter to get gray tones in an image, and with some ingenuity you can place many other textures on the receptive surface of the stone or plate.

MANIÈRE NOIRE

To make a white line drawing on a black background, which is called *manière noire*, the area to be blackened is coated with tusche or asphaltum to make it completely black. Then it is treated with a weak etch, rolled up with ink, and dusted with talc to help dry the ink. Now the stone is ready for the image, which can be scraped with needles, an X-Acto knife, razor blades, and scrapers, in an approach similar to the way a mezzotint is developed.

You can coax gray tones out of the black areas by applying a weak solution of nitric acid and gum arabic either with a brush or sponges. The more you use the acid, the lighter the tones will become. Blot up the etch with blotters or another sponge when you achieve the tone you want. The stone is now ready to be processed like a new drawing. Details on this method can be found in *The*

EUGÈNE CARRIÈRE
Sleeping Child, **1897**
Lithograph scraping technique
National Gallery of Art, Washington, D.C.
Rosenwald Collection

Tamarind Book of Lithography by Garo Antreasian and Clinton Adams or *The Techniques of Fine Art Lithography* by Michael Knigin and Murray Zimiles.

Using Transfer Paper

There are several advantages to making your drawings on transfer paper instead of working directly on the stone:

1 It is easier to draw on paper than on stone. The weight of stones is a distinct handicap when moving them or setting them on an easel or drawing table.

2 The drawing on transfer paper does not have to be reversed. It automatically reverses when placed on the stone or plate and then comes back to its original orientation when printed.

3 A variety of textured or dimensional surfaces can be placed on the stone by the transfer method, such as type matter, leaves, coins, rubbings of wood textures, metal gratings, screening, and the like. These can include photocopy transfers of photographs, newspaper or magazine pages, maps, charts, and other items of visual interest.

Conversely, there are disadvantages to using transfer paper:

1 Very precise drawings with fine, thin lines may blur slightly in the transfer because the grain of the stone may not correspond exactly to the tooth of the paper. This can somewhat be alleviated by very fine graining of the stone (with 320 aluminum oxide powder or fine pumice) or by using fine-grained aluminum plates.

2 Drawings on uncoated transfer papers may blur because the paper does not stick to the stone and shifts when pressure is applied in the press.

TYPES OF TRANSFER PAPER

In general there are two types of transfer paper: uncoated and coated.

Uncoated transfer papers For uncoated paper, you can use almost any paper whose surface is not too absorbent and likely to lessen the grease content of the drawn image. Among the papers that are suitable are Basingwerk, plate-finished one-ply Bristol, vellum, tracing paper, bond paper, and Somerset Satin. Because uncoated papers do not transfer wash effects or delicate tonal modeling well, they are used mainly for bold, simple drawings. The paper should be slightly dampened, to a limp but not wet state, and run through the press only once with heavy pressure. Some people recommend using a warm stone in order to get as much image as possible off the paper onto the stone.

Coated transfer papers The best results in transferring images to stones and plates are achieved with coated paper. Some commercially available papers, such as Everdamp, are excellent. Although it has a short shelf life, Everdamp will transfer tusche drawings, stone-to-stone transfers, and other images completely and cleanly. It is made with a coating of carrageen, water, glycerin, and gelatin and must be stored carefully, kept in plastic envelopes with no weight placed on top, because it tends to stick together.

Transparent transfer paper can be used for color-registering drawings to be super-imposed on an already completed portion of an image. You can purchase it ready-made on a thin vellum sheet, or you can make your own by brushing one side of the paper with a solution made from the following formula:

1 quart water

3 ounces gelatin

3 ounces white pigment

Heat the water, mix in the gelatin, and sprinkle in the white pigment. If lumpy, strain through cheesecloth. Use a wide hake brush to spread the coating evenly and let it dry before using.

Other formulas for making transfer papers include fine-ground dental plaster, flour, and starch as their ingredients. Each lithographer seems to develop a favorite formula for each process, so that the variety of compounds and mixtures is bewildering. In any case, do not use gum arabic in the formulas because the gum will desensitize the part of the stone that has no image on it.

Do not use water-soluble tusche on transfer paper because reworking the stroke may dissolve the coating and allow the greasy tusche to be absorbed into the paper, weakening its strength. Instead, use a solvent-based tusche. The tusche stroke can even be removed with the solvent (usually mineral spirits or lithotine) and the area reworked without damage to the coating.

THE TRANSFER PROCESS

1 On the bed of the litho press, position a freshly grained stone or plate large enough to accept the complete drawing.

2 If the transfer is from coated paper, dampen the stone or plate lightly and evenly, as in printing. If the transfer is from uncoated paper, dampen the sheet very lightly—just enough to make the paper limp but not shiny—and place it face down on the dry stone.

3 Lower the backing sheet and tympan into position and pass the sheet through the press. Use normal printing pressure for uncoated paper and slightly less pressure for coated paper. Uncoated paper should go through the press only once to prevent shifting. Coated paper should go through the press three times; then the tympan and backing should be removed and the back of the transfer paper sponged with water. A waterproof barrier (plastic sheet), the backing paper, blotters, and the tympan should be put on top of the paper and run through the press three times again.

4 Check coated transfer paper to see if the drawing has been completely transferred to the stone or plate. As it takes some time for the water to soak through the paper and dissolve the coating, you may have to repeat the sponging of the back of the sheet several times. When the transfer is complete, the paper can be stripped from the stone or plate, leaving the intact drawing on its surface.

5 Fan the image dry and dust it with talc.

6 Apply an etch of gum only and buff smooth.

7 Wash out the image with lithotine and rub up with asphaltum, then fan dry.

8 Roll ink into the image, then dust with talc and rosin.

9 Apply the second etch (see the following section).

Etching a Stone

To ensure that the greasy image is securely and positively bound to the granular limestone surface, it must be chemically etched. The etch consists basically of gum arabic, often mixed with nitric, phosphoric, or tannic acid. Gum arabic comes in powdered or lump form and is also available premixed as a proprietary solution especially for lithographic printing. Gum arabic effectively desensitizes the nongreasy parts of the stone so that they will accept water and not ink during the printing process.

MATERIALS

Litho stone with greasy image

Gum arabic solution (or powder)

Nitric acid (technical grade)

Phosphoric acid

Tannic acid

Asphaltum

Small glass or stainless-steel bowls

Glass graduate and stirring rod

Cellulose sponges

Brushes (camel's hair, rubber-set), 3 inches wide

Spot etching brushes

Fan for drying stones

Cheesecloth and wiping cloths

Powdered rosin

Talc

Cotton

Leather inking roller

Litho ink

Lithotine

Inking slab

PROCEDURE

Place the stone on the worktable with the small glass bowls nearby and the sponges, talc, powdered rosin, and other equipment handy. Mix the etches according to the table below.

STANDARD ETCH TABLE FOR STONES

Drawing Quality	Nitric Acid (drops per ounce gum arabic)
Very delicate (no. 4–5 crayon; very light tusche wash)	0–5
Weak (no. 3 crayon; ¼-strength tusche wash)	6–12
Moderate (no. 1–2 crayon; ⅓-strength tusche wash)	13–18
Strong (½-strength tusche wash)	19–26
Very strong (full-strength tusche wash)	27–33

Note: Light no. 5 crayon is etched with gum only; graphite pencil with half gum, half water.

The proprietary solution can be purchased already prepared, which is convenient and practical. It comes in 14° Baumé, which is thick enough for hand lithography and will not turn sour because it has a preservative in it. The powdered gum can be prepared by mixing with hot water to make a liquid about as thick as maple syrup. If it is lumpy, strain it through cheesecloth. Using a dropper, add the acid to 1 ounce of gum arabic and mix with the glass stirring rod.

The strength of the gum arabic etch is determined by the stone and the quality of the drawing on it. Delicate crayon work needs very weak etches with little or no acid. Tusche needs a stronger etch, as does heavy crayon. Dark gray stones need stronger etches than light gray and yellow stones.

1 Dust powdered rosin over the drawing on the stone with cotton; remove any excess.

2 Dust talc over the stone with cotton; remove any excess.

3 Apply the gum arabic etch with a brush to the drawing according to the varying amounts of greasy deposit on the entire stone.

4 Smooth the etch film and buff down evenly with cheesecloth pads. Fan dry.

5 Wash out the drawing with lithotine solvent. Clean the stone with sponge and water. Fan dry.

6 Apply a thin coat of asphaltum or rubbing ink and distribute thinly and evenly over the stone. The asphaltum fortifies the fatty content of the drawing. Buff down with a rag and dry.

7 Add water with a sponge to the stone. Remove the etch film and excess asphaltum. Keep the stone moist.

8 Roll up with ink and a leather roller.

9 Dust first with rosin, then with talc.

10 Apply a second etch with strengths similar to the first; remove all excess gum and buff down to a thin coating. The stone is ready for the first proof.

The first etch is about 6 minutes; the second about 5. The purpose of two etches is to fix the image securely into the stone so that a consistent edition can be printed. Corrections can be made

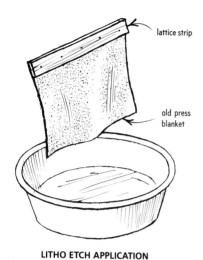

lattice strip

old press
blanket

LITHO ETCH APPLICATION

after the proofs are taken and the image studied. If new work is to be added, the stone must be counteretched to open the surface to new applications of grease from either crayon or brush. Counteretching removes the coating of gum that has sealed the black areas of the stone against accepting ink or other greasy material.

Most printers simplify the etch formula, using only gum arabic and nitric acid. It is a matter of judgment and experience as to what strength acid is applied to the varying amounts of greasiness in the image. Remember that white and yellow stones need weaker etches, and darker gray or gray-blue stones need the strongest etches.

Some printers, particularly in France, use a piece of felt from an old etching blanket (about 10 inches square), stapled to a thin piece of wood like a lattice strip, to distribute the etch over stone. Weak etches may be smoothed with the heel of the hand, but stronger etches should be brushed on and smoothed with a cheesecloth pad or wiping pad. In any case, the gum coat should be very thin and even in order for the wash-out solvent (usually lithotine) to properly remove the crayon and tusche drawing.

Etching a Plate

Aluminum is hydrophilic, or water-loving, making it more difficult for grease to establish a firm base. Zinc, on the other hand, is oleophilic, or grease-loving, and the image is somewhat easier to bind to the plate. The two plates thus have slightly different etching requirements.

ETCHING AN ALUMINUM PLATE

Before it is drawn on, an aluminum plate is usually counteretched with a weak solution of acetic acid (1 part acid to 20 parts water) to sensitize it to the drawing materials. The counteretch is applied thinly with a wide brush and allowed to dry.

After the image has been placed on the aluminum plate, it is ready for the etch. Etch solutions contain phosphoric acid in gum arabic.

ETCH FOR ALUMINUM PLATES
(Parts by Volume)

Drawing Quality	Phosphoric Acid	Gum Arabic (14° Baumé)
Delicate	1	30
Moderate	2	30
Strong	3	30

The acidity of an etch is measured by its pH value, or relative acidity or alkalinity. The scale ranges from 1 as the most acidic to 7 as neutral and then to 14 as the most alkaline. Even a weak gum etch should have a pH of 4 or less in order to properly desensitize and stabilize the plate. Note that aluminum can withstand more acidic etches than zinc. You can test pH values with a kit of testing papers available from suppliers of lithographic materials.

To etch an aluminum plate, use the following procedure:

1 Dust talc over the image drawn on the plate.

2 Apply the etch (approximate pH of 2.0) evenly with a lintless cotton pad or a wide brush. Keep the etch wet and leave on the plate for 2 minutes. Wipe up the excess etch, then dry with a clean pad.

3 Wash off the etch with water.

4 Coat the plate with gum arabic and smooth into a thin film.

5 Wash out the image with lithotine.

6 Apply asphaltum and buff smooth.

7 Roll up with roll-up ink. (The plate may be lacquered at this point to stabilize the image. See "Lacquering Metal Plates.")

The second etch is applied in essentially the same manner as the first:

1 Dust the plate with talc again.

2 Apply the second etch; do not dry.

3 Remove the etch with water.

4 Re-gum the plate (approximate pH of the gum solution is 5.0) and let dry.

5 The plate is now ready for proofing.

ETCHING A ZINC PLATE

Either gum arabic or cellulose gum solution can serve as a base for the etch for zinc, with cellulose gum being slightly more effective. It can be purchased as a ready-made solution with a weak pH (about 5.5) or in an acidified version that is much stronger (pH 2.5). Use the following procedure:

1 Dust talc over the image drawn on the plate.

2 Apply the etch evenly with a lintless cotton pad. Denser parts of the image and tusche washes may need a more acidic gum solution and longer contact with the etch. After 2 minutes buff the etch dry.

3 Wash the plate with a clean sponge and water.

4 Apply a coat of cellulose gum, wipe smooth, and let dry.

5 Wash out the image with lithotine.

6 Rub up the plate with asphaltum or rubbing ink.

7 Clean the plate with sponge and water, keeping it damp.

8 Roll up with ink.

The second etch can be applied in essentially the same manner as the first.

1 Dust the image with talc.

2 Etch the plate with cellulose gum.

3 Wash the plate with sponge and water.

4 Apply a thin, smooth coat of cellulose gum; wipe dry.

5 Wash out the image with lithotine.

6 Apply and distribute a smooth coat of Triple Ink or asphaltum while the lithotine is still wet. (If you are printing in color, apply a thin, even coat of color thinned with lithotine.)

7 Fan dry and wash out with sponge and water.

8 Roll up the image with ink for the first proof.

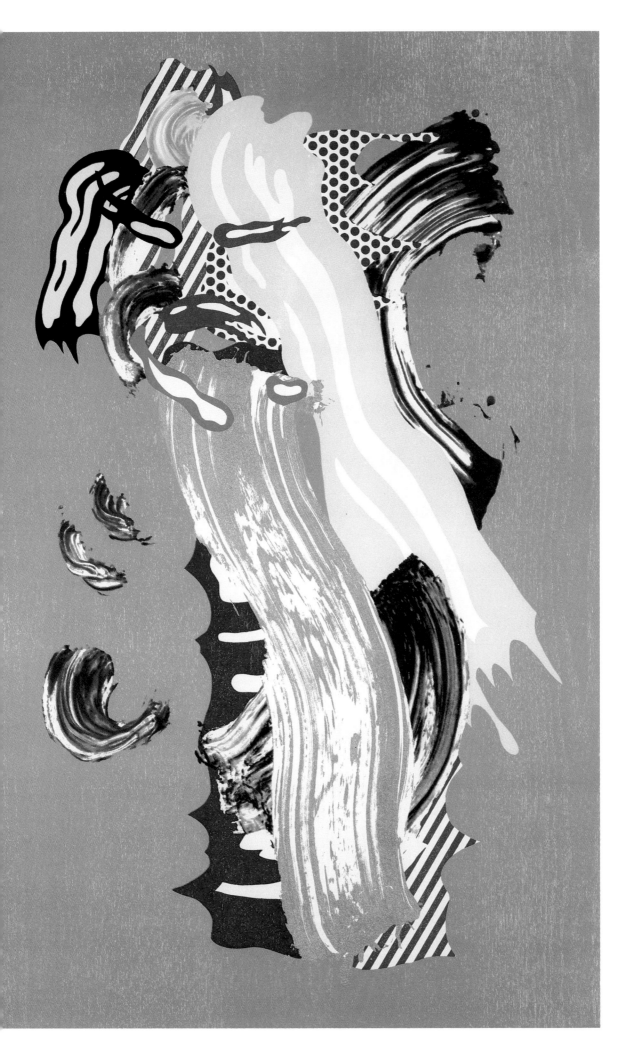

ROY LICHTENSTEIN
Blonde, **1989**

Graphicstudio waxtype,
lithograph, woodcut,
screen print,
57¹³⁄₁₆″ × 37⅜″
© copyright Roy
Lichtenstein and
Graphicstudio,
University of South
Florida, Tampa, 1989
Photo: George Holzer

209

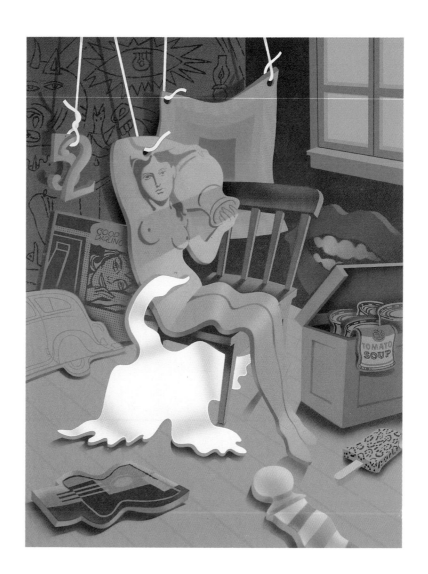

LYNWOOD KRENECK
Every Artist Has an Attic, 1984
40-color screen print with airbrush stencils
(water-based ink), 21¼″ × 16½″
Courtesy of the artist

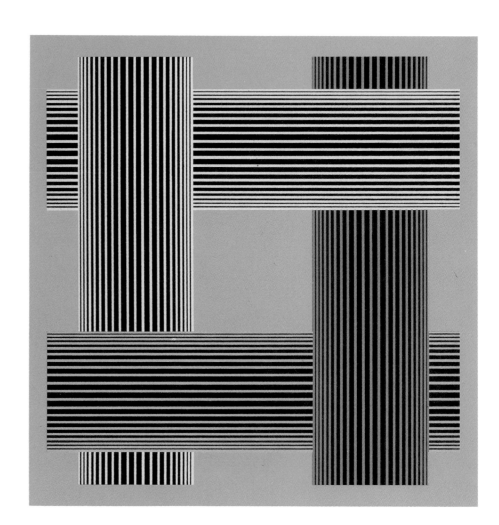

RICHARD ANUSZKIEWICZ
Translumina—Sky Blue, 1989
Screen print with hand-cut stencils on
two-ply museum board, 24″ × 24″
Printed by Norman Lassiter
Courtesy of the artist

LOIS JOHNSON
City Hall, 1988
21-color screen print with hand-drawn and photo-generated transparencies (water-based ink), 30″ × 22″
Courtesy of the artist

MIRIAM SCHAPIRO
Tangerine, 1988
18-color screen print (cut film and hand-drawn Mylar photo stencils; printed with Advance poster color), 8⅜″ × 7½″
Courtesy of the artist

HENRI DE TOULOUSE-LAUTREC
***The Jockey*, 1899**
Color lithograph, 20⅛" × 14³⁄₁₆"
National Gallery of Art, Washington, D.C.
Rosenwald Collection

DAVID HOCKNEY
***Caribbean Tea Time* (front), 1987**
Lithograph, screen print, collage, stencil in
76 colors on folding screen, 84⅝" × 134½"
(four panels)
Printed and published by Tyler Graphics Ltd.
© copyright David Hockney/Tyler
Graphics Ltd. 1987
Photo: Steven Sloman

GEORGE McNEIL
Oh! That One, 1983
Color lithograph, 22¼″ × 28″
Courtesy of the artist

ROBERT ARNESON
The Colonel Is at It Again,
1986
Color lithograph with hand
coloring, 37½″ × 27¾″
Courtesy Landfall Press, Inc.

MICHAEL MAZUR
Wakeby Night, 1983
Monotype, 6′ × 12′
Collection Massachusetts Institute of
Technology
Photo: courtesy Fawbush Gallery

HELEN C. FREDERICK
221 Red, ©1988
Monotype with artist-made papers,
49″ × 49″ × 2″
Courtesy Pyramid Atlantic, Inc.,
Washington, D.C.

MICK MOON
Japanese Box, **1987**

Monotype with collage, 61" × 57½"
Courtesy Dolan/Maxwell, New York and Philadelphia

C. ROBERT SCHWIEGER
Chix of the Nile, 1984
Screen-print construction, 30½" × 20"
Courtesy of the artist

STEVEN SORMAN
From Away (front), 1988

Three-dimensional screen with woodcut,
lithography, collage, screen printing, hand-
painted, hand-carved by the artist,
60½" × 81" × 12"
Produced and published by Tyler Graphics Ltd.
© copyright Steven Sorman/Tyler
Graphics Ltd. 1988
Photo: Steven Sloman

LACQUERING METAL PLATES

To prolong the printing life of a zinc or aluminum plate, it may be desirable to lacquer the image areas of the plate. Lacquering puts a tough, long-lasting film on the printing areas that makes consistent long-run editions possible. The lacquer used is Lith-Kem-Ko-Deep Etch Lacquer C, available from litho-supply houses. Deep V, a vinyl lacquer made by Dan Smith Ink Company, is also very durable.

After the plate has been proofed and corrected and is ready for the edition, apply the lacquer:

1 Thoroughly ink the image with crayon black, then talc the surface.

2 Gum the image evenly.

3 Wash out the image with lithotine, then lacquer thinner, and dry the plate.

4 Rub the lacquer onto the plate with a dry, lintless rag. Buff into a smooth, even film.

5 Apply asphaltum and buff dry.

6 Wash the plate with water and a sponge to remove the asphaltum, gum, and excess lacquer.

7 While the plate is damp, roll it up with printing ink.

Warning: Lacquer thinner usually contains toluene, a dangerous, volatile, and toxic chemical that should be used only with local exhaust ventilation.

Materials for Printing

The lithographic workshop should have its litho press, with accompanying tympan sheet and scraper bar, set up in proper relationship to the worktables that hold inking slabs, water, bowls, sponges, rags, chemicals, and other materials. An area on a tabletop should be reserved for the clean, unprinted paper, and another area for the stacking of prints after they are run through the press. In some cases, good results can be achieved by printing metal plate lithographs on an etching press, but in general a press made for the express purpose of printing lithographs will produce prints more efficiently.

THE LITHOGRAPHIC PRESS

The press used for lithography has several basic parts: a frame holding a traveling bed that moves back and forth, trans-porting the stone or plate, and a yoke that holds the scraper box with its scraper bar. There must also be a mechanism to bring the stone into close contact with the scraper bar, by either raising the bed or lowering the scraper box. There are several variations that are practical, and the selection of one press over another is a matter of preference, availability, and money.

The bed of a litho press can be covered with metal, linoleum, pressed wood, a rubber press blanket, or the like. In any case, the bed should be kept clean and free of dirt, chips, or particles. The pressure on the stone is very strong, and the slightest irregularity can cause a stone to crack.

To print a metal plate, some material must be obtained that will raise the plate to a level where it will contact the scraper. This can be a used litho stone, a piece of Benelux (compressed wood chips in resin), or a slab of aluminum that has been ground level on both sides. Three sheets of ¾-inch birch plywood can be used but will not last long because the water and acids tend to attack the integrity of the bond and the wood itself.

The flat-bed offset-litho press is being used more frequently for editions by professional print shops and some well-equipped university and art school workshops. This press prints the image onto a rubber blanket wrapped around a steel cylinder, which then prints the image on a sheet of paper. This type of press has a very precise register system and is excellent for multicolor images. Most of them are manufactured in Europe.

SCRAPER BAR CONSTRUCTION

The tympan sheet for the direct-litho press can be made of plastic, such as Lexan, Plexiglas, red fiberboard, or fiberglass. It must be strong enough to withstand constant handling and abuse as it transfers pressure from the scraper bar through the paper to the stone underneath. The tympan should be lubricated with either heavy grease or petroleum jelly.

Scraper bars once were made of maple, Benelux, or birch but now are being made of polyethylene, which does not require a leather strip as a cushion on the bottom. Although polyethylene scrapers may need sharpening, they are simpler to maintain. The wooden scrapers on so many presses must have a leather strip along the printing edge, which is usually treated with linseed oil, then stretched tight along the bottom edge and held in place with box nails or screws. If you use common nails, you should predrill the holes to prevent splitting the wood.

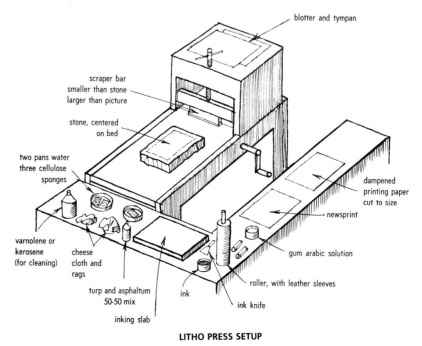

LITHO PRESS SETUP

ROLLERS

The best roller for inking detail in a lithograph is still the leather roller, usually handmade in Germany. It is available in two grains: rough, with the nap on the outside, and fine-grained with the smooth side out. The inside core is hardwood, covered with a layer of woolen felt, then covered by calfskin or cowhide. The leather is sewn by hand along the seam and at the ends. The nap of the leather works into the grain of the stone and picks out the most delicate detail.

The roller must be carefully broken in before use. Start by repeatedly applying neat's-foot oil until the leather is saturated. Scrape off the excess oil with a stiff metal spatula each time it is applied. Then roll in no. 0 lithographic varnish (very loose and soft) every day for a week, lightly scraping after each application. Increase the tackiness of the varnish to no. 5 and apply this for a week, with the same light scraping each time. Then use no. 7 litho varnish for a few days, rolling out the tiny fibers of leather that work loose from the roller surface. Next use black roll-up ink every day, scraping the slab and the roller every time you use it. During scraping, the spatula will raise the nap of the leather in one direction and flatten it in the other. Scraping against the grain removes a little of the nap each time, and at the beginning this is needed; toward the end less nap will come off. Finish each session by scraping with the grain to smooth the roller.

The roller should be wrapped with plastic or aluminum foil after each workout to keep it from drying and hardening, which is the enemy of leather. If you leave the roller unworked for more than a week at a time, coat it with mutton tallow or another nondrying, fatty material and remove the coating from the roller by thorough scraping before doing further work. Frequent use of the leather roller keeps it in good condition and is worth the effort.

There is another roller that has some of the characteristics of the traditional leather roller and is less trouble to maintain. The covering is made of PVC imbedded with thousands of tiny fibers, which give it a surface somewhat similar to the nap on a leather roller. It is called a hickey-picker in commercial offset printing because it has the ability to reduce the number of hickeys (small dots of ink) on a plate. It is easily cleaned and needs no breaking in. Unfortunately, it is even more expensive than a leather roller.

Other rollers are made of polyurethane, Buna N, and rubber, in a variety of durometers from 10 (very soft) to 60 (hard). These rollers are excellent for color work and can be used for black, too. Immediately after printing, they should be cleaned with kerosene or mineral spirits, and because a glaze tends to build up after frequent use, they need an occasional cleaning with a special glaze solvent. Do not use acetone, lacquer thinner, methyl-ethyl ketone, or xylene on the rollers because these harsh solvents will reduce the life of the roller coverings.

Leather cuffs are available from many manufacturers. They fit around the handles and reduce friction on the hands when inking stones and plates and conditioning rollers. A little talcum powder in the cuff makes the handle turn easily. Cuffs can easily be made from 4-by-6-inch rectangles of heavy leather. Soak them overnight in water, then fit them in place with tape or a rubber band and let them dry into shape.

Portable roller racks are essential in the print shop. They keep the roller off the slab, where prolonged contact can cause a flat streak to develop on the roller surface. For long-term storage, rollers should be covered with plastic or kept in a closed cabinet to protect them from dust and dirt.

LITHO ROLLER CLEANING RACK

notched filler pieces cut to suspend roller in air

Roller

covered box of plywood or 1 inch stock

LITHO ROLLER STORAGE BOX

2" x 6" stock

2" x 2" stock with ½ dowel

LITHO ROLLER STORAGE RACKS

PAPER FOR LITHOGRAPHY

Smooth, strong paper is best for printing lithographs. For permanence in edition printing, paper should have some rag or other permanent fiber content and a neutral pH or a high alpha content to prevent acid deterioration. There are many fine papers available today. Among those made in the United States are Lenox 100, Stonehenge, Coventry, Folio, Gallery 100, and Strathmore Bristol—all suitable for lithography. In Europe fine papers abound, including Fabriano Tiepolo, Murillo, Umbria, Rosaspina, Rives BFK, Arches Cover, Italia, Copperplate Deluxe, German Etching, and Rives Heavy. Spain and Holland are making paper again and Guarro Satinado and Utrecht can be used for lithography. From England come Somerset Satin and Textured, Basingwerk, Bockingford, Waterford, and Whatman. Some of these sheets must be dampened to soften them for the litho press.

Japanese papers are often soft and will tend to pick or fluff, leaving tiny particles of fiber in the ink. However, some of them are so handsome that they are used despite their shortcomings, including *in-omachi, kochi, okawara,* and *suzuki* (for

their large size) and *goyu* and *moriki*. The Japanese sheets are rarely dampened because they are so thin that they may tear while wet.

Heavier, slightly textured papers used for watercolors, such as Whatman, Arches, Waterford, Bockingford, Strathmore, Fabriano Classico, and Artistico, must all be thoroughly softened by dampening before they can be used for lithography. In addition, there are many handmade papers now available from John Koller, Twin Rocker, Dieu Donne, Canterbury, Richard de Bas, and others that may be just what certain prints need. They should be exploited for their rich texture and color.

Proofing paper can be machine-made stock such as Mohawk, Beckett Cover, Pastelle, Tuscan Cover, and Hammermill Index. Although most of these are not fully archival, they will make good proofs, suitable for studying the developing image.

Dampening the paper For black-and-white or one-color lithographs, the most sensitive prints are made on damp paper. Dry paper does not show all the delicate textures in tusche washes, for instance, and light crayon work responds better to a slightly dampened sheet. Proofs done on dry paper have a somewhat burned-out look, and delicate nuances may become lost.

Paper should be prepared in advance so that it will be ready when you start to print. Dampen a few sheets with a sponge; slightly wet each side of the sheets, stack them, and put them under a blotter with a weighted plywood board on top to help the moisture soak evenly through the sheets. The fibers should be soft and pliant but not soaking wet, as excess moisture may interfere with the transfer of the image from stone to paper.

For dampening a large number of sheets for an edition or for class work in a workshop, a damp box should be constructed. One is easily made from 1-by-6-inch pine stock for the sides and ¼-inch plywood or pressed board for the bottom. Line the box with vinyl or sheet plastic, leaving enough plastic to fold over and wrap completely around the stack of paper. Put the paper in the box, dampen every other sheet with a wet sponge, and cover the stack with the plastic. Place a plywood sheet on the bundle and a weight on top. After 10 to 12 hours the moisture should have permeated each sheet evenly. A little experimenting will tell you how much water is enough for each type of paper you use. Do not leave paper in the damp box too long or mildew will form.

For work that requires more than one run through the press, usually multicolor impressions, the disadvantages of dampened paper become annoying. Paper stretches when wet and then shrinks back again when dry. The problem is to wet each sheet to precisely the same degree of dampness when printing subsequent colors. In most cases it is easier and more accurate to print on dry paper. Even dry paper is stretched when it goes through the press because of the pressure from the scraper bar, but damp paper gives more trouble than dry.

LITHOGRAPHIC INK

Each printing technique has its own set of requirements for ink, and lithographic inks are manufactured to meet the specific demands involved in producing beautiful lithographs. The ink must, of course, be greasy, and the amount of grease can be varied by the addition of certain modifiers. The ink should have the right amount of tack or stickiness for the image to print crisply and sharply from the stone or plate. The ink should also have enough length or pull, but not so much that it overinks each minute grain. The proper length of ink for hand lithography is about 2 inches. To achieve this, first test the length of the ink after taking it from the can with an ink or putty knife. Place the ink on a corner of the inking slab and mix it with the knife for a minute or two to loosen it. Lift some ink on the knife and see how long a string is formed. It should break at about 2 inches for the proper length for hand lithography. Add magnesium car-

REINER SCHWARZ
Der Apparat
Color lithograph, 12¼″ × 9½″
Courtesy Associated American Artists Gallery

DAMP BOX FOR PAPER

weight

¾″ Plywood top covered with vinyl

cut top smaller than box

1″ x 6″ wood sides plywood bottom covered with vinyl

bonate to make long ink shorter, but not more than one-third of the total volume of ink. Heavy varnish no. 5 or 7 and body gum may also shorten the ink.

Because the initial inking of a stone or plate is vital to the establishment of a secure grease foundation for the image, the first ink used is roll-up ink, which is rich in fatty molecules. The greasy characteristic of ink comes mainly from linseed oil varnish, which is the vehicle that carries the pigment in the ink. Pigment is usually not greasy by itself, and the varnish and other additives in the ink must provide this essential quality. Roll-up ink is sold by many suppliers and makers, including Graphic Chemical, Sinclair & Valentine, Charbonnel, General Printing Ink, Rembrandt Graphic Arts, Daniel Smith, and Handschy Ink and Chemical.

For printing editions, an ink with somewhat less grease content is used because the very greasy ink has a tendency to cause scumming and filling during long runs. Crayon black is usually a good choice for this purpose, as well as some specially formulated inks for edition printing. Charbonnel Noir Velour and Dan Smith Velvet Black AC-63 are formulated for edition printing.

Transfer ink is used to transfer an image from one plate or stone to another. Other inks can sometimes be used for this purpose, but a couple are made especially for transferring. The density and character of the image will control the transfer. Try Sinclair & Valentine's Stiff Transfer Ink FL-61173 or Charbonnel Re-Transfer Ink.

Inks can be adjusted or intermixed to gain the desired qualities of tack, shortness, or drying speed. Additives include the following:

Linseed oil varnishes: from no. 00 (very loose) to no. 7 (thick); no. 8 (very thick) is called body gum. Thin oils reduce tack; heavy oils increase tack.

Magnesium carbonate: to stiffen and shorten ink.

Alumina hydrate: a transparent extender.

Setswell Reducing Compound: a tack reducer made from soy oil that controls gloss and shine when printing one color on top of another.

Cobalt and manganese driers: to shorten drying time; use sparingly.

Reducing oil: to thin ink without increasing greasiness.

Petroleum jelly: to reduce tack without increasing greasiness.

Transparent base (transparent white): to add transparency, particularly to colors.

Eugenol (oil of cloves): to lengthen drying time.

Flash oil: a petroleum-based oil that decreases tack in ink; better for stones than for metal plates.

Printing the Lithograph

The stone or plate will reveal its image only through proper printing procedures. A poorly printed drawing or design tells you nothing about what corrections or additions are necessary and is a waste of time, effort, and money. All the necessary steps must be taken to prepare for the most accurate proof that can be obtained.

MATERIALS

Litho press with scraper bar, tympan sheet, backing sheet, flat slab for plates

Tympan lubricant

Inking slab

Roller (leather or equivalent)

Litho ink

Spatula or putty knife

Varnishes of various types (or other additives as needed)

Magnesium carbonate

Paper (newsprint or proof paper)

Edition paper

Damp box for paper, if necessary

2 water bowls, with extra clean water in a container

2 sponges (one for water, one for wash-out)

Rags or wipes

Lithotine

Asphaltum

Rosin

Talc

Cotton

Gum arabic 14B

Nitric acid with containers

PROOFING THE LITHOGRAPH

Position the stone or plate on the press. The arrangement of the inking slab, press, paper table, and worktable should make it easy to complete the task without unnecessary effort. Paper should be at hand and dampened in advance if this is considered desirable. The ink (a stiff roll-up ink is a good choice for first proofs) should be mixed and placed on the ink slab. The roller can then be charged with ink.

1 Because the stone or plate has been stored with a film of ink or asphaltum protecting the image areas, wash out the ink film with lithotine and a rag or wipe. Let the solvent dry. Rub up the image anew with ink. Then wash the stone with the wash-out sponge and water.

2 Dampen the stone evenly with the clean sponge and water. An assistant is helpful for this operation because the stone must be kept damp throughout the printing.

3 Ink the stone with the roller until the image seems to be at its proper strength. Use different directions for the roller passes (see page 224). Make sure that the stone or plate does not dry out during this process.

4 Place a sheet of paper (newsprint, index, or other inexpensive stock) on the stone. Once it has touched the surface, do not move it or the image will be blurred.

Ink is removed from Richard Haas's *Dallas Skyline* with a rag and lithotine by Ed Archie at Solo Press in New York City.

The black stone of Haas's lithograph is sponged with water by Jon McCafferty.

Haas's lithograph is inked by Ed Archie with a leather roller at Solo Press.

RICHARD HAAS
Dallas Skyline, **1989**
Color lithograph (stone and plate), 29½" × 32"
Published by Solo Press Inc.
Printers: Judith Solodkin and Jon McCafferty

5 Put the backing sheet (a clean blotter is good) on the paper. Put the tympan on top of the backing sheet.

6 Move the press bed so that the scraper bar is on top of the leading margin of the stone, then engage the pressure lever to bring the two together.

7 Grease the tympan and run the stone through the press.

8 Disengage the pressure lever and bring the press bed back to its original position.

9 Lift the tympan and the backing sheet and carefully pull the proof paper from

the stone or plate. This is the first proof. If it is too light, as is usually the case, continue the process of inking and printing until the image comes up to strength. Bring up the image slowly. Overinking can cause it to fill in.

If the image prints satisfactorily, the edition can be completed. This is rarely the case, however. Most lithographic images need some corrective work to develop their full esthetic potential. There are several methods of altering the image, and they require somewhat different techniques.

DELETING AREAS FROM A STONE

To delete areas on a stone, you can scrape or abrade the grease to lessen or eliminate the tone, using razor blades, an etching scraper, or X-Acto knives. The image should first be inked, then dusted with rosin and talc, then sponged with clean water to clarify the drawing. Then the drawing can be scraped or

scratched to remove the greasy ink where it interferes with the artistic success of the image. Do not scrape so deeply that you create channels or gouges in the stone that can later cause problems by filling in with ink and printing as black lines.

Areas that are to be lightened can be modeled by the scraping method; blacks can be made gray, and grays can be made white. Use sharp tools and do not dig into the stone. Snake slips and scotch hones can be used to clean borders and smudges, reduce values, and delete areas. The snake slips can be used wet to make somewhat softer, less sharp deletions than those made by blades and knives. Since all these corrections are made by removing stone particles as well as greasy ink, the areas involved do not accept reworking or additions with the same sensitivity as the original surface, although some reworking can be done if the stone is counteretched to sensitize it to new deposits of grease.

If the image has been improved enough by the corrections to justify continuing to print, the areas that have been scraped or deleted must be spot-etched to

The edges of the drawing may be straightened by using a snake slip—an abrasive stone—against a straightedge.

On this aluminum plate by Leon Golub for the French Bicentennial, Judith Solodkin is deleting an unwanted tone.

Golub's print is inked by Ed Archie and sponged by Jon McCafferty at Solo Press.

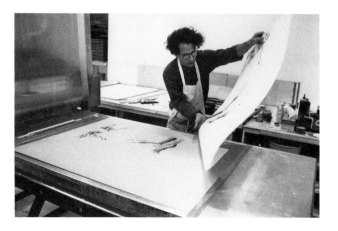

Golub's print is pulled by Arnold Brooks at Solo Press.

desensitize them and make continued printing feasible. Use a moderately strong etch (20 drops of nitric to 1 ounce of gum arabic) for about 2 minutes. Then remove the etch with a sponge, gum the entire stone, and buff it dry. Wash out the ink with lithotine and roll up the image and continue to print.

DELETING AREAS FROM METAL PLATES

While it is possible to remove lines or tones on aluminum or zinc plates by scraping, scratching, and needling, you must remember that the grain on metal plates is only on the surface and the material is not porous like limestone. Scratching or abrading the surface makes it difficult to add new work on top of the correction, and therefore these methods should be used sparingly. If large areas must be removed, it is better to use turpentine, gasoline, or a proprietary plate cleaner. Follow with several applications of lacquer thinner or lacquer "C" solvent to completely remove the greasy image from the plate. You can remove small areas with a Weldon Roberts Retouch Transfer Stick (Brightboy). It is not as abrasive as scotch hone, which removes work quickly but also quickly changes the grain structure of the plate.

Work can be removed from metal plates after proofing by using sodium hydroxide (household lye) on zinc plates, and sulfuric acid on aluminum plates. Both these chemicals are highly toxic and extremely corrosive and should be used carefully; wear rubber gloves and aprons for protection. After the solution has remained on the plate for several minutes, remove it with a sponge and water. Rinse under running water, being careful to avoid drips and splashes. Wash the plate with clean water, dry, dust with talc, and spot-etch with gum arabic solution.

ADDING WORK TO STONE

After the deletions are completed, new drawing can be added to the surface of the stone after it is counteretched. This is done with the stone fully inked, then dusted with rosin and talc. The counteretch solution consists of glacial acetic acid (10 percent) and water (90 percent). It can be brushed on the area that needs reworking, left for several minutes, and then removed with a small sponge and water. A saturated solution of powdered

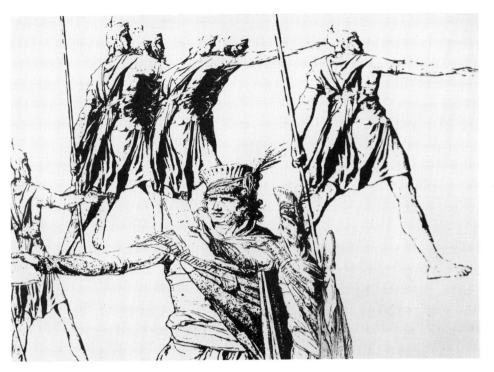

LEON GOLUB
Commemorative Lithograph for the French Bicentennial, 1989
Color lithograph (distorted photographs on Mylar films), 29½" × 41"
Published by Centre National des Arts Plastiques
Printed at Solo Press by Arnold Brooks and Jon McCafferty

potassium alum can also be used as a counteretch. The following procedure is recommended:

1 Ink the stone and dust with rosin and talc. Remove any excess powder.

2 Apply the counteretch with a brush to areas that need new work; leave on for 2 to 3 minutes.

3 Remove the counteretch with a small sponge or blotters. Rinse with water and fan dry.

4 Add the new drawing with crayon, tusche, or other lithographic techniques.

5 Dust the new work with rosin and talc and brush on a weak acid etch (4 drops nitric acid to 1 ounce of gum arabic) for 2 minutes. Remove with blotters or a sponge. Delicate work might require only gum arabic with no nitric acid.

6 Coat the entire stone with a thin film of gum, wipe down with a pad, and fan

dry. The stone can now be washed out, rubbed up, rerolled with ink, and printed, or it can be stored.

ADDING WORK TO METAL PLATES

Zinc and aluminum plates must also be counteretched before new work can be added to the image. Zinc is counteretched with a solution of 10 drops of nitric acid in 3 ounces of water. Another formula that can be used is a 6 percent solution of glacial acetic acid in water. The solution is brushed on the area to be reworked and allowed to stand for 3 minutes before being blotted dry.

Aluminum is counteretched with the following formula:

1 ounce hydrofluoric acid

1 ounce ammonium alum

Water to make 1 gallon

Apply this the same way as for counteretching ink.

After a zinc or aluminum plate has been reworked, with the corrective imagery added in crayon, tusche, or another greasy material, the plate must be either spot-etched with gum arabic solution, as before, or entirely etched. Normally,

crayon work or delicate tonality requires only a weak etch, while tusche or a heavy grease addition may need a much stronger etch. In any case, the etch is dried, washed off with water, then gummed, and the plate is either stored or washed out with lithotine, inked up, and printed.

PRINTING THE EDITION

After a proof is pulled that shows the desired esthetic results—the proper values, forms, and textures of the image—the size of the edition should be determined. The print that best shows the artist's intentions is called the printer's proof (in French, the *bon à tirer* or BAT). This is used as the guide to edition printing and is usually kept nearby for comparison as the edition is pulled.

The actual inking of the roller from the slab to the image is done by the printer, and the manipulation of the roller is important in ensuring an even film of ink on the image areas. The roller should be pushed out to the back part of the ink slab with steady pressure, returned to the near part of the slab, then lifted and given a quarter turn so that, when it is returned to the slab, a new part of the roller encounters the surface with each pass. Slow rolling tends to deposit more ink; snappy rolling picks up ink. Roll at varying angles on the stone in order to distribute the ink as evenly as possible (see page 224). In the printing process it is helpful if an assistant is available to dampen the plate or stone and handle the paper as it goes on and off the printing surface.

Continuous printing can cause the water film to work its way into the ink and emulsify it, causing it to become rubbery and gummy. Remove the old ink from the roller and slab and replace it with fresh ink. Another problem that can occur is scumming, which is noticeable in the nonimage or white areas of the stone or plate, where tiny particles of ink adhere to the surface. Often a renewal of the gum film is enough to control this. To clean a stone, use a fountain solution (very watery gum arabic) with a few drops of phosphoric acid added; soak a cloth pad and clean the

After a correction has been made on an "open" stone at the Atelier Desjobert, it is regummed before printing resumes.

ROLLER PATTERNS FOR INKING LITHO STONES

areas that are troublesome. To clean scumming from metal plates (quite common with zinc), use a fountain solution of a few drops of ammonium phosphate in a very watery solution of gum arabic. If the scumming continues, it may be necessary to use the fountain solution instead of the dampening water for each printing. This constitutes a very mild etch and should be used only until the scumming is cleaned because it can eventually burn out any very delicate work in the image.

Color Lithography

Because the lithographic process permits the combining of complex modeling effects with clean, strong color areas, artists have chosen color lithography for some of their most profound and expressive images. The results are so attractive that many artists are willing to master the registration and printing methods that are essential for success.

PREPARATORY DRAWINGS

Some artists find it difficult to make the various separate plates that are necessary for a color drawing or painting to be transformed into a print. Producing these plates is vital, yet it seems so methodical and tedious a task to some that it stifles their creative spirit. It does take an organized analytical mind to plan and execute the different plates, with the requisite drawing, etching, inking, printing, registering, correcting, and editioning before the initial idea can be seen as conceived.

Preliminary drawings or paintings can be made in pastel, watercolor, acrylic, oil, pencil, or collage. An experienced artist will limit colors to the minimum necessary to express the esthetic intention of the work. Five or six colors, when printed and overprinted, can yield dozens of variations. On the other hand, some textures or effects are better achieved by other techniques, and if the cost in time, effort, and money seems reasonable, then a more elaborate or complicated print might need not only lithography but relief techniques, intaglio methods, collage, or screen printing to properly convey the artistic message.

The color sketch must be analyzed for the separation of colors, with the pos-

sibility of secondary and tertiary hues coming from overprinted areas. Decisions must be made about the creation of a key block, which will carry the heart of the image, and about the colors each plate must accumulate to make the image meaningful. Tracings on vellum or offsets on Mylar can carry the image on the first stone through to the next stone. It may be necessary to draw each color on separate sheets of tracing paper.

COLOR INKS

The pigments used in making color inks in litho printing have changed greatly. Years ago earth colors were used, although they were hard to grind smooth and their coarse pigmentation caused wear on the stones and the rollers. The blacks used in early days were made from charred vegetable matter and produced coarse pigment with low tinting strength. Today carbon blacks are made from oil or natural gas, are very dense and black, and cause no excess wear on stones or plates. Color inks are also often organic in formulation as in azo yellow and red, benzidine yellow, diarylide yellow, dioxazine purple, phthalocyanine blue and green, quinacridone red and violet, or rhodamine red and purple.

Some inks are made for offset lithography printers, by far the largest consumers of printing inks in the world, but they are longer than needed in hand lithography. The offset inks made without driers are suitable for artists' lithographs if they are shortened with magnesium carbonate or heavy varnish (no. 5 or 7). If you use commercial offset inks you may also have to add oil of cloves (eugenol) or castor oil as drying retarders. Some companies, however, still make ink specifically for hand lithography, including Hanco Master Palette Inks by Handschy Ink and Chemical, Graphic Chemical lithographic inks, Daniel Smith lithographic inks, and Sinclair & Valentine inks.

When mixing colors, you need to have a number of ink knives handy so that each can of color has its own knife; otherwise you will either spend lots of time cleaning knives or your color will become contaminated by the other inks on the slab. The best knives are somewhat stiff putty knives about 2 inches

A French power-driven flat-bed litho press at the Bank Street Atelier. Note the inking-distribution rollers necessary to provide thorough, even inking in one pass.

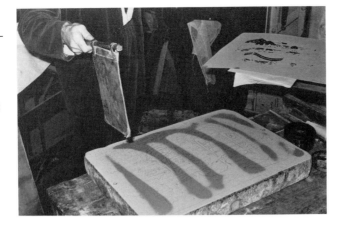

Drying a stone with a fan at the Atelier Desjobert. In the background is a zinc plate that has been prepared as a color plate for the stone.

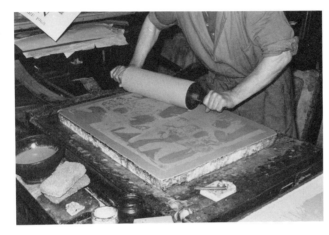

Rolling up a color stone with a composition roller at the Atelier Desjobert.

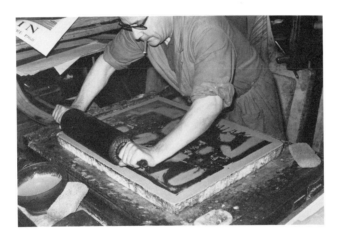

Rolling up a stone with a leather roller to bring up the black at the Atelier Desjobert.

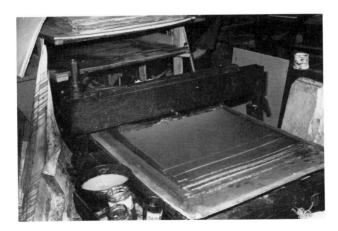

This is a typical French press from the Atelier Desjobert. The stone is pulled under the scraper bar with the lubricated tympan sheet aiding the sliding movement.

wide, although thinner, more flexible palette knives are convenient for mixing inks. Inks should be placed on the slab with several strokes of the wide putty knife, and all lumps and excess color smoothed out in order to speed the even distribution of the ink film on the roller. When mixing colors for edition printing, be sure to mix enough to complete the printing. It is both difficult and time-consuming to match a color that runs out before you are finished.

Transparent white or transparent tint base can be added to colors to make them more transparent so that previously printed colors will show through. Opaque white will reduce the value of a color and make a tint, but often a little white added to a strong dark color brings out the intensity of the hue.

In general, color inks are looser and less viscous than black and need the addition of magnesium carbonate to thicken them and increase their tack. Heavy varnish can also help to do this. Be careful and do not overload the ink with these additives, as the ink may become gritty from magnesium or sticky from varnish. Setswell Reducing Compound keeps ink wet longer and allows better merging of a color area printed on top of another color. It slows the drying of the ink film.

When cleaning up, use rags instead of paper towels and use kerosene on the rollers. Mineral spirits can be used to clean slabs and knives. A final wiping with alcohol on a rag will polish the slab nicely. Do not use alcohol on rollers.

For a color edition the paper is usually kept dry during printing, to avoid the stretching and shrinking that occur when paper is dampened. Some delicate tusche washes are lost on dry paper, however, so if you have a complex image with subtle tonality, print this stone or plate first, then dry the paper under blotters before proceeding with the next color printing.

COLOR REGISTRATION

To make a color lithograph, two basic factors must be considered:

1 The stones or plates must be drawn so that each separate color will print in correct juxtaposition to the others.

2 The prints that are pulled from these stones or plates must maintain this correct register throughout the printing process.

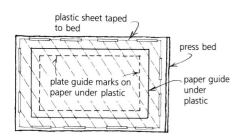

REGISTER GUIDE FOR PRINTING PLATES

guide marks

GUIDE MARKS FOR PAPER

A number of systems have been devised to accommodate these requirements, and the following are some of the most widely used.

Tracing paper master On heavy vellum tracing paper, make an accurate line tracing of your image, either with a sharp pencil or pen and ink. Make a separate sheet to use as a carbon paper, but use pastel or colored chalk instead of typewriter carbon, which may be greasy. The pastel should be smoothed to an even coat with your hand or with cotton. Make the tracing large enough to include corner guide marks for your edition paper, which will contain margins if desired. Now place the traced drawings face down on top of the receptive stone or plate and tape it in position with masking or drafting tape. Slip the pastel carbon sheet, pigmented side against the stone, under your tracing. With a no. 3 or 4 pencil, trace the image onto the stone, lifting the sheets occasionally to check that the lines are transferring adequately. This master tracing can be used to place the basic drawing on each stone or plate and should be carefully preserved. The edges can be reinforced with Scotch Magic tape to protect them from tearing.

One of the disadvantages of this method is that humidity causes the paper to stretch slightly, making very precise registration difficult to achieve. Also, the actual tracing of each transfer drawing can vary slightly, further diluting the accuracy of the register. However, the simplicity of the method makes it suitable for bold color areas that do not require pinpoint registration.

Corner guide register When printing stones, you can use corner guide marks on the stones to position the paper to each color. The corner guide marks are drawn with a lead or brass marker or with waterproof India ink. When print-

ing, first fit the paper, which should have straight edges, into the corner angle and then align the edge of the sheet with the line marked on the bottom right side.

Corner marks for plate and paper When printing from an aluminum or zinc plate, you can cover the press bed with clean paper (use a sturdy sheet, not newsprint) taped down to prevent slippage. The edition paper can be placed on this covering sheet temporarily and the edges marked with pencil. Remove the edition paper and position the plate so that the desired margins are obtained. Mark the edges of the plate with India ink or a hard pencil. Now you have a guide for both plate and paper on the same sheet.

This method assumes that you have aligned all the plates and stone with a system such as the tracing paper master guide, which controls margins and register when the separate images are drawn.

Solvent wash-out method This method makes use of one of the simplest ways to register proofs—with hat pins or needles set firmly into two wooden handles. In the margins of your first stone or plate, draw two small crosses, well away from the image area. Ink the stone full strength and pull a proof, including the register crosses, on smooth paper. Place this proof face down on your new stone and run it through the press. The inked proof will transfer the image to the new stone. Wash the stone with a gasoline-soaked rag. (Be careful—this is a flammable and hazardous procedure.) The ink will be removed but will leave a faint stain on the stone that can be used as a guide for the second color. Now you can finish the second color image in correct juxtaposition to the first. If there is to be more than one color, you can transfer each image onto the succeeding stones, in sequence, to place them in position as they are finished.

To pull the proofs in register, take a proof of the first stone on your paper. Puncture holes in the center of the register crosses, turn the sheet over, and place needles through the holes. Hold the paper with needles in place (a large stone may require two people) and position it over, but not touching, the next stone (which, of course, must be prepared and inked with the correct color). Keep the paper away from the surface of the image until you can place the needles into the register crosses on the second stone. Then let the taut paper slide down the needles until it touches the stone, in register and ready for printing. When printing the edition, you must print all the prints with the first-color stone at the same time, then proceed to the second stone and print all the prints, then the third, and so on.

The needles will wear fine holes into the second, third, and each succeeding stone. It may be necessary to start the holes with a very fine drill. Eventually the holes are removed when the stones are reground.

The gasoline wash-out method has been used for years in the atelier of Edmond and Jacques Desjobert in Paris. Gasoline is so hazardous, though, that it is not recommended for general use. Lacquer thinner can be used instead, which is not quite so flammable but is nevertheless quite dangerous because of its toxic fumes, which necessitate local exhaust ventilation, gloves, and very careful handling.

Aperture register If you want to avoid the needle method, you might prefer to cut a small triangle out of the paper where the register crosses overlap. Use a sharp razor blade. Since each piece of paper in the edition must be cut, keep the crosses well away from the image so that they will not show when the print is matted. With the triangles cut out, you can see the register marks on the second stone and line them up by sight. Because of the recent trend of showing the entire sheet of paper as part of the total image, this method is rarely used today.

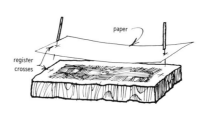

PINHOLE REGISTER FOR LITHO STONES

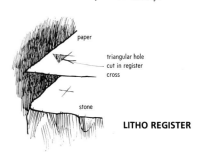

paper

triangular hole
cut in register
cross

stone

LITHO REGISTER

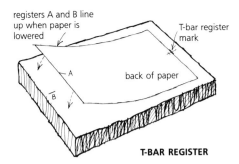

registers A and B line up when paper is lowered

T-bar register mark

back of paper

A

B

T-BAR REGISTER

Another variation of the aperture register method is to punch a hole through the center of the register crosses in the edition paper with a paper punch. This enables you to sight through the round aperture in the paper and line up the register crosses on the stone or plate. Again, this method requires that the holes in the paper be trimmed off or covered with an appropriate mat.

Center mark register (T-bar method) In this system, T-shaped register marks are placed on the stone or plate to align with the edges of the paper. The paper is marked on the back with short, fine center lines on the short sides of the sheet. A T mark is made at the center of each short side of the plate, with the cross bar aligning with the edge of the paper. The center line on the paper must align with the stem of the T, and the edge of the paper with the cross bar (see drawing). The sheet is lowered until the line on each side of the paper lines up with its corresponding T on the plate.

This system requires that all the im-

ages on the stones be properly aligned with their register marks. The register crosses can be scratched lightly into the stone or metal or can be marked with a lead or brass marker (or any nongreasy means that will not wash out with water). The marks on the back of the paper sheets must all be made before printing starts, with each line properly centered on the paper edge.

Transparent overlay When editions require close registration of color plates, it may help to use transparent Mylar sheets to align the colors. After the first color plate has been editioned, a proof of the second color is taken on a sheet of Mylar, a material with good dimensional stability. The ink is dusted with talc and cotton to prevent smearing. The register marks of the plate are also transferred at this time by pen and ink or scratching.

Each impression of the first color is slid underneath the Mylar proof of the second color to check its alignment. If you are using the center mark register system, the T mark can be checked or changed to align properly with the image on the transparent overlay. Each succeeding color can be checked this way. This method works particularly well when a decision is made to add color to a printed black-and-white edition, even though there was no plan for color when the image was first conceived.

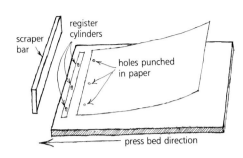

scraper bar

register cylinders

holes punched in paper

press bed direction

PUNCHED-HOLE REGISTER

Punched-hole registration The most accurate registration system employs a device that punches a series of holes through the metal plate and paper at the leading edge of the plate. Flat-bed offset presses frequently use this method to achieve very precise register. Metal cylinders project up through the paper and hold it with no slippage, allowing very precise alignment from plate to plate. The disadvantage is that the paper and the plate must be large enough to clear the press scraper. If stones are being used, each stone must be long enough to ensure that the register cylinders clear the scraper and tympan. The cylinders are cemented to the stone with special adhesive and serve to pull the paper through the press when printing occurs.

ADDITIONAL LITHOGRAPHIC METHODS

Artists' exploration of new imagery and their search for methods of producing work more efficiently have led to the development of special techniques, as well as the revival of more traditional techniques.

Tone Reversals

There are several ways to reverse black areas to white and white to black. If there is any possibility that the original image will be needed at a later date, it is prudent to transfer it to another stone or plate, in case the image is weakened or damaged during the reversal process. Pull enough impressions from the original image before starting the procedure.

SHELLAC METHOD

The shellac method has been in use for many years, but the quality of contemporary shellac has been declining. It is now sold in 3-pound cut (3 pounds of shellac to a gallon of denatured alcohol), which is much thinner than previous solutions.

Materials In addition to standard materials, such as counteretch solution, tusche, ink, and the like, you will need:

Shellac (white or orange)

Denatured alcohol

Tray (to catch excess shellac)

Gasoline

Cotton balls or wipes

Procedure

1 Roll up the stone completely with black roll-up ink. Do not rosin or talc the image.

2 Resensitize the stone with a counteretch of acetic acid to open the undrawn areas of the surface. Wash with water and let dry.

3 To keep the margins clean and white, protect them with tusche, strips of Contact paper, or petroleum jelly.

4 Flood a dilute solution of shellac and alcohol (1 part shellac to 1 part alcohol) over the stone from top to bottom. Do this by tilting the stone at a 20- or 30-degree angle and resting the bottom edge in a tray to collect the runoff. The objec-

tive is to place a thin, even film of shellac over the stone. Some lithographers use a wide soft brush to apply the shellac, but it dries so quickly that it is not easy to obtain an even coat this way.

5 After a few minutes the shellac will dry on the open areas of the stone, but it will still be tacky over the image areas, where the fresh ink slows the drying time. Now wash out the image with gasoline on a rag, wiping cloth, or cotton pad. Do this carefully, as it is the critical step in the process. The shellac will bond to the dry, clean stone as it is removed from the image areas.

6 Etch the stone with a moderately strong etch (15 drops of nitric acid to 1 ounce of gum arabic). This should clean out the remainder of the image without harming the shellac-covered areas, which are acid-resistant.

7 Wash the etch out with water, and ink the dampened stone with a roller and roll-up ink. The ink will adhere to the shellac base, which will now be the positive, or black image, exactly the reverse of the original design. Process and print in the normal manner.

There are variations to this procedure, including the use of phenol (carbolic acid solution) mixed with gasoline, but this is such a toxic mixture that we do not recommend it.

GUM ARABIC REVERSAL

This method is simple in principle but must be carefully executed to work properly. It requires a separate stone or plate to hold the reversed image, which means that the original version can be saved and reprinted later.

Materials In addition to standard lithographic supplies you need:

Fine-powdered gum arabic
Hard-finished smooth paper

Procedure

1 Pull a good proof of the original image on a sheet of smooth, hard-finished paper, such as plate-finished Bristol or Basingwerk heavy, using a stiff black ink. Dry the stone before printing so that dampness does not buckle the paper.

2 While the ink is still fresh and wet on the proof, dust it with finely ground gum arabic powder, which will adhere to the wet ink. Clean off all the excess powder with cotton, then lift and shake the paper to get rid of all loose gum specks, which will produce white spots on the image if not eliminated.

3 Dampen the clean stone, which should be in position on the press. Use more water than for printing but in an even film. This is the key element in the procedure. The dampness should be enough to cause the gum powder to adhere to the plate but not to dissolve it or cause it to run. Place the powdered proof on top of the dampened stone and run through the press with slightly lighter than normal pressure.

4 The gum arabic should now be transferred to the new stone. Remove the paper, dry the stone thoroughly, protect the margins with gum, and fan dry.

5 Roll the surface of the stone with greasy roll-up ink to establish the new image.

6 Wash out the stone with lithotine, using a dry rag or wiping cloth. The stone can now be processed in the usual manner; gummed up, washed out, and rolled up. A second etch may be needed to secure the image to the stone.

Note that the image will be reversed on the second stone and in its original version on the first one. This method also works on metal plates.

White Line Engravings

Although you cannot achieve the same quality of line as in a copper engraving, engraving white lines on stone is much easier and faster than traditional engraving with a burin on a copper plate. This method fell out of favor in the twentieth century, but it was widely used in the nineteenth century for delicate linear work, which was less expensive to produce than with intaglio printing.

Smooth-finished gray limestone is the best surface on which to draw or scratch a design. The stone should be grained with fine Carborundum, and then a moderate etch (15 drops of nitric to 1 ounce of gum arabic) rubbed into the surface. While it is still wet, dust some powdered pigment (black or red oxide)

onto the surface and buff smooth to color the stone. This will make the engraved lines visible.

The engraving can be accomplished with needles, scrapers, burins, or any pointed tool that produces the desired line. Little pressure is needed because the stone offers much less resistance than copper or zinc. Complicated designs can be traced onto the stone with transfer paper made of pastel or Conté crayon. Lettering must be done in reverse unless the image is to be transferred to another stone, in which case the lettering can be done normally.

When the design is completely engraved, wash off the gum coating and dry the stone. The intaglio method is one way to print the image, by filling the incised lines with a short, stiff ink (etching or litho ink works well). Clean the surface with tarlatan, then polish with newsprint. Print on damp paper in a litho press using heavy pressure. A felt blanket is not necessary if the lines are not too deeply incised. Put a few blotters on top of the printing paper to help force it into the lines to pick out the ink.

The engraving can be printed as a relief block if the lines are not filled with greasy ink at any time. The surface of the stone should not be dampened. Rather, the ink should be rolled on a dry stone with a smooth roller (not a leather litho roller). Roll on a thin, even film of stiff ink so that the ink will stay out of the fine lines. Print on dry paper in a litho press using heavy pressure.

The same engraved plate can be printed as a lithograph. In this case the surface is dampened in the usual way and greasy ink is forced into the lines with a leather roller with good nap under firm pressure. Use dampened paper and put blotters under the tympan to force the paper into the incised lines. Print with heavy pressure on the scraper bar for best results.

White Lines on a Black Background

Draw on a sensitized stone or plate with a gum solution to which you have added some watercolor (any color but black; the color is added only so that you can see

what you are doing as you draw). Draw with a brush, pen, or stick dipped in the gum solution, or soak fabrics or other textured materials in the solution and apply them to the stone. The lines or textures will print as white after the process is completed. When the gum has dried, paint over the area with a heavy solution of tusche or litho ink dissolved in turps. The gummed areas will reject the greasy ink and can be washed out with water. The stone must be etched with a fairly strong etch, and the litho process followed as previously described.

Working on Heated Stones

A variety of gray tones can be achieved by working on heated stones, which will melt litho crayons into a fluid material that can be rubbed into the surface. Heat can be applied in a number of ways, with a sunlamp, an oven, a hotplate, or, if you are patient, even a blowtorch. The heat must be applied so slowly that the stone does not crack, which will happen if the outside of the stone gets too hot before the inside is sufficiently warm. Rub the litho crayon with a rag to smooth out the tone to the desired gray. When the stone has cooled, you can add dark lines or areas, or scrape light shapes into the gray background. Etch with fairly strong solutions because the heat dries the grease deep into the pores of the stone.

HEATING THE STONE FOR A DURABLE IMAGE

By melting rosin or asphaltum into the ink film on the stone, a very durable printing base can be established. First ink the stone with a full-strength roll-up of the image. Then dust the surface with powdered rosin or asphaltum and remove all the excess powder with several cleanings with cotton. With the conventional technique you use a blowtorch to melt the rosin and ink film together to form a tough bond on the stone, moving the blowtorch constantly to avoid overheating any one part of the stone. A safer method is to use the hot-air blower from a shrink-wrapping system to apply the heat. The blowers generate up to 500°F and are more than adequate to melt rosin and asphaltum. When the stone has cooled, use a strong etch on the image and print in the usual manner.

M. C. ESCHER
Waterfall, **1961**
Lithograph, 14¾" × 11⅝"
Courtesy Escher Foundation
Photo: Haags
Gemeentemuseum,
The Hague

Frottage Transfers

Freshly printed images from magazines, newspapers, brochures, books, or posters can be transferred to the surface of a sensitized stone or plate. The amount of grease in the ink is important, and old images with thoroughly dried ink do not transfer well. The procedure requires lacquer thinner or lighter fluid, both of which are highly toxic chemicals that should be used only with local exhaust ventilation. You must be able to judge precisely how much time to allow between the application of the solvent and the contact of the printed image to the stone or plate—a few seconds either way can make the difference between success and failure.

MATERIALS

Sensitized stone or plate

Newly printed images from magazines and the like

Clean, white, smooth blotters

Wide brush (3-, 4-, or 5-inch hake)

Lacquer thinner or lighter fluid

Litho or etching press or wooden spoon (for rubbing)

Newsprint

PROCEDURE

1 Place the printed magazine or newspaper image face down on a sensitized litho stone or plate.

2 With a wide brush, spread the lacquer thinner evenly over a piece of blotter just large enough to cover the back of the printed image. The amount of solvent is critical to the success of the process, and you must experiment to find out how much to use. Too much will flood and blur the image; too little will not transfer it.

3 Place the blotter on the back of the printed image. Immediately cover the blotter with more clean blotters or enough newsprint to absorb the excess solvent, making a small pack of protective sheets.

4 Run through a litho or etching press with moderate pressure. You may also hand-burnish the back of the blotter pack with a wooden spoon such as a Japanese rice spoon or a cooking spoon. This will leave streaks in the image, which must be considered part of the esthetic effect.

5 The solvent will soften the printed image enough to transfer it to the plate or stone. Experiment to find the right combination of solvent, time, and pressure to properly execute this procedure.

6 The solvent evaporates in seconds. Etch the image promptly with gum arabic only because the grease content is so weak. Roll up with soft ink sparingly applied to the roller, to increase the grease strength. The second etch should also be a weak one, with only a few drops of acid to an ounce of gum. Otherwise, proceed normally.

Photolithography on Positive Plates

The development of positive lithographic plates, mainly in England, has made it possible to print lithographs in a way that is just beginning to be explored. The image is drawn or otherwise placed on a sheet of translucent plastic such as Mylar, and this plastic sheet becomes a positive transparency. It is placed on top of a photosensitive aluminum plate, and an ultraviolet light is used to expose, or burn, the image into the emulsion on the plate. The image is developed with an appropriate liquid developer, and the plate is washed, gummed, and printed. This process has been used with great success by Mauro Guiffreda of the American Atelier and Circle Gallery in

New York and by Mel Hunter of North Star Atelier in Vermont, who developed the technique through thousands of editions in black and white and in color.

The process has several important advantages. The plastic sheets that carry the image are lightweight, dimensionally stable, and either translucent or transparent, which enables the artist to register successive sheets by placing them on top of each other. The sensitivity of the plate is such that the most delicate pencil drawing can be captured on it. Systems of registration have been developed that are accurate enough to print four-color process plates. In addition, many of the toxic chemicals necessary in stone and conventional plate lithography are eliminated, including nitric, oxalic, hydrofluoric, carbolic, acetic, and tannic acids, as well as lacquer thinner, ether, xylene, and xylol. Not that the Mylar methods are totally harmless, but in general the danger of toxicity is much less than with conventional techniques.

TRANSLUCENT POSITIVES

Although a drawing can be made on any sheet that light can pass through, such as tracing paper, tracing vellum, vinyl, clear or frosted acetate, Plexiglas, Lucite, or Lexan, there are certain materials that are particularly suitable for the technique. The best is Mylar, a DuPont product that is used as a drafting film and as a base for photographic film emulsions. It is dimensionally stable and is made in several thicknesses and with several finishes, from clear to matte. Another material that is suitable is Kronar, a clear sheet that can accept some work from pencils like Stabilo or china markers as well as some airbrushing from water-based sprays. Textured wash effects work best on a clear plastic like Kronar. Stabilene is a Mylar-based clear material with color coatings that can be scraped, scratched, or dissolved away, leaving open areas of clear film that can transmit light and thereby expose the photo-sensitive printing plate underneath. Polypropylene and other plastic sheets are available with different-grained surfaces from N. Teitelbaum in New York, Cadillac Plastics in California, or Charrette in Massachusetts.

MICHAEL KNIGIN
Day Command, **1980**
Lithograph (drawn on Mylar), 33″ × 23¾″
Courtesy of the artist

ODILON REDON
Cyclops, **1883**
Lithograph, 21⁷⁄₁₆″ × 13⁷⁄₈″
Collection, The Museum of Modern Art,
New York
Gift of Victor S. Riesenfeld

Another material that can be used as a base for drawing is glass. It can be used in its smooth, polished state, or it can be grained like a lithographic stone with Carborundum powder. The surface can be made to have a texture similar to limestone, with the Carborundum, from 50 to 280 grit, leaving its roughness on the glass. The glass sheet, which should be ¼-inch-thick plate, is placed carefully on a bed of blotters or old towels soaked in water on a table that is solid enough to withstand the graining procedure. You can use a levigator or a small litho stone to do the actual grinding. Grind the glass in the same way as you would a stone, being careful not to crack it.

It will take a number of grindings, with regular washing of the slurry from the surface, to grain the glass surface evenly to the desired texture. Dry the glass and test a corner with a crayon or pencil to see if it is satisfactory. If not, continue to grain until the surface is suitable. Bevel the edges with a file or protect them with plastic tape. After you have drawn your image on the glass and made a successful plate from it, you can use the same glass over and over again by cleaning the drawing from the surface with solvents and detergents.

DRAWING MATERIALS

Many of the materials you can use to make the image are already familiar. These include the full range of graphite pencils from the hardest to the softest, with the middle and softer leads yielding the most expressive range of tones. Stabilo pencils, china-marking pencils, graphite sticks, litho crayons, Conté crayons, oil pastels, and many other artists' and draftsmen's pencils can be used. Inks and paints can be brushed, sprayed, or penned on the surface, including specially made graphic art ink such as Grumbacher, Speed-o-Paque, and Kodak opaque, as well as Pro-Black, Pel-

ikan ink, liquid tusche, watercolor and acrylic paints, alkyd paints, India ink, and the like. You can even use oil paint, but the time needed to dry the oil film on a plastic or glass sheet makes it impractical. It is a good idea to draw over a light table so that you can check the opacity of the drawing medium on the Mylar. You can clean up unwanted areas, smudges, or mistakes by using liquid cleaners such as bleach, spray cleanser (like Fantastic), ammonia, or alcohol, each of which has a specific action against certain paints or inks.

The making of a positive transparency need not be limited to hand-drawn techniques but can also be done with photographic methods, using a copy camera or an enlarger to capture photo images (see the chapter on photographic techniques). Printed images from newspapers and magazines can be transferred to the transparent sheets with lacquer thinner

or lighter fluid, as described earlier. You must be careful not to allow excess solvent to contact the plastic sheet, however, because some plastics can be dissolved or softened by lacquer thinner or lighter fluid.

EXPOSING THE PLATE

Several manufacturers make the plates that are essential to this method. These are deep-grain anodized-aluminum plates with a presensitized emulsion applied at the factory. One of the plates, the Alympic Gold plate made by Howson-Algraphy in England, is rated the "most responsive of them all" by Mel Hunter in *The New Lithography*. Another plate, also from England, is made by the Frank Horsell Company and is called the Horsell presensitized plate. When baked in an oven at 400°F for 6 to 7 minutes, these plates are said to be capable of yielding 1 million impressions. An American company makes the 3M Endura positive plate, which uses technology similar to that of the English manufacturers. Fuji and Polychrome also make positive plates, and Howson makes a less expensive plate called the Spartan. You must determine by experiment which one best suits your needs. Each of these plates uses a developer specifically made for it, based on an alkaline formula.

When the image is completed on the Mylar or other support, the plate is ready to be exposed or burned with an ultraviolet light. This light can come from a halide, pulsed-xenon, carbon-arc, fluorescent, or incandescent source, and the more powerful the ultraviolet rays, the quicker the exposure will be. More control is possible, however, with a light source that is not too strong since it will not expose the plate too quickly. It is helpful to use a vacuum frame to hold the plate and Mylar transparency immobile during exposure. The exposure time will range from 1 minute to 10 minutes depending on the blackness of the drawing, the strength of the light, and its distance from the plate. You must make a test strip from the image to determine the best exposure for it. If you don't have a vacuum frame, you might try placing the plate and Mylar drawing face to face on a flat table and putting a piece of clear glass on top to ensure close contact during exposure.

Develop the plate under a yellow safelight, using the recommended developer. Pour some developer onto a wiping pad to saturate it, then pour a small puddle onto the plate and quickly and evenly spread the liquid over the surface for 2 minutes. Squeegee the plate with a rubber window squeegee to remove all the excess developer and repeat the process, pouring more developer on the plate and spreading it with the pad. Rinse the plate with water, including the back and any other place the developer might have accumulated.

Before printing from the freshly developed plate, it must be gummed. (If you are just checking the exposure time on a test plate, it is not necessary to gum it.) If any spots, flaws, or hickeys appear on the plate, they should be removed with an image remover, usually a liquid but possibly a gel, which is applied to a dry plate with a brush or some cotton. Keep this chemical away from the rest of your plate because it is powerful and will attack all image areas. Wash carefully and thoroughly to remove all traces of it.

To gum the plate, use the proprietary product recommended for it. Mel Hunter uses Polychrome's plate gum on Polychrome plates and Howson's Kleergum on all the others. Pour a 4-inch-wide puddle of gum onto the wet plate and spread it quickly and evenly with a wiping pad or paper towels. Use a clean pad to buff the surface to a thin, even, tight coat and you are ready to print.

When printing from positive plates, much less water is used in comparison to gum. A wetting agent, even glycerin, can be added to make the water "wetter." The most ink is picked up when the plate is nearly dry.

REGISTRATION

For hand-press registration, the methods already discussed will prove accurate for printing most multicolor images. When precision of less than 1/64 inch (about 1/2 millimeter) is required, special register pins or cylinders about 1/4 inch in diameter can be used. These should be taped to the bed of the press and holes punched through the plate and through each sheet of paper to be printed. Of course, the scraper bar cannot touch these raised cylinder pins, and so the paper must be several inches longer than needed for the image alone. The excess can be trimmed off later.

In order to minimize the misregistration caused by the paper stretching as it passes under the pressure of the scraper bar, it is helpful to prestretch the paper, before it is printed. You can do this by placing the blank sheets face down onto the clean back of a litho plate and running them through the press two or three times. This will remove much of the tendency to stretch during the actual printing cycle.

PRINTING THE POSITIVE PLATE

The anodized-aluminum plates that you use are positive working plates—that is, the dark tones of the image on the translucent positive protect the polymer emulsion on the plate while the light weakens the emulsion, making it soluble in the alkaline developer. The nonimage areas are grease-repellent to a remarkable degree, whereas the image holds firmly to the ink-sensitive emulsion. After gumming, the plate is washed out with water and a clean sponge and, while damp, is inked with a roller, either of leather, polyurethane, or Buna rubber. The film of water deposited by the sponge must be thin and even. The roller should be large enough to cover the image with as few passes as possible. The ink film should be fine enough to capture all the details but strong enough to reveal the richest blacks in the image. If the ink is too thin, stiffen it with rice starch instead of magnesium carbonate, which can be abrasive and cause weakening of the emulsion. These plates can be printed well on flat-bed offset presses, such as Mailander, Steinmesse & Stollberg, or the equivalent.

ELIZABETH MURRAY
Down Dog, **1988**
9-color lithograph (16 printings from 14
aluminum plates and 2 aluminum plate collages),
41″ × 50¾″
Published by Universal Limited Art Editions, Inc.

Photolithography with Diazo Solutions

Although diazo wipe-on solutions are simple to apply, at least in principle, they are being displaced by the more accurate positive working plates just described. The diazo sensitizers have a relatively short shelf life of 90 days. They come in two parts that must be combined before use: a light-sensitive powder and distilled water containing a wetting agent. The mixture must then be quickly and thoroughly spread over the plate or stone and buffed down to a thin, even coat. The coating process is important because streaks are not visible until after the image is developed and then it is too late to correct the irregularity. Stones usually require two coats because of their absorbency.

The image is exposed onto the sensitized plate through a negative transparency, either in a vacuum frame or under a piece of glass, using a high-ultraviolet light. The light hardens the emulsion and forms the ink-receptive surface. When the developer is sponged over the surface of the exposed plate, it removes the sensitizer from the non-image area and coats the image portions with an ink-receptive lacquer base. A dye is included in the developer to make the image visible. After the developer is removed with water, the plate is ready to be gummed. The gum (called asphaltum gum etch or AGE) is poured over the plate, then buffed evenly over the surface and dried. It is washed off with water, and the plate is ready to be rolled with ink and printed.

Ammonium Bichromate Process

This method is rarely used by professional lithographers anymore, and the materials are becoming difficult to find. If stones are to be sensitized by this method they must be ground to a polished surface. The sensitizing solution consists of 4 level teaspoons of powdered albumin to 1 level teaspoon of ammonium bichromate, mixed with 8 ounces of water with 1 teaspoon of household ammonia added. This quantity of solution will prepare several plates or one large stone, which may require more solution because of its absorbency. The solution is poured on the stone or plate and wiped evenly over the surface. The coating may vary in thickness, which makes exposure difficult to control.

A transparent negative can be used to place the image on the sensitized stone or plate. To ensure good contact, place the transparency, emulsion side down, against the dried photo emulsion and weight it in position with a piece of glass. Exposure should be made with ultraviolet light. An alternate method of exposure uses a condenser photo enlarger, which projects the negative onto the sensitized surface—a procedure that takes longer because of the lower ultraviolet light in the normal enlarger bulb. The developing compound is made of lithotine and transfer ink or rub-up ink mixed to a creamy consistency. It is worked across the entire surface of the stone or plate to an even coat. After this has dried, the stone or plate is washed with water to remove all remnants of the sensitizing solution. The image is now ready for a weak etch and is prepared for proofing.

Ammonium bichromate is a toxic compound that should be handled with care and used only with local exhaust ventilation.

Gum Bichromate Process

This method produces a permanent image on the paper of your choice, such as Arches, Rives, Somerset, or BFK. The paper is first coated with acrylic gesso and left to dry. It is then sensitized with a solution of gum arabic and potassium or ammonium bichromate by coating it with a wide brush at room temperature. The solution can be tinted beforehand with watercolor or gouache pigment, such as phthalo blue, alizarin crimson, cadmium red, burnt umber, or Hansa yellow. The sensitized paper can be exposed through a transparent positive or negative with an ultraviolet light. The development is done with running tap water at a lukewarm temperature for as long as necessary to run clear, perhaps 15 minutes or so.

6 Dimensional Prints

Some aspect of depth or dimensionality has existed in the print from the very beginning of printmaking. The play of light on an embossed or sculpted surface is so appealing that many printmakers have tried to perfect methods that will enable them to exploit this quality. In the woodcut the surface is cut or gouged away in order to create the image on the block. This process creates depressions in the wood, and if plaster or paper pulp is allowed to harden on the block, then removed, the depth of the cut is readily apparent. In intaglio methods a metal plate (usually copper or zinc) is etched or incised in order to hold ink that will be printed onto damp paper on an etching press. If the ink is omitted and the plate printed anyway, the result will be an inkless embossing, with the lines raised from the surface of the paper. These techniques have been used for many years to achieve three-dimensional effects in finished prints.

In recent years the quest for increased dimensionality has resulted in prints that are difficult to distinguish from sculpture. The development of cast-paper methods and the increased interest in constructed prints have transformed the subtle contours of embossing into life-size figures, in full relief, or architectural images that barely fit into a room.

LOUISE NEVELSON
Night Sound, **1971**
Lead intaglio, 30″ × 25″
Printed by Sergio Tosi, Milan
Courtesy Pace Editions, New York
Photo: Ferdinand Boesch

ALAN SHIELDS
Color Radar Smile B, 1980

Etching, aquatint, linocut on multicolored TGL
handmade paper, 25″ × 25″
Printed and published by Tyler Graphics Ltd.
© copyright Alan Shields/Tyler Graphics Ltd. 1980
Photo: Steven Sloman

Early examples of dimensionality occur in eighteenth-century Japanese woodcuts in which the paper was embossed by being pressed into the recessed gouged areas of the block. Pressure was applied by either the hand or the elbow of the printer while the blocks were being printed. In Western art two early examples of inkless embossing are the nineteenth-century French prints *The Girl with a Violin* by Alexandre Charpentier and *Algae* by Pierre Roche.

In the twentieth century continuous experimentation by many artists has expanded the idea of dimensionality in the print. Pierre Courtin in France has produced deep engravings that are bas-reliefs cast in paper. The inkless embossings by Omar Rayo in the United States and Marjan Pogacnik in Yugoslavia and the inked prints by Rolf Nesch in Norway are all distinctive in the depth and texture of their impressions. In the 1960s and 1970s, Michael Ponce de Leon, Frank Stella, Charles Hilger, and Garner Tullis also made three-dimensional prints by an adroit use of cast paper.

So many methods are used to create three-dimensional prints that it has become very difficult to categorize them.

Virtually every process of printmaking has been exploited. Screen printing and lithography, because of their photographic capacities, are used to place images on plastic, metal, or cardboard surfaces. These materials can then be manipulated into structures or compositions with three-dimensional aspects. Vacuum forming can induce plastic styrene or vinyl to conform to a variety of shapes. Lead sheeting can be embossed into heavily contoured plates to receive images and textures. By folding, stapling, and sewing, constructions of preprinted paper can be made to assume almost any configuration.

Uninked Embossings

Almost any deeply bitten intaglio plate will produce an embossing that is quite legible if it is run through the press, uninked, into dampened paper. Since the paper must retain all the impressions and indentations, it should be heavy enough to stretch without tearing and should be permanent. The best choice for embossing is rag pulp, such as 300-pound Arches, Classico, or Murillo. Many artists put two or three sheets together when printing very deeply bitten plates, or special papers can be made to take extremely deep plates. Some artists, such as Michael Ponce de Leon, have special sheets handmade that are ¼ to ½ inch thick.

Although tremendous pressure can be obtained in an etching press, a few printmakers find it necessary to also hand-burnish the dampened paper into the plate to capture all the embossing. The paper must not be stapled or taped to a board, or the subsequent shrinking will pull out some of the embossing.

The prints should not be flattened under heavy weights for the same reason. Most embossed prints are dried in the open or under light blotters. They should be kept scrupulously clean because the slightest smear or mark will deface the image.

Frames for embossings should have fillets to keep the glass from touching the print. If mats are used, they should be of adequate thickness to protect the print from the glass. Most embossings look best when displayed with side lighting to bring out the shadows on one side of the image. Intense front lighting can obscure the dimensionality of the image.

Cast-Paper Prints

The popularity of papermaking has led to the growth of paper workshops throughout the country. To service the demand for raw materials, many suppliers will now ship buckets of prebeaten paper pulp or plastic bags full of beaten pulp. It is no longer necessary to have personal access to a Hollander beater when you can easily obtain paper pulp from so many sources. The pulp, usually made from cotton linters, flax, abaca, or sisal, can be used to make cast-paper impressions of three-dimensional molds or other matrixes.

Frank Stella made a series of cast-paper reliefs in 1975 at Ken Tyler's workshop, working with Kathleen and John Koller. He used molds made of brass wire and added color to the shaped sheets with dyes, watercolor, and casein while the sheet was wet and again after it was dry. Robert Rauschenberg, Ron Davis, Alan Shields, and others have used cast paper pulp to create new works, often coloring it with pigments and dyes.

To cast paper pulp from a deeply dimensional plate or an object with bas-relief characteristics, it may be necessary first to make a latex mold of a model. The model can be made from plaster, wood, plastic, clay, or some other sturdy material and should be sealed with silicone spray or several coats of polymer medium. When it is dry, brush on seven or eight coats of liquid latex. Cementex no. 80 and 70-A, formulated for mold making, are approximately two-thirds natural rubber latex. After about three coats, with time for drying between each

HELEN FRANKENTHALER
Gateway (front), 1988
Patinated bronze panels with etching, relief, aquatint, stencil on three sheets of TGL handmade paper, 7′ × 8′ × 9″, each sheet 69″ × 29½″
Produced and published by Tyler Graphics Ltd.
© copyright Helen Frankenthaler/Tyler Graphics Ltd. 1988
Photo: Steven Sloman
Verso of screen is hand-painted by artist on sand-blasted bronze panels with ammonium chloride, pigments, and dyes.

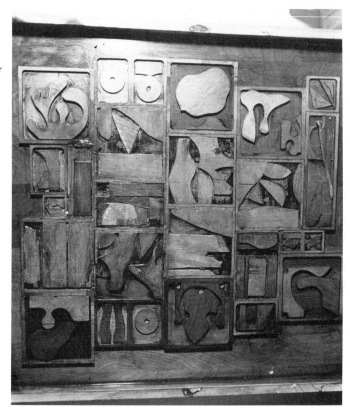

Collage of plywood and other wooden parts by Louise Nevelson for her cast-paper piece *Dawnscape*, 1975. A rubber mold was made from this matrix.

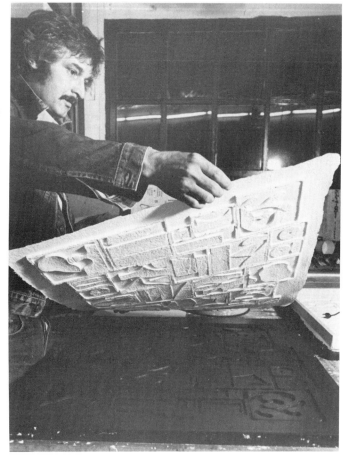

After the paper pulp was placed in the mold for Nevelson's *Dawnscape*, it was put aside for 24 hours to dry. In this photo Charles Hilger removes the paper from the mold at Garner Tullis' Institute for Experimental Printmaking in Santa Cruz, California.

coat, you can sprinkle sawdust between each succeeding coat to increase strength and bulk. You can use a hair dryer to speed up the drying time. The final drying should be for 2 days at room temperature or for 12 hours at 120° to 140°F for each ¼-inch thickness. The rubber should snap back instantly when a sharp point is pressed into it to test for a good cure.

The latex mold needs to be supported during the casting process, and so a plaster shell is usually built over the mold while it still surrounds the model. Remove the latex from the plaster cast after it has dried, then the model, and allow the inside of the latex mold to dry thoroughly, along with the plaster support. Then place the latex back in the plaster base and you are ready to begin casting with paper pulp.

Press in the wet pulp with your fingers, using a stick or brush handle to reach the deepest parts. Be sure to get enough pulp into the deepest recesses in order to achieve the most faithful casting of the original model. Use an old towel or rags to absorb as much water as possible at this stage and shorten the drying time. Press to knit the fibers of the pulp together so that the cast paper will not fall apart when it is removed from the mold. The back of the cast piece can be coated with clear polymer to reinforce it.

A silicone rubber compound made by Dow Corning for casting can be used instead of latex. Called RTV 3110 or 3112, it is extremely sensitive to delicate textures and configurations but is more expensive than latex and is used with a catalyst. Mix 10 parts of RTV 3112 with 1 part of its catalyst by weight. You can expect 45 minutes of working time and 6 hours of curing time at room temperature, with optimum results obtained by curing for 3 days. RTV makes a strong, flexible mold but must also be backed by a plaster support so that the paper pulp can be pressed in properly.

You can cast a freshly made sheet of paper directly onto a dimensional mold if the depth is not so extreme it would tear the sheet. The procedure requires a vacuum table under the objects (see the photos taken at Pyramid Atlantic in Washington, D.C.).

To prepare a mold for casting paper pulp, mix Dow Corning 3112 silicone rubber with its catalyst S. This allows 45 minutes of working time. Pour the rubber mixture on the prepared matrix. The rubber will capture the shapes and textures of the elements used in the design.

After the silicone rubber has set (6 hours), reinforce the back of the mold with plaster of Paris. This will set in 40 minutes.

Press beaten paper pulp made from cotton linters into the finished mold.

After the pulp is compressed and excess moisture has been removed with a towel, pull the flexible mold slowly away from the dried paper casting. The time needed for thorough drying is several days, depending on the temperature and humidity.

Helen Frederick of Pyramid Atlantic in Washington, D.C., is about to couch a freshly molded sheet made of cotton linters. The sheet will be cast over plastic and rubber objects.

The mold is laid over the objects on a vacuum table covered with fiberglass screening and a piece of Pelan, a lightweight polyfelt synthetic.

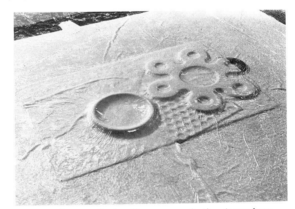

A vacuum is created when the pump sucks the air out from under a plastic sheet placed on top of the newly made sheet of paper.

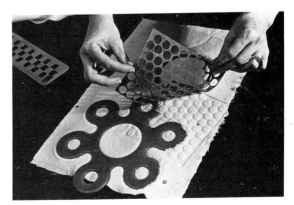

The plastic is removed, the sheet turned over, and the objects removed from the freshly cast paper.

Lead Reliefs

A deeply bitten etching, a woodcut, or a textured collagraph plate can be embossed into sheet lead on an etching press, as long as the depth of relief on the plate is not excessive. About ⅛ to ³⁄₁₆ inch is the maximum that will print with clarity. Cold-rolled sheet lead, available from medical supply houses as a shield for x-ray film, is about .010 gauge in thickness and comes in rolls about 17 inches wide. It is easily cut with scissors or a razor blade. It can be adhered to a heavy paper backing sheet at the same time it is printed, in the same manner as in the *chine collé* process (page 121). The adhesive must work well with the lead, and so the back of the lead sheet may need to be roughened with sandpaper or coarse steel wool. Polymer medium or epoxy will work, as will Elmer's, Sobo, or other white glues. We've had little luck with spray adhesives, which fail to keep a bond for more than a few days.

Your plate or block should be inked and wiped, if necessary, before printing. The lead sheet, cut to size beforehand, will pick up much of the color, just as a sheet of paper would. In addition, the embossed surface may be tinted and wiped with oil-based inks after it is printed.

Lead is a very soft material, easily bruised or scratched. The storage of printed impressions in lead is tricky because the weight of the proofs tends to flatten the embossments of the lowest sheets in the stack. Do not pile many proofs on top of each other.

Constructed Prints

Printed impressions can be cut, folded, and joined into constructions that range from simple cards to elaborate formations that rival the architectural elements of a building. All the printmaking techniques have been exploited for this purpose. The prints—on paper, plastic, wood, cardboard, or combinations of materials—can be glued with a variety of adhesives, stapled, cut and notched, or joined in countless ways to make the finished piece. Pieces can be sewn with thread or cord, stacked or clipped, rolled into cylinders, or made into fairly strong

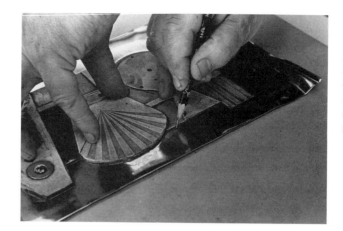

To prepare lead foil for printing with a nonrectangular plate, trace its outline onto the lead with a sharp pencil. Hold it firmly to prevent slippage. Cut the lead foil with a razor blade or an X-Acto knife. Use a sheet of gray chipboard as a cutting surface to obtain smooth cuts.

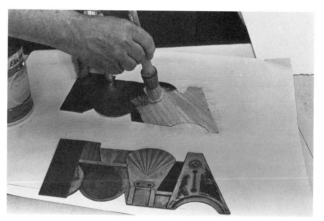

Coat the lead with white glue using a soft brush to ensure an even film.

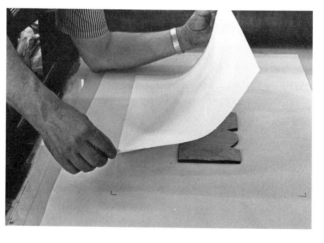

Put the foil, glue side up, on top of the plate. Make sure it fits perfectly. Place dampened printing paper on top. Use corner guides to get consistent margins. Run it through the etching press.

Some edges may have to be burnished down to make a good seal. Do this while the glue is still wet.

self-supporting units that can cover large areas. Thin copper and steel parts from clocks, electronic circuits, and the like may be glued in position on rag board or heavy paper to make an assemblage of printed and embossed images that may be impressed into the soft lead surfaces.

The difficulties inherent in this technique lie in the display and long-term storage of a three-dimensional piece made of a fragile material such as paper. Protection from water, dust, and handling must be provided. The usual plastic box or case that many artists choose for display adds considerably to the weight, cost, and complexity of the piece. Problems in shipping must also be considered, but sculptors handle similar situations as a matter of course. It may not be necessary to assemble a large edition of a complicated construction; instead, sections can be stored in a flat state and put together as the edition is distributed.

Plaster Casts

You can use a woodcut, collagraph plate, or etching plate as a matrix for a plaster cast, which will clearly show the dimensionality of the original. If you use a collagraph plate, it must be thoroughly sealed with lacquer or polymer medium to protect it from the moisture in the plaster. An easy way to proceed is to build a wooden frame of 1-by-2-inch stock around your plate, taping or nailing the corners together. The plaster in the form should be from ½ to 1 inch thick. Any thicker makes the cast too heavy; any thinner makes the cast too weak and likely to break.

For an inked impression, the oil in the ink acts as a lubricant. For an uninked impression, the plate is brushed with a thin coat of mineral oil or tincture of green soap. Liquid plaster is poured over the plate to slightly less than the height

To make a plaster cast of a collagraph plate, construct a ¾-inch wood frame, with the corners nailed together. Attach it to a glass or plastic slab with duct tape. Put the inked collagraph plate, face up, centered within the wood frame.

Mix plaster of Paris in a bucket to a thick consistency, using 1 part of water to 2 parts of plaster. Then pour the plaster onto your collagraph plate. You may tape the plate to the glass with double-sided tape to prevent it from moving.

After 30 to 40 minutes, turn the plaster mold over and pick out the plate, using a burnisher, palette knife, or other tool. Do not let the plaster harden completely or it will be difficult to remove the plate.

of the form. Then a supporting mesh is placed in the plaster. This can be a piece of burlap, window screen, or some other open-mesh fabric, cut to fit. When the plaster sets, the mesh will help solidify it and add strength to the casting. As soon as the plate has set, it can be lifted from the form, the plate removed, and the cast left to harden overnight. The ink will be transferred to the plaster with all the indentations and textures of the plate intact.

Vacuum Forming

The dimensional print has been given great impetus by the use of industrial vacuum-forming machines. Many commercially available vacuum-forming machines are suitable, such as Auto-Vac and Plasti-Vac. It is possible to build your own machine from parts, but the procedure is complicated and requires the mastery of a number of skills, such as carpentry, wiring, plumbing, and soldering, as well as general mechanical ability.

The process is essentially simple, and with very little training, artists can begin to produce unusual and striking images. A heated plastic sheet is placed over an object that is selected as a mold and, by virtue of a partial vacuum created by a compressor, is forced to conform tightly to the object. When cooled, the plastic reproduces the shape of the object around which it has been formed.

The objects that can be reproduced may be constructed of wood, plaster, metal, glass, or plastic. Found objects such as hand tools, toy soldiers, old dolls, machine parts, scissors, thimbles, pencils, and countless other objects can be used as molds. They should not have deep undercuts, however, as the plastic sheet may be wrapped around the object so tightly that it will be difficult to remove. Objects that may be damaged by contact with hot plastic also should not be used, which rules out items made of wax or other materials with a low melting point.

The sheet materials are thermoplastics, such as styrene, butyrate, acetate, and acrylic, which can be softened with heat and shaped over a dimensional form. Materials that are thermosetting are unsuitable, such as polyester and

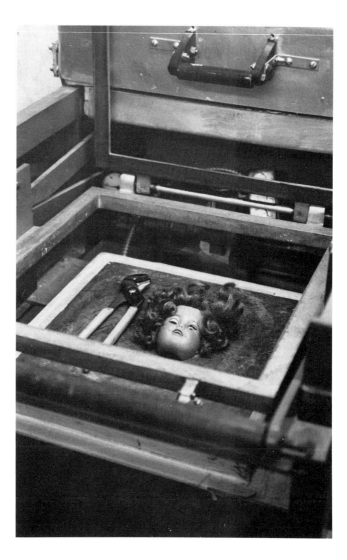

A doll's head and a pair of pliers are placed on the baseboard of the vacuum-forming machine at Pratt Institute, New York. A sheet of plastic will be fitted into the frame.

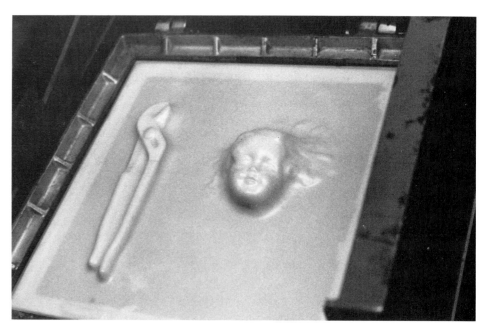

A heating element softens the plastic to make it flexible. It is then lowered onto the baseboard and the vacuum pump sucks the air out, forcing the plastic to conform to the shape of the objects on the baseboard.

Mimi Gross's print *My Grandfather* in process in the studio.

MIMI GROSS
My Grandfather, 1983
Screen-printed, free-standing dimensional print,
23″ × 9½″ × 4½″
Commissioned by the Jewish Museum, New York
Courtesy of the artist
Screen-printed on three separate lithograph plates, sealed with lacquer, and printed with Advance enamel inks. Hand cut and bent after printing at Brand X, New York.

epoxies. Acetate sheets require relatively high heat (500°F) to soften, while acrylic softens at around 300°F.

Place the objects or forms that will act as your mold on the bed of the machine. (The bed will have holes in it to allow the passage of air.) Fit a sheet of thin plastic (.010 to .030 white styrene is a good choice) into the frame of the machine. Turn on the electric heating elements for several minutes to warm up. Pull the heating element into position over the plastic sheet and allow it to soften the plastic. Thin sheets take less time than thick ones. Then lower the frame holding the softened plastic to make contact with your objects. Turn on the vacuum pump; the air being pulled out through the holes will suck the sheet around the forms and shapes of the objects. This will take only a few seconds. When the sheet has cooled and the objects are removed, the plastic sheet will be fixed into a three-dimensional state resembling the original items.

Sewn Prints

The variety of images printed on textiles and the methods of printing them have increased enormously in recent years. Although the history of textile printing goes back thousands of years to Middle Eastern fabric makers, the latest technology in photographic, electrostatic, and heat-transfer printing has enabled creative artists to develop images on fabric that would have been impossible a few decades ago. More traditional procedures in textile printing use the relief process of woodcut, screen printing, the intaglio processes of etching and engraving, and occasionally lithographic methods. The pieces take many forms, such as quilts, soft sculpture, wall hangings, pillows, and stuffed toys and objects. The fabrics that are most suitable for printing are not heavily textured; they are cotton broadcloth or sheeting, linen or finely woven silk, satin or polyester. Roughly textured materials such as corduroy, burlap, bouclé, or upholstery fabrics will not hold the detail of most images.

Because fabrics can be cut and manipulated, stuffed, embroidered, and stitched into an endless parade of shapes,

CLAES OLDENBURG
Soft Drum Set, 1969
Screen print on canvas, sewn and assembled,
10″ × 19″ × 14″
Published by Multiples, Inc., New York
Courtesy Marian Goodman Gallery, New York

artists have exploited these qualities in their creative visions. Images are usually printed on the textile before it is shaped into its final form. In some cases the fabric itself is photosensitized with special emulsions and the image placed by means of light on the cloth, where it is developed by sponges or rags. Electrostatic images can be made on a photocopy machine and then transferred to cloth with a hot iron. Sublistatic printing is a transfer method in which the image is printed on coated paper and then transferred to fabric by pressure and heat. In discharge printing, the image is bleached out of a dyed fabric and another color put in its place at the same time. Whatever method is used, it must be analyzed by the artist to make sure it gives the desired effect.

7 Monotypes

WILLIAM MERRITT CHASE
Portrait of a Woman: Reverie, c. 1890–95
Monotype printed in brown ink, 19½″ × 15¾″
Metropolitan Museum of Art, New York
Purchase, Louis V. Bell, William E. Dodge and Fletcher Funds,
Murray Rafsky gift, and funds from various donors, 1974
Chase was intrigued with the spontaneity, speed, and luminosity of the
monotype. Here he used rag wiping and both wet and dry brush on a fully
inked plate to bring out soft textures and reveal the image of a woman,
probably his wife.

The monotype is an intriguing hybrid among printmaking techniques. It is neither a print nor a painting but a unique combination of both. The method is aptly named because it is one image (mono), painted or drawn with oil paint, water-based paint, or printer's ink directly on a plate and then transferred to paper. Metal plates, plastic sheets, glass, lithographic stones, wood, or any surface that will transfer an image onto paper can be used. The impression can be transferred by hand rubbing (with a rubbing tool or the hand), particularly if the work is painted on glass. Hand rubbing produces sensitive results on Japanese paper, although dampened or dry etching paper yields other qualities that may be interesting. If the base material is firm, the monotype can be printed on a press. For press printing, dampened etching papers are preferred, but interesting results are possible with Japanese paper, handmade papers, cloth, and experimental materials.

The terms *monotype* and *monoprint* are often confused and need clarification. Museum terminology today restricts the designation *monotype* to the printing of an image from a clean, unworked surface containing no scratching or carving, in contrast to an etching plate or woodblock, and no drawing, in contrast to lithographic stone. The monotype is a singular image and cannot be replicated. Editions would be difficult if not impossible to pull.

A *monoprint*, on the other hand, designates a special, often one-of-a-kind, wiping or printing that might also include direct painting onto an already worked etching plate, collagraph plate, woodblock, screen, or lithographic stone. In some instances, editions can be pulled by using unusual wiping tech-

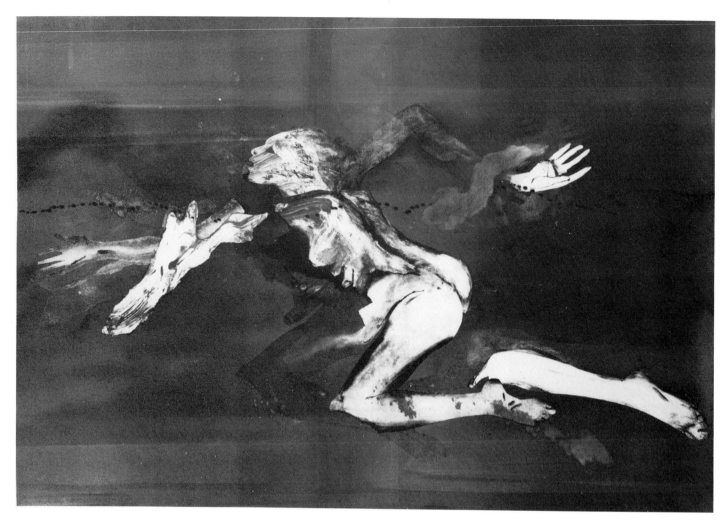

MARY FRANK
Untitled (Woman Swimming—Red), **1980**
Monotype, 23½″ × 35″
Courtesy Zabriskie Gallery, New York
Photo: J. Ferrari
Oil color was brushed on a thin metal cut-out figure, placed on an etching plate with a rolled color background. Dampened paper was placed on the assembled plate and printed in an etching press.

niques, as Rembrandt did so inventively and ahead of his time in *The Three Crosses* (fourth state), *The Entombment* (third state), and other prints. Contemporary artists like Jasper Johns and Jim Dine have taken this concept further by painting in oil or acrylic directly on an already inked plate, lithographic stone, or woodcut, creating handsome monoprints that exploit the rich possibilities of both media.

We hesitate to go beyond these simple definitions because the very nature and beauty of the monotype is its open, free quality, which easily allows innovation.

Origins and Development of Monotypes

The origins of the monotype are difficult to pinpoint, although individual artists probably employed variations on the technique as early as the first intaglio prints of the fifteenth century. Counterproofing, a method related to the monotype, was used in the sixteenth century. In this process an impression of a chalk drawing was run through a press with a dampened sheet that picked up a lighter, reversed image. Early engravers produced counterproofs by running a freshly inked print covered with dampened paper through a press in order to see the image without reversal. Painters pressed paper over heavy pigment to lift excess paint, producing a monotype without planning to do so.

EARLY EXPERIMENTS

An early experimenter in monoprint techniques and one of the most inventive of the early printmakers was Hercules Seghers (1589–1638). Although there is

no evidence that Seghers produced a monotype by painting on a clean plate, he used printmaking as a means to capture singular images rather than to print identical multiple impressions. On his etched plates, he experimented with as many variations as he fancied. And according to current definitions of monotype and monoprint, he may have made the first monoprints. Of the 183 existing impressions from 54 of his etching plates, scarcely any are identical. In these prints color is used profusely, and they may represent the first experiments with color in etchings. Seghers also used colored paper for printing and hand-worked many images after printing. The historian Samuel van Hoostraten, writing in 1678, called his work "printed painting," certainly an apt description.

The first appearance of a monotype is credited to a master draftsman and painter of the Italian Baroque, Giovanni Benedetto Castiglione (1616–1670). Most drawings by Italian artists in the seventeenth century were preparatory in nature, used as guides for larger, more

important paintings, but Castiglione was interested in drawings as works of art in themselves, and this may have led him to the monotype. Ten years Rembrandt's junior, he may also have been influenced by the master's innovative, partly wiped plates. It appears that he spread a heavy film of brown or black ink onto a clean etching plate and drew his white lines with a blunt stick. He may have created tonal areas by using stiff brushes, rags, or his fingers to remove ink. Because plate marks and printing creases appear on the prints, there is no doubt he used a press.

It is interesting to note that there is no identifying reference for the monotype in early literature. Castiglione's technique is described by Adam von Bartsch, director of the Imperial Print Collection of Vienna, in one of his many catalogs from the early 1800s as "imitating aquatint" but is not named. The term *monotype* only appears in 1891, in Sylvester R. Koehler's *Das Monotyp*, which discusses Castiglione, William Blake, William Merritt Chase, and Charles Alvah Walker.

Monotype, however, was not a popular medium. It is about 150 years after Castiglione that we come to William Blake (1757–1827), one of the most important artists to work with monotypes. His inventiveness and individuality, evident in his creative combination of poetry and image, led him to a unique usage of the monotype. His diverse color images were painted thickly with egg tempera on millboard, a durable cardboard used for book covers, and yielded a textural, granular quality when printed. Blake often worked these monotypes further with pen and brush.

DEGAS AND THE IMPRESSIONISTS

In the years succeeding Blake, the monotype almost disappeared. The painter-etchers of the early nineteenth century appear to have promoted and glorified the intrinsic beauty of the etched line. They relegated the printing of their cleanly wiped etchings to the printer and had little interest in experimental wiping. By the late 1860s a revival of etching, with Rembrandt as the inspiration, took hold and created a closer relationship between paintings and etchings.

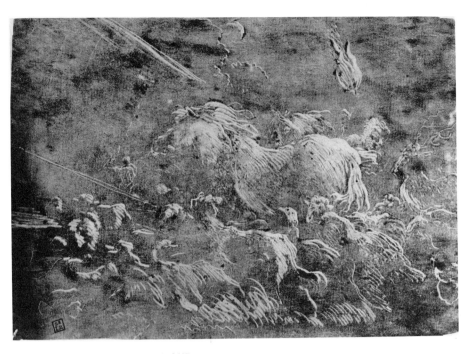

GIOVANNI BENEDETTO CASTIGLIONE
Animals in Noah's Ark
Monotype, 9¾" × 14⁵⁄₁₆"
Metropolitan Museum of Art, New York
Harris Brisbane Dick Fund, 1936
Adam Bartsch, the great print cataloguer of the late eighteenth century, described Castiglione's method as spreading ink over a polished copper plate and drawing and scraping the image into the ink with a blunt instrument (probably of wood to hinder scratching). Areas were probably lightened with a rag, brush, or fingers. Platemarks are often visible, indicating that the plates were run through a press.

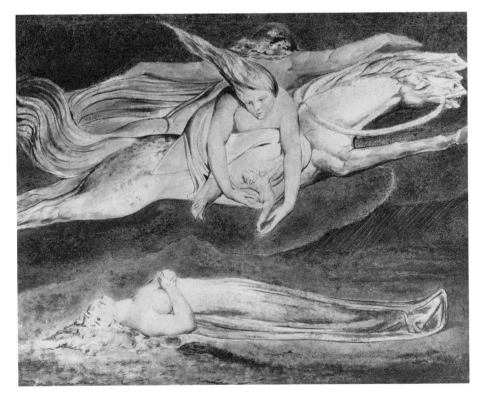

WILLIAM BLAKE
Pity (from Shakespeare's *Macbeth*), 1795
Color monotype in egg tempera, touched with pen, black ink, and watercolor, 15¾" × 20⅞"
Metropolitan Museum of Art, New York
Gift of Mrs. Robert W. Goeht, 1958
Tempera colors were painted on a millboard base; the rain was then depicted by scratching into thick pigment. After printing on an etching press, Blake retouched the impression, as he did many of his monotypes.

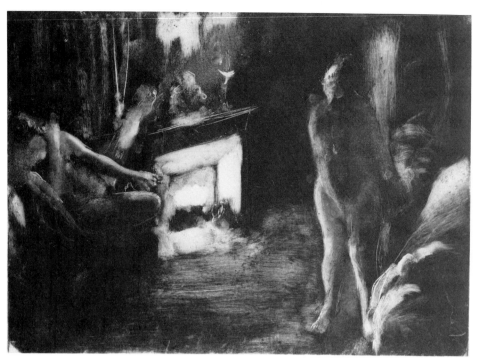

EDGAR DEGAS
The Fireside (Le Foyer), c. 1877–80

Monotype in black ink, 16⁵⁄₁₆″ × 23⅛″
Metropolitan Museum of Art, New York
Elisha Whittelsey Fund and
C. Douglas Dillon Gift, 1968
To reveal the figures gathered around a
fireplace, Degas used rags, brushes, and
fingers to remove the ink from a plate
entirely covered with black ink. The
minimal line work was made by
scratching into the ink with a sharp
instrument.

MAURICE BRAZIL PRENDERGAST
Lady with Umbrella, c. 1891–94

Monotype in oil color and pencil on
Japan paper, 9⅛″ × 4¹⁄₁₆″
Daniel J. Terra Collection
Terra Museum of American Art, Chicago

It was Edgar Degas (1834–1917) who
became entranced with the possibilities
of the creative use of inking and its ma-
nipulation with rags, fingers, and the
hand. He observed the work of his friend
Vicomte Ludovic Lepic, an enthusiastic
experimenter in tonal wiping who called
his method *aux forte mobile* because of
the fluid tonal range it produced. The
etcher-printer Auguste Delatre intro-
duced Degas to the possibilities of
achieving rich blacks through a wiping
method he devised called *retroussage*.
The artists called these early monotypes
printed drawings, and Degas apparently
was hooked by the medium's unique
quality, because he proceeded to create
more than four hundred monotypes.
Many seem to derive not only from the
printing experiments of his friends but
also from developments in photography,
with its light-dark contrasts and interplay
of positive and negative imagery.

Degas worked his monotypes in a vari-
ety of imaginative ways. Rich black ink
covers the plate in some, with the image
revealed through rag and finger wiping
and reapplication with a brush. He built
up the linear structure positively by
painting with a brush or negatively by
drawing with a stick to create a white
line on a black ground. In the 1890s he
created a series of landscapes with col-
ored inks. Often he added pastel to en-
hance the coloration or make the total
statement, using a second pull, or cog-
nate print, in black and white as the
basis for pastel drawings.

Degas was without doubt the master of
the monotype. Other important artists
followed his lead or came upon the
method independently, with a flurry of
monotype images appearing in the late
nineteenth century. Camille Pissarro
(1830–1903) made a few monotypes after
observing Degas, as did Henri de
Toulouse-Lautrec (1864–1901). Paul
Gauguin (1848–1903) worked indepen-
dently and inventively, often with water-
color. He developed a trace monotype,
or transfer drawing, by inking a sheet of
paper, laying another sheet over it, and
drawing on the fresh paper, which re-
ceived the ink in a linear manner. Paul
Klee (1879–1940) used this method de-
cades later for his intriguing drawings.

Several late-nineteenth-century American artists used the medium sensitively and exploratively, including Frank Duveneck (1848–1919); William Merritt Chase (1849–1916), who created luminous, loosely painted portraits; and Maurice Prendergast (1859–1924), who was greatly influenced by Japanese prints.

EARLY-TWENTIETH-CENTURY MONOTYPES

At the turn of the century Pierre Bonnard (1867–1947) and other French artists produced hundreds of richly colored figurative monotypes. These were usually painted with oil colors on smooth glass or metal and paper and pressed with a roller or hand to produce sparkling impressions.

It is not surprising to find that Pablo Picasso (1881–1973), in addition to his exceptional accomplishments as a painter, sculptor, ceramicist, and printmaker, produced hundreds of exceptional monotypes. These freely painted, exuberant works often reflected the style and subject matter that currently engaged him.

Henri Matisse (1869–1954), too, used the monotype to reflect on subjects he used in his lean, linear etchings and his lithographs. He produced some thirty monotypes, deftly and economically drawn with a sharp tool into a flat, rich black, revealing a sensitive white line when printed.

Marc Chagall, Jacques Villon, Georges Rouault, Joan Miró, and Jean Dubuffet all worked in the monotype in diverse personal ways, continuing Degas's legacy. There was some experimentation with monotypes at the Bauhaus, and Oskar Schlemmer (1888–1943) became one of the outstanding practitioners, hand printing twenty-five freely painted, texturally interesting images from glass.

CONTEMPORARY MONOTYPES

After the flurry of interest in the monotype among American artists at the turn of the century, artists in the 1920s and 1930s used it as a kind of diversion rather than as a medium for a body of work. In the 1950s, however, Milton Avery (1893–1965) developed a series of some

two hundred monotypes while recovering from a heart attack in Florida. These prints reflect an inventiveness and experimentality less evident in his other prints. Although his work probably had little effect on the monotype's revival among American artists of the 1960s and 1970s, it is interesting to think of him as a bridge between the two periods.

During the print renaissance after World War II, the monotype was a stepchild. Monotypes were excluded from competitive print exhibitions, and museum exhibitions were rare. Artists in general showed a lack of interest in and knowledge of the medium's potential. A notable exception was Matt Phillips, who has consistently produced and exhibited fine monotypes since the early 1960s. Through his work, his writing, and the

HENRI MATISSE
Seated Nude, c. 1914–17

Monotype, 6¾″ × 4¾″
Metropolitan Museum of Art, New York
Gift of Stephen Bourgeois, 1917
Matisse drew with a pointed instrument directly onto an inked copper plate, using it as a sketch pad. Dampened paper, placed on the plate and run through an etching press, produced this simple, expressive monotype.

KARL SCHRAG
Large Bouquet in May, 1987
Monotype in oil color, 17½″ × 24″
Courtesy of the artist

ALFRED BLAUSTEIN
Three Women, 1985
Monotype using printing ink, 22″ × 30″
Courtesy of the artist

exhibitions he has curated, Phillips has contributed substantially to a renewed interest in the monotype. In addition, the exhibition of Degas's monotypes at Harvard University's Fogg Art Museum in 1968 and "The Painterly Print" exhibition at the Metropolitan Museum of Art in 1980 did much to stimulate a return to this expressive medium.

Artists such as Nathan Oliveira, Richard Diebenkorn, Wayne Thiebaud, Michael Mazur, Mary Frank, Jim Dine, Jasper Johns, Karl Schrag, Helen Frankenthaler, Al Blaustein, Joseph Solman, and Robert Broner are actively working and exhibiting in the medium. Countless others are producing monotypes and discovering personal images. College art departments and professional art schools have incorporated the monotype in their print classes. Exhibitions of monotypes occur more frequently in galleries and museums, and competitive exhibitions now include the monotype as an accepted print category. And so the cycle progresses as artists invent and reinvent methods of working that are right for their needs.

Developing Monotype Imagery

Because the monotype requires only the basic tools and skills of drawing and painting, many artists who might balk at the confines of platemaking love the freedom and painterliness of the monotype. However, this simplicity of means can also be deceptive. The directness of painting on the plate requires a sure hand, a degree of spontaneity, and expeditious execution so the image doesn't dry before it is printed. (The addition of oil of cloves to oil-based ink or paint retards drying.) Gaining experience and control of the medium is best accomplished by doing—by developing a personal image and finding the working method and implements to express it.

Experience in another medium can serve as a guide but not as a vehicle for replication because the monotype has a sensibility of its own. Essentially it is a printed painting. The transfer of images from plate to paper through a press or hand rubbing occasions an important metamorphosis. The brushstroke on the plate is partially absorbed into the paper with a unique translucency that creates a quality of light quite different from a painting on paper or a print. And therein lies the appeal of the monotype.

Some artists find that combining printmaking skills with the painterliness of the monotype can result in inventive and unpredictable imagery. Capitalizing on the process itself and realizing the creative aspects as they evolve can add much to one's own sense of self-discovery.

MATERIALS AND TOOLS

A variety of materials can be used for the base plate, including:

Plexiglas (with filed edges and roughened surface)

Heavyweight vinyl

Metal etching plate (with filed edges and roughened surface)

Discarded thin litho zinc or aluminum plates

Plate glass (for hand rubbing only)

Cardboard (sealed with gesso or acrylic spray)

You can also choose from a variety of painting and drawing materials, as well as printing tools, depending on the effects you want:

Toothbrush

Paintbrushes of all sizes (from soft to stiff)

Foam brushes

Sharpened brush handles or sticks (for different-width lines)

Pencils and erasers

Scissors

Palette and painting knives

Printing inks (oil-based) in a variety of colors

Oil paints

Oil pastels

Createx monoprint colors and base (water-based)

Caran d'Ache water-soluble crayons and pencils

Liquid fiber-reactive dyes (water-based)

Linseed or plate oil

Acrylic spray

Oil of cloves, or eugenol (to retard drying of oil-based inks)

Glycerin or retarder for acrylics (to slow drying of water-based paint)

Powdered magnesium (to stiffen ink for viscosity printing)

Rollers of different sizes

Rubbing tools (see chapter on relief prints for types)

Etching press, felt blankets, and blotters

Etching papers (Arches, Rives, etc.)

Japanese rice papers (especially for hand rubbing)

Rags and cotton swabs

Medium and fine metal files

Solvents (mineral spirits)

For stencil printing, you might experiment with stencil paper, oaktag, or medium-weight vinyl, as well as leaves, grass, and the like. For collage prints, select *thin*, printable found objects, such as string, textured paper, or lace doilies.

TEST PLATE

Because the monotype allows considerable freedom in the choice of materials and in the approach to imagery, it is helpful for artists new to the medium to make a test plate. Although this medium uses methods of painting and drawing that are familiar, it is difficult to know how a crayon mark or the stroke of a paint-filled brush or the rolling out of ink will print.

Select a base plate and experiment with your materials. If Plexiglas or a standard etching plate is used, file the edges as described in the intaglio chapter. Also roughen the Plexiglas surface with medium sandpaper, or sandblast the surface so that ink or paint will adhere better. If you plan to print the test on an etching press, select a base that is sturdy enough to withstand the press pressure and large enough to contain a variety of tests. Glass, of course, cannot be used for press printing, but it can be used for hand rubbing.

NATHAN OLIVIERA
Figure, Summer, #1, 1988
Monotype, 47" × 42"
Published by Experimental Workshop,
San Francisco
Courtesy John Berggruen Gallery, San Francisco
Painted in many colors on an aluminum plate
with six consecutive printings through an etching press.

oil pastels; if they are heavily applied, they will print.

The test plate reveals a lot of information. It indicates what consistency of paint or ink works best, how much linseed oil or solvent to add to the paint or ink, how much ink to use in rolling, how drawing into an inked area with a stick will print, and how much pressure to use when rolling the plate through an etching press. Less pressure is required for a monotype because only the surface is printed. Too much pressure will cause colors to run.

Different Monotype Techniques

When you apply paint or ink to a base plate, you can work positively or negatively. Working positively means you put down imagery with a brush or roller. Working negatively indicates removing the ink with a rag, cotton, brush, or hand. At times you may use both approaches in a monotype; other times you may use only positive or negative means.

Some procedures to try after you have made a test plate are direct printing, direct drawing, and collage and stencil. By experimenting with these methods, you will soon devise a personal approach dictated by your images.

DIRECT PAINTING

Select a variety of tools and materials from the list at the beginning of the chapter. If you print on a press, dampen your paper as discussed in the intaglio chapter. If you intend to hand-rub, refer to the discussion of paper selection at the end of this chapter.

For your first print, you might limit yourself to just one color, black or umber or black with a touch of Prussian blue or dark green. Explore tonal possibilities at first and then move to a fuller palette.

The direct-painting method is very appealing to artists who enjoy working directly from their subjects. It also allows you to work on a large scale, which in most other forms of printmaking can be difficult. Substituting a plate for paper or canvas, you can paint directly on the plate from a live model, still life, or landscape, or create an imaginary subject or abstraction.

Paint some strokes using ink or paint directly from the can or tube, with no solvent or linseed oil added. Try other strokes with a few drops of linseed oil added, then some strokes with solvent added for washes. Use a variety of brushes—stiff and soft, flat and pointed.

Roll out a flat area with a roller and wipe away areas with a rag or cotton swabs and solvent to create lights and tones. This was Degas's method. If the ink is very stiff, add a few drops of linseed oil to loosen it. Ink to be rolled should not be thinned.

Replace detail with brushwork. Add white lines on a black field with a pointed stick or the sharpened back of a brush, achieving lines of different widths. This was Matisse's method. Try

DIRECT-TRACE DRAWING

This simple method, done without a press, as Gauguin used it, produces a linear monotype that has a unique soft-edged quality similar to the tone and line in soft-ground etching. You can work on Plexiglas, a sheet of heavy vinyl, an etching plate, or even glass. However, a sheet of Plexiglas with an abraded surface is the most versatile if you want to add other colors.

1 Roll a thin layer of medium-stiff etching ink on the surface of the Plexiglas. If margins are desired, apply masking tape to the Plexiglas before you roll your ink.

2 Select a dry piece of rice paper or lightweight drawing or etching paper, and place it lightly over the inked plate.

If the paper is the same size as the plate, it will ensure even margins. To keep the paper from slipping, tape it down at the top.

3 Draw your image on the back of the paper with a pencil or ballpoint pen. Use a thicker tool when a wider line is desired. Dark areas can be made by massing your lines. Light and medium tones can be achieved by finger and hand rubbing with varied pressure. Lift the paper occasionally to see the kinds of marks you are making. Take care not to rub your hand over the paper unless you want tones to print. Use a wooden bridge, as described on page 96, to keep hand pressure off the paper. When the work is completed, lift the paper up carefully; you will have an interesting combination of granular line and tones.

ADDING COLORS

After a monotype is printed in the direct painting method, additional colors can be added to the plate as many times as desired and run through the press. Any register system described in the intaglio chapter may be used.

For a trace monotype, the system is a little more complex. Additional colors can be put in by hand, using the trace method or direct painting, and run through the press. When making the initial drawing, however, be sure to use a drawing tool that will leave a strong image on the back of the paper, which can then be used as a guide in registry. Plexiglas should be used for the plate because you can see through it.

Alfred Blaustein uses a brush and printing ink, diluted with paint thinner and linseed oil, to paint directly from a model on a zinc etching plate.

A trace monotype is made by laying Arches paper directly on an inked Plexiglas plate. Pencils of different widths and hardness are used to draw the image on the back of the paper. By varying the pencil pressure and rubbing with the fingers and hand, different-weight lines and tones are produced.

 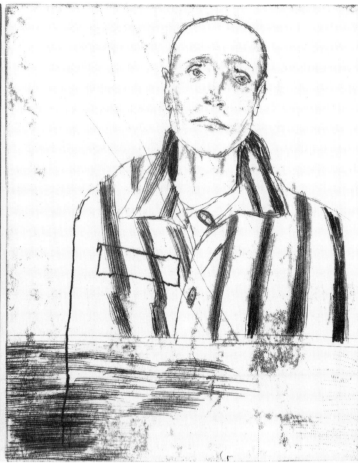

MARY FRANK
Prisoners (Holocaust Series), **1986**

Monotype, each impression 37″ × 25″
Courtesy Zabriskie Gallery, New York
Photo: Sarah Wells
The trace monotype on the right was made by drawing with a sharp instrument on the back of a piece of paper that had been placed over an inked plate. The grays were achieved with light hand pressure. After the trace monotype was made, dampened paper was placed on the inked plate. The paper and plate were run through an etching plate to produce the white-line monotype. The result is two quite different impressions from the same inked plate, one done by hand and one with a press.

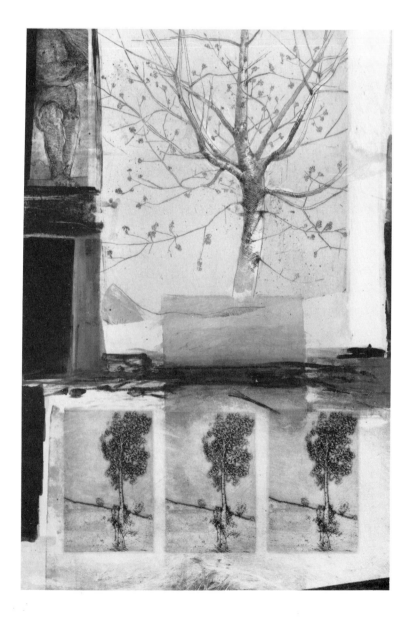

RON POKRASSO
Spring Vacation #6, **1988**

Monotype and etching (5 plates), 23″ × 16″
Courtesy of the artist
Five small etching plates were inked, placed under a sheet of Plexiglas, and together run through an etching press. The images transferred onto the Plexiglas were then used as a guide when painting the monotype. The positions of the etching plates and the Plexiglas were marked on the press. The etching plates were reinked and printed on dampened Arches, which remained engaged under the press roller to ensure accurate registration when the monotype, painted on the Plexiglas, was next run through the press.

1 Cut a sturdy sheet of cardboard at least 4 inches larger than the Plexiglas all around. This will serve as a base for the register system.

2 Position the Plexiglas with even margins on the cardboard and mark its position in pencil.

3 Position your paper over the Plexiglas and mark its position with tape.

4 Measure the distance between the register marks for the Plexiglas and the paper, and mark it on the *back* of the paper in pencil.

5 Remove the Plexiglas from the cardboard; roll a medium-thin, even layer of ink; and then replace the Plexiglas in its register marks on the cardboard and tape the paper in position over the Plexiglas. Proceed to make your trace monotype on the back of the paper.

6 After completing your drawing, remove the Plexiglas and clean off the ink. Leave the paper taped in position.

7 At this point, if you plan to add color in the direct painting method, you might dampen the trace monotype, blot it well, and place it back in its marks under the Plexiglas. (Select paper other than rice paper because it is quite fragile for dampening.) Place the clean Plexiglas on the *back* of the trace monotype, using the penciled marks on the back of the paper to position it.

8 Now paint additional color on the Plexiglas using the drawing on the back of the paper as a guide.

9 When completed, place the newly painted Plexiglas in its register marks on the cardboard, *under* the trace monotype.

10 Run the whole setup through the press with moderate pressure (determined in an earlier dry run). Repeat the process if additional colors are desired.

VISCOSITY PRINCIPLES

By applying the viscosity principles discussed in the intaglio chapter, you can enhance the use of color in a monotype. Painting or rolling some areas with an ink stiffened with magnesium powder and then rolling the surface with an ink made looser with linseed oil can produce magical results as certain areas receive or reject the ink. Combining printmaking skills with the painterliness of the monotype greatly enhances the potential of the medium and can lead to unpredictable imagery.

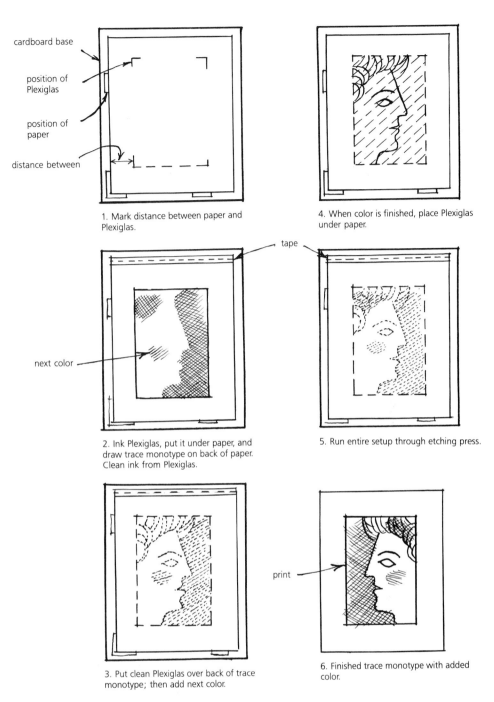

1. Mark distance between paper and Plexiglas.

2. Ink Plexiglas, put it under paper, and draw trace monotype on back of paper. Clean ink from Plexiglas.

3. Put clean Plexiglas over back of trace monotype; then add next color.

4. When color is finished, place Plexiglas under paper.

5. Run entire setup through etching press.

6. Finished trace monotype with added color.

REGISTERING COLORS ON A TRACE MONOTYPE

WORKING WITH WATER-SOLUBLE MATERIALS

It is possible to use water-soluble materials for monotypes. Good results have been achieved with ordinary watercolors. Another possibility is Createx monoprint colors, manufactured by Color Craft, mixed with monoprint base to extend them. These colors work well for a variety of monotype painting techniques using brushes (both traditional and foam), rags, sponges, and the like.

Caran d'Ache water-soluble crayons or pencils applied directly to the plate have the rich quality of drawing; they can also be used in combination with Createx colors. Some artists have achieved very good results by painting with these pigments and crayons on a clay-coated or sized paper or a less absorbent paper such as Rives BFK or Lenox. You can then use the drawing as a plate, place a sheet of dampened paper over it, add a piece of cardboard backing underneath both papers, and run everything through the press with heavy pressure to get a good impression. To check the impression, lift a corner (don't remove the print). If it is not rich enough, spray the

back of the print with water and run it through again.

A great advantage of these water-based materials is that the monotype plate may be made days ahead. Even though the painting may be thoroughly dry, the damp paper and additional spraying will activate the image so it prints well.

Water-based powdered pigment can also be added to a dry monotype or a freshly painted one to achieve interesting effects. The marks of soft lead pencil will also print.

COLLAGE MONOTYPES

Although experience with collage techniques is certainly helpful, even without previous knowledge, you will find that these methods are simple to use with monotypes and encourage inventive solutions. You can combine collage with direct painting and drawing, or use it alone to produce creative images.

We are using the term *collage* for the monotype very loosely. We are not implying that materials are glued down but merely that a collage esthetic is fundamental to the procedure and that loose cutouts are used.

Excellent collage materials can be cut or torn from textured or smooth paper, lace, or cloth. The elements can be sprayed with acrylic to seal their surfaces, so that you can clean and reuse them if you wish. Vinyl and thin sheets of aluminum or zinc used for lithographic plates can also be cut with scissors into desired forms. Other materials that can serve well, whether inked or not, include leaves, thin gaskets, and thin metal grating. Masking tape can be used to introduce linear elements, either inked or left to print white. Thread, string, or rope can be inked or left natural and can become an embossing element when run through the press.

The elements can be inked with small and medium rollers, in multiple colors, and placed on a clean or an inked plate. Further imagery can be added to a clean plate with a roller or brush. If the whole plate has been rolled with ink, you can use a stick, cotton swab, or rags to create linear or tonal areas. If the cutouts are not inked, they will appear white when printed. If heavy paper or thin cardboard is used for the stencils, you will achieve embossed forms.

Registering the printing paper as discussed earlier and layering the imagery

using transparency in your color can be intriguing. Experiment to discover new ways in which to work. Then, when the plate is prepared to your satisfaction, run it through the press.

Collaging colored Japanese or other papers using the *chine collé* method described on page 121 is still another way to enrich the monotype. Commercially printed images can also be added, using the frottage technique.

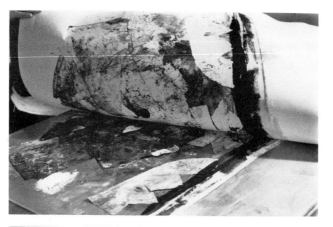

Miklos Pogany begins a monotype in a free, painterly manner by pouring motor oil, paint thinner, and color, squeezed directly from a tube, onto a large etching plate. Loose, torn paper shapes are also inked and placed in position on the plate. The image is developed with rags, fingers, and rollers. Linear forms are added with a brush.

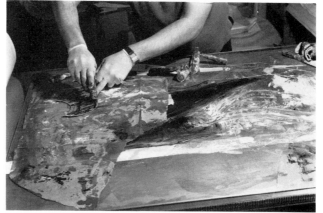

Pogany lays dampened paper over the plate and runs it through an etching press numerous times. He continues to add new color and forms, building layers of transparent and opaque color on Arches etching paper.

MIKLOS POGANY
Metamorphosis of Passing Things, 1988
Monotype, 30½″ × 42½″
Courtesy of the artist
The monotype is printed with oil paint and lithographic ink; the linear structures are drawn with oilstick.

FROTTAGE

Images from freshly printed newspapers and magazines can be transferred to a print by the frottage method. Select the image you desire, in black and white or in color (a photograph, comic strip, or other halftone image); use recently printed material for the best results. Essentially frottage is a monotype method. If you want to print an edition, you must have enough multiple copies of the newspaper or magazine image. Moreover, it is wise to experiment at first to make sure you have control of the method.

You will need lacquer thinner or lighter fluid and a wide, smooth brush to apply this fluid. You can use a blotter or apply thinner to the back of the image to be transferred with the wide brush. Try to avoid overbrushing; instead, cover the piece of paper with as few strokes as possible. Place it, image side up, on top of a previously inked and wiped intaglio plate. Put the damp printing paper over all and run it through the etching press. The lacquer thinner will soften the printing ink on the newspaper or magazine clipping, and that ink will be transferred to the damp paper. After printing, peel off the clipping. You can also print this type of image by hand rubbing. Take an already printed proof or a clean sheet of paper, brush on the solvent, place the clipping with the image side against your print or paper, and rub the back of the clipping with a burnisher or your fingertip.

Time is your enemy in this process, because the most effective solvents dry very quickly. You must work fast and effectively to achieve good results. Large areas can be printed by using wide brushes and printing with an etching press. Acetone will work on some transfers, and since it is less toxic than lacquer thinner, it should be used when it works as well. We find that it is possible to slow the drying speed of lacquer thinner by mixing it with 3 parts of turpentine to 1 part lacquer thinner. Do not let the solvent-soaked paper remain on a collagraph plate for more than a few seconds after printing, because it tends to stick to the sealant that you have used on the plate.

See the chapter on photographic techniques for a discussion of the frottage method of transferring printed photo images or text material to a zinc plate. These images can be etched directly into the plate with dilute acid.

This conical relief roller in Juergen Strunck's studio in Grapevine, Texas, was designed by the artist to roll ink on a specially constructed neoprene inking slab. The roller rotates on an adjustable pivot. Selected colors are placed at one end of the slab and the roller moves in a three-quarter arc, blending the ink on the roller. It is then moved to another pivoting position on the table, where it distributes its ink on an aluminum lithograph plate. *Okawara* or *moriki* Japanese paper is used in printing the image on an etching press. The paper is blotted after printing. Four to six subsequent printings of additional colors are made in the same manner to complete the image. The prints are sometimes unique or printed in small editions (see page 58 for a color reproduction). As the image does not rely on a cut or graven block, this method is similar to the monotype technique.

Paper Selection

The kind of paper you select for printing a monotype test plate or a more developed image is very important. Paper selection is also determined by whether you are printing on a press or by hand. For press printing, any good etching paper is excellent. Try a few different types to see which you prefer. Arches, Rives, Somerset, and Stonehenge are all suitable. (Check the paper chart in the back of the book for more detailed information.) When a press is used, the paper should be dampened in a water bath and the excess water blotted, as described in the intaglio chapter.

When a monotype is to be hand-rubbed, Japanese rice papers produce very fine results. Again, experiment with different weights and colors. *Sekishu, moriki, masa,* and *kochi* are all good. Thin drawing papers can also be used.

Printing the Monotype

To print your monotype on an etching press, place the plate on a clean press bed and lay the damp paper carefully over it, leaving neat, even margins. Put a few sheets of newsprint on top of the paper to catch excess moisture, place felt blankets down flatly over everything, and run it through the press with slightly less pressure than for an etching. This procedure should be followed for all press-printed monotypes.

If you are hand rubbing, use Japanese rice paper or a thin drawing paper. You might try dampening the drawing paper and also using it dry to see which produces the best results. Generally the Japanese rice papers are too thin to dampen except for *kochi,* which you might try dampened.

In order to achieve even margins, you might print with a piece of cardboard cut to your paper size; slip it under the plate,

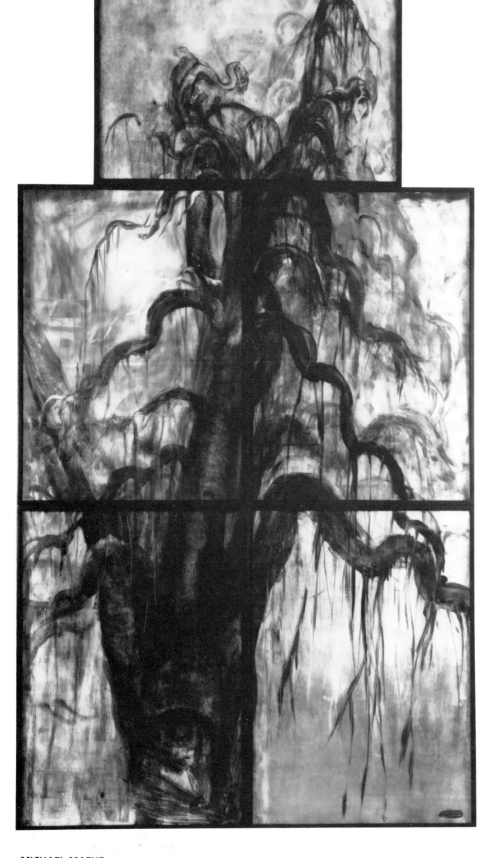

MICHAEL MAZUR
Weeping Beech I, 1988
Monotype on silk, 84½″ × 45½″
Courtesy Fawbush Gallery, New York

keeping the margins even. Then you can line up your paper with the cardboard edges and drop the paper down.

A thin sheet of tracing paper placed between your rubbing tool and the monotype paper is sometimes desirable if thin rice paper is used. It can prevent tearing the paper with the rubbing tool.

PROBLEMS AND CAUTIONS

1 Avoid applying heavy areas of ink or paint; they will print as blobs or, worse still, as runs.

2 Avoid thinning the ink or paint too much because runs will again occur, or desired washes will become nonexistent or too faint.

3 Be sure to place two or three sheets of clean newsprint or drawing paper between your printing paper and the blankets, overlapping the plate. When a run or bleed-through occurs, you don't want to soil the blankets.

4 In press printing, avoid too much pressure and too wet paper. Inks may run and the paper may stick to the plate.

Reworking the Monotype

Many artists enjoy using the monotype as a base and transition for other work, much as Degas did. After the monotype is printed, you can develop the print further by drawing and painting on it with pastels, oil pastels, colored pencils, oil paint, or printing ink. All these materials are compatible with the printed image of the monotype. If paint or ink is used, you can rework it while the print is still wet or wait for it to dry. If pastels, oil pastels, or colored pencils are used, it is best to rework when the print is dry.

SECOND PRINTINGS

If a monotype prints too heavily, you may be able to enhance it. You can simply pull a second print from the over-inked plate or you can make a counterproof (a reversed, lighter image of the print). Place a new sheet of dampened paper over the just-printed monotype, with cardboard underneath as backing; then run it through the press a second time. Some of the heavy color will be removed, and you can even draw on the counterproof to create another image, a method Degas often used.

8 Photographic Techniques

The almost magical power of photography to record and intensify images has made it an indispensable tool for some artists. Virtually all the printmaking techniques have accommodated to photographic processes, including etching, lithography, and screen printing, as well as relief etching on copper or zinc plates, the main relief printing process. There are many approaches to photographic printmaking, ranging from the straightforward photogravures by Edward S. Curtis and the photo-screen prints of car accidents by Andy Warhol to the elaborately arranged compositions of Eduardo Paolozzi or Joe Tilson.

Each technique has its own demands and problems. Over the years many methods have been developed to take advantage of photo images, and we describe a number of these procedures in this chapter. Other photographic techniques are discussed in the chapters on lithographs and screen prints.

Transparencies

To transfer a photographic image to a printing plate, most of the printmaking techniques require a film transparency, either positive or negative, or a handmade positive transparency.

JOHN BALDESSARI
Hell (from diptych Heaven and Hell), **1988**
Photoetching, aquatint, roulette, and scraping, 47¼″ × 31½″
Courtesy Peter Blum Editions, New York
Photo: Zindman/Fremont

HAND-DRAWN POSITIVE TRANSPARENCIES

In many cases it is advisable to put your image on transparent film, such as Mylar or Estar-based, for dimensional stability. However, you can draw with any opaque ink or pencil, litho crayon, or the like on a sheet of translucent vellum, prepared acetate, frosted Mylar, or acetate. If you use noncrawl ink or litho crayon, you can draw or paint on glass to make a positive transparency. The best surface is one that will not buckle or warp when the image is placed on it, and on which the black lines or shapes will be opaque enough to block light when exposure is made in the next step of the photographic process.

LINE AND HALFTONE TRANSPARENCIES

In general, two types of film positives are used in photographic work: the line shot and the halftone. They both use orthochromatic film, such as Kodalith Ortho Film 6556, Type 3, or Kodak Reproduction Film 2566, Estar-based, which resolves all gray tones into either white or black with no gray values. This works well for type, lettering, and solid black areas or lines. When tonal values are needed, a halftone screen must be placed between the film and the light source.

The halftone screen is a grid of fine lines that breaks up the image into tiny squares, which are resolved into black or white dots of varying size, according to their gray value. The screens range in fineness from a low of about 45 lines per inch to a high of 350 or 400 lines, which is so fine that the screen requires specialized printing equipment to capture

the delicate detail. Generally, the artist-printmaker must work with a fairly coarse screen, from 65 to about 130, in order to get effective results on the relatively primitive equipment normally used in print workshops. The screen used can be a Kodak Magenta Contact Screen or a Kodak Gray Contact Screen. Close contact must be maintained between the film and the screen during exposure, and so the use of a vacuum film holder on the camera back is desirable. Screens are expensive and should be handled with care, as one scratch can ruin the ruled surface.

There is a product called Kodalith Autoscreen Ortho Film 2563, Estar-based, which automatically produces a halftone dot pattern when it is exposed to a continuous-tone image, just as if a halftone screen had been used. It is normally produced in small sizes (up to 11 by 14 inches) and has a screen of 133 lines to the inch. The film will make a negative from a photo print, which can be enlarged to produce a positive for larger images. If a negative is used as the initial copy and is projected onto the Autoscreen film, it will produce a positive halftone image directly.

POSITIVE TRANSPARENCIES WITH AN ENLARGER

In some instances adequate positive transparencies can be made from normal negatives with a good condenser-type enlarger. The idea is to produce a transparency the same size as the image in the finished print. As photo enlargers are a good deal cheaper than copy cameras and are found in many school and home workshops, it makes sense to explore the

workings of the enlarger before buying a copy camera. Small photographic negatives can be enlarged onto Kodalith Ortho Film 6556, Type 3, up to the largest size the enlarger can handle. Remember, however, that 35mm and 2¼-inch square negatives lose sharpness when enlarged ten or more times. In any case, since a certain amount of detail is always lost and a sharp edge is difficult to achieve, use the best lens available.

The Kodalith film reproduces certain negatives better than others, depending on the importance of tonal values in the photo. Remember, all gray areas are resolved into black or white.

POSITIVE TRANSPARENCIES WITH A COPY CAMERA

A copy camera is the most efficient instrument for producing consistently good transparencies for photographic printmaking. Cameras vary in price and size. The smaller graphic-arts cameras start at about 14 by 17 inches and range up to units that can handle film 48 by 72 inches. The copy camera is sometimes so large that the back of the camera opens into a separate darkroom, where film can be processed while the material to be photographed is being changed on the copy board (located outside the darkroom).

The lens on a copy camera is called a process lens and is designed to photograph flat copy such as photographs or two-dimensional artwork. Cameras vary slightly, but most have a vacuum back that presses the film flat against the ground glass. The copy board, which holds the artwork to be photographed, also has a method (usually a vacuum) to hold the work flat against its clear glass.

Lighting, which is usually built into the camera, can vary from photo-flood lamps in older units to quartz iodine, pulsed zenon, and fluorescent tubes. Carbon-arc lamps are being phased out because of the toxic dust they produce.

To make a positive transparency:

1 Select the artwork, lettering, photograph, or other flat copy to be reproduced and place it on the copy board.

2 Adjust the lighting and focus the camera to the size of your final image.

3 Load the camera back with a sheet of Kodalith Ortho Film 6556, Type 3 (ISO 6-tungsten). The emulsion side of the film should face the lens when the back

The halftone dot breaks up the picture into thousands of black-and-white dots of varying size, depending on the density of the original tones.

To make a positive transparency, the copy to be photographed is placed in the vacuum frame of the copy camera.

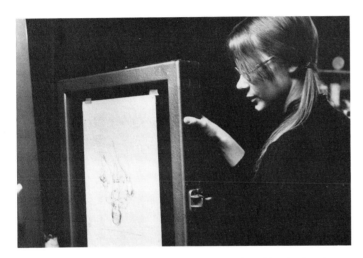

With the drawing sealed by the vacuum, the copy board is raised to the vertical position by Donna Moran at Pratt Institute in Brooklyn.

Two vertical rows of lights are adjusted to illuminate the copy. Focus can be checked on the ground glass. The lens opening has been set.

The film-holder back of the camera is lowered and the film is inserted, using a red safelight. Halftones may need several exposures, from a first flash exposure to the main exposure, and a final "bump" exposure. Follow Kodak's or other manufacturers' directions.

To produce a negative transparency: after exposure, the film is developed in Kodalith Liquid Developer; then put into a stop bath and then a fixer-hardener. It is washed in water at 70° for 10 minutes and hung to dry.

is closed. Use a Kodak lA red safelight. If necessary, make test exposures on the film for varying times and lens openings. When you know the correct exposure, shoot the film.

4 Remove the film (in a red safelight) and develop in Kodalith Liquid Developer for the time recommended on the package. Normally this is from 2 to 4 minutes with continuous agitation.

5 Lift the film by the corner, drain it for a few seconds, and slide it into a tray of stop bath for 10 seconds with vigorous agitation.

6 Put the film in the fixer for at least 60 seconds (less if you use Kodak Rapid Fixer). Leave the film in longer to remove any traces of unexposed light-sensitive material.

7 Wash in clean water, squeegee onto a glass or plastic sheet to remove excess water, and hang the film up to dry.

The positive transparency can now be used to place the image on an intaglio plate, a lithograph stone or plate, or a silkscreen.

A halftone letterpress plate from a commercial photo-engraver's shop is inked with a 6-inch plastic composition roller.

An impression from the halftone engraving is transferred to a litho stone with an 8-inch plastic roller. It could be transferred to an aluminum plate or a sheet of Mylar to make a positive transparency.

Photoetching

In general there are two approaches to photoetching a zinc or copper plate to prepare it for intaglio or relief printing. The first method involves sensitizing the plate yourself with a solution that will react to light. The second method involves buying a presensitized plate from a commercial photoengraver's supply house. The choice of methods depends on your location and the quantity of plates you consume. The self-prepared plates can be made whenever you want, and the chemicals have a shelf life of about a year. Unless you prepare the plate properly, however, the results may not be as good as with a commercially sensitized plate, where the uniform coating yields high-quality results. The commercially prepared plates, however, must be stored carefully, in a cool place, and should be used within a few months. The additional cost per plate is moderate.

SELF-SENSITIZED ETCHING PLATES

The materials needed to sensitize the etching plate yourself include:

Degreased zinc or copper plate
Kodak Photo Resist
Kodak Photo Resist Developer
Kodak Photo Resist Dye (blue or black)
Acetone and scouring powder
Webril Wipes or industrial cotton wipes
Kodak Photo Resist Thinner or lacquer thinner
Glass or vacuum table
Ultraviolet light source
Acid for etching
Hotplate

Some artists use another sensitizer called Rocky Phot-K with Rocky Phot-Green Developer. The process is similar for both products.

1 Clean the plate thoroughly with scouring powder, then acetone, to remove all greasy fingerprints.

2 Under a yellow safelight, put the plate upright in a stainless steel, glass, or porcelain tray. Stand it against a metal rack or brace.

3 Pour the KPR evenly over the plate, from the top. This chemical is formulated for pouring and will achieve the proper thickness on the plate this way.

4 Stand the plate upright against a wall to dry. Keep it away from all sources of ultraviolet light. Pour the excess KPR back in its container. Wash the tray with KPR thinner or lacquer thinner.

5 After 20 minutes or so (depending upon humidity), the plate should be dry. To ensure its dryness, you can heat it very slightly on a hotplate, still under safelight conditions.

6 The plate is ready for exposure to the positive transparency. Use a vacuum table or a sheet of glass to hold the film against the sensitized plate, and place the emulsion side of the film against the emulsion side of the plate. The exposure will vary depending on the source of

After the KPR coating is thoroughly dry, place the plate, face up, on the exposure table. Put your positive transparency on top. Use a vacuum table or a piece of plate glass to hold elements in close contact. Expose the plate with ultraviolet light.

To sensitize a plate for photoetching, pour Kodak Photo Resist fluid over the plate to form a thin even coat. Stand the plate in a glass or stainless tray to catch the excess for reuse.

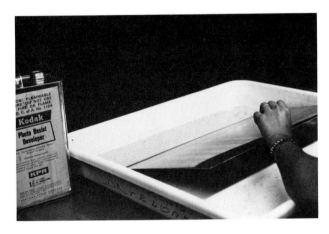

After exposure, develop the plate in KPR Developer for 2 to 3 minutes. Use a stainless tray. Some plastics are softened by the developer.

light. As ultraviolet rays do the actual exposure, refer to the following list of light sources, which goes from highest in ultraviolet to lowest.

Metal halide

Mercury vapor

Black light fluorescent

Carbon arc

Quartz iodine

Sunlamp

Photo flood

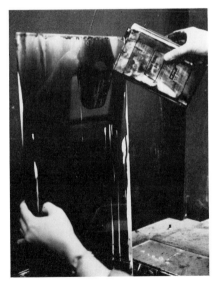

After developing, wash the plate in cold water. Pour on KPR Dye to make the image visible. Again wash the plate in running water and dry. Then heat the plate to 350°F for 5 minutes.

7 After exposure, develop the plate in KPR Developer for 2 to 3 minutes without agitation. Use a stainless steel or glass tray. Wash the plate in cold water.

8 Pour on KPR Dye to make the image visible. Handle the dye with gloves because it is very difficult to remove from hands or clothing. Let the plate dry.

9 Heat the plate on a hotplate at 350°F for 5 minutes to set the resist.

10 Etch the zinc or copper plate in dilute nitric acid (12:1). A copper or brass plate can also be etched in Dutch mordant. Ferric chloride is excellent for fine biting of copper plates, but the plate must be face down in the acid bath. (See the chapter on intaglio prints for more detail.) The resist can be removed when necessary with lacquer thinner, KPR Thinner, or Kodak Resist Stripper PR.

Etch the plate. It may be aquatinted or retouched first.

Note: The above procedures must be done in a well-ventilated room. The resist chemicals are extremely toxic, and continued exposure to them can cause liver or kidney damage and in extreme cases can be fatal. Local exhaust ventilation should be provided at the trays where the chemicals are poured so that the fumes are expelled directly to the outside without penetrating further into the room. Do not attempt to spray the resist or developer without an excellent ventilation system. And be sure to wear a mask suited for this operation. (See the chapter on health hazards.)

PRESENSITIZED ETCHING PLATES

Commercially prepared zinc or copper plates are available from Harold M. Pitman in Secaucus, New Jersey. The plates are made by the Revere Company. Stored in a cool, dry, dark place, they have a shelf life of several months. The following materials are needed for this process:

Presensitized zinc or copper plate

Presensitized developer (dye included)

Webril Wipes or lint-free cloth

Glass or vacuum table to hold film and plate

Ultraviolet light source

Acid for etching

Hotplate

1 Under a yellow safelight place the presensitized plate face up on the exposure table.

2 Position the film transparency on top of the plate, emulsion side down.

3 Put a glass sheet on top of film to ensure good contact; if using a vacuum table, close the glass frame and activate the vacuum.

4 Expose the plate to the light source (see previous method for a listing of good ultraviolet light). Exposure can vary depending on the intensity of the light and its distance from the plate. Make a test strip if necessary.

5 Develop the plate for about 3 minutes. The developer will wash away the emul-

Amy Berkov opens an exposure table at the Manhattan Graphic Center in New York City. It uses a slab of foam rubber to hold the film and plate together so a vacuum device is not needed.

An exposed presensitized plate is removed from the developing tank at Pratt Institute with a hooked metal strip as a holder.

sion that has not been hardened by the light, leaving those areas open for the acid to bite.

6 Flood the plate with warm water to wash off the developer. Dry with a lint-free cloth.

7 Heat the plate on a hotplate for 5 minutes at 350°F. The image will turn a darker color. Cool the plate.

8 The plate is now ready for etching in the acid bath. The resist has become a very hard lacquer compound. The acid used can be weak nitric acid if the plate is zinc or Dutch mordant if the plate is copper. Ferric chloride is good for fine etching of copper.

One of the advantages of this method is that the plate can be rebitten, even after it has been inked, wiped, printed, and cleaned. The lacquer resist withstands all the solvents normally used in the printing process, enabling you to re-etch the plate to deepen certain areas if desired.

The resist can be removed with GAF Metal Pyrolidone or lacquer thinner if necessary.

Photogravure

The fine-art method of photogravure can reproduce a tonal photograph on a copper plate with excellent fidelity to the gradations of values in the image. The plate, when etched, is printed by the usual intaglio process on an etching press. The following method, which uses sensitized carbon tissue, is described from notes taken during a discussion with Clinton Cline of the University of Colorado in Boulder.

The materials needed include:

Fine-grain negative

Fine-grain panchromatic film

Copper plate

Lye solution or pumice powder

Asphaltum powder

Hotplate

Carbon tissue paper

Potassium dichromate solution

Plastic or glass sheet

Rubber squeegee

Ultraviolet light source

Ferric chloride (in varying solutions)

Lacquer thinner

1 Select a fine-grain negative—a 4-by-5 is preferred, but a 35mm is acceptable.

2 Enlarge to the correct size on fine-grain panchromatic film, making a film positive.

3 Take a copper plate slightly larger than the film positive and clean it thoroughly with lye solution or fine pumice powder.

4 Dust the plate with very fine asphaltum powder to 50-50 coverage as in an aquatint.

5 Fuse the asphaltum to the plate on a hotplate or flame until the plate turns gunmetal blue. Cool.

6 In a darkroom, sensitize a sheet of carbon tissue paper in a 3 percent solution of potassium dichromate solution at 60°F for 3 minutes.

7 Still in the darkroom, squeegee the tissue on a plastic sheet until dry.

8 Prepare two trays of distilled water, one at 60°F, one at 75° to 80°F. Place the copper plate in the warm water (75° to 80°F) until it is warm.

9 To expose the carbon tissue, use ultraviolet light with the film positive in a vacuum table. A sunlamp takes about 10 minutes; stronger light sources, less.

10 Take the carbon tissue with the image on it and submerge it in the 60°F water. As it starts to curl, pick it up by diagonal corners and press it to the copper plate with a rubber squeegee.

11 Wait 15 minutes for it to dry. Put it back into 85°F water in a tray and move back and forth. Increase the temperature to 110° to 115°F. An edge of gelatin film should come up in a few minutes. Now peel off the backing sheet of carbon tissue. Keep water flowing to wash off the dichromate, but avoid a direct stream on the image.

12 Remove the plate from the water and dry it vertically for about 15 minutes.

13 Tape around the edge with masking tape. Protect the back of the plate with Contact paper (which is a plastic sheet).

14 Bite the plate in ferric chloride solution according to the following schedule:

 44° Baumé: 4 to 7 minutes
 42° Baumé: 5 to 6 minutes
 40° Baumé: 2 minutes
 38° Baumé: 1 minute

Check to see that highlights are not overbitten. Occasionally place the plate in full-strength ferric chloride at 48° Baumé to condition it.

15 Clean off the asphaltum with lacquer thinner.

16 Proof and print the plate in the usual way for an intaglio plate.

Collotype

The collotype process, patented in France in 1855, was perfected by Dr. Joseph Albert of Leipzig in the 1860s and has since been used very successfully for reproducing watercolors, drawings, and photographs. The process is also called heliotype, Albertype, Autotype, or Artotype.

This method of printing uses a plate made of sensitized gelatin, which, when exposed to light through a negative, hardens in direct relation to the amount of light to form a printing surface that reflects the tonal values of the negative. The fragility of the gelatin limits the number of proofs that can be pulled to a

ROSEMARIE BERNARDI
Base Lines: Large Cats/Small People
Photo intaglio, 24″ × 36″
Courtesy of the artist

EDWARD BERNSTEIN
House (diptych)
Photoetching and aquatint, 14½″ × 20″
Courtesy of the artist

few thousand at best. There is no artificial halftone screen—only the very finely reticulated surface of the gelatin.

A thin coating of gelatin that has been sensitized by either potassium or ammonium dichromate is poured over a grained aluminum plate (glass was originally used) to an even thickness. After the plate is dried in darkness, a photographic negative is usually used as the image source and is placed on top of the gelatin. When light passes through the negative, it hardens or tans the sensitized emulsion in direct relationship to the amount of light. The plate is developed by soaking it in water mixed with glycerin and ammonia for as long as 30 minutes.

The hardened or tanned areas of the plate resist the water, while the unexposed portions swell according to the amount of light received; that is, more light yields harder gelatin, which equals

darker tones. After the surface water is removed, the plate is inked with a roller that places ink on the hardened areas in a full range of grays. It can then be printed on a flatbed litho or rotary offset press. The surface must be very carefully handled because the gelatin is susceptible to damage. The principle is simple, but the process requires painstaking effort and control. Because of its idiosyncratic nature, the process is seldom used today. Some renewed interest, however, has been shown at the Visual Arts Research Institute at Arizona State University in Tempe, where they are investigating the characteristics of the Woodburytype process and the collotype, both photogelatin methods.

Helio-Relief Process

The helio-relief process was conceived by Donald Saff and developed by the Graphicstudio staff at the University of South Florida at Tampa, under the supervision of Deli Sacilotto. Using this method you can, with the aid of photographic silkscreen emulsion, place an image on a plywood block. The emul-

sion is adhered to the plywood under a safelight. Mylar separation negatives are hand-drawn from an original work by the artist, placed in contact with the dried emulsion, and exposed by ultraviolet light, which hardens the emulsion. The unexposed emulsion is washed off with water and the block dried. The block is then pressure-blasted with aluminum oxide grit, which cuts into the wood surface that is not protected by emulsion.

This process captures minute detail in high relief to an extraordinary degree. Special deepening and texturing of certain areas can be accomplished with normal woodcut gouges, chisels, and knives, as used by Philip Pearlstein and assisting technicians at Graphicstudio on his work *Jerusalem, Kidron Valley* (see page 47). The blocks are then treated with urethane varnish, inked with rollers, and relief-printed on a litho press.

Copier Art

The growth of copier technology in the past twenty years has attracted many artists who like the ease and rapidity of

image reproduction by these machines. Among the artists who have used the copier to create distinctive and unusual images are Antonio Frasconi, Sonia Sheriden, Joan Lyons, Thomas Hovorka, Judy Levy, Karen Lightener, and Keith Smith.

The initial concept of the copier as a business tool is what motivated Chester Carlson to develop the process, in 1938, for the Haloid Company of Rochester, New York, a forerunner of the Xerox Corporation. Other companies introduced similar processes, including RCA (then the 3M Company), IBM, and Eastman Kodak. The acceptance of the new process was universal, and now many manufacturers in this country and Japan make highly sophisticated copiers that can be found in virtually every factory, library, office, and industry in the United States.

The copier relies on static electricity and photoconductive materials that conduct electricity in the dark and lose the charge when struck by light. The resultant image is then dusted with a powdered ink toner and is transferred to a sheet of paper by electrostatic charge from the back. This image is permanently fused with the paper by heat— giving sense to the name *xerography*, from the Greek word *xeros*, for "dry," and *graphos*, for "write."

Copying machines offer the possibility of experimenting with a variety of imagery. Drawings; photographs and slides; magazine and newspaper reproductions; and collages of leaves, labels, tools, keys, coins, gadgets, and a multitude of other materials can all be duplicated by these obliging machines. The images can be printed on paper, plastic, or plywood; transferred to fabric, Masonite, or particle board; assembled into constructions, books, posters, or brochures; and sewn on pillows, quilts, sheets, or clothing.

In general, copiers are designed for specific functions. Some machines duplicate black-and-white high-contrast images, such as typed or printed characters; others are better at tonal images, such as photographs or drawings. Some duplicate color images. Some are fast; others are slow. Some can enlarge or reduce copies; others cannot. There is no single machine that can copy all the different types of images that the public demands, and thus a great variety of copiers are made by many companies throughout the world. We will describe several of the most popular machines.

An Egyptian goddess/queen is conjured up.

plate XIV

AUDREY FLACK
An Egyptian Goddess/Queen Is Conjured Up,
1986
Lithograph with letterpress, 27″ × 18¼″
Printed by Joseph M. Segura and John Risseeuw
Visual Arts Research Institute,
Arizona State University

BLACK-AND-WHITE COPIERS

The copier has the capacity to print a rich black that some artists prize as being denser and stronger than the blacks possible with lithography. Most images are permanent, depending on the quality of the paper and the process.

Xerox 1090 This high-speed copier is suitable for volume printing as well as single-copy duplication. It is a high-contrast machine, good for type and black-and-white line copy only. It is not designed to reproduce photographs or tonal images with any fidelity.

OCE 1725 Made by a division of Ricoh, a Japanese corporation, this copier is suitable for single-copy duplication and low-volume production. It yields good

reproduction of tonal images, such as photographs and modeled drawings.

Kodak Ektaprint 250 This machine prints black-and-white copy only at a very high speed approaching that of a slow offset-lithograph press. It is designed for high-volume production.

Daito SZ-920 This copier prints black-and-white copies up to 42 inches wide by virtually any length that will fit on a roll of paper. It will enlarge or reduce images and is designed to duplicate large drawings and plans.

Shacoh 920 Like the previous machine, this copier makes large copies on paper 42 inches wide by any manageable length on paper, polyester film, vellum, tracing paper, and so forth. It enlarges and reduces in black-and-white only.

COLOR COPIERS

The permanence of the color toners used in some machines is poor, and fading or discoloration occurs after a short time or upon exposure to light.

Xerox 6500 Color Copier One of the standard production copiers in the color area, this machine has been responsible for many artists' experiments in past decades, although it is now considered a dinosaur by some. It uses three primary colors, with stable dyes, which are all fairly permanent when placed on good paper. It does not enlarge or reduce and prints on an 8½-by-14-inch sheet of paper; it is slow, but relatively cheap to operate.

Canon Color Laser Copier This highly efficient duplicator of color originals can reproduce slides and negatives, distort images by elongating or shrinking one dimension, and enlarge by 400 percent or reduce to 50 percent on 14-by-17-inch paper. It has good color controls and produces an amazingly accurate reproduction of original art. Problems with this machine include a high initial cost and frequent maintenance requirements.

3M Color in Color This copier, one of the initial successes in color copying, produces images in less than 60 seconds. Some have been transferred to cloth and others joined in sequential images to make mural-sized presentations, overcoming the handicap of the 8½-by-11-inch size. Unfortunately, the color dyes are not permanent, and fading or discoloration has been common.

Sharp CX 500 This color copier requires special coated paper. It enlarges to 400 percent in 2x increments. It will handle an 8½-by-14-inch sheet of paper, but the largest printable image is about 8½-by-11-inch.

Other copiers are made by such manufacturers as Mita, Savin, Itek, and IBM. Each machine should be analyzed for its function, efficiency, and suitability to the demands that will be made upon it.

Diazo Printers

In this method of printmaking, which has dominated the blueprint field and also been used by artists for some years, the paper is pretreated with diazo sensitizers, exposed with ultraviolet light passing through transparent or translucent positives, and developed by anhydrous ammonia vapor. Other reprographic systems using toxic chemicals such as ferricyanide are disappearing because of strict Environmental Protection Agency regulations against the careless disposal of the waste material from these processes.

The blueprint, brownprint, and related methods produce an image that fades rapidly in strong light and grows weaker with time. Because most of the commercially available paper has a sulfite pulp base, it turns brittle in a short time and has a very short life. There are more durable supports with a longer life, such as Mylar or an aluminized glossy stock called Technifax, which has a clear polyester surface, but as the diazo image is not an archival image, the process is being supplanted by copier prints. These now reproduce drawings 42 inches wide by virtually any length with permanent black toners that do not fade.

Other Imaging Systems

There are a number of other systems for producing multicolor images using photographic techniques. They require negative transparencies and are proprietary processes, which means that each can be used only with the chemicals and materials supplied by the manufacturer.

Letrachrome, for example, uses light-sensitive color inks that are applied to a special paper. After the negative is exposed to ultraviolet light, the paper is developed in water to wash out the unexposed areas. Many colors can be applied to the same paper to achieve overprinting effects. Letraset's INT process uses its own light-sensitive paper and needs a special developer. Only one color per sheet is possible. Dynamark, Omicron, Color-Key, and Chromatec are similar photo-imaging systems, used by graphic artists and available from art-supply stores that cater to this industry.

9 Computers and the Print

JEREMY GARDINER
Physician, **1986**
Iris 2044 ink-jet printer, 30″ × 22″
Courtesy of the artist

The recent development of the computer as a tool for the generation of visual images has attracted many artists looking for new directions. The computer's unique ability to combine or transform a variety of images into fresh visions makes it an exciting new medium for designers, painters, and printmakers. The machine can assimilate photographs, drawings, video images, and other material into its circuitry, where they can be elongated, expanded, fragmented, repeated, colored, recolored, given dimension, rotated, and otherwise restructured. These effects can be stored on disk and considered later for additional alterations without the earlier versions being destroyed. Realistic as well as abstract images can be achieved, often in seconds. From the first graphic images done by Ben F. Laposky with his "oscillons" in 1950 to the complex motion-picture sequences of *Star Trek II,* the varied possibilities of the computer in the hands of the creative artist are emerging.

One of the initial problems with computer-generated images was translating the image from the screen into a printed form. Visual effects were spectacular but could be captured only by videotaping or photographing the image, either directly from the monitor screen or by using an internal film recorder. Now there are programs available that will color-separate images for photographic methods, and there are printers that will place the image on paper directly from the computer. The cost of the equipment at first was staggering but today has come down to a level where individual artists can afford the necessary basic hardware.

Basic Hardware

The artist has a wide choice of computer equipment suitable for graphic or visual expression. *Hardware* is defined as the physical elements of a computer system, such as the central processing unit, keyboard, monitor, and printer. The computer's capacity to run sophisticated programs on high-resolution monitors rests in the power of its memory chips, which is measured in bytes, a unit of data capacity. One byte is a group (usually 8) of bits necessary to represent a letter, number, or symbol. A kilobyte (K or Kb) is a unit of computer memory equal to 1,024 bytes, which is often rounded off to 1,000. A megabyte (M or Mb) is 1,024 kilobytes, or 1,048,576 bytes, which is often rounded off to 1 million.

Bytes are measured in two areas of the computer. The first is RAM (random-access memory), which is the memory in a chip that uses or temporarily stores or manipulates data or programs. This data will be lost if the computer is turned off or if a copy is not made on a disk—a flat plate coated with magnetic material that stores computer information for future use. Certain software may need more RAM than the computer hardware normally supplies, but this can be overcome by adding expansion cards. These cards can add memory or speed and act as bridges to the printer and monitor.

The second memory in a chip is ROM (read-only memory), contained in the central processing unit, whose data cannot be altered or lost when power is shut off.

CENTRAL PROCESSING UNIT

Some computers and their related software have been designed with the needs of the visual artist in mind. Apple's Macintosh computer, for example, was designed with strong consideration given to desktop publishing and graphics. It has an impressive ability to manipulate type and black-and-white images, considering its low cost. The Commodore Amiga, another economical computer, has a color monitor and a good desktop publishing capacity, although its software does not have as broad a range as the Macintosh. The IBM PC is a more powerful computer than the other two machines and can support sophisticated color and graphics programs; moreover,

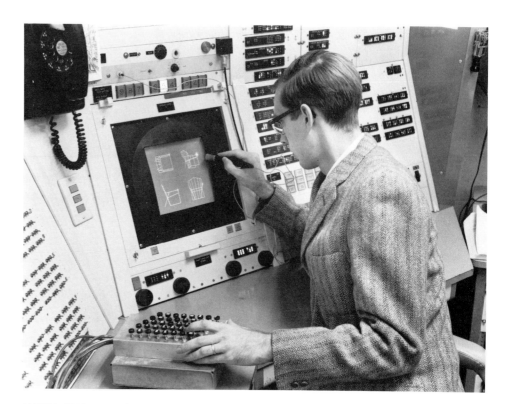

At MIT in 1962, Ivan Sutherland, working on his doctoral thesis, built one of the first interactive computer graphics systems. The user could draw on the screen with a light pen. Then, with a push of the buttons, various drawing functions refined the image. (Reprinted with permission of Lincoln Laboratory, Massachusetts Institute of Technology, Lexington, Massachusetts.)

there is a long list of compatible machines that can function off software designed for IBM, including the Compaq computers.

MONITORS

The major concern in choosing a monitor screen, which displays the images and calculations of the computer, is its resolution, which is measured in pixels. A pixel is a picture element or point of light that is the smallest unit of an image on a video monitor. A basic monitor for business and financial use may have a resolution of 640 pixels across and 400 pixels down, or a 640 × 400 screen. A color or graphics monitor may need a higher resolution for better detail.

There are other factors to consider in choosing a monitor. One is the measurement in dpi (dots per inch), which indicates how tightly the pixels are packed on a 1-inch line. For black-and-white screens there is a choice of two configurations: one shows only black or white pixels, while the other can depict from 4 to 256 tones of gray. For desktop publishing monitors there is a choice of several proportions, such as "landscape" (horizontal) or "portrait" (vertical); landscape can present two pages side by side and portrait can present only one.

Color monitors are made in two systems, either RGB (red-green-blue) or composite. Composite tends to be less expensive because it uses only one signal to create colors while RGB uses three signals, which merge to form hues and tints. RGB monitors are either digital or analog, with digital screens limited to specific colors and analog screens allowing for a wide spectrum of colors.

HAND-HELD CONTROLS

The usual package purchase of a computer includes only a mouse as a drawing instrument. A mouse is a hand-held pointing device that can move the cursor (an on-screen indicator or location figure) by being rolled over a flat surface, such as a desktop. The cursor can indicate functions or show the progression of an on-screen activity. The mouse is a rather primitive tool for an artist, however, and a graphics tablet with a stylus allows greater flexibility and more con-

trol in drawing or painting on the monitor. The graphics tablet can act as a support for a sketch to be digitized with the stylus.

VIDEOGRAPHICS AND WORKSTATIONS

Personal computers can be upgraded to higher-end videographic capacity by the use of specialized boards and software. The board is inserted into a slot inside the PC to add more graphics ability, such as higher resolution, color video capture, color manipulation, and the capacity to support more sophisticated software. Presently the Truevisions Targa 16 video board run by TIPS software is an excellent example. This system can manipulate digitized images and create graphics with drawing functions or combine the two with impressive ease.

The sophistication of work done on personal computers has encouraged workstation manufacturers, formerly associated only with mainframe and high-end interactive graphics applications, to build computers that bridge the gap between PCs and mainframes. Workstations are designed specifically for graphic manipulation in two and three dimensions. Presently there is no unified computer language for many of these systems, which include those made by Sun Microsystems, Apollo, Tektronik, and Digital Equipment Corporation.

At the top of the line are Cubicomp and Quantel Paintbox. Cubicomp's Picture Maker system for three-dimensional modeling has been chosen by several university art departments for its modeling and rendering capabilities as well as for its affordability.

IMAGE PROCESSORS

Imagery can be input into a computer by drawing on a digitizing tablet or by drawing with a mouse. However, there are also other methods of input, such as videodigitizers, scanners, and OCR (optical character recognition) software. All these systems, in one way or another, translate images into electronic codes that the computer can store on a disk or translate back into the image on its monitor.

With the proper software, almost all computers can accept video information. A TV camera, with the aid of programming, can thus act as a videodigitizer, translating three-dimensional forms into

BECK AND JUNG
Box Bus I, 1986
Computer-generated lithograph, 27″ × 20″
Courtesy of the artists

input. When acquiring a digitizer, it is best to get a lens with greater resolution instead of one with sophisticated features. Most black-and-white TV cameras will record 300 lines per inch, whereas most color TVs can resolve 250 lines per inch. Since software may require more than 25 seconds to scan an image, a tripod or copy stand is required.

Scanners generally achieve higher resolution with flat art. They input information into the computer in two major ways. One type is a hand-held or table-top model that digitizes tones of gray and color. Another system, often using the same hardware but different software, inputs characters through a stored template of type. Called optical character recognition, this system is used to translate type-

written documents rather than graphic images.

Three different inexpensive styles of scanners are hand-held scanners, fixed-position copy-stand scanners, and ThunderScan. Hand-held scanners with a resolution of 300 dots per inch are passed over the images to be digitized. Software for these scanners allows further manipulation of the images. Fixed-position copy-stand scanners can scan objects up to 1 inch high, so that small packages and other objects can be digitized into the computer. ThunderScan, designed for Apple II and Macintosh computers, replaces the ribbon in an ImageWriter printer, where it scans the image with a resolution from 72 dpi to 188 dpi. The software permits a range of functions, including magnification of the image up to 800 percent or a reduction to 25 percent of the original size.

Although more expensive than the hand-held models just described, table scanners deliver faster results. Some can even scan in color.

SIMONE BERGER
Untitled (tryptich), 1989
Computer screen print (water-based ink)
Created at Cooper Union School of Art,
New York
Courtesy of the artist
A Polaroid photograph was fed into a Macintosh
computer with a scanner and manipulated.
Kodaliths were made from a printout, exposed
onto a sensitized screen, and printed in two
colors with water-based ink.

OUTPUT DEVICES

Although making prints from a com-
puter will be discussed in more detail
later in this chapter, it should be noted
here that there are two basic ways to
transfer a computer image from a
monitor to a printmaking medium. The
first is with a computer printer, which
comes in several forms: daisy-wheel
printers, dot-matrix printers, pen plot-
ters, ink-jet printers, thermal printers,
laser printers, plus a few others. Many of
these printers are designed for business
letters or black-and-white desktop pub-
lishing. Good color printers are at pres-
ent quite costly. The inks and dyes used
in many colors may be impermanent.
Pen plotters and ink-jet printers have fre-
quently been experimented with because
of their ability to take wear and tear and
produce strong color images.

The second way to capture a computer
image is by taking a photograph, either
directly from the monitor screen or from
an internal film recorder. The negatives
or slides can then be made into positive
or negative transparencies for use in pho-
toetching, photolitho, or photo-screen
printing techniques. Although much of
computer technology today is designed
for commercial artists or graphic design-
ers, fine artists can adapt the methods to
their own needs.

Software

Software consists of the instructions in
computer language that tell the com-
puter what to do. These instructions
control the programs the system will run.
The matching of software to hardware
depends on the computer's capacity to
handle the demands of the software.
Software is usually contained in a hard
or floppy disk that is inserted into the
computer.

There are many software programs of
particular interest to the visual artist.
Such programs include desktop publish-
ing (the layout of type and pictures),
paint programs (drawing and color), and
CAD (computer-aided design for archi-
tecture and drafting). Many other types
of software are available, for animation
and music, but we will concentrate on
still images only.

DESKTOP PUBLISHING PROGRAMS

These programs make it possible to pro-
duce booklets, brochures, newsletters, or
small books with a professional ap-
pearance. Page processors let the user
design and lay out complex pages with
text and images together. One of the
most popular software languages is
PostScript, developed by Adobe Systems;
it offers a wide range of type styles and
can handle a variety of images on many
pages. The artist using a desktop publish-
ing system must be careful to check that
each program in it is compatible with
the other word processing or graphics
programs necessary to complete the
publication.

One software system for desktop pub-
lishing is Professional Page, designed by
Gold Disk for the Amiga computer. It is
one of the few programs that can pro-
duce color separations, which are used
for making printing plates. Professional
Page can also support fine-detail
PostScript laser printers and color ink-jet
printers. Documents in a wide range of
text file formats can be entered into the
system. Graphics can be incorporated
from videodigitizers, paint programs, op-
tical scanners, CAD, and other formats,
making Professional Page a powerful pro-
gram. Color separations can also be ac-
complished with this software.

Another software system is Pagemaker
by the Aldus Corporation, which has
evolved from the first desktop publishing
program for the Apple Macintosh com-
puter. It has built-in graphics and is a
comparatively low-cost system. Page-
Maker is also workable on IBM and its
compatibles. Page layout can be con-
trolled with predesigned templates, or
new templates can be created and stored.
Columns of text can be filled with great
speed from an Autoflow function that
automatically fills each column on 128
pages if needed. Text can also be
wrapped around or placed on top of im-
ages or charts. Images can be rescaled,
and the text will conform to the new
layout. Scanned images can have their
contrast changed with a simple com-
mand. PageMaker can be used with a
wide choice of printers, from the Im-
ageWriter dot-matrix printer or a
PostScript-compatible laser printer to an
advanced Linotronic typesetting system
from Linotype that can deliver 2,540
dots per inch.

The Ventura Publisher system by Xerox Corporation is the most popular desktop publishing system for the IBM PC and its compatibles. It is a sophisticated system, better suited for long documents than short, and allows for great exactness in page layouts. It can accept many graphic programs and prints out on a wide range of printers. In addition, color separations can be accomplished on the latest version of Ventura. The user should be knowledgeable about typesetting and page design in order to get the best results from this software.

Other software suitable for desktop publishing includes Ready, Set, Go! by Letraset and PFS: First Publisher by Software Publishing Corporation, for inexpensive, one-color publications.

Although computer printers can produce crisp printed materials, the duplication of a large number of copies is often delegated to an offset press or high-speed copier, particularly when black-and-white copies are needed. Smaller numbers in an edition can be printed on a laser printer.

PAINT PROGRAMS

These programs have lured many artists to explore the possibilities offered by computers. Using a paint program the artist can create images on the computer screen with a mouse or a stylus. Rectangles and circles can be drawn, elongated, and altered; perspective can be achieved; images can be "cut" and "pasted"; patterns can fill an area. Dazzling colors and tones can be produced instantly on the monitor screen from a menu of colors and textures, and then changed with great flexibility. Some programs have airbrush-like functions for coloring and overprinting. On the more expensive systems, photographs can be placed into the computer's memory. Video images can be read, stored, and released in certain machines.

MacPaint and MacDraw, the first graphics programs from Macintosh, helped to establish the company's leadership with their easy drawing and filling capacities. The MacDraw system allows the artist to see an image being scaled up or down.

Deluxe Paint II, developed by Electronic Arts for the Amiga, Apple II GS, IBM PC, Atari, and other computers,

lets the artist manipulate many visual effects, including perspective, repeat patterns, rotation, enlarging, reducing, and so forth.

Deluxe PhotoLab, also by Electronic Arts, even offers a solution to the problem of color separation for printing. Most paint programs control color through the three primary colors of light—red, green, and blue. These color tints, hues, and saturations can be indicated. Deluxe Photo Lab is unusual in having a function called Separate. It separates magenta, cyan, yellow, and black and, through a "Make Black-White" function, presents each color in black and white, which allows art to be prepared for use in another print medium (such as lithography or screen printing).

Printmaking assisted by a paint program Thomas Porett created a computer print titled *Counterpoints* in 1988 by first

videodigitizing photographs of dancers into a Commodore Amiga computer. Once in the computer, the images were manipulated further with Deluxe Paint II, and printed on a Xerox 4020 color ink-jet printer. Color separations were made and the final image was offset-printed on a Heidelberg offset-litho press with the collaboration of Chuck Gershwin. All of this work was done at the University of the Arts in Philadelphia.

Porett's Amiga computer was able to handle 2.5 megabytes of RAM, which was enough to assimilate about 1 second of dance in the Live! digitizer capture mode, or twenty-seven frames of video

MEL ALEXENBERG
Corporate Angel, 1988
3-plate color etching and aquatint, 30″ × 22″
Courtesy of the artist
A Rembrandt drawing of an angel was digitized and elongated using an IBM-PC with Lumina software.

THOMAS PORETT
Counterpoints, **1988**
Detail of overprinted proof from
Xerox 4020 ink-jet printer
Courtesy of the artist

imagery with a screen resolution of 320 x 400 pixels in thirty-two colors. These images were stored on a floppy disk and reviewed with individual frames selected for transfer as files on another disk. Next, these images were reworked and simplified on separate disks for use in a montage of dancers, which was then assembled into the Deluxe Paint II program. After many attempts at "cutting and pasting," the images were made into "brushes" as a method of storing each element. (The brush is a rectangular area that can be copied from any image on the screen. A brush can be shrunk, rotated, flipped, put into perspective, or bent around a cylinder, among other effects. Porett used the brush as a way of saving disk storage space when making color maps of an image.)

Another dance session was photographed with a 35mm camera, and the resultant color prints were assembled into a collage, then digitized. With this visual information combined into an assemblage from the first digitized group, and with sets of images overprinted to increase the complexity and develop the idea of sequential motion, the final motif took shape as a dual image. The print was designed in two horizontal strips of 400 x 700 pixels butted next to each other and then overprinted with another image of the same size. The ultimate image, which was 8 ½ inches high by 27 inches long, was printed on a Xerox 4020 ink-jet printer, taking 25 minutes to print one copy.

After this computer-printed copy was produced, Porett then experimented with printing the image by offset lithography. At the time the printing was done, there were no inexpensive color separation systems available. However, the print was completed after much experimenting by Chuck Gershwin. Afterward they learned that the Deluxe Photolab software would have saved countless hours of color separating.

COMPUTER-AIDED DESIGN (CAD)

These programs offer the artist tools for modeling and drawing plans, elevations, sections, and simulations of three-dimensional structures. Forms can be manipulated in space as wireframe models or structures. A wireframe drawing describes the edges of a form with lines while leaving the surfaces open. CAD is virtually indispensable for architects and interior designers because of its capability for precise drawing and rendering. Software programs for CAD are available for most computers, with Auto-CAD, produced by Autodesk for IBM, serving as a standard for the industry. It is a powerful program that runs more smoothly if the computer has a hard disk for greater data storage. It makes drafting and manipulating a form in space clear and precise.

Printmaking assisted by CAD In 1984 Frank Stella was working on a series of prints that were, in part, aided by an Evans & Sutherland Multi-Picture System computer at the New York Institute

of Technology. A CAD program designed by Michael McDermott and Michael O'Rourke was used to create wireframe drawings that simulated three-dimensional imagery. The wireframe form could be seen on the computer in six different points of view and then elongated, modified, and transposed. Stella's creative process alternated between two-dimensional surfaces made of Styrofoam and paint or computer printouts to three-dimensional models made of wood and cardboard or metal reliefs. The computer screen and its CAD printouts acted as a transition between flat art and sculptural variations. This changing from two-dimensional to three-dimensional imagery could continue as long as needed to crystallize the forms into a print.

Parts of Stella's *Giufà e la berretta rossa*, in the early stages, consisted of a low relief made of Fome-Cor with stripes painted on the surfaces to emphasize the dimensionality of the volumes. A photograph was taken, and the shapes translated into a CAD drawing. The two-dimensional cones and cylinders then became a computer wireframe drawing, which could be manipulated on the computer screen. A fully dimensional model made of balsa wood, archival cardboard, and Styrofoam was constructed by using a 24-by-30-inch printout as a working plan or blueprint. This model could then be fabricated into large metal reliefs. The computer was used to compare and refine shapes for possible variations. The final image was printed out by the computer on an 11-by-14-inch sheet of paper. Stella drew on this printout before the image was enlarged by photography and exposed on magnesium plates for etching and proofing. The plates were then jigsawed so that the inking could be controlled. The proofs were often recollaged to make new designs, and a new plate would be jigsawed from two or more of the original plates. This process gave birth to many offshoots and variations, which the artist was able to use for other projects, store for future use, or reinterpret.

These images show the development of Frank Stella's *Giufà e la berretta rosa* (page 297). On the top left is a photo of a three-dimensional cardboard model of the shapes. Below it is a Styrofoam model to which black-and-white printed elements have been adhered. A photo of this model was used by the computer programmers to create the wireframe drawing shown below right, in which the shapes are seen from the front and tilted to the left. The image above right is a wireframe computer printout reworked with a pen by Stella and chosen by him to be enlarged and exposed onto the magnesium plate.

Printing from Computers

Computer printers as a direct source of fine-art prints are still so new and undeveloped that their potential is virtually unmapped. At the moment the needs of the artist-printmaker and the capacities of current computer printers do not mesh perfectly. Some artists are concerned about permanency of colors and archival quality of papers, and this prevents them from embracing computer printing technology. However, the rapidly expanding industry may offer new developments and procedures that can be incorporated into the fine artist's world. Ultimately the computer's capacity for fine art depends on the artist, not on the limitations of the machine.

Instead of the conventional matrix used in etching, lithography, woodcut, or screen printing, the computer delivers a sequence of coded electronic information and the artist has little chance to control the process by hand, the traditional way of making art. Some artists have been using the computer printer as a device to separate colors or to produce camera-ready art. Then they make positive or negative transparencies that can be incorporated into an older printmaking method, such as photoetching or photolithography. Many computer printers can print on Mylar or acetate, which allows data to be enlarged by projection on a screen. This technique can also be used to prepare negative and positive transparencies.

Another possibility is to substitute the liquid tusche or autographic ink used in lithography for the ink in the jet nozzles on plotters and printers. The image can be placed on transfer paper, which can, in turn, be fixed to a stone or plate for lithographic processing and printing.

CHOOSING A PRINTER

One difficulty for the artist is choosing an appropriate printer. Daisy-wheel printers are designed for type characters and are generally too crude for graphic images. Dot-matrix printers work by impacting small needles or pin heads to form an image or character. The 24-pin printer has the greatest clarity. Overall, however, the pattern of the needles leaves evidence of this type of printer.

Thermal printers are related to dot-matrix printers in having a pin system. While the dot-matrix printer drives a pin

to a ribbon and then onto the paper, the thermal printer heats a pin that melts a waxy ink from a ribbon onto the paper. Thermal color printers produce colors that are more vivid than those from dot-matrix printers, particularly for low-cost systems. Indeed, the color intensity from thermal printers rates among the strongest of all color printers. The drawbacks include questionable colorfastness and the necessity for special papers for each machine. Okidata makes an inexpensive machine, while Cal Comp, Mitsubishi, and QMS produce some of the finest higher-resolution printers.

A fourth type of printer is the ink-jet, which fires ink through miniature nozzles. Although the printers are sturdy, the nozzles sometimes clog. However, ink-jet technology is currently producing images that approach laser-print quality, the standard for mid-priced printers. Sharp's JX-730 color ink-jet printer has a resolution of 180 dpi and is said to be able to accept plain paper, unlike other color printers. Printers that can handle large images are ink-jet printers such as 3M's Scanamural and the pen plotters.

The laser printer is an electromagnetic printer similar to a copier. The laser printer draws on a negatively charged drum. Wherever the laser hits the surface, it becomes receptive to the toner ink. The drum rotates and comes in contact with positively charged paper. The toner is transferred and fused with heat and pressure.

Black-and-white laser printers, currently the desktop publishing standard, have a resolution of 300 dpi. A hairline is a good way to evaluate the number of dots per inch. A hairline is the thinnest line that can be printed, and on a Macintosh screen that would be $\frac{1}{72}$ inch wide. The Laserwriter by Apple prints a line that is $\frac{1}{300}$ inch wide, and the Linotronic 100 prints a line $\frac{1}{1270}$ inch wide.

When evaluating desktop publishing printers, remember that these units are

not designed for high-volume production or long printing runs. This need can be better met by offset lithography or electrostatic copier technology. In addition, desktop publishing printers usually sacrifice the clarity of a graphics image for the sharpness of the text type. Most artists want a printer with a large image capacity and control of the image rather than typographic detail.

There are also color laser printers, but they are currently about four or five times more expensive than black-and-white ones. QMS is one of the leading manufacturers.

When color plotters came on the market in the 1950s, they were one of the finest means of recording a computer's image as hard copy. The artist Mark Wilson, for example, often uses a Tektronix flatbed pen plotter, which allows constant inspection and easy pen changes. Draftmasters by Hewlett-Packard is known for its reliability, while the Mutoh Industries F-910A accepts pen or pencil for its plots.

In the search for more direct printing methods, Isaac Victor Kerlow has made some experimental etchings by placing a hard-grounded etching plate on a pen plotter and replacing the pen with a sharp needle. The computer draws or plots through the wax ground before the plate is bitten in acid. This method has its problems, however, as the needle tends to catch on the surface of the metal as it moves over the plate.

This photo from the DEC VAX 11/780 computer screen shows the wireframe drawing for the construction of Kerlow's spiral in *Pyramid in Black and White Number Five* (opposite).

Yet another type of printer is the high-resolution image setter, which creates the black-and-white final copy by a photographic process that places the image on paper or film. The resolutions possible on some image setters are so high that they exceed the capacity of current printers. Outputs of 1,270 to 2,540 dpi are common. Gray tones have greater contrast on image setters than on laser printers; lights become lighter and darks turn blacker. The image-setting machines from companies like Compugraphic, Linotype, and Ilek Graphix produce the sharpest resolution possible in computer printers. These machines are used to produce camera-ready art; they are not designed for long print runs. As this book is being written, color image setters are being introduced by Intergraph and Monotype; both will produce color separations.

Photographing Computer Images

The image on a computer screen presents many artist-printmakers with color they have never seen: color coming directly from light. Transferring that truly luminous color to a print is difficult, so artists often display their images as Cibachromes, which are fairly permanent prints made from color slides. As noted earlier, the slide can be made directly from the monitor screen, or it can be made on a film recorder, which gives greater resolution and accuracy. (Matrix Instruments is one of the leading manufcturers of film recorders.) The TV tube in a film recorder permits fine control of the beam color and intensity, making the most precise slides and photos possible. Color separation of an image can be made with paint software and a film recorder or with primary color filters placed in front of a camera.

The possibilities of photographic translations of computer imagery can be seen in the print *Dialogue*, for which Myril Adler used a Mindset computer with a mouse, a PGS HX-12 monitor, and Lumena software. To create her color etching, she departed from the specific colors on the monitor. In the Lumena program's color-mixing selection, there is a random map function, which assigns random colors to each individual color area in an image. Adler chose a number of versions with varying contrasts in tonal areas. In addition to the random map function, the monitor also presents three primary color guns mixed on the screen and read as distinct textures of dots, lines, and patterns. Adler photographed different versions of her image from the monitor screen using a Data Cam 35 Minolta camera. (The Data Cam hood fits around the monitor to eliminate distortion of the image.) She then enlarged the 35mm black-and-white film to produce the final four Kodalith positive transparencies, which she exposed on Rocky Phot-sensitized copper plates and etched in ferric chloride. Adler then printed the intaglio plates using Daniel Smith etching inks with transparent white and linseed oil to complete her translation of the luminosity of the monitor screen into a color etching.

New Aspects of Computer Printing

The range of choices in computer printing is constantly expanding. Ideas such as the computer-controlled stencil-cutting machine for screen printing may facilitate printmakers' experimentation. Another example of the adaptation of commercial computer technology can be seen in the way Tom Wesselmann used a factory computer cutting tool to create multiple laser-cut drawings from thin sheets of steel.

One of the four plates used in Myril Adler's color print *Dialogue D IX* (page 298). The photo-etched aquatint contains a pattern from the differently colored pixels that were on the computer screen.

10 Paper for Prints

Of all the ancient techniques essential to printmaking, such as woodcut or engraving, none is so venerable or so unchanged as the art of papermaking. For almost two thousand years the essential principles of this craft have remained the same.

Origins and Development of Papermaking

Recently, the date for the invention of paper has been put back to 107 B.C., but traditionally credit is given to Ts'ai Lun, a Chinese eunuch in the court of Ho-Ti. This illustrious man used bits of waste fabric, tree bark, old rags, fish nets, and the like to produce the first sheets of true paper in the year A.D. 105. In any case, he was the person who first claimed official recognition for this event and is revered in China and Japan as the patron of papermaking.

The invention of paper spread from China to Korea and later Japan, about 610. It then meandered eastward to Persia, where a papermaking center grew up after 751. Eventually, the technique spread to Egypt and Morocco, and from there to Spain and Italy (exactly which

MARTHA ZELT
Another Time, 1985
Woodblock and collagraph printed on handmade papers with twine, wood, and fabric, 40″ × 30″
Courtesy of the artist

JOHN RISSEEUW
1987—Twenty years for the JMKAC!
Cast paper pulp with letterpress printing,
16″ × 21″
Courtesy of the artist

was the first is the subject of some dispute). The first Italian paper mill was not established until about 1276, in Fabriano, more than a century later than a similar mill in Xātiva, Spain.

European paper was made from different materials than Oriental paper, and the products were not similar. The Europeans used cotton and linen cloth and rags as the source of the fibers that were to be macerated, and when the sheet was finished it was sized with a gelatin solution made from animal hides, hoofs, and bones. The result was a tough, opaque paper that could withstand the scratching of the scribe's quill pen. In contrast, Oriental paper was soft, translucent, and rarely sized because it had to accept the calligrapher's brushstroke in an absorbent manner—and only on one side of a sheet. (Oriental papers are never used on both sides.)

At first the vegetable fibers were beaten by hand with sticks and hammers. This led to the development of stamping machines, powered by water, animals, wind, or people. These machines were first used in the Orient and appeared in Spain in 1151. Fibers were beaten by stamping machines in Europe until the invention of the Hollander beater in 1680 in the Netherlands. By the end of the eighteenth century, the Hollander had replaced stamping machines throughout Europe.

The actual inventor of the cylinder beater is unknown, so it is called a "Hollander" after the country in which it was first produced. It consists of a rounded wooden or iron tub, which on one side has a revolving rocker (at first made of wood, then metal). This rocker contains a series of knives or cutters that macerate and fragment the rags or fibers, which are suspended in water.

The demand for paper was so great that more and more mills began to operate. Wood pulp was suggested in 1719 in France by René Antoine Ferchault de Réaumur, who had observed wasps making nests of macerated wood filaments, and this caused other scientists and scholars to investigate all sorts of vegetation as possible sources of paper pulp. In Germany, Jacob Schäffer experimented, around 1765, with a large variety of materials, including wasp nests, moss, vines, cabbage stalks, and corn husks, as well as many types of trees. It was left to Matthus Koop of England to construct in 1801 the first mill to make paper commercially from fibers other than linen or cotton rags.

The hand-molded method of papermaking was incapable of producing enough to satisfy the burgeoning demand, and a papermaking machine, originally designed by a Frenchman,

Nicholas-Louis Robert, was developed by an English group. An engineer named Bryan Donkin, with the financial backing of Henry and Sealy Fourdrinier, patented and built a machine in 1803 that made paper in a continuous roll. The Fourdrinier name has since been associated with the earliest papermaking machines and their offspring.

With the advent of the newer techniques, papermaking began to expand in all the industrial nations. Paper collars and shirts were made and accepted by the public to the point that by 1870, one manufacturer was making 75 million a year. An amazing number of products were made of laminated paper, including coffins, furniture, bookcases, roofs of houses and churches (in Norway), trays, parts of carriages, drain pipes, and carpets. In most cases the paper was laminated, sealed with varnish or oil, and treated to make it rigid and waterproof.

KENNETH POLINSKIE
Nasty Urchins II, 1985
Artist-made paper with pigmented fibers,
41″ × 62″
Courtesy of the artist

Principles of Papermaking

The method of producing handmade paper has changed very little over the centuries. The basic ingredient of paper is the cellulose fibers that have been beaten or separated so that when mixed with water they form a pulp. These fibers are made from a variety of plant materials, such as wood, cotton, mulberry, bark, flax, and the like. The basic equipment consists of a mold, which is essentially a screen to catch the pulp, with a frame (or deckle) to prevent the pulp from running over the edge of the mold. The mold is dipped into a vat or basin of pulp suspended in water. If the mold is lifted out of the vat while in horizontal position, the fibers of the pulp will be caught in the mesh of the screen. With a shake or two, the fibers intertwine and a sheet of paper is formed. The deckle is removed and the fresh sheet is deposited ("couched") on a stack of previously formed sheets of paper interleaved with felt blankets. When the stack (or "post") is high enough, about 18 inches or so, it is placed in a press and any excess water is squeezed out. The sheets now can be dried, sized, and finished to achieve the desired smoothness and absorbency.

(Unsized paper is used frequently in printmaking, while sized sheets may be used for watercolor, drawing, pastel, pen and ink, and so forth.)

In commercial papermaking, the mold is in a machine that essentially consists of a cylinder and vat. The pulp is deposited on the revolving screen of the cylinder mold, and the sheet is formed with the fibers running mainly in the direction of the rotation. This means that the cross direction (against the grain) has a different strength and susceptibility to stretching than the long direction. Continuous rolls of paper are produced by sophisticated versions of the Fourdrinier machine.

The quality of the paper depends on the composition of the stuff that makes the pulp, not the way it is made. Cotton linters are used to make many papers called "rag" paper, and there is no technical reason why machine-made paper cannot be as long-lasting and printable as handmade paper. With the development of alpha pulp from cellulose fibers and the addition of buffering compounds to control the pH of the paper, it is possible to make archival sheets that will last indefinitely.

HAND MOLD

The basic tool in making paper is the mold. It is simply a porous screen made of cloth, wire, or strips of plant material, which molds the beaten fibers into a sheet while allowing the water to drain out from under. There are many ways to make a mold, depending on how long it is to last and how often it will be used.

Mold frame The basic support for the mold is a sturdy frame, usually made of mahogany, which can first be boiled in water several times, then dried slowly to prevent warping. Oak or maple maybe used, too. The size of the wood stock should be determined by the size of the frame. A good size is 23 by 33 inches, which uses $\frac{3}{4}$-by-$\frac{1}{2}$-inch stock.

The strongest construction uses dovetailed corners; ship-lapped corners, though used, are less durable. The corners are then glued with waterproof glue and should also be braced with copper or brass reinforcements, attached with flathead brass screws.

The underside of the frame should be rounded for ease of handling. To keep the mold cover (described below) from sagging, the frame should also have wooden ribs built into it. The ribs should be tapered with a plane or cut to fit on a circular saw and sanded. It may be possible to purchase wooden (even mahogany) shutter louvers, made to almost exactly the proper shape for a mold support brace from a local lumberyard or sawmill.

The supporting ribs can be attached to the frame in several ways. Drill holes with a $\frac{1}{8}$-inch bit into the inside of the frame $\frac{1}{4}$ inch deep. Drill corresponding holes into the ends of the rib. Fill each hole with waterproof glue and insert a $\frac{1}{8}$-inch round dowel as a peg, $\frac{1}{2}$ inch long. Also glue the ends of the rib into the frame. You may use a corrosion-proof nail (stainless steel, aluminum, brass, or

FRANK STELLA
Grodno (I), **from the Paper Relief Project, 1975**
Paper-pulp relief, collage, hand-colored, on white HMP handmade paper, 26″ × 21½″ × 1¾″
Produced and published by Tyler Graphics Ltd.
© copyright Frank Stella/Tyler Graphics Ltd. 1975
Photo: Steven Sloman

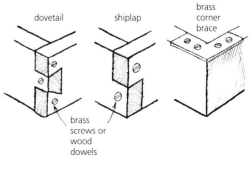

PAPER MOLD CONSTRUCTION

copper) as an additional fastener to the frame. If the ribs are longer than 10 or 12 inches, you may need to add a heavy copper bracing wire 6 or 8 inches, drilled through each rib.

The ribs should be level with the top of the frame to make a solid support for the mold cover. Note again that the ribs are tapered, causing a slight suction when the water drains out of the bottom, so the liquid pulp adheres to the cover.

Mold screen A laid mold screen has fine copper laid wires running in one direction across the frame, spaced from 20 to 50 wires per inch. Another series of wires, called chain wires, are at right angles to the first, spaced about 1 inch apart; they hold the laid wires in position. In contrast a wove mold has equally spaced wires running in both directions, like an ordinary window screen, only finer. It produces fine, even-textured paper.

The wove mold screen is much easier to make than the laid mold screen. Buy two grades of copper, bronze, or stainless steel screening, one a coarse no. 8 mesh and the other a no. 30 mesh. Cut the coarse mesh to fit the mold frame and stitch it to the supporting ribs and frame with very fine brass or copper wire, drilling tiny holes in the wood for this purpose. Now place the finer mesh screening on top of the coarse screen and sew it to the ribs of the frame. The screen edges should be covered with strips of

thin copper to keep the fine wire from catching the deckle or collecting any excess pulp.

The laid screen, which is more work, consists of two different meshes of wire. The first—a coarse screening—may be of even weave (similar to a wove screen). It is the second layer—on top—that gives the distinctive pattern to the paper. As already noted, it consists of copper wires (about 20 to the inch), running parallel to each other and at right angles to the ribs. They are held together by the finer chain wires. Both layers of screening are stitched to the wooden frame with fine copper wire through holes drilled into the ribs and frame.

Deckle The deckle, which fits on top of and around the edges of the frame, acts as a tiny fence to keep the pulp from running over the edge of the mold. It is what determines the actual size of the sheet to the wet pulp. It must be made with care and, as it takes a lot of stress, the corners should be well fitted and reinforced with copper angles.

WATERMARKS

Thin copper wires, either sewn or soldered to the mesh of the screen, will form a line of thinner paper, which can be seen when held up to the light. Such watermarks have been used for more than 700 years to identify the paper manufacturer. Watermarks are also used to distinguish sizes of sheets. Most serious papermakers have their own design cast into each sheet of paper.

Tonal watermarks Delicate modeling effects can be created in watermarks. First, wax (half beeswax and half paraffin) is melted and poured onto glass until

it forms a sheet about ¼ inch thick. A sculptor then carves delicately into this material to model the form of the portrait or other subject. The more wax that is removed, the lighter the tone. When the carving is complete, it is cast into plaster or copper by making an electrotype, which is backed with lead or a like metal as a support. To transfer the image, a wove screen may be embossed or pressed into the copper electrotype. Although this can be done by hand burnishing, sometimes male and female dies are made and the screen is then pressed between the two to form the image. Making tonal watermarks requires a high degree of technical skill; it is a technique used by many nations in printing of currency, as it is extremely difficult to counterfeit.

BEATER

Because of the high cost of a good Hollander beater, many substitutes have been tried. You can macerate linen or cotton rags in a mortar and pestle, using water to liquify the pulp, if you have lots of time and need only a few sheets of paper. An electric food blender will also work if it is fed tiny bits of linens or small scraps of good paper. You must, however, have lots of water and patience and be prepared to ruin the blender motor every so often. Washing machines, boat propellers, and a fascinating variety of other mixing devices have also been used as beaters.

The ultimate solution is a professionally made Hollander. They come in a variety of sizes, from 1 pound (dry weight of rags or fibers) up to 150 pounds and more. The cost is high, but then

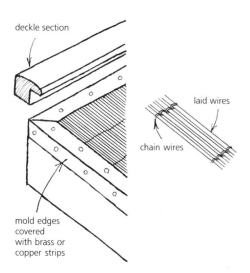

deckle section

laid wires

chain wires

mold edges covered with brass or copper strips

LAID MOLD CONSTRUCTION

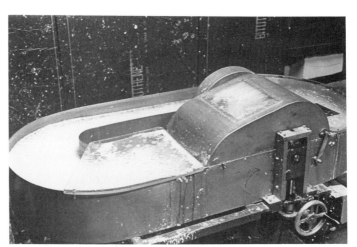

This Missassauga Hollander beater, designed and built by Helmut Becker for Pyramid Atlantic in Washington, D.C., is beating pulp made with cotton linters.

most good things are expensive. Essentially, the Hollander is an elliptical tank in the shape of a race track, with an electric motor–driven roller containing metal bars that macerate the pulp against a bed plate. The pulp moves in a continuous flow through the circuit, being forced under the roller and shredded into smaller and smaller fibers. Adjustments to the space between the bed plate and the rocker are essential.

VAT

A good-sized sturdy tub or basin is required to hold the liquid stuff or pulp. It must be deep enough to accept the mold when it is dipped in vertically; at the same time it must be large enough to accommodate the width and length of the mold without splashing and wasting the pulp when the mold is leveled and brought out of the vat. The vat should be set about waist high, so that the operator can work comfortably and efficiently.

The materials used for vat construction are varied, depending on conditions, costs, and availability. Present-day vats are usually made of wood, plastic, or metal. To make an inexpensive vat, you can use a large, reinforced plywood box, give it several coats of polyurethane varnish, and line it with heavy vinyl. Don't forget that water weighs almost 70 pounds a cubic foot; your construction must be strong enough to withstand the stress.

During the papermaking process, the water should be heated, not only for the vat operator's comfort, but because the water will evaporate faster and increase productivity. The pulp should be agitated often to keep the fibers in even suspension throughout. In a small operation, this can be done with a paddle or stick. Larger vats may have a mechanically driven agitator built in, originally called a "hog."

RAW MATERIAL

It is in the choice of material to be beaten, whether cotton, linen, wood, or plants, that the paper gets its basic quality. The basic component is cellulose and the length of the fibers is vital. They must not be too long or they will be irregular and wild. They cannot

be too short or the paper will lose its strength because the fibrils will not bond together to form a sheet. They must be well hydrated, and the fibrillated ends must interlock solidly. Synthetic fibers of nylon, rayon, polyester, and so forth will not fibrillate or absorb water and thus cannot be used.

Because cellulose fibers contain lignin and other chemicals that can discolor or destroy the life of the paper, the raw fibers must be cooked in a caustic solution. Some further treatments may be necessary, such as sizing, bleaching, dyeing, coloring, or the addition of calcium carbonate or other chemicals.

Cotton One of the most commonly used plant materials for paper is cotton, which is available in several forms. Cotton linter is made from seed hair of the cotton ball after the long staple fibers have been removed for making cloth. It is made in two cuts, which can be used for sheets or cast-paper sculpture. It can be obtained ready to use as wet, beaten pulp in pails or as unbeaten linters in sheets or bales. Cotton rags, which make very long-fibered, strong paper, come from cloth cuttings. They can be purchased as ready-to-use pulp or as half-stuff, or half-beaten pulp, requiring beating in a Hollander. Raw cotton is also available, both cooked and beaten (ready to use) and uncooked and unbeaten. It makes a strong paper.

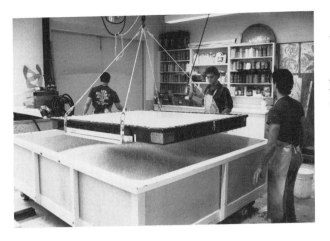

A large mold is lifted from the vat by a motorized hoist at Tyler Graphics.

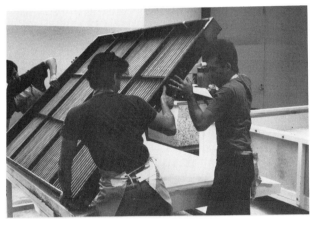

Paul Imboden, Tom Strianese, and Jim Lefkowitz (left to right) couching a newly made sheet of pulp onto couching table at Tyler Graphics' paper mill.

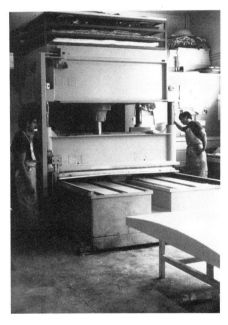

A Platen press is used to press a newly made sheet of pulp at Tyler Graphics. This press will also print intaglio and relief plates.

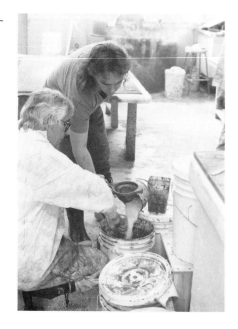

Ken Tyler, assisted by Michael Mueller, mixes Cel-Vinyl color into wet pulp for James Rosenquist's paper piece *The Bird of Paradise Approaches the Hot Water Planet* (see page 302), at Tyler Graphics Ltd.

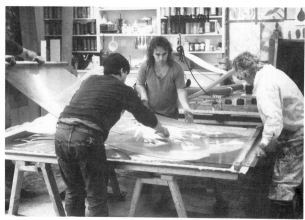

Ken Tyler, Paul Imboden, John Fulton, and Michael Mueller (clockwise from right) position a plastic stencil onto a newly made sheet of pulp for Rosenquist's print.

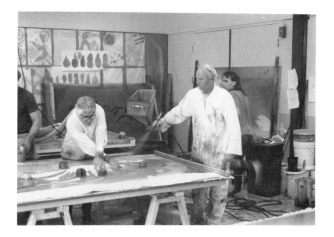

Rosenquist sprays dyed paper pulp from a pattern pistol through the plastic stencil, while Tyler holds pieces of the plastic down against the base paper.

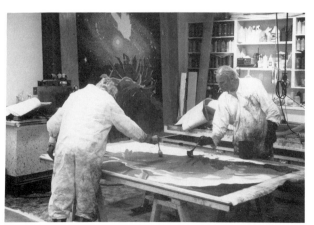

Rosenquist and Tyler complete the image by ladling paper pulp directly onto the sheet.

Flax This strong, off-white fiber is the source of linen cloth. It comes as line flax, with long fibers, or flax tow, with shorter fibers. It may be ordered raw and unbeaten or cooked and ready to use, in pails. Linen cloth may be unbleached or bleached from old linen cloths or new woven strips.

Other fibers A variety of other materials can be used. Sisal—commonly used for string, cord, and rope—is a cream-colored fiber that comes in ready-to-use pulp or sheet form. Abaca, from banana tree leaves, is the same as Manila hemp, from which ropes are made. It makes a pulp with natural dark flecks, which bleaching removes. It is obtainable as pulp or unbeaten as dry particles. Kapok, from a South Pacific tree, makes a handsome cream-colored paper, which has dark specks when raw fibers are used. Among the many other fibers available are straw from wheat, Russian hemp, ramie, and esparto grass (from South America).

Japanese fibers These fibers do not need to be beaten in a Hollander; they will respond to beating by hand or a stamper. *Kozo*, the most common of the Japanese fibers, makes a strong, useful paper. It comes from the inner bark of the paper mulberry tree. *Mitsumata*, another fiber, makes a softer, weaker paper with a warm gray-tan color. It has a shorter fiber than *kozo* and beats faster. *Gampi*, a well-regarded fiber, makes a hard, crisp, glowing sheet, very resistant to insect attack, with a greenish color. It grows wild and is difficult to harvest. Sold unbeaten, as are all Japanese fibers, it is expensive.

Making a Sheet of Paper

The first step is to prepare the raw material for the sheet—beating it properly and mixing it with water in the vat. Now you are ready to dip the mold, with its deckle, into the pulp (called stuff). Dip about two-thirds of the way in. Pull the mold through the pulp until you scoop out enough material to cover the mold. With a slight tilt, you can level the pulp

Helen Frederick of Pyramid Atlantic removes a mold from the vat of pulp and allows it to drain for a few seconds before shaking it from side to side to interlock the fibers.

The newly formed sheet is couched on a felt blanket by Frederick. Another felt will be placed on top of the sheet to help absorb moisture.

within the mold, and then, with a side shake—first to one side, then another—you can set the fibers in cross directions. This shaking action helps to strengthen the bond between the fibers. (The thickness of the sheet is determined by the dilution of the stock and the amount that is lifted up by the vat's stroke.) The mold is now placed on the drainboard, still in a level position, to drain some of the water out. The deckle is lifted and the sheet is ready to be couched. The newly formed sheet is in a very delicate state at this moment. If a drop of water falls on the freshly made surface, it will make a thin spot that cannot be removed.

COUCHING

In couching (pronounced "cooching" after the French), the mold is turned over so the sheet is pressed against a clean felt and then, in a rocking motion, the sheet is transferred to the felt. There should be no wrinkles or pulls in the sheet. Another felt is pitched on top of the freshly made paper and the next sheet is couched, building up the stack (or post). When the post is full, it is usually transferred to a press that can exert enough pressure to squeeze excess water from the newly formed sheets. Years ago these presses were called "Samsons" for their formidable size and strength.

DRYING

After pressing as much water as possible from the wet paper, it may be parted into bundles of four or five sheets and hung over ropes or rods. Some people recommend pressing the sheets in a wringer-type press to squeeze more water out than by the traditional vertical presses. If this is attempted, only a few sheets at a time should be pressed and provision must be made for the quantity of water that will be expelled. The felts can be run through the press with the sheets, at least for the first pressing. After much of the moisture is out, the paper can be stripped from the felts and re-pressed in small batches. The texture of the finished paper will be affected by these pressings, as the surface is receptive and sensitive.

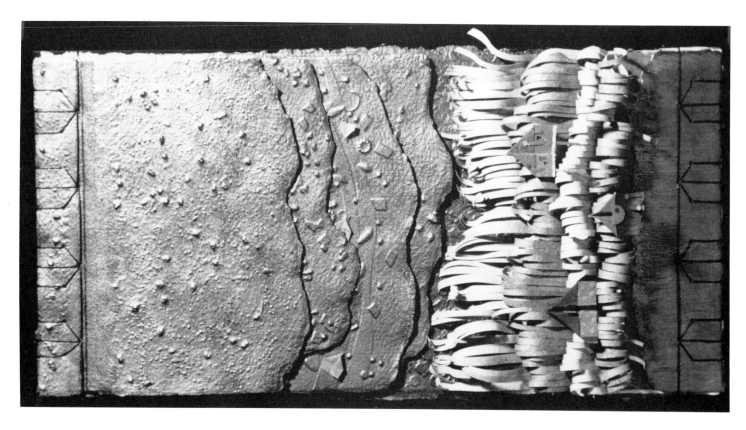

DOLPH SMITH
Surf's Up in Tenarkippi, 1987
Handmade paper and graphite, 8½″ × 18″
Courtesy of the artist

SIZING

Japanese papers are often sized with a vegetable-based size, but European and American papers usually use animal size, purchased in cake or block form. The size is dissolved in warm water and can be applied by brushing with a 6-inch hake brush or by immersing each sheet in a tray or basin of size. Brushing uses less size and only one side of sheet may be sized, if desired. However, more drying area is needed because each sheet should dry without touching another sheet. In the immersion method, stacks of sized paper may be pressed, then hung up to dry. Commercially made papers are sized in a tube with a continuous felt blanket carrying the paper into a bath of warm size, which penetrates the fibers faster and deeper than a cold solution.

Unsized paper is called waterleaf. It can be used for printing etchings, collagraphs, and lithographs, but is unsuitable for pen drawings or writing because the surface acts like a blotter and an inked line will feather or blur. In addition, it is difficult to erase on waterleaf paper because the surface is pulled into threads where it is abraded.

FINISHING

Most papers for printmaking are left unfinished, with the rough-textured surface created by the felts. However, it is possible to smooth out the face of the sheets by pressing them between zinc or plastic plates. Several pressings with increased pressure will further polish the paper. In commercial mills paper is run through highly buffed circular steel rollers under great pressure. When the rollers are heated, the paper is called hot-pressed and the finish is quite smooth. Cold-pressed paper is not as polished.

Certain textures, even those simulating watermarks, can be impressed into commercially produced papers with a dandy-roll—a hardened steel roller that has a design or texture embossed into the surface, which is transferred to the sheets under pressure, even after they are thoroughly dry.

TESTING FOR ACIDITY

For archival paper that will not disintegrate or turn brittle over the years, the sheet must have a neutral pH. This can be tested with a pH testing pen, which has a chemical ink that changes color when applied to papers whose acidity is in question. Another system of testing pH uses plastic strips with four different indicator papers bounded to them. These bridge the entire 0–14 pH range with a sensitivity of ±0.5.

Art of the Book

BONNIE STAHLECKER
Masks of the Mind, **1984**
Cut-out profiles, letterpress
Mellan Berry Press, Indianapolis
Courtesy University of the Arts, College of Art and Design, Philadelphia
Photo: Wayne Fowler

From a creative standpoint, the book has moved in many directions, some of which run counter to the traditional idea that a book is a series of pages with text and illustrations. One "book," for example, may be printed on colored paper pulp that has been formed into a landscape painting and imprinted with a poem, with the sheet then folded and boxed. Another may use type as a design element in juxtaposition to the words and ideas themselves, as in concrete poetry. Some books are obscure in meaning; others are political or social in their views; many relate to "pop" culture; some are public expressions of private dreams. Some go far afield, as when the entire book is permanently sealed in plastic or fabric, never meant to be opened. These can more accurately be described as sculpture or book objects than books.

A book may exist in one copy only, rather than as part of an edition—a concept that has had a wide following, partly because the unique book has been produced for centuries, since the time when manuscripts were hand-lettered in a monastery. However, we believe that the technical procedures of printmaking cry out for multiple copies, even if editions of handmade books usually do not exceed several hundred copies and more likely range from ten to fifty. It is also our belief that, if the book is a work of art, it should be well crafted, with powerful, expressive, or poetic imagery. Good printing and excellent illustrations;

FRANCESCO CLEMENTE
From *The Departure of the Argonaut*, 1986
Color lithograph, book size 25⅝″ × 39⅜″
Courtesy Petersburg Press, New York

JIM LEE
From *A Calling Out*, 1984
Nursery rhyme, letterpress book
Blue Moon Press, Newington, Connecticut
Courtesy University of the Arts, College of Art and Design, Philadelphia
Photo: Wayne Fowler

fine typography, layout, paper, and binding; and all the other details that make a work of art are admirable qualities in the book.

There are many types of privately printed books and artists' books. The most common are books printed by offset lithography, usually in fairly large editions of one thousand or more. Because most of these are printed by local commercial printers, the quality of printing and binding is not good. Even if the concept is strong, the appearance and the feel of the book are affected. Many artists' books fall in this category.

Next are the deluxe books printed on quality paper with illustrations from woodcuts and linocuts, etchings, lithographs, silkscreens, or other fine-art techniques. These books—bound in cloth, leather, or paper—are produced in small editions and are usually expensive. The illustrations generally determine the price of the volume, with well-known artists sometimes commanding prices of well over a thousand dollars per copy.

Another group of books, or book works, take their inspiration from other communication methods, such as scrolls, clay tablets, manuscripts, pop-up books, gravestones, and telegrams. Many of these are one-of-a-kind objects and relate to the book only by inference or allusion. Although this type of work does not naturally fall under the scope of printmaking, if it uses the print in some form, it deserves discussion here.

Some books are produced using rubber stamps, photocopies, or photographic processes. Others are produced on the computer using desktop publishing systems (see the chapter on the computer and prints). Some consist of collages of magazine pages, postcards, or other material. Plant material, rubber bands, paper clips, and a bewildering variety of stuff have also been used to create objects that are called books.

The artist-printmaker has an advantage when it comes to producing finely printed books because the creation of an edition of prints is similar to the making of a book. The techniques of relief printing and lithography are particularly suited to the printing of text matter, while all of the print techniques can be used for illustrative and design elements. The current growth of interest in private publishing has brought a flourishing of imaginative and daring new books. New

technologies, such as electronic copiers, computer printers, and inexpensive offset lithography, have made printing much less expensive and less demanding than in the past. Phototypesetting is available in almost every city in the country and, in conjunction with offset printing, makes the setting of type and its printing a relatively easy task. Thanks to high-resolution copiers that can reproduce type and art with ever-increasing sharpness, the facilities for producing text matter are virtually everywhere.

It is important to be sensitive to the flavor and spirit of the art and the text. Choosing an expressive (or contrasting), letterform or type can be a major element in designing your book or portfolio edition. Many of the classic works, both modern and contemporary, have been distinguished by the elegance of lettering and typography. The "mood" of the book—serene, mysterious, explosive, humorous—can be enhanced by the selection of type style. There are many helpful books on lettering and typography now available in design and art libraries.

Planning a Book

The making of a book requires certain powers of organization and careful planning. Many artists with exceptional ability as image makers fail to understand that the work in a book must be coordinated in advance so that everything joins together in a related sequence of images and words.

PAPER

After the theme or the content of the book has been decided, the first consideration is what paper will carry the message. Size is vital because the folding of the sheet must yield pages and sections that can be bound together into a coherent volume. You should choose the paper before designing the page or making the plates or blocks. Try to select a size that will yield the least waste. If you want to save a deckle, you must consider in advance where to fold the sheet.

Remember that paper has a grain and that the sheet folds better along the grain

RUDY POZZATTI
From *Darwin's Bestiary*, by Philip Appleman, 1986
Woodcut, 17¾" × 13"
Calligraphy by Darlene, printed by Frederic Brewer
Echo Press, Bloomington, Indiana

than against it. If there are too many sheets folded against the grain, the book will not bind correctly and may gap open when it is completed. There are several ways to test for grain direction:

1 Take a full sheet and fold it in half lengthwise. Open it and fold it in half the short way. Compare the curves of the fold along the short way. The tighter fold will show the grain direction.

2 If you can trim a sheet, cut two thin strips, about ½ by 4 inches, from edges at right angles to each other. Identify one with a mark from a pencil. Dampen each strip with a sponge or rag and hold them upright. The long-grain strip (with the grain) will remain upright while the short-grain strip (against the grain) will fold over.

long short

TEST FOR GRAIN DIRECTION

3 Place a sheet on a table and turn it lengthwise about a foot. Put another sheet next to it and fold it along the short direction. The sheet that remains folded or comes back more slowly is folded with the grain. The sheet that is folded against the grain will spring back more quickly. It is possible to fold against the grain, but the fold should be scored first with the tip of a burnisher or the edge of a coin.

DUMMY

In order to determine how your book should be printed, it is essential that you make a schematic plan, or "dummy." It should show how many pages are necessary, which edge is the top of the page, where the illustrations and type are to be placed, how the sheet is to be folded, and which way the grain will run. Without a dummy, even the simplest book becomes difficult to print.

Use an inexpensive paper such as newsprint and make the dummy the same size as your finished book, so that you can take actual measurements from it. You can tape proofs of the type or illustrations in position on the dummy to judge the correct layouts *before* you start printing the finished sheets for your book.

Don't forget to allow for adequate front (or preliminary) matter, which may include a half-title, frontispiece, title page, copyright page, dedication, preface, contents, or other introductory information. The colophon, which contains details about the printing, paper, type, size of the edition, and so forth, usually appears at the end of the text matter, sometimes after a blank page or two.

IMPOSITION

The placement of type and illustrations on a sheet of paper so that, when folded, slit, and trimmed, the pages will turn in order is called imposition. The simplest impositions are the following:

1 One sheet folded in half makes four pages (two on the front side and two on the back). It is called a folio.

2 One sheet folded in half and folded again makes eight pages (four on each

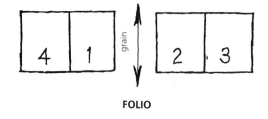

FOLIO

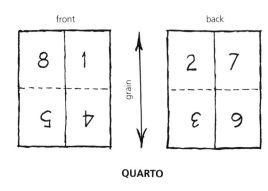

QUARTO

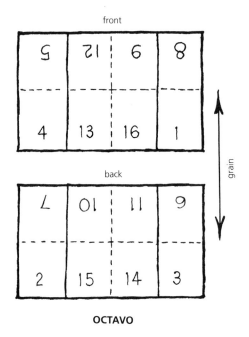

OCTAVO

side) and is called a quarto. In this case the fold on the bottom (or tail) of the sheet is slit to free the pages (dotted lines.)

3 One sheet folded three times, making sixteen pages (eight on each side), is called an octavo. It is slit along the dotted lines to free the pages.

The standard way to fold a sheet in book production is to take page 1 (or the lowest odd-numbered page) and place it horizontally, face down on the left. To make the first fold, bring the right-hand edge of the sheet up and over to the left. Align the bottom corners and sides and

crease the fold with a bone or plastic burnisher. Next, fold the top edge down to the bottom and burnish the fold again. Finally, bring the right side of the sheet (now two folded edges) up and over to the left to complete the folding of the sheet. In order to make the last fold easier, you may need to slit the long edges partly before burnishing.

The sections of a book (sometimes called signatures) can be four, eight, sixteen, or thirty-two pages. By placing differing sections together, it is possible to make a book of almost any number of pages in multiples of four. By tipping in individual sheets with glue, an almost unlimited variety of pages is possible. Books can also have pockets for additional smaller items, such as cards, maps, and envelopes.

You can place a double-page spread of illustrative material in your book if you can plan so that the sheet will fall in the center of a section, eliminating the need for precise register of two halves of an image. This method does away with the need to cut blocks or plates in half in order to print illustrations that are not in the center of the section. The only problem to be solved is that the thread that holds the sheets together in the binding will be visible and may have to be colored to blend with the image.

Printing the Book

Many methods of printing books are in use today, including lithography, letterpress, screen printing, photocopying, and gravure. Even laser-jet printing has been used for small editions. However, the classic techniques of printing are still best for producing a sharp, crisp impression of type with rich tonal illustrations. We will describe these processes first.

LETTERPRESS PRINTING

Traditionally, the most admired method of printing text matter has been letterpress printing direct from metal type. The typesetting method may be foundry (hand-set) or linotype or monotype (cast hot metal). While these traditional processes have diminished greatly since off-

set lithography has proliferated, they have not completely disappeared. Some linotype operators are prospering, admittedly on a reduced scale of operation, and their shops are located throughout the United States. The equipment necessary for the operation and repair of linotype machines is still obtainable through a network of suppliers. Many universities are establishing collections of different fonts of metal foundry types. Wood type, usually of large display letters, used for title pages, covers, and posters, is now bringing high prices in the secondhand market. New wood and metal type can be obtained from the American Printing Equipment Supply Company, although much of the metal casting is done in England.

In addition to type, woodcuts, linocuts, relief etchings, relief collagraphs, and other relief surfaces that can be made type high (.918 inch) can be printed on a letterpress machine. It is usually better to print type separately from woodcut blocks because type matter normally uses much less ink, but this has to be determined for each project. Collagraphs can usually be mounted on ¾-inch plywood to bring them up to the proper height. They must be well sealed with polymer or lacquer spray to withstand the rigors of press printing.

Large relief prints that will not fit in a cylinder proof press can be printed on an etching press. In order to print a page of type, however, it may be essential to use the smaller proof press. Fold the sheet, if necessary, and print it carefully while still folded. Do not use too much impression or the embossing will show through all the pages.

The best letterpress printing is done on slightly dampened paper, with a solid impression made from type that has been inked with a lean film of ink. This means that each sheet has to be dried under blotters to prevent cockling. The amount of effort to complete this step has made this technique less popular these days.

The press used for letterpress printing must be of adequate size to handle the sheet. Letterpress machines include platen or jobbing presses, made by Chandler and Price, Kelsey, and Craftman, among others. The disadvantage of

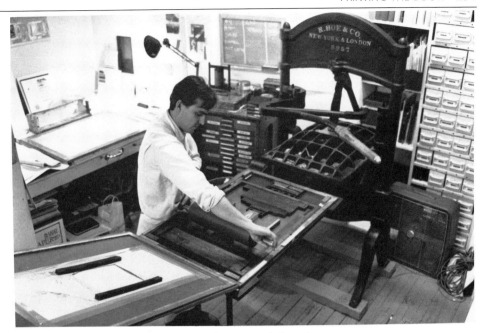

Peter Kruty inks a locked-up form on his hand press at Solo Press, in New York. Two type-high metal bars keep the inking roller level.

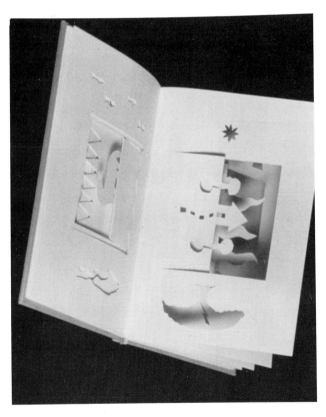

CLIFTON MEADOR
It Was All He Read
Letterpress, with die-cut interior pages, 7" × 5"
Courtesy Pyramid Atlantic, Washington, D.C.

these presses is the relatively small size of the sheet they can accommodate. Many of the older presses are still running after decades of service and still print well, but only small-size pages are printable.

Proof presses or galley presses made by Washington, Albion, Reliance, Lion, and Columbia are able to handle larger sheets but are slow and cumbersome. Make-ready (the process of adjusting the pressure by shimming) is difficult and time-consuming. The most practical so-

lution in letterpress printing is a cylinder-type proof press, such as the Vandercook or equivalent. The rugged strength of these machines is evident, as many are still being used every day in schools and shops all over the country. Make-ready is virtually eliminated with these presses and automatic inking on the later models makes it possible to print at a fairly rapid rate (100 to 200 impressions per hour).

Larger production presses, such as the Kluge, Heidelberg, or Kelly, are wonderful for book work, but running these machines efficiently requires a professional print shop with its attendant pressmen and maintenance. The best letterpress books, such as those printed by Stinehour and A. Colish in the United States, and Fequet and Baudier in France, are very expensive propositions and require major funding and careful planning.

LITHOGRAPHIC PRINTING

The bulk of all printing in the United States is done by offset lithography, which is based on the principles of lithography. Essentially an image is reproduced photographically on a thin metal plate, which is treated so that only the image area will accept ink. The inked image is then transferred ("offset") onto a rubber blanket, from which it is printed on paper. This method virtually dominates commercial printing. Most magazines, newspapers, posters, and other print jobs are reproduced by this process.

With offset lithography, type matter can be set by phototypography or by pressure graphics, such as Letraset, Prestype, Instant, or Formatt. It is easy to make a pasteup of artwork, collage material, and design shapes and have it ready for the offset printer's camera in no time at all. Some printers will even run rag papers or other imported special sheets if you provide the stock and pay for the extra supervision it may need.

Many fine artists, however, still use direct lithography from stones and zinc or aluminum plates, and most fine-art print workshops have direct-litho presses. Illustrations and design elements are easy to print with this method, but written or text matter has to be placed on transfer paper first; for metal plates, photographic processes can be used. More often, typographic material is printed separately on an offset-litho press, usually run by a local job printer. There are, however, a few large flatbed offset presses at work in the better-equipped workshops and universities. They can handle large sheets and are ideal for books and posters, as well as the largest fine-art prints.

INTAGLIO PRINTING

Etchings, aquatints, and other gravure methods of printing can yield detailed and exquisite tonal effects for book illustrations. However, it is difficult to print typographic material by these methods. The fact that each plate has to be inked and wiped separately makes the procedure very slow, and therefore large editions with many etchings take a long time to print. Also, embossment of the plate mark makes the back of the sheet difficult to use for type material. One way to surmount this obstacle is to use the French fold technique:

1 Start with a sheet that is twice the size of a double-page spread of your book. Make a dummy that indicates this. Position your etchings so they fall on the sheet as shown.

2 Print the type by letterpress first, then print the etchings. (It makes sense to print all the type first because if there is any waste, it is better to throw out type pages than destroy a laboriously printed etching.)

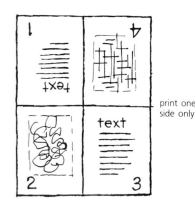

print one side only

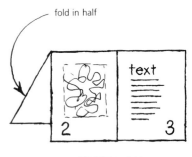

fold in half

FRENCH FOLD

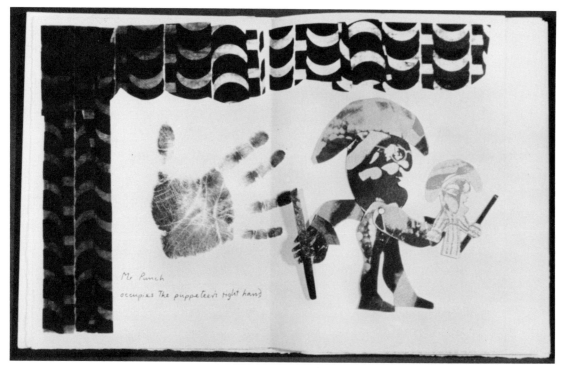

RON KING
From *The Left-Handed Punch* by Roy Fisher, 1986
Circle Press Publications, Guilford, Surrey, England
Courtesy University of the Arts, College of Art and Design, Philadelphia
Photo: Wayne Fowler

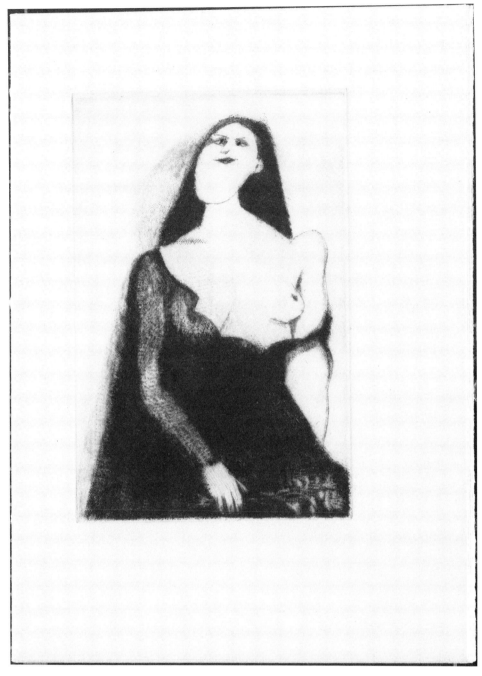

GERSON LEIBER
Declarations, **1987**
Intaglio (mezzotint, drypoint) with letterpress text, 9″ × 6½″
Oil Creek Press
Courtesy of the artist

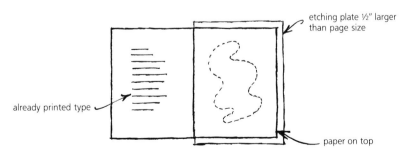

already printed type

etching plate ½″ larger
than page size

paper on top

ELIMINATING PLATE MARK

3 Fold the sheet in half, as shown. The back of the sheet, which is not printed, is not seen. Each page is a double sheet, and the embossment is invisible.

It is also possible to print an etching from a plate that is larger than the page size to eliminate the plate mark on the back. Be sure to put one edge of the plate in the gutter of the spread as shown. The back of the sheet then has no embossment or plate mark to interfere with the printed type.

With intaglio printing, because the etchings must be printed on damp paper, all the sheets should be dried under blotters. Also keep in mind that etching ink dries very slowly and that, because of the raised quality of the printed lines, the prints tend to rub off on the facing sheet. Slipsheets of nonacid paper should be sewn in or tipped in over the print as a protective shield.

SILKSCREEN PRINTING

The silkscreen method is excellent for achieving multicolored images and large areas of color and texture. Little sophisticated equipment is necessary, and the speed of printing makes silkscreen attractive to the book artist. However, even with photo-screen techniques it is not easy to print a type style that has delicate, thin strokes or serifs, or other details too small for the mesh of the silk to capture. In general, gothic or bold typefaces in larger sizes are suitable for screen printing, but small or delicate faces should be printed by letterpress, lithography, or electrostatic copiers.

Another caution is that silkscreen printing deposits ink so heavily that it tends to scratch or mark more easily than other printing methods. This is particularly evident on large areas, so you should handle printed sheets with care when collating or binding copies.

The screen technique can also be used to apply glue to paper being used for books made with the *chine collé* technique. The screen allows the glue (methyl cellulose or other) to be deposited smoothly and evenly—without running—on the sheet, which is adhered to another, heavier base sheet. Because the glue is water-based, it can easily be cleaned off the squeegee and the screen.

CLARE CHANLER FORSTER
There Is You and Me
Xerography book, mounted, with text, 8½″ × 11″
Courtesy Pyramid Atlantic, Washington, D.C.

COPIER PRINTING

Recent advances in copier technology have made it possible to print very precise lines and small details in seconds. The machines are expensive, but shops throughout the country are making this process available for pennies per page. Halftones and photographs can successfully be translated by copier onto paper. Moreover, copiers can print directly from original objects, such as hands, feet, faces, bottles, small tools, and so forth, eliminating the need to make a photograph for use as camera-ready art. Many copiers can handle very fine rag papers if the sheets are not too thick. Color copiers can approximate photo images from slides or from other color images, such as drawings, paintings, postcards, and magazines ads. Copiers can also enlarge or reduce your original material.

A drawback to copier technology has been the limitation on the size of images. Today, however, there are giant copiers that can print pictorial material up to 42 inches wide by lengths of 15, 20, or 30 feet (as long as the roll of paper the machine takes) in one pass. The artist's challenge is how to make use of this technical advance as a valid art form.

Because of its low cost, copier printing should prove very valuable to book artists who are doing experimental work. The new equipment can print type matter quickly, cheaply, and with outstanding clarity and sharpness. Sizable editions are possible without the expense and effort required in printing from cast-metal type.

The potential of copier technology is still being explored. A number of artists have found commercial printers who permit them to experiment with equipment during off-hours. In any case, electrostatic methods of printing seem destined to grow enormously in the near future (see also the chapter on photographic techniques).

Opposite:
RICHARD MINSKY
From *Holy Terror* by Flo Conway and
Jim Siegelman, 1988
Photocollage made into laser line, transferred to magnesium photoengraving plate hot-stamped into binding, 9″ × 6″
Courtesy of the artist

MARGOT LOVEJOY
Homage to DeVries I, 1982
Pop-up book, color photocopy, collage, and mixed media, 14″ × 9″
Courtesy of the artist

Binding the Book

The art of binding a book is varied and complex, with many types of binding possible, depending on the use, size, value, as well as esthetic considerations of the particular book. Although we cannot cover all the binding possibilities here, you should be aware of the problems that will arise when it is time to bind your sheets and prepare them properly. Most important is to plan your imposition properly in advance so that the pages will fall in the correct order within the sections (or signatures).

SIMPLE SEWING

There is a simple method of sewing books of just a few sections that requires no special equipment and can be done by any artist interested in the possibility. If you have a section of sixteen pages or two sections of eight pages or more, keep the pages together, with the first and the last pages acting as the inside sheet of a folded cover (see drawing) that encloses

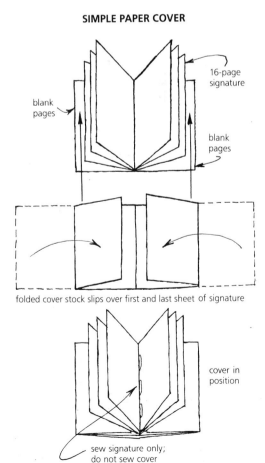

SIMPLE PAPER COVER

16-page signature

blank pages

blank pages

folded cover stock slips over first and last sheet of signature

cover in position

sew signature only; do not sew cover

GEORGES ROUAULT
Divertissement, 1943
Published by Teriade, Paris
Courtesy University of the Arts, College of Art and Design, Philadelphia
Photo: Wayne Fowler

all the pages. Use a heavier piece of cover stock to wrap around the entire bundle. Sew all of this together to keep the sheets in place.

Too many pages, however, make this method impractical. It works only for thin volumes that do not require a spine.

SPIRAL OR PLASTIC BINDING

These commercial binding processes may be suitable for certain books. They usually employ a punching machine that cuts through all the pages at once and requires about ½ inch extra width on all the pages to allow for the holes. This method is destructive to any illustration or graph that attempts to cover two pages of a spread. The material that connects the pages can be a wire coil or a plastic sheet cut to fit the punched holes.

SIDE-STITCH BINDING

It is possible to bind a book by sewing through the side of the sheets. This process is suitable for single sheets, but keep in mind that the book will not lie flat when open. Side stitching is suitable only for books that do not lie flat.

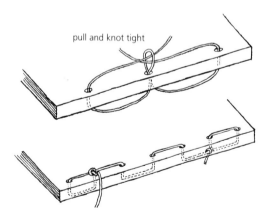

pull and knot tight

SIDE-STITCHING METHODS

FRANK STELLA
Giufà e la berretta rossa, 1988

Computer-generated imagery; relief, aquatint, engraving,
etching, on white TGL handmade paper, 77¾″ × 58″
Printed and published by Tyler Graphics Ltd.
© copyright Frank Stella/Tyler Graphics Ltd. 1988
Photo: Steven Sloman

THOMAS PORETT
Counterpoints, 1988
Xerox 4020 ink-jet print (overprinted proof),
17½″ × 25½″
Courtesy of the artist

MYRIL ADLER
Dialogue D IX, 1988
Color intaglio with computer-generated images,
9½″ × 13³⁄₁₆″
Courtesy of the artist

CARL T. CHEW
Artozoic Scene, 1986
Computer-generated screen print, 16½″ × 22″
Courtesy of the artist

Below:
MARK WILSON
CTM-B10, 1986
Computer-generated image, 19″ × 24″
Courtesy of the artist

"CTM B10" © 1986 Mark Wilson

JIM DINE
Youth and the Maiden, **1987–88**

Helio-relief woodcut and etching with hand painting, 78¾″ × 140⅞″
© copyright Jim Dine and Graphicstudio, University of South Florida, Tampa, 1988
Photo: George Holzer

ANTONIO FRASCONI
Monet at Giverny II, **1979**
Xerox print
Courtesy Terry Dintenfass Gallery, New York

ROBERT RAUSCHENBERG
Soviet/American Array III,
1988

Color photogravure
Printed by Craig Zammiello
Universal Limited Art Editions,
New York

301

JAMES ROSENQUIST
The Bird of Paradise Approaches the Hot Water Planet, **1989**

Colored pressed paper pulp, lithograph, collage, 97″ × 85¼″
Printed and published by Tyler Graphics Ltd.
© copyright James Rosenquist/Tyler Graphics Ltd. 1989
Photo: Steven Sloman

CHUCK CLOSE
Susan, **1988**
Stenciled handmade paper, 38″ × 31″
© copyright Pace Editions, New York, 1988

LLOYD MENARD
Untitled
Mixed media on handmade paper, 27″ × 36″
Courtesy of the artist

ANTONIO FRASCONI
From *Travels Through Tuscany*, 1985

Color woodcut
Courtesy University of the Arts, College of Art
and Design, Philadelphia
Photo: Wayne Fowler

CLAIRE VAN VLIET
From *Aunt Sallie's Lament* by
Margaret Kaufman, 1988

Letterpress, cut pages, 11" × 105" (fully opened)
The Janus Press, West Burke, Vermont
Courtesy of the artist

ED COLKER
From *Two Poems* by Michael Anania, 1985

Printed by offset lithography from plates made
from hand-painted acetate transparencies
by Red Ink Productions; hand-bound at the
Center for Book Arts, New York City; 11" × 8"
Courtesy of the artist

IV

The meaning of the game
is neither odd nor even,
nor what is lost or found.

Numbers are only numbers,
a play of hands without touch.
She wanted the day to speak

to her of love, if only
in mute reflections, lowering
her face into the flowering light.

If the color hesitates one moment,
if the numbered petals leave one
petal imitating fire, something

flares like bass to feathered bait
or music to the memory of song.

12 Business of Prints

There is such a demand for prints today that printmaking has become a big business, employing not only the artists who create the images, but also printers, dealers and their staffs, and a wide range of other assisting personnel, including framers, bookkeepers, publicists, salespeople, secretarial help, and packing and shipping specialists. The volume of print sales is larger now than ever before, with many galleries dealing exclusively in prints and most galleries selling prints made by their painters and sculptors, and thereby reaching a much larger market for artworks.

Workshops run by master printers and equipped with new technological means for printing have made large editions easier to produce. Many artists who originally might have had little interest in printmaking are now collaborating with printers who support them with technical knowledge and assistance and are involved in the business of prints. Sometimes fine work results; often there is an overproduction of mediocrity.

Thousands of prints are also being produced by graduates of excellent print departments in colleges, universities, and professional schools throughout the country. Again, they run the gamut in quality, although many of them are excellent.

ROBERT RAUSCHENBERG
Bellini #4, 1988

Intaglio (photogravure from 11 plates),
60″ × 38½″
Printed by Craig Zammiello and Shi Ji-hong
Courtesy Universal Limited Art Editions,
West Islip, New York

One would think a glut on the market would result from such high-volume production. Where do all the prints end up? What opportunities does the artist have for exposure? Fortunately, there are many possibilities. Competitive exhibitions of a high level are numerous in the United States, and some foreign shows are worth participating in. Galleries of varying quality are highly visible in large and small cities and some towns. Print publishers exist in fairly large numbers in or near large cities. Opportunities for artist-printmakers are quite good, and because prints are lower in price, they are easier to sell than paintings or sculpture. Besides, no matter what the state of the print market, we are convinced that a significant number of artists will still create beautiful prints because of their love for the medium.

Edition Size

After you have finished work on the plate and it has been proved to be satisfactory, you should determine the edition size. The number of prints to be pulled will depend on a variety of factors—the demand for your work, the durability of the plate or block and the time it takes to print. When an artist is starting out, editions are usually small. Twenty-five to fifty are realistic numbers. Estimate how many galleries might be handling the print, plus a reserve of about twenty prints.

If a work is difficult to print and you are eager to go on to new images, you may find it expedient to print only part of the edition if it is an etching, collagraph, or woodcut. Print ten or fifteen impressions and record exactly how many in your record book. As the need arises you can print more because these plates and blocks can be cleaned and stored with ease. It is more difficult to print lithographs or screen prints in batches because the setup time is longer and because the printing is usually quicker than with other techniques; it really doesn't take that much longer to print the entire edition at once. Of course, complicated color printing presents a real problem because it is not easy to rematch colors exactly when you need more impressions and even the sequence of printing must be carefully listed in order to ensure the proper overlay of color upon color.

We usually keep a folder on each print that has not been completely editioned. It contains an offset impression of the plate with color notes and packets of ink wrapped in vinyl and taped shut. Larger amounts of ink may be kept in plastic containers or tin cans and sealed with a vinyl protector seal. Color keeps well for several years when saved this way, making it possible to set up for reprinting in a short time.

KINDS OF PROOFS

There are numerous designations for proofs. An understanding of the differences is important.

State proofs These are early proofs that show developmental changes in a plate or block before the final edition is printed.

Trial proofs These are early working proofs with experimental changes in color or wiping to visualize various effects.

Bon à tirer proof This French term means "good to print." This is a print that meets the artist's esthetic and technical demands. It is this print that is used by the printer as an example for the edition.

Artist's proofs Common practice is that 10 to 15 percent of an edition is reserved for the artist. These "proofs" are identical to impressions in the edition in most instances.

Presentation proofs Often identical to the edition, these are reserved as gifts to individuals or institutions and usually are not sold.

Printer's proof This is the proof presented by the artist to the printer of the completed edition.

Cancellation proof After an edition has been printed, the plate or block may be defaced with a scratch, a hole, or lines to make sure that further prints cannot be pulled without bearing the cancellation marks. Sometimes cancellation proofs are taken and occasionally they are sold, for much less than the regular edition. Plates by famous artists are usually chosen for this kind of restrike, and some of these prints have achieved substantial prices on the open market.

Wax proof A proof from an intaglio plate that has been smoked, this shows the work when pressed into a sheet of paper that has been covered with white wax. It is used when a press is not available.

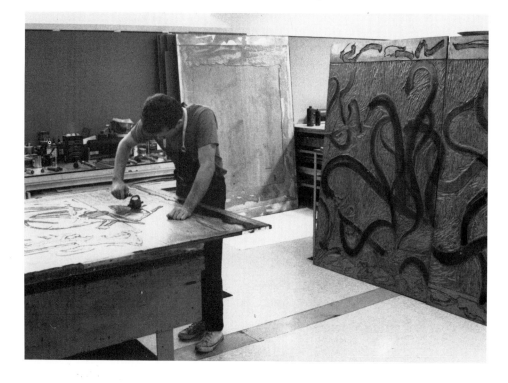

Jim Lefkowitz inks a large plywood relief block for a Frank Stella print at Tyler Graphics Ltd. in Mount Kisco, New York. In the background are two woodblocks from Steven Sorman's screen *From Away.*

RESTRIKES

When a plate is reprinted after it has left the artist's possession or control, the prints are called restrikes. If the plates are not worn or not damaged, the quality of the proof may be excellent and the equal of earlier editions. Woodcuts, if press-printed, can yield thousands of impressions. Hand printing wears out the blocks quickly (although when a Japanese printer uses a baren skillfully the block may give thousands of proofs). Wood engravings wear extremely well, particularly in the press, and may give tens or hundreds of thousands of impressions.

Line etchings on copper normally yield many hundreds of prints. Steel or chrome facing will harden the surface of the copper and make editions in the thousands possible. One of our students completed a series of copper plate etchings for a publisher and had to sign nineteen thousand impressions from one plate before the edition was complete. Aquatint, on the other hand, wears rapidly, and mezzotint or drypointed plates wear even more quickly. Two or three hundred impressions are possible from a drypoint if it is steel-faced, but rarely more.

Collagraphs do not wear well in printing because the materials—paper, cardboard, fabric, and the like—are inherently fragile. Editions of more than one hundred are not very common, and more than two hundred are rare, so that restrikes are unlikely in most cases. However, as technology improves and new adhesives and sealants are developed, who can say how many prints can be obtained from a collagraph plate?

Lithographs, properly prepared, will produce thousands of impressions. Offset lithographs have the potential for printing so many proofs that some collectors consider them to be commercially printed.

Screen prints, depending on the techniques used, vary widely in their potential for restrikes; in some cases editions in the thousands are feasible. When hand coloring or airbrushing is used on the finished print, the size of the edition usually shrinks and restrikes are difficult. Pochoir or stencil prints can be done in large numbers if the stencils are brass or copper. Paper and cardboard stencils wear out quickly, and the constant recutting of the stencil makes large editions unlikely.

Edition Numbering

The custom of numbering prints is fairly recent, certainly no more than one hundred years old. Dealers are the prime beneficiaries of the numbering system, because they can better control the proofs in each edition and keep track of how many are left to sell. The price usually goes up as the edition sells out. Unfortunately for the artist, if the image is very popular and can sell many more impressions after the edition is exhausted, it is not considered ethical to pull more proofs and sell them without making changes, thus creating another "state" of the plate. This has led to certain artists printing more "artist's proofs" than in the regular edition. Many contracts with publishers call for a maximum of 10 to 15 percent of the edition to be labeled "artist's proofs." As in most affairs, the integrity of the artist and the dealer is necessary to maintain the trust and confidence of the collector.

If the edition consists of one hundred prints that are all printed at the same time, it is almost impossible for the numbering to reflect which one was actually number one, which was number two, and so on. Because the prints are normally dried under blotters or newsprint, the stacks are shuffled many times before they are signed and numbered. If the prints are printed in batches, as they are sold or distributed, the numbering may more accurately show their place in the edition.

SIGNING AND NUMBERING

Keep a clean work surface apart from your printing area to organize your prints. When an edition is completed, examine the prints carefully to see that they are satisfactory. Do not crease or buckle the paper by careless handling. Imperfect impressions should be removed. All the accepted prints should be free of smudges, fingerprints, or other defects. If the edition has been printed in a professional manner, these will be minimal. Some erasing is possible, but because certain water-leaf papers are very soft, test a scrap first. Use an art gum, white plastic eraser, or dry cleaning pad (a new type of eraser consisting of a grit-free powder in a soft covering) to remove smudges and dirt. A single-edge razor blade can be used to scrape away specks

of ink. If the paper fibers are raised, place a clean scrap of paper over the area and burnish it with your thumbnail to flatten the fibers again.

Signing prints is a relatively recent practice in the history of the print. James Abbott McNeill Whistler was one of the first artists to do so, and numbering became a twentieth-century custom. Pencil is usually used, but the artist must judge how and where to place the title, number, and signature on the print. Traditional practice is for the inscription to be placed under the image, with the signature on the right, the title in the middle, and the number on the left. The number includes the individual print number and the total edition number, written as a fraction. If the edition consists of fifty prints, the numbering is $\frac{1}{50}$, $\frac{2}{50}$, $\frac{3}{50}$, and so on until 50/50 is reached. As just noted, although some artists try to number the impressions in the actual order of printing, numbering usually does not reflect the actual printing sequence but merely indicates an acceptable impression in the edition.

THE CHOP MARK

A chop mark is used as an identification symbol by the printer, publisher, or workshop. It is made of metal and is inserted into a blind stamper, a simple stamping device. The chop is generally placed in the lower margin of the print,

Chop mark of Solo Press, in New York, directed by Judith Solodkin.

Chop mark of Robert Blackburn, artist, master printer, and director of the Printmaking Workshop in New York.

near the artist's signature. When the paper is placed in the blind stamper with the chop mark in place and the handle pressed, a neat, embossed image of the chop appears on the print.

Recordkeeping

You must keep accurate and thorough records on each print that you produce. Every edition should be listed on a separate sheet, with the title, size, year, price, and general information placed near the top of the page. Each print from the edition should get a line or two, showing the edition number or type of proof, where it is (dealer, buyer, museum), printer's initials, date sold, price received, paper, and other information pertinent to the individual print.

You should also keep a book on a monthly basis, listing all sales with title and edition number as a cross check. This will serve as an income tax record. Some artists are now using computers to help them keep their records. Once you set up an appropriate system, computers allow you to easily manage your prints. You must be diligent about putting all your information into the computer, however, or the method will not work.

PRICING

There is no standard set of prices for any particular type of print. Obviously, artists whose work is in demand can get more money than artists whose work is hard to sell. Start your prices on the low side. Check the catalogs of print shows to see what current prices seem to be. As your work sells, increase your prices. Proceed cautiously to avoid raising prices too high, failing to sell, and then having to lower your prices to meet the market. Most dealers have a good idea about what a print will bring, and you should consider their suggestions.

Matting the Print

The hinged mat is a traditional protective enclosure for works on paper, particularly the print. It consists of a sheet of cardboard with an aperture cut in it that is hinged to the longest side of a backing board trimmed to the exact size of the mat itself.

MATTING MATERIALS

Use only 100 percent rag board, which is pH neutral, when you are preparing a permanent or long-term installation. This is also called museum board because it is the only kind of material museums use to mount their prints. It comes in two-ply and four-ply weights in sheets that are 20 by 30, 32 by 40, and 40 by 60 inches. It is available in white, natural, tan, gray, and black. The white and natural are generally preferred because these colors provide a neutral field for viewing the print. The two-ply is adequate for small prints, but large prints need the four-ply. A heavyweight etching paper or watercolor paper that is 100 percent rag can also be used for matting small prints if they are not going to be framed.

Less expensive mat board produced by a variety of manufacturers is adequate for temporary matting only. The core center of ordinary mat board is wood pulp, with a better-grade paper covering the surface. In time, the cut edge will turn brownish and the chemicals in the pulp center and outer layer will discolor the print.

Only neutral pH paper should be used to hinge the print to the backing board. A gummed linen tape prepared for this purpose is available in art-supply stores with good printmaking departments and from Talas Library Suppliers in New York City and Light Impressions in Rochester, New York. Strips of etching and heavyweight Japanese paper such as *hosho*, *kozo*, *moriki*, and *mulberry* can also be adhered with organic paste such as wheat or rice paste or with methyl cellulose. Self-adhering tapes such as masking tape and vinyl tape should never be used.

MEASURING THE MAT

Cutting mats requires the right tools and considerable patience and perseverance. A clean sturdy table topped with a large piece of three-ply chipboard for cutting is desirable. A heavy metal straightedge with a strip of masking tape on its back

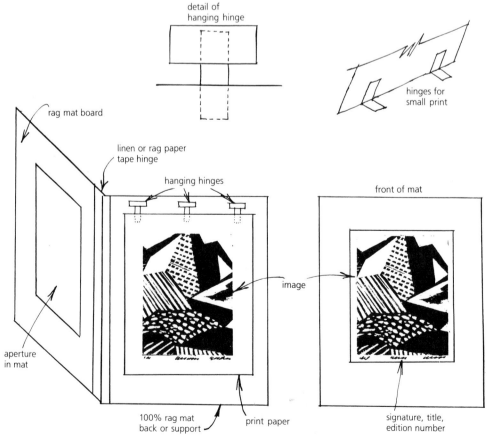

detail of
hanging hinge

rag mat board

linen or rag paper
tape hinge

hanging hinges

hinges for
small print

front of mat

image

aperture
in mat

100% rag mat
back or support

print paper

signature, title,
edition number

CONSTRUCTION OF HINGED MAT

Eileen Foti, master printer, and Kira Sowanick, press assistant, print an edition in print workshops used for classes and edition printing for invited professional artists at Mason Gross School of the Arts, Rutgers University, New Brunswick, New Jersey.

to keep it from slipping, single-edge razor blades with a handle device or a mat knife that is kept sharp, a sharp HB pencil, and two- or four-ply mat board are the basic needs.

The size of the mat should not be excessive. Margins of 3 to 5 inches are fairly good as a general rule, with the 3-inch size for small prints and up to 5 inches for large prints. We usually make the top and side margins the same width and the bottom about ½ to 1 inch larger. The overall size of the mat will be determined by first measuring the image. Add ½ inch to the top and each side and ¾ inch to the bottom, where the title, signature, and edition number will appear. This will give you the aperture size. Add 3 inches to each side and the top and then 3½ inches to the bottom. This will give you the outside dimensions of the mat and backing board, which should be exactly the same size. Of course, if you are using a precut sectional frame, you should round out the dimensions to the next larger size that will fit the precut frame.

Measuring can be done on the front or the back of the mat, and the aperture can be cut from either side. Cutting from the back will protect the front surface and prevent overcutting on corners. When finished with the cutting, erase all visible pencil markings so they do not offset onto the print.

CUTTING THE MAT

The actual cutting tools depend on personal preference. We generally use single-edge razor blades in a sturdy wooden holder and discard them after a few cuts in order to have the sharpest possible blade. Other artists like the mat knife, either sharpening or changing the blade as needed. Some people consider a mat cutter best, although good ones are not cheap. Try different methods and select the one that is best for you.

Two-ply rag boards can be cut in a single stroke. Four-ply boards may require two cuts. Be sure to cut with the straightedge to the left of the lightly penciled guideline (to the right if you are left-handed), so that if there is some slippage you will not cut into the mat and ruin the job. Turn your work so that you are always cutting toward you. If you are a novice, practice on some scraps of mat board. Keep a steady hand and try to end your corners without overcutting.

Cutting a bevel is a little more difficult than a straight cut. A slanted-edge straightedge or T-square can help greatly by guiding the knife or razor blade. A mat cutter is the best tool for cutting bevels.

ASSEMBLING THE MAT

After the mat is cut, hinge it to the backing board, using a strip of linen tape or 100 percent rag paper tape with an organic glue. Hinge the longest inside edges so that the mat opens easily. Press the tape down firmly and evenly. Position the print in the aperture so that a little more space appears at the bottom for the signature, title, and numbering. Attach the print to the backing with linen tape or 100 percent rag paper tape and organic glue. This can be done by attaching two strips of tape about 2 inches in length to the top back of the print, protruding 1 inch beyond the print. Place two more strips of linen tape about 3 inches long across the two protruding strips, fastening them securely to the backing board. The print will now hang freely from the top only, allowing for the shrinkage and expansion caused by changing weather conditions. If the print is small and lightweight, a folded hinge about 1 by 2 inches can be used, folded the long way and attached to the back of the print and the backing board.

More and more print images are being printed to the paper's edge. This is a very attractive way to print some images, but it does present problems for matting. We have found it useful to make a ring of tape, about 4½ inches in length, and secure it well at the overlap. Flatten out the ring and apply paste to the front and back surfaces. Attach one surface to the back of the print and the other surface to the backing board. Press them firmly together. A large print may need three or four of these rings to hold the sheet solidly.

ACETATE AND VINYL WRAPPING

Since many contemporary prints are oversized and printed to the edge of the paper, more and more competitive exhibitions accept prints that are wrapped in vinyl or acetate. This is a fine method for temporary mounting. Fome-Cor

board ¼ to ½ inch thick is good as backing because it is white, lightweight but sturdy, and comes in large sizes. Allow about ⅛ to ¼ inch beyond the print size so that the print edge will not crease during wrapping. Place a sheet of medium-weight vinyl or acetate, at least 3 inches larger on all sides than the backing, on a clean table. Place the print and the backing face down on the vinyl and pull the plastic around tightly to the backing board, securing it with tape. Masking tape or Scotch Magic tape will do. The corners can be neatly folded and pressed flat or slit so that they are mitered and lie flat. Be sure that there are no ripples on the face of the print.

A method called shrink-wrapping, often used to enclose new books in plastic, is good for temporary mounting. Special rolls of lightweight polyethylene are needed, which come folded along one edge to help make the envelope necessary to seal in the print. The plastic roll is cut with an electrically heated wand that seals the cut edges as you use it. The print, with a backing board of Fome-Cor or mat board, is slipped into the open side of the plastic, which is then trimmed and sealed with the wand. An electric hot air blower is then used to shrink the plastic tightly around the backed print. Follow the manufacturer's instructions closely to avoid burning through the thin plastic sheeting.

Shrink-wrapping is useful for shipping and temporary display of works on paper, but it is inadvisable for long-term storage or exhibition. The plastic covering lies so tightly against the face of the print that no air space exists between the two, which can cause condensation problems and buckling or staining of the print.

FLOATING THE PRINT

A method of mounting widely used today is to float a print without a mat on a rag board or linen board. This is especially attractive for oversize prints and for prints with the image to the paper's edge. The effect is quite handsome because the deckle edge of the paper can be seen and there is a sense of the paper as an intrinsic, beautiful part of the finished print.

Prepared linen boards of actual linen cloth mounted on a cardboard backing in a wide selection of tones are available in many art-supply stores. Trim the board to the correct size with a sharp razor blade (paper cutters will fray the edges) to the size you need for your frame. Hinge-mount the print to the linen board (as described under "Assembling the Mat"), but be sure your frame has a plastic, wood, or metal fillet to keep the proper separation between glass and print. Be prepared to pay extra for archival-quality mounting boards that will not deteriorate and ruin your prints. Many boards are now acid- and lignin-free, and some are buffered with calcium carbonate. Most manufacturers now offer these products.

Framing the Print

The selection of a frame that is esthetically pleasing and economical is often difficult. Prints have very special framing requirements with which the artist must become familiar. There are many excellent framers who are knowledgeable, but there are many others who know little or nothing about the proper handling of prints and can cause irreparable damage to your work. Print galleries often provide framing services, and a reputable dealer should know how to frame a print. If you use an individual framer, select one who specializes in prints and will thus use 100 percent rag mat board, correct hinging, and a dustproof, tightly assembled frame.

MAKING YOUR OWN FRAMES

Frames are expensive, often costing more than the print to be framed, and so young artists often elect to make their own frames. Keep them simple; prints look best with unpretentious frames. A conservation frame with air space between the glass and the face of the print is best.

All works on paper should be covered with glass or clear plastic to prevent dirt and humidity from harming the fragile sheet. Glass dulls the image, acts as a mirror over dark areas, and is very fragile. Plexiglas or Lucite is a good substitute because it is lighter and harder to break. UF-3 Plexiglas even acts as a filter to reduce harmful ultraviolet light. (If

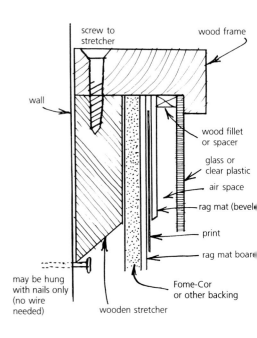

SUGGESTED FRAMING SYSTEM

glass is used, a thin sheet of .040-inch-thick polystyrene, called a KSH ultraviolet filter, can be placed between the glass and the print to screen out 75 percent of the ultraviolet rays.) Unfortunately, Plexiglas scratches easily and has a magnetic quality that attracts dust. In general, glass is practical for small prints (22 by 28 inches or less), while Plexiglas is preferred for larger sizes.

There are several methods of clipping together the print, mat, glass, and backing board into a temporary display that looks professional and is inexpensive to assemble. They include gallery clips, Eubank frames, Swiss clips, and Uniframes, all available from most framing and art-supply stores. These systems are not for permanent hanging, however, because they are not sealed and are very fragile, making handling or moving risky.

SECTIONAL FRAMES

The most economical frame is the metal sectional frame in aluminum, available plain or anodized in colors. It can be purchased in a variety of contours, so that the print can be separated from the glass with a fillet of wood or plastic.

Although sectional frames are not very sturdy for large prints, if they are reinforced across the back with wire they may suffice for some installations.

Wooden frames in certain sizes are now available as prefabricated units at prices comparable to the metal sectional frames. These are stronger and usually look better than the aluminum frames, but the size range is limited.

PLEXIGLAS BOXES

Readily available in art-supply and department stores, Plexiglas boxes are handy for quick framing. Framers will also make up plastic boxes in custom-ordered sizes. Again, be sure to mat the print or use some method that will keep the plastic from touching the surface of the print.

Storing Prints

The proper storage of your prints is an important consideration whether you are a neophyte printmaker or an experienced one. The only difference is that the more established printmaker has more to store, unless he or she is fortunate enough to sell out every edition made.

ENVELOPES AND PORTFOLIOS

If at all possible, prints should be stored flat. For the beginner or someone with limited funds, sturdy envelopes, preferably made of 100 percent rag paper, are adequate. Slipsheets of acid-free glassine paper should be placed between each print. The envelopes can be labeled and stored on simple open shelves.

Portfolios with dustproof flaps are also good for storing prints if they are kept flat. However, they are fairly expensive, and only about fifteen or twenty prints can be stored in each one, since glassine slipsheets will add to the bulk.

SOLANDER CASES

Solander cases, excellent dust- and moisture-proof boxes made with spring latches, are ideal for storing prints. Made of rigid material, they can be stacked one on top of another. They are most often used by galleries and museums and are fairly expensive.

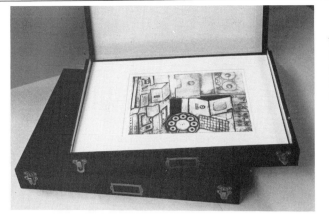

This dust-proof solander case has an interlocking edge that seals with a metal spring clasp. It is suitable for prolonged storage of small prints.

Prints can be stored vertically or horizontally in the Romano-Ross workshop. Shelves are spaced 3 to 6 inches apart.

The most efficient storage for prints and paper is in metal blueprint files. Four- and five-drawer sections are most common.

SHELVES

An inexpensive way to store prints is to create sliding shelves in a new or existing storage unit. The shelves can be made of ¼-inch fir plywood or Masonite reinforced with 1-inch stock lumber across the front. You can screw in 1-by-2 or smaller strips to the inside of the storage space to act as shelf nests or guides. We have constructed many shelves of this nature by having the lumberyard precut the plywood to the desired size.

BLUEPRINT DRAWERS

The best and most convenient, but most expensive way to store prints is to place them in dustproof metal blueprint drawers, with acid-free glassine paper placed between each print. Unfortunately, these are expensive and hard to find secondhand. Buy large-size drawers even if you are not doing large prints now—you may later. Metal drawers last a lifetime and having them too large is far better than too small. A good, moderate size is 36 inches long and 24 inches wide with

a depth of about 3 inches. Do not get them too deep or it will be difficult to pull out prints from the bottom.

If metal drawers are out of the question economically, old oak blueprint drawers can occasionally be found in secondhand office-furniture establishments. Again, try to find shallow drawers, because wooden drawers are extraordinarily heavy.

Shipping Prints

One of the great assets of making prints is that the artist can send the same image to many exhibitions and place it in numerous galleries. This involves handling and shipping. Exhibition fees seem to rise constantly, as do shipping charges. Be selective in sending, but also perfect your shipping methods to ensure the safe arrival of your work.

BY U.S. MAIL

The U.S. Post Office will insure work for its full value up to $400 (not a generous allowance). Size restrictions may be a hindrance and rulings often change, so it is best to check with your local post office. Present regulations limit the maximum size to 100 inches (length plus girth) and the weight to 70 pounds.

If you are shipping more than one matted or unmatted print, slip-sheet them and wrap them in paper, then in plastic. Use two pieces of 1/8-inch Masonite for your package, cut 2 inches larger than your prints so that if the corners are bruised in transit, the prints will not be damaged. Do not use corrugated board; it is usually not strong enough. Tape the wrapped prints to one of the Masonite pieces, centering them so they will not slip. Include any invoice or listing with the package. Place the two sheets of Masonite together and seal them with wrapping tape. If you plan to register the package, the post office requires that you use only gummed or reinforced paper tape on the exterior so that they can stamp their seals. Address the outside clearly with a dye marker or India ink. Keep your insurance receipt until the package is received and then file it for tax purposes.

BY UPS

United Parcel Service is a very reliable firm for shipping prints, but they have restrictions on sending original artworks and their insurance may be invalidated in case of a loss because of this restriction. Of course, you can label your works "Printed Matter," but that may cause questions if you attempt to place a high valuation on the package of prints. Find out from your local office what regulations are currently in effect.

TUBE SHIPPING

Using a tube for shipping prints is easy if the prints are not too large to roll or too heavily embossed. Shipping charges are less, but you must use a very sturdy tube and capped or uncapped sturdy tubes are expensive. Some good art-supply stores carry heavyweight tubes, but often the best ones must be bought directly from a supplier.

We have found an excellent substitute to be the heavyweight cardboard cores used for rolling carpets. They have a hollow core and a skin about 1/2 inch thick. They come in very long lengths but can be cut to size with a hacksaw. Select the largest diameters you can get. Carpet dealers are usually happy to have you take them off their hands.

Tube ends can be cut from heavy cardboard and taped securely. Place crumpled tissue loosely at each end of the tube so that the print will not move about. Roll the print in tissue, making its diameter just slightly smaller than the inside of the tube. An outer covering of thin paper can be taped around the print so it can be removed easily from the tube.

CRATING AND AIR FREIGHT

If you begin to have large exhibitions out of town, you will find crating a necessity. An exhibition of twenty or thirty matted prints will require a hard-sided crate. You can have 1/4- or 1/2-inch plywood, depending on the crate size, cut at your local lumberyard. For the sides, use stripping that is 1/2 by 3 or 4 inches. Use screws for strength on large crates, nails on smaller ones.

We have used air freight on various domestic carriers. Most will give you full insurance and careful handling. We usually take the crate to the airport, but pickup service is available at an extra charge. Generally, shipping charges are fairly reasonable, and an added advantage is that most air-freight offices are open twenty-four hours.

Distributing Your Prints

A print publisher is essentially the distributor of an edition. Print publishers may or may not finance and supervise the printing process, but they do bear the costs of advertising and promoting the sales of the particular prints they publish. Often, an artist acts as the publisher and handles all the details pertaining to sales and distribution of his or her own prints. The publisher acts as wholesaler to other dealers, who may sell from the same edition at the same retail price as the publisher.

A print dealer is usually the retail outlet for the print edition. The dealer may or may not have a gallery to show the works and may buy the prints from the publisher at an agreed percentage of the list price. The print dealer may also sell the prints on consignment from the artist directly, paying the artist only on completion of a sale. A publisher may also sell prints directly to the public, becoming a dealer as well.

The artist usually finds it easier to complete an edition of prints than to sell them. People not involved in creating prints seem to have more success in displaying and distributing them. If you can do both well, you might consider becoming your own publisher, as some organized artists have done. Normally, however, artists need a publisher and gallery owner or dealer so that they can concentrate on the production of prints and leave the actual distribution to those more attuned to the commercial world.

Substantial costs are incurred in advertising, stocking, displaying, selling, handling, matting, shipping, and billing prints. A dealer's markup must cover all these aspects of doing business, and the dealer must also pay rent, heat, light, electricity, and salaries. This may explain why the amount the artist gets seems so small on an edition sold outright to a dealer/publisher. The artist

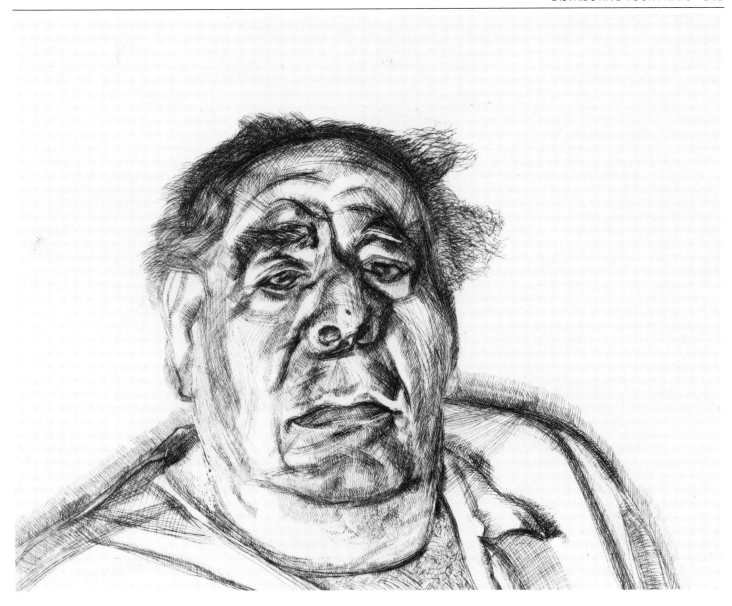

LUCIAN FREUD
Lord Goodman, 1987
Etching, hand-colored, 18⅞″ × 21⅞″
Courtesy Brooke Alexander, New York
Photo: Ivan Dalla Tana

may receive from 10 to 30 percent, rarely more, of the final sales price of a print when a substantial edition is involved. The dealer/publisher then decides whether to wholesale the prints to other dealers or galleries, usually at 50 percent of retail price, or to sell the prints directly to the public through a brochure or advertisements in magazines or newspapers. This costs money and takes time, which is also expensive. If you deal with a publisher, find out where your prints will be sold, how much the publisher will charge other dealers for your work, where your work will be advertised, and in what manner it will be presented to the public. Find out what other artists think of the publisher. It will be your reputation that suffers if the publisher handles your artwork in a tasteless and vulgar manner.

There are many nonprofit organizations and print clubs that commission prints from artists. Be sure all the details are spelled out in writing before you deliver an edition to one of these groups. Many artists have been disillusioned by the treatment they received from well-intentioned groups. What happens if the entire edition is not distributed? Will the remainder be wholesaled to a commercial dealer? Find out before you deliver. Protect yourself; no one else will. Have an understanding with the publisher as to how many impressions will become artist's proofs, to be used as the artist wishes. Will the plate be canceled? Can a second edition in different colors be issued after the first edition is gone? There are so many possibilities for problems that only a few can be mentioned.

CONSIGNMENT SALES

If you leave your work with a dealer and expect to be paid when it is finally sold, you have left your work on consignment. This is a venerable and common procedure that works for both the artist and the gallery owner. Normally the artist makes a better percentage with this type of sale, as the dealer keeps from one-third to one-half of the sales price and the artist gets the rest. Have this specified in writing on the receipt for your work when the dealer signs it. Make sure that you have a time limit on how long the dealer will keep your work and how quickly you will be paid when it is sold. Will the work be displayed in bins, on the wall, or kept in drawers or portfolios? Since every detail of the sales operation cannot be stated on the receipt, you must rely on the dealer's integrity and

honesty. Check with other artists who have had experience with the dealer to see whether they are satisfied.

Consignment works well for the dealer, too, who does not have to pay for work in advance and can therefore keep many more prints on hand. Remember, it is in the dealer's own interest to keep an artist happy by paying promptly and by maintaining an honest relationship. It is only occasionally that trouble will arise if you limit your consignments to reputable and established dealers. Be careful of small, out-of-town dealers. Check them thoroughly by talking to other artists who are represented by them. It is hard to get work back from a distant state if problems arise.

Once in a while a dealer will like your work well enough to buy it outright. The usual arrangement is 50 percent on a sale of this nature, but dealers are always looking for a bargain and may offer less, particularly to new talent. If they buy your work, it is because they think it can be sold easily. A certain amount of faith and trust is essential to a good relationship with a dealer or gallery.

The Print Dealer's Perspective

To supplement our discussion of the business of prints from the artist's point of view, we are including some insights from a dealer. We hope this will give artists some information on how the dealer relates to the artist and to the selling of his or her prints. Sylvan Cole, director of the Sylvan Cole Gallery in New York City, a fine-art gallery devoted to prints, has generously given us some of his ideas on artists and their work. His remarks follow:

Since fine prints are produced in editions, the distribution brings the artist to the marketplace. Today the artist who makes prints has a larger number of dealers and publishers than at any time in history. It is possible for an artist whose work is of high caliber to have as many as thirty or forty dealers across the country offering his or her work for sale.

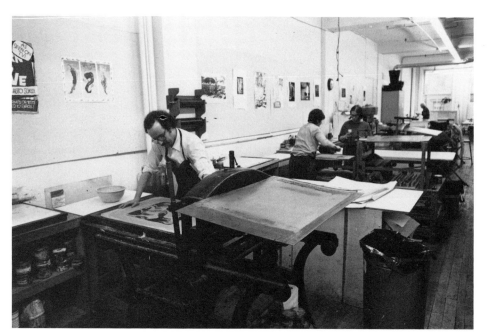

Rand Huebsch, one of the founders of the Manhattan Graphic Center in New York, works on a plate in the lithography area. This is a cooperative venture with funds and staffing supplied by participating artists.

The Garner Tullis Workshop in New York is set up exclusively for monotypes printed on a hydraulic press.

Several artists have dealers in foreign countries as well.

What follows is a summary of the various procedures in offering your prints for sale.

PREPARING A PORTFOLIO OF YOUR PRINTS

Once you have a collection of six to ten prints of uniform high quality, the works should be made ready for presentation. If size permits, they should be matted or placed in glassine folders. All should fit into a portfolio case for easy handling. Be sure to edit your portfolio. Take out experimental and student work. The work presented should be recent (done within the past two or three years) and the best of what you have done. Carry with you a typed personal biography that includes your art background (including artists with whom you have studied), exhibitions, museum purchases, awards, and so forth.

FINDING A DEALER OR PUBLISHER

The first dealers to go to are the ones in your own community. For other dealers located in other parts of the country, a list of print dealers is published by *Art in America* in their Annual Guide. The best way to check on dealers is to visit the gallery and see the kind of work handled, how it is presented, and so on. Another source is your fellow artists. It might be wise to call some and ask if their business dealings with a dealer have been favorable.

Once you have established those galleries that are of interest to you, it is usually best to contact the director and make a specific appointment to show your work. If you are visiting a city for just a day or two, an appointment made by phone or mail is necessary.

PRICING YOUR PRINTS

There is no great mystery in establishing a price for your work. Obviously, if you have an edition of thirty prints you must set a price low enough to allow for the sale of this edition. Do not think that the fact that the edition is "small" (less than fifty impressions) will persuade the public to pay a premium for an unknown artist. You should price the prints to allow for a dealer commission, which is usually 50 percent of the selling price. It is my belief that artists coming into the marketplace for the first time should try to come up with the lowest price within reason. Remember, the more prints you sell, the more people you reach. Each one, in a sense, becomes a continuing advertisement for your work.

Suppose you arrive at a price for a thirty-edition print of $100. This is the price at which it should be sold, whether you send off an impression to a dealer or to a museum competition. Do not listen to those people who always contend that your prints are priced too low. It is always a bit embarrassing to lower one's prices rather than raise them. Once you have established your price, stick to it regardless of the dealer's commission rate. In other words, do not give the print to a dealer to sell at $100 and then enter it in a national competition, where

the commission is 25 percent, at $75. Each print should be sold at the same price wherever it is sold.

Of course, if a print of yours starts to sell well and over a third of the edition is gone, you should consider raising the price. This is done by notifying all the dealers of the change. You should effect the change on the first of the month following notification so all the dealers will have the new price at the same time. Once you are down to a few prints in an edition, price is no longer a factor and you can go for any price you set or withdraw the prints from sale for future escalation.

FINANCIAL ARRANGEMENTS: CONSIGNMENTS

At this point you have put together your portfolio, made your appointment, priced your work, and met with a dealer who wants to have your prints for resale. The usual procedure is for the dealer to take these prints from you on consignment. This means that the dealer will offer them for sale and, when a print is sold, will pay you the proceeds less his or her commission. You are therefore placing your faith in the hands of the dealer. Here are some simple rules to follow:

1 Never leave more than six prints (different impressions) with an unknown dealer.

2 Always get a receipt from a dealer. This should be a printed receipt with the dealer's name and address and your name and address on it, along with the title(s) of the print(s), the edition number of each, and the selling price of each. The commission arrangement should be spelled out on the receipt.

3 In addition, you may wish to prepare your own receipts for the dealer to sign containing the information outlined above.

4 The dealer should advise you of sales and mail you a check for your share of the proceeds. Ideally, the dealer will report to you every three months. Some dealers report monthly and some every six months. I think it is a good idea to check in with the dealer after three months have elapsed. If nothing has been sold, it may be best to request the return of your work.

5 Some distributors or publishers will have you consign an entire edition. In this case you should have the cost of printing, paper, ink, and other expenses covered. The procedure is to divide the return as the prints get sold after the distributor or publisher recovers the expenses of printing the edition. The advantage here is that you will share in the proceeds of sale and get the benefit of a price increase should this occur.

FINANCIAL ARRANGEMENTS: SELLING OUTRIGHT

Selling outright to a dealer or publisher falls into two basic classifications: (1) selling an entire edition, or (2) selling a number of assorted prints, say, ten, twenty, or thirty at a time.

The sale of an entire edition can be fraught with problems. It is possible to get a flat sum of money from the publisher or distributor. Usually this is 20 to 25 and sometimes 33⅓ percent of the market price. For example, if your print would normally sell for $100 and you sell an edition of 100, you would receive upon delivery of the print $2,000 or $2,500. There is nothing really wrong with this arrangement, provided you find a distributor who can resell your edition to dealers or to the public. If the distributor or dealer cannot arrange for this resale, it is possible for him or her to go out of business and have your prints liquidated for a few dollars apiece.

The other option is selling small quantities of assorted prints at "a price." You should have an agreement with the dealer to resell your work at your usual selling price. The purpose of selling a number of prints outright is that it saves on recordkeeping and gives you immediate cash for your work. There is no established formula here. The dealer will buy the collection for 25 to 40 percent of your usual selling price. If you have prints that are selling well at a 50 percent commission, you would be foolish to accept such an offer.

PETER MILTON
Hotel Paradise Café (*Interiors IV*), 1987
Light-sensitive-ground etching, mixed technique,
24" × 35⁷⁄₁₆"
Courtesy Fitch-Febvrel Gallery, New York

EXCLUSIVES

Beware of the dealer who wishes to handle your work exclusively. It makes sense to grant an exclusive arrangement within a city or state, but to grant national or worldwide exclusivity is unwise unless the dealer or publisher guarantees you a reasonable amount of money per year and provides a way out if the exclusive arrangement does not work.

Keep in mind that for the most part, dealers are well meaning. It is to their benefit as well as yours to establish a positive relationship. Dealer/artist relationships have existed for more than two hundred years. However, it is your responsibility to protect yourself from the unscrupulous few.

Once you have established a working relationship with a reputable dealer, it is up to you to make sure your records are in order and in agreement with the material you receive from the dealer. The gallery should be contacted regularly, new prints shown, and up-to-date biographical information given. In short, it requires genuine effort on the artist's part to help keep the relationship an active and productive one.

Printer-Publishers and Collaborative Prints

The recent proliferation of printers who have turned to print publishing has given birth to a large number of technically complex and colorful prints. These works could not have been achieved by the artist, usually a painter, working alone, because the skills and craftsmanship needed are more than one person could possibly master. Collaboration in music and theater is common, but it is

still a new phenomenon in the visual arts. And, of course, not all collaborations work perfectly. But the very quantity of publishing coming from collaborative workshops says that many artists find this method of printmaking productive and rewarding.

From the beginning with Tatyana Grosman's Universal Limited Art Editions in 1957 and the Tamarind Lithography Workshop in 1959, the idea of the printer becoming the distributor/publisher has spread throughout the print world. No longer does this printer work for an hourly wage, but rather for a percentage of the total income from the sale of the edition. These entrepreneurial print workshops include, in a partial listing, Tyler Graphics Ltd., with Ken Tyler as director; Crown Point Press with Kathan Brown; Garner Tullis Workshop; Experimental Workshop; Derrière L'Étoile Studios with Maurice Sanchez; Solo Press with Judith Solodkin; Landfall

Press with Jack Lemon; Graphicstudio in Tampa, Florida, with Donald Saff and Deli Sacilotto; Gemini G.E.L. with Stanley Grinstein and Sidney Felson; and Cirrus Editions with Jean Milant. There are also workshops that print steadily for other publishers but occasionally publish their own editions, such as Brand X, Trestle Editions, Simca Print Artists, Styria Studio, and a growing number of university art departments.

From these collaborative workshops, come a variety of new images in an outpouring of brilliant colors, textures, and other effects that would have been unthinkable in the first half of the twentieth century. Monotype and hand coloring, for example, are not only accepted in contemporary editions, they are welcomed with open arms and, more important, with open pocketbooks. For it must be remembered that all this technical expertise and effort is not cheap. Presses are built that cost as much as a moderately priced house; workshops are necessarily large with air-conditioning and other expensive equipment. The technicians are highly skilled craftspeople, who must be paid accordingly. Editions must be documented, collated, publicized, exhibited, stored, shipped, insured, and otherwise handled, requiring bookkeepers, photographers, designers, typists, and a variety of other helpers, each adding to the overhead of the workshop. The result is a print that must, of necessity, be expensive. Prints now can cost what an expensive painting cost a few decades ago. Print publishing is now a speculative venture with considerable risks. Every printer-publisher needs a well-known artist whose work has a ready market to offset unsold editions by little-known artists.

Inevitably a particular workshop excels in certain methods and techniques and tends to produce work that exploits this capability. In other words the work from each print shop has a certain character, and artists should try to choose craftspeople whose abilities parallel their own creative goals. Some artists, however, seem to be able to hold onto their artistic identity while working with a number of shops.

The Artist and the Law

The legal problems that an artist-printmaker may encounter can be confusing and upsetting. So many different areas of the law can be involved that we have asked Franklin Feldman to outline some of the major trouble spots for you. He has wide knowledge of the problems of artists, is a well-known attorney with a prominent Wall Street firm, has represented artists and collectors, and makes and collects prints. He teaches a seminar at Columbia Law School on "Law and the Visual Arts" and is co-author of *Art Law*. His remarks on the artist and the law follow:

Artists, like most mortals, inevitably come into contact with the law. Although in many areas the rules applicable to artists vary little, if at all, from those that apply to everyone, in certain areas the rules are peculiar to artists and must be understood by them if they are to gain maximum protection for their creative endeavors.

There are three principal areas that concern most working artists: (1) the right to reproduce work; (2) the tax aspects relating to the sale, gift, or bequest of such work; and (3) the relationship between the artist and the dealer. The following discussion sets forth the highlights of these areas.

THE RIGHT TO REPRODUCE WORK

In all important respects, the right to reproduce art is governed by the United States Copyright Act. This statute, which stems from the United States Constitution, has been essentially based on the principle that in order to protect the right to copy (thus the term *copyright*), a notice to the world reserving that right must be affixed to the work in some accessible and conspicuous place so as to "give reasonable notice of the claim of copyright." The statute provides the form of notice to be used. It states that the notice merely say "Copyright or "Copr." or "©" with the name of the artist (or an abbreviation by which the name can be recognized) and the year of first publication. Thus the following notice affixed to the work would suffice:

© JOHN ARTIST 1989

Until October 1988 this notice was required on all published works in order to have the benefits of United States copyright protection. In October 1988 the United States passed legislation that was intended for the first time to make the United States a party to the Berne International Convention for the Protection of Literary and Artistic Works. The Berne Convention, to which more than seventy-five countries adhere, provides that local formalities shall not be a prerequisite to obtaining copyright protection. Accordingly, it is no longer mandatory for artists to place a copyright notice on their work to obtain copyright protection in the United States or in any of the other countries that are parties to the Berne Convention. This can be a major benefit to all visual artists. The statute provides, however, that an artist "may" (rather than "shall") place the notice on the work. The 1988 amendment to the Copyright Act provides that if the requisite notice has been placed on the work "to which a defendant in a copyright infringement had access, then no weight shall be given to such a defendant's interposition of a defense based on innocent infringement in mitigation of actual or statutory damages."

It should be noted, however, that the revised statute that provides for Berne Convention adherence applies only to claims that accrue after its effective date. Thus, works published earlier must still comply with the United States Copyright Act as it existed prior to the 1988 amendment. Accordingly, knowledge of the Copyright Act, which became effective January 1, 1978, is still important with respect to works created and published before the effective date of United States adherence to the Berne Convention.

There are relatively minor exceptions to the notice requirement. If the notice has been omitted from "no more than a relatively small number of copies" (as in the case of multiple originals such as prints) or if the work is registered with the Copyright Office within five years after publication without notice, and "a reasonable effort is made to add notice to all copies" that are distributed to the public after the omission has been discovered, the omission of the copyright notice is not fatal.

Registration of the work is not a condition of copyright protection. Registration is, however, necessary for an American artist to bring an infringement suit. This has been changed with respect to foreign authors now that the United States is a party to the Berne Convention. If there were a failure to register within three months of publication, the artist would still have the copyright (and the right to enjoin any further copying and recover actual damages and profit from the infringer), but would lose the right to statutory damages and attorney's fees. It is

therefore recommended that registration be made. At the very least, registration provides information on the name and address of the artist so that communication can be made. Registration simply requires a completed application available from the Copyright Office, two copies of the work, and a ten-dollar fee.

The right to copy work is regarded as a right distinct from the right to tangible possession of the work. Thus it is possible to sell a painting or a print and retain the copyright. Indeed, under the Copyright Act, unless the copyright is specifically granted to the purchaser of the work, it is reserved to the artist.

One problem often confronting artists with respect to reproduction rights involves the question of whether the artist created the work as part of a specific assignment, that is, whether the work was done "for hire." If so, the copyright

belongs to the person who has hired the artist. In the case of an employee, the result is clear: the copyright belongs to the employer. In the case of a freelance artist (not a traditional employee), the question can be more difficult. The statute now provides that, in nine specific categories of commissioned work, copyright is with the person who ordered the work if a written agreement states that the work is for hire. Recent decisions have, however, raised difficult questions about who may be an "employee" if there were "supervision and control" by the commissioning party. If at all possible, therefore, the artist in all work-for-hire situations should insist that the copyright belong to him or her. It is contemplated that the entire question re-

CHRISTO
Wrapped Automobile (Project for Volvo 122 - 5), 1984
Lithograph and collage, 22" × 28"
Courtesy Landfall Press, New York
© copyright Christo 1984

lating to work-for-hire situations will shortly be reviewed by the United States Congress.

There are other ways to limit the reproduction right. Often the artist is employed by a magazine or periodical to create an image for that publication, usually to illustrate an article or to produce the cover illustration. In such a situation, it would be appropriate for the artist to limit the grant of rights solely to "the first right of publication" with all other rights reserved to the artist.

TAXES

There are two essential taxes that must be considered by the artist: income and estate taxes.

Income taxes Generally, the sale or exchange of work created by the artist gives rise to taxable income. Thus, if an artist exchanges work with another artist, each has in effect "sold" a work and each is required to report as earned income the value of his or her work. Furthermore, if an artist should exchange a work for other services—such as dental or medical services—the artist (as well as the dentist or physician) is required to report the transaction as a sale and to report the value of the dental (or medical) work as income received.

One feature distressing to most artists is related to contributions of art to charitable institutions, such as a museum. Under present law, a gift by an artist of a work created by him or her results in a deduction only for the cost of materials—and not the fair market value of the work. This is based on the principle that gifts of personal services to a charitable institution do not give rise to a deduction for the value of one's services. This is equally true for a physician or lawyer who may contribute services to a nonprofit organization, such as a hospital or, indeed, to a museum, and receives no deduction.

Mary Ann Rose and Frances Moore, artists, and Clare Romano, at the Printmaking Workshop in New York. Founded more than 30 years ago by Robert Blackburn, its present director, it is one of the oldest nonprofit print workshops. Open workshops are used by professional artists and serve as classrooms for students. Invited artists use private studios for printing.

Estate taxes One of the most difficult problems facing an artist—and the family of an artist—arises upon his or her death. As a first proposition, there is little doubt that an artist—like anyone with significant assets, present or potential—should have a will. In the absence of a will, the property of a deceased person will pass under the laws of intestacy, which generally means that it will pass in certain ratios to certain blood relatives, but perhaps not in the way the person would have wanted. Furthermore, without a will a bond will generally be required for the administrator of the estate, which means an outlay for an insurance premium to purchase the bond. Generally, this is a thoroughly unnecessary expense.

Under the Internal Revenue Code all assets of a decedent must be valued and the estate tax must be paid on the net value of the estate (the gross estate less debts, property passing to a surviving spouse, bequests to charity, and adminstration expenses). In the case of the artist who leaves a substantial body of unsold work, this can be a staggering problem. Particularly when the artist established a consistent pattern of sales, the Internal Revenue Service can, and often

does, take the position that all items in the estate must be valued at amounts that approximate individual selling prices of works. And, of course, one cannot pay the estate taxes with artwork, but only with cash. The problem may become particularly acute in the case of the printmaker who leaves a number of plates of which the entire edition has not been printed at the date of death, but where there is the real possibility that future printings may be made to complete the edition.

One ameliorating aspect is the rule that where there is a large body of work that cannot readily be sold at one time, some discount for this "blockage" should be applied. The amount of blockage is not a precise number and generally requires negotiation with the Internal Revenue Service. Another mitigating factor is that where the principal asset of an estate consists of a trade or business representing a substantial part of the estate (at least 35 percent), payment of the estate tax attributable to those assets can be deferred over a ten-year period com-

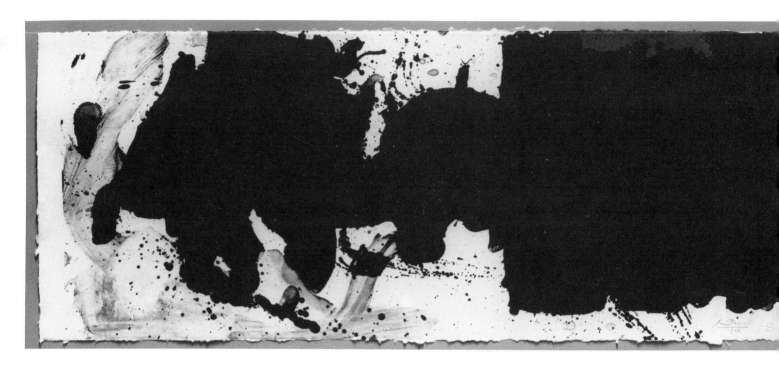

ROBERT MOTHERWELL
Black with No Way Out (from *El Negro*),
1983
Lithograph on white TGL handmade paper,
15″ × 37¾″
Printed and published by Tyler Graphics Ltd.
© copyright Robert Motherwell/Tyler
Graphics Ltd. 1983
Photo: Steven Sloman

mencing five years after the date of death. In such a case, however, interest would have to be paid on the deferred portion of the tax. In situations where it is relatively clear that the value of art will be a significant part of an estate—and where the values can be substantial—the artist should contemplate some estate planning. Such planning would involve the use of the marital deduction, *inter vivos* (during life) gifts to members of one's family, use of insurance, and testamentary gifts to charities. This is one area where the services of a lawyer are strongly recommended.

It should be pointed out that as of January 1, 1989, the first $600,000 net value of any estate is free of federal estate tax.

RELATIONSHIP WITH DEALERS

The artist's relationship with his or her dealer runs the full gamut of possibilities. Some dealers have elaborate agreements, but most have simple "letters of understanding" or no written agreements at all. Unfortunately, the bargaining power of most artists is such that the artist is delighted to have any representation at all and focuses on the agreement only when trouble arises.

Some of the problems have been mitigated by legislation. In twenty-seven states (including New York, California, and Illinois), statutes have been enacted that generally provide that work delivered by an artist to a dealer is "on consignment" and title to the work does not pass until the artist has been paid in full (less, of course, the commission due the dealer). One troubling question involves the rights of the creditors of the dealer as against the work in the possession of the dealer. In most states the statutes provide that the artist prevails over the dealer's creditors. In some states, however, this would not generally be the case, and it may be necessary for the artist to file a document (known as a financing statement) with the secretary of state and, in some states, with a local filing office.

There are some important provisions that an artist might consider incorporating in an agreement with the dealer: (1) the duration of the representation; (2) exclusivity or nonexclusivity of the relationship; (3) if exclusive, whether sales made directly by the artist require no payment of any commission to the dealer; (4) the extent to which the dealer may reduce prices or extend credit to a purchaser; (5) the reservation of reproduction rights to the artist; (6) the extent to which the dealer agrees to provide the artist with solo shows or incorporate the work in group shows; and (7) the extent to which certain expenses are to be incurred and shared (such as catalogs, framing, advertisement, and publicity). As the artist gains prominence and sophistication, the contracts with dealers will become more precise and less conducive to misunderstandings or unhappiness. Although lack of a clear written contract with one's dealer in the past has, nevertheless, led to the creation of exciting art, a loose arrangement is recommended only in small doses and with infrequency in the sensitive relationship that must exist between artist and dealer.

13 Health Hazards

ROBERT LONGO
Arena Brains, **1986**
Lithograph, 44½" × 29"
Published by Artists' Space
Printed at Derrière L'Etoile by
Maurice Sanchez, James Miller,
and Michele French
The flame is four-color process;
the head hand-drawn lithography.

Artists often overlook the hazards inherent in printmaking while they are intent on their creative endeavors. It is essential for printmakers to understand the hazards of the processes they use and how to minimize the risks involved. Print workshops should have clearly defined safety precautions posted and enforced to prevent accidents and to avoid unhealthy situations.

Exposure to toxic materials in the print shop can happen in several ways. One of the primary health hazards in printmaking is the inhalation of toxic vapors and gases from solvents, acids, and other chemicals. A common fault is improper or inadequate ventilation for these substances. Another common hazard is repeated skin contact with certain chemicals, mainly through the hands and forearms. A third common way toxins enter the body is through inadvertent ingestion of harmful compounds, mainly while eating or drinking in the workplace. A commonsense practice of washing your hands before eating or of restricting food and drink to other areas should reduce this danger considerably.

Materials used in the shop should be labeled correctly and any toxic ingredients noted. Many manufacturers do not list the components of their products for a number of reasons, including the possibility of competitors copying their "secret recipes" for art materials. If the ingredients of an ink or other chemical are not listed, you can request a Material

Safety Data Sheet (MSDS) from the manufacturer in writing. The company must respond to companies with employees, or it can be reported to the Occupational Safety and Health Adminstration (OSHA). The data sheets should be filed in a notebook and kept accessible.

Tolerance to chemicals varies from person to person. Children are particularly susceptible to chemical toxins. It is advisable for pre-teens to use only water-based inks, but high school students can use oil-based inks and odorless paint thinner with adequate supervision and good ventilation. Some health experts recommend that pregnant women not work with many common solvents.

Be aware that although many art products are labeled "nontoxic," these labels only indicate that the product is not an immediate danger to health. The product may not have been tested for long-term hazards such as cancer or birth defects. Some children's products carry a "CP" or "AP" seal of approval from a certifying agency called the Arts and Crafts Materials Distributers. These products have passed more rigorous screening.

With toxic materials, be sure to read the labels carefully. If a product recommends that "adequate ventilation" or a "well-ventilated area" be used, this is a warning that the product is potentially dangerous. Use such products outdoors, in a spray booth, or with a suitable exhaust system. Don't be misled by the wording. The caution label on a well-known aerosol product reads: "No lead in formula; no fluorocarbons; no methylene chloride; no hexane; no methoxy- or ethoxy-ethanol or their acetates." This may make the users think they can discount the caution label. *Heed the caution label.* (For further reading, see the bibliography.)

In any case, keep a list of local emergency numbers near a telephone in the shop. It should include the fire and police departments, a doctor, a nearby hospital, and the nearest poison center, among other emergency numbers.

Equipping a Safe Shop

The layout of the print shop should be planned with the prevention of health hazards in mind. It is important that the presses and tables be in correct alignment and that work areas be adequately lit, but it is just as vital that proper ventilation be planned and that storage cabinets for potentially dangerous chemicals be constructed of fireproof materials. Budgets seem to revolve around the size of the press or other printing equipment, and only at the last minute is money found for masks, gloves, fans, fire extinguishers, and first-aid kits. However, one serious accident or lawsuit for personal liability can make all other expenses seem trivial, so prepare in advance to have a safe print shop. It will be money well spent.

Etching presses and paper presses exert tremendous pressure and are the source of many accidents, from crushed fingers to mashed toes. Motor-driven presses should be restricted to professional workshops and used only by experienced artists—do not let beginners run them. They should be equipped with dead-man switches, so that the power will stop if pressure is released. Better still, have two-hand switches installed on power-operated etching presses, so that release of either hand will stop the press. Make sure that all press beds are held in place by strong metal stops that really work. Motorized etching presses should have guard bars installed near the rollers to prevent fingers from going underneath to straighten out the blankets.

Plate choppers and paper cutters are another hazard in the shop, and definite instructions on their safe use are required by OSHA. The guillotine-type plate cutter should have a guard.

The print shop should have all entrance doors locked—with a key-operated lock that only authorized persons have the key for—to keep out children or other inexperienced persons. Fire extinguishers and first-aid kits are necessities described in detail later in this chapter. Smoking should not be permitted where flammable solvents are used, and in general the entire print shop should be a no-smoking area.

VENTILATION

The most common health hazard in the print shop is caused by poor ventilation. This causes toxic materials to be inhaled into the nose, mouth, and lungs, sometimes with deadly effect. These materials can take various physical forms, such as dusts, mists, fumes, vapors, or gases, but all can be minimized or eliminated by proper ventilation.

Another danger is created when flammable liquids vaporize. A high concentration of such vapors can form an explosive atmosphere at room temperature, which can be set off by a spark, a lit cigarette, or even static electricity.

There are two basic types of ventilation systems. The first is dilution ventilation, which reduces the concentration of toxic air in the room with fresh, clean

The roller on this motorized etching press at the University of California at Long Beach is protected by a metal guard, keeping hands away.

air. Blowers or vents bring in fresh air, while the diluted air mixture is removed through exhaust fans or blowers. This method is only adequate for small amounts of moderately toxic gases or vapors. It is not suitable for particle dust and fumes or for highly toxic airborne chemicals.

A more efficient type of ventilation is local exhaust. This system removes contaminants at their source and vents them to the outside. The contaminants are captured by a hood or booth, which draws polluted air away from the workers' breathing zone (see drawing). From the hood, the strong airflow moves contaminants through the ducts and exhausts them to the outside. In some cases, air cleaners are needed in the system to meet federal or local air-quality standards.

Certain processes require specific systems. Spray booths are recommended for all aerosol work, such as airbrush painting, staining, and the like. Because many spray compounds are flammable, the system should be spark- or explosion-proof. Slot or lateral-vent hoods with low openings right over the work surface are good for acid baths and some airbrush techniques. Canopy hoods situated overhead will capture hot gases or vapors that naturally rise—for instance, above hotplates. Hoods should be constructed so

A ventilation chamber at the University of Wisconsin, Madison, is large enough to contain a paint-drying rack.

slotted vent

LOCAL EXHAUST VENTILATION

that artists cannot work under the hood, where they would breathe the contaminant. An elephant trunk hood with a flexible duct can be positioned right next to the toxic source, such as sanding or soldering. In all cases the capacity of the system's fan or blower should be adequate to draw contaminated air into the hood.

A particularly common problem occurs in the photographic darkrooms used for some etching, screen-printing, and lithographic techniques. Make every effort to purchase presensitized plates rather than sensitizing your own. Photographic processes release very harmful gases and vapors into the air, which require local exhaust ventilation. Overhead vents are normally not suitable because they draw contaminated air through the workers' breathing zone. Even for simple black-and-white developing, the air in small darkrooms should be changed twenty times an hour.

To avoid dust, wood or plastic glove boxes should be constructed for handling toxic powders, such as pigments and dyes. These should be about 20 inches square, with a transparent top and round holes cut in each side just large enough for your arms to fit through.

RESPIRATORS AND MASKS

The ventilating system in the print shop should be sufficient to minimize exposure to hazardous mists, fumes, gases, and dusts; an air-purifying respirator or mask is only a last resort. These devices provide only limited protection. Moreover, they are uncomfortable to wear, difficult to fit, and need frequent replacement of filters and cartridges to ensure protection. In any case, you must use a respirator or mask suited to the particular hazard you are confronting. All masks, filters, and cartridges should be approved by the National Institute for Occupational Safety and Health (NIOSH) for the specific contaminant.

Because rosin is an allergen, a mask rated for toxic dust is advised as protection against rosin dust. When buying a dust mask, look for one with two straps (single-strap masks are not approved by NIOSH for toxic dusts). Everyone should have his or her own mask, tested to make sure it fits the individual face. A mask that allows dust to penetrate around the edges is useless. This type of mask is suitable only for particles of dust,

such as wood chips, rosin powder, or flying grit. Goggles should be worn when there is danger of particles getting in the eyes. A mask approved for dusts offers no protection against other contaminants such as toxic vapors, acid gases and fumes, paint spray mists, or other chemicals.

GLOVES

The print shop is a place where everyone, at one point or another, uses gloves as protection from toxic or dangerous materials. Protective barrier creams provide a minimum of insulation against the harmful chemicals that are in everyday use. Leather work gloves should be sufficient for handling hotplates, when melting rosin powder or smoking a ground. In other cases wear the proper glove for the contaminant that you are using. Almost all the impermeable gloves, made from vinyl (polyvinyl chloride), rubber, neoprene, latex, or nitrile, are protection against dilute acids, alkalis, and alcohols. However, only Buna N rubber is adequate against lacquer thinner (toluene or xylene).

Gloves should fit properly and should be washed with soap and water after immersion in toxic chemicals. Dust the inside of the gloves with baby powder or cornstarch to minimize sweating and irritation. Clean your hands thoroughly after working in the print shop, using soap and water after you use waterless hand cleaners.

FIRE EXTINGUISHERS

Every shop should have the proper fire extinguisher for the chemicals in use and the fires that might occur. The wrong extinguisher can spread a fire instead of containing it. In fine-art print shops, class ABC fire extinguishers are the best choice. Smoke detectors are also valuable because of the warnings they give.

FIRE EXTINGUISHERS

Class of Fire	Type of Fire	Water	Carbon Dioxide	Dry Chemical	Dry Powder
A	Wood, paper, textiles	Yes	Small fibers only; follow with water	Use only multi-purpose chemical	No
B	Flammable liquids, gases, such as oil, paint, or grease solvents	Foam type only; do not use with acetone or alcohol	Yes	Yes	No
C	Electrical	No	Yes	Yes	No
D	Combustible metals such as zinc, aluminum, magnesium	No	No	No	Yes, but depends on metal burning

Note: Chart adapted from National Fire Protection Association. Class ABC fire extinguishers should be used in all fine-art print workshops.

FIRST-AID KITS

For print workshops, a more complete kit is necessary than is normally used in the home. Order a standard first-aid kit from an industrial-supply house. It should contain at least the following items:

Aspirin

Sodium bicarbonate

Salt (sodium chloride)

Merthiolate

Burn ointment

Aromatic spirits of ammonia

Assorted bandages (ranging from small plastic adhesive bandages to large compresses)

Scissors

Tweezers

Adhesive tape

Paper cups

As noted before, all emergency phone numbers and procedures should be prominently displayed.

Handling Hazardous Materials

Certain acids, chemicals, and solvents are essential to some print techniques, and thus it is inevitable that artists must use them. A little time spent in learning proper procedures will help to make a creative effort a safe and successful one.

ACIDS

A number of acids are in common use in the print shop, and artists should be aware of emergency procedures before they start to use these corrosive solutions. If an accident happens, you may have only seconds to prevent serious injury, and there will be no time to read warning labels. When mixing powerful acids, artists or technicians should wear gloves, gauntlet style, of neoprene rubber. Goggles are advisable. *Always pour acid into water.* A violent, heat-producing reaction may occur if water is poured into acid.

A safe studio will have an eyewash fountain and a deluge shower located in the immediate vicinity. If acid gets into the eye, flush the eye for 15 minutes and call a doctor immediately for further instructions. In case of an accidental spill on clothing and skin, remove the clothing and flush with lots of water. For an acid burn to the skin, flush with water and get medical advice. Be sure to tell the doctor or EMS what kind of acid caused the burn.

Small spills of dilute acid on the floor or table can be neutralized with baking soda. Have a good-sized box handy. Mop up the residue with paper towels or newspaper and put them in a plastic trash bag that you discard promptly. If anyone accidentally swallows a toxic liquid, such as acid, turpentine, paint thin-

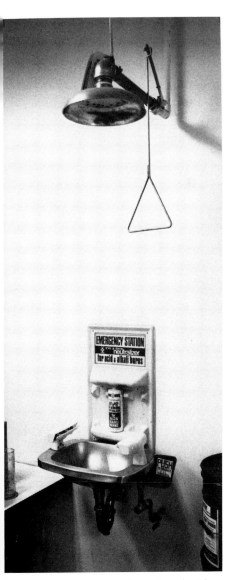

The emergency shower washes off accidental chemical spills at the University of the Arts, College of Art and Design, in Philadelphia.

ner, petroleum distillate (kerosene, naphtha, benzine), or the like, call the nearest poison-control center or EMS for advice and quickly get the patient to the nearest treatment center.

The habit of standing over the acid tray while etching a plate should be avoided. Local exhaust ventilation should be provided for all acid areas. Enclosed acid chambers provide the best protection. As you can see from the following descriptions of common print shop acids, the fumes and vapors can be dangerous.

Store acids in a locked cabinet that is approved for acid storage—never store them in a flammable cabinet. Acids

should be kept away from other chemicals such as alkalis, ammonia, and sodium hydroxide. When disposing of an exhausted acid bath, mix the acid with large amounts of water and pour it into a sink drain with running water. Do not dispose of full-strength acid this way, as it takes enormous amounts of water to safely dilute it.

Nitric acid This acid produces highly flammable hydrogen gas bubbles when etching zinc, but hydrogen gas itself is not a health hazard. When strong nitric solutions are used on deeply bitten plates, the solution can heat up and cause the release of a brownish gas of nitrogen oxides, a dangerous chemical. Bear in mind that some nitric acid vapor is constantly being released by the bath. Nitrogen oxides are also being released in small amounts because even light decomposes them. Cover the baths when they're not in use and provide local exhaust ventilation when they're in use.

Note that there are no approved respirator cartridges for either nitric acid or nitrogen oxides. Nitrogen oxides have poor odor-warning capacity, and a heavy exposure can cause pulmonary edema.

Dutch mordant This mixture of hydrochloric acid, potassium chlorate, and water generates chlorine gas, a highly toxic substance, when first mixed. Cartridges approved for acid gases provide some protection from the gas. Potassium chlorate is a very combustible material and spilling it into rosin dust can cause an explosion. It should be stored away from heat and other combustibles.

Ferric chloride The least dangerous of the acids used to etch copper, ferric chloride produces few harmful emissions. Skin contact, however, should be avoided because it can cause irritations. Some ventilation should be provided.

Vented acid compartment in the studio of Rudy Pozzatti in Bloomington, Indiana. The black siphon on the left wall is used to drain solutions back into their containers.

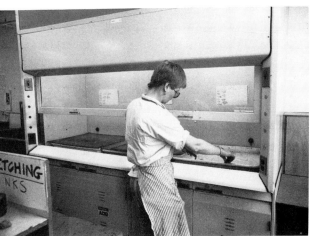

This glass-faced ventilated compartment by Allied-Fisher is used for acid solutions by Laurel Schwass-Drew at the University of the Arts, College of Art and Design, in Philadelphia.

Sulfuric acid This acid is particularly dangerous to the skin and respiratory system. Fumes or splashing can severely damage the eyes. Sulfur oxides may be released, which can cause lung damage.

Acetic acid As a concentrated solution, this acid can cause severe burns and its vapor is harmful. However, very low concentrations, such as vinegar with its 3 to 5 percent acetic acid, are not hazardous.

Phosphoric acid As a highly concentrated solution, phosphoric acid is highly toxic by all routes of exposure. It is safe only when dilute.

Oxalic acid As a solution or as a dust when dry, this acid can cause severe burns to the skin, eyes, or mucous membranes. Even low concentrations are irritating.

Gallic acid This is a mild skin, eye, and respiratory irritant.

Tannic acid Although related to gallic acid, tannic acid is a liver toxin and suspected carcinogen. It usually enters the body by ingestion.

Hydrofluoric acid This extremely toxic acid is used to etch glass. It is highly dangerous and should be handled only with special training and care.

SOLVENTS

Proper handling of the solvents used in printmaking will reduce your exposure to these chemicals. Get in the habit of wearing gloves when cleaning plates, blocks, and screens. Pour the solvent on a rag first rather than directly on the plate, to limit the amount of solvent used. Dispose of saturated rags and paper towels promptly in a safety waste can, which will control the evaporation of solvents into the air. Waste cans should be emptied daily in a busy shop.

SAFETY DISPOSAL CAN

SAFETY SOLVENT CAN

Metal safety storage cans should be color-coded and labeled for the various solvents that are kept in the workshop and stored in fireproof metal cabinets if the solvent is flammable. A flammable liquid is one whose flash point is under 100°F (38°C). (See the solvent chart in this chapter.) Because many artists' chemicals are flammable, smoking and use of open flames should be severely restricted in the print shop.

The smell of a solvent is not an accurate indication of its toxicity. Acetone, although it has a penetrating odor, is one of the least toxic solvents. Odorless paint thinner has little smell but can be more harmful. All solvents, except the universal solvent—water—should be handled with care.

Exposure to solvents by inhalation is measured in threshold limit values (TLVs). This measures, in parts per million, a safe exposure for 8 hours a day with no adverse health effects. The

higher the TLV, the safer the chemical. A low TLV is more dangerous. However, because some chemicals are absorbed through the skin, the TLV only partly indicates the toxicity of the substance.

You should not wash your hands in solvents. If your hands are particularly dirty, use baby oil first, which will weaken the contaminant's bond to your skin. Then use a hand cleaner such as Boraxo, Gre-solvent, Goop, or Dif, some of which contain lanolin or other beneficial ingredients.

INKS

Many inks contain chemicals as pigments or dyes. Inhalation of certain powdered chemicals can be very hazardous. We recommend that you buy your color already formulated from a reliable ink manufacturer. However, if you must grind powdered pigment into inks, use a respirator with all pigments, especially the following:

Cadmium pigments
Carbon black
Cobalt blue
Chrome colors
Diarylide yellow
Molybdate orange
Phthalo blue and green
Raw umber
Red Lake C
Talc white
White lead

Some commercial inks contain lead or manganese driers. If possible, replace with cobalt linoleate drier, which is less harmful.

Hazards in Specific Printmaking Techniques

All printmaking methods harbor health hazards, and care should be taken to understand what these are and how they can be avoided.

RELIEF PRINTING

The woodcut and linocut are mechanically dangerous because sharp knives and gouges are essential to the craft of carving the wood or linoleum. Proper methods should be taught to beginners. If power saws are used to cut blocks, they should be restricted to experienced personnel only. If caustic soda (sodium hydroxide) is used to etch linoleum, it should be handled with care as it can cause bad burns and is very toxic. When ink is cleaned from blocks, the solvents evaporate into the room, which must have adequate ventilation. Ideally, students in a classroom should clean their blocks under local exhaust ventilation.

INTAGLIO PRINTING

The dangers of various acids and solvents have just been described, but there are other potential hazards with intaglio printing. Sharp needles and burins, for example, should be kept in canvas rolls with cork stoppers on the points. In the engraving process, burins cause sharp spurs in the metal, which can puncture the hand if they are not removed promptly.

Smoking plates with an open flame can cause fires and should be undertaken with caution. Moreover, this technique creates highly toxic emissions requiring ventilation. Electric hotplates frequently cause burns, and they should have a red safety light that lights up when the hotplate is turned on. Use window screening as a plate handler when melting rosin in the aquatint technique. An explosion can occur if sparks are generated in a closed box filled with rosin dust. If a steel rod is used in a turning device, be sure it revolves in a brass bushing as two steel elements may generate sparks.

As already mentioned, printing presses require safety features. Motorized presses should have roller guards and safety switches. In a classroom it is even better to have all presses hand-cranked.

LITHOGRAPHY

The weight of litho stones is a danger whenever they are moved. Many shops have small forklift trucks to handle them. A sturdy table with wheels, the same height as the press and worktable, is an inexpensive solution for moving stones.

The stones may be drawn upon with crayons made of lamp black, which is a skin irritant, so thin surgical gloves should be used for protection. Other processes in preparing the stones use acid etches, rosin, talc, and various solvents, which should all be used with caution. Cleaning the image from the printed stone may require phosphoric or carbolic acid, both dangerous. Other toxic chemicals, such as hydrochloric acid, tannic acid, sulfuric acid, saturated oxalic acid, and potassium dichromate, may be employed in certain lithographic techniques. All are potentially hazardous and require careful handling.

SCREEN PRINTING

The danger in oil-based screen printing comes mainly from the high volume of solvents released into the air through evaporation or oxidation. Oil-based inks contain large volumes of solvents, such as mineral spirits, lacquer thinner (toluene or xylene), benzine, naphtha, and kerosene. Vinyl inks contain isophorone, which might induce narcosis or, with multiple exposure, cause kidney and liver damage. Ventilation is a prime concern in the screen-printing shop, and the construction of a good venting system will be the most expensive component of the studio. If heat is used in drying certain inks, even more solvent is evaporated into the air, requiring a greater volume of ventilated air.

Cleanup of screens after printing with oil-based inks requires large quantities of solvents, and local exhaust ventilation should be specially designed for these areas. As waste cans are filled rapidly in the workshop, they should be disposed of promptly.

The complaints of artists making screen prints have led to the widespread introduction of water-based inks into the

process. Many schools, universities, and industries have switched to these safer materials and more will follow. It is doubtful if all hazardous chemicals can be eliminated from screen printing, but the growing awareness of the dangers inherent in some of the conventional methods is an encouraging sign.

PHOTOGRAPHIC TECHNIQUES

Because a photo darkroom is an enclosed space, toxic vapors and fumes can reach dangerous levels very quickly. Therefore, efficient local exhaust ventilation is a necessity over the offending trays and sinks. Photo-developing chemicals use aromatic hydrocarbons (xylol or xylene) for zinc or copper plates, and their vapors are very toxic. Resists include methyl cellosolve acetate in their formulations, which is capable of causing birth defects, reproductive system and kidney damage, and nervous system deterioration. It can be absorbed through the skin and penetrates most gloves in minutes. Photo stencils in screen printing use ammonium dichromate, hydrogen peroxide, silver nitrate, and caustic soda—all harmful in varying degrees. Potassium and ammonium dichromate are flammable and highly toxic through inhalation. Use all these materials with care; some are suspected carcinogens.

Diazo sensitizers, used in some newer methods, are eye irritants. Even the light sources in some photo techniques can be harmful. Carbon-arc lamps give off toxic fumes containing nitrogen oxides, ozone, and carbon monoxide; they should be replaced because there is a possibility that they may cause emphysema and pulmonary scarring. All light sources in photo printmaking give off large amounts of ultraviolet radiation, which is harmful to the eyes; they should thus be used with caution.

SOLVENTS

Common Name	Chemistry	Toxicity Rating	Threshold Limit Value (TLV)	Flash Point	Use	Hazard	Precaution
Acetone	Acetone	2	1000	15°F	Paint remover; dissolves plastic and lacquer	*Slight.* Can cause narcosis in high vapor concentration. Very flammable.	Well-ventilated area.
Ammonia	Ammonia	5			Cleaning solution	*High.* Danger to eyes, nose, respiratory tract.	Well-ventilated area; wear gloves.
Denatured alcohol/ethanol	Ethyl alcohol	2	1000	61°F	Paint and varnish remover, shellac thinner, lacquer solvent, rosin	*Slight to moderate.* Chronic ingestion causes liver damage.	Well-ventilated area.
Rubbing alcohol	Isopropyl alcohol	2–3	400	60°F	Paint and varnish remover, shellac thinner, lacquer solvent, rosin	*Slight to moderate.* Eye, nose, throat irritant.	Well-ventilated area.
Wood alcohol/methanol	Methyl alcohol	4	200	60°F	Paint and varnish remover, shellac thinner, lacquer solvent, rosin	*Moderate to high.* Can cause narcosis, nervous system or liver damage. Can cause blindness through ingestion.	Use other alcohol if possible or local exhaust ventilation.
Benzene	Benzol	5 +	− 10	12°F	Paint remover, plastic solvent	*High.* Carcinogen; damages bone marrow.	Do not use.
Benzine	Petroleum distillate	4		20°– 55°F	Paint thinner	*Moderate to high.* Depresses central nervous system.	Local exhaust ventilation; wear gloves.
Ether	Ether	5			Etching ground thinner	*High.* Dangerous.	Local exhaust ventilation.
Gasoline	Petroleum distillate	5		− 50°F	Rubber solvent, paint thinner, degreaser, cleaning fluid	*High.* Extremely flammable, explosive.	Do not use. Substitute naphtha.
Kerosene	Petroleum distillate	4		100°– 165°F	Paint thinner, cleaner, rubber solvent	*Moderate to high.*	Well-ventilated area.
Kodak Photo Resist	Methyl cellosolve acetate, xylene	5	25– 100		Etching photo resist	*High.* Liver, kidney, and brain damage; easily absorbed through skin.	Local exhaust ventilation; use respirator and gloves.
Lacquer C solvent	Methyl ethyl ketone	4		22°F	Lithography solvent	*Moderate to high.* May cause dermatitis.	Exhaust ventilation.
Lacquer thinner	Toluene, xylene, xylol	4 +	100	45°– 75°F	Paint and lacquer thinner, remover	*Moderate to high.* Kidney and liver damage.	Local exhaust ventilation.
Lithotine	Petroleum distillate (mostly mineral spirits with pine oil added)	4	100	90°F	Cleaner, paint thinner	*Moderate to high.* Skin, eye, nose irritant.	Well-ventilated area.
Mineral spirits (Varnolene, Varsol, odorless paint thinner)	Petroleum distillate	4	100	90°F	Cleaner, paint thinner, etching ground thinner	*Moderate to high.* Skin, eye, nose irritant.	Well-ventilated area.
Naphtha	Petroleum distillate	4		20°– 55°F	Cleaner, paint thinner, etching ground solvent	*Moderate to high.* Skin, eye, nose irritant.	Well-ventilated area.
Rubber cement thinner	Hexane, naphtha, benzol	4 +		− 50°– − 9°F	Frottage, thinning rubber cement	*Moderate to high.* Avoid skin contact and inhalation.	Local exhaust ventilation or replace with nontoxic glue.
Turpentine/gum spirits	Spirit of turpentine	4		95°F	Paint thinner	*Moderate to high.* Accidental entry to lungs can be fatal.	Well-ventilated area.

14 School Printmaking

KENNY HILL (age 14)
Ocean View

Cardboard and paper print, 8⅜" circle
Teacher: Caroline Rister Lee, Gilmore J. Fisher Junior High School,
Ewing Township, New Jersey
Three separate plates were cut from one circular image, inked with soft-rubber
brayers, reassembled, and printed on an etching press.

Printmaking is a creative activity that can be explored by a wide range of students in elementary, junior high, and high school classes. Many of the relief techniques are particularly suited for younger children in the early grades, from ages six to thirteen. The methods we describe are fairly simple and can be attempted by most students with a good chance of success. Although printmaking is not as direct as painting or drawing because it requires the making of a plate or matrix before the final image is obtained, this fact does not seem to discourage too many students. There is a basic sensibility to craftsmanship that many students respond to, and most of them enjoy the process of making the plate or block and then printing it. And exposure to the rapidity and freedom of making a monotype can be very stimulating.

The tactile skills that are developed by working with tools, glues, inks, rollers, and the like and the organization necessary to complete a work are helpful to a child. Because the criteria used in art activities are visual instead of verbal, new and exciting worlds are opened to the young person. These aid in the maturing and developing of the child and, in some cases, may offer an area in which a nonverbal youngster can excel. The confidence that can be built by a successful project in art can lead to increased self-esteem, which in turn can have positive effects on the student's outlook toward other subjects.

MIYOKO BAENSCH (age 15)
Monotype, 12½″ × 10″
Teacher: Natalie Schifano, Hastings High School, Hastings, New York

ELIZABETH BARTFELD (age 10)
Monotype with scratched lines and stencil (water-based color), 8¾″ × 8¾″
Teacher: B.J. Greenberger, Lawrence Public School, Lawrence, Long Island

An excellent way to introduce the concept of the print to young children is to have them make monotypes. Although the monotype is not a true print medium because it cannot be duplicated, it does show quickly how an impression can be made from an inked surface. Another way to introduce the print is to have children collect found objects from their homes and neighborhoods or from visits to other places. Many of these can be inked and printed as a collage or collagraph.

Tools given to young children should be carefully selected. Sharp tools should be eliminated for the very young, and older children should be supervised in small groups if they are allowed to handle gouges and knives. Simple, easy-to-obtain materials are best. Water-based inks are easier to clean up than oil-based inks. It is true that more advanced classes will get better results from oil-based inks because they dry more slowly and allow for more complex color methods than water-based inks, particularly in making etchings. We list the materials and tools necessary for each technique.

Because children are particularly susceptible to the health hazards inherent in certain materials, such as oil paint, some solvents, sharp knives, presses, and so forth, these should be either eliminated or carefully controlled by the teacher. Certain chemicals, such as acids, rubber cement thinner, lacquer thinner, and photo-resist chemicals, should either be forbidden or be used with great care and a clear knowledge of their toxicity and potential for harm. Good ventilation should be provided where necessary, and adequate cleanup equipment, such as soap, paper towels, and nonhazardous solvents, should be available. It is also helpful to have an assistant or teacher's aide in the room to assist in the handling of new materials and to keep creativity from becoming chaos.

Monotypes

(All ages)

The monotype image can be painted on a smooth, nonabsorbent surface such as Plexiglas, Lucite, glass, linoleum, hardboard, or vinyl.

MATERIALS

Water- or oil-based ink or paint
Brushes or flat sticks and sharpened end of a brush
Roller
Palette knife
Wooden kitchen spoon or doorknob (for rubbing)
Newsprint or bond paper
Rags or paper towels
Water or solvent (for cleanup)

PROCEDURE

The monotype can be quick and spontaneous or it can be thoughtful and painterly, depending on circumstances and personalities. It is one print taken from a design that is painted or developed by a variety of means on a hard, nonabsorbent surface with either water- or oil-based inks. A sheet of thin drawing paper or Japanese rice paper is rubbed with the hand, a rag, or a spoon, and the impression, or monotype, is transferred to the paper. Numerous colors can be applied by brush or by roller. If a brush is used, a free, painterly effect with many colors is easy to achieve. Fingers, sticks, rags, and a roller's edge can be employed to draw into the colors. A pal-

ette knife can blend colors, and solvent (either water or mineral spirits) can be sprinkled or dabbed onto the surface to achieve blending or running effects in the colors.

Still another variation, similar to stencil printing, is to lay thin, cut-out pieces of paper on the inked surface of a mono-type painting and then take an impression of the partially masked image. The paper shapes will print as open white forms with colors around them. (See the monotype chapter for additional procedures that may be applicable.)

Object Prints

(All ages)

Objects found in the immediate environment, if flat enough and resistant to ink, can be printed onto a sheet of paper.

MATERIALS

Flat pebbles, leaves, feathers, textured wood, coins, embossings, license plates, flattened tin cans, raised letters, old plastic blocks, gaskets, and the like

Water- or oil-based ink or paint

Palette knife (for mixing)

Smooth inking slab (made of any non-absorbent, easily cleaned material, such as glass, plastic, Formica, sheet metal, or enamel pan)

Soft-rubber roller or brayer

Spoon (for rubbing)

Newsprint or rice paper

Rags or paper towels

Water or solvent (for cleanup)

PROCEDURE

If an object has a flat enough surface to receive the roller, it can be inked and printed. In Japan fresh fish have been inked and printed by hand with wonderful results. Avoid sharp or excessively rough surfaces because they will tear the paper.

Ink the objects with color applied with a soft-rubber roller or brayer, place a sheet of paper over the inked objects, and rub the paper with fingers or a

wooden spoon. Print either in single sheets or in an arrangement on a large sheet of paper. Impressions made on small papers can be cut out and pasted down on larger sheets for a small mural.

MARY AND RUTH (ages 8 and 9)
Object print (water-based ink)
Shells, oak leaf, and hemlock branch inked with a brayer and printed by hand rubbing.

CHRIS KOPEC (age 14)
Bladed Steel

Object print, 4″ × 4″
Teacher: Caroline Rister Lee, Gilmore J. Fisher Junior High School, Ewing Township, New Jersey
The metal object was glued to cardboard, relief-inked, and printed on an etching press.

Offset Roller Prints

(All ages)

This variation of the object print is somewhat easier to control as far as the positioning of the object is concerned. However, it does require two rollers or brayers, one usually larger in diameter than the other.

MATERIALS

Objects with interesting shapes or textures

2 soft-rubber rollers (one 2 or 3 inches in diameter)

Water- or oil-based ink or paint

Palette knife

Inking slab

Newsprint or other paper

Rags or paper towels

Water or solvent (for cleanup)

PROCEDURE

Ink the object with a small-diameter soft-rubber roller (a Hunt Speedball soft-rubber roller is a good choice) until a heavy

ROBERT (age 9)
Offset roller print (water-based ink), 11½″ × 4½″
The bottom of a child's sneaker was rolled with a heavy buildup of ink; then a clean, soft brayer was rolled over the inked sneaker to pick up the pattern of the sole, and rolled out on paper.

quantity of ink builds up on the surface. Take a second, clean roller of large enough diameter to encompass the entire image that has been inked. (A 3-inch-diameter roller has a circumference of more than 9 inches.) Press the clean roller over the inked surface of the object to pick up an impression. Now roll out the impression onto your sheet of paper, thereby transferring the image to your paper. Each time you do this, you must clean the large roller to prepare it for the next impression.

Cardboard and Paper Prints

(Age 10 and older)

Scissors can be used by young children with stiff paper or shirt cardboard. Older children can use X-Acto knives or razor blades to cut the cardboard, but discretion should be used in allocating these tools.

MATERIALS

Shirt cardboard, box board, chipboard, mat board, stiff paper, or other cardboards

Scissors, X-Acto knives, or single-edge razor blades in holders

Texturing tools (wood rasp, screws, etc.)

White glue (Elmer's, Sobo, or equivalent)

Brushes (for glue)

Oil- or water-based ink or paint

Inking slab

Rollers or brayers

Paper for printing (bond, rice paper, newsprint)

Rags or paper towels

Water or solvent (for cleanup)

PROCEDURE

Cut images out of thin cardboard or paper, using scissors, knives, or blades. Glue these shapes down on heavier board with white glue. Coat the surface of the paper with a dilute mixture of white glue and water (50 percent glue, 50 percent water). Be sure that all cardboard forms are glued down well and that the entire surface is thoroughly dry

NANDINI SINHA (age 16)
Untitled
Collagraph, 14" × 12"
Teacher: Nadine Gordon, Briarcliff High School, Briarcliff Manor, New York
A cardboard collagraph was relief-rolled with two colors blended simultaneously on the plate (rainbow roll) and printed on an etching press.

LOUISA (age 13)
Cardboard and paper print (water-based ink), 7¼" × 11"
Silhouetted heads were cut out of shirt cardboard and paper, glued together with Elmer's glue, and relief-inked with a brayer.

before printing. It is necessary to coat the cardboard with dilute glue to seal the surface; if this is not done, the board will peel up and disintegrate during inking.

In a well-supervised small group, older children (junior high and up) can be allowed to cut into two- or three-ply chipboard with an X-Acto knife. A drawing or other guidelines can be put right on the board with a soft pencil. The cardboard can then be cut and peeled

away from the form, leaving the image in low relief.

Textures can be hammered and impressed into the surface with anything that will make a mark, such as a pizza cutter, a nail, a rasp, or bottle caps. The indentations will print as white marks after the surface has been sealed with dilute white glue, dried, inked, and printed.

Stencil Prints

(All ages, simplified for younger children)

This medium can produce simple work in one color or complex designs in many colors, depending on the energy and interest of the students and teacher.

MATERIALS

Thin, stiff Bristol board or oaktag

Scissors

Masking tape

1 or 2 soft-rubber rollers or brayers

Water- or oil-based ink or paint

Palette knife

Inking slab

Newsprint or bond paper

Rags or paper towels

Water or solvent (for cleanup)

PROCEDURE

By cutting openings or holes in Bristol board or oaktag with scissors, a shape or silhouette of an image can be produced. Tape the cut stencil to a tabletop. Slip a sheet of newsprint or bond paper under the stencil. Roll an inked brayer across the open area to produce the print.

If stencil areas are isolated, more than one color, each with its own roller, can be employed. More advanced students might cut two or three stencils and overlap them on the same print. Color registration can be achieved with cardboard stops glued or taped to the table to guide the paper.

ELLEN (age 6)
Stencil print (water-based ink), 7½" × 10"
Cars drawn on stiff paper were cut out with small scissors and the openings inked with a brayer.

JON LE VINE (age 14)
Jonathan's Treasures
Cardboard and object print,
11⅞" × 8⅞"
Teacher: Caroline Rister Lee,
Gilmore J. Fisher Junior High
School, Ewing Township,
New Jersey
Coins, a key, and a feather were glued onto a cardboard, inked, and printed on damp paper on an etching press.

Styrofoam Prints

(Age 7 to 10)

Soft foam plastic (Styrofoam or Fome-Cor board), found in some food trays and packing material, can be used as a quick substitute for linoleum or wood.

MATERIALS

Soft foam plastic

Pencil, stick, or similar hard object

Soft-rubber rollers or brayers

Water- or oil-based ink

Spoon (for rubbing)

Newsprint or bond paper

Rags or paper towels

Water or solvent (for cleanup)

PROCEDURE

The foam plastic can be indented with a pencil, stick, or other hard object. When the surface is rolled with ink from a soft-rubber brayer, these indentations will show as white lines or areas. When paper is placed on top of the foam plastic and rubbed with the hand or a spoon, or even another clean roller, the image will be transferred to the paper. Because of the softness of the material, it is not possible to rub more than a few impressions from these plates, but they are so easy to make that younger children enjoy the method.

Collage Prints

(All ages)

This basic method for making prints is easy to do, uses common materials from the household or the classroom, and affords a strong textural experience to the student.

MATERIALS

Stiff cardboard or thin Masonite (as backing board)

Cloth of various textures (lace, corduroy, denim, netting), paper with rough surface, flat sticks, string, sand, sawdust, cat litter, metal mesh grating, cellophane tape, masking tape, or coins

Scissors

White glue (Elmer's or Sobo), acrylic gesso, or polymer medium

Polymer medium (optional)

Inking slab

Palette knife

Water or oil-based ink or paint

Soft-rubber rollers or brayers

Spoon (for rubbing)

Newsprint, rice paper, or filter paper

Water or solvent (for cleanup)

Rags or paper towels

PROCEDURE

The plate can be developed by making a sketch as a guideline on cardboard or Masonite backing board, or by freely assembling interesting textures and forms without a sketch. With white glue, gesso, or polymer medium, attach the materials to the sketch. Be sure everything is glued down well and as flat as possible. Coat the entire surface with a dilute coat of white glue, gesso, or polymer medium. Be sure everything is completely dry before inking, even if you must wait until the next session to take a proof.

Unusual effects can be achieved with articles of clothing, such as shirts, gloves, pants, and even sweaters and soft caps. These can be immersed in polymer medium or gesso and glued to a backing board. After everything is thoroughly dried, preferably overnight, the plate can be inked and printed.

Masking tape and cellophane tape can be used to create interesting linear designs. String, sandpaper, even rice and beans can make lines and textures when glued to the plate. Smooth surfaces print very dark, while rough surfaces yield light proofs.

Small soft-rubber rollers or brayers should be used for inking on a generous film of ink. Textures require more ink than a smooth, flat surface. Different colors on small rollers can be used on the same plate to produce a colorful print. Place the paper on top of the inked plate and rub with your hand, a rubbing spoon, or the handle of a palette knife. Soft papers are best, such as mulberry, *moriki*, or other Japanese papers, but newsprint will produce adequate results.

MARTHA (age 11)
Woodcut (water-based ink), 9½″ × 12″
Simple Japanese woodcut tools were used to cut
soft pine shelving.

Woodcuts and Linocuts

(Age 12 and older)

These classic relief print techniques are suitable only for older children because of the sharp tools used.

MATERIALS

Wood (pine, poplar, or spruce); no. 2 common shelving in widths of 6 to 12 inches is suitable

Linoleum or heavy vinyl flooring

Woodcut tools (knives, gouges, and chisels; only a few are needed)

Bench hook (for holding block while gouging)

India ink

White chalk or pastel

Palette knife

Water- or oil-based ink or paint

Inking slab

Rollers or brayers

Newsprint or soft Japanese paper

Rags or paper towels

Water or solvent (for cleanup)

PROCEDURE

When using wood, select soft or easily cut pieces. Although balsa wood is soft and easily cut, it is expensive and yields only a few prints. Pine, poplar, or spruce

LORELEI SHARKEY
Linocut, 8″ × 5″
Teacher: Chuck Miley, Summer Arts Institute, Rutgers University, New Brunswick, New Jersey

are better choices. Sometimes lumberyards will give scrap ends of wood to schoolchildren free. Blacken or color the block with India ink so that cuts can easily be seen. White chalk or pastel can be used to depict the design or subject. Sometimes the wood will suggest a direction or image by its grain or knots, which can be made more visible by rub-

bing with a copper suede brush or a steel brush to wear down the soft areas and let the hard, grainy ridges stand out.

Woodcut knives, gouges, and chisels are available in sets in art-supply stores and hobby shops. Hunt Speedball makes a set with removable tips that is adequate. Some inexpensive Japanese tools are sold in sets, and while the steel is soft, they are usable.

Use simple V or C gouges at first for quick cutting. Try stamping or pounding textured materials into the soft wood grain.

Linoleum and soft-vinyl sheets are easy to cut with the same tools as in woodcutting. If linoleum is set out in full sun or on a heat duct or radiator, it will soften and cut more easily. Tools dull quickly in this abrasive flooring material and must be sharpened frequently to retain their efficiency.

For additional instructions, see the discussion of woodcuts in the chapter on relief prints.

3M Vinyl and Acetate Prints

(Age 10 and older)

Another simple relief-print method uses 3M vinyl (produced by the Minnesota Mining and Manufacturing Company) or heavy acetate. Both these materials are soft enough to be easily cut with scissors.

MATERIALS

3M vinyl or acetate
Scissors or other sharp instruments
Pencils
Palette knife
Water- or oil-based ink or paint
Inking slab
Rollers or brayers
Paper (newsprint, bond, or Japanese paper)
Rags or paper towels
Water or solvent (for cleanup)

PROCEDURE

In addition to cutting, the vinyl or acetate can be scratched with nails, compass points, or other sharp instruments. Good prints can also be made from the round vinyl tops used on coffee cans. After the circular ridge is cut away, the remaining material can be cut, punched, or scratched. You can have your students make a collage of a number of these pieces, which are inked separately, then reassembled for the final print.

Glue Prints

(All ages)

Interesting prints can be made with white glue, acrylic gesso, or other binding agents or fillers.

MATERIALS

White glue (Elmer's or Sobo, acrylic, gesso, Liquid Steel, Plastic Wood, and the like)
2-inch cardboard squares
Palette knife
Inking slab
Water- or oil-based ink or paint
Soft-rubber brayers or rollers
Newsprint or bond paper
Paper towels or rags
Water or solvents (for cleanup)

PROCEDURE

Squeeze the glue right out of its tube or container onto the cardboard backing. You can draw with it or use the small cardboard squares to manipulate it into patterns or textures. You can also drip it or paint with it to create the desired image or composition. Allow it to dry, then seal the entire surface with a thin, diluted coat of gesso or white glue. The surface can be inked and printed when it is dry. The glue will harden into ridges and lines that will yield many prints.

Stamped Prints

(All ages)

Inventive little stamps can be made by cutting designs into potatoes or pencil erasers.

MATERIALS

Large, firm potatoes
Ruby erasers, Art Gum, or other pencil erasers
Masking tape
Cardboard squares
Paring knife or X-Acto knife
Oil- or water-based ink or paint
Rollers or brayers
Palette knife
Inking slab
Newsprint, bond, or rice paper
Rags or paper towels
Water or solvents (for cleanup)

PROCEDURE

Sharp knives can be used to cut shapes and forms into the erasers or the potato. Heavy layered cardboard can also be cut and peeled away to produce a simple low-relief design. Attach a little handle made of masking tape to the back of the newly cut stamp and ink the image by tapping it in some ink rolled out on an

ELLEN (age 6)
Glue print (water-based ink), 7⅞″ × 14¼″
An Elmer's glue squeeze bottle was used to draw and drip the image onto a cardboard plate. When dry, the plate was inked with a soft-rubber brayer and printed by hand rubbing on rice paper.

inking slab. You can also roll the ink directly onto the relief surface of the stamp. Stamp the design in multiple colors, with repeats and overlaps, on newsprint, bond, or rice paper. These little stamps can be saved and used again.

Paper Plate Lithography

(Age 14 and older)

An inexpensive and simple substitute for a litho stone or a zinc plate is a Litho-Sketch plate. This plate is easy to draw on with grease or wax crayons and tusche. Because it is paper it can be carried easily, used as outdoor sketching paper, and, with little effort, printed on a variety of presses.

MATERIALS

Litho-Sketch plate

Litho-Sketch plate solution

Litho or grease crayons and pencils

Tusche with brushes

Sponge or cotton pads

Brayer

Litho ink

Bond or drawing paper (for printing)

Rags

Mineral spirits or a similar solvent (for cleanup)

PROCEDURE

Although the quality of tone obtained does not equal the tonal variety yielded by stone or zinc, the simplicity of the process may be attractive. The plate must be moistened between each inking with a proprietary solution called Litho-Sketch plate solution, which is applied with a cotton pad or sponge. The ink must be a greasy litho ink. It should be rolled over the surface with a thin film and the image built up by three or four printings, as in stone or zinc lithography.

CHRISTINA REYES (age 15)
Landscape
Paper plate lithograph, 12″ × 14″
Teacher: Nadine Gordon, Briarcliff High School,
Briarcliff Manor, New York

Drypoint, Embossing, and Etching

(Age 16 and older)

With drypoint, embossing, and etching students can achieve diverse and exciting tonal images, with a unique linear delicacy.

MATERIALS

Zinc plates (small sizes suggested)

Scraper or burnisher

Metal files (medium and fine)

Drypoint needles

Hard ground

2-inch flat hair brush

Nitric acid

1 gallon plastic storage bottle and plastic funnel

Acid-proof tray

Rubber gloves

Etching ink

3-inch cardboard squares for wiping

Tarlatan

Etching press with felt blankets

Blotters

Etching paper

Rags or paper towels

Odorless paint thinner (for cleanup)

PROCEDURE

Drypoints are made by scratching into a beveled zinc or copper plate with a sharp needle to raise a burred line. The plates are inked, wiped, and printed on dampened paper using an etching press. It is the raised line that catches the ink and produces the soft line characteristic of drypoint. (See the intaglio chapter for details.)

Embossings can be made by printing a woodcut, collagraph plate, linocut, or deeply etched zinc plate without ink on dampened paper using an etching press with felt blankets. (See the chapter on dimensional prints.)

Etchings are produced by covering a zinc plate with hard ground, drawing through the ground with a needle, and etching the plate in a dilute solution of 8 parts water to 1 part nitric acid. The plate is then cleaned, inked with etching ink, wiped with tarlatan, and printed on dampened paper with an etching press. Copper plates may be used, but the biting is slower. Many variations of this technique are possible (see the intaglio chapter).

15 Sources and Charts

Suppliers

GENERAL SUPPLIES

Aiko's Art Materials, American Printing Equipment Supply, Dick Blick, Fine Art Materials, Graphic Chemical & Ink, Hunter-Penrose, Hunt Manufacturing, Intaglio Printmaker, Heinz Jordan, T. N. Lawrence & Son, Melbourne Etching Supplies, New York Central Art Supply, Pearl Paint, Harold Pitman, Polychrome, Rembrandt Graphic Arts, Roberts and Porter, Daniel Smith, Utrecht Linens

CHEMICALS AND ACIDS

Amend Drug and Chemical, Beacon Chemical, City Chemical, Philip Hunt, Shementov (oil of cloves in quantity)

FRAMING AND MATTING

Charles T. Bainbridge's Sons, Light Impressions, Process Materials, Talas, United Manufacturers Supplies

HEALTH AND SAFETY

Advanced Products, Center for Occupational Hazards (information), Direct Safety, Freund Can, Lab Safety, Magid Glove & Safety Manufacturing, Safety Supply Canada

INKS

Intaglio F. Charbonnel, Cronite, Rudolph Faust, Graphic Chemical & Ink, Handschy Ink & Chemical, T. N. Lawrence & Son, Lorilleux–LeFranc, Rembrandt Graphic Arts, Daniel Smith, F. Weber

Letterpress Sun Chemical, Superior Printing Ink

Lithographic Bordon Chemical, Graphic Chemical & Ink, Handschy Ink & Chemical, E. Harris, Leber Ink, Sinclair & Valentine, Daniel Smith, Sun Chemical, Superior Printing Ink

Screen print (water-based) Advance Process Supply, Dolphin Papers, Hunt Manufacturing, TW Graphics Group

INTAGLIO SUPPLIES

Felt blankets Aetna Felt, Chas. W. House Sons, Pacific States Felt

Plates C. George, Graphic Chemical & Ink, Harold Pitman

Steel facing Hudson Chromium

Rubber sheets Canal Rubber

Tarlatan A & S Textile, Graphic Chemical & Ink, Gross-Kobrick

Press beds (phenolic) Canal Equipment, Jendan Industrial Supply

LITHOGRAPHIC SUPPLIES

Lith-Kem, Metzger Litho Supplies, Polychrome, Polyproducts, Precision Lithograph, Roberts and Porter, Rembrandt Graphic Arts, Daniel Smith

Drafting film Charrette, N. Teitelbaum

Carborundum King and Malcolm, U.S. Grinding Wheel

Litho stones Graphic Chemical & Ink, Rembrandt Graphic Arts

Photo plates and supplies Graphex, Howson-Algraphy, Roberts and Porter

PAPER

Amsterdam Art, Andrews/Nelson/Whitehead, Coast Paper, Crestwood Paper, Dolphin Papers, Fine Arts Materials, Lindenmeyer Paper, New York Central Art Supply, Rising Paper, Saxon Paper, Twinrocker Handmade Paper, Yasutomo, Zellerbach Paper

PAPERMAKING SUPPLIES

Carriage House Paper, Dieu Donné Press & Paper, Gold's Artworks, Lee S. McDonald, Paper Source, Paragon/Timothy Moore, Pyramid Atlantic, Texas Hand-Made Paper Supply

Beaters Helmut Becker, David Reina Designs

PHOTO TECHNIQUES SUPPLIES

Kwik International Color, Light Impressions

Photo equipment Arkin-Medo, Chemco Photo Products, Minnesota Mining & Manufacturing, Nu-Arc, Rockland Colloid

Photo resists Freundorfer (Rocky-Phot), Eastman Kodak (KPR), Harold Pitman (KPR)

Photogravure tissue Autotype, Hanfstaenge

PIGMENTS

Daniel Smith, E. I. DuPont de Nemours, Fezandie & Sperrle

PLASTICS

Canal Plastic Center, Commercial Plastic & Supply, Polyproducts

PORTFOLIOS (Storage Boxes)

Brewer-Cantelmo, Spink & Gaborc

PRESSES

See page 340.

RELIEF-PRINT SUPPLIES

Letterpress equipment American Printing Equipment Supply, Kelsey

Linoleum Samuel Aronson, Daniel Smith

Wood engraving blocks American Printing Equipment Supply, T. N. Lawrence & Son

ROLLERS AND BRAYERS

Apex Printers Roller, Samuel Bingham, Charles Brand, Hunt Speedball, Ideal Roller and Graphics, Jomac Roller, Rembrandt Graphic Arts, Daniel Smith, United Rubber Supply

SCHOOL SUPPLIES

Chaselle, Jerry's Artorama

SCREEN-PRINTING SUPPLIES

Advance Process Supply, Atlas Silkscreen Supply, Behsen's Silk Screen Supply, Calcom Graphic Supply, Colonial Printing Ink, E. Harris, Naz-Dar/KC, Standard Screen Supply, Texas Screen Print Supply, Ulano, Victory Factory

Photo Chemco Photo Products, Dynachem, Majestech, Photo Process Screen Manufacturing, Ulano

TOOLS

Bel Arts (custom trays), Edward C. Lyons (printmaker's), Robert McClain (Japanese), Frank Mittermeir, Edw. C. Muller

Addresses of Suppliers

A & S Textile Co., Inc.
164 W. 25 St.
New York, NY 10001
212-255-2580

Advance International, Ltd.
119 Deepcut Bridge Rd.
Deepcut, Camberley
Surrey GUI66SD
England
25-283-7171

Advance Process Supply Co.
34-06 Skillman Ave.
Long Island City, NY 11101-2396
718-937-6400

6480 Corvette St.
City of Commerce, CA 90040-1793
213-685-3400

400 N. Noble St.
Chicago, IL 60622-6383
312-829-1400

445 Blvd. Guimond
Longueuil, Montreal,
Quebec J4G 1L8
Canada
514-879-9000

Advance Products Co.
1021 Spring Garden St.
Philadelphia, PA 19123

Aetna Felt Co.
2401 W. Emaus Ave.
Allentown, PA 18103
800-526-4451 / 215-791-0900 /
212-929-5262

Aiko's Art Materials
3347 N. Clark St.
Chicago, IL 60657
312-404-5600

Amend Drug & Chemical Co.
83 Cordier St.
Irvington, NJ 07111
201-926-0333

American Printing Equipment Supply Co.
42-25 9 St.
Long Island City, NY 11101
718-729-5779

Amsterdam Art
1013 University Ave.
Berkeley, CA 94710
415-548-9663

Andrews/Nelson/Whitehead
31-10 48 Ave.
Long Island City, NY 11101
718-937-7100

Apex Printers Roller Co.
1541 N. 16 St.
St. Louis, MO 63106
314-231-9752

Arkin-Medo
131-27 Fowler Ave.
Flushing, NY 11355
718-445-4000

Samuel Aronson
135 W. 17 St.
New York, NY 10011
212-243-4993

Atlas Silkscreen Supply
1733 Milwaukee Ave.
Chicago, IL 60647

Autotype
2050 Hammond Dr.
Schaumburg, IL 60173

Charles T. Bainbridge's Sons, Inc.
50 Northfield Ave.
Edison, NJ 08817
201-225-9100

Beacon Chemical Co., Inc.
125 MacQuesten Pkwy. 5
Mt. Vernon, NY 10550
914-699-3400

Helmut Becker
Pyramid Atlantic
6925 Willow St. NW
Washington, DC 20012

Behnsens Silk Screen Supply
950 Richards
Vancouver, British Columbia
Canada

Bel Arts
Pequann
Pequannock, NJ 07440

Samuel Bingham Co.
7978 E. Baltimore St.
Baltimore, MD 21224
800-638-7658
(Other locations nationwide)

Dick Blick
PO Box 1267
Galesburg, IL 61401
309-343-6181

Bordon Chemical Corp.
6455 E. Canning St.
Los Angeles, CA 90040
213-726-2626

Charles Brand
45 York St.
Brooklyn, NY 11201-1420
718-797-1887

Brewer-Cantelmo Co.
116 E. 27 St.
New York, NY 10016
212-685-1200

Brookstone Co.
127 Jose Farm Rd.
Peterborough, NH 03458
603-924-7181

Cadillac Plastics & Chemical Corp.
11255 Vanowen St.
North Hollywood, CA 91605
818-980-0840

Calcom Graphic Supply
2836 10 St.
Berkeley, CA 94710

Canal Equipment
66 Greenpoint Ave.
Brooklyn, NY 11222
718-389-2899

Canal Plastic Center
345 Canal St.
New York, NY 10013
212-925-1164

Canal Rubber
329 Canal St.
New York, NY 10013
212-226-7339

Carriage House Paper
Brickbottom 1 Fitchbury St.
C 207
Somerville, MA 02143
617-629-2337

Center for Occupational Hazards
5 Beekman St.
New York, NY 10038
212-227-6220

F. Charbonnel
13 Quai de Montebello Court
Rue de l'Hotel Colbert
Paris 75005
France

Charrette
31 Olympia Ave.
PO Box 4010
Woburn, MA 01888
(Also in Boston, Cambridge,
New York, New Haven)

Chaselle, Inc.
9645 Gerwig Lane
Columbia, MD 21046
301-381-9611

Chemco Photo Products
30 Colonial Dr.
Piscataway, NJ 08854
201-981-0990

City Chemical Co.
132 W. 22 St.
New York, NY 10011
212-929-2723

Coast Paper
798 Beatty Street
Vancouver, British Columbia
Canada

Colonial Printing Ink
180 E. Union Ave.
East Rutherford, NJ 07073
201-933-6100
(Also in New York, Chicago,
Los Angeles, Orlando)

Commercial Plastic & Supply Corp.
98-31 Jamaica Ave.
Richmond Hills, NY 11418
718-477-5000

Createx Colors
14 Airport Park Rd.
East Granby, CT 06026
203-653-5505

Crestwood Paper Co.
315 Hudson St.
New York, NY 10013
212-989-2700

25 Evergreen
Mill Valley, CA 94941
415-383-8989

Cronite Co.
8707 Kennedy Blvd.
North Bergen, NJ 07047
201-869-4000

Dieu Donné Press & Paper
3 Crosby St.
New York, NY 10013
212-226-0573

Direct Safety Co.
7815 S. 46 St.
Phoenix, AZ 85040
800-528-7408

Dolphin Papers
624 E. Walnut St.
Indianapolis, IN 46204
313-832-6004

E. I. DuPont De Nemours Co.
Pigments Dept.
Wilmington, DE 19899
302-774-1000

Dynachem Corp.
1670 S. Amplett Blvd.
San Mateo, CA 94402

Eastman Kodak Co.
1133 Ave. of Americas
New York, NY 10036
212-930-7630

Rudolph Faust, Inc.
542 South Ave.
East Cranford, NJ 07016
201-276-6555

Fezandie & Sperrle, Inc.
(a division of Tri-Con Colors)
16 Leliarts Lane
Elmwood Park, NJ 07407
201-794-3800

Fine Art Materials, Inc.
346 Lafayette St.
New York, NY 10012
212-982-7100

Freund Can Co.
155 W. 84 St.
Chicago, IL 60620
312-224-4230

Freundorfer
15-51 Commercial Dr.
Elgin, IL 60120
312-931-7300

The C. George Co.
40 Ellish Parkway
Spring Valley, NY 10977
914-356-0978

Gold's Artworks, Inc.
2100 N. Pine St.
Lumberton, NC 28358
800-356-2306

Graphex
150 S. 118 St.
PO Box 14069
Milwaukee, WI 53214-0069
800-828-8080

Graphic Chemical & Ink Co.
728 N. Yale Ave.
PO Box 27
Villa Park, IL 60181
312-832-6004

Gross-Kobrick
370 W. 35 St.
New York, NY 10001
212-564-1150

Hanfstaenge Gmb. H & Co.
Beschichtung Stechnik
Dieselstrafe 12
D-8046 Garching
West Germany

Handschy Ink and Chemical Co.
2525 N. Elston Ave.
Chicago, IL 60647

528 N. Fulton St.
Indianapolis, IN 46202
(Also in Cincinnati, Milwaukee,
Minneapolis, Fenton, MO,
Riverdale, IL)

E. Harris Co., Ltd.
1397 Odlum Dr.
Vancouver, British Columbia
Canada

Heinz Jordan & Co., Ltd.
42 Gladstone Ave.
Toronto 3, Ontario
Canada

Chas. W. House Sons
PO Box 158
Unionville, CT 06085
800-243-7063

Howson-Algraphy, Inc.
480 Meadow Lane
Carlstadt, NJ 07072
201-935-4560

Hudson Chromium Co.
20-20 Steinway St.
Long Island City, NY 11105
718-275-8100

Philip Hunt Co.
707 Army St.
San Francisco, CA 94124
415-951-3228

Hunter-Penrose Ltd.
7 Spa Rd.
London, SE 16 3QS
England
01-237-6636

Hunt Manufacturing Co.
230 S. Broad St.
Philadelphia, PA 19102-4167
215-732-7700

5940 Ambler Dr.
Mississauga, Ontario L4W 2N3
Canada
416-624-3888

Hunt Speedball
Speedball Rd.
Stateville, NC 28677
800-438-0977

Ideal Roller and Graphics Co.
2512 W. 24 St.
Chicago, IL 60608
312-247-5600

33 Hayes Memorial Dr.
Marlboro, MA 01752
508-481-0900

Intaglio Printmaker
323 Goswell Rd.
London EC1
England

Jendan Industrial Supply Corp.
PO Box 611
Glen Cove, NY 11542
212-389-2899

Jerry's Artorama
117 S. Second St.
New Hyde Park, NY 11040

Jomac Roller Co.
181 Broad St.
Carlstadt, NJ 07072
201-935-0333

The Kelsey Company
30 Cross St.
PO Box 941
Meriden, CT 06450
203-235-1695

King and Malcolm
57-10 Grand Ave.
Maspeth, NY 11378
718-386-4900

Kwik International Color Inc. Ltd.
111 Eighth Ave.
New York, NY 10011
212-929-3800

Lab Safety
PO Box 1368
Janesville, WI 53547
608-754-2345

T. N. Lawrence & Son Ltd.
2-4 Bleeding Heart Yard
Greville St., Hatton Gardens
London EC1N 8SI
England

Leber Ink Co.
PO Box 606
Tukwila, WA 98067
206-251-8700

Light Impressions Corp.
439 Monroe Ave.
Rochester, NY 14607-3717
800-828-6216
(in NYS 800-828-9629)

Lindenmeyer Paper Co.
11-12 53 Ave.
Long Island City, NY 11101
718-392-4400

Lith-Kem Co.
46 Harriet Pl.
Lynbrook, NY 11563

Lorilleux–LeFranc
161 Rue de Republique
Puteaux, Seine
92500 France

Edward C. Lyons
3646 White Plains Rd.
Bronx, NY 10467
212-515-5361

Robert McClain
Japanese Prints & Supplies
2380 Springs Blvd.
Eugene, OR 97403
503-343-1980

Lee S. McDonald, Inc.
PO Box 264
Charlestown, MA 02129
617-242-2505

Magid Glove & Safety Manufacturing
2060 N. Kolmar Ave.
Chicago, IL 60639
312-384-2070

Majestech Corp.
PO Box 440
Route 100
Somers, NY 10589
800-431-2200

Melbourne Etching Supplies
227 Brunswick St.
Fitzroy, Victoria,
Australia

Metzger Litho Supplies
150 Bay St.
Jersey City, NJ 07302
201-792-7200

Minnesota Mining & Manufacturing
St. Paul, MN 55101
(Available through local suppliers)

Frank Mittermeir, Inc.
3577 E. Tremont Ave.
PO Box 2
Bronx, NY 10465-002
212-828-3843

Edw. C. Muller
3646 White Plains Rd.
Bronx, NY 10467
212-881-7270

Naz-Dar Company
1087 N. North Branch St.
Chicago, IL 60622
312-943-8338

Naz-Dar/KC East
430 Industrial Ave.
Teterboro, NJ 07608-1007
201-288-7440

Naz-Dar/KC West
7211 Patterson Dr.
Garden Grove, CA 92640
714-894-7578

New York Central Art Supply Inc.
62 Third Ave.
New York, NY 10003
800-242-2408
(In NYS 212-473-7705)

Nu-Arc Co., Inc.
175 Varick St.
New York, NY 10014
212-255-7330

Pacific States Felt & Manufacturing
843 Howard St.
San Francisco, CA 94103

Paper Source Ltd.
1506 W. 12 St.
Los Angeles, CA 90015
213-387-5820

Pearl Paint Co., Inc.
308 Canal St.
New York, NY 10013
212-431-7932
(Also in Paramus, NJ, and
East Meadow, NY)

Photo Process Screen
Manufacturing Co.
179 W. Berks St.
Philadelphia, PA 19122

Harold Pitman Co.
515 Secaucus Rd.
Secaucus, NJ 07094
201-865-8300

Polychrome Corp.
3313 Sunset Blvd.
Los Angeles, CA 90026

137 Alexander St.
Yonkers, NY 10701
914-965-8800

Polyproducts Corp.
Room 25
13810 Nelson Ave.
Detroit, MI 48227

Precision Lithograph
PO Box 308
Cortecelli St.
Florence, MA 01060
413-584-3703

Process Materials Corp.
301 Veterans Blvd.
Rutherford, NJ 07070
201-935-2900

Pyramid Atlantic
6925 Willow St. NW
Washington, DC 20012
202-291-0088

David Reina Designs, Inc.
24 Harvard Ave.
Maplewood, NJ 07040

Rembrandt Graphic Arts Co.
The Cane Farm
Rosemont, NJ 08556
800-622-1887

Rising Paper Co.
Park St.
Housatonic, MA 01236

Roberts and Porter
26-15 123 St.
Flushing, NY 11354
718-939-7000

Rockland Colloid Corp.
599 River Rd.
Piermont, NY 10968
914-359-5559

Safety Supply Canada
214 King St. East
Toronto, Ontario M5A 1J8
Canada
416-364-3234

Saxon Paper Co.
240 W. 18 St.
New York, NY 10011

Shementov Corp.
PO Box 455
West Orange, NJ 07052
201-673-2350

Sinclair & Valentine
4101 S. Pulaski Rd.
Chicago, IL 60632

Daniel Smith, Inc.
6500 32 Ave. NW
Seattle, WA 98117
206-783-8263

Spink and Gaborc, Inc.
11 Troast Ct.
Clifton, NJ 07011
201-478-4551

Standard Screen Supply Corp.
Active Process Supply Co.
480 Canal St.
New York, NY 10013
212-925-6800

Sun Chemical Corp. Inc.
General Printing Ink Div.
135 W. Lake
North Lake, IL 60164
312-562-0550

Superior Printing Ink
70 Bethune St.
New York, NY 10014
212-741-3600

Talas
213 W. 35 St.
New York, NY 10001
212-736-7744

N. Teitelbaum
1080 Brook Ave.
PO Box 444
Bronx, NY 10456

Texas Hand-Made Paper Supply
PO Box 710356
Dallas, TX 75371
214-824-2240

Texas Screen Print Supply
304 N. Walton
Dallas, TX 75226
800-366-1776

TW Graphics Group
7220 E. Slauson Ave.
City of Commerce, CA 90040
213-721-1400

Twinrocker Handmade Paper
RFD 2
Brookstone, IN 47923
317-563-3210

Ulano Corp.
255 Butler St.
Brooklyn, NY 11217
718-622-5200

832 E. Rand Rd., Unit 17
Mt. Prospect, IL 60056
312-392-1446

15335 Morrison St.
Sherman Oaks, CA 91403
818-986-2690

United Manufacturers Supplies, Inc.
80 Gordon Dr.
Syosset, NY 11791
516-496-4430

United Rubber Supply Co., Inc.
54 Warren St.
New York, NY 10007
212-233-6650

U.S. Grinding Wheel
104 Grand St.
New York, NY 10013
212-226-2891

Utrecht Linens, Inc.
33 Thirty-fifth St.
Brooklyn, NY 11232
718-768-2525
(Also in Chicago, New York City,
Philadelphia, Washington, Boston)

Victory Factory
Screen Frames
184-10 Jamaica Ave.
Hollis, NY 11423
718-454-2255

F. Weber Co.
Wayne & Windrim Ave.
Philadelphia, PA 19144
215-329-3980

Winstons Ltd.
150 Clerkenwell Rd.
London EC1
England

Yasutomo & Co.
Dept. AA-4
24 California St.
San Francisco, CA 94111

Zellerback Paper Co.
234 S. Spruce St.
South San Francisco, CA 94118
(West coast dealer for
Andrews/Nelson/Whitehead)

Etching and Lithographic Presses

Manufacturer	Comments	Manufacturer	Comments
American-French Tool Co. Rte. 117 Coventry, RI 02816 401-821-0452	Solid, strong presses, steel beds. Micrometers coarsely marked. Durable, solid rollers. Large sizes available.	The Griffin Co. 1745 E. 14 St. Oakland, CA 94606 415-533-0600	Wide range of sizes in both etching and lithographic presses. Also makes rollers in a variety of durometers.
Oliviero Bendini Via Modigliani, 31 40133 Bologna, Italy	Geared presses with extension roller arms to keep blanket taut. Thin steel beds. Table and floor models.	Hunter-Penrose Ltd. 7 Spa Rd. London SE16, England 01-237-6636	Solid presses with cast-iron frames, steel beds, in range of sizes. Can be used for etchings or lithographs.
Dick Blick PO Box 1267 Galesburg, IL 61401 800-322-8183	Direct drive or geared, steel or phenolic resin beds. Small to medium sizes.	Printmakers Machine Co., Inc. 724 N. Yale PO Box 71 Villa Park, IL 60181 312-832-4888	Sturges presses and Dickerson Combination presses in wide range of sizes, many geared, many with steel beds, some with Fibresin beds, solid steel top rollers. Sold by Graphic Chemical. Also makes lithographic presses.
Charles Brand 45 York St. Brooklyn, NY 11201-1420 718-797-1887	Strong, well-made presses with accurate micro-dial indicators. New large-size presses available, as well as wide range of other sizes.	Product Design Co. 1 Hermann Court Norwalk, CT 06856 203-853-1516	Both hand-operated and motorized hydraulic-system, vertical-stroke presses. Limited size range.
Bunch Engineering 2456 Springrose Circle Verona, WI 53593 608-845-5360	Custom-made large-size etching presses, up to bed size 72″ × 144″. Geared, motorized. Top roller up to 12″ diameter steel tubing with 1″ wall thickness.	Rembrandt Graphic Arts Can Farm Rosemont, NJ 08556 609-397-0068	Litho and etching presses in several sizes: Penguin and Graves (small); Pelican and Elephant (larger). Microgauges optional. Steel beds, sturdy construction.
Conrad Machine Co. 1525 S. Warner Whitehall, MI 49461 616-893-7455	Many sizes of geared presses, with choice of steel, Benelux, or aluminum beds. Options include motorization, micrometer gauges, casters. Combination litho-etching press available.	Sakura Color Products Corp. 1-10-17 Nakamichi Higashinari-Ku, Osaka, Japan 03-263-4221	Exporters of S.N. Zokei presses. Very wide range available, with steel beds, gearing systems, motorized models in larger sizes, as in SCR series.
Craftsmen Machinery Co. 840 Main St. Millis, MA 02054 617-376-2001	Sells other manufacturers' presses.	Takach-Garfield Press Co. 3207 Morningside Dr. NE Albuquerque, NM 87110 505-881-8607	Litho and etching presses, with large-size presses available. Gear drives. Solid construction. Widely used.
Ettan Presses Daniel Smith, Inc. 4130 First Ave. South Seattle, WA 98134 206-223-9599	Presses in several sizes, with bed plates of laminated phenolic resin making all presses light in weight. Micrometer scales standard. Medium- and large-size presses may be motorized.	Wright Press 09548 County Road 215 Grand Junction, MI 49056 616-434-6847	Combination etching and litho press, motor-driven, with either top roller or scraper bar. Die-block material bed plate.

Water-Based Screen Inks

Name	Fabric	Color Range	Transparent Base & Additives	Cleanup	Comments
Createx Pure Pigment (Color Craft Ltd)	240–270 monofilament polyester	30 or more colors in soft plastic bottles with dispensing tops, permanent, nontoxic	Lyntex Base for transparency (12 drops pigment to ½ pint base), or 2 parts Createx Gouache Medium to 1 part Lyntex Base for more opacity. Small amounts of Isopropyl alcohol improve printing.	Warm water hosing	Compatible with Hunt Speedball colors and base. Do not add water to Createx colors.
TW Graphics WB 1000 Ink and Concentrates	up to 280 monofilament polyester	Excellent range; any color in Pantone Color Guide (commercial-printing color system) may be created; colors blend well. Very stable during storage.	Very good transparent base; can be used with clear base for vivid transparency. Tiny amounts of concentrates are added to the base. Use Butol Carbitol as a thinner and retarder; do not use water.	Warm water hosing; TW Graphics S-032 Screen Cleaner (let sit for few minutes and hose with warm water)	Inks have some odor; use with good ventilation.
Hunt Speedball Permanent Acrylic Ink	up to 280 monofilament polyester	16 colors; artists' acrylics can be added to transparent base to vary palette. Good consistency, can be used right out of container, good shelf life.	Good-quality transparent base. Createx Lyntex also compatible for transparency. A few drops of water or glycerin help slow drying, or add Retarder Base.	Warm water hosing; Wisk or other dilute liquid detergent for difficult areas; isopropyl alcohol for dried ink	Mist screen with water during printing pauses; "print out" with water to clear screen, then add ink.
Hunt Speedball Water Soluble Ink	up to 200 monofilament polyester (finer may clog)	10 colors (limited in blues and greens); watercolors or gouache can be added to transparent base to extend range. Ink tends to be thick and lumpy; must be mixed well.	Good-quality transparent base. A few drops of water and transparent base improve consistency.	Warm water hosing; sponging for difficult areas	Mold may form in warm weather—scrape off and use.
Advance Aqua Set Textile Ink WIT Series	196 monofilament	Very good range; fluorescent and process colors available but some consistency variation.	Transparent base causes yellowing. Add a drop at a time of water or glycerin to adjust consistency, or use WIT 866 Bodying Agent to thicken ink. Retarder available.	Warm water power hosing, liquid detergent, and sponge; Advance T902 Fast Wash Up good for clogging	Developed as a textile ink; when printing fabric, desirable to heat set (check manufacturer's instructions).

Screen-Printing Inks

Type	Fabric	Stencil	Stock	Drying	Cleanup	Comments
Poster (matte, semi-gloss, high-gloss)	All	All	*Excellent:* paper, cardboard, corrugated board. *Good:* wood, cork, Masonite. *Fair:* canvas, cloth, leather, oilcloth, glass, plastic.	Solvent evaporation. Flat: 20–30 min.; gloss: 15–20 min.	Mineral spirits	For opacity, use directly from can; for transparency add transparent base. Thin sparingly with mineral spirits. Sealing varnish can be printed over finished print for protection.
Enamels (high-gloss)	All	All	*Excellent:* glass, metal, wood, Masonite, Formica, felt, cloth, oilcloth, canvas, rubber, polyethylene, polyester, acetate, anodized aluminum, Mylar. *Good:* paper, cardboard, foil paper, ceramic tile, polystyrene, Lucite, Plexiglas, leather.	Oxidation. Fast: air-dry 60 min. Or 4–6 hrs.	Mineral spirits	Very durable, brilliant colors. Thin sparingly with mineral spirits.
Vinyl (flat, gloss)	All	Photographic or hand-cut water-soluble film stencil	Vinyl film (rigid and flexible), Lucite, pyroxilin-coated cloth, Plexiglas, foil paper. May be used in vacuum-forming machine.	Solvent evaporation. 20–40 min. depending on brand.	Vinyl thinner or prepared screen washup manufactured by screen-printing supplier	Must thin with manufacturer's thinner, which is very toxic. Use exhaust fan, gloves, and mask.
Acrylic	160–200 monofilament, depending on ink brand	Photographic or hand-cut water-soluble film stencil	Acrylic, cellulose acetate, cellulose acetate butyrate, styrene, rigid vinyl, Plexiglas, Lucite, polystyrene, polyethylene. May be used in vacuum-forming machines.	Solvent evaporation and polymerization. Time varies; some 30 min.; others require heat curing.	Prepared screen washup manufactured by screen-printing supplier	Use manufacturer's thinner.
Industrial lacquer	All	Direct photo emulsion or water-soluble knife-cut film stencil	Proxylin, lacquer-coated surfaces, wood, paper, cardboard, foil, rigid plastics.	Solvent evaporation; 20–40 min.	Commercial washup	Inks and solvents highly toxic and flammable; use with caution. Need excellent ventilation and fire protection.
Decal lacquer	All	Direct photo emulsion, indirect photo film, or hand-cut water-soluble film stencil	Decals, paper, cardboard	Solvent evaporation; 1–2 hrs.	Commercial washup	Thin with lacquer thinner or manufacturer's product.
Fluorescent (daylight)	10XX multifilament or 200 monofilament or coarser	All	Paper, cardboard	Solvent evaporation; 20–30 min.	Mineral spirits or manufacturer's recommended screen wash	New formulations easier to use, but permanence questionable.

Note: These are some of the more commonly used inks. Check commercial catalogs for additional types and detailed information. Also check the table on page 340 for water-based screen inks. Drying times are those suggested by commercial screen-printing supply catalogs, but depend on atmospheric conditions.

Papers for Printmaking

Name	Size	g/m²	Content	Comments
ANW Drawing	32 × 40 & rolls	226	100% rag	White or cream. From Andrews, Nelson, Whitehead.
ANW Interleaving	25 × 38 & rolls	45	Sulfite	Also in rolls 42 in. × 250 yd. From Andrews, Nelson, Whitehead.
Aqaba (Tableau)	24 × 36 & rolls	30	Hemp	Soft, grayish white, translucent, machine-made for relief prints. Sheets available in white and black; rolls in white only, 40 & 60 in. wide.
Arches Cover	19 × 25½, 22 × 30, 24¾ × 35, 29 × 41, 31½ × 41½	250, 270, 300	100% rag	Popular sheet by Arjomari, France. White, buff, black. Buff fades to white, white darkens with exposure to light. pH varies, absorbs color well. Useful for many techniques. Rolls 42 & 50 in. × 10, 20, 100 yd.
Arches 88	22 × 30, 30 × 42	300, 350	100% rag	Smooth sheet, good for screen prints. May have low pH, needs testing. Rolls 51½ in. × 10, 20, 100 yd.
Arches En-Tout-Cas	Rolls 52 in. × 10 yd.	280	25% rag	CP one side, rough other side. Similar to Arches Cover but cheaper. For students and proofs.
Arches MBM Ingres	26 × 40	105	75% rag	Cream, chamois, black, white. Lightweight.
Arches Text	26 × 40	120	100% rag	White and cream, laid and wove.
Arches Watercolor	22 × 30, 26 × 40, 29½ × 41, 40 × 60	185–850	100% rag	Handsome textured sheets for intaglio. Too rough for relief and litho unless printed damp. Test for screen printing. Rolls 43 in. × 10 yd.
Basingwerk Heavy or Light	26 × 40	155, 120	Esparto, sulfite	Smooth, no deckles, prints well. Stable, permanent, off-white. Useful sheet from England.
Blotters, Cosmos	19 × 24, 24 × 38, rolls 46 in. wide	360	Sulfite	Indispensable, though not archival. Special orders for larger sizes.
Canson Mi-Tientes	19½ × 25½	160	65% rag	35 colors for charcoal and pastel. Good for *chine collé* if dampened first. Some colors run. Rolls 51 in. × 11 yd.
Canterbury Cover	22 × 31	350	100% rag	20 colors, may vary from batch to batch because handmade. May need dampening. Expensive.
Chiri	22 × 35	36	*Kozo* & wood pulp	Lightweight, good for *chine collé*. Tan color with imbedded vegetable fiber. Fragile.
Copperplate	22 × 30, 30 × 40	250	25% rag	Mold-made, unsized, soft, absorbent like a blotter. Fragile when wet, prints well.
Copperplate Deluxe	22 × 30, 30 × 40	250	75% rag	CP with 4 deckles. Curls at edges. Dampen carefully. Also made by Renker in Germany.
Coventry Rag	22 × 30, 26 × 40, 30 × 44, 38 × 50, 50 × 44	235, 290, 320	100% rag	Machine-made from Crestwood. White and off-white, no deckles, smooth or vellum.
Crestwood Black	22 × 30, 32 × 44	250	100% rag	Machine-made. Also in rolls 33 in. × 30 yd.
Dieu Donné	Up to 22 × 30	Varied	Varied	Handmade from many fibers.
Domestic Etching	26 × 40	75	50% rag	No deckles, lightweight, machine-made. Inexpensive.
Fabriano Artistico	22 × 30	200, 300, 600	100% rag	CP, HP, rough in all weights. Must be soaked because heavily sized. Good for etching, collagraph, and embossing.
Fabriano Classico	27½ × 39, 20 × 30	350, 600	50% rag	Mold-made, sized, takes erasing well. Good for intaglio and embossing.
Fabriano Esportazione	22 × 30	200–600	100% rag	CP and rough only. For intaglio after soaking. Beautiful sheet.
Fabriano Ingres	27½ × 39½	160	Sulfite	19 colors, 2 deckles, large sheet. May stain other sheets in *chine collé*.
Fabriano Murillo	27½ × 39½	360	15% rag	4 colors plus white, black. For intaglio and litho if dampened.
Fabriano Perusia	19 × 26 laid	100	100% rag	Cream only. Useful for calligraphy and books.
Fabriano Roma	19 × 26	130	100% rag	8 strong colors may stain. Handmade, laid.
Fabriano Rosapina	27½ × 39	200, 285	40% rag	Mold-made, white and cream, slightly sized.
Fabriano Tiepolo	22 × 30, 27 × 39	240–290	100% rag	Mold-made, 4 deckles.
Folio	22 × 30, 38 × 50	250	100% rag	Machine-made by Crestwood in white, black, buff, gray, antique, Kraft. Rolls 32 in. × 30 yd.
Frankfurt	25 × 38	120	Sulfite & rag	Mold-made in Germany in white and cream.
Gallery 100	23 × 28, 25 × 38, 26 × 40	250	100% rag	Machine-made by Rising (U.S.). White only, smooth or vellum. Suitable for most techniques.
Gampi-Torinoko	20 × 30	95	100% *gampi*	Handmade in Japan in white and cream.
German Etching	22 × 30, 30 × 40	300	75% rag	Unsized, white. Little strength when wet. Spray lightly, wrap in plastic overnight. Stretches.
Giovanni (Italia)	20 × 28, 28 × 40	310	50% rag	New name. White, soft, may mottle when overprinted in colors. For intaglio and embossing.
Glassine	24 × 36, 36 × 48		Acid-free	Sheets, plus rolls to 100 yd.
Goyu	21 × 29	50	*Kozo* & sulfite	Handmade. For woodcut and wood engraving.
Guarro Satinado	27 × 39	356	100% rag	Spanish, white, super HP. Useful.
Hayle	15 × 20	110	100% rag	Good for books, small prints. From Barcham Green.
HMP Handmade	4 × 5 to 32 × 46	Varied	Varied	Made by John Koller.
Hosho	19 × 24	85	Sulfite	Handmade. Deposits lint on press rollers. Use for woodcuts.

Note: This chart offers only a selected group of papers. Sizes are approximate. Fiber contents may vary.
CP = cold-pressed; HP = hot-pressed; g/m² = grams per square meter.

Name	Size	g/m²	Content	Comments
Hosho Student	16 × 22	95	Sulfite	Inexpensive, soft, unsized.
Ingres Antique	19 × 24	95	Sulfite	9 colors, lightweight.
Inomachi (Japon Nacre)	22 × 30	180	100% kozo	Irregular in thickness and size. 4 deckles. Handmade. Beautiful swirling fibers. Best for relief prints. OK for litho or intaglio if dampened.
Invicta	17 × 22, 22 × 30	155	100% rag	English, mold-made, 4 deckles, HP, cream only.
Iyo Glazed	17 × 22	84	Sulfite	Handmade, chain laid, 4 deckles. Dampen slightly.
Japanese Etching	24 × 36	45	40% mitsumata & sulfite	Slightly sized, cream, lightweight.
Johannot	20 × 26, 22 × 30	125, 240	75% rag 25% esparto	White, 4 deckles, somewhat crisper than Arches, by same maker. Suitable for most techniques.
Kitakata	16 × 20	30	Mitsumata	Handmade, buff, lightweight. For books, chine collé.
Kochi	20 × 26	109	Kozo & sulfite	Heavy, for relief printing. Dampen slightly for litho.
Kozo	24 × 36		100% kozo	Long fibers, unsized. Varies because handmade.
Lana Gravure	22 × 30, 30 × 40	250–300	100% rag	Mold-made in France. For intaglio, litho, relief.
Langley	22 × 31	130	100% rag	Hard surface, medium weight, handmade. For intaglio and litho.
Lenox 25	25 × 38, 38 × 50	190, 250	25% rag	Called Art Print paper. May discolor, no deckles, inexpensive. Good for most proofing and drawing. Rolls 80 in. × 20 yd.
Lenox 100	22 × 30, 38 × 50	250	100% rag	Better-grade sheet by Crestwood. White, no deckles. Good for edition printing for most techniques. Rolls 80 in. × 20 yd.
Masa	21 × 31	70	Sulfite	Inexpensive, for woodcuts. Rolls 42 in. × 30 yd.
Mirage	26 × 40	310	100% rag	Machine-made, no deckles, white, plate or vellum.
Mohawk	26 × 40	120	Sulfite	Machine-made, for proofs. White, no deckles.
Moriki	25 × 37	40	Kozo & sulfite	10 colors, handmade. Fine for chine collé.
Mulberry	24 × 33	45	Kozo & sulfite	Classic, tears easily. For relief prints.
Nideggen	25 × 38	120	Sulfite & rag	Mold-made, wavy laid lines.
Okawara	12 × 16, 14 × 35, 36 × 72	60	100% kozo	Handmade, natural color, 4 deckles. Large size is machine-made. Student grade available. For woodcuts.
Ragston	26 × 40	125	Rag & sulfite	Lightweight, machine-made by Curtis.
Rives BFK	19½ × 25½, 22 × 30, 29 × 41, 30 × 44	240, 250, 280, 300	100% rag	Mold-made, lightly sized, not quite opaque. White, cream, gray, tan, but not all colors in all sizes. Standard paper and deservedly popular. Made by Arjomari, France. Rolls 42 in. × 10, 20, 100 yd.
Rives Light or Heavy	19 × 26 to 26 × 40	155–175	100% rag	Thinner paper for books, drawings, and prints. Sized, erases well. Too thin for collagraphs.
Saunders	22 × 30, 27 × 37, 30 × 40, 40 × 54	178–638	100% cotton	Wide range of weights, tub-sized, erases well. Must be soaked for printmaking. From St. Cuthbert's Mill.
Sekishu	24 × 39	30	Kozo & sulfite	Natural and white, tears easily. For woodcuts and chine collé.
Sekishu-Torinoko	21 × 29	26	Gampi	Light, crisp. Also comes in kozo fiber.
Somerset	22 × 30, 27 × 37, 40 × 54	250, 300	100% cotton	Satin finish for aquatints, lithos, screen prints. Also textured finish. White, soft white, sand, cream. Made in England. Rolls 60 in. × 10, 20, 100 yd.
Stonehenge	22 × 30, 26 × 40, 30 × 44, 38 × 50	250, 320	100% rag	White, warm white, cream, natural, gray, fawn (which may bleed after soaking). Also in white rolls 50 in. × 150 yd.
Strathmore Bristol	23 × 29, 30 × 40	Varied	Varied	Different qualities in 1 to 5 plies.
Strathmore Charcoal	19 × 25	150	Sulfite & rag	14 colors, medium weight, machine-made.
Strathmore Gemini	22 × 30	233	100% cotton	Mold-made, CP, HP, rough. Strathmore makes many papers that work well for prints.
Suzuki	36 × 72	60	Kozo & sulfite	Large, white, handmade, nice texture. Excellent for woodcuts and other relief prints.
Torinoko	21 × 31	125	Kozo & sulfite	Handmade, soft, strong. Useful for many techniques.
Tovil	15 × 20	110	100% rag	English, handmade, hard-sized, cream.
Umbria	12 × 17, 20 × 28	150	100% rag	White and cream. Made by Fabriano.
Utrecht	14 × 17, 29 × 41	250	100% rag	White and buff. Useful for most techniques. Made in Holland.
Utrecht Watercolor	10 × 14 to 22 × 30	Varied	100% rag	Made in Holland.
Whatman Printmaking	22 × 30, 27 × 40	250–270	100% rag	Two surfaces, English, limited production.
Whatman Watercolor	22 × 30	185–400	100% rag	HP, CP, rough. Beautiful sheets.

Bibliography

General

Artist's Proof. Periodical & annuals. Ed. F. Eichenberg. New York: Pratt, 1961–71.

Baro, G. *Thirty Years of American Printmaking.* New York: Brooklyn Museum, 1977.

———. *Twenty-Second National Print Exhibition.* New York: Brooklyn Museum, 1981.

Bindman, D. *The Complete Graphic Works of William Blake.* London: Thames & Hudson, 1978.

Bretell, R., et al. *The Art of Paul Gauguin.* Washington, D.C.: National Gallery of Art, 1989.

Brunner, F. *A Handbook of Graphic Reproduction Processes.* New York: Hastings House, 1962.

Carey, F., & Griffiths, A. *The Print in Germany, 1880–1933.* New York: Harper & Row, 1984.

Castleman, R. *American Impressions: Prints Since Pollock.* New York: Knopf, 1985.

———. *Contemporary Prints.* New York: Viking, 1973.

———. *Prints of the Twentieth Century.* New York: Museum of Modern Art, 1976.

Daniels, H. *Printmaking.* New York: Viking, 1971.

Eichenberg, F. *The Art of the Print.* New York: Abrams, 1977.

Eppink, R. N. *The History and Techniques of Printmaking.* Norman: University of Oklahoma Press, 1971.

Field, R. S. *Jasper Johns: Prints, 1970–1977.* Middletown, Conn.: Wesleyan University, 1978.

Fine, R. E. *Gemini G.E.L.: Art and Collaboration.* New York: Abbeville, 1984.

———. *Lessing J. Rosenwald: Tribute to a Collector.* Washington, D.C.: National Gallery of Art, 1982.

Flint, J. *Jacob Landau: The Graphic Work.* Trenton: New Jersey State Museum, 1982.

Gascoigne, B. *How to Identify Prints.* New York: Thames & Hudson, 1986.

Gedeon, L. H., ed. *Collaborative Works.* Tempe: Arizona State University, 1986.

Geske, N. A. *Rudy Pozzatti, American Printmaker.* Lawrence: University Press of Kansas, 1971.

Getlein, F., & Getlein, D. *The Bite of the Print.* New York: Potter, 1963.

Gilmour, P. *Ken Tyler, Master Printer.* New York: Hudson Hills/Australian National Gallery, 1986.

———. *Modern Prints.* London: Studio Vista/Dutton, 1970.

Hayter, S. W. *About Prints.* London: Oxford University Press, 1962.

Helen Frankenthaler, Prints: 1961–1979. New York: Williams College/Harper & Row, 1980.

Heller, J. *Printmaking Today.* Rev. ed. New York: Holt, Rinehart & Winston, 1971.

Hollstein, F.W.H. *Dutch and Flemish Etchings, Engravings & Woodcuts, 1450–1700.* Amsterdam: Hertzberger, 1949.

———. *German Engravings, Etchings and Woodcuts, 1400–1700.* Amsterdam: Hertzberger, 1954.

Ivins, W. *How Prints Look.* Reprint. Boston: Beacon, 1943.

———. *Prints and Visual Communication.* Reprint. New York: Da Capo, 1969.

Journal of the Print World. Periodical. New Hampshire: Lane, 1986–89.

Karshan, D. *American Printmaking.* Washington, D.C.: Smithsonian, 1969.

Knappe, K.-A. *Dürer: Complete Engravings, Etchings, and Woodcuts.* New York: Abrams.

Maxwell, W. C. *Printmaking.* Englewood Cliffs, N.J.: Prentice-Hall, 1977.

Mayor A. H. *Prints and People.* New York: Metropolitan Museum of Art, 1971.

Melot, M., et. al. *Prints: History of an Art.* New York: Skira/Rizzoli, 1981.

Passeron, R. *Impressionist Prints.* New York: Dutton, 1974.

Peterdi, G. *Printmaking.* New York: Macmillan, 1971.

Picasso: Sixty Years of Graphic Works. Los Angeles: Los Angeles County Museum of Art, 1966.

The Print Collector's Newsletter. Periodical. New York: Print Collector's Newsletter, 1974–88.

Print Quarterly 3, no. 4. London: Print Quarterly, 1986.

Print Review. Periodical. Ed. A. Stasik. New York: Pratt, 1972–84.

Roger-Marx, C. *Graphic Art of the Nineteenth Century.* New York: McGraw-Hill, 1962.

Sachs, P. J. *Modern Prints and Drawings.* New York: Knopf, 1954.

Saff, D., & Sacilotto, D. *Printmaking.* New York: Holt, Rinehart & Winston, 1978.

Sasowsky, N. *The Prints of Reginald Marsh.* New York: Potter, 1976.

Stein, D. M., & Karshan, D. H. *L'Estampe Originale.* New York: Museum of Graphic Art, 1970.

Whitford, F. *Japanese Prints and Western Painters.* New York: Macmillan, 1977.

Zigrosser, C. *The Book of Fine Prints.* New York: Crown, 1956.

———. *Prints and Drawings of Käthe Kollwitz.* New York: Dover, 1969.

Relief Prints

Berdecio, R., & Appelbaum, S., eds. *Posada's Popular Mexican Prints.* New York: Dover, 1972.

Binyon, L., & Sexton. J.J.O. *Japanese Color Prints.* London: Frederick, 1954.

Eichenberg, F. *The Wood and the Graver.* New York: Potter, 1977.

Field, R. S. *Fifteenth Century Woodcuts and Metalcuts.* Washington, D.C.: National Gallery of Art, 1965.

Gentoles, M. *Masters of the Japanese Print.* New York: Abrams, 1964.

Hentoff, N. *Frasconi Against the Grain.* New York: Macmillan, 1974.

Hillier, J. *Utamaro.* London: Phaidon, 1961.

Hind, A. M. *An Introduction to the History of Woodcut.* New York: Dover, 1935.

Karshan, D. *Picasso Linocuts, 1958–1963.* New York: Tudor, 1968.

Leighton, C. *Wood Engraving and Woodcuts.* Reprint. London: Studio, 1948.

Leonard Baskin: The Graphic Work, 1950–60. New York: Far Gallery, 1970.

Mackley, G. E. *Wood Engraving.* London: National Magazine, 1948.

Michener, J. *The Floating World.* New York: Random House, 1954.

Robertson, R. *Contemporary Printmaking in Japan.* New York: Crown, 1965.

Rothenstein, M. *Frontiers of Printmaking.* New York: Reinhold, 1966.

———. *Relief Printing.* New York: Watson-Guptill, 1970.

Rumpel, H. *Wood Engraving.* Geneva: Editions de Bonvent, 1972.

Simmons, R., & Clemson, K. *The Complete Manual of Relief Printmaking.* New York: Knopf, 1988.

Strauss, W. L. *Chiaroscuro.* Boston: New York Graphic Society, 1973.

Ward, L. *God's Man.* New York: Cape & Smith, 1929.

Yoshida, T., & Yuki, R. *Japanese Printmaking.* Rutland, Vt.: Tuttle, 1966.

Intaglio Prints

Bohlin, D. G. *Prints and Related Drawings by the Carracci Family.* Washington, D.C.: National Gallery of Art, 1979.

Brunsdon, J. *The Technique of Etching and Engraving.* New York: Reinhold, 1965.

Burke, J. D. *Charles Meryon.* New Haven: Yale University Art Gallery, 1974.

Chamberlain, W. *The Thames and Hudson Manual of Etching and Engraving.* London: Thames & Hudson, 1972.

The Complete Etchings of Goya. New York: Crown, 1943.

Edmondson, L. *Etching.* New York: Reinhold, 1973.

Gabor Peterdi Graphics 1934–1969. New York: Touchstone, 1970.

Gross, A. *Etching, Engraving and Intaglio Printing.* London: Oxford University Press, 1970.

Hayter, S. W. *New Ways of Gravure.* London: Oxford University Press, 1966.

Hind, A. M. *A Catalog of Rembrandt's Etchings.* New York: Da Capo, 1967.

———. *A History of Engraving and Etching from the 15th Century to 1914.* New York: Dover, 1963.

Jacobowitz, E. S. *The Prints of Lucas Van Leyden and His Contemporaries.* Washington, D.C.: National Gallery of Art, 1983.

Karshan, D. *The Graphic Art of Mary Cassatt.* Washington, D.C.: Smithsonian, 1967.

Lalanne, M. *A Treatise on Etching.* Boston: Estes & Lauriat, 1885.

Leaf, R. *Intaglio Printmaking Techniques.* New York: Watson-Guptill, 1976.

Lehrs, M. *History and Critical Catalog of German, Netherlandish and French Copper Engravings in the 15th Century.* New York: Collector's Editions, 1970.

Levenson, J. A., et al. *Early Italian Engraving from the National Gallery of Art.* Washington, D.C.: National Gallery of Art, 1973.

Lieure, J. *Jacques Callot.* New York: Collector's Editions, 1970.

Lochman, K. A. *The Etchings of James McNeill Whistler.* New Haven: Yale University Press, 1984.

Lumsden, E. S. *The Art of Etching.* 1922. Reprint. New York: Dover, 1962.

McNulty, K. *Peter Milton: Complete Etchings.* Boston: Impressions Workshop, 1977.

Morrow, B. F. *The Art of Aquatint.* New York: Putnam's, 1935.

Moser, J. *Atelier 17.* Madison: University of Wisconsin, 1977.

Pennell, J. *Etchers and Etching.* New York: Macmillan, 1931.

Reddy, K. *Intaglio Simultaneous Color Printmaking.* Albany: State University of New York Press, 1988.

Rembrandt: Experimental Etcher. Boston: Museum of Fine Arts. New York: Pierpont Morgan Library, 1969.

Shestack, A. *The Complete Engravings of Martin Schongauer.* New York: Dover, 1969.

Varnedoe, J.K.T., & Streicher, E. *Graphic Works of Max Klinger.* New York: Dover, 1977.

Wees, D. J. *Darkness Visible: The Prints of John Martin.* Williamstown, Mass.: Sterling & Francine Clark Art Institute, 1986.

Collagraphs

Glen Alps Retrospective: The Collagraph Idea. Bellevue, Wash.: Bellevue Art Museum, 1979.

Hentzen, A. *Rolf Nesch.* New York: Universe Books, 1969.

Hutton, H. *The Technique of Collage.* New York: Watson-Guptill, 1968.

Nagel, S. *The Collagraph.* New York: Wittenborn, 1973.

Romano, C. "The Collagraph Print." *American Artist,* Nov. 1972.

——— & Summer, E. *The Collagraph*. New York: Pratt, Dec. 1975.

Stoltenberg, D. *Collagraph Printmaking*. Worcester, Mass.: Davis, 1975.

Summer, E. "The Collagraph." *Counterproof* 2, no. 2. Philadelphia: Print Club, 1979.

Wenniger, M. *Collagraph Printmaking*. New York: Watson-Guptill, 1975.

Wolfram, E. *History of Collage*. New York: Macmillan, 1976.

Woods, W. F. *The Graphic Work of Rolf Nesch*. Detroit: Detroit Institute of Arts, 1969.

Woody, R. O., Jr. *Polymer Painting*. New York: Van Nostrand Reinhold.

Screen Prints

Banzhaf, R. A. *Screen Process Printing*. Bloomington, Ill.: McKnight, 1983.

Biegeleisen, J. I. *The Complete Book of Silk Screen Printing Production*. New York: Dover, 1963.

———. *Screen Printing*. New York: Watson-Guptill, 1971.

Johnson, L. M., & Stinnett, H. *Water-Based Inks*. Philadelphia: University of the Arts, College of Art and Design, 1987

Kinsey, A. *Introducing Screen Printing*. New York: Watson-Guptill, 1968.

Kreneck, L. *Water-Based Screenprinting*. Lubbock, Tex.: Mesa, 1988.

Saff, D., & Sacilotto, D. *Screenprinting*. New York: Holt, Rinehart & Winston, 1979.

Sternberg, H. *Silk Screen Color Printing*. New York: McGraw-Hill, 1942.

Williams, R., & Williams, D. *American Screenprints*. New York: National Academy of Design, 1987.

Lithographs

Adhémar, J. *Toulouse-Lautrec: His Complete Lithographs and Drypoints*. New York: Abrams, 1965.

Antreasian, G., & Adams, C. *The Tamarind Book of Lithography*. New York: Abrams, 1971.

Cliffe, H. *Lithography*. New York: Watson-Guptill, 1965.

Dortu, M. G. *Toulouse-Lautrec et son oeuvre*. New York: Collector's Editions, 1970.

Flint, J. *The Prints of Louis Lozowick*. New York: Hudson Hills, 1982.

Gilmour, P., ed. *Lasting Impressions: Lithography as Art*. London: Alexandria, 1988.

The Graphic Works of Odilon Redon. New York: Dover, 1969.

Hullmandel, C. *The Art of Drawing on Stone*. London, 1835.

———. *On Some Improvements in Lithographic Printmaking*. London, 1827.

Knigin, M., & Zimiles, M. *The Contemporary Lithographic Workshop Around the World*. New York: Van Nostrand Reinhold, 1974.

———. *The Techniques of Fine Art Lithography*. New York: Van Nostrand Reinhold, 1970.

Lieberman, W. S. *Tamarind*. New York: Museum of Modern Art, 1969.

Man, F. H. *Artists' Lithographs*. New York: Putnam's, 1970.

Mellino, A. *Odilon Redon*. New York: Da Capo, 1968.

Meyer, F. *Marc Chagall: His Graphic Work*. New York: Abrams, 1957.

Senefelder, A. *A Complete Course of Lithography*. Reprint. New York: Da Capo, 1969.

Wengenroth, S. *Making a Lithograph*. London: Studio, 1936.

Dimensional Prints

Bayer, H.; Gropius W.; & Gropius, I., eds. *Bauhaus, 1919–1928*. Boston: Branford, 1959.

Gentille, T. A. *Printed Textiles*. Englewood Cliffs, N.J.: Prentice-Hall, 1982.

Holstein, J. *The Pieced Quilt*. Boston: New York Graphic Society, 1973.

Marsh, R., & Marsh, G. *Imaginative Printmaking*. London: Pitman, 1975.

Newman, T. R. *Innovative Printmaking*. New York: Crown, 1977.

Monotypes

Frank, M. *Persephone Studies*. New York: Brooklyn Museum, 1987.

Ives, C.; Kiehl, D. W.; Reed, S. W.; & Shapiro, B. S. *The Painterly Print*. New York: Metropolitan Museum of Art, 1980.

Janis, E. P. *Degas: A Critical Study of the Monotype*. Cambridge, Mass.: Fogg Art Museum, 1968.

Laliberte, N., & Mogelon, A. *The Art of Monoprint*. New York: Van Nostrand Reinhold, 1974.

Langdale, C. *Monotypes by Maurice Prendergast in the Terra Museum of American Art*. Chicago: Terra Museum of American Art, 1984.

Marsh, R. *Monoprints for the Artist*. London: Tiranti, 1969.

Palmer, F. *Introducing Monoprints*. New York: Drake, 1975.

Plous, P. *Collaborations in Monotype*. Seattle: University of Washington Press, 1988.

Rasmusen, H. N. *Printmaking with Monotype*. Philadelphia: Chilton, 1960.

Reed, S. W., & Shapiro, B. S. *Edgar Degas: The Painter as Printmaker*. Boston: Museum of Fine Arts, 1984.

Photographic Techniques

Bunnel, P., ed. *Nonsilver Printing Processes*. New York: Arno, 1973.

Crawford, W. *Keepers of Light*. Dobbs Ferry, N.Y.: Morgan & Morgan, 1979.

Eastman Kodak. *Basic Photography for the Graphic Arts*. Rochester, N.Y.: Kodak, 1977.

Fossett, R. O. *Screen Printing Photographic Techniques*. Cincinnati: Signs of the Times, 1973.

Hunter, M. *The New Lithography*. New York: Van Nostrand Reinhold, 1984.

Kosloff, A. *Photographic Screen Printing*. Cincinnati: Signs of the Times, 1972.

Macrorie, J. T. "Collotype." *Print Review* 6 (1976): 63–72.

Sacilotto, D. *Photographic Printmaking Techniques*. New York: Watson-Guptill, 1981.

Wade, K. E. *Alternative Photographic Processes*. Dobbs Ferry, N.Y.: Morgan & Morgan, 1978.

Computers and the Print

Computer Pictures Magazine. March 1988.

Goodman, C. *Digital Visions, Computers and Art*. New York: Abrams, 1987.

Hannaford, S. "Going to Lino!" *Personal Publishing* 5, no. 1 (1989).

McNeill, D. *Quick and Easy Guide to Desktop Publishing*. N.C.: Computer Publications, 1987.

Personal Computing. "Buyer's Guide-Laser Printers." *Personal Computing* 12, no. 12 (1989).

Reveaux, T. "A Mac of Many Colors." *MacUser* 5, no. 1 (1989).

Seybold, J., & Dressler, F. *Publishing from the Desktop*. New York: Bantam, 1987.

Paper for Prints

Barrett, T. *Japanese Papermaking*. New York: Weatherhill, 1983.

Bell, L. A. *Plant Fibers for Papermaking*. McMinnville, Ore.: Lilliaceae, 1981.

Eberle, I. *The New World of Paper*. New York: Dodd, Mead, 1969.

Farmer, J. *New American Paperworks*. San Francisco: World Print Council, 1982.

———. *Paper as Medium*. Washington, D.C.: Smithsonian, 1978.

Heller, J. *Papermaking*. New York: Watson-Guptill, 1978.

Honolulu Academy of Arts. *Tapa, Washi and Western Handmade Paper*. Honolulu: Academy of Arts, 1981.

Hughes, S. *Washi: The World of Japanese Paper*. New York: Kodansha, 1978.

Hunter, D. *Papermaking*. 1943. Reprint. New York: Dover, 1978.

———. *Papermaking Through 18 Centuries*. New York: Rudge, 1939.

Kern, M. E. *The Complete Book of Hand Crafted Paper*. New York: Coward, McCann & Geohegan, 1980.

Kunisaki, J. *Kamisuki Chōhōki: A Handy Guide to Papermaking*. Trans. C. E. Hamilton. Berkeley: University of California, Book Arts Club, 1948.

Narita, K. *A Life of T'Sai Lung and Japanese Paper-making*. 1954. Reprint. Paper Museum, 1980.

Robison, A. *Paper in Prints*. Washington, D.C.: National Gallery of Art, 1977.

Studley, V. *The Art and Craft of Handmade Paper*. New York: Van Nostrand Reinhold, 1977.

Toale, B. *The Art of Papermaking*. Worcester, Mass.: Davis, 1983.

Turner, S., & Skiöld, B. *Handmade Paper Today*. New York: Beil, 1983.

Wilkinson, N. B. *Papermaking in America*. Eleutherian Mills/Magley Foundation, 1975.

Art of the Book

Blumenthal, J. *Art of the Printed Book, 1455–1955*. New York: Pierpont Morgan Library, 1973.

Diehl, E. *Bookbinding*. 1946. Reprint. New York: Dover, 1980.

Hofer, P. *The Artist and the Book, 1860–1960*. Boston: Museum of Fine Arts, 1961.

Ikegami, K. *Japanese Bookbinding*. New York: Weatherhill, 1986.

Johnson, A. W. *The Thames and Hudson Manual of Bookbinding*. London: Thames & Hudson, 1978.

Johnson, P. *Creative Bookbinding*. Seattle: University of Washington Press, 1963.

Levarie, N. *The Art and History of Books*. New York: Da Capo, 1968.

Lyons, J., ed. *Artists Books*. Layton, Utah: Smith, 1987.

Smith, K. A. *Structure of the Visual Book*. Visual Studies Workshop Press, 1984.

Steinberg, S. H. *Five Hundred Years of Printing*. Middlesex, England: Penguin, 1966.

Thomas, A. G. *Great Books and Book Collectors*. New York: Excalibur, 1975.

Wheeler, M. *Modern Painters and Sculptors as Illustrators*. New York: Museum of Modern Art, 1938.

Business of Prints

Banks, P. N. *Matting and Framing Documents and Art Objects on Paper*. Chicago: Newberry Library.

Crawford, T. *Legal Guide for the Visual Artist*. New York: Hawthorn Books, 1975.

Dolloff, F. W., & Perkinson, R. L. *How to Care for Works of Art on Paper*. Boston: Museum of Fine Arts, 1971.

Donson, T. B. *Prints and the Print Market*. New York: Crowell, 1977.

Feldman, F., & Weil, S. E. *Art Works: Law, Policy, Practice*. New York: Practising Law Institute, 1974.

———, ——— & Biederman, S. D. *Art Law*. Boston: Little, Brown, 1988.

Glaser, M. T. *Framing and Preservation of Works of Art on Paper*. New York: Parke Bernet Galleries, 1971.

Merryman, J., & Elsen, A. *Law, Ethics and the Visual Arts*. New York: Bender, 1979.

Health Hazards

Art Hazards News. Periodical. Ed. M. McCann. New York: Center for Occupational Hazards, 1978–89.

Carnow, B. *Health Hazards in the Arts and Crafts*. Chicago: 1974.

Clarke, N., et al. *Ventilation.* New York: Lyons, 1984.

McCann, M. *Artist Beware.* New York: Watson-Guptill, 1979.

Moses, C., et al. *Health and Safety in Printmaking.* Edmonton: Occupational Hygiene Branch, Alberta Labour, 1978.

Qualley, C. A. *Safety in the Artroom.* Worcester, Mass.: Davis, 1986.

Shaw, S. *Overexposure: Health Hazards in Photography.* Carmel, Cal.: Friends of Photography, 1983.

School Printmaking

Andrews, M. *Creative Printmaking.* Englewood Cliffs, N.J.: Prentice-Hall, 1963.

Bevlin, M. E. *Design Through Discovery.* 4th ed. New York: Holt, Rinehart & Winston, 1984.

Gaitskell, C. D., et al. *Children and Their Art.* 4th ed. New York: Harcourt Brace Jovanovich, 1982.

Gorbaty, N. *Printmaking with a Spoon.* New York: Reinhold, 1960.

Green, P. *Introducing Surface Printing.* New York: Watson-Guptill, 1967.

————. *New Creative Printmaking.* New York: Watson-Guptill, 1964.

Jacobson, L. *Children's Art Hazards.* Natural Resources Defense Council.

Kent, C., & Cooper, M. *Simple Printmaking.* New York: Watson-Guptill, 1966.

Pelty, P., & Rossol, M. *Children's Art Supplies Can Be Toxic.* New York: Center for Occupational Hazards, 1984.

Weiss, H. *Paper, Ink, and Roller.* New York: Scott, 1978.

Glossary

Acetate. Clear plastic sheet, often used for registered overlays, handmade transparencies, and wrapping mounted prints.

Acetic acid. Acid used for degreasing plates and screens and other applications.

Acetone. Volatile, flammable liquid ketone made by dehydrogenation of isopropyl alcohol; used as a solvent in printmaking.

Acidity. Quality of residual acid that may affect the life of paper. *See also* pH scale.

À la poupée. Method of applying two or more colors to an intaglio plate with small dabbers made from rags or felt.

Alpha pulp. High-grade wood pulp used for permanent paper and board.

Alum. Aluminum sulfate. Used in lithography in counteretching a plate or stone; used in papermaking to aid water resistance.

Aluminum plate. Alloy of aluminum sheet used in lithography and suitable as a base plate for collagraphs.

Ammonium bichromate. Used in screen prints as an emulsion to light-sensitize the screen; very powerful. *See also* Potassium bichromate.

Aquatint. Intaglio method on zinc or copper plates in which tones are obtained by powdered rosin or paint spray. Acid bites these tones into the plate to various depths, deeper bites yielding darker tones.

Archival. Permanent.

Arkansas stone. Hard stone used with oil to sharpen metal tools to a fine edge.

Artist's proofs. Proofs for the artist outside the regular edition; marked as A/P. Also called *épreuve d'artiste.*

Asphaltum. Tar product used as an acid resist in etching and inking base in lithography.

Autographic ink. Greasy tusche used in lithography to create solid tones or lines.

Baren. Japanese implement used to print woodcuts. It is made from a coil of bamboo cord on a backing of paper plies glued together, and is covered with bamboo leaf sheathing.

Base plate. Support that holds together a variety of materials in a collagraph. It may be cardboard, Masonite, metal, or plastic.

Baumé hydrometer. Instrument for measuring the specific gravity or density of a solution.

Benzene. Dangerous solvent that should be replaced.

Benzine. Solvent from petroleum naphtha. Use with local exhaust ventilation.

Bevel. Slant or inclination given to the edge of an intaglio plate to facilitate press printing.

Bite. Corrosive effect of acid on a metal plate.

Bleach. Chlorine used in screen printing to reclaim nylon or metal screens. Also used in papermaking to whiten paper pulp.

Bleed print. Image that extends beyond one or more edges of the paper.

Blind embossing. Embossed print without ink.

Blind stamp. Small embossed seal pressed into the paper as a distinguishing mark; a chop mark.

Block-out. Substance that, when applied to the screen, plate, or stone, will stop ink from reaching the print.

Blueprint. Method of copying using a light-sensitive process; usually developed with ammonia fumes.

Bon à tirer (BAT). Print used as a guide by the printer for an edition. All prints are compared to it for excellence.

Bordering wax. Wax used to build walls around an etching plate so that acid can be contained.

Brayer. Small hand roller used to spread a film of ink over plates and blocks.

Bridge. Device on which to rest the hand while working on an image to prevent touching the surface.

Buffering. Usually an alkaline added to paper to give it a higher pH.

Burin. Steel engraving tool for cutting into wood or metal.

Burnisher. Piece of polished hardened steel, either curved or straight, used to smooth rough areas of a plate. A burnisher can also be a wood or plastic rubbing implement used to print a relief block.

Burr. Metal shards thrown up by a drypoint needle as it scratches a zinc or copper plate; these hold ink and yield a soft, blurry line.

Byte. Unit of computer memory that usually represents eight characters.

Calender. To create a smooth surface on paper with rollers or other devices.

Cancellation proof. Proof taken from a defaced or marked plate or block to show that no more perfect prints can be pulled.

Carbon-arc lamp. Source of ultraviolet light used in photo printmaking processes. It releases a toxic dust and is being replaced.

Carbon tissue. Gelatin-coated paper made light-sensitive for photogravure.

Carborundum. Commercial form of silicon carbide, an abrasive powder used to create tonal areas on plates or to grain litho stones.

Cellulose gum. Synthetic gum used in lithography as an etch.

Chiaroscuro woodcut. Early form of European color printing that uses a key block, then several other blocks with clear tonal changes.

Chine collé. Method of adhering thin pieces of colored paper to the larger printing paper at the same time that the inked image is printed.

Chop mark. Embossed design, usually of a printer, publisher, artist, or collector, placed on the edge of a print.

Chromolithography. Nineteenth-century term for multiple-plate color lithography.

Clean wipe. Final wiping of an intaglio plate with the edge of the hand or paper to polish the entire surface as clean as possible.

Cliché verre. Photographic print made from an image scratched into an emulsion on glass.

Cold-pressed. Medium finish put on paper through the use of cold rollers.

Collagraph. Print made from a collage of various materials glued together on a cardboard, metal, or hardboard plate.

Collotype. Reproductive printing technique that is based on a photogelatin process and can yield a wide tonal range.

Colophon. Facts of production, placed at the end of book or on the reverse of the title page.

Color separation. Production of a different plate or screen for each color to be printed.

Consignment. System of leaving prints with a dealer and receiving payment only after they have been sold.

Copyright. Exclusive, legally secured right to an original work; offers protection of the work from unauthorized use.

Couching. In papermaking, the transfer of wet pulp from a mold to a felt for drying.

Counteretch. To resensitize a lithographic plate so that it will accept new drawing.

Counterproof. Offset from a wet print onto damp paper, made by putting them face to face and running them through an etching press.

Creeping bite. Tonal gradations achieved by slowly lowering an etching plate into acid.

Crevé. In etching, when closely spaced lines over-etch and become eaten away.

Criblé. Relief print made by punching the design into a metal plate with small tools.

Cursor. On a computer monitor, the indicator that shows where the next function will happen. It is controlled by a mouse, stylus, or other device.

Dabber. Soft piece of felt, leather, or cloth used to apply ink or ground to a plate.

Damp box. Sheets of dampened paper wrapped in plastic and sealed to distribute uniform dampness.

Deckle. Wooden frame used with the papermaker's mold that helps to establish the exact size of the sheet. Also refers to the rough edge of the untrimmed paper as it comes from the mold.

Diazo. Light-sensitive photo-chemical compound used in various printmaking processes.

dpi. Dots per inch.

Dry magnesia. Magnesium carbonate, a white powder used to stiffen etching and printing ink when it is too soft and runny.

Drypoint. Intaglio method in which a sharp needle or diamond point is used to scratch a line onto a metal plate. The resultant burr of metal that is raised holds more ink than the incised line itself and gives the rich, velvety stroke characteristic of the technique. The plate wears out rapidly because the burr soon breaks off during printing.

Duotone. Two-color halftone, usually black and a color.

Durometer. Relative hardness of a substance; used to grade rollers or brayers.

Dutch mordant. Etch made of hydrochloric acid, potassium chlorate, and water and used on copper plates.

Echoppe. Seventeenth-century etching tool designed to leave a mark in a hard ground that resembles the thick and thin line of an engraving.

Edition. Number of prints pulled from a plate, not counting trial proofs, artist's proofs, and other proofs outside the edition.

Electrotype. Method of duplicating a surface through the use of a mold and thin copper electroplating.

Embossing. Raised impression made by a metal or collage plate on dampened paper or similar material.

End grain. Hardwood block used for wood engraving; the wood is cut at a right angle to the grain and that surface used for engraving.

Etching. Intaglio method in which lines are incised in a metal plate by acid. The surface is covered with an acid-resistant ground that is scratched to expose the lines to the acid.

Etching blanket. Woven or pressed felt that acts as a cushion between the printing plate with its paper and the steel rollers of the etching press. The blanket forces the paper into the deepest recesses of the plate.

Etching ink. Easily wiped ink of pigment ground with plate oil.

Eugenol. Chemical oil used to retard the drying of ink; has the same characteristics as oil of cloves.

Extender. Substance used in inks to increase volume and transparency.

False bite/Foul bite. Accidental etching of areas thought to have been covered by ground.

Felt side. Side of a piece of paper that contacts the felt when the paper is couched.

Ferric chloride. Etch used with water for copper.

Flash point. Temperature at which the fumes from a liquid ignite.

Floating a print. Method of centering an unmatted print on a larger backing sheet, adhering it in position, then framing or wrapping it.

Flood stroke. In screen printing, the first of a double stroke of a squeegee for sharp printing. With the screen raised, ink is lightly pulled across the screen; to print, full pressure is used on the return stroke.

Floppy disk. Flexible computer memory disk for the storage of data.

Fountain solution. In lithography, a mildly acidic solution sometimes used to dampen stones or plates.

French chalk. Talcum used to dust lithographic images; currently replaced with baby powder.

Frisket. Masking device, usually a paper or plastic sheet, used to protect certain areas of a design from ink or paint.

Frottage. Technique of rubbing textures of various surfaces through a piece of paper or cloth with chalk, crayon, or the like.

Gelatin. Animal jelly used in collotype and related processes; also used as a size for paper.

Gesso. Common white ground or size for raw canvas; composed of titanium white mixed with a binder of polymer emulsion. It may be used as an adhesive for collagraphs.

Glacial acetic acid. Concentrated acetic acid.

Glassine. Thin, nonabsorbent paper used as a slipsheet between proofs for long-term storage or while they are drying.

Glaze cleaner. *See* Lacquer thinner.

Gloss medium. Polymer emulsion that dries very smooth and prints as a white area in intaglio; useful in tonal printing of collagraphs or as an adhesive.

Gouge. In relief, a tool used to remove wood or linoleum from the block.

Graded roll. Two or more colors of ink placed on a roller, usually with some merging of color where they meet.

Grain. In relief, the texture caused by the annual growth of the tree; in lithography, the creation of a drawing surface on the stone or plate through grinding with an abrasive.

Graver. *See* Burin.

Gravure. *See* Intaglio.

Ground. In etching, an acid-resistant substance applied to the plate through which the design is drawn. Waxes, resins, and asphaltum are among the materials used to make grounds.

Gum arabic. Secretion from the acacia tree used in lithographic etches and to help the stone reject ink and accept water. Also included in some intaglio lift-ground formulas.

Gypsography. Archaic relief process in which a metal plate was cast from a thin plaster film into which an artist had drawn.

Half-stuff. Half-beaten paper pulp.

Halftone. Image translated into dots that vary in size according to the tonality of the original.

Helio-gravure. Older photoetching process.

Helio-relief. Relief process in which a light-sensitive emulsion is applied to wood and, after developing, is etched by sandblasting and inked by relief methods. Developed by Graphicstudio in Tampa.

Heliotype. *See* Collotype.

Hollander. Device that macerates rags into pulp for papermaking.

Hors commerce. HC proof; print outside the edition and not for sale.

Hot-pressed. Smooth finish on paper made through the use of heated rollers.

Hydraulic press. Device using hydraulic pressure to print deep-relief plates by compressing two metal slabs against each other with a vertical movement.

Hydrochloric acid. Powerful acid used to mix Dutch mordant.

Hydrophilic. Water-loving.

Intaglio. Method of printing in which ink is forced into incised lines or recessions on a plate, the surface wiped clean, dampened paper placed on top, and paper and plate run through an etching press to transfer the ink to the paper. Encompasses etching, engraving, aquatint, collagraph, and other techniques.

Iron perchloride. *See* Ferric chloride.

Kerosene. Flammable petroleum distillate used as a solvent for removing ink and other substances.

Key block. In relief, one block with all the main forms; used to orient other color blocks.

Kozo fiber. Fiber of inner bark of the mulberry tree; used by many Japanese papermakers.

Lacquer. Liquid spirit varnish, or synthetic organic coating used to cover or seal a collagraph plate from inks and solvents.

Lacquer thinner. Powerful solvent often used for cleaning; also for frottage transfers. Use with local exhaust ventilation.

Laid screen. Papermaking mold with two weights of brass wires in the screen. The pattern of the wires is evident in the finished paper.

Lead relief. Embossment of a deep-relief plate or object into a sheet of lead, which is usually glued to a sheet of heavy paper.

Letterpress. Relief press used for printing type and other material.

Levigator. Heavy metal disk with an off-center handle for graining litho stones.

Lift ground. Etching process in which an image is drawn on the plate with a water-soluble liquid paint, the plate covered with hard ground, then submerged in water. The water swells the paint, thus breaking through the hard ground.

Linoleum cut. Sheet linoleum gouged or cut to produce an image or texture, then inked and printed by the relief or intaglio method.

Linseed oil. Yellowish oil compressed from flaxseed; used as a binding agent in printer's and etching inks.

Linters. Cellulose fibers from ginned cottonseed. It has many uses, such as batting or padding, and is rolled into sheets for use in certain cotton papers.

Lithography. Printing process based on the unmixability of water and grease; usually done on limestone or grained metal plates.

Litho stone. Smoothly surfaced limestone, usually from Bavaria, that receives the greasy ink that makes up a lithograph image.

Lithotine. Used in lithography as a turpentine substitute.

Long ink. Printing ink that pulls into long strings when mixed.

Magnesium carbonate. *See* Dry magnesia.

Magnesium plates. Lightweight plates often used in commercial photoetching.

Mat board. Cardboard sheet normally used for matting pictures but often used as the base plate in a collagraph.

Mat medium. Polymer emulsion that dries clear and fairly smooth; used as a transparent adhesive.

Matrix. Plate used in printing, such as the zinc, copper, or aluminum plate used in etching or the collage plate used in collagraph.

Metal halide. Powerful source of ultraviolet light used for photo processes.

Mezzotint. Intaglio process in which the entire surface of a metal plate, usually copper, is rocked with a serrated tool to produce a roughened surface that, when inked, yields a rich black. Tones are produced with scrapers and burnishers.

Micrometer gauge. Device on an etching press that controls the pressure of the upper roller on the printing plate and paper.

Mineral spirits. Petroleum distillate used as a solvent for cleaning and thinning ink, ground, or paint.

Mold. In papermaking, screen in a wooden frame used to make paper sheets.

Monoprint. Unique print pulled from a plate that already has an image incised into it, in contrast to a monotype, where the surface is unworked.

Monotype. Print pulled from a painting on a nonabsorbent plate, such as zinc, copper, or plastic. Usually one impression is made.

Mordant. Acid used for etching.

Mounting board. Cardboard sheet made of either wood pulp or cotton fibers and used as a backing or mat for prints and drawings.

Mouse. Hand-held computer device that, when rolled on a surface, moves a cursor on the monitor.

Muller. Grinding device with a handle, usually made of glass or steel, which is used to mix pigment with oil or other compounds.

Museum board. Sheet of cotton fibers with a neutral pH that makes a permanent, nonyellowing mat for prints and drawings; sometimes called rag board.

Mylar. Trade name for a dimensionally stable plastic that is often used as a transparency base in photo processes.

Naphtha. Volatile petroleum distillate for cleaning. Use with local exhaust ventilation.

Neoprene. Synthetic rubber made from chloroprene with superior resistance to oils, gasoline, sunlight, and the like; used in making rollers and brayers.

Newsprint. Cheap paper made from groundwood pulp, bleached with sulfuric acid; used as utility paper.

Nitric acid. Mordant used in varying dilutions as the etching agent for copper or zinc plates.

Offset printing. Printing that uses an intermediary transfer such as a rubber blanket before the paper is printed. There is no reversal of the image in this process.

Oil of cloves. Pale yellow oil made by pressing cloves; added to etching and printing inks to slow drying.

Oleophilic. Oil-loving.

Optical character recognition (OCR). Computer scanning system designed for "reading" and manipulating type.

Organza. Dress fabric of plain weave, usually rayon, nylon, or silk, that may be glued to a base plate to produce a tonal range in a collagraph.

Paint program. Computer program or operating functions for drawing, manipulating, and coloring graphic images.

Phosphoric acid. Used in lithography as a counteretch.

Photogravure. Photomechanical intaglio process that can achieve continuous tones.

pH scale. Chemical table of alkalinity and acidity, ranging from 0 to 14. Less than 7 indicates acidity; 7 is neutral; more than 7 is alkaline.

Pin register. Two long pins used to control color registration in printing lithographs or woodcuts.

Pixel. In computers, the individual element that forms an image on a video monitor.

Planographic. Printed from a flat surface, such as a lithographic plate.

Plate. Matrix that holds the inked design in a variety of printmaking techniques.

Platen. Relief printing press with a metal plate that puts the paper against the inked plate.

Plate oil. Linseed oil thickened by evaporation to produce a more viscous oil; used in mixing etching ink to the proper consistency.

Pochoir. Method of applying color through thin stencils of copper, brass, or paper.

Polymer medium. Acrylic polymer latex that may be used as binder for artist's pigments and is transparent when dry. Although thinned with water, it is insoluble when dry.

Potassium bichromate. In photo screen printing, a light-sensitive salt used to sensitize emulsions. *See also* Ammonium bichromate.

Potassium chlorate. Chemical compound used in making Dutch mordant for etching copper plates.

Presentation proof. Proof inscribed by the artist for some special person or purpose.

Press bed. Steel or composition slab that carries the inked etching or collagraph plate between the etching press rollers.

Printer's ink. More complex in chemical composition than etching ink; usually contains pigment plus oils, binders, driers, extenders, and other chemicals.

Printer's proofs. Impressions from a plate assigned to the printer; not counted in the edition.

Proof. Impression made from a plate or block in order to check the progress of the design.

Pulp. Cellulose fibers that, when mixed with water, make the substance from which paper is formed. It may be wood pulp in cheaper papers or cotton, linen, or other fibers in more expensive papers.

PVA adhesive. Polyvinyl acetate adhesive, a strong permanent glue. Not soluble in water when dry.

Rag board. *See* Museum board.

Rag-wipe. To remove ink from the surface of an intaglio plate with a rag, usually tarlatan or crinoline.

Rainbow roll. *See* Graded roll.

Random-access memory (RAM). Computer memory in a chip that is temporary and is lost when the machine is turned off.

Read-only memory (ROM). Computer memory in a chip used for permanent storage.

Register. System used to correctly align the plates or blocks of a color print.

Register marks. Crosses or other marks used to help align the different plates or blocks of a color print.

Relief. Printmaking method in which the inked surface of the plate or block prints and areas or lines that are gouged out do not print. Examples include woodcut, linoleum cut, relief etching, and relief collagraph.

Remarque. Trial sketches made in the margin of an etching plate to test acid and ground.

Reproduction rights. Rights to control the use of an artist's creative work; remain with the artist unless assigned to others. *See also* Copyright.

Restrike. Print pulled from a plate or block after the edition has been completed; may occur years later when the plate has passed into the possession of someone other than the artist.

Retroussage. Process of lightly rubbing an intaglio plate, after it has been inked in the normal way, with a soft rag to produce a blurred, fuzzy effect.

Reworked plate. Plate or block that has had new material or corrections added to initial image.

Rice paper. Chinese paper; often incorrectly used to denote Japanese papers.

Rocker. Hardened steel tool with a curved, serrated edge; used to roughen a metal plate for mezzotints.

Roller. Tool with a rolling cylinder, usually made of plastic soft enough to deposit a film of ink onto a metal or collage plate. Many other materials are used, including rubber and gelatin.

Rosin. Resin from pine trees. In etching, it is used in varnish and grounds; in lithography, it is used to strengthen ink on the stone before etching.

Rotogravure. Commercial intaglio process in which printing is done from a cylindrical plate.

Roulette. Engraving tool with a revolving head of hardened steel on which a dotted, lined, or irregular pattern is incised; used in intaglio processes.

Rubber hone. Fine abrasive contained in a rubber stick for erasing or polishing images on a lithographic plate.

Rub-up. Rubbing the surface of a lithographic image with a greasy ink to make it more receptive.

Scanner. In computers, a machine with a photosensitive device that translates images into a digital code. Images can then be stored or displayed in the computer.

Scoop coater. In screen printing, a trough for coating light-sensitive emulsions onto the screen.

Scorper. Wood-engraving chisel.

Scotch stone. Abrasive stick used in lithography to delete or lighten tones.

Scraper. Tool made of hardened steel in a triangular shaft; used to remove zinc or copper from etching plates.

Scraper bar. In a lithographic press, a bar that applies pressure through the tympan sheet and paper to the inked plate or stone.

Screen. In screen prints, the mesh that is stretched over a frame for printing; in halftones, the dot pattern used to translate tonalities.

Screen print. Stencil process using a mesh stretched over a frame. Ink is forced through openings in the mesh, which can be blocked by a variety of methods.

Serigraph. *See* Screen print.

Shore hardness scale. Table for measuring the hardness of a roller, ranging from 20 (soft) to 60 (hard).

Short ink. Printer's ink that is so stiff that it breaks off the mixing knife like butter.

Silicon carbide. *See* Carborundum.

Silkscreen. *See* Screen print.

Size/Sizing. Glutinous material made of flour, varnish, glue, or resin that is used to fill the pores of paper.

Slipsheet. Thin sheet of paper (glassine, newsprint, thin bond) used as a separator between impressions of a plate.

Snake slip. In lithography, compressed pumice used to clean areas of a stone.

Snake stone (water-of-Ayr stone). In lithography, a stone used as an abrasive to remove unwanted areas of a stone.

Soft ground. In etching, acid-resistant coating containing petroleum jelly or tallow to prevent it from hardening when dry, so that textures can be impressed into it.

Solander case. Sturdy, lined case made of wood or heavy cardboard, with a dust-proof lid; used for long-term storage of prints and drawings.

Solvent. Liquid that dissolves a substance such as ink, paint, or ground.

Spit bite. Tones bitten into an aquatinted intaglio plate by direct application of acid solutions with a brush or dropper.

Squeegee. Rubber or plastic blade used to force ink through the mesh in screen printing.

State proof. Proof pulled from a plate still being developed in order to see what is actually in the plate at any one stage.

Steel facing. Thin coating of iron electrolytically deposited on the surface of a copper plate to prolong its printing life.

Stencil. Masking material, such as paper, fabric, or plastic, cut or perforated to allow ink or paint to pass through and print on another surface.

Stylus. Hand-held penlike computer device that can move a cursor on the monitor.

Sugar lift. *See* Lift ground.

Sulfuric acid. Chemical compound used in lithography and etching.

Tallow. Rendered animal fat; used to condition leather rollers in lithography and to make soft ground for etching.

Tannic acid. Soluble phenolic substance used in certain lithographic etch formulas to strengthen the gum arabic as it dries.

Tarlatan. Sheer cotton fabric in plain weave; used as a wiping cloth for etchings and collagraphs.

Toluol. Liquid aromatic hydrocarbon, volatile and toxic, used in lacquer thinner.

Top roll. Thin film of ink placed on the upper surfaces of an inked plate with a roller.

Transfer paper. In lithography, may be used for drawing the image, which is then deposited on the surface of the stone or plate under pressure.

Transparent base. In screen printing, a colorless substance used to extend ink, increase its translucency, and improve its consistency.

Trap. In a multiple-block print, the slight overlap between colors that prevents white lines from appearing on the print.

Trial proof. Test impression pulled from a plate or block to check the latest state of the image.

Tusche. Greasy drawing material used in lithography and screen printing.

Tympan. In lithography printing, a flat greased sheet used to transfer the pressure of the scraper bar across the sheet of paper.

Type high. In letterpress printing, the height of metal type (.918 inch).

Vacuum forming. Process in which a preheated sheet of plastic is shaped around a three-dimensional object by sucking out the air beneath it.

Vellum. Paperlike material made from animal skins; also called parchment. Most contemporary vellums are wood or cotton pulp.

Videodigitizer. Camera that translates images into electronic codes so that a computer can assimilate the information.

Viscosity. Stickiness of a fluid, such as etching or printing ink.

Waterleaf paper. Paper without sizing.

Watermark. Slightly thicker part of the papermaker's mold, usually in the form of a design or letter, that indicates the source of the paper. The watermark is thinner than the rest of the sheet.

Wax coating. Adhesive for paper or cardboard. The wax is melted or softened with heat and applied with a roller device.

Whetstone. Abrasive stone used with water for sharpening metal tools.

Whiting. Calcium carbonate pumice used to polish etching plates; also the main component in lithographic stones.

Woodburytype. *See* Collotype.

Woodcut. Plank of wood that is inked on the surface to reveal a relief image or texture. Cuts, gouge marks, and indentations do not print and show as white.

Wood engraving. End grain of wood that is cut and inked on the surface to reveal a relief image.

Wove screen. Papermaking mold with fine brass wire in the screen. The pattern of the wires is not evident in the finished paper.

Xylography. *See* Woodcut or Wood engraving.

Zinc plate. Sheet of zinc alloy that may be used as a base plate for a collagraph. Heavier weights are normally used in etching; thinner weights, in lithography.

Index

Abstract Expressionists, 74
Acetate, for school printmaking, 335; wrapping, 309–10
Acetone, 172, 328
Acetylene torch, 80
Acid, for aluminum etch, 94; for cutting intaglio plates, 80; for etching, 47–48, 92–96, 98, 101–02, 107; health hazards, 324–26; intaglio techniques, 89–116; trays, 94–95
Acidity, of paper, 286
Acrylic inks, 183, 341
Acrylic polymer emulsion, as adhesive, 137, 240
Additives, 169, 184
Adhesives, in collagraphs, 136–38; in lead reliefs, 240; in relief prints, 53
Adler, Myril, 278, 278, 298
Albers, Josef, 146
Albert, Joseph, 265
Albion press, 28
Alexenberg, Mel, 273
Allison, Dan, 139
Alps, Glen, 133, 137
Altman, Harold, 99
Alum, 37, 39–40
Aluminum plates, collagraph, 136; collotype, 266; intaglio, 79, 94; lithographic, 202, 206, 208, 217, 222, 223, 232
Aluminum screen frames, 147, 151
American Atelier, 230
Ammonium bichromate process, 234
André, Johann, 192
André, Philipp, 195
Antreasian, Garo, 198
Anuszkiewicz, Richard, 210
Aquatint, 76, 98–103; creeping bite, 108; flour-of-sulfur, 103; image-making for, 101; materials, 98–100; origins of, 71–72; reaquatinting in, 101–02; sandpaper, 102; spit bite, 107–08; spray-paint, 100; white effects, 103
Arakawa, 198
Archie, Ed, 220, 221, 222
Arms, John Taylor, 92
Arneson, Robert, 213
Artist's proof, 306
Art Nouveau, 72
Asphaltum, in etching ground, 76, 89; for etching linoleum, 47; for etching stone, 207; as stop-out, 92, 97
Autremont, Louis D', 144
Avati, Mario, 86, 87
Avery, Milton, 7, 249
Azuma, Norio, 179

Baensch, Miyoko, 330
Bailey, William, 93
Baldessari, John, 259
Baldung Grien, Hans, 3
Balsa collage print, 52–53
Banker, Thomas, 192
Barbiere, Domenico de, 67
Baren, 15, 38, 39, 42
Barlach, Ernst, 7
Barnet, Will, 124, 125, 146
Bartfeld, Elizabeth, 330
Bartlett, Jennifer, 182, 198
Baskin, Leonard, 8, 8, 42
Basquiat, Jean-Michael, 148
Bauhaus, 249
Baumé, 94
Beardon, Romare, 198
Beater, 282–83
Beck, 271

Becker, David, 110
Becker, Helmut, 282
Beckmann, Max, 7
Beeswax, 76, 89, 105
Bellini, Giovanni, 68
Bellows, George, 196
Bench hooks, 13
Berger, Simone, 164, 272
Bernardi, Rosemarie, 265
Berne Convention, 317–19
Bernstein, Edward, 266
Beveling, 80–81; of collagraph forms, 134
Bewick, Thomas, 4, 5, 42
Bichromate emulsion, 181
Binding, book, 295–96
Biting, etching plates, 95
Blackburn, Robert, 74, 307, 319
Blake, William, 28, 72, 73, 192, 247, 247
Blankets, etching, 111–12
Blaue Reiter, 7
Blaustein, Alfred, 88, 250, 251, 253
Block book, 2, 3
Block-out solution stencil, 162
Block-out stencil, 162–69, 172–82
Blooteling, Abraham, 70
Bochner, Mel, 103
Bois Protat, 2
Bonington, Richard Parkes, 195
Bonnard, Pierre, 194, 249
Bookbinding press, 28
Bookmaking, binding, 295–96; planning, 289–90; printing, 290–94
Bosman, Richard, 29
Botticelli, Sandro, 4
Box board, 135
Boxwood, 43
Boys, Thomas Shotter, 195
Brand X, 185, 317
Braque, Georges, 132
Brass plates, 79
Brayers; see Rollers
Brazing, 138
Bresdin, Rodolphe, 194
Bridge, 96, 97
Bristol board, 135
Broner, Robert, 251
Brooks, Arnold, 222
Brown, Bolton, 196
Brown, Kathan, 316
Brücke, Die, 7, 195
Brushes, for etching grounds, 89; for Japanese woodcuts, 38, 39, 40, 41–42; for woodblocks, 16–17
Burgkmair, Hans, 4
Burin, 75, 84–86
Burnishers, 44, 49, 87
Burnishing, 88
Burr, 82–84, 86
Business aspects, 305–20; distribution and sales, 312–16; edition size, 306–07; legal problems, 317–20; matting and framing, 308–11; printer-publisher collaboration, 316–17; record-keeping, 307–08; shipping, 312; storage, 311–12

Calder, Alexander, 74
Callot, Jacques, 68, 69, 86
Canaletto, 71
Cancellation proof, 306
Caravaggio, 69
Carbon paper transfers, multiple-plate, 124; woodcut, 19–20; wood engraving, 44
Carborundum, in collagraphs, 133, 139; for grinding litho stones, 200
Cardboard, in collagraphs, 132–33, 139, 141; for inking etchings, 113; intaglio plates, 80; relief prints, 8, 32, 33, 51–52; in school printmaking, 332; for screen-print register, 154
Carlson, Chester, 267
Carpi, Ugo da, 4

Carrière, Eugène, 206
Casarella, Edmund, 8, 52, 132–33
Cassatt, Mary, 6, 72, 83, 117
Castellon, Federico, 191, 197, 204
Castiglione, Giovanni Benedetto, 246–47, 247
Cast-paper prints, 237–39
Cellocut, 51
Central processing unit, 270
Cézanne, Paul, 193
Chagall, Marc, 74, 249
Chalon, H. B., 192
Charcoal, for relief-print drawings, 16, 17, 19, 20, 44
Charcoal, engraver's, 81, 88
Charcoal offset drawing, 19–20
Charpentier, Alexandre, 236
Chase, William Merritt, 245, 247, 249
Chéret, Jules, 194
Chew, Carl T., 299
Chiaroscuro, in etching, 69–70; woodcuts, 4
Chieh, Wang, 2
Chine collé, 121–23, 124, 240, 293
Chipboard, in collagraphs, 135, 137; for registration, 32; for screen-print baseboard, 147
Chiriani, Richard, 184
Chisels, 11–12, 37, 40–41, 43
Chop mark, 307–08
Christo, 318
Chromolithography, 194
Cibachromes, 278
Circle Gallery, 230
Cirrus Editions, 317
Clamps, 13, 79, 152
Clemente, Francesco, 58, 288
Cline, Clinton, 264
Close, Chuck, 75, 303
Cole, Sylvan, 314–16
Cole, Thomas, 195
Colescott, Warrington, 62
Colker, Ed, 304
Collaborative prints, 316–17
Collage, in intaglio, 121–23 (see also Collagraph); in monotype, 256; in relief print, 49–53; in school printmaking, 333–34
Collagraph, 75, 76, 131–42; adhesives, 136–39; base materials, 134–36; history of, 132–33; preparing, 133–42; printing, 142; texturing, 139–42
Collotype, 131, 265–66
Color printing, on copier, 268; intaglio, 117–30; Japanese woodcut, 37–42; lithographic, 224–27; oil-based screen print, 185–87; water-based screen print, 171–72; woodcut, 28–42
Columbian press, 28
Computer-aided design (CAD), 274
Computer-generated images, 269–78; hardware, 270–72; photographing, 278; printers for, 276–78; software, 272–74
Consignment, 313–14, 315
Constructed prints, 240–41
Contact paper, 158
Cooper, Richard, 195
Copier art, 266–68, 294; color, 268
Copper plates, for collagraphs, 136, 138; for intaglio, 75, 76, 78–79, 82, 84, 85, 96, 102; for photo-etching, 262–64; for relief etchings, 27, 51
Copy camera, 260
Copyright, 317–18
Corinth, Lovis, 72, 195
Cornstarch, with ink, 179, 184; sizing, 177
Corrections, etching, 96; linocut, 46; lithograph, 221–22; nonacid intaglio, 87–88; relief etching, 48–49; woodcut, 22–23; wood engraving, 44
Cotton, for paper, 283
Couching, 285

Counteretch, 208
Courtin, Pierre, 236
Cranach, Lucas, 3, 4
Crayon, block-out stencil, 162, 163; Caran d'Ache, 163, 255; Conté, 202; lithographic, 83, 85, 103, 147, 157, 163, 176, 177, 202–03; watercolor, 157, 163; wax, 85, 103, 147, 157, 162, 176, 177
Creeping bite, 108
Crevé, 108
Criblé, 75, 86
Crown Point Press, 8, 75, 316
Currier, Nathaniel, 195
Curtis, Edwards, 259
Cut-plate method, for color intaglio, 118–20

Dabbers, 90, 113–14, 117–18
Dacron, 149
Daisy-wheel printer, 276
dalle Greche, Domenico, 4
Damer, Jack, 198
Daumier, Honoré, 192, 193, 200
Davies, Arthur B., 196
Davis, Ron, 237
Davis, Stuart, 7, 197
Dealer, 312–16, 320
Deckle, 282
Degas, Edgar, 6, 102, 193, 248, 249, 251, 252, 258
Degreasing, intaglio plates, 81
de Kooning, Elaine, 77
Delacroix, Eugène, 192, 192
Delatre, Auguste, 248
de Negker, Jost, 4
Denril, 158
Derrière l'Etoile Studios, 316
Deshaies, Arthur, 42, 55
Desjobert, Atelier, 84, 204, 225
Desjobert, Edmund, 197, 201
Desjobert, Jacques, 197, 201
Desktop publishing, 272–73
Diazo printers, 268
Diazo solutions, 181, 233
Diebenkorn, Richard, 64, 198, 251
Dimensional prints, 235–44; cast-paper, 237–39; constructed, 241–41; embossed (uninked), 237; lead relief, 240; plaster cast, 241–42; sewn, 243–44; vacuum-formed, 242
Dine, Jim, 8, 65, 75, 198, 246, 251, 300
Dixon, Kathleen, 50
Donkin, Bryan, 280
Doré, Gustave, 42
Dosa; see Sizing
Dosabake, 40
Dot-matrix printer, 276
Doughty, Thomas, 195
Drawing, for collagraphs, 133; for drypoint, 83–84; for etchings, 91, 95–97, 123–24; for line engravings, 85; for lithographs, 202–06, 224; for screen prints, 147, 162–64, 176–79; for woodcuts, 16–20, 19, 28–29; for wood engravings, 44
Drawing fluid resist, 162–63
Draw tool, 79
Drypoint, 70, 75, 82–84; drawing for, 83; inking, 84; materials, 82–83; printing, 84; for school printmaking, 336
Dubuffet, Jean, 150, 249
Dummy, 290
Dürer, Albrecht, 3, 3, 4, 21, 66, 68, 68, 75, 82
Durometer, of rollers, 130
Dutch mordant, 93–94, 96, 102, 325
Duveneck, Frank, 249

Echoppe, 68–69, 86
Edition, numbering, 307–08; size, 306–07
Eichenberg, Fritz, 42, 43
Electrostatic printing; see Copier art

Embossing, for collagraphs, 131, 132; as intaglio technique, 76, 237; for school printmaking, 336; uninked, 237
Emulsions, for photolithography, 232; for photo screen printing, 164–69, 181–82
Enamels, 183, 341
Engelmann, Godefroy, 194
Engraving, intaglio, 75, 84–86; cutting plates, 85; drawing, 85; history of, 65–68; materials, 84–85; printing, 86
Engraving, white line, 228
Engraving, wood, 4, 42–45; cutting, 44; drawing for, 44; history of, 4, 42; materials, 43–44; printing, 44
Enlarger, 260
Enogu-bake, 39, 41
Ensor, James, 72
Epoxy, for collagraph plates, 136, 138; for lead reliefs, 240
Epoxy resin ink, 189
Ernst, Max, 74
Escher, M. C., 229
Escobar, Marisol, 198
Estes, Richard, 173
Etching, intaglio, 75, 76, 89–116; acids for, 92–94; aquatint, 98–103, 106–08; biting in, 95; color, 117–30; ground, 89–95; history of, 68–75; lift-ground, 103–06; line, 95–96; photo, 262–64; printing, 109–16; for school printmaking, 336; soft-ground, 96–97
Etching, lithographic, of plate, 208, 217; of stone, 207–08
Etching, relief, 46–49
Etching press, 26–27, 112, 115, 340
Eugenol, 111, 120, 220; *see also* Oil of cloves
Experimental Workshop, 316
Expressionists, 7, 72, 195
Extenders, 169, 184, 220

Fabric, for screen prints, 143, 144, 149, 157, 165, 187–88; for sewn prints, 243–44; for texturing collagraphs, 140
Fantin-Latour, Henri, 193
Feininger, Lyonel, 7
Feldman, Franklin, 317–20
Felson, Sidney, 317
Fendi, Peter, 194
Ferric chloride, 94, 96, 102, 325
Film, for screen prints, 167–68, 179–82
Finiguerra, Maso, 66
Fire extinguishers, 324
First-aid kits, 324
Flack, Audrey, 267
Flax, 284
Flocking, 185–86
Flood stroke, 171
Flour-of-sulfur, aquatint, 103
Fluorescent inks, 183, 341
Foam-rubber, etching method, 108
Forster, Clare Chanler, 294
Foti, Eileen, 309
Found objects, in collage relief prints, 49–51; in collagraphs, 141; in dimensional prints, 242; in intaglio, 126; in object prints, 331–32
Fourdrinier, Henry, 280
Fourdrinier, Sealy, 280
Frame, screen, 147–48
Framing, 310–11
Francis, Sam, 198
Frank, Mary, 246, 251, 254
Frankenthaler, Helen, 8, 237, 251
Frasconi, Antonio, 8, *11*, 12, *18*, 33, 55, 267, 300, 304
Frederick, Helen C., 214, 239, 285
Freezer wrap, 158
French fold, 292

Freud, Lucian, *313*
Frisket, 156, 162; *see also* Maskoid
Frottage, in monotypes, 257; transfers for lithography, 229–30
Fulton, John, 284
Funk, Joe, 198
Fuseli, Henry, 192, 195

Gardiner, Jeremy, 269
Garner Tullis Workshop, 238, *314*, 316
Gauguin, Paul, 6, *6*, 7, 12, 194, 248
Gaulon, Cyprien-Charles-Marie-Nicolas, 192
Gavarni, Paul, 192
Gemini Editions, 75, 317
Géricault, Théodore, 192
Gershwin, Chuck, 273–74
Gessner, Konrad, 195
Gesso, for collagraphs, 134, 135, 137, 139, 140, 141; for linocuts, 46; for relief prints, 52, 54, 56; for woodblock correction, 22
Giacometti, Alberto, 74
Gikow, Ruth, 145
Ginzel, Roland, 133
Gloves, 111, 165, 324
Glue, animal, 37, 39–40; for blocking out stencils, 156, 174–75; carpenter's, 23; for collagraph, 136–38; jade, 56, 123; LePage's, 172, 173, 176, 177–78; prints, 335; white, 23, 46, 52, 134, 135, 137, 240
Goltzius, Hendrik, *4*
Golub, Leon, 198, 222, 223
Gotlieb, Harry, 145
Gouache, 38
Gouges, for line engravings, 85; for woodcuts, 9, 11–12, 37, 40–41; for wood engravings, 43, 44
Goya, Francisco, 71–72, *72*, 101, 192, *193*
Grain, of paper, 289–90; of wood, 17, 21, 23
Graphicstudio, 266, 317
Graphite, 21
Grashow, James, 56
Gravers, 14, 43, 85
Gray board, *see* Chipboard
Grinstein, Stanley, 317
Gris, Juan, 132
Groove and cord method, 150–51
Grosman, Maurice, 74
Grosman, Tatyana, 74–75, 198, 316
Gross, Mimi, 243
Grounds, etching, 75, 76, 89–92, 95–96; ball, 90; Janes, 91; liquid hard, 89, 95; liquid soft, 91–92; paste soft, 92; smoking, 91; staging-ink, 91; wax, 95–96
Guiffreda, Mauro, 230
Gum arabic, in lift ground, 103, 105; in limestone etch, 207–08; for lithographic tone reversal, 228; for spit bite, 107
Gum bichromate process, 234
Gutenberg, Johannes, 3
Gwathmey, Robert, 145

Haas, Richard, 220, 221
Haden, Francis Seymour, 95
Halftone, 260
Hand-embossed prints, 49
Hand-flipping registration, 126
Hand press, 28
Hand printing, of woodcuts, 2, 23–24
Hand wiping, of etchings, 114
Hard ball ground, 90
Hardboard, for collagraphs, 136; for relief prints, 53
Hard ground, 75, 76, 89, 90
Hardware, computer, 270–72
Harunobu, 4, 49
Hayter, Stanley William, 74, *74*, 127, 130
Haze removers, 172

Health hazards, 321–27; of acids, 324–26; equipment and, 322–324; of inks, 326; in intaglio printing, 327; in lithography, 327; in photographic techniques, 327; in relief printing, 327; in screen printing, 327; of solvents, 326, 328
Heckel, Erich, 7, 195
Helio-relief, 266
Henderson, Edward, *109*
Henri, Robert, 196
Hilger, Charles, 236, 238
Hill, Kenny, 329
Hills, Robert, 192
Hind, Arthur M., 66
Hinges, 13, 79, 152
Hiroshige, Ando, 4, 6, 38
Hockney, David, *212*
Hofmann, Hans, 145
Hogarth, William, 71
Hokusai, Katsushika, 4
Holbein the Elder, Hans, 3
Hollander beater, 280, 282–83
Hopper, Edward, 74
Hovorka, Thomas, 267
Huebsch, Rand, 314
Hullmandel, Charles, 195
Hunter, Mel, 230, 232
Hydrochloric acid, 93–94

Illustration board, 135
Imboden, Paul, 283, 284
Impasto, 179
Imposition, 290
India ink, for drawing, 16, 17, 18, 44; in lift ground, 103
Inking, cardboard reliefs, 52; collage reliefs, 51; drypoint, 84; etchings, 113–15; intaglio color plates, 117–30; Japanese woodcuts, 38, 41–42; linocuts, 46; screen prints (water-based), 170–72; woodcuts, 23–24, 33–34; wood engravings, 44
Ink-jet printer, 276
Inks, drypoint, 82, 84; engraving, 86; etching, 110–11, 117; health hazards of, 326; Japanese woodcut, 37–38, 40–42; lithograph, 204, 219–20, 224–25; relief print, 16, 33–35; screen print (oil-based), 182–85, 341; screen print (water-based), 169–70, 340
Intaglio, 65–130; acid techniques, 89–116; for book illustration, 292–93; color, 117–30; health hazards, 327; history, 65–75; materials, 78–81; nonacid techniques, 82–88; photoetching, 262–64; photogravure, 264–65; *see also* Collagraphs
Isabey, Eugène, 192

Jackson, J. B., 49
Jacomet, Bruno, 190
Jacquette, Yvonne, *61*
Janes ground, 91
Japanese paper, 280, 284, 308; for color relief printing, 35; fibers, 284; for hand-embossed prints, 49; for Japanese woodcuts, 39; for lithography, 218–19; for mono-types, 257; for woodcuts, 16, 26, 39
Japanese register method, 32
Japanese woodcut method, 4–6, 37–42; cutting technique, 40–41; drawing for, 40; materials, 12, 37–39; paper sizing for, 40–41; printing, 41–42
Jawlensky, Alexei, 7
Jensen, Bill, *111*
Jig, gouging, 13; sharpening (for burins), 84, 85
Jigsaw register method, 32–33

Johns, Jasper, 75, 77, *176*, 198, 246, 251
Johnson, Lois, *211*
Jules, Mervin, 145
Jung, *271*
Jungers, Adja, 8

Kahn, Wolf, *170*
Kandinsky, Wassily, 7, 195
Katz, Alex, 8, 146, *188*
Katzheimer, Lorenz, *16*
Kelly, Ellsworth, 146
Kent, Rockwell, 197
Kento, 12, 41
Kerlow, Isaac Victor, 276, *276*, 277
Key-block method, 28
Khuda, Shamsi, 124
King, Ron, 292
Kirchner, Ernst Ludwig, 7, *7*, 195
Klee, Paul, 7, 195, 248
Knigin, Michael, 198, *230*
Knives, stencil, 156; woodcut, 10–11
Koehler, Sylvester R., 247
Kohn, Misch, 42, *122*
Koller, John, 237
Koller, Kathleen, 237
Kollwitz, Käthe, 7, 72, 73, 195
Koop, Matthus, 280
Kopec, Chris, *331*
Kreneck, Lynwood, 158, *160*, 161–62, *210*
Kruty, Peter, 291
Kubin, Alfred, 195

Lacquer, 136; adhesive, 52, 138; block-out stencils, 174, 176; film stencil, 159–160, 179, 181; inks, 183, 341; thinner, 18, 137, 138, 217, 328
Landau, Jacob, 9
Landfall Press, 316–17
Landon, Edward, 145
Lanzedelly, Josef, 194
Laposky, Ben F., 269
Lasansky, Mauricio, 74, *101*
Laser printer, 276
Law, art, 317–20; dealer relation-ships, 320; reproduction rights, 317–19; taxes, 319–20
Lawrence, Jacob, *180*
Lead reliefs, 240
Le Blon, Jacob Cristoph, 72
Lebrun, Rico, 197
Lee, Jim, 288
Lefkowitz, Jim, 283, 306
Lehrer, Leonard, 234
Leiber, Gerson, 293
Lemon, Jack, 317
LePage's glue, 172, 173, 176, 177–78
Lepic, Vicomte Ludovic, 248
Letterpress printing, 290–92
Levigator, 200
Le Vine, Jon, 333
Levy, Judy, 267
Lichtenstein, Roy, 145, 198, *209*
Liebermann, Max, 195
Lift ground, 76, 103–07; formula for, 103; Peter Milton's procedure, 105; with spit bite, 107
Lightener, Karen, 267
Limestone; *see* Stone, lithograph
Line etching, 95–96
Linocuts, 46–47; Picasso's, *1*, 8, 33, 46; for school printmaking, 334–35
Linoleum, for collagraphs, 136; for etching, 46–47; for linocuts, 46, 334–35; rollers, 14
Linseed oil, 13, 16, 85, 127, 129, 220; as plate oil, 110–11
Lipschitz, Jacques, 74
Liquid aluminum, as adhesive, 136, 138
Liquid hard ground, 89, 95
Liquid soft ground, 91

Liquid steel, as adhesive, 136, 138
Lithography, 191–208, 217–34; ammonium bichromate process, 234; color, 224–27; etching stones and plates in, 207–08, 217; frottage in, 229–30; health hazards, 327; heated stones in, 229; history of, 191–98; lacquering plates in, 217; manière noire, 205–06; materials, 199–205; Mylar, 230–232; offset, 292; paper plate, 336; photo, 230–33; printing, 217–24, 292; tone reversals, 227–28; transfer process, 206–07; white lines, 228–29
Lithotine, 207–08, 328
Lockup bar, 26, 27
Longo, Robert, *231*
Lovejoy, Margot, 295
Lozowick, Louis, 197, *197*
Lun, Ts'ai, 279
Lyons, E. C., 14
Lyons, Joan, 267

Maccoy, Guy, 145
Magazine transfer, 164
Magnesium, 34, 35, 127–30, 220, 225; intaglio plates, 79; lithography plates, 202
Makeready, 27, 28
Manet, Edouard, 6, 193
Manière noire, 205–06
Mantegna, Andrea, 67, 68
Maple, endgrain, 43
Marc, Franz, 7
Marden, Brice, 146
Margo, Boris, 51, 132
Marin, John, 74
Martin, John, *71*
Masanobu, 49
Mask, 323–24
Maskoid, 156, 162, 176; stencil, 178–79
Massey, Charles, 198
Masson, André, 74
Master E. S., 66
Master of the Housebook, 66
Master of the Playing Cards, 66
Master PW, 66
Mat, 308–10; assembling, 309; cutting, 309; floating, 310; measuring, 308–09; wrapping, 309–10
Mat board, for collagraphs, 134–35, 137; for relief prints, 33; *see also* Museum board
Matisse, Henri, 46, 196, *197*, 249, *249*, 252
Mat registration, 124
Maurer, Louis, 195
Mayor, A. Hyatt, 4, 69
Mazur, Michael, *214*, 251, 258
McCafferty, Jon, 221, *222*
McDermott, Michael, *274*
McGarrell, James, 198
McNeil, George, *213*
Meador, Clifton, *291*
Meeker, Dean, 133
Menard, Lloyd, *303*
Meryon, Charles, 72
Metal foil, 141
Metallic powders, 183–84
Metal print, 132
Mezzotint, history of, 70–72; mock, 87; technique, 75, 86–87
Milant, Jean, 317
Miller, George C., 197
Milton, Peter, 105–06, *106, 315*
Minimalists, 146
Minsky, Richard, *294*
Miró, Joan, 72, 196, 249
Mizubake, 39, 41
Modeling paste, for collagraphs, 137; for correcting woodcuts, 22; for relief prints, 56
Mold, paper, 281–82
Monet, Claude, 194
Monitor, computer, 270

Monoprints, 163, 245–46
Monotypes, 37, 245–58; collage and, 256; colors in, 253–55; direct painting of, 252; direct-trace drawing for, 253; frottage in, 257; history of, 246–51; materials, 251, 255–56; paper, 257; printing, 257–58; reworking, 258; for school printmaking, 330–31; test plate, 251–52; trace, 254–55; viscosity principles in, 255
Moon, Mick, *215*
Moore, Frances, 319
Moran, Donna, *157,* 261
Moran, Thomas, 195
Morandi, Giorgio, 96
Motherwell, Robert, 198, *320*
Moti, Kaiko, 74
Mounting board; *see* Mat board
Mourlot, 196
Mouse, computer, 270
Moy, Seong, 8
Mueller, Michael, 284
Müller, Otto, 7
Multiple-plate printing, 123–26
Multiple-tint tool, 85
Munakata, 12
Munch, Edvard, 7, 21, *21*, 32, 195
Murray, Elizabeth, 233
Museum board, for collagraphs, 135; for matting, 308, 309; for relief prints, 51
Myers, Frances, 34
Mylar, for hand-drawn transparencies, 163, 260; for photolithography, 230–32; for screen printing, 155, 157, 158, 163, 166

Nama, George, 108
National Institute for Occupational Safety and Health, 323
National Serigraph Society, 145
Needle, drypoint, 82–83; pin register, 32
Nelson, Robert, 198
Neoprene, 154
Nesch, Rolf, *63*, 132, 133, *138*, 236
Nevelson, Louise, 75, 198, 235, 238
Newton, Isaac, 72
Nitric acid, health hazards, 325; for intaglio, 92–93, 95, 96, 98, 101–02, 107; for lithography, 207–08; for relief etching, 47–48
Nolde, Emil, 7, *7*, 195
North Star Atelier, 230
Nylon, 149

Oaktag, 28, 120
Object prints, 331–32
Off-contact printing, 171–72
Offset lithography, 292
O'Hara, Frank, 74
Oil of cloves, 111, 114, 120, 127
Oil paints, 183
Oil pastels, 162
Oldenburg, Claes, 146, *244*
Olds, Elizabeth, 145
Oliviera, Nathan, 198, 251, 252
One-plate method, 72, 117–118, 124
Op Art, 145–146
Organdy, 149
Organza, for collagraph, 140
O'Rourke, Michael, *274*
Orozco, José Clemente, 7
Otis, Bass, 195
Oxman, Katja, *62*

Paint programs, 273–74
Palmer, Fanny, 195
Paolozzi, Eduardo, 259
Paone, Peter, *33*
Paper, 342–43; for book, 289–90; cast, 237–39; chine collé, 121–23; collagraph, 140, 142; drypoint, 82, 84; etching, 109, 112–13, 115, 116; for hand-embossed prints, 49; Japanese, 39, 49, 122, 218–19; line engraving, 86; lithography, 206, 218–19; monotype, 257;

relief print, 16, 35, 44; screen print, 170; stencil, 157–58, 164, 173; transfer, 206–07; *see also* Papermaking
Paper cuts, 132–33
Papermaking, 279–86; history of, 279–80; principles, 281–84; process, 284–86
Paper prints, 332
Paper wiping, 115
Paste soft ground, 92
Peale, Rembrandt, 195
Pearlstein, Philip, 8, *47*, 266
Pear wood, 9–10
Pechstein, Max, 7, 195
Pencils, Caran d'Ache water-soluble, 255; charcoal, 19, 20, 133; colored, 123; grease, 85; litho, 83; Stabilo, 163
Pennell, Joseph, 196
Permanence, color, 33–34
Peterdi, Gabor, 74, 93
Petroleum jelly, for liquid soft ground, 91–92
Pfaff, Judy, *30*
Pfeiffer, Werner, *241*
Philipon, Charles, 192
Phillips, Matt, 249–251
Photocopies; *see* Copier art
Photocopy transfer method, 18–19, 164
Photoetching, 262–64
Photogelatin method, 265–66
Photogram, 163
Photographic techniques, 259–68; for collotype, 265–66; for computer imagery, 272, 278; for copier art, 266–68; for diazo prints, 268; for etching, 262–64; for gravure, 264–65; health hazards of, 327; for helio-relief, 266; for lithography, 230–33; for screen printing, 163–69, 181–82; transparencies for, 259–62
Photogravure, 264–65
Photo mount paper, 158
Picasso, Pablo, *1*, 8, 33, 46, 72–74, *73, 108,* 132, 195, *196,* 249
Pigment, black etching, 110–11; color litho, 224–25; health hazards of, 326; permanence of, 34; water-based (Ukiyo-e), 38, 41–42
Pike oil, 13, 85
Pilsworth, John, 144
Pine, 9, 17, 18
Pin register, 32
Piranesi, Giovanni Battista, 71, *71*
Pissarro, Camille, 6, 193, 248
Plant material, for collagraphs, 140–41
Plaster, blocks for relief prints, 54; casts, 241–42
Plastic sheets, for collagraphs, 136, 141
Plastic Wood, 22, 56, 141
Plate chopper, 79
Plate oil, 110–11, 127, 129
Plates, cardboard, 132–33; collagraph, 134–42; lithographic, 202, 208
Plates (intaglio), acids for, 92–95; beveling, 81; cleaning, 116; cutting tools for, 79–80; degreasing, 81; grounding, 89–92; inking and wiping, 113–14; polishing, 81, 88; printing, 115–16; selection of, 78–79
Plexiglas box, 311
Plugging, 23, 44
Plywood, for collagraphs, 136; for linoleum mounting, 46; for registration, 30, 32; for relief prints, 10, 17, 18, 19, 37; for screen-print baseboards, 147, 152
Pochoir process, 189–90
Pogacnik, Marjan, 236
Pogany, Miklos, 256
Pokrasso, Ron, 254
Polinskie, Kenneth, 280
Polishing intaglio plates, 81, 88
Pollaiuolo, Antonio, 67, 68

Pollock, Jackson, 74, 145, *146*
Polyester, 149
Polyurethane varnish, 151–52
Ponce de Leon, Michael, 236, 237
Pop Art, 145–46
Poplar, 9, 17, 18, 27
Porett, Thomas, 273–74, *274,* 298
Portfolio, 311, 314
Posada, José Guadalupe, 7, 48, *48*
Poster board, for collagraphs, 135
Poster colors, for screen prints, 183, 341; with woodcuts, 16–17, 19, 21, 28, 29, 38
Potassium chlorate, 93–94
Potassium dichlorate, 94
Poupée, à la; see One-plate method
Power tools, for intaglio, 80, 83; for woodcuts, 14
Pozzatti, Rudy, 198, 201, 289, 325
Prendergast, Maurice Brazil, *248,* 249
Presentation proof, 306
Press, bookbinding, 28; etching, 26–27, 112, 115, 340; hand, 28; letter, 291; lithographic, 217, 340; proof, 291; Vandercook, 26–27, 291
Pricing, 308, 315
Printer, computer, 276–78
Printer-publishers, 316–17
Printer's proof, 306
Printing, books, 290–92; cardboard reliefs, 52; collage reliefs, 51; collagraphs, 142; computer, 272, 276–78; drypoints, 84; engravings, 86; etchings, 112–16; intaglio, 75, 84, 86, 112–16; linocuts, 46; lithographs, 220–32; monotypes, 257–58; screen prints (oil based), 172, 185–87; screen prints (water based), 170–72; woodcuts, 23–28; wood engravings, 44–45; *see also* Color printing
Process colors, 34
Projection, 168–69
Proofs, intaglio, 109, 124; kinds of, 306; lithography, 220–21; woodcut, 20, 21–22
Pyramid Atlantic, 238, 239, 282, 285

Raffael, Joseph, *10*
Rag board; *see* Museum board
Raimondi, Marcantonio, 68, *69*
Rainbow roll, 35–36, 185
Rapp, Gottlob Heinrich von, 192
Rauschenberg, Robert, 146, 198, 237, *301, 305*
Rayo, Omar, 236
Réaumur, René Antoine Ferchault de, 280
Reddy, Krishna, 74, 127, *127,* 130
Redon, Odilon, 194, *195, 231*
Reducers, *184*
Reduction prints, 8, 28, 33, 185
Register frame, 30
Registration, intaglio, 123–27; Japanese method of, 41; litho-graph, 225–27, 232; screen print, 154–56, 187; woodcut, 30–33, 41
Relief etching, 46–49; linoleum, 46–47; zinc plate, 47–49
Relief prints, 1–56; adhesives for, 56; cardboard, 8, 32, 33, 51–52; collage, 49–52; embossed, 49; etching, 46–49; hardboard panel, 53; health hazards, 327; history of, 1–8; linocut, 46–47; plaster block, 54–56; for school print-making, 334–36; stamping, 54; woodcut, 9–42; wood engraving, 4, 9, 42–45
Rembrandt van Rijn, 66, 69–70, 70, 75, 82, 96, 246, 247
Renoir, Auguste, 194
Repoussage, 88
Reproduction rights, 317–19
Resist stencils; *see* Block-out stencils
Respirators, 323

Restrikes, 307
Retarders, 169, 184
Retroussage, 248
Rettich, Jerome, *190*
Reuter, Wilhelm, 192
Reuwich, Erhardt, 3, *5*
Reyes, Christina, *336*
Risseeuw, John, *280*
Rivera, Diego, 7
Rivers, Larry, 74, 198
Rivets, 139
Robert, Nicholas-Louis, 280
Roche, Pierre, 132, *132*, 236
Rocker, mezzotint, 70, 75, 86–87
Rodin, August, 83
Roller prints, offset, 331
Rollers, 14–15; gelatin, 14, 15, 90;
 leather, 14, 207, 218; linoleum,
 90; for lithographs, 218; Lucite,
 14; paint, 113; plastic, 14, 15, 112;
 Plexiglas, 15; rubber, 14, 15, 112
Romano, Clare, 8, 25, 53, *64*, 133,
 134, 319
Roosevelt, Franklin D., 145
Rose, Mary Ann, 319
Rosenquist, James, 75, 145, 198,
 284, 302
Rosin, for aquatint, 98–102; for
 deep etching, 48; for false biting,
 95; in lift ground, 105; in liquid
 hard ground, 89; in stop-out
 varnish, 92
Rosin dust-bag method, 98
Rosin dust-box method, 98–99
Ross, John, 8, *60*, *61*, *131*, 133, *136*
Ross, Tim, *16*, *54*
Rothenstein, Michael, 8
Rouault, Georges, 72, 249, 296
Roulette wheel, mezzotint, 87
Rowlandson, Thomas, 71
Rubber cement, 138
Rubber tile, 136
Rubbing tools, 15–16
Rupert, Prince, 70

Sacilotto, Deli, 317
Saff, Donald, 266, 317
Salle, David, 29
Samaras, Lucas, 146
Sanchez, Maurice, 316
Sand, for collagraphs, 139
Sandpaper, aquatint, 102; for
 beveling, 81; for collagraph
 tonality, 139; for polishing, 88; for
 squeegee blades, 154
Scanners, 271
Schäffer, Jacob, 280
Schanker, Louis, 7
Schapiro, Miriam, *211*
Schlemmer, Oskar, 249
Schmid, Simon, 191
Schmidt-Rottluff, Karl, 7, 195
Schongauer, Ludwig, 3
Schongauer, Martin, 3, *66*, *67*
School prints, 329–36; acetate, 335;
 cardboard, 332; collage, 333–34;
 glue, 335; intaglio, 336; linocut,
 334–35; monotype, 330–31;
 object, 331; offset roller, 331–32;
 paper plate lithograph, 336;
 stamped, 335–36; stencil, 333;
 Styrofoam, 333; 3M vinyl, 335;
 woodcut, 334–35
Schrag, Karl, 250, *251*
Schwarz, Reiner, *219*
Schwass-Drew, Laurel, *325*
Schwieger, C. Robert, *216*
Schwitters, Kurt, 132, *132*
Scoop coater, 157
Scorpers, 43, 44
Scrapers, 87–88
Screen, 147–53; alignment blocks,
 152; baseboard, 152; cleaning,
 172, 186; fabric stretching,
 149–51; frame construction,
 147–48; raising devices, 153;
 shellac, 151–52; taping, 151
Screen printing, 143–90; of books,
 293; equipment, 147–56, 157,
 172; fabric for, 149–51; on fabric,
 187–88; on glass, 189; health

hazards, 327; history of, 143–46;
 oil-based ink methods, 172–90,
 341; paper, 170; *pochoir* process,
 189–90; printing, 170–72,
 182–85; register guides, 154–56;
 screen construction, 147–53;
 squeegee, 153–54; stencil
 techniques, 156, 157–68, 172–82,
 189–90; water-based ink methods,
 156–72, 340; on wood, 188
Seghers, Hercules, 69, 72, 75, 246
Selectasine method, 144
Senefelder, Alois, 191–92, 194, 195
Serigraph, 145; *see* Screen printing
Sewn prints, 243–44
Shahn, Ben, 145
Sharaku, 4
Sharkey, Lorelei, *334*
Sheeler, Charles, 196–97
Shellac, for block-out stencils, 156,
 174, 175–76; for collagraphs, 138;
 for lithographic tone reversals,
 227–28; as sealant in screen
 printing, 147, 151–52
Sheridan, Sonia, 267
Shields, Alan, 236, 237
Shipping, 312
Shrink-wrapping, 310
Shunsho, 49
Siegen von, Ludwig, 70
Signature, 307
Silk, 149
Simca Print Artists, 317
Simon, Samuel, 144
Sims, Marian, *187*
Sinha, Nandini, *332*
Siqueiros, David Alfaro, 7
Sizing, paper, 39–40, 286; screens,
 175–77
Slevogt, Max, 195
Sloan, John, 74, *74*
Smith, Dolph, 286
Smith, Keith, 267
Smoking, hard ground, 91
Sodium hydroxide, 46–47
Soft-ground etching, 75–76, 96–97,
 108
Software, computer, 272–274
Solander case, 311
Soldering, 138
Solman, Joseph, 251
Solodkin, Judith, 222, *307*, 316
Solo Press, 82, 220, 221, 291, 316
Solvents, 184; health hazards, 326,
 328
Solvent technique, 36
Sorman, Steven, 20, *216*, 306
Sowanick, Kira, 309
Spit bite, 107–08
Spit stickers, 43
Split font, 35, 185
Spray-paint aquatint, 100
Squeegee, 143, 147, 153–54, 157;
 sharpening, 154
Stack, Dan, 82
Staging-ink ground, 91
Stahlecker, Bonnie, 287
Stamping, 54, 335–36
Stasack, Edward, 133, *134*
State proof, 306
Steel engravings, 79
Steg, James, 133
Stella, Frank, 8, *8*, 35, 57, 63, 75,
 119, 236, 237, 274, 275, 281,
 297, 306
Stencils, block-out, 162–69,
 174–76; for impasto, 179; in
 intaglio, 120–21; lacquer film,
 159–60, 181; Mylar and tape,
 158–59; for oil-based ink, 172–82,
 189–90; paper, 157–58, 172–74;
 photographic, 163–69, 179–82;
 pochoir, 189–90; resist, 162–63,
 176–79; in school printmaking,
 333; for water-based inks, 157–69;
 water-soluble, 160–62
Sternberg, Harry, 145, *146*
Stones, lithograph, 199–202,
 221–23; grinding, 200–02;
 heated, 229; preparing, 199–200
Stop-out varnish, 92, 95

Storage, of prints, 311–12
Stothard, James, 192
Stothard, Thomas, 195
Strianese, Tom, 283
Strunck, Juergen, 58, 257
Styria Studio, 189, 317
Styrofoam prints, 333
Sulfuric acid, 94, 326
Sumi ink, 37, 38, 40
Summer, Evan, 76
Summers, Carol, 8, 36, *36*
Suppliers, 337–39
Surface roll, 118
Surrealists, 194
Sutherland, Ivan, 270
Swift, Dick, 15
Sylvan Cole Gallery, 314
Symbolist poets, 194

Tag paper, 190
Tamarind Lithography Workshop,
 75, 197, 316
Tape, for collagraph texture, 140; for
 matting, 308, 309; for screen, 151,
 157; stencil, 159
Tarlatan, 84, 114, 118
Taxes, 319–20
Template registration, 125–26
Textile printing, 144, 187–88,
 243–44
Texture, aquatint, 98; collagraph,
 139–42; linocut, 46; lithograph,
 203, 204–05; screen print, 162,
 163, 175, 177, 179; soft-ground,
 96–97; woodcut, 10, 14, 21, 35
Thermal printer, 276
Thiebaud, Wayne, 58, 251
3M vinyl prints, 335
Thunberg, Carl Peter, 4
Tiepolo, Giovanni Battista, 71
Tilson, Joe, 198, 259
Tinting, in woodcuts, 17
Tint tools, 43
Titian, 4
Toishi, 37
Tone, aquatint, 98, 100–02, 106–
 08; collagraph, 133, 139–42;
 engraving, 86; etching, 70–72,
 74; from hand printing, 24;
 mezzotint, 86–87; photographic,
 260
Toners, 183
Toulouse-Lautrec, Henri de, 6, 194,
 212, 248
Tracing-paper transfer, for block-out
 stencils, 175; for collagraph, 133;
 for drypoint, 83; for multiple-
 plate images, 124; for woodcut, 20
Tran, Daihue, *168*
Transfer methods, collagraph, 133,
 226; film transparency, 259–62;
 intaglio, 83, 126–27; lithograph,
 206–07, 226, 229–34; monotype,
 245, 252–58; screen print,
 163–69, 181–82; woodcut, 18–20;
 wood engraving, 44
Transparencies, film, 260–62; for
 screen prints, 163–64
Transparent base, for oil based inks,
 33–34, 35, 184, 189, 220, 225;
 for water-based inks, 169
Trapped-paper registration, 125
Trapping, of color, 31
Trays, acid, 94–95; water, 109–10
Trestle Editions, 317
Trial proof, 306
Trova, Ernest, 146
Tullis, Garner, 236; *see also* Garner
 Tullis Workshop
Tusche, lithographic, 202–03; in
 screen printing, 145, 147, 156,
 176–78
Tyler, Ken, 75, 119, 198, 237, 284,
 316
Tyler Graphics Ltd., 20, 32, 35, 119,
 283, 284, 306, 316
Tympan, 190, 217

Uchima, Ansei, 37, 39
Ukiyo-e, 2, 4–6, 12, 28, 37–42
Ulano, Joseph, 144
Ulano Amba film, 160–62, 164

Universal Limited Art Editions, 74,
 198, 316
Upson board, 136
Utamaro, 4, 49

Vacuum forming, 242
Vandercook press, 26–27, 47
van Gogh, Vincent, 6, 194
van Hoostraten, Samuel, 246
van Leyden, Lucas, 3, 68
van Vliet, Claire, *304*
Varley, John, 192
Varnish, overprinting, 184;
 polyurethane, 151–52
Vasarely, Victor, 146
Vat, for paper, 283
Velonis, Anthony, 145, *145*
Veneer collage print, 52
Ventilation, 322–23
Vibro-tool, 14, 83
Videodigitizers, 271
Videographics, 271
Villon, Jacques, 72, 249
Vinyl, inks, 183, 341; tiles, 136;
 wrapping, 309–10
Viscosity method, intaglio, 127–30
Visualizing paper stencil, 173
Visual Arts Research Institute, 266
von Bartsch, Adam, 247
Vuillard, Edouard, 194

Walker, Charles Alvah, 247
Walmsley, William, 198, *199*
Ward, Lynd, 42, 44, 45, *45*
Warhol, Andy, 143, 145, 259
Watercolor, crayon monoprint, 163;
 with woodcut, 28, 29, 37, 38
Watermark, 282
Wax, with collagraphs, 138; ground,
 95–96; liquid, 176, 178; proof,
 306
Wayne, June, 75, 197
Weishaupt, Franz, 194
Weldon, Dan, 200
Wengenroth, Stow, 197
Wesselmann, Tom, 278
West, Benjamin, 192
Whetstone, 37
Whistler, James Abbott McNeill, 6,
 72, 90, 196, 307
Whiting, 78
Wilson, Mark, 276, 299
Wiping, hand, 114–115; paper, 115
Wood, alignment blocks, 147, 152;
 for collage prints, 52–53; for
 engraving, 43; for Japanese
 woodcut method, 37; for screen
 printing, 188; for woodcuts, 9–10,
 37
Wood, Grant, 197, *197*
Woodcut, 2–42; color, 28–42;
 correcting, 22–23; cutting, 17–18,
 20–21; hand printing, 23–24;
 history of, 2–8; Japanese, 37–42;
 materials, 9–16; press printing,
 24–28; proofing, 21–22; for
 school printmaking, 334–35;
 transfer methods, 16–20
Wood engraving; *see* Engraving,
 wood
Works Progress Administration, 7,
 74, 145
Workstations, computer, 271
Worsager, Hyman, 145
Wrapping prints, 309–10

Xavier, Saint Francis, 4
Xerography; *see* Copier art

Yoshida, Toshi, 41, 42
Yoshikumi, Toyokawa, 5

Zaage, Herman, 99
Zelt, Martha, 279
Zinc plates, for collagraph, 136, 138;
 for intaglio, 75–76, 79, 82, 92–
 93, 95–96, 102; for lithograph,
 202, 208, 217, 222, 223; for
 photoetching, 262–64; for relief
 etching, 27, 47–49, 51
Zirke, Joe, 198